An Illustrated History of the Maṇḍala:
From Its Genesis to the *Kālacakratantra*

An Illustrated History of the Maṇḍala:
From Its Genesis
to the
Kālacakratantra

Kimiaki Tanaka

Wisdom

Wisdom Publications
199 Elm Street
Somerville, MA 02144 USA
wisdompubs.org

Library of Congress Cataloging-in-Publication Data
Names: Tanaka, Kimiaki, author.
Title: An illustrated history of the mandala: from its genesis to the
 Kalacakratantra / Kimiaki Tanaka.
Other titles: Indo ni okeru mandara no seiritsu to hatten. English
Description: Boston: Wisdom Publications, 2018. | English version of
 the author's dissertation, submitted to the University of Tokyo in
 2007, and published in 2010 by Shunjusha. | Includes bibliograph-
 ical references and index. |
Identifiers: LCCN 2017055299 (print) | LCCN 2018002765 (ebook) |
 ISBN 9781614292920 (ebook) | ISBN 9781614292784 (pbk.:
 alk. paper)
Subjects: LCSH: Mandala (Buddhism) | Tantric Buddhism—India. |
 Buddhist art and symbolism—India.
Classification: LCC BQ5125.M3 (ebook) | LCC BQ5125.M3 T356413
 2018 (print) | DDC 294.3/437—dc23
LC record available at https://lccn.loc.gov/2017055299

ISBN 978-1-61429-278-4 ebook ISBN 978-1-61429-292-0

22 21 20 19 18
5 4 3 2 1
Cover design by Jim Zaccaria.
Interior design by Gopa & Ted2, Inc.
Set in Diacritical Garmond Premier Pro 11.25/14.4.

Contents

List of Figures

Chapter 3: Maṇḍalas of the *Prajñāpāramitānayasūtra*

Chapter 4: The Emergence of the Vajradhātu-maṇḍala

Chapter 5: The Emergence of the Guhyasamāja-maṇḍala

Chapter 6: Maṇḍalas of the Mother Tantras

Chapter 7: The Maṇḍala of the *Kālacakratantra*

Chapter 8: The Development of the Maṇḍala and Its Philosophical Meaning

Foreword

While I was reading through *An Illustrated History of the Mandala: From Its Genesis to the Kālacakratantra* by Kimiaki Tanaka, I was reminded of a story told about Atisha (ca. 982–1042 CE), the Bengali prince become superb Buddhist teacher and great benefactor of Tibet, way back in the day. It is said that in his late twenties he was still a layman, an anointed prince, and also a good Buddhist scholar and practitioner—and then he had a vivid dream. A group of ḍākinīs (beautiful enlightened angels) approached him carrying a huge, ornate chest and asked him: "Are you interested in the Tantras?" His dream persona responded "Yes" enthusiastically. "We have some texts here, would you like to see them?" "Of course! Thank you!" In his dream he approached the chest and the ḍākinīs opened the cover for him to look inside. He was shocked. There were stacks of glowing texts, some in Sanskrit, some in alphabets he did not know. Those titles he could read he had never even heard of, and he reached eagerly into the chest. As soon as he did, they gracefully but firmly withdrew the chest and shut the lid, saying in celestial chorus, "If you would like to learn them, you must give up your princely leisure—go to Bodhgaya and become ordained as a monk—then you can study full time and really practice!" Upon awakening, the prince changed his life as he had been urged.

I think the reader of Dr. Tanaka's extraordinarily vast and deep magnum opus of the historical development of the Indic Buddhist Tantras will have an experience somewhat like that, just as I did. What a richness of mandalas! How far-reaching is Dr. Tanaka's study and analysis of those many mandalas! This is clearly a go-to work that no scholar specializing in the study of the Indo-Tibetan Buddhist Tantras can afford to ignore. I feel honored to write this brief foreword to it. In doing so, of course, I cannot pretend to be able to match Dr. Tanaka's immense scholarship in this field—his book is such a comprehensive compendium survey of the state of the art of modern scholarly study of this rich field. It is of immense value in orienting anyone who intends to delve deeper into any of the many Tantras he surveys.

One of the great virtues of the book is its lavish illustration with numerous photographs of works of Indic and Tibetan Buddhist art that visually support Dr. Tanaka's many insights into the sources and development of the mandala sciences and arts that unfolded over the 1,700 years of Indic Buddhist history and the subsequent eight centuries of Tibetan preservation, recovery, and further refinement of the traditions and practices. Particularly helpful are his many tables, charts, and diagrams that enable the reader to visualize the intricate details of the many Tantric mandalas in use in the tradition. I learned a lot in my first reading of the work, and hope to learn a lot more by focusing on specific chapters and following up on the many sources Tanaka cites.

Further, my enthusiasm for this work is intensified by my sense that Dr. Tanaka is aware

that modern studies of the Buddhist Tantras are still just in their beginnings. Dr. Tanaka comes from the Japanese scholarly tradition, masterfully combining philology, art historical and curatorial expertise, and Buddhist philosophical study. He occupies the summit of that tradition of secular Tantric study that stems from the Shingon school of Japanese Buddhism. Very significantly, he has a strong philological command of the fragmentary Sanskrit Tantric literature along with the voluminous Tibetan translations of Sanskrit works as well as the Tibetan critical scholarship on the tradition. He deploys his interdisciplinary knowledge to create this masterful summa of Indo-Tibetan Tantrism from this "modern," "art historical," and "historicist" point of view, only very subtly going deeper into the underling philosophy and practice.

The "modern" aspect has to do with the angle of viewpoint: he looks out on a complex scientific, artistic, spiritual, and social tradition from the "modern" vantage, from which the mandalas and Tantras are exotic and fascinating, among the doings of certain pre-modern people. The art historical aspect has to do with cataloguing in detail the many representations of beings—"deities"—such people thought of as higher beings. The historicist point of view is inherited from the Western culture, where things are ultimately to be understood as impersonal processes happening in a progressive time, from the original "genesis" to a kind of conclusion, an end of time. Fittingly, he finds the endpoint in the "Wheel of Time" (Kālachakra) Tantra mandala! The modern scholar feels she or he has understood something fully when it has been located in a timeline of the history of the cumulative actions of religious actors who themselves seem to live outside of history.

Actually, Tibetan scholars of recent centuries and the present are the heirs of the Indic Tantric scholars, artists, and yogic practitioners who have created, practiced, and sustained the Tantras for millennia (and still do). They also agree in a sense about the historical development of the esoteric Tantric element of Universal Vehicle Buddhism. But their sense of the history derives not from a cumulative process of development, but rather a cumulative process of revelation. That is, the Indo-Tibetan tradition assumes the source of all mandalas in the mind of a fully enlightened human being, a buddha ("enlightened") being who became something more than human by virtue of an expansion of consciousness in a super-realistic wisdom sense. That buddha being also fully understood the realities of time and space, knowing "history" as a process involving the repeated lifespans of evolving beings. That buddha being not only secured his/her/its own evolutionary transmutation into a perfectly liberated and effectively engaged state, but he/she/it also undertook compassion's responsibility to assist countless other interconnected beings to win their own freedom and success in an identically satisfactory manner, each one requiring its own evolutionary time. Such progression would never be a matter of mechanical fate, but could take more or less time, and the buddha being's responsibility is to see to it that it should be as short a time as possible for each, since suffering would rule them until they discovered their own beatific realities.

Hence the mandala of that sort of being is a representation of that being's existence as a community of beings, a field of beings, a holographic field in which each being fully exists in each other being, and yet each is uniquely him-, her-, or it-self. What is viewed by the modernist as an un-self-aware process, a random historical development, is viewed by the Indo-Tibetan scholar-adept (*paṇḍitasiddha*, *mkhas grub*) as a directed unfolding of a vision of a suffering-free communal life of beings constantly present through a continuum of

rebirths, intially hiding its presence and gradually manifesting itself more and more openly to the more and more beings entangled in it.

I find this interior view to underly Dr. Tanaka's most daring insight, I think quite unique, that the mandala itself derives from the sculptural and architectural tableaus of the earliest extant buddha-images always together with companion retinues. This clearly indicates to me the realm *from which* the richness of his work derives and *toward which* his insight points. After all, the ancient Indic sculptural constructions he presents in the photographs themselves model the actual presence of the living Buddha.

That is to say, Dr. Tanaka's insights *come from* and are supported by a scholarly literature (I like to call it a "Tantric Abhidharma," an "inner-scientific" tradition that is more technical, pychological, biological, and even neuroscientific than religious) accumulated over centuries in India and Tibet, only fragmentarily available in Indic languages but widely available in thousands of Tibetan works. He quotes Nāgārjuna, Āryadeva, Chandrakīrti, Abhayā-karagupta, Buddhashrījñānapada, and so on in India, and in Tibet expert scholars from the different orders, but especially from the great scholar-adept Tsongkhapa (1357–1419)—and these people are not unaware informants but are themselves members of a tradition of scientific and philosophical scholarship.

And Dr. Tanaka's insights point *toward* the enormous literature contained in the Tibetan Tengyur collection of translations of Indian "Tantric Abhidharmic" works and their Tibetan commentaries and analytic treatises, and also ultimately *toward* the living tradition of adept scholar-practitioners who are still keeping the tradition alive in their own bodies and minds and in their own contemporary scholarly and scientific writings.

Prof. Tanaka is reserved about explicating what he has discovered, the point of all the complex mandalas and iconographic forms, coming to them in brief passages only at the end of his encyclopedic work, in his masterful chapter 8, "The Development of the Maṇḍala and Its Philosophical Meaning." He thereby clearly evinces his awareness that the *toward* he indicates is more than just a path for the scholarly specialists who are the immediate readership of his magnificent encyclopedia.

He hints at a path that might well be taken by a few of those in newer generations who will approach this realm of the mandala fields of highly evolved beings as scientists and explorers of the inner worlds of the human mind and body-brain, taking it in an existential way, as mattering in the great ocean of potential lifestyles and life forms.

I therefore heartily commend Dr. Tanaka on this admirable and significant work, which will remain as not only an encyclopedia for those wishing to catalogue the endeavors of Indic and Tibetan Tantric adepts and scholars but also an elegant and reliable portal into the realities of the mandala fields as the hi-tech evolutionary technologies that they are.

<div align="right">

Robert A. F. Thurman
Jey Tsong Khapa Professor of Indo-Tibetan Buddhology, Columbia University
President, Tibet House US, President, American Institute of Buddhist Studies,
Columbia Center for Buddhist Studies, New York City
March 31, 2018

</div>

Introduction: What Is the Maṇḍala?

1. The Definition of the Maṇḍala

T HE AIM OF THIS BOOK is to clarify the history of the genesis and development of the maṇḍala from the fifth and sixth centuries, when the archetype of the maṇḍala appeared in India, down to the eleventh century, when the *Kālacakratantra* appeared just before the disappearance of Buddhism in India. Accordingly, I must first briefly define the maṇḍala.

In Japan, the maṇḍala has been represented by the twin maṇḍalas of the two worlds (*ryōkai mandara* or *ryōbu mandara*),[1] consisting of the Garbha (Taizō) and Vajradhātu (Kongōkai) maṇḍalas introduced by Kūkai in the early ninth century. The Garbha-maṇḍala expounded in the *Vairocanābhisambodhisūtra* and the Vajradhātu-maṇḍala expounded in the *Sarvatathāgatatattvasaṃgraha* have played important roles in the development of the maṇḍala. In India, however, these two maṇḍalas came into existence independently and were not treated as a pair. Therefore the Sino-Japanese view of the maṇḍala, centered on these two maṇḍalas, is not applicable to India.

The maṇḍalas of late tantric Buddhism, which rapidly developed from the ninth century, were transmitted to Nepal—the only country on the Indian subcontinent where traditional Mahāyāna Buddhism still survives—and to Tibet, the faithful successor to Indian Mahāyāna Buddhism. Tibetan Buddhism, in particular, still preserves more than one hundred representative maṇḍalas of Indian Buddhism, ranging from those of its early stages to those of late tantric Buddhism.[2] However, their shape has been unified in a layout in which a square pavilion is encompassed by an outer protective circle that is not represented in Sino-Japanese maṇḍalas, and even maṇḍalas belonging to early esoteric Buddhism are depicted in accordance with this layout.[3] Therefore the landscape maṇḍalas of Japanese esoteric Buddhism and the maṇḍalas of the eighth to ninth centuries discovered at Dunhuang, China, not being encompassed by circles, do not fall under the maṇḍala as defined in Tibet and Nepal.

For example, Mori Masahide[4] has written of the reliefs of the eight great bodhisattvas in Ellora Cave 12 that "if they are maṇḍalas, they should be encompassed by circles, but they are not,"[5] and he rejects the view that they are maṇḍalas. His opinion accords with the common conception of Tibetan and Nepalese maṇḍalas. But if we were to strictly apply this definition to Sino-Japanese maṇḍalas, not only early landscape maṇḍalas but even the two-world maṇḍalas would end up not being maṇḍalas, since they do not have an outer protective circle, and the concentric arrangement of deities is also not seen in Sino-Japanese maṇḍalas, except in the *shiki-mandara* (used in esoteric rites of initiation and spread out like a carpet on top of a wooden altar).

Thus it is very difficult to define the maṇḍala in a way that is applicable to all examples of maṇḍalas ranging from the earliest stages to late tantric Buddhism. Here, I define a maṇḍala as an icon that represents the worldview of Buddhism, or Buddhist cosmology and philosophy, by arranging Buddhist deities in accordance with a specific pattern.

Therefore even if an icon arranges many deities around a buddha, but presents only a bird's-eye view of the assembly and has no specific pattern, we will not regard it as a maṇḍala. In Japan, there are several maṇḍalas of Pure Land Buddhism and of the syncretic fusion of Shinto and Buddhism (*shinbutsu shūgō*) that present a bird's-eye view of a particular landscape but have no specific pattern. These maṇḍalas of Japanese origin will not be considered in this book, since we are concerned primarily with the genesis and development of the maṇḍala in India.

An important characteristic of the maṇḍala is that it represents Buddhist cosmology or philosophy by assigning categories of Buddhist doctrine to the deities depicted in the maṇḍala or to parts of the maṇḍala's pavilion. Maṇḍalas arranged in specific geometric patterns did not come into existence all at once. The assignment of doctrinal categories such as the five aggregates (*pañcaskandha*), four elements (*caturmahābhūta*), and twelve sense fields (*dvādaśāyatana*) to the deities arranged in a maṇḍala makes it possible to symbolize Buddhist ideas by means of specific geometric patterns. Such symbolism gradually evolved with the development of Buddhist philosophy and art.

For example, in Bamiyan Caves Jd (388) and Ed (222) (regrettably destroyed by the Taliban), there existed ceiling paintings of Maitreya surrounded by numerous buddhas seated concentrically. According to radiocarbon dating, Cave Jd was created between the mid-fifth and mid-sixth centuries,[6] and it can be regarded as a precursor of the maṇḍala with a geometric pattern. However, we are unable to identify each seated buddha, since they do not have any iconographically distinguishing features. Therefore it is difficult to say that these paintings symbolized particular Buddhist ideas. In this manner, even if an icon has a specific pattern, this alone does not allow us to call it a maṇḍala in the same sense as the maṇḍalas of esoteric Buddhism in later times.

Throughout this book we will see that the establishment of a one-to-one correspondence between deities and doctrinal categories occurred only after the emergence of the Yoga tantras from around the second half of the seventh century onward. Therefore, strictly speaking, the above definition cannot apply to early maṇḍalas either.

2. The History of Maṇḍala Studies in Japan

Next, I wish to briefly survey the history of maṇḍala studies in Japan. The study of the maṇḍala in Japan has enjoyed a history of twelve hundred years since the introduction of the maṇḍala at the start of the Heian period in the early ninth century. From the tenth to twelfth centuries in particular the study of esoteric ritual and iconography reached a peak, and many works on the two-world maṇḍalas and other maṇḍalas were composed. Thereafter, through to the eighteenth century, the study of esoteric iconography stagnated owing to a decline in the social demand for esoteric rituals. In such circumstances, the production of the Genroku edition of the two-world maṇḍalas by Kōgen (1638–1702) of Ninnaji temple and Sōkaku (1637–1720) of Kushūon'in was a notable project that aimed to reproduce the original two-world maṇḍalas brought back by Kūkai.[7] The two-world maṇḍalas of the

Shin'an subbranch of the Shingon sect[8] produced by Jōgon (1639–1702), on the other hand, were an attempt to restore the two-world maṇḍalas on the basis of textual sources without placing absolute trust in Kūkai's version. These two maṇḍala projects represented a return to the classics, a scholastic trend of the early modern Edo period, even though they ended up moving in the opposite direction.

After the Meiji Restoration in 1868, the critical study of Buddhism began in Japan with the introduction of the scientific methods of the West. However, the study of esoteric Buddhism was not easily modernized, since its subject matter was itself exclusionary.

When the first course on Buddhism was established at the former Tokyo Imperial University, there was some debate about whether it was appropriate to give lectures on a specific religion at a national university. The course was accordingly called "Indian Philosophy," since Buddhism had originated in India. Since then, the prevailing view in departments of Indian philosophy has been that the proper way to study Buddhism is through a philosophical approach and that ritual, art, the administration of religious orders, and so on are not suitable subjects for Buddhist studies. The maṇḍala was considered to be a subject suited to departments of art history, since it is a pictorial representation even though it symbolizes Buddhist philosophy.

On Mount Kōya (Kōyasan), the seat of the head temple of the Shingon sect, there was established a hierarchy of *gakuryo*, or monks who engaged in doctrinal study, *gyōnin*, or practitioners of esoteric Buddhism, and *hijiri*, who collected donations through proselytization. I was once told by the late Professor Horiuchi Kanjin of Kōyasan University that there is a saying on Mount Kōya that *siddham* (Sanskrit calligraphy) and *shōmyō* (liturgical chanting) are for foolish monks. In other words, the study of Sanskrit calligraphy and religious art as represented by liturgical chanting should be entrusted to dull-witted monks, while *gakuryo*, or elite monks, should engage in doctrinal studies. Even today many researchers at universities established by Buddhist sects do not study esoteric ritual and iconography. While this may be partly because open discussion of ritual and so on is regarded as a violation of a practitioner's vows (*samaya*), it would also seem to reflect the tradition of an emphasis on doctrinal studies.

It is thus significant that two pioneers in the study of esoteric Buddhist iconography appeared not among esoteric scholar-priests but among art historians, namely, Ōmura Seigai (1868–1927) and Ono Genmyō (1883–1939), the latter of whom belonged to the Jōdo sect. Ōmura published the first scientific study of esoteric Buddhism (*Mikkyō hattatsushi*) in 1918 and was awarded the Japan Academy Prize for it. He was, however, harshly criticized by scholar-priests of the Shingon sect.

Meanwhile, on Mount Kōya there appeared Toganoo Shōun (1881–1953), who, responding to scientific criticism, not only bolstered the traditional doctrines of esoteric Buddhism but also began to reconstruct the original form of esoteric Buddhism in India by utilizing the Tibetan Tripiṭaka that had recently been brought to Japan.[9] He decided to publish a series of studies on esoteric ritual that had until then been transmitted secretly, and his publications on the maṇḍala (1927), the *Prajñāpāramitānayasūtra* (1930), and esoteric Buddhist ritual (1935) are still consulted today. It is also worth noting that he nurtured successors such as Sakai Shinten (1907–88) and Horiuchi Kanjin (1912–97), who, utilizing Sanskrit and Tibetan materials, have led the study of esoteric Buddhism in Japan.

Basing himself on Tibetan materials and archaeological discoveries, Toganoo argued

for the existence of the eighteen tantras of the Vajraśekhara cycle in 100,000 stanzas that Ōmura had rejected as a fiction. The task of identifying the second and other tantras of the Vajraśekhara cycle was carried out mainly by his successor, Sakai, and some of these will be discussed in detail in later chapters of this book.

Thus in prewar Japan the study of the maṇḍala was carried out by art historians not affiliated to religious orders and by scholar-priests belonging to esoteric Buddhism. Ōmura was on friendly terms with Gonda Raifu, one of the leaders of the Buzan subbranch of the Shingi Shingon lineage, while Ono delivered lectures at Kōyasan University. Thus the relationship between art historians not affiliated to religious orders and scholar-priests of the Shingon and Tendai schools was not always antagonistic. There is, however, a sharp contrast between the art-historical and iconographical approach of an outsider and the traditional doctrinal and philosophical approach of a scholar-priest belonging to a religious order.

After World War II, the circumstances of maṇḍala studies did not immediately change. In 1970 Matsunaga Yūkei was appointed professor at Kōyasan University. He had studied under Hadano Hakuyū at Tōhoku University and introduced modern textual criticism to Kōyasan University. Hadano was well known as an authority on Tibetan studies, but he also published many important articles on Indian esoteric Buddhism, most of which are included in volume 3 of his collected works (1987). Hadano's research on Indian esoteric Budhism was continued mainly by Matsunaga, whose critical edition of the *Guhyasamāja-tantra* (1978) and history of the establishment of esoteric Buddhist scriptures (1980) became pioneering works in Japanese research on late tantric Buddhism, for he drew attention to the *Guhyasamājatantra* and its explanatory tantras, in contrast to earlier Japanese research on Indian esoteric Buddhism, which had ended with the emergence of the *Vairocanābhisambodhisūtra* and *Sarvatathāgatatattvasaṃgraha*.

The study of the Mother tantras, on the other hand, had to await the advent of Tsuda Shin'ichi, who published many studies on these tantras, centered on the Saṃvara cycle. Apart from several pioneering studies by Toganoo and Hadano, Japanese research on the *Kālacakratantra* began with my *Chō mikkyō: Jirin tantora* (1994).

Among other scholars of esoteric Buddhism affiliated to the Shingon sect, Yamamoto Chikyō introduced Giuseppe Tucci's *Theory and Practice of the Mandala*[10] to Japanese readers for the first time, while Takata Ninkaku published partial Japanese translations of the *Sngags rim chen mo* by Tsongkhapa (1357–1419) and the *Rgyud sde spyi'i rnam par gzhag pa* by Khedrup Jé (1385–1438).[11] Kitamura Taidō undertook investigations of Gyüme Tantric College in exile and published, in collaboration with Tsultrim Kelsang Khangkar, studies and translations of many esoteric Buddhist texts of the Geluk school. These scholar-priests also published articles on the maṇḍala, and in particular Kitamura's efforts to bring Tibetan maṇḍalas to the notice of the general public through his curating of exhibitions of Tibetan art and so on deserve special mention.

In the field of art history, meanwhile, Sawa Ryūken (1911–83), Takata Osamu (1907–2006), Yanagisawa Taka (1926–2003), and Ishida Hisatoyo (1922–2016) published studies on the maṇḍala. Sawa Ryūken not only made an outstanding contribution to Japanese research on esoteric Buddhist iconography but also initiated the exploration of medieval Indian Buddhist sites in India, the cradle of esoteric Buddhist art. His research on Indian esoteric Buddhist iconography was continued by Yoritomo Motohiro (1945–2015), who participated in Sawa's expeditions, and others.

Takata Osamu, famous for his study of the origins of buddha statues (1967), was the only graduate of a department of Indian philosophy among the art historians mentioned above. He also made an enormous contribution to the field of maṇḍala studies with, for example, a study of wall paintings of the two-world maṇḍalas in the five-storied pagoda of Daigoji temple and made public for the first time three sets of two-world maṇḍalas—version A, version B, and the Einin version—discovered in the attic of the treasury at Tōji in 1954. Furthermore, no art historian other than Takata, who had a thorough knowledge of Sanskrit, would have been able to write about the Sanskrit inscriptions in the *Gobu shinkan* (1954).

It would be safe to say that *Mandara no kenkyū* (1975) by Ishida Hisatoyo is the most important work in the history of Japanese research on the maṇḍala. The *Taizō kyūzuyō*, an old scroll drawing of the Garbha-maṇḍala thought to have been transmitted by Vajrabodhi and Amoghavajra, shows major differences in the arrangement and iconography of its deities when compared with the present version of the Garbha-maṇḍala (*Genzu*) and *Taizō zuzō*, another old scroll drawing of the Garbha-maṇḍala attributed to Śubhākarasiṃha. Ishida discovered that these differences originated in misidentifications of deities by Enchin (814–891), who had brought the original version of the *Taizō kyūzuyō* to Japan, and he corrected the names of the deities. It now became possible to compare four versions of the Garbha-maṇḍala: *Genzu*, *Taizō kyūzuyō*, *Taizō zuzō*, and *Daihi taizō sanmaya mandara*, the last being a version of the *Taizō zuzō* in which the deities are represented by symbols (*samaya*). Ishida thus clarified the process whereby Huiguo (746–806) compiled the present version of the Garbha-maṇḍala with reference to earlier versions.

The above state of maṇḍala studies, when it was pursued by art historians not affiliated to religious orders and by scholar-priests of the Shingon and Tendai sects, did not change until the 1980s. However, after the establishment of the Association for the Study of Buddhist Iconography in 1982 the situation gradually changed. It is significant that the first chairman, Sawa Ryūken, the former chairman, Yoritomi Motohiro (who was a member of the initial managing committee), and Tamura Ryūshō, who was a member of the initial managing committee and was later appointed vice chairman (1988) and chairman (1990), while all belonging to the Shingon sect, specialized in Buddhist art. These priests-cum-art-historians helped to bring together scholars of esoteric Buddhism and art historians, who had until then been conducting their research separately, and the Association for the Study of Buddhist Iconography has provided an opportunity for both groups to exchange views and information.

In 1990 Yoritomi published a monumental study that reconstructed the history of the origins and development of groupings of four or five buddhas, the main components of the maṇḍala. This method of research was styled "deity history" (*sonkaku-shi*), and since then it has become customary among Japanese scholars to refer to all deities of Buddhism, including buddhas, bodhisattvas, wrathful deities, and protective deities, as *sonkaku*.

Tachikawa Musashi, meanwhile, who started his career as a researcher of Mādhyamika philosophy, was closely involved in the publication of *Tibetan Maṇḍalas: The Ngor Collection* (1983). He not only taught at Nagoya University but also directed many research projects and exhibitions based at the National Museum of Ethnology in Osaka. He deserves high recognition for having given many young scholars the chance to conduct research and present the results of their research.

The next generation after Yoritomi and Tachikawa is scholars born in the 1950s and 1960s. They include myself, Noguchi Keiya (Taishō University), Okuyama Naoji (Kōyasan University), and Shimada Shigeki (Tōyō University), followed by Sakurai Munenobu (Tōhoku University) and Mori Masahide (Kanazawa University). Although these scholars specialize in Indo-Tibetan esoteric Buddhism, they have an interest in the maṇḍala and have published many books and articles on the subject.

Among art historians, studies by Matsubara Satomi (Waseda University), who has published a series of articles on the *Shosetsu fudōki* by Shinjaku (886–927), an imperial prince who became a monk, and by Tsuda Tetsuei (National Research Institute for Cultural Properties, Tokyo) merit attention. However, in recent years research on the maṇḍala among art historians has been generally sluggish, and their interest would seem to have shifted from the maṇḍala to Buddhist iconography in general and to the iconography of secular art. This means that it is impossible to go beyond Ishida's monumental work by relying solely on Japanese source materials.

Mori has divided the development of maṇḍala studies in Japan into five periods: (1) the dawn of maṇḍala studies (up to 1955), (2) the age of the publication of pictorial materials (ca. 1955–75), (3) the age of the impact from abroad (ca. 1975–85), (4) the age of synthesis and interpretation (1985–95), and (5) the new age (1995–). While I have no objections regarding the dawn of maṇḍala studies, I cannot accept his dating of the age of the publication of pictorial materials to ca. 1955–75, for the publication of pictorial materials started with Ōmura's *Sanpon ryōbu mandarashū* (1913), which reproduced three important versions of the two-world maṇḍalas (Takao, Kojima, and Tōji versions), and even after 1975 there have appeared important pictorial publications, such as Shinbo Tōru's *Besson mandara* (1985).

I agree with Mori that a major turning point in maṇḍala studies after World War II occurred in 1975. This was, however, because Ishida's *Mandara no kenkyū* was published in this year, and the series of studies that ultimately culminated in this book began with an article published in 1962. Also around this time there appeared in addition to Takata's above-mentioned study of the *Gobu shinkan* his study of the murals of the five-storied pagoda at Daigoji (1959) and an article on Tōji's two-world maṇḍalas (1961), Yanagisawa's study of a line-drawn version of the Vajradhātu-maṇḍala (1966), and a study of the Takao maṇḍalas brought out by the National Research Institute for Cultural Properties (Tōkyō Kokuritsu Bunkazai Kenkyūjo 1967). As a result of these publications, basic research on most of the important examples of painted and line-drawn maṇḍalas in Japan had now appeared, and therefore the years 1955–75 can be regarded as the age of consolidation in the study of Japanese maṇḍalas.

The impact from abroad began with Sawa's *Mikkyō bijutsu no genzō* (1982), which brought the news of the discovery of esoteric icons belonging to the Vairocanābhisambodhi cycle in Orissa, and the exhibition "Mandara no shutsugen to shōmetsu" (Maṇḍala: Now You See, Now You Don't) held at Seibu Museum in 1980, where a Tibetan sand maṇḍala was shown to the public for the first time. An exhibition of the Ngor maṇḍalas at Laforet Museum (1982) was followed by the publication of the Ngor maṇḍalas by Kōdansha in 1983. In 1985, a comprehensive study of the maṇḍala murals in Alchi monastery, Ladakh, was published (Katō et al. 1985). Therefore the impact from abroad should be set from 1980 to 1985, when several large events were staged in Japan to introduce Tibetan maṇḍalas to the Japanese public. Several Tibetan maṇḍalas, most of them block prints, had already been brought to

Japan by Kawaguchi Ekai (1866–1945), Tada Tōkan (1890–1967), and others, but full-scale research on the Tibetan maṇḍala began only after this period.

Next, the age of synthesis and interpretation (1985–95) and the new age (1995–) are somewhat ambiguous, since Mori's criteria are unclear. In 1987 my *Mandara ikonoroji* was published. Although this book was written for the general public, it also aimed to reconstruct the historical development of the maṇḍala through a comparison of Japanese and Tibetan maṇḍalas, which had until then been studied separately. Therefore it might be considered as an example of synthesis and interpretation, albeit in a sense different from Mori's original intention. The present book, too, is intended to further advance this method of research on the basis of archaeological and textual discoveries of recent years.

Mori further maintained that the new age started around 1995. An epoch-making work of this new age may be Sakurai Munenobu's study of the rituals of Indian esoteric Buddhism (1996). Around the same time, several other scholars such as Moriguchi Mitsutoshi, Inui Hitoshi, Tanemura Ryūgen, and Mori himself embarked on the study of the ritual texts of esoteric Buddhism. It goes without saying that in these ritual texts the maṇḍala plays a very important role. But because such ritual texts focus not on iconography but on rituals in which the maṇḍala is used, this had been a field not of Indian philosophy but of religious studies.

Thus maṇḍala studies is a discipline spanning the fields of Indian philosophy, art history, and religious studies. Although there has been a tendency among researchers engaged in philosophical and doctrinal studies to eschew this discipline, it is to be hoped that in the future further advances will be made from fresh perspectives.

3. The History of Maṇḍala Studies in the West

As is indicated by the specific mention of the "impact from abroad" in Mori's periodization of maṇḍala studies in Japan, during the 1970s and 1980s the Tibetan maṇḍala was introduced to Japan from the West, where Tibetan Buddhism had been transmitted and a so-called maṇḍala boom had occurred. Accordingly, in this section I wish to survey the history of maṇḍala studies in the West.

The first encounter with the maṇḍala in the West may have been the exhibition of Émile Guimet's three-dimensional maṇḍala at the Paris World Exposition in 1878. It was exhibited at the Trocadéro and was favorably received by visitors. When Guimet visited Japan in 1876, he had been deeply impressed by the three-dimensional maṇḍala in the assembly hall (*kōdō*) at Tōji produced by Kūkai, and he had asked Yamamoto Mosuke, a Buddhist sculptor in Kyoto, to make a replica and ship it to France.[12]

The group of figures in the Tōji *kōdō* consists of twenty-one deities: five buddhas, five bodhisattvas, five *vidyārājas*, and Brahmā, Indra, and the four celestial kings. It was a three-dimensional maṇḍala based mainly on the *Ninnōkyō gohō shosonzu* (Illustrations of the Deities of the Five Directions in the *Renwang jing*), brought back to Japan by Kūkai. Guimet, however, omitted Brahmā and Indra and added the four bodhisattvas Samantabhadra, Mañjuśrī, Avalokiteśvara, and Maitreya, belonging not to the Vajradhātu cycle but to the Garbha cycle. This three-dimensional maṇḍala was exhibited in the Musée Guimet established by Guimet. But after his death it was put in storage and forgotten until it was repaired and put back on display in the annex on the Avenue d'Iéna. Guimet's maṇḍala was created

in the nineteenth century, and in spite of its iconographical value its artistic value is not very high.

Thus the first maṇḍala to be introduced to the West belonged to Japanese esoteric Buddhism. However, its influence was rather short-lived, and the full-scale introduction of the maṇḍala did not occur until the dissemination of Tibetan Buddhism in the West, which began with the exile of the leaders of Tibetan Buddhism, starting with the Fourteenth Dalai Lama, after the Tibetan uprising in 1959. However, there existed several pioneering works in the West before 1959.

The publication of *The Tibetan Book of the Dead* in 1927 by W. Y. Evans Wentz and Kazi Dawa Samdup paved the way for the transmission of Tibetan Buddhism to the West. *The Tibetan Book of the Dead* was a translation of the *Bar do thos grol*, part of the *Zhi khro dgongs pa rang grol*, a *gter ma* (or treasure) text on the one hundred peaceful and wrathful deities discovered by Karma Lingpa of the Nyingma school. As will be discussed in chapters 5 and 6, the one hundred peaceful and wrathful deities are a synthesis of the Vajradhātu-maṇḍala and deities of late tantric Buddhism of comparatively early origin appearing in the *Guhyasamājatantra* and *Sarvabuddhasamāyogatantra*. When a German translation of *The Tibetan Book of the Dead* was published in 1938, Carl Jung wrote a preface for it, and this marked the beginning of the introduction of the maṇḍala to the West.

After his break with Freud, Jung suffered from a mental disorder, seeing visions and hearing voices. In 1916, when his mental crisis was heading toward recovery, he drew his first maṇḍala. During World War I, he made it a daily habit to draw a cosmogram similar to a maṇḍala in his notebook. Later he discovered that similar figures were depicted by his patients, and so he came to use the maṇḍala in his psychoanalysis.

But it is highly questionable whether Jung possessed a correct understanding of the maṇḍala in Buddhism at this point.[13] Around 1916, when Jung drew his first maṇḍala, there hardly existed any reliable studies of the Buddhist maṇḍala in the West. Giuseppe Tucci's *Theory and Practice of the Mandala* (first published in Italian), a classic of maṇḍala studies in the West, did not appear until 1949.

Tucci was a great scholar familiar with the classics of the East, and he made a great contribution to the study of the Indo-Tibetan maṇḍala. But his *Theory and Practice of the Mandala* was written to elucidate the basic ideas of the traditional Oriental religions of Buddhism, Hinduism, and Taoism, and it is not an objective introduction to the Buddhist maṇḍala per se.

In addition, mention may be made of Lama Anagarika Govinda as a pioneer in introducing the maṇḍala to the West. A German, he started his career as a scholar studying Sanskrit and Pāli, but he later encountered Tibetan Buddhism in Darjeeling in British India and thereafter devoted himself to the esoteric Buddhism of Tibet.[14] Although he did not publish any independent study of the maṇḍala, his ideas about the maṇḍala are revealed in his *Foundations of Tibetan Mysticism* (1959), *Mandala: Der heilige Kreis* (1961), and *Psycho-Cosmic Symbolism of the Buddhist Stupa* (1976).

In the United States, meanwhile, we cannnot forget the contributions of Alex Wayman, who published together with his teacher, F. D. Lessing, *Mkhas Grub Rje's Fundamentals of the Buddhist Tantras*, later reprinted as *Introduction to the Buddhist Tantric Systems* (1968), which is a translation of Khedrup Jé's *Rgyud sde spyi'i rnam par gzhag pa* with copious annotations. It was the first introduction to Tibetan esoteric Buddhism faithful to an original

text. Wayman's *Buddhist Tantras* (1973) and *Yoga of the Guhyasamājatantra* (1977) are also widely read by students of Indo-Tibetan esoteric Buddhism.

Among more recent works, Martin Brauen's *Das Mandala* (1992) merits attention. For many years, Brauen worked as curator at the Ethnographic Museum in Zurich and played an important role when the Kālacakra initiation was held by the Fourteenth Dalai Lama at Rikon in 1985. Consequently this book explains the maṇḍala theory and cosmology of the *Kālacakratantra*. In 2002 Mori Masahide published a Japanese translation based on the English version of this book.

The above-mentioned studies of the maṇḍala by Western scholars tend to present the author's own interpretation of the maṇḍala rather than being scientific or objective studies based on textual sources. When the Indian religion of Buddhism was first introduced to China, Chinese intellectuals interpreted it in accordance with the concepts of Taoism with which they were familiar. This was styled *geyi* (concept-matching) Buddhism. Only one hundred years have passed since the maṇḍala was introduced to the West, and so it is perhaps inevitable that the interpretation of the maṇḍala in the West, with its cultural traditions completely different from those of the East, should have come to resemble concept-matching.

However, Tucci, Govinda, and Wayman were scholars familiar with the original texts of Indo-Tibetan Buddhism, and their knowledge was far more wide-ranging than is the case with Japanese scholars, among whom compartmentalization has prevailed, and it is a fact that their studies contain important points overlooked by Japanese scholars. In this book, the philosophical interpretation of the maṇḍala will be discussed in chapter 8.

4. Aims and Methods

In India, Buddhism fell into decline after the thirteenth century as a result of repeated Muslim invasions. Consequently examples of the maṇḍala have not survived in India apart from some exceptional cases to be discussed later. Therefore the maṇḍalas of Sino-Japanese esoteric Buddhism, which inherited the middle phase of Indian esoteric Buddhism dating from around the second half of the seventh century, are important exemplars of the maṇḍala. But even then it is not the present version of the two-world maṇḍalas created by Huiguo but older versions of the Garbha-maṇḍala and Vajradhātu-maṇḍala closer to the Indian originals, such as the *Taizō zuzō*, *Taizō kyūzuyō*, and *Gobu shinkan*, that provide our basic data.

Among the maṇḍalas of Tibeto-Nepalese Buddhism, which mainly inherited Indian late tantric Buddhism, on the other hand, examples from before the fifteenth century are important. In Tibet, the Geluk school established by Tsongkhapa in the early fifteenth century constituted the mainstream of Buddhism. In the tantric colleges of the Geluk school, the iconometry of the maṇḍala established by Tsongkhapa became an absolute authority, and since then standardized maṇḍalas have been produced. If we analyze examples pre-dating the fifteenth century, we notice that there existed various opinions about iconometry and the design of parts of the maṇḍala. Therefore we must examine Tibeto-Nepalese examples pre-dating Tsongkhapa in order to reconstruct the original form of the maṇḍala in India.

Examples of the maṇḍala have also been discovered in Dunhuang and Khara-khoto, both oasis towns along the Silk Road. There have been discovered several examples from Tang China and Xixia, while others date from the later Mongol empire. They are irreplaceable works for evoking the maṇḍala of former Chinese esoteric Buddhism.

The publication of books and articles on the maṇḍala requires a large number of illustrations. But it is sometimes difficult to include sufficient illustrations because of copyright issues. It was for this reason that I published *Maṇḍala Graphics* (2007, 2013) on the basis of an image database created by using computer graphics, in turn based on the *Vajrāvalī* and *Mitra brgya rtsa* maṇḍala sets held by the Hahn Cultural Foundation in Korea. If a maṇḍala mentioned in this book is included in these maṇḍala sets, the corresponding number (e.g., V-1 or M-16) has been added for reference.

As for textual sources, not only are the esoteric Buddhist scriptures and ritual manuals included in the Chinese and Tibetan canons important, but so are their Sanskrit originals, discovered mainly in Nepal and Tibet. When I embarked on the study of the maṇḍala in the 1970s, most of these Sanskrit texts had not yet been published, even when they were known to exist in manuscript form. Moreover, the number of texts for which diplomatic editions had been published was very small. Nowadays it is possible to refer to the original Sanskrit texts, since quite a number of esoteric Buddhist scriptures have been published.

In this regard, the former Central Institute of Higher Tibetan Studies (CIHTS, now known as the Central University of Tibetan Studies), established in 1967 by the government of India and the Fourteenth Dalai Lama, has played an important role. In addition, the Nepal-German Manuscript Preservation Project (NGMPP),[15] a joint project run by the government of Nepal and the German Oriental Society, has photographed large numbers of unidentified Sanskrit manuscripts and fragments in Nepal and made it possible to utilize them for research. The *Vajrācāryanayottama*, which includes Nāgabodhi's *Viṃśativididhi*, a work that will be cited frequently below, is a good example of such a manuscript photographed by the NGMPP. In Tibet, too, where much of its cultural heritage was lost during the Tibetan uprising in 1959 and the subsequent Cultural Revolution, precious Sanskrit manuscripts such as the *Amoghapāśakalparāja* have been discovered and are being edited.

In the study of Buddhist iconography such as the maṇḍala, it becomes important to elucidate the origins and character of individual deities. However, in the Chinese canon the standardization of deity names, even in the case of very popular deities, was not achieved until the translator Xuanzang (596/602–664) appeared. Thus it often happens that the name of the same deity is translated in different ways or the names of different deities are translated by the same name.

For example, Ākāśagarbha is usually translated as Xukongzang in Chinese. However, Xukongzang appearing in the *Daji xukongzang pusa suowen jing* turns out to be not Ākāśagarbha but Gaganagañja, judging from the corresponding Tibetan translation, the *Āryagaganagañjaparipṛcchā nāma mahāyānasūtra*. Gaganagañja is translated as Xukongku in Chinese translations of the *Prajñāpāramitānayasūtra* and *Sarvatathāgatatattvasaṃgraha* and, along with Ākāśagarbha, is counted as one of the eight great bodhisattvas of the *Prajñāpāramitānayasūtra*. It is clear, therefore, that Ākāśagarbha and Gaganagañja were considered to be different deities in India.[16]

On the other hand, it can be confirmed that the original Sanskrit of Xukongyun, a bodhisattva appearing in the *Xukongyun pusa jing*, was Ākāśagarbha from the corresponding Tibetan translation, the *Āryākāśagarbha nāma mahāyānasūtra*. Therefore Xukongyun is identical with Ākāśagarbha even though the Chinese translation is different.

Ākāśagarbha is referred to as Khagarbha in late tantric Buddhism after the *Guhyasamāja-*

tantra. This is because in the *Piṇḍīkrama*, belonging to the Ārya school of the *Guhyasamāja-tantra*, Ākāśagarbha is given as Khagarbha for metrical reasons. Therefore Ākāśagarbha and Khagarbha should be regarded as identical.

In this book, dealing with the history and development of the maṇḍala, it will be necessary to trace the names of deities not in their Chinese or Tibetan translations but back to the original Sanskrit. Until recently we were unable to ascertain the original names of deities, since the Sanskrit manuscripts of many Buddhist texts had not yet been discovered or published. As this situation has dramatically improved in recent years, I have tried to seek out the original Sanskrit equivalents of proper names frequently used in Sino-Japanese and Tibetan Buddhist iconography whenever possible. The historical study of the origins of a deity frequently makes it clear that a particular Mahāyāna sūtra influenced certain esoteric Buddhist scriptures and maṇḍalas.

Esoteric Buddhist literature explains many mudrās, mantras, and spells (*dhāraṇīs*). If we compare these mudrās and mantras, we notice that some esoteric Buddhist sūtras inherited those of certain preceding texts, while not referring at all to those of other, earlier texts. This fact enables us to classify esoteric Buddhist scriptures into several groups and to posit the historical development of esoteric Buddhism. A good example can be seen in the *Samāyoga-tantra*, which inherited the mantras of deities from the *Paramādyatantra*. This corroborates the hypothesis that the Mother tantras developed from the *Prajñāpāramitānayasūtra* cycle.

Chapter 3 of the *Sarvatathāgatatattvasaṃgraha* inherited the mudrās of deities belonging to the Lotus family from the *Amoghapāśakalparāja*. Japanese scholars used to think that there was a large gulf separating the Kriyā tantras, belonging to early esoteric Buddhism, and the Yoga tantras, starting with the *Sarvatathāgatatattvasaṃgraha*. But it turns out that the *Sarvatathāgatatattvasaṃgraha* adopted various elements of early esoteric Buddhism and rearranged them in accordance with the new system of five families and the thirty-seven deities of the Vajradhātu-maṇḍala.

Thus the aim of this book is to elucidate the historical development of esoteric Buddhism and the maṇḍala, paying particular attention to proper names, mudrās, and mantras, which have tended to be overlooked by scholars specializing in philosophy and doctrine.

I have previously published several books in which I mainly employed the methods of iconography, identifying a deity from the number of faces and arms, body color, and other attributes. Details of iconographical identification that have already been clarified in these earlier studies (to which the reader is alerted when appropriate) have not been explained in this book, since my purpose here is not to identify the deities in a maṇḍala but to elucidate the historical development of the maṇḍala.

The historical development of the maṇḍala used to be considered on the basis of the origins of the esoteric Buddhist scriptures that describe the maṇḍalas in question. However, the dates of a scripture and the maṇḍala described in it do not always coincide. For example, the *Mañjuśrīmūlakalpa* was thought to have originated in the second half of the eighth century, since a prophecy of the advent of king Gopāla, the founder of the Pāla dynasty, occurs in chapter 53 ("Rājyavyākaraṇaparivarta"). However, among the maṇḍalas of early esoteric Buddhism the maṇḍala described in the *Mañjuśrīmūlakalpa* preserves some early elements, for this maṇḍala is based on chapters 2–3 ("Maṇḍalavidhānaparivarta"), which pre-date the completion of the *Mañjuśrīmūlakalpa* itself.

The Vajrasattva-maṇḍala of the *Paramādyatantra* and the sixty-two-deity maṇḍala of

Cakrasaṃvara, on the other hand, cannot be depicted correctly without referring to commentaries and ritual manuals, since the description in the corresponding tantras is too succinct and tends to be misinterpreted. In these cases, the maṇḍala had not yet achieved its present style when the basic scripture came into existence.

Examples of such discrepancies between the description in the basic scripture and the current style of the maṇḍala are quite frequent and can be seen between the *Vairocanābhisambodhisūtra* and the current version of the Garbha-maṇḍala in Sino-Japanese Buddhism and between the *Guhyasamājatantra* and the maṇḍalas of the Ārya and Jñānapāda schools in India. Therefore it is not enough to consider the date of the basic scripture for reconstructing the historical development of the maṇḍala, and we must carefully compare examples of the maṇḍala and its texual sources.

There are some maṇḍalas that were once popular and frequently produced but later fell out of favor over time. The Garbha-maṇḍala is a good example of this. The decline of the Garbha-maṇḍala was due not to a change in popular tastes but to the appearance of the Vajradhātu-maṇḍala, which embodied a more sophisticated system. Later, the Vajradhātu-maṇḍala was forced into decline because of the great popularity of late tantric Buddhism, which occurred owing to the introduction of a revolutionary idea known as *skandhadhātvāyatana* (aggregates, elements, and sense fields) in the *Guhyasamājatantra*, which established the maṇḍala theory of late tantric Buddhism.

The *Kālacakratantra* was the last tantra to appear in India. It inherited the maṇḍala theory of the *Guhyasamājatantra*, although it modified the *Guhyasamāja* system to a considerable extent. This, too, did not reflect a change in popular tastes but was a means of integrating maṇḍala theory with the cosmology of Buddhism.

Thus the development of the maṇḍala has been due to its characteristic feature, namely, the fact that it symbolizes the Buddhist view of the world by means of particular patterns. The sole purpose of this book is to elucidate the process of the historical development of the maṇḍala, and toward this end I have employed a variety of means.

The practice of late tantric Buddhism consists of the generation stage (*utpattikrama*), in which the practitioner visualizes the deities of the maṇḍala and endeavors to unite with them, and the completion stage (*utpannakrama/niṣpannakrama*), which artificially induces mystical experiences through physiological yoga. The generation stage will be an important topic throughout this book, whereas the completion stage, which does not include visualization of the maṇḍala, will be mentioned only when necessary.

The final topic to be considered in this section is the relationship between the maṇḍala and Hinduism. Recently, with advances in the study of Hindu tantrism, it has come to light that there are many maṇḍalas and maṇḍala-like icons in Hinduism too. But whereas the chronology of esoteric Buddhism has already been established in half-century units on the basis of large numbers of Chinese and Tibetan materials, the chronology of Hindu tantras has not yet been so well established, since there are very few non-Indic materials on Hindu tantras.

As for relics, examples of Buddhist maṇḍalas can be seen in many parts of Asia from the ninth century onward. Most relics of Hindu maṇḍalas, on the other hand, are works of modern times, and examples that may date back to medieval times are very rare. Hinduism will be an important consideration in chapter 6, dealing with the Buddhist Mother tantras, which were strongly influenced by the Hindu Śākta tantras. But in other chapters the histor-

ical development of the maṇḍala has been elucidated as an autonomous process of evolution within Buddhism.

I am of the view that the maṇḍalas of Hinduism also developed from a simple to a more complex structure and toward greater consistency with Hindu ritual and doctrine. However, regarding historical developments, the development of the Buddhist maṇḍala, for which there exists an abundance of materials in many languages, will be clarified first. This is the reason this book deals exclusively with the Buddhist maṇḍala.

1. The Genesis of the Maṇḍala

1. Triads as Objects of Worship

IN ORDER TO ELUCIDATE the historical development of the maṇḍala from its genesis in India to its final stage, the *Kālacakratantra*, we need to know something about the history of Buddhist art in India. This chapter surveys the history of Indian Buddhist art from its origins to the appearance of the primitive form of the maṇḍala.

Buddhism has a long history of approximately 2,500 years, starting from the time of the Buddha Śākyamuni. The oldest extant examples of Buddhist art were produced in the second century BCE at Sanchi and Barhut, although initially images of the Buddha were not objects of worship.

The question of whether buddha images originated in Gandhāra, in modern-day Pakistan, or in Mathurā, in the modern Indian state of Uttar Pradesh, has been the subject of much debate among scholars. However, iconographically speaking, the influence of Gandharan iconography can be seen in early Mathuran sculpture,[17] and so it would seem natural to assume that Gandharan images slightly pre-dated those of Mathurā.

In Gandharan art, the triad was adopted as an object of worship from the earliest stage. On the lid of the well-known and controversial Kaniṣka Casket, the Buddha is flanked and worshiped by Brahmā and Indra. This combination is based on the legend of the Buddha's descent from Trayastrimśa Heaven, attended by Brahmā and Indra, after having preached to his deceased mother. It symbolizes the ascendancy of Buddhism over Brahmanism, which worships Hindu gods.

There are also frequent examples of a triad with two bodhisattvas. In many examples of Gandharan art, we cannot identify the attendant bodhisattvas because there is no inscription. However, many scholars identify the figures in this type of Gandharan triad as Śākyamuni, Maitreya (the future Buddha of this world), and Avalokiteśvara (the bodhisattva of compassion), a triad that continued to be reproduced until the Pāla dynasty (eighth to twelfth centuries), especially in eastern India. The reason seems to have been that this type of triad was the main image at the site of the Buddha's enlightenment, known as Vajrāsana and corresponding to present-day Mahābodhi Temple.[18]

A Buddha triad, dated to the twenty-third year of Kaniṣka's reign, has been unearthed at Ahichatra, the ancient capital of the kingdom of Northern Panchala in central India, that has a bodhisattva holding the buds of a lotus on the right side and Vajrapāṇi, a protective deity, on the left (fig. 1.1). It is debatable whether or not the bodhisattva holding lotus buds represents Avalokiteśvara, but since Avalokiteśvara appears as an important figure in

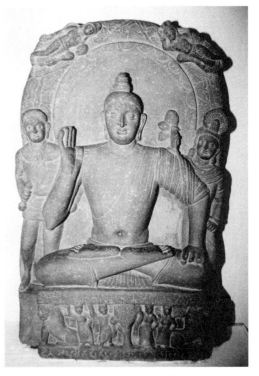

FIG. 1.1. BUDDHA TRIAD FROM AHICHATRA (NATIONAL MUSEUM, NEW DELHI)

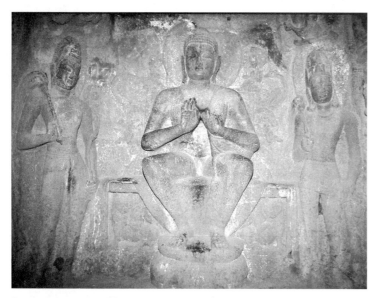

FIG. 1.2. BUDDHA TRIAD (CHAPEL 3, NASIK CAVE 23)

early Mahāyāna sūtras from the second century, it is possible that it is Avalokiteśvara.

In early Buddha triads, the iconography of the left and right attendants sometimes presents a contrast. For example, in the Gandharan triads mentioned above, Maitreya is generally rendered as a young Brahmin and Avalokiteśvara as a young warrior-king (*kṣatriya*). This is based on the prophecy that Maitreya, the future Buddha, will be born the son of a Brahmin when he appears on earth. In Mathuran triads, on the other hand, Avalokiteśvara is shown as a nobleman holding lotus buds and Vajrapāṇi as a *yakṣa* bodyguard with a snake around his neck.

In terms of philosophical ideas, when Avalokiteśvara appears flanking Amitābha in the Amitābha triad, he is said to represent Amitābha's compassion, while Mahāsthāmaprāpta represents his wisdom. In the triad consisting of Śākyamuni, Mañjuśrī, and Samantabhadra,[19] Mañjuśrī is said to represent Śākyamuni's wisdom, while Samantabhadra represents his practice (*caryā*) and vows (*praṇidhāna*), as these are the respective domains of these two bodhisattvas. It was thus customary to contrast attributes of the main deity by means of the iconography of the attendants.

In the post-Gupta period (500–750 CE), many triads with attendants who can be clearly identified iconographically as Avalokiteśvara and Vajrapāṇi were created in cave temples in western India. However, a Japanese scholar has presented a new interpretation of the most renowned example, Padmapāṇi and Vajrapāṇi in the wall painting of Cave 1 at Ajantā, suggesting that they are not bodhisattvas but gatekeepers.[20] There is a possibility that several examples, particularly triads in which the main deity forms the dharma-wheel mudrā (*dharmacakra[pravartana]-mudrā*) with both hands, represent Amitābha, Avalokiteśvara, and Mahāsthāmaprāpta, since in Tibet and Nepal Mahāsthāmaprāpta in the Amitābha triad is often depicted in the likeness of Vajrapāṇi.[21]

Nevertheless, it is an established fact that the triad consisting of a main deity, Avalokiteśvara, and Vajrapāṇi is very common in cave temples throughout western India. Furthermore, the position of the two attendants is fixed, with Avalokiteśvara on the right and Vajrapāṇi on the left (fig. 1.2). In triads of this type, Vajrapāṇi is depicted not as a *yakṣa* but as a bodhisattva. This fact reminds us that Vajrapāṇi once received a prophecy, recorded in the *Āryatathāgatācintyaguhyanirdeśa* of the Ratnakūṭa cycle, that he would be reborn in Abhirati—the realm of Akṣobhya in the east—after having protected one thousand buddhas of the Auspicious Eon (Bhadrakalpa) and would then become a buddha.[22] Thus by being promised enlightenment in the future by the Buddha, Vajrapāṇi rose in status from bodyguard to bodhisattva and eventually became the main deity of esoteric Buddhism. Moreover, the triad of Śākyamuni, Avalokiteśvara, and Vajrapāṇi developed into the Buddha, Lotus, and Vajra families of the Garbha-maṇḍala.

2. Depictions of the Buddha's Sermons

The triad emerged in India as an object of worship not long after the appearance of buddha images and developed, over time, into more complex figures. Scholars differ in their views about the meaning of such groups of figures. For instance, there is a well-known Gan-

dharan stele unearthed at Mohammed Nari (second to third century, Central Museum, Lahore) that shows the Buddha displaying the dharma-wheel mudrā and preaching with many buddhas and bodhisattvas arranged around him. This stele had been interpreted as a depiction of the miracle of Śrāvastī, since one thousand buddhas who had emerged from the body of the Buddha are depicted in both corners at the top and there is a lotus pond at the bottom.

More recently, however, it has been suggested that it represents Amitābha's paradise, Sukhāvatī, or the Buddha preaching a Mahāyāna sūtra.[23] In depictions of eight scenes from the Buddha's life, which became established from the post-Gupta period through to the Pāla dynasty, the Buddha invariably displays the dharma-wheel mudrā in depictions of the appearance of one thousand buddhas, or the miracle of Śrāvastī. Before the establishment of the meditation mudrā (*dhyāna-mudrā*) in esoteric Buddhism, though, Amitābha was frequently depicted with the dharma-wheel mudrā.[24] Moreover, scenes arranged around the Buddha are difficult to identify, except for the appearance of one thousand buddhas, which is also seen in other examples from Gandhāra, and so one should be cautious about the identification of this stele. Generally speaking, it is only natural to interpret a group of bodhisattvas and deities centered on the Buddha displaying the dharma-wheel mudrā as a depiction of a sermon by the Buddha.

Textually speaking, the production of painted scrolls called *paṭa* started in India around the third century CE,[25] and the method of producing a *paṭa* is explained in early esoteric Buddhist scriptures that appeared from the sixth to seventh centuries. Typical examples include the *Mahāmaṇivipulavimānaviśvasupratiṣṭhitaguhyaparamarahasyakalparāja* (hereafter *Mahāmaṇivipulavimānakalparāja*), *Mañjuśrīmūlakalpa*, *Wenshushili fabaozang tuoluoni jing*, and *Dafangguang Manshushili jing* (aka *Guanzizai pusa shouji jing*).

Among these texts, the *Mañjuśrīmūlakalpa* explains the methods (*paṭavidhāna*) for four types of *paṭa*: upper, middling, lower, and fourth.[26] Through my own research, I have confirmed the existence of a tradition of *paṭa* (or thangka) based on the *Mañjuśrīmūlakalpa* that has continued down to modern times.

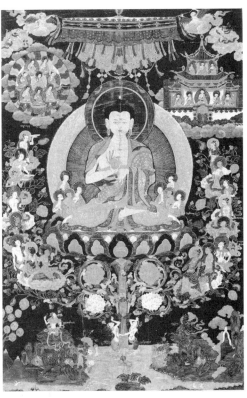

The Hahn Cultural Foundation in Korea possesses a unique thangka called "Mthong ba don ldan."[27] This thangka depicts a buddha forming the dharma-wheel mudrā with both hands and seated on a lotus throne supported by two *nāga* (serpent) kings, Nanda and Upananda, in the center. The buddha is flanked by sixteen bodhisattvas and eight monks, and eight tathāgatas ("one who has thus gone") and eight *pratyekabuddhas* (solitary realizers) are arranged along the top of the canvas. The composition of this painting tallies with a *paṭa* described in the "Prathamapaṭavidhānavistara" of the *Mañjuśrīmūlakalpa* (fig. 1.3). Stylistically speaking, this thangka is a modern work, but old examples with the same combination of attendant figures, dating from the thirteenth to fourteenth centuries, are found in other collections.

I also discovered a fifteenth-century ritual manual for the rite, or *sādhana*, of the *paṭa* of the *Mañjuśrīmūlakalpa*,[28] and I noticed that the names of the deities inscribed on the above thangka coincide with those given in this manual. It is highly likely that the Tibetan "Mthong ba don ldan" preserves the iconography of the Indian *paṭa*, since Tibetan Buddhist art is conservative by nature.

The iconographic features of the *paṭa* described in early esoteric Buddhist scriptures are as follows. They are centered on a buddha displaying the dharma-wheel mudrā flanked by

FIG. 1.3. MTHONG BA DON LDAN (HAHN CULTURAL FOUNDATION)

attendant bodhisattvas, Vajrapāṇi and Maṇivajra in the case of the *Mahāmaṇivipulavi-mānakalparāja*, Mañjuśrī and Maitreya in the case of the *Wenshushili fabaozang tuoluoni jing*, Mañjuśrī and Avalokiteśvara in the case of the *Dafangguang manshushili jing*, Mañjuśrī and Maitreya in the case of the upper *paṭa* of the *Mañjuśrīmūlakalpa*, and Mañjuśrī and Avalokiteśvara in the case of the middling *paṭa* of the *Mañjuśrīmūlakalpa*. All of these are thus based on the triad, to which are added various bodhisattvas, wrathful deities, and protective deities.

It is worth noting that seven tathāgatas in the case of the *Wenshushili fabaozang tuoluoni jing* and eight in the case of the *Mañjuśrīmūlakalpa* are depicted in the upper part of the *paṭa*. Amitābha and Akṣobhya (?) are included among the seven tathāgatas of the *Wenshushili fabaozang tuoluoni jing*, while Saṃkusumitarājendra, Vairocana, and Bhaiṣajyaguruvaiḍūr-yarāja are included among the eight tathāgatas of the *Mañjuśrīmūlakalpa*.[29] Amitābha, Akṣobhya, and Bhaiṣajyaguru are representative buddhas of other worlds, while Vairocana is the cosmic buddha expounded in the *Avataṃsakasūtra*. However, as will be seen in section 5 below, he was also thought to be a buddha of the world below. These tathāgatas thus seem to have been selected from among popular buddhas of other worlds. However, there is no mention in the above-mentioned scriptures of their realms or their location.

We can see groups of figures based on the triad and centered on a buddha displaying the dharma-wheel mudrā together with a retinue in Indian reliefs dating from the same period.[30] There is a relief of a large group of figures that developed from the triad in Kanheri Cave 90, and some scholars have suggested that it may be a primitive form of the maṇḍala (fig. 1.4). The Kanheri caves are divided into two periods, and this cave belongs to the late period— seventh to eighth centuries.[31]

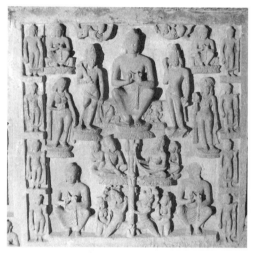

FIG. 1.4. THE BUDDHA PREACHING THE DHARMA (KANHERI CAVE 90)

A group of figures on a side wall of this cave adds buddhas, bodhisattvas, and goddesses to the triad centered on a buddha displaying the dharma-wheel mudrā. The main deity sits on a lotus throne, the stem of which is supported by two *nāga* kings, a feature that is found elsewhere only on the pedestal of Cundā in Japan. It is worth noting that in the chapter on the upper *paṭa* in the *Mañjuśrīmūlakalpa* there is a description of a lotus throne of the main deity supported by the two *nāga* kings, Nanda and Upananda.[32] The same description occurs also in the *Wenshushili fabaozang tuoluoni jing*,[33] *Dafangguang Manshushili jing*,[34] and *Guangda lianhua zhuangyan mannaluo mie yiqiesui tuoluoni jing*.[35] Moreover, images of buddhas thought to be the buddhas of the four or eight directions are arranged around the periphery of the relief,[36] so that it resembles a maṇḍala.

However, this relief does not show the buddhas and bodhisattvas assembled in a pavilion, which is characteristic of the maṇḍala in later times. Moreover, the buddhas of the four or eight directions do not have any iconographically distinguishing features, being either seated images with the dharma-wheel mudrā or standing images with the boon-granting mudrā (*varada-mudrā*). Therefore this relief seems to remain within the bounds of sculptural renderings of the *paṭa* for worship purposes.

Judging from the symbolism of the dharma-wheel mudrā, it may be supposed that the main deity is preaching to his retinue, starting with the two attendants of the triad. Therefore the bodhisattvas and protective deities arranged around a buddha displaying the dharma-wheel mudrā must represent the audience listening to the Buddha's sermon.

In the principal Mahāyāna sūtras it is customary to list the names of the listeners to the Buddha's teachings at the start of the sūtra. Among the listeners, there are bodhisattvas who

play important roles in the sūtra, such as asking questions of the Buddha. However, many of them are seldom mentioned in the rest of the sūtra even though their names are listed at the start.

Depictions of the Buddha preaching a specific sūtra with listeners arrayed around him are a very common motif in Buddhist paintings in East Asia, where Mahāyāna Buddhism flourished, but no examples have yet been discovered in India. In Japan, a pictorial representation of the Buddha preaching that follows a certain pattern is termed a *setsue mandara*, or "sermon assembly maṇḍala."

The *setsue mandara* of the *Prajñāpāramitānayasūtra*, which has been transmitted in Japan, is centered on Vairocana displaying the meditation mudrā, and the eight great bodhisattvas of the *Prajñāpāramitānayasūtra* are arranged around the main deity as listeners.[37] The maṇḍala for the *Bhaiṣajyagurusūtra* rite, on the other hand, thought to have been transmitted at the time of the Tibetan Tufan empire (seventh to ninth centuries CE), is unusual for a Tibetan maṇḍala in that it does not have a circular outer enclosure, showing instead only a rectangular palace, and this would suggest that its origins go back to the old style of India (fig. 1.5).[38]

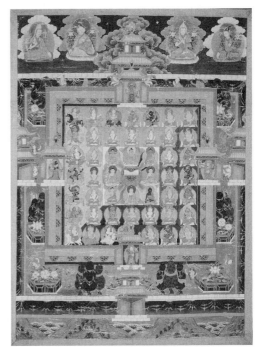

This maṇḍala is centered on the Sanskrit manuscript of the *Bhaiṣajyagurusūtra*, surrounded by the seven buddhas described in the *Saptatathāgatapūrvapraṇidhānaviśeṣavistarasūtra*, headed by the medicine buddha, Bhaiṣajyaguru, and Śākyamuni, the expositor of the *Bhaiṣajyagurusūtra*. Next, sixteen bodhisattvas are depicted in the second sector, and twelve *yakṣa* generals and twelve protectors of the directions are depicted in the third sector. Among these figures, the sixteen bodhisattvas consist of Bhaiṣajyaguru's two attendants Candravairocana and Sūryavairocana, the two bodhisattvas Mañjuśrī and Trāṇamukta, appearing in the *Bhaiṣajyagurusūtra*, and twelve leading bodhisattvas who were among the thirty-six thousand bodhisattvas present when the *Saptatathāgatapūrvapraṇidhānaviśeṣavistarasūtra* was taught (see fig. 1.6).

The *Lotus* maṇḍala (or maṇḍala of the *Saddharmapuṇḍarīkasūtra*), based on the *Chengjiu miaofa lianhua jingwang yuga guanzhi yigui* attributed to Amoghavajra, shows many bodhisattvas who were present when the *Saddharmapuṇḍarīkasūtra* was expounded. They include Nakṣatrarāja, who is not listed in the Chinese translation by Kumārajīva but is mentioned in the Tibetan translation and Sanskrit manuscripts from Nepal. This would suggest that Amoghavajra constructed the *Lotus* maṇḍala by referring to a Sanskrit manuscript that he had brought with him from India. It also suggests that there was a custom in India of including bodhisattvas who had attended the preaching of a certain sūtra in the maṇḍala for the corresponding sūtra rite.

Meanwhile, Inagaki Hisao has shown that the sixteen bodhisattvas of the Bhadrakalpa arranged in the outer sector of the Vajradhātu-maṇḍala are closely related to the bodhisattvas mentioned at the start of the *Anantamukhanirhāradhāraṇī*.[39]

As esoteric Buddhism developed, the number of figures depicted in a maṇḍala, especially bodhisattvas, increased dramatically. And if we seek the origins of these bodhisattvas, we are led to listeners to the Buddha's teachings mentioned in the principal Mahāyāna sūtras. Moreover, many of them are seldom mentioned in the main text of the sūtras, even though their names are listed at the beginning. Therefore the bodhisattvas depicted in a maṇḍala were not always selected on account of their doctrinal importance. In fact, I would surmise that listeners were depicted around a preaching Buddha in a bird's-eye view of the assembly

of a Mahāyāna sūtra, and as this developed into the "sermon assembly maṇḍala" following a certain pattern, they came to be arranged in the outer sector of the maṇḍala.[40]

3. The Genesis of the Landscape Maṇḍala

In India, except for several cases to be mentioned later, almost no examples of the maṇḍala have survived. In Japan, on the other hand, prototypes of the maṇḍala that developed from the triad have been transmitted. One example of such a primitive maṇḍala is the Shōugyō mandara, based on chapter 64 of the *Mahāmeghasūtra* and used in rain-making rites.

FIG. 1.6. DEITIES OF THE MAṆḌALA FOR THE *BHAIṢAJYAGURUSŪTRA* RITE

GROUP OF DEITIES		SANSKRIT NAME
Seven Medicine Buddhas		Bhaiṣajyaguruvaiḍūryaprabhārāja
		Suparikīrtitanāmadheyaśrī
		Ratnacandrapadmapratimaṇḍitasvaraghoṣarāja
		Suvarṇabhadravimalaratnaprabhāsavrata
		Aśokottamaśrī
		Dharmanirghoṣasāgaraśrī?
		Dharmasāgaraparamamativikrīḍitābhijña?
Expositor of the *Bhaiṣajyagurusūtra*		Śākyamuni
Sixteen bodhisattvas	Two attendants of Bhaiṣajyaguru	Sūryavairocana
		Candravairocana
	Two bodhisattvas appearing in the *Bhaiṣajyagurusūtra*	Mañjuśrī
		Trāṇamukta
	Bodhisattvas who were present when the *Saptatathagatapūrvapraṇidhanaviśeṣavistarasūtra* was expounded	Avalokiteśvara
		Maitreya
		Sudarśana
		Mahāmati
		Sarvāśokatamonirghātanamati
		Merukūṭa
		Pratibhānakūṭa
		Mahāmerukūṭadhara?
		Amoghavikrama
		Gadgadasvara
		Suvicintita?
		Vajrapāṇi

GROUP OF DEITIES		SANSKRIT NAME
Protective deities	Twelve *yakṣa* generals	Kiṃbhīra
		Vajra
		Mekhila
		Antila
		Anila
		Saṇṭhila
		Indala
		Pāyila
		Mahāla
		Cindāla
		Caundhula
		Vikala
	Protectors of directions	Indra
		Agni
		Yama
		Nairṛti
		Varuṇa
		Vāyu
		Vaiśravaṇa
		Īśāna
		Brahmā
		Pṛthivī
		Sūrya
		Candra

There are several representations of the Shōugyō mandara. A typical example is a line drawing held by Tōji temple in Kyoto that shows a triad of Śākyamuni, Avalokiteśvara, and Vajrapāṇi in a pavilion in the center (fig. 1.7). The pavilion is surrounded by a vast expanse of ocean from which *nāga* kings worship the Buddha in the pavilion, their serpent's hoods growing out of their shoulders. This image symbolizes the Buddha's ordering the *nāga* kings to bring rain.

This Shōugyō mandara does not have any geometric pattern seen in mandalas of later times. Instead it presents a bird's-eye view of the pavilion, depicting it in the manner of a Japanese temple. This is a primitive form of the mandala that preceded the appearance of the square pattern symbolizing a pavilion where the deities assemble that is seen in later mandalas. The scholar Ishida Hisatoyo called this a "landscape mandala" (*jokei mandara*). In addition to the Shōugyō mandara, we can mention two other examples of primitive landscape mandalas: the Jeweled Pavilion mandala (Hōrōkaku mandara), based on the *Mahāmaṇivipulavimānakalparāja*, and the mandala of the Place of Enlightenment (Bodaijō mandara), based on the *Bodhimaṇḍālamkāradhāraṇī*.

Ishida started using the term "landscape mandala" only in his *Mandara no mikata*,[41] and in his earlier writings he used the traditional term *setsue mandara*, explaining it as follows: "First, the deities who have gathered to listen to the Buddha's sermon were depicted as part of a natural landscape, and this is called a *setsue mandara*. Examples of this are common in mandalas of Pure Land Buddhism pre-dating esoteric Buddhism, and in esoteric Buddhism, too, there exist several examples such as the Shōugyō mandara and Bodaijō mandara."[42] However, the *setsue mandara* includes several mandalas with a geometric pattern, such as the aforementioned mandala of the *Prajñāpāramitānayasūtra*. Here, I use the term "landscape mandala" to refer to early mandalas showing a bird's-eye view of a particular landscape. Such mandalas developed from the triad and could be said to lie midway between painted icons for worship purposes and the mandala.

In fact this is evidenced in the *Mahāmaṇivipulavimānakalparāja* as a painted icon for worship purposes in the "Chapter on Drawing Images," whereas the production of a mandala with almost the same deities is explained in the "Chapter on Constructing Mandalas."[43] An example held by the Freer Gallery of Art based on the "Chapter on Drawing Images" depicts the deities from a bird's-eye view, whereas another example, formerly held by the subtemple Hōbodai'in of Tōji, depicts inner and outer sectors that are square and four gateways, or *toraṇas*, in the four entrances to the inner and outer sectors. These characteristics of the latter seem to have been inherited by later mandalas.[44] Thus the *Mahāmaṇivipulavimānakalparāja* shows a differentiation between painted images for worship purposes and the mandala.

The earliest Chinese translation of this work is the *Mouli mantuoluo zhoujing* by an unknown translator dating from the Liang dynasty (fifth to sixth centuries). In addition, Sanskrit fragments of this work have been discovered among the Gilgit manuscripts.[45] According to Matsumura Hisashi, these fragments belong to a comparatively new group among the Gilgit manuscripts. There can at any rate be little doubt that a primitive form of the *Mahāmaṇivipulavimānakalparāja* had come into existence by the sixth century. Therefore I surmise that the differentiation between painted icons for worship purposes and the mandala had already begun in the sixth century at the latest.

Examples of the Jeweled Pavilion mandala are preserved only in Japan, and they depict

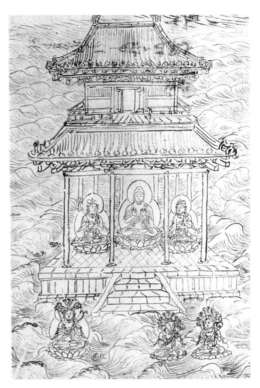

FIG. 1.7. SHŌUGYŌ MANDARA (TŌJI TEMPLE, KYOTO)

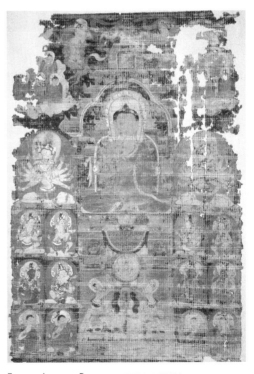

FIG. 1.8. JEWELED PAVILION MANDALA FROM KHARA-KHOTO (STATE HERMITAGE MUSEUM, ST. PETERSBURG)

the pavilion in the form of a Japanese-style wooden structure. The manner in which land-scape maṇḍalas were rendered in medieval India, on the other hand, where the maṇḍala has its origins, had long been a mystery. But recently an interesting example of the Jeweled Pavilion maṇḍala was identified among paintings discovered by the Russian explorer Kozlov in 1908. It is a 108 × 160 centimeter color painting on cotton, discovered in a collapsed stūpa

FIG. 1.9. ARRANGEMENT OF DEITIES IN THE JEWELED PAVILION MAṆḌALA

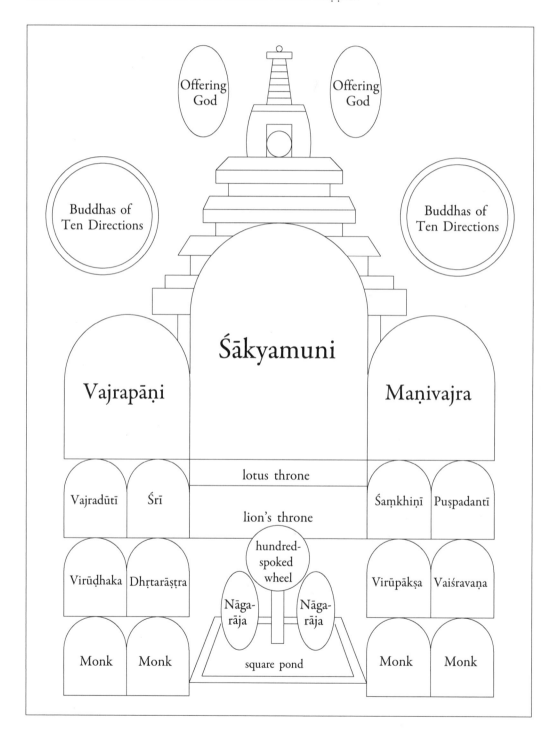

called Suburgan at Khara-khoto (figs. 1.8 and 1.9), that, until now, had been called "Buddha Śākyamuni Preaching the Prajñāpāramitā."[46] In the center is a pavilion with Śākyamuni displaying the dharma-wheel mudrā and flanked on the right by a white bodhisattva with four faces and twelve arms and on the left by a blue bodhisattva with four faces and sixteen arms. In short, the iconography of this painting coincides with the Jeweled Pavilion maṇḍala centered on Śākyamuni, Vajrapāṇi, and Maṇivajra.[47]

This painting is the only extant example of the Jeweled Pavilion maṇḍala produced outside Japan, although, stylistically speaking, it dates from as late as the thirteenth century. It is also noteworthy for the fact that the pavilion is represented as a *toraṇa*-like multistoried structure crowned with a stūpa, similar to the *toraṇa* seen in the four entrances to Tibetan maṇḍalas. Further investigation is needed to determine whether this type of representation of the pavilion goes back to landscape maṇḍalas that formerly existed in India or whether it was the result of inferences drawn from pavilions found in Tibetan maṇḍalas. Regardless, this painting raises fresh questions about the historical origins of the maṇḍala. The triad—particularly that consisting of Śākyamuni, Avalokiteśvara, and Vajrapāṇi in landscape maṇḍalas like the Shōugyō mandara—eventually developed into maṇḍalas of a larger scale with geometric patterns.

4. From Buddhas of Other Worlds to Buddhas of the Four Directions

In maṇḍalas from the middle phase of esoteric Buddhism and later, like the Garbha- and Vajradhātu-maṇḍalas, five buddhas are arranged in the center and four cardinal directions and become the principal members of the maṇḍala. The five buddhas came into existence by combining Vairocana, the cosmic buddha of the *Avataṃsakasūtra*, with the buddhas of the four cardinal directions. The deities arranged in the center and four cardinal directions are thought to correspond to five buddhas, even in maṇḍalas that do not depict five buddhas. In this section I shall consider the evolution of the buddhas of the four directions.

The cult of buddhas in other worlds is one of the religious beliefs peculiar to Mahāyāna Buddhism. Recent research has shown that several progressive schools (*nikāyas*) recognized the existence of buddhas in other worlds,[48] and even conservative Theravāda Buddhism in Southeast Asia transmits the names of buddhas in other worlds that are different from those of Mahāyāna Buddhism.[49] However, the spread of the cult of buddhas in other worlds began after the emergence of Mahāyāna Buddhism. Memories of the Buddha were cherished by Buddhists long after the Buddha's *parinirvāṇa* (nirvāṇa-after-death), and there arose the idea of rebirth in another world where the Buddha is still alive and teaching.

Akṣobhya in Abhirati and Amitābha/Amitāyus in Sukhāvatī were widely worshiped as buddhas of other worlds, the former in the east, the latter in the west. Among the buddhas of other worlds, Akṣobhya is thought to have been the earliest. The *Akṣobhyatathāgatasya vyūha* was translated into Chinese as early as the Later Han dynasty. In addition, there is no mention of Amitābha in the *Akṣobhyatathāgatasya vyūha*, whereas Akṣobhya is mentioned in the *Smaller Sukhāvatīvyūha* centered on Amitābha.[50] Eventually Amitābha appeared as a powerful savior surpassing Akṣobhya and became the representative buddha of other worlds. As Mahāyāna Buddhism developed, there appeared new buddhas of other worlds, such as Bhaiṣajyaguru in the east. However, no examples of clearly identifiable images of

buddhas in other worlds apart from Amitābha and those among buddha pentads of esoteric Buddhism have been discovered. Thus the cult of buddhas in other worlds is thought to have been somewhat limited in India, even though it spread widely throughout the rest of Asia.

The names of these buddhas are frequently mentioned even in comparatively early Mahāyāna sūtras, although their names seldom coincide. For example, there is a story in the *Saddharmapuṇḍarīkasūtra* of sixteen brother-princes—including a former incarnation of Śākyamuni—who propagated the sūtra and became buddhas of worlds in the ten directions. Although these sixteen buddhas include Akṣobhya in the east and Amitābha in the west, the names of the other buddhas seldom occur in other Mahāyāna sūtras.[51] It is worth noting that in the section mentioning the names of the buddhas of the six directions in the *Smaller Sukhāvatīvyūha*, an early Mahāyāna sūtra, the names of the buddhas of other worlds include not only Akṣobhya in the east and Amitāyus[52] in the west but also Ratnaketu in the west and Dundubhisvaranirghoṣa in the north.

FIG. 1.10. THE *SMALLER SUKHĀVATĪVYŪHA* AND BUDDHAS OF THE FOUR DIRECTIONS

Kumārajīva's translation

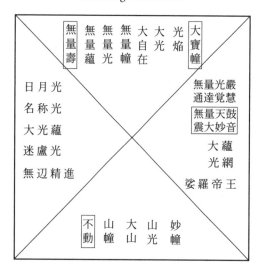

Smaller Sukhāvatīvyūha

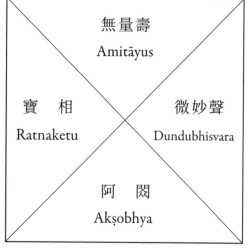

Xuanzang's translation

Suvarṇaprabhāsasūtra

Ratnaketu coincides with the name of the buddha in the south among the buddhas of the four directions in the *Suvarṇaprabhāsasūtra*, to be discussed below, while Dundubhi-svaranirghoṣa corresponds to Dundubhisvara, the buddha in the north among the buddhas of the four directions in the same sūtra. Thus the names of the buddhas of the worlds in the six directions given in the *Smaller Sukhāvatīvyūha* are thought to have influenced the four-buddha theory of later Mahāyāna sūtras. The reason that the buddhas of other worlds mentioned in the *Smaller Sukhāvatīvyūha* developed into the four-buddha theory of the later maṇḍala via the *Suvarṇaprabhāsasūtra* may be due to the former's popularity as the basic scripture of Pure Land Buddhism and its compactness and ease of recital.

5. The Four-Buddha Theory of the *Suvarṇaprabhāsasūtra*

According to the *Suvarṇaprabhāsasūtra*—a third-phase Mahāyāna sūtra dating from the Gupta dynasty—when a bodhisattva named Ruciraketu doubted that the life span of the Buddha, who had accumulated enormous merit from previous lives, could have been only eighty years, four buddhas—Akṣobhya (east), Ratnaketu (south), Amitāyus (west), and Dundubhisvara (north)—appeared and explained that the Buddha's life span is infinite.[53] These four buddhas are mentioned in other chapters, too, and are regarded as representative deities of this sūtra, and accordingly they are known as the "four buddhas of the *Suvarṇaprabhāsasūtra*."

The four-buddha theory of the *Suvarṇaprabhāsasūtra* was inherited by late Mahāyāna and early esoteric Buddhist scriptures.[54] Among these latter works, the four buddhas of the *Guanshiyin puxian tuoluoni jing* and *Tuoluoni jijing* are basically identical to those of the *Suvarṇaprabhāsasūtra*, except for slight differences in the Chinese translations of their names. The *Ligouhui pusa suowen lifofa jing*, on the other hand, has added buddhas of the four intermediate directions, the nadir, and the zenith, resulting in buddhas of the ten directions.

Jñānaraśmirāja and Vairocana, added in the *Ligouhui pusa suowen lifofa jing* as the buddhas of the nadir and the zenith, are also found in the *Ratnaketuparivarta* of the Mahāsannipāta cycle. The Chinese translation of the *Mahāsannipātasūtra* by Dharmakṣema mentions only Akṣobhya in the east and Amitāyus in the west and omits the rest, with the comment that "south and north are as above."[55] The Sanskrit manuscript and the Chinese translation by Prabhākaramitra, on the other hand, give the names of six buddhas,[56] which can be ascertained in the romanized edition as follows: Akṣobhya (east), Ratnadhvaja (south), Amitāyus (west), Dundubhisvara (north), Vairocana (nadir), and Jñānaraśmirāja (zenith).[57] Thus the *Ratnaketuparivarta* added the two buddhas of the nadir and the zenith. The reason that Ratnaketu was changed to Ratnadhvaja in the *Ratnaketuparivarta* was probably to avoid confusion with the Ratnaketu of the title of this *dhāraṇī-sūtra*.

The *Ratnaketuparivarta* seems to pre-date the *Suvarṇaprabhāsasūtra*, since the oldest Chinese translation by Dharmakṣema mentions only Akṣobhya in the east and Amitāyus in the west. Nevertheless, the four-buddha theory of the *Suvarṇaprabhāsasūtra* is thought to have influenced the buddhas of the six directions in the *Ratnaketuparivarta* and to have further developed into the buddhas of the ten directions in the *Ligouhui pusa suowen lifofa jing*.

Vairocana appears as the buddha of the nadir in the *Ratnaketuparivarta* and *Ligouhui pusa suowen lifofa jing*. Some scholars have pointed to the possibility that this Vairocana

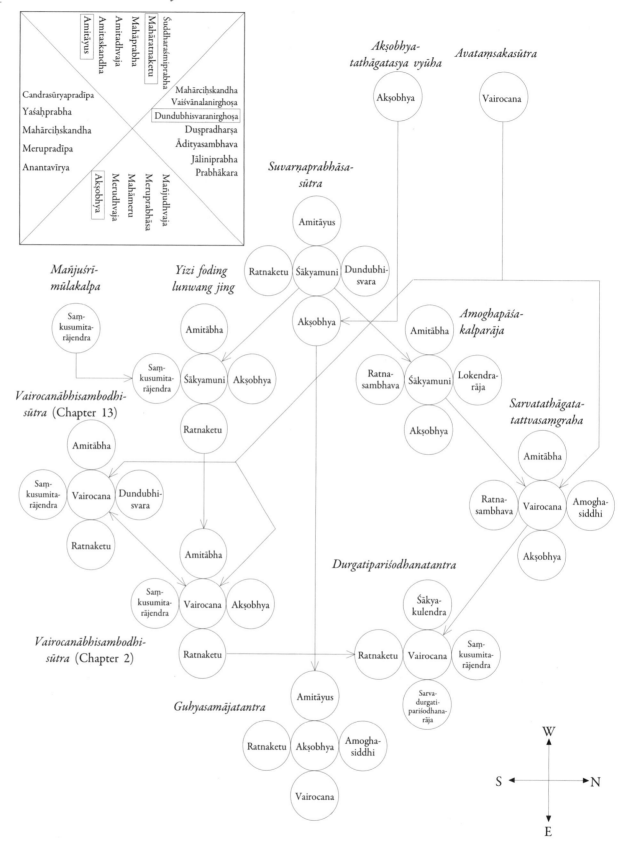

FIG. 1.11. FROM BUDDHAS OF OTHER WORLDS TO THE FIVE BUDDHAS

Smaller Sukhāvatīvyūha

Śuddharaśmiprabha
Mahāratnaketu
Amitāyus
Amitaskandha
Amitadhvaja
Mahāprabha

Mahārciḥskandha
Vaiśvānalanirghoṣa
Dundubhisvaranirghoṣa
Duṣpradharṣa
Ādityasambhava
Jāliniprabha
Prabhākara

Candrasūryapradīpa
Yaśaḥprabha
Mahārciḥskandha
Merupradīpa
Anantavīrya

Mañjudhvaja
Meruprabhāsa
Mahāmeru
Merudhvaja
Akṣobhya

Akṣobhya-tathāgatasya vyūha

Akṣobhya

Avataṃsakasūtra

Vairocana

Suvarṇaprabhāsa-sūtra

Amitāyus

Ratnaketu Śākyamuni Dundubhi-svara

Akṣobhya

Mañjuśrī-mūlakalpa

Saṃ-kusumita-rājendra

Yizi foding lunwang jing

Amitābha

Saṃ-kusumita-rājendra

Śākyamuni Akṣobhya

Ratnaketu

Amitābha

Amoghapāśa-kalparāja

Ratna-sambhava Śākyamuni Lokendra-rāja

Akṣobhya

Vairocanābhisambodhi-sūtra (Chapter 13)

Amitābha

Saṃ-kusumita-rājendra Vairocana Dundubhi-svara

Ratnaketu

Amitābha

Saṃ-kusumita-rājendra Vairocana Akṣobhya

Ratnaketu

Sarvatathāgata-tattvasaṃgraha

Amitābha

Ratna-sambhava Vairocana Amogha-siddhi

Akṣobhya

Durgatipariśodhanatantra

Śākya-kulendra

Ratnaketu Vairocana Saṃ-kusumita-rājendra

Sarva-durgati-pariśodhana-rāja

Vairocanābhisambodhi-sūtra (Chapter 2)

Amitāyus

Guhyasamājatantra

Ratnaketu Akṣobhya Amogha-siddhi

Vairocana

W
S ← → N
E

developed into the main deity in the center of the maṇḍala,[58] known as Mahāvairocana in Sino-Japanese Buddhism. Vairocana first appears as a buddha in the *Avataṃsakasūtra*, one of the early Mahāyāna sūtras. Some scholars have pointed out that the name "Vairocana" is related to Virocana, a king of the Asuras.[59] The reason that Vairocana was assigned to the nadir seems to have been an association with the Asuras' underground abode (*pātāla*).

The *Yizi foding lunwang jing*, an early esoteric Buddhist scripture, gives another series of five buddhas, centered on Śākyamuni as in the *Suvarṇaprabhāsasūtra*, with Ratnaketu in the east, Saṃkusumitarāja/rājendra in the south, Amitābha in the west, and Akṣobhya in the north. Here there has been added Saṃkusumitarāja/rājendra, not included among the four buddhas of the *Suvarṇaprabhāsasūtra*, and it would seem that as a result Ratnaketu shifted to the east and Akṣobhya to the north. Saṃkusumitarājendra appears in the *Mañjuśrīmūlakalpa* as a buddha of another world named Kusumāvatī in the northeast where Mañjuśrī resides. Saṃkusumitarājendra seems to have been a popular buddha of another world, since his name is also mentioned in several *dhāraṇī-sūtras*.[60]

In the *Aṣṭasāhasrikā Prajñāpāramitā* it is mentioned that a bodhisattva named Ratnaketu resides in Akṣobhya's pure land, Abhirati.[61] It has been suggested that the reason for Ratnaketu's shift from south to east is this passage in the *Aṣṭasāhasrikā Prajñāpāramitā*. But there remains the question of why Akṣobhya, lord of Abhirati, moved from east to north.

If we change the central buddha of the five buddhas of the *Yizi foding lunwang jing* from Śākyamuni to Vairocana, the resultant five buddhas coincide with those of chapter 2 of the *Vairocanābhisambodhisūtra*. In addition, the same five buddhas also occur in the *Vajrapāṇyabhiṣekatantra*, a middle-phase esoteric Buddhist scripture related to the *Vairocanābhisambodhisūtra*.[62]

Chapter 13 in the latter part of the Chinese translation of the *Vairocanābhisambodhisūtra* (chapter 16 in the Tibetan translation), on the other hand, gives five buddhas among whom Akṣobhya in the north has changed to Dundubhisvara (Divyadundubhimeghanirghoṣa in the Genzu mandara), and the Genzu mandara, the current version of the Garbhamaṇḍala, adopts this combination of five buddhas. It seems strange that the combination of five buddhas forming the basis of the maṇḍala is not congruent in the same sūtra. But if we assume that Saṃkusumitarājendra was added later to the four buddhas of the *Suvarṇaprabhāsasūtra*, this inconsistency within the *Vairocanābhisambodhisūtra* can be explained logically.[63]

6. Four Buddha Images in Stūpas

Early Mahāyāna sūtras thus taught the existence of many buddhas in other world-realms, and it was not unusual to mention buddhas of other worlds in four, six, or ten directions. However, apart from images of Amitābha, no image of a buddha clearly identifiable as the buddha of another world has been discovered in India. In this respect, the four buddha images of the main stūpa at Sanchi are worthy of note.

At Sanchi, following the traditions of the earliest Buddhist art of India, the Buddha was not represented in human form. His presence was indicated instead by a symbol, such as a bodhi tree, a dharma wheel, or a pair of footprints. In the first half of the fifth century, four images of the Buddha were installed against the walls of the stūpa facing its four entrances.[64] These buddhas are thought to have been donated by a follower of Mahāyāna Buddhism,

since three of them are accompanied by two attendant bodhisattvas, the buddha facing the southern entrance being accompanied by Brahmā and Indra.[65] I surmise that these four buddhas are the earliest extant example of buddhas of the four directions in India (fig. 1.12).

At Sanchi, there is also a great stūpa in which are enshrined the relics (*śarīra*) of the Buddha, and it is thought to symbolize the Buddha after his entry into nirvāṇa. The follower(s) of the Mahāyāna who installed the four images of the Buddha in the cardinal directions of the main stūpa at Sanchi intended, in accordance with the *Suvarṇaprabhāsasūtra*, to symbolize the eternity of the Buddha whose relics are enshrined in the stūpa.

The four images of the Buddha at Sanchi do not have any iconographic characteristics like the four buddhas in later maṇḍalas, since all of them form the meditation mudrā with both hands. Therefore it is difficult to determine objectively whether they were created as buddhas of the four directions. However, it is worth noting that the idea of the buddhas of the four directions appeared during the Gupta dynasty and was associated with the Buddha's eternity.

Gyaraspur, 50 kilometers to the northeast of Sanchi in the suburbs of Vidisha, once flourished as a commercial center in central India, and there survives in this village the Dekhinath stūpa, datable to the Gupta period. Four high-relief images of the Buddha (now placed in storage by the Archaeological Survey of India) were installed in the four cardinal directions of the stūpa.[66] In contrast to Sanchi, where all the buddhas display the meditation mudrā, the four buddhas of Gyaraspur display different mudrās: meditation mudrā (east), boon-granting mudrā (south), dharma-wheel mudrā (west), and meditation mudrā (north). These mudrās do not, however, coincide with those of the two-world maṇḍalas of Japan, except for the boon-granting mudrā of Ratnasambhava in the south. In addition, the dharma-wheel mudrā in the west is interesting if we consider that in many cases, apart from the five buddhas of esoteric Buddhism, Amitābha forms the dharma-wheel mudrā with both hands.

Some scholars have doubted, on the basis of their artistic style, whether these four buddhas were originally created as a set.[67] However, the combination of two meditation mudrās and the boon-granting mudrā and dharma-wheel mudrā cannot be explained from the structure of the stūpa, which arranges the eight major events in the life of the Buddha

FIG. 1.12. FOUR BUDDHA IMAGES AT SANCHI

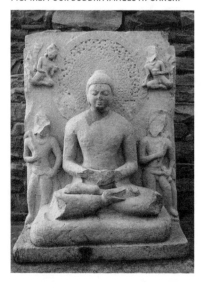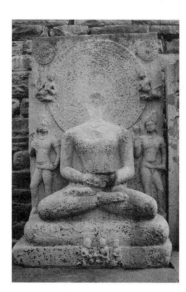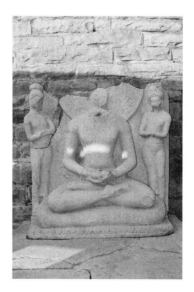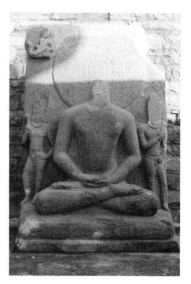

around the dome.[68] There can be no doubt that they were created as the buddhas of the four directions.

Buddhas of the four directions identical to those of the *Suvarṇaprabhāsasūtra* frequently appear in late Mahāyāna and early esoteric Buddhist sūtras. However, the mudrās of the four buddhas are not explained in these texts even though their names are frequently mentioned, and this means that there had not yet been established any firm view about the iconography of the four buddhas.

The four buddhas at Gyaraspur show different mudrās from those of the two-world maṇḍalas. This suggests that there existed differences of opinion about the names and iconography of the buddhas of the four directions, and these opinions eventually converged through a process of trial and error to form the established theory seen in the two-world maṇḍalas, particularly the Vajradhātu-maṇḍala.

In China, on the other hand, the Four-Gate Pagoda at Dongshentongsi in Shandong province built in 611 enshrines four buddhas back to back around the square central pillar of the pagoda (fig. 1.13).[69] When I visited the temple in 2006, these four buddhas had been designated by the Chinese authorities as Akṣobhya (east), Ratnasambhava[70] (south), Amitābha (west), and Dundubhisvara (north) in accordance with the *Suvarṇaprabhāsasūtra*, although these names have not been confirmed in any inscription or historical records. The Japanese scholar Naitō Tōichirō (1896–1939) surmised that, judging from the circulation of sūtras in China at the time, the four buddhas of the Four-Gate Pagoda were based on the *Suvarṇaprabhāsasūtra*.[71] The three buddhas in the east, south, and west of the Four-Gate Pagoda display the meditation mudrā, while the buddha in the north has both hands on his knees. One is reminded of the fact that at Sanchi the four buddhas all display the meditation mudrā. At any rate, it is noteworthy that the four stūpa buddhas, who first appeared in the Gupta dynasty, were transmitted to China as early as the beginning of the seventh century and that actual examples have survived.

Meanwhile, in Japan, particularly during the Nara period in the eighth century, there was a custom of installing four buddhas on the altar on the first floor of a wooden pagoda. The four buddha statues at Saidaiji are thought to have been enshrined in the former East Pagoda of this temple. Their traditional names are Akṣobhya (east), Ratnasambhava (south), Amitābha (west), and Śākyamuni (north), although these identifications are somewhat doubtful.[72]

The prototype of the four pagoda buddhas in East Asia may have been the four stūpa buddhas found at Sanchi, Gyaraspur, and so on, whose names and mudrās had not yet been fixed. The four stūpa buddhas consisting of representative buddhas of other worlds went on to develop into the four buddhas arranged in the cardinal directions of the maṇḍala.

FIG. 1.13. FOUR-GATE PAGODA AT DONGSHENTONGSI (SHANDONG PROVINCE)

7. The Genesis and Development of the Eight Great Bodhisattvas

Buddhas and bodhisattvas were important members of maṇḍalas in the early and middle phases of esoteric Buddhism. As has been seen, the four or five buddhas of the maṇḍala originated in buddhas of other worlds who appeared in Mahāyāna sūtras, and the bodhisattvas depicted in the outer square of the maṇḍala originated in the audiences of Mahāyāna sūtras.

In contrast, bodhisattvas who were not merely members of the audience but had doctrinal importance formed groups of four, six, or eight bodhisattvas and occupy important

positions, such as at the center or on the central axes of the maṇḍala. In particular, the eight great bodhisattvas are known to have played an important role in the genesis of the Garbha-maṇḍala, the culmination of the development of the maṇḍala consisting of three families (fig. 1.14).[73]

The eight great bodhisattvas are a grouping of the eight principal bodhisattvas worshiped in Mahāyāna Buddhism, and various combinations were known. These combinations can be classified into seven groups, and the most popular combination in India—Avalokiteśvara, Maitreya, Ākāśagarbha, Samantabhadra, Vajrapāṇi, Mañjuśrī, Sarvanīvaraṇaviṣkambhin, and Kṣitigarbha—has been referred to as the standard eight great bodhisattvas.[74]

Among these bodhisattvas, examples of Maitreya and Avalokiteśvara are found in Gan-

FIG. 1.14. GARBHA-MAṆḌALA AND EIGHT GREAT BODHISATTVAS

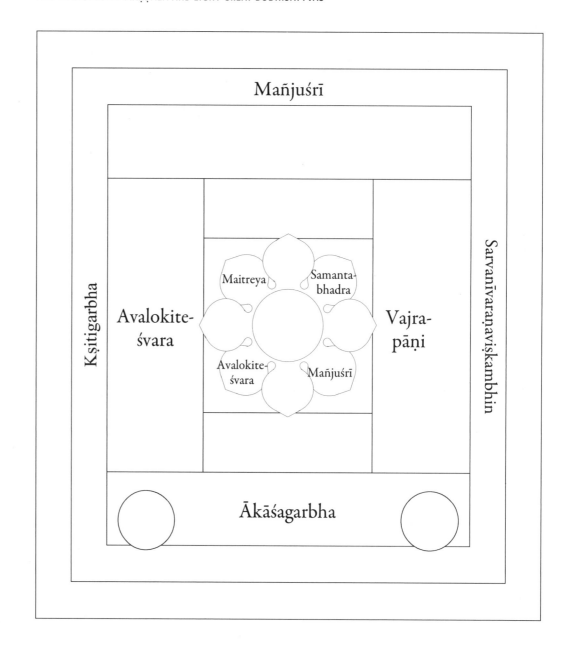

dharan sculptures, while Mañjuśrī and Samantabhadra are frequently mentioned from early Mahāyāna scriptures onward. Vajrapāṇi was merely a protective deity in Gandharan sculpture and was promoted to the ranks of bodhisattvas only in middle and late Mahāyāna scriptures. Sarvanīvaraṇaviṣkambhin's first appearance may be in the oldest Chinese translation of the *Anantamukhanirhāradhāraṇī* (first half of the third century).[75]

Ākāśagarbha and Kṣitigarbha, on the other hand, are not mentioned in early Mahāyāna scriptures and are thought to have appeared from the time of the middle and late Mahāyāna sūtras. An exception is the appearance of Kṣitigarbha as a member of the audience at the start of the *Daśabhūmikasūtra*, an early Mahāyāna sūtra. However, this list mentions many bodhisattvas whose names end with *-garbha*, starting with Vajragarbha, the chief protagonist in the *Daśabhūmikasūtra*. Moreover, Kṣitigarbha is missing in all of the corresponding Chinese translations. Therefore there is a strong possibility that Kṣitigarbha was added to the list of bodhisattvas after the composition of the *Daśabhūmikasūtra*.

The oldest Chinese translation to mention the standard eight great bodhisattvas and their maṇḍala is the *Shizizhuangyanwang pusa qingwen jing* translated by Nati, who arrived in China in 663. Therefore the standard set of eight great bodhisattvas had been established in India by the middle of the seventh century at the latest. The order of the eight great bodhisattvas mentioned in this sūtra coincides with that of the *Aṣṭamaṇḍalaka nāma mahāyānasūtra*, translated into Chinese by Amoghavajra. The *Rnam par snang mdzad 'khor dang bcas pa la bstod pa*, a Tibetan text discovered at Dunhuang, pays homage to Vairocana surrounded by the eight great bodhisattvas, Acala, and Trailokyavijaya,[76] and the names of the eight great bodhisattvas coincide with those of the *Shizizhuangyanwang pusa qingwen jing*.

The *Wenshushili fabaozang tuoluoni jing*, which has not received much attention from scholars and was translated by Bodhiruci, who arrived in China in 693, describes an icon in which ten bodhisattvas resembling the standard eight great bodhisattvas flank Śākyamuni, five on each side. It is worth noting that Vimalakīrti is included among these ten bodhisattvas. In addition, this sūtra mentions eleven buddhas, the names of some of whom resemble the names of the five buddhas of the Garbha-maṇḍala.[77]

Therefore the *Wenshushili fabaozang tuoluoni jing*, like other early esoteric Buddhist scriptures translated by Bodhiruci, is thought to represent a stage in the process of development that led to the *Vairocanābhisambodhisūtra*, and it also suggests affinities between the standard eight great bodhisattvas and the Garbha-maṇḍala. As will be seen later, the standard eight great bodhisattvas occupy an important position in the Garbha-maṇḍala.

8. Vairocana and the Eight Great Bodhisattvas

Many examples of the eight great bodhisattvas have been discovered and identified in India. Among these, the most common examples are of four bodhisattvas in relief arranged on both sides of the main deity's halo or seat. In many such cases, the main deity is a buddha displaying the dharma-wheel mudrā. An image of Vairocanābhisambodhi, unearthed from Chapel 5 at Ratnagiri, Orissa, is notable for the fact that he is accompanied by the eight great bodhisattvas in his halo, four on each side (fig. 1.15).

The Ratnagiri statue is currently the only Indian example of Vairocanābhisambodhi accompanied by the eight great bodhisattvas. However, many examples of this combination

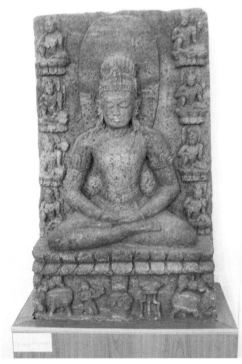

FIG. 1.15. VAIROCANĀBHISAMBODHI (ARCHAEOLOGICAL MUSEUM, RATNAGIRI)

have been identified outside India. Stein painting no. 50 from Dunhuang in the British Museum was thought to be of Amitābha, but I think this, too, depicts Vairocanābhisambodhi accompanied by the eight great bodhisattvas, some of whom have Tibetan captions.[78] Therefore this painting may be assumed to date from during or slightly after the annexation of Dunhuang to the Tibetan empire in the eighth century.

The same combination of Vairocanābhisambodhi[79] and the eight great bodhisattvas occurs in a wall painting in Yulin Cave 25, thought to have been executed in 776–81. Unfortunately, the wall is damaged and the four bodhisattvas painted on the right side have disappeared. But we can identify Ākāśagarbha and Kṣitigarbha in the upper register and Maitreya and Mañjuśrī in the lower register on the left side of the main deity from the inscriptions in Chinese characters.[80]

A wooden portable shrine centered on a seated figure displaying the meditation mudrā, now kept at the Nelson-Atkins Museum in the United States, was discovered somewhere in the Silk Road region. In this shrine, two other bodhisattvas have been added to the combination of the main deity (Vairocanābhisambodhi) and the eight great bodhisattvas. One of these two bodhisattvas pats the head of a monk, thought to be the donor of this shrine, while the other bodhisattva confers a water initiation on him. There is an inscription with the word *byang chub* on the back of the shrine,[81] and this shrine, too, was produced in the Silk Road region during its Tibetan occupation.

In addition, Vairocanābhisambodhi and the eight great bodhisattvas have been identified on the south wall of the main chamber of Dunhuang Cave 14.[82] The iconography of the main deity and the eight great bodhisattvas shows interesting parallels with Stein painting no. 50 and Yulin Cave 25. Thus the iconography of Vairocanābhisambodhi accompanied by the eight great bodhisattvas was fixed to a certain degree in the Silk Road region when it was under Tibetan rule.

At Samye in central Tibet, on the other hand, combinations of a main deity and the eight great bodhisattvas occur in all three stories of the main building (Dbu rtse), for which the cornerstone-laying ceremony was performed in 775. According to the *Rgyal rabs gsal ba'i me long*, a chronicle of Tibetan Buddhism, the first story in Tibetan style was centered on an auspicious image of Śākyamuni accompanied by the eight great bodhisattvas, to whom two other bodhisattvas—Drimé Drakpa (Vimalakīrti) and Gawai Pal (Sanskrit unknown)—and also Acala and Trailokyavijaya were added to make a total of thirteen figures. Among the eight great bodhisattvas, (Ākāśagarbha,) Maitreya, Avalokiteśvara, and Kṣitigarbha are on the right of Śākyamuni, and Samantabhadra, Vajrapāṇi, Mañjuśrī, and Sarvanīvaraṇaviṣkambhin are on his left.[83]

The second floor in Chinese style, on the other hand, was centered on Vairocana. Buddhas of the past, present, and future, Bhaiṣajyaguru, and Amitābha were arranged in front of the main deity, and on both sides were the above-mentioned Vimalakīrti and Gawai Pal together with the eight great bodhisattvas. Two wrathful gatekeepers named King and Kang were also added to these figures. Kingkang is a phonetic transcription of *jingang*, the Chinese translation of *vajra*, pronounced *kinkang* in Middle Chinese, and so they represent a pair of Chinese-style gatekeepers holding a vajra.

The third floor in Indian style was centered on Vairocana "facing all directions," that is, with four heads. Two each of the eight great bodhisattvas were arranged around Vairocana in each of the four cardinal directions.[84]

The main deity on the second floor was called simply "Vairocana," and so we cannot ascertain whether the main deity was Vairocanābhisambodhi, Vajradhātu-Vairocana, or Sarvavid-Vairocana. Nor can we surmise this from the present situation, since the main deity has been completely replaced since the Cultural Revolution. The main deity on the third floor may have been four-headed Vajradhātu-Vairocana or Sarvavid-Vairocana (see chapter 4), since he is described as "facing all directions." Today, following the complete reconstruction since the Cultural Revolution, the four buddhas of the Vajradhātu-maṇḍala are enshrined here back to back.

It is worth noting that Vimalakīrti, Gawai Pal, and two wrathful deities were added to the eight great bodhisattvas on the first and second floors. The addition of Vimalakīrti to the eight great bodhisattvas is found in the *Rnam par snang mdzad 'khor dang bcas pa la bstod pa*, mentioned in the previous section, and also in Sŏkkuram cave near Kyŏngju in Korea.

The addition of the two wrathful deities Acala and Trailokyavijaya, on the other hand, is found in the Jimyō-in of the Garbha-maṇḍala and in the assembly hall (*kōdō*; today known as the *kondō*) on Mount Kōya in Japan. It is also worth noting that the combination of the eight great bodhisattvas with Acala and Trailokyavijaya coincides with the Sonshō mandara in the Amoghavajra tradition.

According to Hugh Richardson, an old statue of Vairocana accompanied by the eight great bodhisattvas, four on each side, and produced at the time of the Tufan kingdom was kept at Nesar, a renowned *gter gnas* in Nyangtö.[85] Unfortunately, when I visited the site in 2001, the statue of Vairocana had already been destroyed during the Cultural Revolution. Richardson also reported that the chapel at Nesar enshrining Vairocana was called "Okmin," that is, Akaniṣṭha Heaven. This was presumably to differentiate it from another chapel enshrining the five buddhas of the Vajradhātu-maṇḍala, also destroyed during the Cultural Revolution. It should be noted that the *Rnam par snang mdzad 'khor dang bcas pa la bstod pa* also mentions Akaniṣṭha Heaven as the abode of Vairocana.

Richardson does not describe the iconography of this statue of Vairocana ('Og min Rnam par snang mdzad). However, I met one Phuntsok, who used to be a monk at Nesar but returned to secular life during the Cultural Revolution and is now the custodian of the only remaining chapel at Nesar, that of Prajñāpāramitā, called Yumchenmo Lhakhang. He described from memory the iconography of the deities.[86] The main deity of the chapel enshrining the five buddhas (Sangs rgyas rigs lnga) displayed the enlightenment mudrā (*bodhyagrī-mudrā*; aka knowledge fist) holding a vajra[87] with both hands, whereas the main deity of the Okmin chapel ('Og min Rnam par snang mdzad) was one-faced and two-armed and displayed the meditation mudrā with both hands. This Vairocana, facing north, was attended by the eight great bodhisattvas, four on each side, and two wrathful deities, Acala (Mi g-yo ba) and Trailokyavijaya (Khams gsum rnam rgyal), were installed on both sides of the entrance to the chapel. I was thus able to confirm that the main deity of the Five Buddhas chapel was Vajradhātu-Vairocana, whereas that of the Okmin chapel was Vairocanābhisambodhi.

In eastern Tibet, reliefs of Vairocana displaying the meditation mudrā with both hands and attended by the eight great bodhisattvas have been discovered in Jamdun near Chamdo and also in Bido, Yushu (Tib. Yus hru'u) county, in Qinghai province, which traditionally belonged to Khams, or eastern Tibet. It is evident from the inscriptions that these reliefs date from 804 (Jamdun)[88] and 806 (Bido).[89]

Thus we find that there are quite a few examples of the combination of Vairocanābhisambodhi and the eight great bodhisattvas along the Silk Road under Tibetan rule and in central Tibet. The statue of Vairocanābhisambodhi accompanied by the eight great bodhisattvas from Ratnagiri has been dated to the eighth to ninth centuries on the basis of stylistic features,[90] and this date coincides approximately with the textual sources and examples from various parts of Asia mentioned above.

The *Rnam par snang mdzad 'khor dang bcas pa la bstod pa* states that Vairocana in Akaniṣṭha Heaven is accompanied by the eight great bodhisattvas, Acala, and Trailokyavijaya. At Nesar, Vairocana accompanied by the eight great bodhisattvas and two wrathful deities was called "'Og min Rnam par snang mdzad," that is, "Vairocana in Akaniṣṭha Heaven." As will be seen later, this combination can be interpreted as a selection of the principal deities of the Garbha-maṇḍala.

According to late Mahāyāna Buddhism, the Buddha's *sambhogakāya* (enjoyment body, visible only to advanced bodhisattvas), without leaving the Akaniṣṭha Heaven, expounds the Mahāyāna teachings only to high-ranking bodhisattvas.[91] Therefore Vairocanābhisambodhi accompanied by the eight great bodhisattvas is thought to represent the Buddha's *sambhogakāya* expounding the Mahāyāna teachings to high-ranking bodhisattvas in the Akaniṣṭha Heaven.

9. *Vidyārājas* and Wrathful Deities

As has been explained, the principal members of the maṇḍala in the early and middle phases of esoteric Buddhism were buddhas and bodhisattvas. However, wrathful deities appeared in the maṇḍala as emanations or attendants of the principal deities even in early maṇḍalas. In early esoteric Buddhism, such a deity was called "vajra" or "wrathful" (*krodha*). They were called "vajras" because these wrathful deities were thought to be emanations or attendants of Vajrapāṇi, who subjugates the enemies of Buddhism. Let us now consider the origin of these wrathful deities.

In Mahāyāna Buddhism there appeared a cult of spells called *dhāraṇīs*. The "Dhāraṇīparivarta" of the *Saddharmapuṇḍarīkasūtra* demonstrates that such *dhāraṇīs* already existed as spells in early Mahāyāna sūtras. Subsequently after the emergence of esoteric Buddhism, comparatively short spells called "mantras" were frequently used. *Dhāraṇīs* and mantras are sometimes referred to collectively as *mantra-dhāraṇī*, but *dhāraṇīs* are lengthy and consist of many meaningless words, whereas mantras are comparatively short, and sometimes doctrinal propositions of Mahāyāna Buddhism have become mantras, which are therefore thought to represent a doctrinally more developed form.[92] Esoteric Buddhism was styled *mantrayāna*, or the Mantra Vehicle, because great importance was placed on the recitation of mantras.

Further, some mantras or *dhāraṇīs* thought to be especially efficacious were deified and worshiped. Deifications of such secret incantations include the *vidyārājas* and *uṣṇīṣa* (or "topknot") deities. *Vidyārāja* means "king of *vidyās*" and refers to a deity thought to be most efficacious when his *vidyā*, or mantra/*dhāraṇī*, is recited. Acalanātha, Trailokyavijaya, and Yamāntaka are typical of such *vidyārājas*. Their extremely wrathful, multiheaded, and multiarmed iconography can be interpreted as an expression of their supernatural powers. Most *vidyārājas* are associated with a specific mantra or *dhāraṇī*.

For example, various forms of Acalanātha arose from the time of early esoteric Buddhism through to late tantric Buddhism. Most of them include in their mantras the characteristic word *caṇḍamahāroṣaṇa* and the seed syllables *hāṃ māṃ*. Trailokyavijaya similarly has a characteristic mantra beginning with "*oṃ sumbha nisumbha*,"[93] from which his epithet "Sumbharāja" derives. Yamāntaka has a mantra that contains the distinctive seed syllable *ṣṭrī*. Thus the essence of the *vidyārāja* cult exists not in any specific iconography but in distinctive mantras or *dhāraṇīs*.

In the iconography of Tibetan Buddhism, the *vidyārāja* is not used as a category for classifying deities, and the deities corresponding to *vidyārājas* in Sino-Japanese esoteric Buddhism are called *khro bo*, or "wrathful deities." Further, the wrathful deities who became the principal deities in the scriptures of late tantric Buddhism are called *yi dam*, or "tutelary deities."[94] It is therefore doubtful whether *vidyārāja* was established as a category for classifying deities in India. However, it is worth noting that "*bhagavan vajra*" (O glorious vajra!) in the mantra "*oṃ śumbha niśumbha huṃ gṛhṇa gṛhṇa huṃ gṛhṇāpaya huṃ ānaya ho bhagavan vajra huṃ phaṭ*"[95] in the "Trailokyavijayapaṭala" of the *Sarvatathāgatatattvasaṃgraha* was changed to "*bhagavan vidyārāja*" in the *Guhyasamājatantra*, which gives virtually the same mantra.[96] This fact suggests that Trailokyavijaya/Sumbha was at any rate called a *vidyārāja* in India.

Mahāmāyūrī, on the other hand, who is worshiped as a deity who wards off all kinds of misfortunes, starting with poisonous snakes, has an exceptionally peaceful appearance similar to that of a bodhisattva even though she is classified among the *vidyārājas* in Sino-Japanese esoteric Buddhism. This is because she was originally a goddess, as is indicated by the fact that she is known as a *vidyārājñī* (queen of *vidyās*) in Sanskrit. Such female deifications of *vidyās* came to play an important role later in tantric Buddhism.

Representative *vidyārājas* in the early and middle phases of esoteric Buddhism are Acala and Trailokyavijaya. In the Garbha-maṇḍala, these two deities are placed in the southwest and northwest corners of the first square, whereas in the Sonshō mandara they are placed to the right and left of Vairocana, the main deity.[97] As mentioned above, these two wrathful deities were added to Vairocanābhisambodhi accompanied by the eight great bodhisattvas in Tibet in the eighth to ninth centuries.

The origin of Acala is explained in the *Dilisanmeiye budongzun shengzhe niansong bimi fa*. When the Buddha attained enlightenment, the Hindu god Maheśvara refused a summons from the Buddha and produced various kinds of filth and excrement with which he then surrounded himself. On the orders of the Buddha, Acala manifested Impure Vajra (i.e., Ucchuṣma), who devoured the excrement and other filth, seized Maheśvara, and took him away to the Buddha. But Maheśvara escaped seven times, and so Acala subjugated Maheśvara, who was reborn in a world called Huiyu and became a tathāgata called Riyuesheng. Having witnessed this, all the other Hindu gods went to where the Buddha was, entered into the great maṇḍala, and received its blessings.[98]

The origin of Trailokyavijaya, on the other hand, is explained in detail in the "Trailokyavijayapaṭala" of the *Sarvatathāgatatattvasaṃgraha*. When the Buddha attained enlightenment, Vajrasattva manifested a great wrathful *yakṣa* who subdued worldly deities. However, Maheśvara, the lord of the triple world, and his consort Umā, trusting in their own power, would not obey the Buddha's orders. Vajrasattva then produced an extremely wrathful figure that eventually brought their lives to an end. But on account of the merit gained through

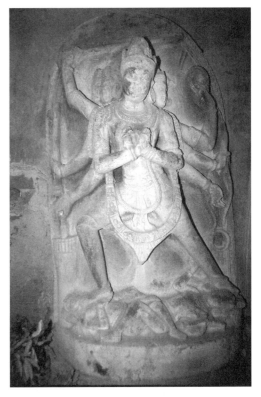

FIG. 1.16. TRAILOKYAVIJAYA
(MAHANT COMPLEX, BUDDHAGAYA)

having been trampled to death by Vajrapāṇi, Maheśvara was reborn in a world below called Bhasmācchanna and became a buddha named Bhasmeśvaranirghoṣa. After his enlightenment Maheśvara returned to this Sahā world and followed Vajrasattva's orders.[99]

Thus in stories explaining the origins of representative *vidyārājas*, Hindu deities appear as examples of evil beings difficult to lead to enlightenment by ordinary means. The *vidyārāja* was provided with the power to subdue Maheśvara or Śiva, the most powerful among these Hindu deities.

Yamāntaka, one of the Five Great Vidyārājas in Sino-Japanese esoteric Buddhism, is a wrathful deity whom Mañjuśrī manifested in order to subdue Yama, the Hindu god of the underworld. Yamāntaka was thought to be most effective in *abhicāra* (or *abhicāruka*) rites for vanquishing or killing the enemies of Buddhism.[100]

The origins of Amṛtakuṇḍalin, also counted among the five great *vidyārājas* in Sino-Japanese esoteric Buddhism, are unclear. However, his epithet Vighnāntaka in the Guhyasamāja cycle suggests that this wrathful deity was conceived of as a wrathful deity for subduing Gaṇeśa, a Hindu deity thought to be the leader of *vighna*s. In Japan, it is customary to perform the rite of Amṛtakuṇḍalin to rebuke Gaṇeśa when one has failed to obtain one's objectives by performing a ritual centered on Gaṇeśa.[101] In Tibet and Nepal, there has been transmitted an icon of Vighnāntaka trampling Gaṇeśa underfoot.[102] These facts suggest that Amṛtakuṇḍalin was originally a wrathful deity meant to subdue Gaṇeśa.

In addition, in the Dharmadhātuvāgīśvara-maṇḍala and a ritual manual for the eight *mahākrodhas* from Dunhuang,[103] we can see wrathful deities trampling the corresponding Hindu deities under their feet. In this way, wrathful deities of the early and middle phases of esoteric Buddhism are thought to be emanations of Vajrapāṇi and so on produced for the subjugation of particular Hindu deities. In this case, the wrathful deity is the foe of the Hindu god. However, it must not be forgotten that the wrathful deity also assumes the attributes of the Hindu god whom he subdues. Yamāntaka took over Yama's vehicle, the buffalo, while Vighnāntaka inherited Gaṇeśa's attribute of removing obstacles and bringing success. Many examples of this kind can be found.

It has been suggested on the basis of similarities between Acala and Śiva that Acala was a Buddhist version of Śiva. But although this thesis was popular for a time, it was not accepted in academic circles,[104] and while it has some persuasive points, its confusion of subjugator and subjugated needs to be corrected.

One cannot make sweeping generalizations that the relationship between Buddhism and Hinduism in India was antagonistic, since there was interfusion and borrowing on both sides. There are many examples in which the demonic rite of a Hindu deity who was supposed to have been subjugated was adopted by Buddhism. However, we must bear in mind that Buddhists took a particular stance toward Hinduism when they adopted Hindu deities and their cults.

10. *Uṣṇīṣa* Deities

There is another type of deification of mantras or *dhāraṇī*s in esoteric Buddhism called an *uṣṇīṣa* deity. An *uṣṇīṣa* deity has been explained as the deification of the topknot, or *uṣṇīṣa*, one of the thirty-two signs of a great man (*mahāpuruṣalakṣaṇa*), or Buddha. Alternatively, the *uṣṇīṣa* deity is described as a *vidyārāja* belonging to the Buddha family.

Uṣṇīṣa deities appear in many Mahāyāna and early esoteric sūtras. In many cases, these sūtras begin with the following story. A celestial being who has been predicted to die and descend to hell visits Indra, the king of gods, and asks to be saved, but Indra is unable to save him. When the celestial being then seeks the help of the Buddha, the latter emits a ray of light from the top of his head (*uṣṇīṣa*) that purifies the celestial being's evil karma and saves him from going to hell, and for the sake of sentient beings in the future who cannot meet the Buddha, an *uṣṇīṣa-dhāraṇī* with the same efficacy as the ray of light in purifying evil karma is expounded.

Such stories are found, for example, in the various versions of the *Uṣṇīṣavijayādhāraṇī* and the *Foding fang wugou guangming ru pumen guancha yiqie rulai xin tuoluoni jing*, and this type of story seems to have become the standard introductory tale for the *uṣṇīṣa* cult, since another similar tale is also found in the *Durgatipariśodhanatantra*,[105] an esoteric Buddhist scripture centered on *uṣṇīṣa* deities and belonging to the Yoga tantras. Owing to these circumstances, *uṣṇīṣa* deities were thought to be effective in the expiation of a dead person's sins or for the repose of his soul. The maṇḍala rite of the *Durgatipariśodhanatantra* is frequently performed even today in Nepal and Tibet at funeral ceremonies. This represents a vestige of the cult of *uṣṇīṣa* deities that has disappeared in India.

The reason that *uṣṇīṣa* deities were thought to be *vidyārājas* of the Buddha family is that *uṣṇīṣa-dhāraṇīs* were expounded not by Vajrapāṇi or protective deities, but by the Buddha himself. Like *vidyārājas*, the principal *uṣṇīṣa* deities are collectively known as the three, five, and eight *uṣṇīṣa* deities. In the maṇḍala of the *Guhyatantra*,[106] an early esoteric Buddhist scripture, *uṣṇīṣa* deities are depicted in the east of the first square as part of the retinue of Śākyamuni, whereas in the Garbha-maṇḍala the three *uṣṇīṣa* deities and five *uṣṇīṣa* deities are depicted in the east of the second square, also as part of the retinue of Śākyamuni. Both these examples would suggest that *uṣṇīṣa* deities belong to the Buddha family.

In the early and middle phases of esoteric Buddhism, *uṣṇīṣa* deities were usually depicted as bodhisattvas. However, in late tantric Buddhism the principal *dhāraṇīs*, such as the *Uṣṇīṣavijayā*, *Sitātapatrā*, and so on, were depicted as female deities, since *dhāraṇī* is a feminine noun. In the thirty-two-deity maṇḍala of Akṣobhyavajra belonging to the Ārya school of the *Guhyasamājatantra* (see chapter 5), Uṣṇīṣacakravartin among the ten wrathful deities is depicted as a three-headed and six-armed wrathful deity. Thus *uṣṇīṣa* deities in bodhisattva form had been replaced by female or wrathful deities by the time of late tantric Buddhism.

11. *Aṣṭamaṇḍalaka* and the Nine-Panel Grid

As mentioned above, the principal bodhisattvas worshiped in Mahāyāna Buddhism formed a group called the eight great bodhisattvas, and these eight bodhisattvas played an important role in the maṇḍala. The standard eight great bodhisattvas appear in many maṇḍalas, such as the Sonshō mandara (Amoghavajra tradition), the Amitābha-maṇḍala of Sino-Japanese Buddhism, the Akṣobhyavajra-maṇḍala of the Ārya school of the *Guhyasamājatantra*, and the maṇḍala of forty-two peaceful deities of the Nyingma school of Tibetan Buddhism, and they play an important role in each maṇḍala. In addition, as will be seen in chapter 2, the maṇḍala of the eight great bodhisattvas, in which the main deity is surrounded by the standard eight great bodhisattvas, is described only in the *Aṣṭamaṇḍalakasūtra*, and three examples in relief are found in Ellora Cave 12 in west India.

There are many ways of arranging the eight great bodhisattvas in a maṇḍala. Among these, the most common is to arrange them clockwise around the main deity, starting from the right, in accordance with the most popular order: (1) Avalokiteśvara, (2) Maitreya, (3) Ākāśagarbha, (4) Samantabhadra, (5) Vajrapāṇi, (6) Mañjuśrī, (7) Kṣitigarbha, and (8) Sarvanīvaraṇaviṣkambhin. If they are arranged in this manner, starting from the right attendant Avalokiteśvara, the left attendant Vajrapāṇi is on the opposite side of the main deity. It thus became possible for the three-family system deriving from the triad of Śākyamuni, Avalokiteśvara, and Vajrapāṇi to merge with the grouping of the eight great bodhisattvas (see fig. 1.17).

It turns out that the name of the maṇḍala of the eight great bodhisattvas in Sanskrit is not *aṣṭabodhisattva-maṇḍala* but *aṣṭamaṇḍalaka*,[107] meaning "that which has eight circles." This tallies with a description of the maṇḍala of the eight great bodhisattvas in the *Shizi zhuangyanwang pusa qingwen jing*, according to which "eight circles are arranged inside a square."[108]

Could it be that the maṇḍala was originally not a square symbolizing a pavilion where the deities assemble but rather circles of the eight great bodhisattvas arranged inside the pavilion? In order to verify this possibility, it would be necessary to demonstrate that the *aṣṭamaṇḍalaka* was popular in India when esoteric Buddhism emerged and was synonymous with the maṇḍala. In this regard, I would draw attention to a passage in the *Śrīguhyasamājamaṇḍalopāyikāviṃśatividhi* (hereafter *Viṃśatividhi*) that reads: "The wheel in the center [of the maṇḍala] is similar to the *aṣṭamaṇḍalaka*."[109]

Here the circle in the center of the Guhyasamāja-maṇḍala is said to be "similar to the *aṣṭamaṇḍalaka*." As will be seen in chapter 5, the central circle of the Guhyasamāja-maṇḍala differs from the maṇḍala of the eight great bodhisattvas, consisting instead of the five buddhas and four buddha-mothers. Moreover, the maṇḍala of the eight great bodhisattvas is described as "eight circles arranged inside a square," whereas the center of the Guhyasamāja-maṇḍala is a circle divided into nine parts in the form of two pairs of intersecting lines.[110] In spite of such differences, the reason that the *aṣṭamaṇḍalaka* is referred to here is that the maṇḍala of the eight great bodhisattvas was so popular in India at the time that every esoterically inclined Buddhist knew about it.

As discussed earlier, the original form of the maṇḍala was the landscape maṇḍala, which does not have any geometrical structure symbolizing a pavilion where deities assemble; instead, the deities are arranged in the pavilion depicted from a bird's-eye view. However, the landscape maṇḍala does not have a circular shape, and so it remains questionable why such an icon was called a *maṇḍala*, or "circle."

It was noted earlier that a Sanskrit fragment of the *Mahāmaṇivipulavimānakalparāja*, which describes a typical landscape maṇḍala, has been discovered at Gilgit, and the term *maṇḍala* already appears

FIG. 1.17. SONSHŌ MANDARA AND EIGHT GREAT BODHISATTVAS

2. Maitreya	3. Ākāśa-garbha	4. Samanta-bhadra
1. Avalo-kiteśvara	Vairocana	5. Vajrapāṇi
8. Sarva-nīvaraṇa-viṣkambhin	7. Kṣiti-garbha	6. Mañjuśrī

If the eight great bodhisattvas are arranged clockwise around the main deity, starting from the right, Vajrapāṇi is on the opposite side of the main deity to Avalokiteśvara. It thus becomes possible for the three-family system deriving from the triad of a main deity, Avalokiteśvara, and Vajrapāṇi to merge with the grouping of the eight great bodhisattvas.

in this text. Therefore if we wish to trace the origins of the maṇḍala to the maṇḍala of the eight great bodhisattvas, we must prove that it had already come into existence by the sixth century at the latest. In the *Shizizhuangyanwang pusa qingwen jing*, the oldest Chinese translation to mention the eight great bodhisattvas, the term "eight maṇḍalas" frequently occurs. Therefore we can confirm that the maṇḍala of the eight great bodhisattvas already existed in the seventh century. But a textual source datable to the sixth century has yet to be discovered.

This pattern has been referred to as a "nine-sector structure formed by two pairs of intersecting lines."[111] In ritual manuals in Sanskrit, however, this pattern is called *navakoṣṭha* (nine-panel grid),[112] and accordingly I shall hereafter refer to this type of pattern as a nine-panel grid. The nine-grid panel was carried over via the Vajradhātu-maṇḍala to the maṇḍalas of late tantric Buddhism, starting with the *Guhyasamājatantra*, and became one of the basic patterns of the maṇḍala.

12. The Maṇḍala as an Eight-Spoked Wheel

The *cakra* (wheel) is also frequently used as a basic pattern of the maṇḍala. In the wheel pattern, the main deity is depicted on the hub and the attendants are arranged on the spokes. There are patterns of four-, six-, eight-, and twelve-spoked wheels, although this wheel pattern is not often found in Japan. However, the Dairin mandara (Mahācakra-maṇḍala)—a *besson mandara*, or maṇḍala of a relatively small scale centered on one particular deity—is a typical example of a maṇḍala with an eight-spoked wheel and is a developed form of the maṇḍala of Sahacittotpādadharmacakrapravartin described in the *Prajñāpāramitānayasūtra*.[113] It has been noted that the maṇḍala in the shape of an eight-spoked wheel originated in the *Prajñāpāramitānayasūtra*.[114]

Buddhism had made use of many symbols before the introduction of images of the Buddha. Representative of these symbols was the *dharmacakra*, or dharma wheel, symbolizing the Buddhist teachings. Therefore it was natural that the wheel (*cakra*) should be adopted as a basic pattern of the maṇḍala.

In Japan, the *cakra* is depicted as the dharma wheel and the attendants are placed between the spokes. In Tibet, on the other hand, the wheel is frequently depicted in the shape of the *cakra* as a weapon[115] and the attendants are placed on the spokes.[116]

Maṇḍalas in the shape of the *cakra* as a weapon are frequently encountered not only in Tibet but also in Dunhuang paintings, such as a maṇḍala of the Amoghapāśa pentad (Musée Guimet, EO 3579), the Durgatipariśodhana-maṇḍala in line drawing (Bibliothèque nationale de France, Pelliot chinois no. 3938),[117] and a maṇḍala of seed syllables of the *Durgatipariśodhanatantra* in line drawing (Bibliothèque nationale de France, Pelliot tibétain no. 389).[118] Therefore maṇḍalas in the shape of the *cakra* as a weapon also originated in India.

In Tibet, it is known that many of the maṇḍalas taking the shape of a wheel are those centered on wrathful deities. The *Guhyasamājatantra* explains the visualization of a yellow ten-spoked wheel turning at high speed in which ten wrathful deities are arranged on the spokes.[119] In Tibet, this meditation was practiced for the protection of the practitioner before the production of a maṇḍala.[120] In a ritual manual for eight wrathful deities discovered at Dunhuang, the eight-spoked wheel with eight wrathful deities is called the "wheel of

FIG. 1.18. MANDALAS IN THE SHAPE OF AN
EIGHT-SPOKED WHEEL

Dharmacakra: attendants are placed between the spokes

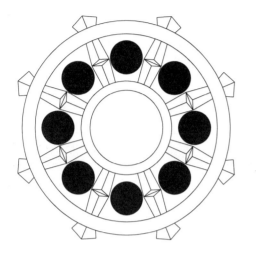

Cakra as a weapon: attendants are placed on the spokes

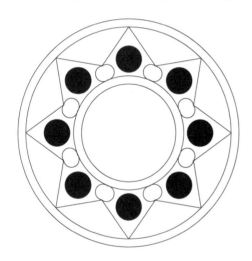

command" (*ājñācakra*).[121] The "wheel of command" is the wheel corresponding to *vidyārā-jas* in the triple-wheel theory. It turns out that the wheel with wrathful deities on the spokes was called the "wheel of command" because it compels enemies of Buddhism to obey the Buddha's orders.

In the section on generating Vajrahetu in the *Sarvatathāgatatattvasaṃgraha*, Vairocana enters a *samādhi* to generate a bodhisattva named Sahacittotpāditadharmacakrapravartin, whose symbol is a *cakra*, and recites the mantra "*vajrahetu*," whereupon Vajradhara becomes the Great Maṇḍala of Adamantine Realms and so forth; having appeared, these maṇḍalas enter the heart of Vairocana, where they combine and become one, producing the form of an adamantine wheel (*vajracakravigraha*).[122] Thus the *Sarvatathāgatatattvasaṃgraha* identified the *cakra* with the maṇḍala even though the Vajradhātu-maṇḍala itself has a nine-panel grid as its basic pattern. This fact suggests that the pattern of the eight-spoked wheel originating in the *Prajñāpāramitānayasūtra* was well known as a basic pattern of the maṇḍala. The maṇḍala with a wheel as its basic pattern was transmitted from the *Prajñāpāramitā-nayasūtra* through late Yoga tantras such as the *Durgatipariśodhanatantra* to late tantric Buddhism. In the iconography of Indo-Tibetan Buddhism in later times, a wheel together with the nine-panel grid became one of the basic patterns of the maṇḍala.

The lotus, another basic pattern of the maṇḍala, first appears in the *Vajrapāṇyabhiṣeka-tantra*, one of the predecessors of the *Vairocanābhisambodhisūtra*. However, in the *Tuo-luoni jijing* and the *Susiddhikarasūtra*, texts belonging to early esoteric Buddhism, there is a description of a lotus in the center of the maṇḍala as the seat of the main deity. Chapter 2 of the *Vairocanābhisambodhisūtra*, the texual source of the eight-petaled lotus at the center of the Garbha-maṇḍala, has only:

> Its eight petals are quite perfect, the stamens are all imposingly lovely,
> And wisdom-seals [in the shape] of vajras are visible between all the petals.
> From the center of this flowery pedestal Vairocana, the victorious honored
> one, appears.[123]

There is no mention of four buddhas and four bodhisattvas being depicted on the eight lotus petals. Therefore the lotus pattern was originally the seat of the main deity. However, it is worth noting that three basic patterns of the maṇḍala—the lotus, the wheel, and the nine-panel grid—had already come into existence by the sixth to seventh centuries when the maṇḍala had just appeared in India. Subsequently maṇḍalas in a great variety of patterns appeared in India.

2. The Emergence of the Garbha-maṇḍala

1. The Evolution of the Three Families from Triads

AS WE SAW in the previous chapter, the landscape maṇḍala, a primitive form of the maṇḍala, came into existence after its main members—buddhas, bodhisattvas, and wrathful deities—had appeared in India. The landscape maṇḍala based on the triad developed alongside esoteric Buddhism, and a full-scale maṇḍala consisting of three families—Buddha, Lotus, and Vajra—evolved in due course. The Garbha-maṇḍala described in the *Vairocanābhisambodhisūtra* represents the culmination of maṇḍalas of the three-family system. In this chapter, it will be seen how the Garbha-maṇḍala, with its complicated structure, evolved from earlier maṇḍalas of the three-family system.

As we saw, a buddha statue from Ahichatra (second century CE) has Padmapāṇi and Vajrapāṇi on both sides as attendants. Thereafter, many examples of the triad consisting of the Buddha, Avalokiteśvara (Padmapāṇi), and Vajrapāṇi were produced in India, with most of them having been found in western India and Orissa.

The triad from Ahichatra places Vajrapāṇi on the right and Padmapāṇi on the left of the Buddha. However, later examples from western India and Orissa often place Avalokiteśvara (Padmapāṇi) on the right and Vajrapāṇi on the left of the main deity. The maṇḍala of the three-family system, which places the Lotus family centered on Avalokiteśvara on the right of the main deity and the Vajra family consisting of Vajrapāṇi's retinue on the left, evolved from this type of triad.

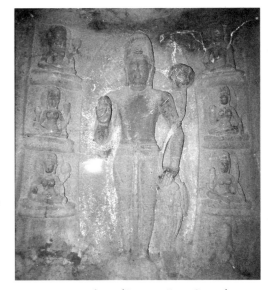

FIG. 2.1. AVALOKITEŚVARA (CHAPEL 3, NASIK CAVE 23)

Nasik, in Maharashtra in western India, is a famous site sacred to Hinduism. However, Buddhist caves were dug into the hillside of a mountain about 8 kilometers south-southwest from the city center. Yamada Kōji considers these caves to date from the seventh to eighth centuries, although earlier studies had placed them in the sixth to seventh centuries.[124] At any rate, the date and iconography of the Nasik caves correspond to the transitional period after the fall of the Gupta dynasty through to the efflorescence of Pāla art, when the *Vairocanābhisambhodhisūtra* and Garbha-maṇḍala evolved from early esoteric Buddhism. In these Nasik caves we can find an interesting combination of deities in Chapel 3 belonging to Cave 23.

In Chapel 3 there is enshrined a seated buddha with the dharma-wheel mudrā in the center of the front wall, with Avalokiteśvara and Vajrapāṇi flanking the main deity.[125] Moreover, it is worth noting that Avalokiteśvara and Vajrapāṇi are arranged in the center of the two side walls, and on both sides of the main deity eight small attendants are arranged in four registers (see figs. 2.1 and 2.2). Unfortunately, owing to erosion by ground water, we

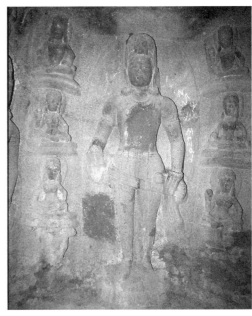

FIG. 2.2. VAJRAPĀṆI (CHAPEL 3, NASIK CAVE 23)

cannot distinguish the iconographical features of the attendants in the lowest register, but the other attendants each have clear iconographical features such as gender, attributes, and sitting pose.

At this stage it is difficult to identify the names of each of the small attendants. Nevertheless, it would be natural to suppose that there have been collectively arranged here the attendants of the Lotus family centered on Avalokiteśvara and those of the Vajra family centered on Vajrapāṇi. They could also be regarded as the attendants of the Lotus and Vajra families in maṇḍalas of the three-family system. The Lotus family of the current version of the Garbhadhātu-maṇḍala (Genzu mandara) consists of twenty-one principal deities, and if we add to these minor attendants, the total number of deities is thirty-four. The Vajra family, on the other hand, consists of twenty-one principal deities and, if we add minor attendants, thirty-two deities in all.

However, when compared with these, the Lotus and Vajra families originating in the *Vairocanābhisambodhisūtra* were far smaller in scale. According to chapter 2 of the *Vairocanābhisambodhisūtra*—the textual source of the Garbha-maṇḍala—the Lotus family consists of only seven attendants and the Vajra family of only four attendants. The Vajra family increases to as many as twenty-four deities[126] with the addition of attendants listed in later chapters such as chapters 9 and 11. Thus the original members of the Lotus and Vajra families are thought to have been quite few in number. Therefore the attendants of Avalokiteśvara and Vajrapāṇi in Chapel 3 of Cave 23 at Nasik were already of the same scale as the Lotus and Vajra families of the Garbha-maṇḍala in its original form.

Among textual sources, the *Tuoluoni jijing* translated in 653–654 by Atikūṭa, who came to China in 651, presents the basic concept of the three families in the first half of the seventh century. This scripture, said to have been extracted from a larger work,[127] consists of twelve fascicles: it explains the deities belonging to the Buddha family in fascicles 1 and 2, Prajñāpāramitā in fascicle 3, Avalokiteśvara and other bodhisattvas in fascicles 4–6, deities belonging to the Vajra family in fascicles 7–9, Hindu deities in fascicles 10 and 11, and a general maṇḍala gathering together all the deities in fascicle 12, the final fascicle. Thus it classifies Buddhist deities into three families consisting of the Buddha, Lotus, and Vajra families and adds a group of protective deities adopted from Hinduism.

Two types of general maṇḍala are described in the *Tuoluoni jijing*, one 12 cubits in size and the other 16 cubits. The general maṇḍala in 12 cubits consists of three concentric squares, called inner, second, and outer, respectively. Depicted in the center is the main deity, an *uṣṇīṣa* deity or any buddha or bodhisattva thought to be suitable for the *sādhana*. In the east of the inner and second squares deities belonging to the Buddha family, such as Śākyamuni and Prajñāpāramitā, are depicted; in the north, deities belonging to the Lotus family, such as Avalokiteśvara and Mahāsthāmaprāpta; in the south, deities belonging to the Vajra family, such as Vajrarāja and Vajra Mother (i.e., Māmakī); and in the west of the inner square, the two bodhisattvas Samantabhadra and Maitreya. The west of the second square, on the other hand, is occupied by Hindu deities such as Maheśvara and Umādevī. In the outer square protective deities such as the Four Great Kings (*caturmahārāja*) and protectors of the eight directions are arranged, with four wrathful deities in the four corners (see fig. 2.3).

The general maṇḍala in 16 cubits, meanwhile, is of even larger scale and consists of four concentric squares. All the deities are depicted as mudrās, or symbols. As in the case of the general maṇḍala in 12 cubits, they are composed of the three families—Buddha, Lotus,

and Vajra—with Hindu deities in the outer square. This maṇḍala includes four *uṣṇīṣa* deities who have the same names as the four buddhas of the *Suvarṇaprabhāsasūtra*, and this is noteworthy as the first appearance of the buddhas of the four directions in a maṇḍala. However, these four buddhas are collectively arranged in the east of the second square, and their positions do not reflect the directions of their own pure lands. When the maṇḍala consisting of three families emerged, there had been no way of arranging them other than to depict them together in the upper part of the maṇḍala, since all *uṣṇīṣa* deities belong to the Buddha family (see fig. 2.4).

Thus the *Tuoluoni jijing* consists of three families both in the classification of its deities and in the structure of its maṇḍalas. When considered in connection with other early esoteric Buddhist scriptures, Subāhu in the center of the southern strip of the second square and *Vajrasvastikara in the southeast corner of the inner square attract our attention. Subāhu is the principal member of the audience in the *Subāhuparipṛcchā*, an early esoteric Buddhist scripture, while *Vajrasvastikara seems to be identical with the bodhisattva Susiddhikara of the *Susiddhikaramahātantra* (to be discussed below). It would seem that these two texts were already circulating when the *Tuoluoni jijing* was translated into Chinese even though

FIG. 2.3. GENERAL MAṆḌALA IN 12 CUBITS OF THE *TUOLUONI JIJING*

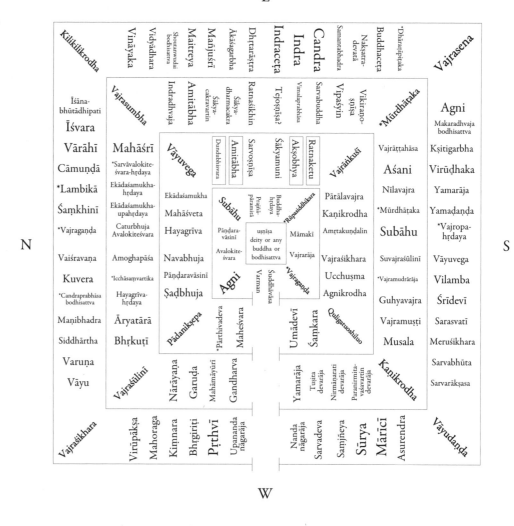

FIG. 2.4. GENERAL MAṆḌALA IN 16 CUBITS
OF THE *TUOLUONI JIJING*

they were translated after the *Tuoluoni jijing*. At any rate, the *Tuoluoni jijing* provides us with important information about Indian esoteric Buddhism in the early seventh century.

2. The Maṇḍalas of the *Guhyatantra* and *Susiddhikaramahātantra*

As was seen in the previous chapter, the triad consisting of Śākyamuni, Avalokiteśvara, and Vajrapāṇi developed into three families in sixth-century India, and from the second half of the sixth century to the early seventh century the three families developed into more complex maṇḍalas.

The *Guhyatantra* is an early esoteric Buddhist scripture that explains the general rules for maṇḍala rites, and it exerted an influence on the maṇḍala rites of late tantric Buddhism through the *Viṃśatividhi*. The *Guhyatantra* describes a maṇḍala of a comparatively large scale based on the three-family system, although its structure differs considerably in the Chinese and Tibetan translations.[128]

In this maṇḍala the main deity (Vairocana in fig. 2.5) is depicted on the pericarp of the lotus in the center. According to the Tibetan translation, the main deity is surrounded in the four directions by manuscripts of four important Mahāyāna sūtras, the *Prajñāpāramitā*,

FIG. 2.5. *GUHYATANTRA* AND LORDS OF THE THREE FAMILIES

Īśāna Śuddhāvāsas Indra Śuddhāvāsas Sūrya Agni

Siddhārtha Ākāśagarbha Mahāsthāma-prāpta Mañjuśrī Maitreya bodhisattvas of Bhadrakalpa Vimalagata

Uṣṇīṣa-cakravartin Śakti Ūrṇa Locanā Śākyamuni Mahod-gatoṣṇīṣa Cintāmaṇi-dhvaja attendants

Maheśvara

Umā

Yakṣas

*Āśāparipūrakā Aparājitā Sumbha

Vajrasena

Mahāśrī Vajramuṣṭi

Gaurī Vajrāṅkuśī Brahman

Tārā Māmakī

Avalokite-śvara *Prajñāpāramitā* *Gaṇḍavyūha* Vajrapāṇi Subāhu Yama

Pāṇḍaravāsinī *Suvarṇaprabhāsa* Vairocana Pādanikṣepa Seven vidyādhara ascetics

Yaśomati Vajraśṛṅkhalā

Śvetā *Tathāgataguhyaka* Vajradaṇḍa Mūrdhagata

Ekajaṭā Ucchuṣma

Vaiśravaṇa

Yakṣas

Haṃ・vajra・Amṛtakuṇḍalin

Upananda Nanda

Vāyu Candra Vāsuki Vairocana Asurendra Prahlāda Balin Pṛthvī Varuṇa Rāhu Asurendra Grahas Gaṇapati Mātṛs Naimīti

Hārītī

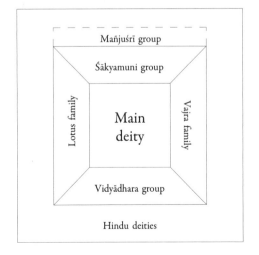

Mañjuśrī group
Śākyamuni group
Lotus family — Main deity — Vajra family
Vidyādhara group
Hindu deities

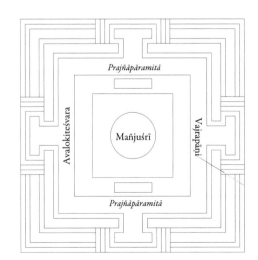

Prajñāpāramitā
Avalokiteśvara — Mañjuśrī — Vajrapāṇi
Prajñāpāramitā

Gaṇḍavyūha, *Tathāgataguhyaka* (corresponding to the *Tathāgatācintyaguhyanirdeśa* of the Ratnakūṭa cycle), and *Suvarṇaprabhāsa*.

The lotus in the center is surrounded by two concentric squares. Depicted in the left (north) of the inner square are deities belonging to the Lotus family, starting with Avalokiteśvara, while in the right (south), deities belonging to the Vajra family, starting with Vajrapāṇi, are arranged. In the east, *uṣṇīṣa* deities and deifications of the Buddha's characteristics,[129] corresponding to the deities of the Śākyamuni sector of the later Garbha-maṇḍala, are arranged. The sector in the west, on the other hand, corresponds to the Vidyādhara sector in the Garbha-maṇḍala of later times, although most of this sector is empty except for two *nāga* kings in the western gate. The reason that the *nāga* kings have been placed in the western gate seems to be that they were thought to be protectors of the west.[130] But their inclusion may also be associated with the relief of a group of figures in Kanheri Cave 90 mentioned in the previous chapter, in which the stem of the lotus throne of the main deity is supported by two *nāga* kings. In this case they would support the hypothesis that the maṇḍala evolved from the *paṭa* used for worship purposes. In the outer square Mañjuśrī and his retinue are depicted in the east, while protective deities originating in Hinduism are arranged in the south, west, and north.

The structure of the inner square is based on the three-family system, and the main deity, Śākyamuni, and Mañjuśrī are arranged vertically along the central axis. We can interpret this as a development from the triad, if we consider that the three families evolved from the triad of Śākyamuni, Avalokiteśvara, and Vajrapāṇi and that in early esoteric Buddhism Mañjuśrī was thought to be a representative bodhisattva of the Buddha family.[131]

The Genzu mandara, the current version of the Garbha-maṇḍala, consists of twelve sectors. Among these, the Susiddhikara sector is not explained in the *Vairocanābhisambodhisūtra*. Furthermore, the sectors in the Genzu mandara are square and demarcated by lines, whereas the primitive Garbha-maṇḍala depicted only three concentric squares and the strips in the four cardinal directions of each square were not demarcated by lines. The Japanese scholar Ishida Hisatoyo has therefore called these sectors of the early versions of the Garbha-maṇḍala "groups," as in, for example, the Mañjuśrī group and Omniscience group (with a triangle symbolizing the Buddha's omniscience).

In the maṇḍala of the *Guhyatantra*, five groups—the Avalokiteśvara group, Vajra[pāṇi] group, Śākya[muni] group, Mañjuśrī group, and group of Hindu deities—among the eleven groups of the primitive Garbha-maṇḍala already existed, while two groups—the central lotus group and Vidyādhara group—were in the process of developing (see fig. 2.5).

Thus the landscape maṇḍala originating in the triad evolved into a more complicated maṇḍala consisting of three families and composed of two concentric squares. The triple-square structure of the Garbha-maṇḍala can be regarded as a further extension of this line of development.

It should be noted that there is no tradition of the maṇḍala of the *Guhyatantra* in present-day Tibetan Buddhism. There is, however, a maṇḍala of the lords of the three families[132] based on this text. This maṇḍala is centered on Mañjuśrī, flanked by Avalokiteśvara and Vajrapāṇi on the right (north) and left (south), while manuscripts of the *Prajñāpāramitā* are depicted at the top and bottom of the maṇḍala. Thus this maṇḍala integrates a large number of deities belonging to the three families into the three bodhisattvas Mañjuśrī (Buddha family), Avalokiteśvara (Lotus family), and Vajrapāṇi (Vajra family) (see fig. 2.5). The *Guhya-*

tantra gives no explicit description of this maṇḍala, but it does state that if one is unable to depict the maṇḍala deities in their human form, images of the lords of the three families should be placed on the maṇḍala, while other deities should be represented by mudrās, or symbols.[133] Therefore the idea that Mañjuśrī, Avalokiteśvara, and Vajrapāṇi were the lords of the three families is thought to have originated in India.

The *Susiddhikaramahātantra* is an early esoteric Buddhist scripture classified in Tibet as a general tantra[134] of the Kriyā tantras, and among the Kriyā tantras it has been systematized to a certain extent. Although it does not describe a full-scale maṇḍala, in several chapters maṇḍalas of a comparatively small scale for accomplishing various objectives are explained: a maṇḍala for inviting deities to empower an article for effectuation, maṇḍalas for redressing deficiencies and effectuating various articles, a secret maṇḍala common to the three families, maṇḍalas for retrieving an article for effectuation that has been stolen and for accomplishing all deeds common to the three families, an initiation (*abhiṣeka*) maṇḍala, and a maṇḍala for "irradiating" articles for effectuation.

Among these maṇḍalas, separate maṇḍalas are explained for each of the three families in the case of the maṇḍalas for redressing deficiencies and effectuating various articles. These are noteworthy as precursors of the "separate maṇḍala," which extracted a particular group of the Garbha-maṇḍala. The secret maṇḍala common to the three families and the maṇḍala for inviting deities to empower an article for effectuation, on the other hand, incorporate the three families even though they are small-scale maṇḍalas.

In the secret maṇḍala common to the three families, the main deity or a vase (*kalaśa*) is placed in the center, while a mudrā (symbol) of a tathāgata is depicted in the east, of Avalokiteś-vara in the north, and of Vajra(pāṇi) in the south, each of which is flanked by the *vidyā* of the family mother and the *vidyā* "accomplisher of [all] deeds." In addition, symbols are arranged on the outside. Among these, a begging bowl (*pātra*) and robes (*cīvara*) are thought to be symbols of the Buddha's teaching, while a water pitcher (*kuṇḍī*) and a stick (*daṇḍa*) are frequent attributes of multiarmed forms of Avalokiteśvara in esoteric Buddhism, and a vajra and a hammer (*mudgara*) are attributes of wrathful deities belonging to the Vajra family. The western sector (bottom), on the other hand, is occupied by protective deities adopted from Hinduism, such as Rudra, Gaurī, Kuvera, and Lakṣmī (fig. 2.6a).

In the maṇḍala for inviting deities to empower an article for effectuation, the article to be effectuated is placed on the pericarp of the lotus in the center. The Buddha, Tejorāśyuṣṇīṣa,

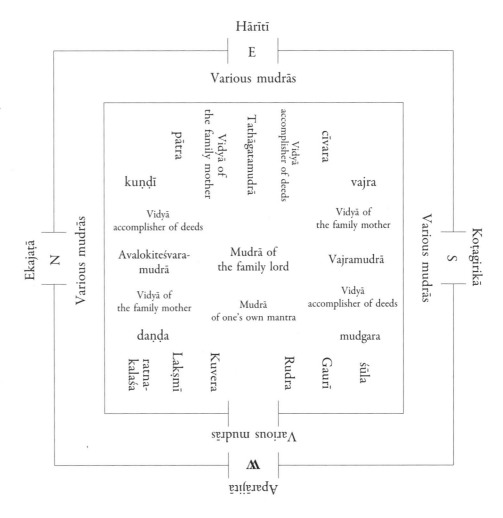

FIG. 2.6A. SECRET MAṆḌALA COMMON TO THE THREE FAMILIES IN THE *SUSIDDHIKARAMAHĀTANTRA*

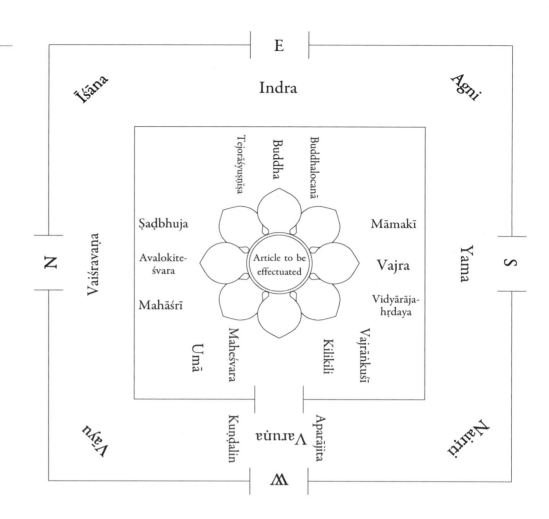

and Buddhalocanā are arranged in the east; Avalokiteśvara, Mahāśrī, and the Six-Armed One in the north; and Vajra(pāṇi), Māmakī, and Vidyārājahṛdaya in the south. To the north of the western gate are Maheśvara and his consort, while to the south of the western gate the Buddhist wrathful deities Kilikili and Vajrāṅkuśa are arranged. Furthermore, in the western gate of the outer square are the two *vidyārājas* Aparājita and Amṛtakuṇḍalin, while the protectors of the eight directions are arranged in the eight directions (fig. 2.6b).

In this fashion, the maṇḍalas in the *Susiddhikaramahātantra*, which place deities of the Buddha family in the upper part (east), those of the Lotus family on the left (north), and those of the Vajra family on the right (south), are typical examples of maṇḍalas consisting of the three families even though they are small in scale. In the lower part of these maṇḍalas, meanwhile, are arranged Hindu deities starting with Śiva. In the maṇḍala for inviting deities to empower an article for effectuation, the two *vidyārājas* Amṛtakuṇḍalin and Aparājita and the wrathful deities Kilikili and Vajrāṅkuśa, meant to subjugate Hindu deities and all belonging to the Vajra family, are arranged in the lower part.

This arrangement coincides with the description found in the *Guhyatantra*: deities belonging to the Buddha family are arranged in the east, those belonging to the Lotus family are in the north, and those belonging to the Vajra family are in the south; all the deities

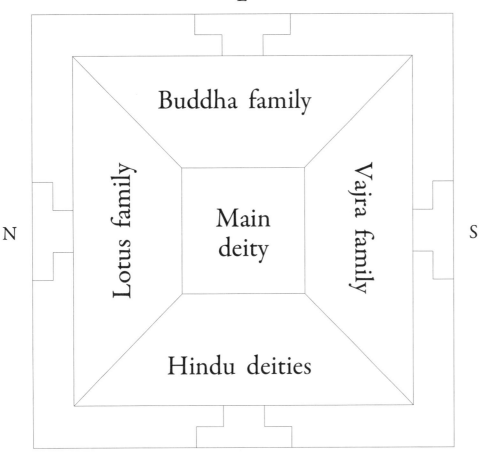

E

N

S

W

Buddha family

Lotus family

Main deity

Vajra family

Hindu deities

FIG. 2.6C. ARRANGEMENT OF THE THREE FAMILIES

and retainers belonging to the three families rejoice if they are duly invited and worshiped, and on a seat in the west all the *deva*s are invited and worshiped as above.[135] This arrangement also coincides with the general maṇḍala of the *Tuoluoni jijing* and could therefore be regarded as a general rule for early maṇḍalas consisting of the three families (fig. 2.6c).

In the *Susiddhikaramahātantra*, different functions are assigned to the deities belonging to each of the three families. The mother of the Buddha family is Buddhalocanā, that of the Lotus family is Pāṇḍaravāsinī, and that of the Vajra family is Māmakī; the *vidyārāja* of the Buddha family is Uṣṇīṣavijaya, that of the Lotus family is Hayagrīva, and that of the Vajra family is Sumbha; the *mahākrodha*, or "great wrathful one," of the Buddha family is Aparājita, that of the Lotus family is Śivāvaha, and that of the Vajra family is (Amṛta)kuṇḍalin.[136]

These deities were to play important roles in the maṇḍala down to late tantric Buddhism through the Garbha-maṇḍala. Particularly, to the mothers of three families—Buddhalocanā, Pāṇḍaravāsinī, and Māmakī—was added Tārā, and these four buddha-mothers became important members of the maṇḍalas of late tantric Buddhism. This is supported by the fact that the mantras of Buddhalocanā and Pāṇḍaravāsinī appearing in the *Susiddhikaramahātantra* are similar to those of Buddhalocanā and Pāṇḍaravāsinī in the *Guhyasamājatantra*.[137] Mantras of the mothers of the three families also appear in chapter 4 of the *Vairocanābhisambodhisūtra*, "A Treasury of Mantras in Common Use," but they are not

the same as those of the *Susiddhikaramahātantra*. The *Sarvatathāgatatattvasaṃgraha* does not mention the mothers of the three families, whereas the *Sarvarahasya*, an explanatory tantra, does refer to the four buddha-mothers,[138] although there is a strong possibility that they were reintroduced from the *Guhyasamājatantra*. In spite of belonging to early esoteric Buddhism, the *Susiddhikaramahātantra* thus has elements that were directly connected to later tantric Buddhism without passing through the *Vairocanābhisambodhisūtra* and *Sarvatathāgatatattvasaṃgraha*.

3. The Maṇḍala of the *Mañjuśrīmūlakalpa*

The *Mañjusrīmūlakalpa* is an early esoteric Buddhist scripture that is classified in Tibet as the lord of the Buddha family in the Kriyā tantras.[139] One chapter was translated into Chinese by Amoghavajra,[140] but the entire text was translated only in the Northern Song dynasty. However, Śubhākarasiṃha refers to it as "the Sanskrit text on Mañjuśrī" in his commentary on the *Vairocanābhisambodhisūtra*, the *Darijing shu*.[141] Therefore the main body of the text is thought to have existed already in the sixth to seventh centuries.

Early in the twentieth century a Sanskrit manuscript of the *Mañjusrīmūlakalpa* was discovered at a Jain temple in South India, and in 1920–25 the first critical edition was published by G. Shastri. Since then, it has attracted the attention of many scholars. The National Archives of Nepal in Kathmandu also possesses two manuscripts (both incomplete).[142] In Japan, Horiuchi Kanjin turned his attention to grammatical peculiarities in the text,[143] while Matsunaga Yūkei, following on from a study by J. Przyluski, considered the date of the text.[144] In addition, Yamashita Hiroshi has discussed the position of its maṇḍala in the development of maṇḍalas consisting of the three families.[145]

The *Mañjusrīmūlakalpa* is important, as the Sanskrit, Tibetan, and Chinese versions are all extant, whereas most of the original texts of early esoteric Buddhist scriptures have been lost. Moreover, when compared with the *Amoghapāśakalparāja* (to be discussed below), in which differences between the Sanskrit and Tibetan on the one hand and the Chinese on the other are quite pronounced, the three versions of the *Mañjusrīmūlakalpa* do not differ all that much, at least not in the main body of the text. This would suggest that the text of the *Mañjusrīmūlakalpa*, including its grammatical irregularities, had already become fixed at an early stage.

It may be mentioned, however, that in the "Rājavyākaraṇaparivarta" toward the end there is a prophecy concerning the advent of the king Gopāla, the founder of the Pāla dynasty. Therefore this part is thought to date from after the second half of the eighth century.[146] This chapter is also quoted in a Tibetan manuscipt discovered at Dunhuang, and there has been added a prophecy about Tibet that is not found in either the Sanskrit original or the current Tibetan translation.[147] This shows that the "Rājavyākaraṇaparivarta" was frequently altered in accordance with historical circumstances after the compilation of the main body of the *Mañjusrīmūlakalpa*. However, as mentioned, the main part of this scripture, which explains the production of the maṇḍala and *paṭas*, had already come into existence by the sixth to seventh centuries.

In chapters 2 and 3 ("Maṇḍalavidhānaparivarta") the *Mañjuśrīmūlakalpa* describes a large-scale maṇḍala consisting of three concentric squares, to which an outer square has been added. This section contains important information about the maṇḍala of early esoteric

Buddhism. A critical edition of the Tibetan translation of chapters 2 and 3 was published by A. Macdonald together with a chart of the maṇḍala as reconstructed by herself,[148] in which she showed this maṇḍala facing east, like the Vajradhātu-maṇḍala. However, her diagram should be turned upside down (except for the inner square), since as a general rule the maṇḍalas of early esoteric Buddhism face west.[149]

The *Mañjuśrīmūlakalpa* is frequently mentioned in esoteric Buddhist texts composed in Tibet,[150] but no example of its maṇḍala has been found in Tibet. In Japan no diagram of this maṇḍala has been created because, even though there is a Chinese translation, there are some problematic points regarding the description of the maṇḍala in the *Mañjuśrīmūlakalpa*. After the maṇḍala has been explained, a summary of the same maṇḍala is introduced with the phrase "in brief," and there exist considerable differences between the first and second explanations regarding the arrangement of Hindu deities in the outer square. I have accordingly presented a new diagram of the maṇḍala, based on my own edition of the text.

FIG. 2.7. MAṆḌALA OF THE *MAÑJUŚRĪMŪLAKALPA*

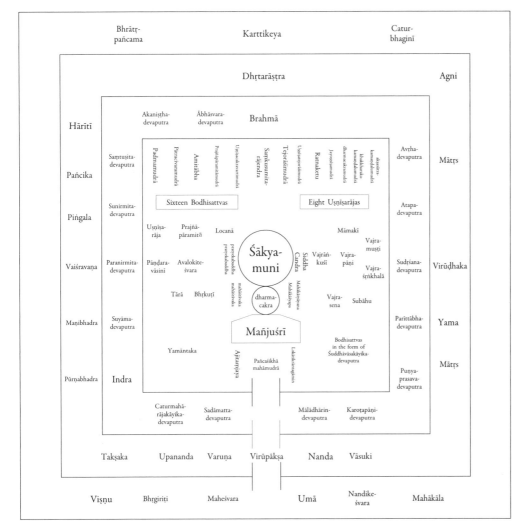

Macdonald reconstructed the outer square mainly with reference to the second explanation of the maṇḍala, but I have drawn up two diagrams, one based on the first explanation (fig. 2.7) and the other revised with reference to the second explanation (fig. 2.8).

The maṇḍala is on a large scale, being centered on Śākyamuni in the inner maṇḍala (*abhyantara-maṇḍala*), which is composed of the three families, and surrounded by three outer squares and four small maṇḍalas (*maṇḍalaka*) in the shape of the four elements—earth, water, fire, and wind. The *Mañjuśrīmūlakalpa* indicates the positions of the deities in the inner square not in terms of east, west, south, and north but in terms of left, right, top, and bottom. If we arrange these deities in a concentric fashion as in other maṇḍalas, they cannot be housed in the inner square, since the distribution of the deities becomes very unbalanced. Therefore the deities of the inner square were not arranged in a concentric fashion, as in later Indo-Tibetan maṇḍalas, but in such a way that all the deities faced the bottom (west, in this case), as in Sino-Japanese maṇḍalas in hanging scroll format.

Such an arrangement is similar to the *paṭa* seen earlier in chapter 1. It turns out that this

FIG. 2.8. MAṆḌALA OF THE *MAÑJUŚRĪMŪLAKALPA* (ARRANGEMENT OF DEITIES IN OUTER SQUARES CHANGED ON THE BASIS OF THE SUMMARY OF THE MAṆḌALA)

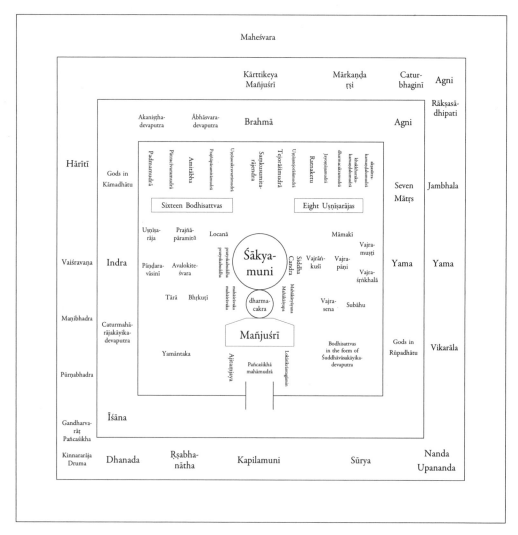

maṇḍala arranges three concentric squares around a landscape maṇḍala like the *paṭa*. The outer squares are occupied by Hindu deities, whose total number exceeds that of the Buddhist deities depicted in the inner square.

In this maṇḍala not only the main deity Śākyamuni, but also the three tathāgatas Saṃkusumitarājendra, Amitābha, and Ratnaketu are depicted in the inner square, and Macdonald placed these three tathāgatas in the western, southern, and northern gates. However, it has become clear that these three tathāgatas should be depicted in the center, south, and north of the upper part of the inner square, respectively. As has been seen in chapter 1, in the *Mañjuśrīmūlakalpa* Saṃkusumitarājendra is the lord of another world named Kusumāvatī in the northeast, and he is depicted in the gate along the central axis, presumably because he is the lord of Mañjuśrī, representative of the Buddha family.

In addition, Amitābha's position above Avalokiteśvara suggests that the idea of a connection between Amitābha and the Lotus family already existed in the *Mañjuśrīmūlakalpa*. Therefore the relationship between Amitābha and Avalokiteśvara, as well as that between Saṃkusumitarājendra and Mañjuśrī, had already been fixed in the *Mañjuśrīmūlakalpa*, and it is to be surmised that Amitābha's position above the Lotus family and Saṃkusumitarājendra's position above the Buddha family were determined accordingly.

If Ratnaketu depicted above Vajrapāṇi is related to the Vajra family, then the three tathāgatas Saṃkusumitarājendra, Amitābha, and Ratnaketu correspond to the Buddha, Lotus, and Vajra families, respectively. This is worth noting as a forerunner of the theory of five tathāgatas as the lords of the five families that appear in the *Sarvatathāgatatattva-saṃgraha*. However, the positions of Saṃkusumitarājendra, Amitābha, and Ratnaketu in the maṇḍala do not reflect the directions of their pure lands, as in the 16-cubit maṇḍala of the *Tuoluoni jijing* described earlier.

If we add Akṣobhya or Dundubhisvara, not included in the above three tathāgatas, from among the four buddhas of the *Suvarṇaprabhāsasūtra*, we get the four buddhas of the Garbha-maṇḍala according to chapters 2 and 13 (chapter 16 in the Tibetan translation), respectively. This supports my theory, mentioned in chapter 1,[151] that the five buddhas of the Garbha-maṇḍala came into existence through the addition of Saṃkusumitarājendra to the four buddhas of the *Suvarṇaprabhāsasūtra*.

Thus the *Mañjuśrīmūlakalpa* describes a maṇḍala of a very large scale among maṇḍalas consisting of the three families. However, in its structure it has merely added three outer squares to an inner square similar to that of a landscape maṇḍala. It preserves a primitive form when compared with the maṇḍalas of the *Guhyatantra* and *Susiddhikaramahātantra*, which, although smaller in scale, have a concentric layout. Moreover, it is not well-balanced vertically and horizontally when compared with the general maṇḍala of the *Tuoluoni jijing*, which has an almost symmetrical structure vertically and horizontally even though it is based on the three-family system.

Therefore when compared with the general maṇḍala in the early seventh century, the maṇḍala of the *Mañjuśrīmūlakalpa* shows a more primitive form of the maṇḍala. It represents a transitional period from the landscape maṇḍala to the full-scale maṇḍala with a geometric pattern. However, Saṃkusumitarājendra of this sūtra was adopted by the *Vairocanābhisambodhisūtra* and became one of the five buddhas of the Garbha-maṇḍala. In this respect, the *Mañjuśrīmūlakalpa* may be said to occupy an important position, bridging the gap between the *Suvarṇaprabhāsasūtra* and *Vairocanābhisambodhisūtra*.

4. The *Amoghapāśakalparāja* and Its Maṇḍala

The *Amoghapāśakalparāja* is an early esoteric Buddhist scripture that is classified in Tibet as the lord of the Lotus family in the Kriyā tantras.[152] It was translated into Chinese by Bodhiruci between 707 and 709,[153] and it had already been translated into Tibetan at the time of the Tufan kingdom, since a Tibetan translation is recorded in the *Ldan dkar ma* catalogue.[154] Therefore like the *Mañjuśrīmūlakalpa*, the main body of this text had already come into existence in the seventh century.

No Sanskrit manuscript had been known except for the *Amoghapāśahṛdayadhāraṇī*, corresponding to the first chapter, until a complete manuscript was discovered in Tibet, which researchers have begun editing.[155] Ishida Hisatoyo, meanwhile, demonstrated that Śubhākarasiṃha referred to the *Amoghapāśakalparāja*, particularly its "Chapter on the Vast Emancipation Maṇḍala," for composing the *Taizō zuzō* with regard to the iconography of deities who are not described in detail in the *Vairocanābhisambodhisūtra*.[156]

Recent studies have shown that there are no major differences between the Sanskrit manuscript of the *Amoghapāśakalparāja* discovered in Tibet and the Tibetan translation, whereas the Chinese translation by Bodhiruci has been considerably augmented. Especially in the "Maṇḍalavidhikalpa" (corresponding to the "Chapter on the Vast Emancipation Maṇḍala" of the Chinese translation), quite a number of deities who do not appear in the Sanskrit and Tibetan versions have been added together with descriptions of their iconography, and these additions concerning the Garbha-maṇḍala played an important part in Ishida's analysis of the *Taizō zuzō*. It has been pointed out that Bodhiruci may have had some material deriving from a primitive version of the *Vairocanābhisambodhisūtra* on the basis of which he supplemented iconographical descriptions not found in the original manuscript of the *Amoghapāśakalparāja*.[157]

There exist other instances, too, in which only the Chinese translation contains iconographical descriptions that are absent in the Sanskrit original and Tibetan translation.[158] These discrepancies have until now been considered to be due to differences in the original manuscripts or to supplementation by the translator. However, I would posit a different situation, namely, the possibility that illustrations may have been attached to the original Sanskrit manuscript used for the Chinese translation. Sanskrit manuscripts of esoteric Buddhist texts containing illustrations of images or mudrās are not rare and are styled *citrasahita* or *mudrācitrasahita* in Nepal. Śubhākarasiṃha, too, frequently states in his *Darijing shu* that reference should be made to illustrations, such as when he writes that "the secret mudrā held by [the deity] is as in the illustration"[159] or "their forms are all as in the illustrations."[160]

Iconographical descriptions found in the Chinese translation of the *Amoghapāśakalparāja* are all descriptive, as, for example, when the meditation mudrā is explained as follows: "press down on the palm of the left hand with the back of the right hand." In the *Mañjuśrīmūlakalpa*, we find precursory references to the principal mudrās, such as "*varapradāna*" for the boon-granting mudrā and "*dhyānagatacetas*" for the meditation mudrā.[161] Thus some consensus about the principal mudrās already existed in sixth- to seventh-century India. Therefore I surmise that Bodhiruci did not translate iconographical explanations found in the original manuscript but described in Chinese the forms found in illustrations attached to the manuscript.

In Tibet and Nepal there have survived many examples of maṇḍalas centered on Amoghapāśa. These include a unique maṇḍala of Amoghapāśa transmitted in Nepalese Buddhism, about which Pratapaditya Pal has already published a study,[162] but it is not based on the *Amoghapāśakalparāja*. The maṇḍala of the Amoghapāśa pentad and the sixteen-deity Amoghapāśa maṇḍala,[163] frequently found in Tibet, are thought to be extractions of the principal deities from the *Amoghapāśakalparāja*, although these maṇḍalas are not directly mentioned. Three maṇḍalas centered on Avalokiteśvara have been discovered in the Mogao Caves at Dunhuang, and I have shown that they are maṇḍalas combining the Amoghapāśa pentad with deities belonging to the Garbha-maṇḍala and Vajradhātu-maṇḍala.[164]

Ritual manuals on the Vast Emancipation maṇḍala (Vimokṣa-maṇḍala) were composed also in Tibet,[165] but no examples have been discovered in Tibet. As in the case of the *Mañjuśrīmūlakalpa*, if we depict the Vast Emancipation maṇḍala on the basis of the description given in the Tibetan translation of the *Amoghapāśakalparāja*, it is difficult to house all the deities in the square pavilion because the arrangement of the deities will become somewhat unbalanced. This may be why this maṇḍala was not popular in Tibet.

The Chinese translation succeeded in creating a horizontally and vertically symmetrical maṇḍala by supplementing many deities. Although we do not have any examples that have been transmitted down through the ages in Japan, Tajimi Miyoko, a modern Buddhist painter, has re-created it (fig. 2.9).[166]

As was seen above, the Vast Emancipation maṇḍala has attracted the attention of scholars since, while centered on Śākyamuni, its four buddhas are almost the same as those of the Vajradhātu-maṇḍala: Akṣobhya in the east, Ratnasambhava in the south, Amitābha in the west, and Lokendrarāja in the north. However, the Sanskrit manuscript and Tibetan translation mention only Śākyamuni, Amitābha, and Lokendrarāja, and Akṣobhya and Ratnasambhava are missing.

When we look at the arrangement of the bodhisattvas supplemented from the *Vairocanābhisambodhisūtra* in the Chinese translation of the *Amoghapāśakalparāja*, we find that bodhisattvas belonging to the Vajra family and Lotus family, Ākāśagarbha and Kṣitigarbha with their attendants, and Śākyamuni and his attendants are arranged in the east, west, south, and north, respectively (figs. 2.9 and 2.10). This tallies with the arrangement of the four buddhas: Akṣobhya together with the Vajra family in the east, Amitābha together with the Lotus family in the west, Ratnasambhava together with Ākāśagarbha and Kṣitigarbha in the south, and Lokendrarāja[167] together with Śākyamuni's attendants in the north. This arrangement has clearly been influenced by the *Sarvatathāgatatattvasaṃgraha*. Therefore the Vimokṣa-maṇḍala of the Sanskrit and Tibetan versions would have come into existence no later than the early seventh century, while the augmented maṇḍala described in the Chinese translation must postdate the *Vairocanābhisambodhisūtra* and *Sarvatathāgatatattvasaṃgraha* (or at least chapter 1 of the latter).

The *Amoghapāśakalparāja* explains many mudrās and mantras. Since the discovery of the Sanskrit manuscript, it has been found that the mudrās of several deities coincide with those of deities belonging to the Lotus family described in chapter 3 of the *Sarvatathāgatatattvasaṃgraha*.[168] This would suggest that the original Sanskrit text of the *Amoghapāśakalparāja* directly influenced the *Sarvatathāgatatattvasaṃgraha*, particularly chapter 3, which explains the rites of the Lotus family.

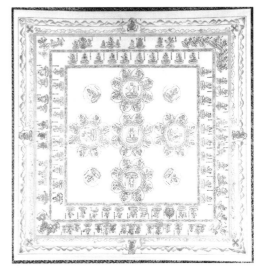

Fig. 2.9. Vast Emancipation maṇḍala
(restored by Tajimi Miyoko)

Fig. 2.10. Vast Emancipation maṇḍala

E

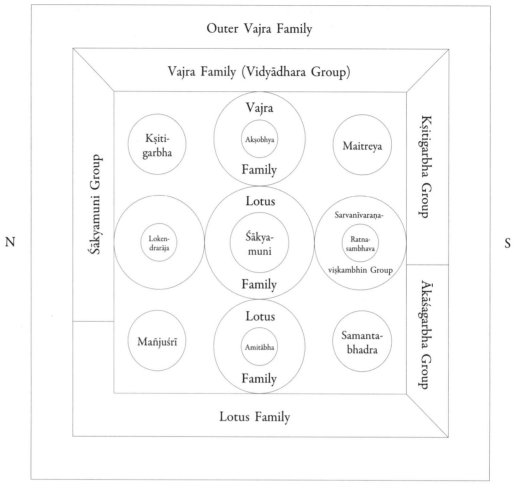

Outer Vajra Family

Vajra Family (Vidyādhara Group)

Kṣiti-garbha

Vajra

Akṣobhya

Family

Maitreya

Lotus

Lokendrarāja

Śākyamuni

Family

Sarvanīvaraṇa-

Ratnasambhava

viṣkambhin Group

Lotus

Mañjuśrī

Amitābha

Samantabhadra

Family

Śākyamuni Group

Kṣitigarbha Group

Ākāśagarbha Group

Lotus Family

N

S

W

5. The Discovery of Esoteric Icons
Belonging to the Vairocanābhisambodhi Cycle in India

After the ninth century, the Vairocanābhisambodhi cycle declined rapidly in India, and until recent years no excavated items related to the Garbha-maṇḍala had been identified. However, images of Vairocanābhisambodhi and stūpas and groups of figures thought to be related to the Garbha-maṇḍala have been discovered in Orissa, considered to have been the homeland of Śubhākarasiṃha, the translator of the *Vairocanābhisambodhisūtra* into Chinese. Thus the origin of the Garbha-maṇḍala is gradually becoming clearer.

A buddha statue 110 centimeters tall, unearthed at Lalitagiri, Orissa, and now kept in storage on-site, is noteworthy, for it became the starting point of the discovery of esoteric Buddhist icons belonging to the Vairocanābhisambodhi cycle in India. This image, stylistically thought to date from the eighth century, a buddha statue without ornaments or a sash placed crosswise from the shoulder, forms the meditation mudrā with both hands, and has a crown of braided hair with hair falling down over the shoulders. There are also lions

in high relief to the left and right of the throne. In 1980 a joint research team from Japan discovered an inscription on the upper part of the halo that was deciphered as *"namaḥ samantabuddhānāṃ aḥ vī ra hūṃ khaṃ"* (Homage to all buddhas! *Aḥ vī ra hūṃ khaṃ*!). This is identical to the mantra of Vairocanābhisambodhi transmitted in Japanese esoteric Buddhism. Since this discovery, many buddha statues with the same iconography have been identified as Vairocanābhisambodhi by Japanese scholars (fig. 2.11).[169]

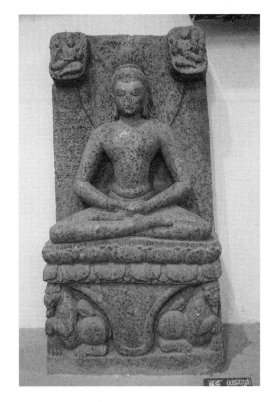

Vairocanābhisambodhi does not have curly hair and instead has hair falling down over his shoulders from a crown of braided hair (*jaṭāmukuṭa*). This shows that Vairocana is not a *nirmāṇakāya* like Śākyamuni, who appeared on earth and attained enlightenment after having renounced secular life and performed austerities. The meditation mudrā seems to symbolize the fact that Vairocana is in a state of profound meditation in the abode of the *sambhogakāya*.[170]

At Ratnagiri near Lalitagiri there have been discovered, in addition to the image of Vairocanābhisambodhi accompanied by the eight great bodhisattvas mentioned in chapter 1, other statues of Vairocanābhisambodhi, including one at Ratnagiri Elementary School and one in Chapel 4. They are important not only as examples of Vairocanābhisambodhi from India but also because they possess iconographical elements that are helpful for considering the origins of the Garbha-maṇḍala.

Among these statues, the one in Chapel 4 at Ratnagiri faces east, whereas the main deity, Vairocanābhisambodhi in *sambhogakāya* form, is enshrined in the front of the chapel, to the west (fig. 2.12a). It is flanked by seated images of Avalokiteśvara and Vajrapāṇi. Avalokiteśvara has a lotus stem (currently missing) in his left hand and makes the gesture of making it bloom with his right hand (fig. 2.12b). This iconography is explained in the *Prajñāpāramitānayasūtra* and also coincides with the main deity of the Lotus family in the Garbha-maṇḍala. The five buddhas carved in relief on Avalokiteśvara's crown correspond to those of the Vajradhātu cycle centered on Vairocana displaying the dharma-wheel mudrā. Thus these images contain elements not belonging to the Vairocanābhisambodhi cycle. Avalokiteśvara is, moreover, surrounded by four female attendants on both sides of the halo and throne. Among these attendants the goddess on the left of the halo is Tārā, while that on the right of the throne is Bhṛkuṭī. These two goddesses are not only the flanking attendants of Avalokiteśvara but also the principal attendants on both sides of Avalokiteśvara in the Lotus family of the Garbha-maṇḍala.

Vajrapāṇi, although in a poor state of preservation, holds a vajra in his right hand and a vajra-topped bell in his left hand, with his left elbow squared. These features are not those of Vajrapāṇi in the Garbha-maṇḍala but those of Vajrasattva in the Vajradhātu-maṇḍala (fig. 2.12c).

Thus the arrangement of the images in Chapel 4 at Ratnagiri has been drawn from the principal deities in the first square of the Garbha-maṇḍala. These images, like others of Vairocanābhisambodhi from Ratnagiri, are stylistically thought to have been produced during the eighth and ninth centuries. Therefore they would postdate the emergence of the Garbha-maṇḍala. As noted above, the iconography of Avalokiteśvara and Vajrapāṇi has been influenced by the *Sarvatathāgatatattvasaṃgraha*, and so these images do not belong purely to the Vairocanābhisambodhi cycle. However, their arrangement corresponds to the basic structure of the Garbha-maṇḍala. We can surmise that such combinations of deities developed into the Garbha-maṇḍala.

FIG. 2.11. VAIROCANĀBHISAMBODHI (ASI STORAGE, LALITAGIRI, ORISSA)

Outside Orissa, a seated buddha with the meditation mudrā (ninth century) has been unearthed at Nālandā.[171] As well, there are several images possibly identifiable as Vairocanābhisambodhi, such as a seated bodhisattva with the meditation mudrā held by the Archaeological Museum, Sarnath (tenth century), and a seated bodhisattva with the meditation mudrā in the Musée Guimet (eleventh century, Nepal). But such identifications are still speculative, since there is no conclusive proof such as a mantra or an inscription as in the case of the Lalitagiri image.

Meanwhile, at Udayagiri, one of the three major Buddhist sites in Orissa, there exists a large stūpa in comparatively good condition. Three of the high-relief buddhas on this stūpa have been identified as Akṣobhya (east), Ratnasambhava (south), and Amitābha (west), since they form the earth-touching mudrā (*bhūmisparśa-mudrā*), boon-granting mudrā, and meditation mudrā, respectively. The buddha in the north also forms the meditation mudrā and has been identified as Vairocanābhisambodhi, a frequent icon in Orissa, since he has high braided hair. Consequently, the four buddhas of Udayagiri have been interpreted by Japanese scholars as a combination of Vairocanābhisambodhi, the main deity of the Garbha-maṇḍala, and three of the four buddhas of the Vajradhātu-maṇḍala.[172]

As to why Vairocanābhisambodhi, the main deity of the stūpa, was installed in the north, several interpretations are possible. One possibility is that, among the four buddhas of the Vajradhātu-maṇḍala, Amoghasiddhi was the least popular and so he was replaced by Vairocana, the main deity of the stūpa.[173] Furthermore, in India, particularly in Orissa with its intense heat, the entrances of houses and monasteries often face north. There is thus a possibility that the main stūpa at Udayagiri also faced north, in which case it would be natural to enshrine Vairocana, the main deity, in the north and arrange the other three buddhas—Akṣobhya, Ratnasambhava, and Amitābha—in the east, south, and west.[174]

In addition, five buddhas in high relief have been discovered at Languli, also in Orissa, where excavations are being conducted by the state government.[175] These five images are arranged halfway around a monolithic votive stūpa. Their mudrās are, moving clock-

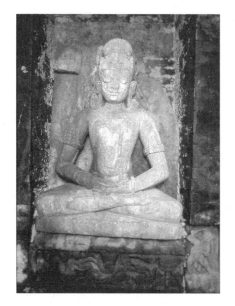

FIG. 2.12A. VAIROCANĀBHISAMBODHI
(CHAPEL 4, RATNAGIRI)

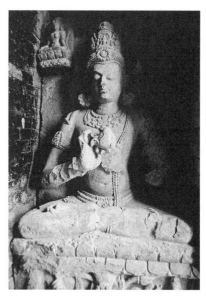

FIG. 2.12B. AVALOKITEŚVARA
(CHAPEL 4, RATNAGIRI)

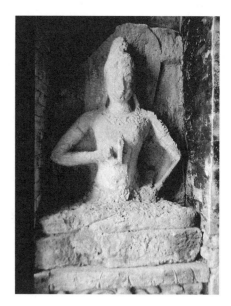

FIG. 2.12C. VAJRAPĀṆI
(CHAPEL 4, RATNAGIRI)

wise from northeast to southwest, the meditation mudrā, fearlessness mudrā (*abhaya-mudrā*), earth-touching mudrā, boon-granting mudrā, and meditation mudrā. Buddhas with the meditation mudrā thus occur twice at Languli. There are several combinations of the five buddhas in esoteric Buddhism, but only the five buddhas of the Garbha-maṇḍala include two single-headed and two-armed buddhas with the meditation mudrā.

Among these five buddhas at Languli, the buddha image in the center (south) displaying the boon-granting mudrā corresponds to Ratnasambhava in the Vajradhātu-maṇḍala. The buddhas in the southeast and southwest with the earth-touching mudrā and meditation mudrā can be identified as Akṣobhya in the east and Amitābha in the west, respectively. The buddha in the east displaying an unusual form of the fearlessness mudrā frequently seen in Orissa (with the right hand, its fingers extended, resting on the right thigh rather than being held in front of the chest) seems to be Amoghasiddhi in the north, since he is positioned in the north compared with the other three images. If we identify the remaining buddha in the northeast as Vairocanābhisambodhi, we can interpret these figures as the five buddhas of the Garbha-maṇḍala (fig. 2.13).[176]

There is thus a possibility that the five buddha statues from Languli are the five buddhas of the Garbha-maṇḍala even though four of them display the same mudrās as the four buddhas of the Vajradhātu-maṇḍala. When considered in this light, the identity of the four buddhas at Udayagiri, hitherto interpreted as a combination of buddhas of the Garbha-maṇḍala and Vajradhātu-maṇḍala, also needs to be reconsidered.

6. Cave 12 at Ellora and the Sonshō Mandara

Ellora, 25 kilometers northwest of the city of Aurangabad in Maharashtra, is the largest cave-temple complex in India, and Hindu, Buddhist, and Jain rock-cut temples have been constructed side by side. The most prevalent view regarding the Buddhist caves—Caves 1 to 12—is that they were built from the southernmost, Cave 1, to the northernmost, Cave 12, which is the most recent. Caves 11 and 12, together known as the "late Buddhist caves," are characterized by a group of figures resembling a maṇḍala. Cave 12, known as "Teentaal" (three-storied), enshrines an image of a seated buddha as the main deity in the center of each story.

On the second story of Cave 11 and on each story of Cave 12, the main deity and the eight great bodhisattvas are enshrined in a single chamber. On the second story of Cave 11, the grouping of the main deity and the eight great bodhisattvas is found in the left (11.2.1) and right shrines (11.2.3). The main deities of both shrines are seated buddhas with the earth-touching mudrā and are thought to be either Śākyamuni in the cross-legged *vajrāsana* pose or Akṣobhya. Among the eight great bodhisattvas, Avalokiteśvara and Vajrapāṇi are rearmost and double as flanking attendants of the main deity. This fact suggests that the group of figures at Ellora developed from the triad of Śākyamuni, Avalokiteśvara, and Vajrapāṇi.

The first story of Cave 12, on the other hand, is centered on a seated buddha image displaying the dharma-wheel mudrā, with the eight great bodhisattvas arranged on both sides. The main deity has been variously identified as Śākyamuni, Amitābha, or Vairocana. On only

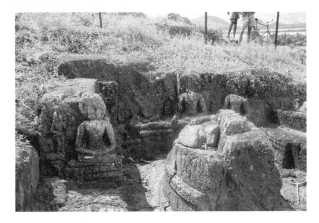

FIG. 2.13. FIVE BUDDHAS AT LANGULI

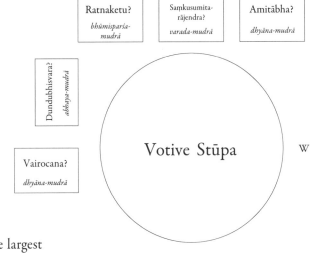

| Ratnaketu? | Saṃkusumita-rājendra? | Amitābha? |
| *bhūmisparśa-mudrā* | *varada-mudrā* | *dhyāna-mudrā* |

Dundubhisvara? *abhaya-mudrā*

E

Vairocana? *dhyāna-mudrā*

Votive Stūpa

W

N

FIG. 2.14. MAṆḌALA OF THE EIGHT GREAT
BODHISATTVAS (ELLORA CAVE 12)

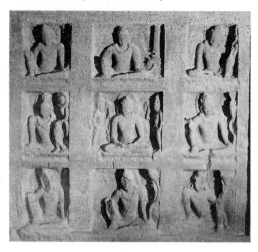

Maitreya	Ākāśa-garbha	Samanta-bhadra
Avalokite-śvara	Vairocana	Vajrapāṇi
Sarva-nīvaraṇa-viṣkambhin	Kṣiti-garbha	Mañjuśrī

FIG. 2.15. SONSHŌ MANDARA

Maitreya	Ākāśa-garbha	Samanta-bhadra
Avalokite-śvara	Vairocana	Vajrapāṇi
Kṣiti-garbha	Sarva-nīvaraṇa-viṣkambhin	Mañjuśrī

this story, the flanking attendants from among the eight great bodhisattvas are not Avalo-kiteśvara and Vajrapāṇi but Avalokiteśvara and Kṣitigarbha (or Ākāśagarbha, according to G. Malandra).[177]

Meanwhile, the second story of Cave 12 is centered on a seated buddha image displaying the earth-touching mudrā, with the eight great bodhisattvas arranged on both sides. The main deity can be identified as Śākyamuni in the *vajrāsana* pose, since the earth goddess and Aparājitā, who drove away Māra, are carved in relief on his throne.[178] The two flanking attendants, Avalokiteśvara and Vajrapāṇi, have been placed separately from the eight great bodhisattvas.

On the second and third stories, Mañjuśrī and Maitreya are placed in the rearmost posi-tion next to two flanking attendants. The same arrangement is also found in Tibet. This is because Mañjuśrī and Maitreya are thought to represent the two major schools of Mahāyāna Buddhism, Mādhyamika and Vijñaptimātra.

The third story is also centered on a seated buddha image displaying the earth-touching mudrā, with the eight great bodhisattvas arranged on both sides. Here, too, the two flanking attendants, Avalokiteśvara and Vajrapāṇi, are separate from the eight great bodhisattvas. Thus the total number of bodhisattvas comes to ten.

The most interesting feature of Cave 12 is that maṇḍalas centered on a buddha with the meditation mudrā and surrounded by the eight great bodhisattvas are carved in relief on five walls on the first (including 12-1-2) and second stories (fig. 2.14). Scholars differ in their views regarding the identication of the eight great bodhisattvas on the basis of their attributes. If we follow Yoritomi's view,[179] the arrangement of the maṇḍala of the eight great bodhisattvas is as shown in fig. 2.14.

If we compare this with the Japanese Sonshō mandara transmitted by Amoghavajra, it more or less coincides, except that in the latter Sarvanīvaraṇaviṣkambhin has been substi-tuted for Kṣitigarbha. In the Sonshō mandara the eight great bodhisattvas are arranged clockwise around the main deity, starting from Avalokiteśvara, the right-hand attendant, in accordance with the most popular arrangement, which follows the *Shizizhuangyanwang pusa qingwen jing*: (1) Avalokiteśvara, (2) Maitreya, (3) Ākāśagarbha, (4) Samantabhadra, (5) Vajrapāṇi, (6) Mañjuśrī, (7) Sarvanīvaraṇaviṣkambhin, and (8) Kṣitigarbha (fig. 2.15). It is worth noting that in both cases Avalokiteśvara and Vajrapāṇi are arranged symmetrically on both sides of the main deity.

The Indian art historian G. Malandra has asserted that buddha images with the earth-touching mudrā in the late Buddhist caves at Ellora are Śākyamuni or Akṣobhya, while those with the meditation mudrā are Vairocana. She also considers that the arrangement of the group of figures brought to completion in Cave 12 at Ellora is nothing other than a representation of a maṇḍala as an object of worship.[180] This view, interpreting the groups of figures in the late Buddhist caves at Ellora as maṇḍalas, seems to me to have some merit, although she has made several errors regarding Tibetan and Chinese materials, such as her confusion of the Caryā tantras, starting with the *Vairocanābhisambodhisūtra*, and the Yoga tantras, starting with the *Sarvatathāgatatattvasaṃgraha*.

Furthermore, basing herself on the inscriptions and a stylistic comparison of stone pillars, Malandra has put the date of Cave 12 between 700 and 730 CE, just before the construction of Hindu caves by the Rāṣṭrakūṭa dynasty. Some scholars have dated the late Buddhist caves at Ellora to as late as the tenth century. I consider Malandra's dating to be more reasonable,

since there are few multiheaded and multiarmed images at Ellora and there is an abundance of Buddhist icons related to the Garbha-maṇḍala, whereas the only Buddhist icon belonging to the Vajradhātu cycle is the triad of Vajradhātu-Vairocana.[181]

The Metropolitan Museum of Art, meanwhile, has a terracotta maṇḍala consisting of a circle divided into a grid of nine sections in which the deities are arranged (fig. 2.16).[182] The main deity is a seated buddha with the dharma-wheel mudrā flanked by Avalokiteśvara and Vajrapāṇī, but the iconographical features of the other bodhisattvas are not clear. It is difficult to date, although the Metropolitan Museum of Art places it in the sixth century. It is, at any rate, important for considering the emergence of the maṇḍala of the eight great bodhisattvas.[183]

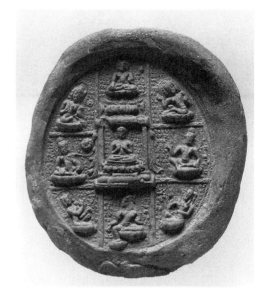

FIG. 2.16. TERRACOTTA MAṆḌALA (METROPOLITAN MUSEUM OF ART)

7. The Maṇḍala of the *Vajrapāṇyabhiṣekatantra*

As mentioned in chapter 1, an image of Vairocanābhisambodhi accompanied by the eight great bodhisattvas was discovered in Orissa. At Ellora in western India, on the other hand, there have been found not only the combination of a main deity and the eight great bodhisattvas but also five examples of a maṇḍala in which the eight great bodhisattvas are arranged around the main deity. In addition, examples of Vairocanābhisambodhi combined with the eight great bodhisattvas and dating from around the eighth to ninth centuries have been found not only in India but also along the Silk Road and in Tibet. This iconography is thought to symbolize Vairocana's preaching to high-ranking bodhisattvas in the Akaniṣṭha Heaven. In this section I shall consider how this combination relates to the Garbha-maṇḍala.

The *Vairocanābhisambodhisūtra* came into existence through a long process of trial and error, and there are thought to have been texts indicative of the transition from early esoteric Buddhism to the *Vairocanābhisambodhisūtra*, although most of them have been lost. The *Vajrapāṇyabhiṣekatantra*, classified among the Vajra family of the Caryā tantras in Tibet,[184] is one transitional scripture bridging the gap between early esoteric Buddhism and the *Vairocanābhisambodhisūtra*.[185] There is no corresponding Chinese translation, although the *Jingangshou guangming guanding jing zuisheng liyin sheng wudongzun da weinuwang niansong yigui fa pin* is thought to be in some way related to this text.

The maṇḍala explained in the *Vajrapāṇyabhiṣekatantra* has an inner square in which an eight-petaled lotus similar to that of the Garbha-maṇḍala is depicted. The four buddhas of the Garbha-maṇḍala (Akṣobhya in the north) are arranged on the lotus petals in the four cardinal directions. Four buddhas were depicted in the general maṇḍala in 16 cubits explained in the *Tuoluoni jijing*, as mentioned earlier. Four buddhas are also arranged in the four cardinal directions of the inner square of the Vast Emancipation maṇḍala described in the Chinese translation of the *Amoghapāśakalparāja*, although there is no mention of the four buddhas in the Sanskrit manuscript or Tibetan translation of this text. There is thus a possibility that the four buddhas in the Chinese translation were introduced from another, later text. The *Vajrapāṇyabhiṣekatantra*, on the other hand, is the earliest text among esoteric Buddhist scriptures of definitely Indian provenance in which four buddhas are arranged in the four cardinal directions of the maṇḍala.

In the second square, there are arranged the eight great bodhisattvas: Mañjuśrī (east), Samantabhadra (southeast), Vajrapāṇi (south), Sarvanīvaraṇaviṣkambhin (southwest), Ākāśagarbha (west), Maitreya (northwest), Avalokiteśvara (north), and Kṣitigarbha

(northeast), each accompanied by attendants.[186] If we compare this arrangement with the Garbha-maṇḍala, the directions of Mañjuśrī (east), Vajrapāṇi (south), Ākāśagarbha (west), and Avalokiteśvara (north) coincide while the positions of Sarvanīvaraṇaviṣkambhin (south in outer square) and Kṣitigarbha (north in outer square) have been rotated 45 degrees counterclockwise.

Samantabhadra and Maitreya do not have their own sectors in the Garbha-maṇḍala and are depicted on the petals of the central lotus.[187] In the Genzu mandara, on the other hand, Samantabhadra is depicted on the lotus petal in the southeast, as in the *Vajrapāṇyabhiṣekatantra*, but Maitreya is depicted in the northeast, which does not match the *Vajrapāṇyabhiṣekatantra*. However, in chapter 13 of the Chinese translation of the *Vairocanābhisambodhisūtra*—the textual source for the central lotus petal—Maitreya is placed in the northwest, which coincides with the *Vajrapāṇyabhiṣekatantra*. The reason that Maitreya has moved from the northwest to the northeast is not clear. In the Sonshō mandara and the

FIG. 2.17. MAṆḌALA OF THE *VAJRAPĀṆYABHIṢEKATANTRA*

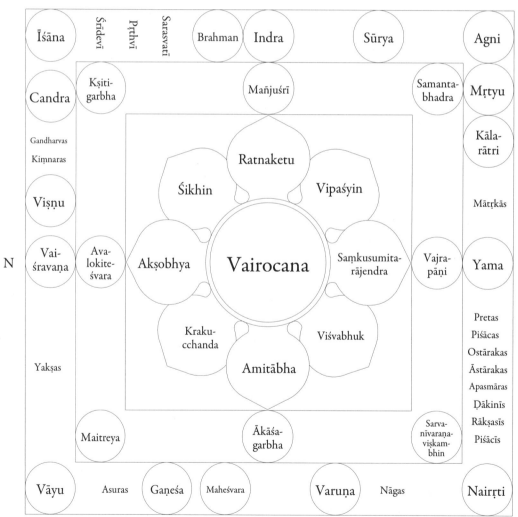

maṇḍalas in Ellora Cave 12, Maitreya is placed in the upper left corner, corresponding to the northeast in the Garbha-maṇḍala. But the most probable explanation is that the positions of Maitreya and Avalokiteśvara were transposed so as to bring Avalokiteśvara closer to Amitābha in the west.[188]

Depicted in the outer square of the maṇḍala of the *Vajrapāṇyabhiṣekatantra* are deities adopted from Hinduism. As will be seen below, the arrangement of these protective deities is also thought to have greatly influenced the second square of the Garbha-maṇḍala (fig. 2.17).

In this chapter I have mentioned many maṇḍalas pre-dating the Garbha-maṇḍala. Among these, the maṇḍalas of the *Guhyatantra* and *Vajrapāṇyabhiṣekatantra* are considered to be forerunners of the Garbha-maṇḍala. Chronologically speaking, the *Vajrapāṇyabhiṣekatantra*, classified among the Caryā tantras, is much closer to the *Vairocanābhisambodhisūtra* than to the *Guhyatantra*, one of the Kriyā tantras, and it is an indispensable text for considering the emergence of the Garbha-maṇḍala.

8. Examples of the Garbha-maṇḍala in Tibet

The Garbha-maṇḍala came into existence in the seventh century in India, but primitive examples have not been preserved in China or Japan. The Garbha-maṇḍala was also transmitted to Tibet, the *Vairocanābhisambodhisūtra* being translated into Tibetan in the second half of the eighth century.[189] In Tibet reference was made to two commentaries by Buddhaguhya, who was active during the eighth century[190] when tantric Buddhism had already emerged in India.[191]

Unlike Śubhākarasiṃha, who revised and enlarged the Garbha-maṇḍala described in the *Vairocanābhisambodhisūtra* in his commentaries, Buddhaguhya did not change the original Garbha-maṇḍala explained in the text. Therefore the Tibetan Garbha-maṇḍala follows the Indian original more closely than does the Sino-Japanese Genzu mandara. In the Tibetan Garbha-maṇḍala, problems present in the original Indian version, such as vertical and horizontal asymmetry in the arrangement of the deities, have been left unresolved. In order to reconstruct the Garbha-maṇḍala originating in India, it is essential to examine examples from Tibet that preserve its primitive form.

The tradition of the Garbha-maṇḍala belonging to the Vairocanābhisambodhi cycle had been thought to have disappeared in Tibet, since present-day esoteric Buddhism in Tibet is centered on the late tantric Buddhism that developed in India after the ninth century. However, it turns out that the tradition of the Garbha-maṇḍala still exists in Tibet, for an example in line drawing was included in a maṇḍala collection published by Lokesh Chandra in 1967.[192] This tradition is evident in the Ngor maṇḍalas, based on the *Rgyud sde kun btus* by Jamyang Khyentse Wangpo (1820–92) and Jamyang Loter Wangpo (1847–1914), two leaders of the nonsectarian movement in eastern Tibet and reproduced from Phende Rinpoche's collection by a Tibetan painter (Lokesh Chandra version). Subsequently another Ngor maṇḍala set in tsakalis,[193] brought out of Tibet by Thartse Khen Rinpoche, was reprinted by Kōdansha in 1983, and a fine color plate of each maṇḍala became available (Ngor version).[194]

There is another Tibetan version of the Garbha-maṇḍala preserved at Tateyama Museum in Toyama prefecture, Japan. It is important since it is larger in size than the Ngor version and the iconography of each deity is clear even though, judging from its style, it was created as late as the nineteenth century.[195]

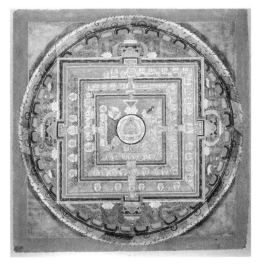

FIG. 2.18. TIBETAN GARBHA-MAṆḌALA (NGOR VERSION)

FIG. 2.19. TIBETAN GARBHA-MAṆḌALA

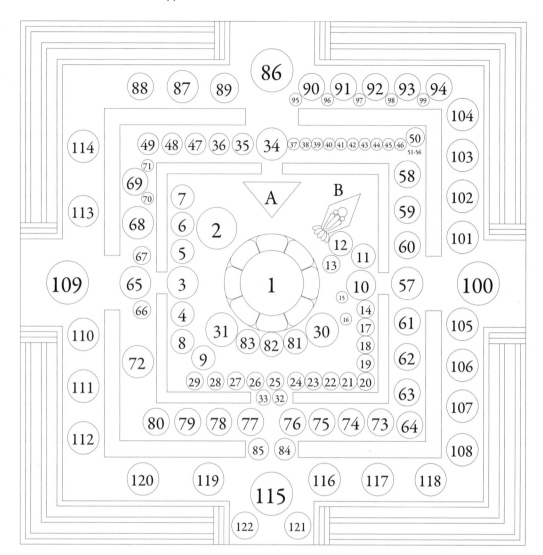

Based mainly on an example in the Ngor maṇḍalas

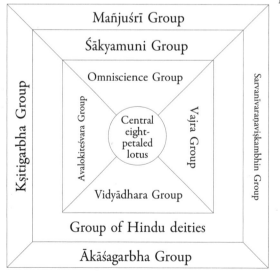

Fig. 2.20. Deities of the Tibetan Garbha-maṇḍala

Tibetan Translation	Chinese Phonetic Transcription	Sanskrit
Central Eight-petaled Lotus		
1. rNam par snang mdzad		Vairocana
Omniscience Group		
A. Chos 'byung		Dharmodaya
2. Nam mkha' spyan ma	誐誐曩嚕(引)左曩 (T. 853)	Gaganalocanā
B. Yid bzhin gyi nor bu		Cintāmaṇi
Avalokiteśvara Group		
3. sPyan ras gzigs dbang		Avalokiteśvara
4. sGrol ma		Tārā
5. Khro gnyer can		Bhṛkuṭī
6. mThu chen		Mahāsthāmaprāpta
7. Grags 'dzin ma	耶輸陀羅 (T. 1796)	Yaśodharā
8. Gos dkar mo	半拏囉嚩悉寧 (T. 1796)	Pāṇḍaravāsinī
9. rTa mgrin can	何耶揭利婆 (T. 848 [chap. 2])	Hayagrīva
Vajra[pāṇi] Group		
10. rDo rje 'dzin		Vajradhara
11. Mā ma kī	忙莽鷄 (T. 848 [chap. 2])	Māmakī
12. rDo rje rtse mo	素支 (T. 848 [chap. 11])	Vajrasūcī
13. Attendant		
14. rDo rje lu gu rgyud		Vajraśṛṅkhalā
15–16. Attendants		
17. Khro zla gtso bo		Krodhacandratilaka
Twelve Vajradharas — 18. Nam mkha' dri med		Gaganāmala
19. rDo rje 'khor lo		Vajracakra
20. rDo rje mche ba des pa	蘇囉多 (T. 1796)	Vajradaṃṣṭra-Sūrata
21. rNam par grags pa skal chen	尾棄夜多 (Ennin)	Vikhyāta-Mahābhāga
22. rDo rje mgon po mchog 'dzin		Vajrāgra
23. rDo rje zhi ba		Śivavajra
24. rDo rje chen po		Mahāvajra
25. rDo rje mthing ga		Nīlavajra
26. rDo rje pad ma yangs pa'i mig		Vajrapadma-Viśālanetra?
27. rDo rje bzang po		Suvajradhara
28. sPros pa med par gnas pa		Aprapañcavihārin
29. Nam mkha' mtha' yas 'gro ba		Gaganānantavikrama
Vidyādhara Group		
30. Mi g-yo ba		Acalanātha
31. 'Jig rten gsum las rnam rgyal		Trailokyavijaya
32. gDul dka'	訥囉駄二合 囉沙二合 (T. 848 [chap. 4])	Durdharṣa
33. mNgon phyogs	阿毘目佉 (T. 848 [chap. 4])	Abhimukha

Chart continues on next page

Tibetan Translation		Chinese Phonetic Transcription	Sanskrit
ŚĀKYAMUNI GROUP			
34. Shā kya thub pa			Śākyamuni
35. Sangs rgyas spyan			Buddhalocanā
36. mDzod spu		鬱那 (Ennin)	Ūrṇā
Five Uṣṇīṣas	37. gTsug tor gdugs dkar po	悉怛多鉢怛囉鄔瑟抳灑 (T. 848 [chap. 4])	Sitātapatroṣṇīṣa
	38. rGyal ba'i gtsug tor	誓耶 (T. 1796), 夜要頂 (Ennin)	Jayoṣṇīṣa
	39. gTsug tor rnam rgyal	微誓耶 (T. 1796)	Vijayoṣṇīṣa
	40. gTsug tor rnam par 'thor ba	微吉羅拏 (T. 1796)	Vikiraṇoṣṇīṣa
	41. gZi brjid phung po	諦殊羅施 (T. 1796)	Tejorāśyuṣṇīṣa
Five Śuddhāvāsa	42. dBang phyug	伊瑣羅 (Ennin)	Īśvara
	43. Kun tu me tog	三曼多高蘇馬 (Ennin)	Samantakusuma
	44. 'Od kyi phreng ba can	羅師美摩履 (Ennin)	Raśmimālin
	45. Yid mgyogs	摩悩耶波 (Ennin)	Manojava
	46. sGra rnam par sgrog	瑣羅箒娃 (Ennin)	Svaraviśruti
Three Uṣṇīṣas	47. gTsug tor cher 'byung		Mahodgatoṣṇīṣa
	48. gTsug tor gyen du 'byung	阿毗于知加多 (Ennin)	Abhyudgatoṣṇīṣa
	49. gTsug tor sgra dbyangs mtha' yas	阿難多瑣羅 (Ennin)	Anantasvaraghoṣoṣṇīṣa
GROUP OF HINDU DEITIES			
50. Me lha			Agni
Six Ascetics	51. 'Od srung	迦攝 (T. 848 [chap. 11])	Kāśyapa
	52. Gau ta ma	驕答摩 (T. 848 [chap. 11])	Gautama
	53. Mar gad ta	末建拏 (T. 848 [chap. 11])	Mārkaṇḍa
	54. Ga rgha	竭伽 (T. 848 [chap. 11])	Khaḍga
	55. Va shi spa		Vasiṣṭha
	56. Aṃ gi ras	倪刺娑 (T. 848 [chap. 11])	Aṅgiras
57. gShin rje			Yama
58. 'Chi bdag			Mṛtyu
59. Dus mtshan ma			Kālarātri
Mother-Goddesses	60. gZhon nu ma	俱摩利 (T. 848 [chap. 11])	Kaumārī
	61. Khyab 'jug ma		Vaiṣṇavī
	62. Phag mo	嚩囉曳	Vārāhī
	63. Ca mu ṇḍi		Cāmuṇḍā
	64. bDen bral		Nairṛti
65. lHa'i dbang po			Indra
66–67. Indra's attendants			
68. Chu lha			Varuṇa
69. Nyi ma			Sūrya
70. rGyal ba			Jaya
71. rNam par rgyal			Vijaya
72. Tshangs pa			Brahman
73. Sa'i lha mo			Pṛthvī
74. dByangs can ma			Sarasvatī
75. Khyab 'jug			Viṣṇu
76. sKem byed			Skanda
77. Rlung lha			Vāyu
78. bDe byed			Śaṃkara

Tibetan Translation	Chinese Phonetic Transcription	Sanskrit
79. U ma		Umā
80. Zla ba		Candra
81. gZhan gyis mi thub pa		Aparājita
82. gZhan gyis mi thub ma		Aparājitā
83. Sa bdag		
84. Klu dga' bo		Nanda
85. Nyer dga		Upananda
MAÑJUŚRĪ GROUP		
86. rDo rje dam pa sbyin pa		Mañjuśrī
87. gZhon nu dra ba'i 'od can	惹里寧鉢羅(二合)婆 (T. 853)	Jālinīprabha
88. gZhon nu dri ma med pa'i 'od	彌馬羅波羅(婆?) (Ennin)	Vimalaprabhākumāra
89. gZhon nu rin chen cod pan can	阿羅加(for 多?)那武屈多 (Ennin)	Ratnamakuṭa
90. sKra can ma		Keśinī
91. Nye ba'i skra can ma		Upakeśinī
92. sNa tshogs ma		Citrā
93. Nor ldan ma	嚩素摩底 (T. 852, T. 853)	Vasumatī
94. 'Gugs ma	阿㰖伊捨尼 (Ennin)	Ākarṣaṇī
95–99. Phyag brnyan ma		
SARVANĪVARAṆAVIṢKAMBHIN GROUP		
100. sGrib pa thams cad rnam sel	薩縛儞縛囉拏尾曪劍避 (T. 853)	Sarvanīvaraṇaviṣkambhin
101. Ngo mtshar can	憍覩褐羅 (T. 853), 憍都褐羅 (T. 1796)	Kautūhala
102. Sems can kun la mi 'jigs byin	薩婆薩怛嚩(二合引)婆闍娜娜 (T. 852, T. 853)	Sarvasattvābhayaṃdada
103. Ngan song thams cad spong ba	薩縛(引)鉢(引)也惹訶 (T. 853)	Sarvāpāyaṃjaha
104. sKyong sems blo gros	跛哩怛羅(二合引)拏捨也摩底 (T. 853)	Paritrāṇāśayamati
105. Byams pa mngon du 'byung ba	摩訶(引)每嫡哩也(二合)毘喻(二合)嗢蘗多 (T. 853)	Mahāmaitryabhyudgata
106. sNying rje gdungs pa	摩訶(引)迦嚕拏莫囉(二合)扼多 (T. 852)	Mahākaruṇāmṛdita
107. gDung ba thams cad zhi byed	薩婆娜(引)賀鉢羅(二合)捨弭 (T. 852)	Sarvadāhapraśāmin
108. Blo gros bsam yas	阿進底也摩底 (T. 852)	Acintyamati
KṢITIGARBHA GROUP		
109. Sa yi snying po		Kṣitigarbha
110. Rin chen 'byung gnas	囉怛曩(二合)迦囉 (T. 853)	Ratnākara
111. Rin chen lag	囉怛曩播抳 (T. 853)	Ratnapāṇi
112. Sa 'dzin	馱囉抳馱囉 (T. 853)	Dharaṇiṃdhara
113. Rin chen phyag rgya can	囉怛曩(二合)謨捺囉(二合)賀薩多 (T. 853)	Ratnamudrāhasta
114. bSam pa brtan pa	涅哩(二合)茶地也(二合引)捨也 (T. 853)	Dhṛḍhādhyāśaya
ĀKĀŚAGARBHA GROUP		
115. Nam mkha'i snying po		Ākāśagarbha
116. Nam mkha'i blo gros	誐誐曩摩(上)帝(引) (T. 853)	Gaganamati
117. rNam dag pa'i blo gros	毘秫馱摩(上)帝(引) (T. 853)	Viśuddhamati
118. sPyod pa'i blo gros	左哩怛囉摩(上)帝(引) (T. 853)	Cāritramati
119. Nam mkha' dri med	誐誐曩(引)摩囉 (T. 853)	Gaganāmala
120. brTan pa'i blo gros		Sthiramati
121. 'Dul dka'		Durdharṣa
122. mNgon phyogs		Abhimukha

Among the sources cited for the Chinese phonetic transcriptions, "Ennin" refers to a line drawing of the *samaya-maṇḍala* of the Garbha-maṇḍala deriving from Śubhākarasiṃha's lineage that was brought back to Japan by Ennin (794–864).

A thangka put on the market by a London art dealer in 1993[196] is a fine work that is stylistically no later than the thirteenth to fourteenth century. However, its iconography is irregular, with the central deity facing east, and the arrangement of the deities is the reverse of the norm. Further consideration will need to be given to its origin. It was sold to a collector, and its current whereabouts are unknown (Rossi and Rossi version).

As an example of the Garbha-maṇḍala in present-day Tibet, we can point to a thangka in the possession of the Kālacakra College in Labrang monastery, Gansu province. From a stylistic point of view, it is thought to have been created after the establishment of the course on the *Vairocanābhisambodhisūtra* in this college in 1861 (fig. 2.21a).[197]

At Raja monastery in Golok county, Qinghai province, there has been transmitted a line drawing of a *samaya-maṇḍala* of the Garbha-maṇḍala (with only Vairocanābhisambodhi represented by his seed syllable) used when creating a maṇḍala in colored powders (figs. 2.21b and 2.22).[198] Toga Meditation Museum in Toyama prefecture, Japan, where I am chief curator, has purchased a Garbha-maṇḍala newly painted by Sha'u Tserang, an Amdo painter, through Raja monastery.[199]

I had previously noticed that a set of deities of the Garbha-maṇḍala existed in the vast collection of cast statuettes enshrined in the Baoxianglou, a pavilion in the grounds of the Palace of Kindness and Tranquility (Cining gong) in the Forbidden City, Beijing, details of which were published under the title *Two Lamaistic Pantheons* by W. E. Clark.[200] The Baoxianglou collection consists of about one hundred statuettes, from the main deity Vairocanābhisambodhi to Paritrāṇāśayamati in Sarvanīvaraṇaviṣkambhin's sector. Moreover, all their features, including their attributes and mudrās, are clearly distinguishable. After analyzing the iconography of this collection, I noticed that it tallies most closely with a manual on the Garbha-maṇḍala by the First Panchen Lama, Losang Chökyi Gyaltsen (1570–1662).[201]

It turns out that, in addition to the Baoxianglou collection, at least seven sets of three-dimensional maṇḍalas were produced during the reign of the Qianlong emperor. Buddhist temples enshrining these sets of bronze images were known as *liupin folou*, but most of these images were scattered and lost during the period of political disturbance from the fall of the Qing dynasty to the Sino-Japanese War of 1937–45.[202]

The Amoghapāśa chapel (2Wa')[203] in the Great Stūpa of Gyantse preserves murals depicting various deities from the Garbha-maṇḍala (fig. 2.23), while the Samantabhadra chapel (2Eb')[204] in the same stūpa preserves a mural depicting twenty-five bodhisattvas from the Garbha-maṇḍala. These can be dated back to the fifteenth century, when the stūpa was constructed, and are valuable material for the iconography of the Tibetan Garbha-maṇḍala, since the form of each deity can be clearly distinguished.

When compared with Sino-Japanese examples, notable features of the Tibetan Garbha-maṇḍala are as follows:

1. In the central lotus only Vairocanābhisambodhi is depicted, and the four buddhas and four bodhisattvas are not depicted on the eight lotus petals.
2. The *vajradharas* serving as attendants of the Vajra family are counted as sixteen in the Sino-Japanese tradition but as twelve in Tibet.
3. These twelve *vajradharas* are depicted either in the western sector or in the southern sector of the first square.

4. The triangle in the Omniscience sector faces downward, the reverse of the norm in Japan.
5. The total number of the deities is around 122.

Thus the Tibetan Garbha-maṇḍala is more faithful to its textual source, chapter 2 of the *Vairocanābhisambodhisūtra*, than the Japanese Genzu mandara. Śubhākarasiṃha, in his commentary on the *Vairocanābhisambodhisūtra*, indicated that the second and third squares of the Garbha-maṇḍala should be interchanged, but the Tibetan Garbha-maṇḍala has not incorporated any such major changes to the explanation given in the *Vairocanābhisambodhisūtra*.

Next, I wish to consider the first of the five points noted above. In chapter 2 of the *Vairocanābhisambodhisūtra*, the names of four buddhas appear in the explanation of the white sandalwood maṇḍala. However, there is no mention of these four buddhas in the explanation of the Garbha-maṇḍala itself. The arrangement of the five buddhas and four bodhisattvas on the central eight-petaled lotus as seen in the Japanese Garbha-maṇḍala is based on chapter 11 of the *Vairocanābhisambodhisūtra*.[205] The Tibetan Garbha-maṇḍala does not depict four buddhas and four bodhisattvas on the central eight-petaled lotus, since it is based mainly on chapter 2.

The Rossi and Rossi version depicts the four buddhas, namely, Ratnaketu (east), Saṃkusumitarājendra (south), Amitābha (west), and Dundubhisvara (north), not on the central eight-petaled lotus but in the archways above the four gates. Their iconography is the same as the corresponding buddhas among the four buddhas of the Vajradhātu-maṇḍala.

The Toga Meditation Museum version, on the other hand, depicts the four buddhas of the Garbha-maṇḍala in the wish-fulfilling trees (*kalpataru*) sprouting from vases placed on the roof of the maṇḍala pavilion. Their iconography is as follows: Ratnaketu in the east displays the meditation mudrā, Saṃkusumitarājendra in the south displays the boon-granting mudrā, Amitābha in the west displays the fearlessness mudrā, and Dundubhisvara in the north displays the earth-touching mudrā. In this case, the mudrās of the four buddhas seem to have been determined in accordance with their body color.[206]

Next, let us consider points 2 and 3. The attendants of the Vajra family are not explained in chapter 2 of the *Vairocanābhisambodhisūtra*. However, in chapter 11 ("The Secret Maṇḍala") their names are given as follows: Gaganāmala, Vajracakra, [Vajra]daṃṣṭra, Sūrata, Vikhyāta, Mahābhāga, Vajrāgra, Śiva[vajra], Mahāvajra, Nīlavajra, [Vajra]padma, Viśālanetra, Suvajra[dhara], Vajra, Aprapañcavihārin, and Gaganānantavikrama.[207] Tibetan Buddhism, on the other hand, counts them as twelve, equating Vajradaṃṣṭra with Sūrata, Vikhyāta with Mahābhāga, Vajrapadma with Viśālanetra, and Suvajradhara with Vajra.

These twelve *vajradharas* are depicted in the western sector of the first square in the Ngor, Lokesh Chandra, Rossi and Rossi, and Labrang versions, but in the southern sector, namely, in the sector of the Vajra family, in the Tateyama and Raja versions. In the Sino-Japanese Garbha-maṇḍala, the *Taizō zuzō* and Genzu mandara depict sixteen *vajradharas* in the southern sector of the first square, while the *Taizō kyūzuyō* arranges them between Acala and Trailokyavijaya in the western sector of the first square. It is thus evident that there existed differences of opinion regarding their placement. In addition, the Tateyama version depicts more than sixteen *vajradharas*.

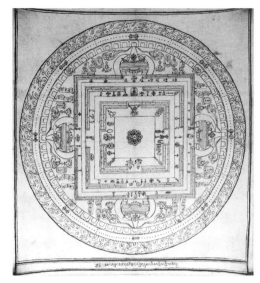

FIG. 2.21B. LINE DRAWING OF THE GARBHA-MAṆḌALA (RAJA MONASTERY, QINGHAI)

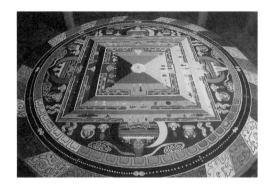

FIG. 2.22. SAND MAṆḌALA OF THE GARBHA-MAṆḌALA (RAJA MONASTERY, QINGHAI)

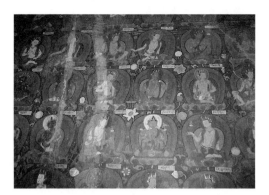

FIG. 2.23. DEITIES OF THE GARBHA-MAṆḌALA IN THE
AMOGHAPĀŚA CHAPEL, GREAT STŪPA OF GYANTSE

Next, as regards point 4, Śubhākarasiṃha, in his commentary on the *Vairocanābhisam-bodhisūtra*, explains that "one should depict a symbol of omniscience. It is a reversed triangle of a pure white color."[208] In Japan, too, the Garbha-maṇḍala of the Shin'an subbranch of the Shingon sect founded by Jōgon (1639–1702) depicts the symbol of omniscience as a reversed triangle.[209] Therefore with regard to the shape of the symbol of omniscience, Tibetan examples are thought to be faithful to the Indian original.

Lastly, let us consider point 5, concerning the total number of deities. Many manuals in Tibet, starting with the aforementioned First Panchen Lama's ritual manual, describe a Garbha-maṇḍala consisting of 122 deities, and most of the extant examples tally with this number. In the Japanese Genzu mandara, Agni's attendants are five seers and, with the addition of Vasu's wife, six seers in all are depicted. The Tibetan manual by Butön, on the other hand, mentions only five seers, whereas the one by the First Panchen Lama prescribes six seers in accordance with chapter 11 of the *Vairocanābhisambodhisūtra* (chapter 13 in the Tibetan translation). But in examples depicting only five seers, such as the Ngor version, the total number of deities is not 122 but 121.

In the Tateyama version, in which many attendants of the Vajra family have been added, the number of deities has significantly increased. The total number of deities in the Amoghapāśa chapel in the Great Stūpa of Gyantse, on the other hand, is 109, since thirteen deities are completely missing: (13) attendant of Vajrasūcī, (15)–(16) attendants of the Vajra family, (53)–(56) four of Agni's six seers, (59) Kālarātri, (60)–(63) Mātrikās, and (73) Pṛthvī.

The Tibetan examplars all differ somewhat from one another in their iconography and the arrangement of the deities. This is unusual for Tibetan maṇḍalas, the details of whose iconography are generally fixed. However, compared with the Japanese Garbha-maṇḍala, the Tibetan Garbha-maṇḍala is more faithful to its textual source, chapter 2 of the *Vairo-canābhisambodhisūtra*, although it turns out that partial reference was also made to other chapters of the *Vairocanābhisambodhisūtra*, such as chapter 11.

9. The Evolution of the Inner Square

As noted, the maṇḍala consisting of three families that developed from the triad of Śākya-muni, Avalokiteśvara, and Vajrapāṇi came into existence in India around the sixth century. The maṇḍala of the *Guhyatantra*, described above, is typical of such maṇḍalas composed of three families. This type of maṇḍala developed into the Garbha-maṇḍala described in the *Vairocanābhisambodhisūtra*. The rest of this chapter will show how the Garbha-maṇḍala evolved from primitive forms of the maṇḍala consisting of three families and belonging to the early and middle phases of esoteric Buddhism, in the order of the inner, third, and second squares.

In the *Guhyatantra*, the main deity of the maṇḍala was any buddha or bodhisattva. A similar situation is also found in the *Tuoluoni jijing* and *Susiddhikaramahātantra*. However, in the *Guhyatantra* Śākyamuni was already placed in the east of the inner square, and it has been argued therefore that Vairocana was intended as the main deity.[210]

It has also been pointed out that a version of the Vimokṣa-maṇḍala in the Sanskrit, Tibetan, and Chinese versions of the *Amoghapāśakalparāja* is the earliest maṇḍala with Vairocana as the main deity.[211] Although this is correct at the present point in time, it is to

some extent a matter of chance whether or not the Sanskrit original of a Buddhist scripture has survived, and the Sanskrit original of the *Vairocanābhisambodhisūtra* has not yet been discovered. I therefore pay particular attention to the *Guhyatantra* with respect to the shift of the main deity from Śākyamuni to Vairocana.

In the *Guhyatantra*, Śākyamuni, who has yielded the position of main deity to Vairocana, is found in the east of the inner square. In the Garbha-maṇḍala, Śākyamuni has moved to the second square and the entire square has become a maṇḍala centered on Śākyamuni. Thus the *Guhyatantra* influenced the evolution of the Garbha-maṇḍala in many respects.

As for its structure, the sector of Śākyamuni in the east of the inner square consists of ten deities. In the west of the inner square, corresponding to the Jimyō-in in the Genzu mandara, are depicted only two *nāga* kings, guardians of the western gate. As a result, a noticeable imbalance occurs between the upper and lower parts of the inner square. Both maṇḍalas have many protective deities in common, but their arrangement differs considerably. Thus it is difficult to say that the maṇḍala of the *Guhyatantra* was the direct ancestor of the Garbha-maṇḍala.

As was seen in chapter 1, the five buddhas on the central eight-petaled lotus came into existence by combining Vairocana of the *Avataṃsakasūtra* and the buddhas of the four directions in the *Suvarṇaprabhāsasūtra*. However, the five buddhas of the Garbha-maṇḍala and Vajradhātu-maṇḍala evolved through different processes, with those of the Garbha-maṇḍala inheriting a system into which Saṃkusumitarājendra had intruded.

As was seen above, Saṃkusumitarājendra was regarded as the lord of another world named Kusumāvatī in the northeast, where Mañjuśrī resides. In the maṇḍala of the *Mañjuśrīmūlakalpa*, Saṃkusumitarājendra was depicted in the eastern gate along the central axis. This suggests that Saṃkusumitarājendra was thought to be associated with the Buddha family on account of his relationship with Mañjuśrī, a representative bodhisattva of the Buddha family. If my reconstruction of the maṇḍala is correct—placing Saṃkusumitarājendra, Amitābha, and Ratnaketu in the center, north, and south of the upper part, respectively—then these three buddhas would have been associated with the Buddha, Lotus, and Vajra families, respectively.

The *Vairocanābhisambodhisūtra* makes the buddha of the north Akṣobhya in chapter 2 but Dundubhisvara in chapter 13. There is thus an inconsistency between the first and second halves of the text. This fact suggests that the compiler of the *Vairocanābhisambodhisūtra* adopted three tathāgatas from the *Mañjuśrīmūlakalpa* and either Akṣobhya or Dundubhisvara, who do not appear in the *Mañjuśrīmūlakalpa*, as the remaining buddha among the four buddhas of the *Suvarṇaprabhāsasūtra*.

As mentioned earlier, in the maṇḍala of the *Guhyatantra* there already existed five of the eleven groups of the primitive Garbha-maṇḍala: Kannon-bu (Avalokiteśvara group), Kongō-bu (Vajrapāṇi group), Shaka-bu (Śākyamuni group), Monju-bu (Mañjuśrī group), and Ten-bu (group of Hindu deities). In contrast, the Henchi-bu (Omniscience group, with a triangle symbolizing the Buddha's omniscience) and Jimyō-bu (Vidyādhara group) in the east and west of the inner square had not yet been completed. Let us consider the evolution of these two groups.

The Henchi-in (Omniscience sector) consists of seven deities comprising five principal deities, Uruvilvākāśyapa, and Gayākāśyapa. The Henchi-bu explained in the *Vairocanābhisambodhisūtra* consists of only three deities, namely, a triangle symbolizing omniscience, a

wish-fulfilling jewel, and Gaganalocanā. The *Taizō zuzō* (to be discussed below) adds deities symbolizing various virtues of the Buddha (about thirty in number) that are explained in chapter 9 of the *Vairocanābhisambodhisūtra*, some of which correspond to deities in the Śākyamuni group.[212] This is understandable if we bear in mind the fact that the Śākyamuni group was originally located in the east of the inner square in the *Guhyatantra* and *Susiddhikaramahātantra*.

The triangle symbolizing omniscience and the wish-fulfilling jewel among the three original deities are depicted not in human form but as symbols. But in the *Taizō zuzō* the triangle has been replaced by a bodhisattva holding the triangle, and the wish-fulfilling jewel has been replaced by a bodhisattva (Ūrṇā) holding a jewel in her right hand. The Genzu mandara has restored the triangle, but the wish-fulfilling jewel has been replaced by a bodhisattva named Mahāvīra holding a jewel in his left hand.

The Garbha-maṇḍala explained in chapter 2 of the *Vairocanābhisambodhisūtra* is a *mahāmaṇḍala*, or a maṇḍala that depicts all the deities in human form. The reason that the *Taizō zuzō* changed the above symbols into deities in human form seems to have been to standardize the representation of all the deities in human form. Why would chapter 2 of the *Vairocanābhisambodhisūtra* have prescribed that only the triangle symbolizing omniscience and the wish-fulfilling jewel be depicted as symbols?

In early maṇḍalas the sector in the east of the inner square was occupied by the Śākyamuni group of later maṇḍalas. In the Garbha-maṇḍala, however, it was necessary to fill the blank in the east of the inner square by introducing new deities, since Śākyamuni had moved to the east of the second square.

The *Mañjuśrīmūlakalpa* stipulates that the principal deities should be depicted both in human form and as symbols in the same maṇḍala. In this maṇḍala the symbols of the principal deities are arranged in the upper part of the inner square. Accordingly, the empty space in the upper part (i.e., east) of the inner square of the Garbha-maṇḍala seems to have been used to depict symbols.

It should be pointed out that the triangle, also known as *sarvatathāgatajñāna-mudrā*, is considered to be a symbol of omniscient buddhas, beginning with Vairocana. The wish-fulfilling jewel, called "seal of world-saving buddhas and bodhisattvas" in the *Vairocanābhisambodhisūtra*, is regarded as a symbol of buddhas and bodhisattvas who save sentient beings. In the Garbha-maṇḍala these were therefore placed together in the east of the inner square, in contrast to the *Mañjuśrīmūlakalpa*, which depicts the symbols of the principal deities together with the deities themselves. If we take into account the fact that deities symbolizing the Buddha's various virtues were originally symbols of deifications of Śākyamuni's virtues, we can rationally solve the question of why those in the Shaka-bu (Śākyamuni group) and Henchi-bu (Omniscience group) overlap in the *Taizō zuzō*.

Lastly, let us consider the Jimyō-bu (Vidyādhara group) in the west of the inner square. In the maṇḍala of the *Guhyatantra*, there is a space that is empty except for two *nāga* kings, the guardians of the western gate. The Garbha-maṇḍala added Acala and Trailokyavijaya to these two *nāga* kings. In the Genzu mandara, Prajñāpāramitā is depicted in the center of the western sector and two further wrathful deities, Yamāntaka and Vajrahūṃkāra, have been added. However, these three deities are not included in the original Jimyō-bu explained in the *Vairocanābhisambodhisūtra*. Several examples from Tibet, on the other hand, here depict (81) Aparājita, (82) Aparājitā, and (83) Earth Goddess, who were, however, originally

attendants of Śākyamuni.[213] Furthermore, the two *nāga* kings have been moved to the outmost square (Gekongō-bu [Outer Vajra group]) in the Genzu mandara.

In the maṇḍalas of the *Tuoluoni jijing* and *Susiddhikaramahātantra*, deities belonging to the Buddha, Lotus, and Vajra families occupy the eastern, northern, and southern sectors of the inner square, while Hindu deities starting with Śiva are arranged in the west of the inner or second square. However, after it had become established as a general principle that Buddhist deities should be depicted in the inner square and protective deities in the outer square, Hindu deities originally depicted in the west of the inner square moved to the west of the second square. This was the reason for the empty space in the west of the inner square in the maṇḍala of the *Guhyatantra*.

In chapter 1, we saw that Acala and Trailokyavijaya were originally wrathful deities meant to subjugate Śiva and other Hindu deities, and in the Sonshō mandara and so on they are arranged on both sides of Vairocana as flanking attendants. In Tibet, meanwhile, there have been found not a few examples of Vairocanābhisambodhi and the eight great bodhisattvas attended by Acala and Trailokyavijaya. This would suggest that these two wrathful deities were well known as attendants of Vairocana. The reason that they were depicted in the west of the inner square was not only to conform to the custom in Indian Buddhist iconography of wrathful deities being positioned at the feet of the main deity, but also so that they could subjugate the Hindu deities who had moved to the west of the outer square.

10. The Evolution of the Third Square

Among the three concentric squares of the Garbha-maṇḍala, the inner square remains within the schema of the three families. The second square, on the other hand, became a maṇḍala of Śākyamuni, who had yielded the position of main deity to Vairocana, and of protective deities who had received the teachings from Śākyamuni. The third square, centered on Mañjuśrī, is made up of bodhisattvas worshiped in Mahāyāna Buddhism.

The structure of the third square, which arranges Sarvanīvaraṇaviṣkambhin, Ākāśagarbha, and Kṣitigarbha in the south, west, and north, respectively, is difficult to explain on the basis of the three families. In this section I consider the evolution of the bodhisattvas arranged in the third square of the Garbha-maṇḍala.

As was seen in chapter 1, many examples of the combination of Vairocanābhisambodhi and the eight great bodhisattvas from the eighth to early ninth centuries have been identified in various parts of Asia. But the arrangement of the eight great bodhisattvas in the Sonshō mandara and the maṇḍala of the eight great bodhisattvas in Ellora Cave 12 does not match the arrangement of the eight great bodhisattvas in the Garbha-maṇḍala.

The maṇḍala of the *Vajrapāṇyabhiṣekatantra* arranged the eight great bodhisattvas in the second square outside the eight-petaled lotus, which is similar to the Garbha-maṇḍala. If we compare their arrangement with the Garbha-maṇḍala, the directions of Mañjuśrī (east) and Ākāśagarbha (west) tally, while the positions of Sarvanīvaraṇaviṣkambhin (south) and Kṣitigarbha (north) have been rotated 45 degrees counterclockwise. Samantabhadra and Maitreya, who do not have their own sectors in the Garbha-maṇḍala, are depicted on the central lotus petals.[214] Thus the arrangement of these bodhisattvas in the Garbha-maṇḍala was influenced by the *Vajrapāṇyabhiṣekatantra*.

In addition, the *Vairocanābhisambodhisūtra* mentions twenty-five bodhisattvas in the

third square: four bodhisattvas (as well as five young girls) in the Mañjuśrī group, nine bodhisattvas in the Sarvanīvaraṇaviṣkambhin group, six bodhisattvas in the Kṣitigarbha group, and six bodhisattvas in the Ākāśagarbha group. However, the *Vajrapāṇyabhiṣeka-tantra*, stating only that the eight great bodhisattvas "are accompanied by attendants," does not give their names.

Most of the attendant bodhisattvas in the third square seldom appear in the maṇḍalas of earlier esoteric Buddhist scriptures. The sole exception is a maṇḍala in the *Amoghapāśakalparāja* called the Supreme Vast Emancipation Lotus maṇḍala. However, as has been noted, most of the bodhisattvas shared with the third square of the Garbha-maṇḍala are found only in the enlarged part of the Chinese translation. Therefore they would seem to have been reintroduced from the *Vairocanābhisambodhisūtra*.

Next, let us consider how the attendant bodhisattvas in the third square of the Garbha-maṇḍala evolved. If we depict the deities of the third square faithfully to the *Vairocanābhi-sambodhisūtra*, we get nine deities in Mañjuśrī's group in the east, six deities in Ākāśagarbha's group (as well as two *nāga* kings) in the west, six deities in Kṣitigarbha's group in the north, and nine deities in Sarvanīvaraṇaviṣkambhin's group in the south. This results in an imbalance both vertically and horizontally. Śubhākarasiṃha accordingly states in his commentary on the *Vairocanābhisambodhisūtra* that bodhisattvas of the Bhadrakalpa should be depicted in all the empty spaces,[215] and in the "maṇḍala transmitted by the *ācārya*" a large number of bodhisattvas of the Bhadrakalpa have been supplemented. These include both bodhisattvas referred to simply as "bodhisattva of the Bhadrakalpa" and bodhisattvas with specific names who have been supplemented from interlocutors in other Mahāyāna sūtras.

According to the *Guhyatantra*, on the other hand, in the east of the third square one should place Mañjuśrī, Mahāsthāmaprāpta, the Buddha's elder son (Sanskrit name not known), Ākāśagarbha, Sarvārthasiddhi, Vimalagata, and one thousand bodhisattvas of the Bhadrakalpa, starting with Maitreya.[216] This means that one thousand bodhisattvas of the Bhadrakalpa, starting with Maitreya, should be depicted in the east of the third square, which corresponds to Mañjuśrī's group in the Garbha-maṇḍala.

In the Vajradhātu-maṇḍala, on the other hand, sixteen bodhisattvas collectively known as the "sixteen bodhisattvas of the Bhadrakalpa" are arranged four each in the four quarters of the outer square. They are thought to be the leading figures among one thousand bodhi-sattvas destined to become buddhas during this present eon, called the Bhadrakalpa. But their names only partially coincide with those of the one thousand buddhas of the Bhadrakalpa listed in the *Bhadrakalpikasūtra* and so on.[217] There exist several combinations of sixteen bodhisattvas.[218] The sixteen bodhisattvas of the Bhadrakalpa in the Vajradhātu-maṇḍala are closely related to the bodhisattvas mentioned at the start of the *Anantamukhanirhāra-dhāraṇī*, one of the earliest *dhāraṇī* sūtras, which was translated into Chinese nine times, starting with the *Wuliangmen weimichi jing* at the time of the kingdom of Wu (third century). The size of the audience also gradually increased, finally reaching twenty-three bodhi-sattvas in Amoghavajra's translation (twenty-five in the Tibetan translation). Most of the bodhisattvas coinciding with the sixteen bodhisattvas of the Bhadrakalpa were added at the time of Amoghavajra's translation. Therefore it is unlikely that the *Anantamukhanirhāra-dhāraṇī* had links with the sixteen bodhisattvas of the Bhadrakalpa from the very outset. However, it is reasonable to suppose that the sixteen bodhisattvas of the Bhadrakalpa were selected from among the listeners of Mahāyāna and *dhāraṇī* sūtras.

GROUP	SANSKRIT	PP	SP	VK	AM	RK	GT	AAM	VA
Mañjuśrī Group	Mañjuśrī	◎	◎	◎	◎	◎	○	○	◎
	Jālinīprabha			◎	◎			○	◎
	Vimalaprabhākumāra							○	
	Ratnamakuṭa								
Sarvanīvaraṇaviṣkambhin Group	Sarvanīvaraṇaviṣkambhin				◎				◎
	Kautūhala					◎			
	Sarvasattvābhayaṃdada								
	Sarvāpāyaṃjaha				◎				
	Paritrāṇāśayamati							○	
	Mahāmaitryabhyudgata								
	Mahākaruṇāmṛdita								◎
	Sarvadāhapraśāmin								◎
	Acintyamati					◎	○		
Kṣitigarbha Group	Kṣitigarbha								◎
	Ratnākara	◎	○	○					◎
	Ratnapāṇi		◎			◎			◎
	Dharaṇiṃdhara		◎						
	Ratnamudrāhasta	◎		◎					◎
	Dhṛḍhādhyāśaya								○
Ākāśagarbha Group	Ākāśagarbha				◎		○		◎
	Gaganamati						●		
	Viśuddhamati						●		
	Cāritramati						●		◎
	Gaganāmala						●		
	Sthiramati						●		◎

PP: *Pañcaviṃśatisāhasrikā Prajñāpāramitā*; SP: *Saddharmapuṇḍarīkasūtra*; VK: *Vimalakīrtinirdeśasūtra*; AM: *Anantamukhanirhāradhāraṇī*; RK: *Ratnaketuparivarta*; GT: *Guhyatantra*; AAM: *Aṣṭākṣaramañjuśrīdhāraṇī* (T. 1184); VA: *Vajrapāṇyabhiṣekatantra*.

◎ Refers to bodhisattvas who are named in the corresponding texts.

○ Refers to bodhisattvas who appear in the corresponding texts but are not named.

● Explained in note 219.

We can infer from Śubhakarasiṃha's instruction to fill the empty spaces of the third square with bodhisattvas of the Bhadrakalpa that the bodhisattvas in the third square of the Garbha-maṇḍala had the same significance as the sixteen bodhisattvas of the Bhadrakalpa in the Vajradhātu-maṇḍala. Accordingly, I compared the listeners listed at the start of Mahāyāna and early esoteric Buddhist scriptures with the twenty-five bodhisattvas in the

third square of the Garbha-maṇḍala (fig. 2.24). I referred mainly to the Sanskrit originals or, if these were not available, to the Tibetan translations, since the names of bodhisattvas in Chinese translations vary depending on the translator.

Among these bodhisattvas, Mañjuśrī is well known and his retinue is also mentioned in many Mahāyāna sūtras. We can assume that his retinue was organized into the Mañjuśrī group.

Four bodhisattvas in Kṣitigarbha's retinue are frequently mentioned as listeners in Mahāyāna sūtras, such as the *Prajñāpāramitā* (in 25,000 stanzas), *Saddharmapuṇḍarīka*, and *Vimalakīrtinirdeśa*. In Kṣitigarbha's group, the attendants appeared earlier than Kṣitigarbha himself, since the Kṣitigarbha cult is thought to have appeared in late Mahāyāna Buddhism. Therefore in contrast to the Lotus and Vajra families, it is inconceivable that the popularity of the Kṣitigarbha cult gave rise to various attendants who were later organized into the Kṣitigarbha group. The reason that these bodhisattvas were affiliated to Kṣitigarbha seems to have been the association with the jewel (*ratna*), his attribute, in their names in the case of (110) Ratnākara, (111) Ratnapāṇi, and (113) Ratnamudrāhasta and the association with the earth (*kṣiti/dharaṇi*) in the case of (112) Dharaṇiṃdhara.

It is difficult to identify the names of members of Ākāśagarbha's retinue in the lists of listeners of earlier Mahāyāna and *dhāraṇī* sūtras.[219] The reason that these bodhisattvas were affiliated to Ākāśagarbha seems to have been the association with sky (*ākāśa/gagana*) in his name in the case of (119) Gaganāmala and (116) Gaganamati and the association with Ākāśagarbha's intelligence (*mati*) in the case of (117) Viśuddhamati, (118) Cāritramati, and (120) Sthiramati.

In Sarvanīvaraṇaviṣkambhin's group, the *Anantamukhanirhāradhāraṇī* mentions (103) Sarvāpāyaṃjaha together with Sarvanīvaraṇaviṣkambhin among the audience of this *dhāraṇī* sūtra. Furthermore, these two are included among ten bodhisattvas originally mentioned as listeners in early translations before Amoghavajra.[220] Kautūhalika, corresponding to (101) Kautūhala in the Garbha-maṇḍala, appears in the *Ratnaketuparivarta*. As noted earlier, the *Ratnaketuparivarta*, which expounds a six-buddha system that developed from the four buddhas of the *Suvarṇaprabhāsasūtra*, exerted an influence on esoteric Buddhism in later times. Kautūhala seems to have been incorporated into the *Vairocanābhisambodhisūtra* from the *Ratnaketuparivarta*.

The *Vajrapāṇyabhiṣekatantra*, on the other hand, lacks a standard introduction at the beginning but mentions the place and audience in volume 2.[221] It is worth noting that Snying rje can, corresponding to (106) Mahākaruṇāmṛdita, and Gdung ba thams cad rab tu zhi ldan, corresponding to (107) Sarvadāhapraśāmin, who do not appear in other scriptures, are included in the listeners mentioned in volume 2.

Thus the twenty-five bodhisattvas in the third square of the Garbha-maṇḍala are thought to have been selected from among listeners of Mahāyāna and early esoteric Buddhist scriptures pre-dating the *Vairocanābhisambodhisūtra*, even though we cannot find roughly matching sets of listeners, as in the case of the *Anantamukhanirhāradhāraṇī* and the sixteen bodhisattvas of the Bhadrakalpa.

Among the foregoing texts, the *Vajrapāṇyabhiṣekatantra*, which has twelve matching listeners, seems to be the closest. As mentioned above, the *Vajrapāṇyabhiṣekatantra* played an important role in the evolution of the Garbha-maṇḍala. However, it does not enumerate the attendants of the eight great bodhisattvas. Therefore the Garbha-maṇḍala selected suit-

able listeners from volume 2 of this text and allocated them among the groups of Mañjuśrī, Sarvanīvaraṇaviṣkambhin, Ākāśagarbha, and Kṣitigarbha.

In the Genzu mandara, Śākyamuni and Mañjuśrī, the main figures in the second and third squares, are depicted with their backs to the *toraṇa* of the eastern gate. The gates of the Japanese Garbha-maṇḍala, called "vajra gates," depict the Indian *toraṇa* from a bird's-eye view, in contrast to the "lotus gates" of the Vajradhātu-maṇḍala and Tibetan maṇḍalas, which depict gates as geometrical patterns.

The layout in which the main deity has his back to a *toraṇa* is somewhat similar to the Jeweled Pavilion maṇḍala from Khara-khoto mentioned in chapter 1, which represented the pavilion as a *toraṇa*-like multistoried structure crowned with a stūpa. This shape is very similar to the *toraṇa* depicted above the four gates of Tibetan maṇḍalas.

In the Tibetan Garbha-maṇḍala, the *toraṇa* is depicted only above the four gates of the outermost third square. This means that Mañjuśrī, the main deity of the third square, is depicted in the eastern gate with his back to the *toraṇa*, just like Śākyamuni as the main deity of the Jeweled Pavilion maṇḍala from Khara-khoto. In the Japanese Genzu mandara, only Mañjuśrī in the east is depicted inside a gate, whereas in the Tibetan Garbha-maṇḍala Sarvanīvaraṇaviṣkambhin, Ākāśagarbha, and Kṣitigarbha are also depicted with their backs to the *toraṇa* in the gates in the south, west, and north, respectively.

The maṇḍala of the *Mañjuśrīmūlakalpa* mentioned above enclosed the inner square, which resembles a landscape maṇḍala, with three concentric outer squares. This fact suggests that the outer squares of the Garbha-maṇḍala represent an expansion of a primitive maṇḍala like the landscape maṇḍala.

11. The Evolution of the Second Square

In the second square of the Garbha-maṇḍala are depicted Śākyamuni, who had yielded the position of main deity to Vairocana, and his retinue (Śākyamuni group). In addition, in the south, west, and north of the second square are arranged gods of Brahmanism or Hinduism who had become protective deities after receiving Śākyamuni's teaching (group of Hindu deities).

The Śākyamuni group consists of Buddhalocanā and *uṣṇīṣa* deities collectively known as the five or three *uṣṇīṣas*. As was seen in chapter 1, *uṣṇīṣa* deities, the deifications of *dhāraṇīs* expounded by the Buddha, are regarded as *vidyārājas* of the Buddha family, and for this reason they are arranged in the Śākyamuni group. Ūrṇā, on the other hand, the deification of the circle of hair on the Buddha's forehead, developed into a group of deities called "deities symbolizing the Buddha's various virtues" in the *Taizō zuzō*, described below.

Ishida showed that these deities are deifications of mudrās and mantras explained in chapter 9 of the *Vairocanābhisaṃbodhisūtra* (chapter 11 in the Tibetan translation).[222] These mudrās and mantras were not deified in Tibet except for the aforementioned Ūrṇā, although they played an important role in Tibetan ritual manuals on the Garbha-maṇḍala.[223]

The group of Hindu deities occupying the northern, western, and southern strips of the second square has been considered problematic. We can point to the *Mañjuśrīmūlakalpa* (figs. 2.7 and 2.8) and the *Vajrapāṇyabhiṣekatantra* (fig. 2.17) as precedents for placing Yama and mother-goddesses in the south of the outer square. The *Guhyatantra*, on the other

hand, differs in that Yama is depicted in the south of the outer square but the seven mother-goddesses are arranged in the west (fig. 2.5).

Next, the Garbha-maṇḍala arranges the principal deities of Hinduism, such as Śiva, Umā, Kumāra, and Viṣṇu, in the west. As was seen above, early maṇḍalas composed of the three families place Śiva and his consort in the west of the inner square. However, Hindu deities were moved to the western strip of the second square once the principle that Buddhist deities are depicted in the inner square and protective deities in the outer square was established.

The *nāgas*, Candra, and Pṛthvī are thought to follow the arrangement of the inner and outer squares in the west of the maṇḍala of the *Guhyatantra*. The *Vajrapāṇyabhiṣekatantra*, on the other hand, does not follow this arrangement except for the *nāgas* and Maheśvara (i.e., Śiva), who are depicted in the west. It is puzzling that Varuṇa, traditionally located in the west in accordance with the system of protectors of directions (*dikpāla*), is depicted in the north in the Garbha-maṇḍala.

As for the northern strip, Indra, Brahmā, and Sūrya are arranged in the east of the outer square in the *Mañjuśrīmūlakalpa*, *Guhyatantra*, and *Vajrapāṇyabhiṣekatantra*. The general maṇḍala of the *Tuoluoni jijing* belongs to the same group, since it places Indra, Brahmā, and Candra in the east of the outermost square. However, the *Guhyatantra* placed Mañjuśrī in the center of the eastern strip of the outer square, as a result of which both Buddhist and Hindu deities are depicted in the eastern strip of the outer square. In order to avoid this situation, it seems that the Garbha-maṇḍala moved the protective deities in the east to the north.[224] Thus in the Garbha-maṇḍala there was no space for the *yakṣa* deities who occupied the north of the outer square in the *Guhyatantra*, *Vajrapāṇyabhiṣekatantra*, and *Tuoluoni jijing*.[225]

Ishida, basing himself on the switch in the positions of Śākyamuni and Mañjuśrī in the Garbha-maṇḍala, classified the arrangement of protective deities into two groups, group A of the Śubhākarasiṃha tradition and group B of the Amoghavajra tradition. With respect to the protective deities in the north, he argued that "group A is made up of *yakṣa* deities centered on Vaiśravaṇa, while group B is centered not on Vaiśravaṇa but on Indra flanked by Sūrya, Varuṇa, and Brahmā."[226]

The difference between these two traditions seems to have originated in the fact that in earlier scriptures such as the *Mañjuśrīmūlakalpa*, *Guhyatantra*, *Vajrapāṇyabhiṣekatantra*, and *Tuoluoni jijing* protective deities arranged in the east of the outer square were moved to the northern strip of the outer square in the Garbha-maṇḍala. That is to say, group A left the *yakṣa* deities as they were in the north, whereas group B moved the deities located in the east of the outer square in earlier scriptures to the north.

Thus the protective deites of the Garbha-maṇḍala developed from the outer squares of the maṇḍalas of the foregoing *Mañjuśrīmūlakalpa*, *Guhyatantra*, and *Vajrapāṇyabhiṣeka-tantra*. The Garbha-maṇḍala, in order to avoid the overlapping of deities in the east of the outer square, moved protective deities originally depicted in the east to the north, and this is thought to have led to various inconsistencies in the arrangement of deities.

12. *Taizō Zuzō*

The Garbha-maṇḍala, which is thought to have emerged in the seventh century in India, thus had several problematic aspects, such as the asymmetry of its arrangement. Subse-

quently, when the *Vairocanābhisambodhisūtra* and Garbha-maṇḍala were transmitted to China, efforts were made to improve the system underpinning the Garbha-maṇḍala so as to create a more developed maṇḍala. These efforts were eventually brought to fruition by Huiguo in the Genzu mandara.

This book deals mainly with the genesis and development of the maṇḍala in India, and I do not discuss in detail the process whereby Huiguo created the Genzu mandara, since Ishida Hisatoyo has already published a monumental work dealing with this subject. However, versions of the Garbha-maṇḍala pre-dating the Genzu mandara, particularly the *Taizō zuzō* deriving from the tradition of Śubhākarasiṃha and the *Taizō kyūzuyō* deriving from the tradition of Vajrabodhi and Amoghavajra, are important. They seem to reflect to some extent the original Indian form of the Garbha-maṇḍala in the eighth century, since their compilers Śubhākarasiṃha and Vajrabodhi were both Indian masters, while Amoghavajra also studied in India. Therefore I shall consider below the character of these two versions of the Garbha-maṇḍala.

As mentioned above, the primitive Garbha-maṇḍala consisted of an inner square, including the central eight-petaled lotus centered on Vairocana, a second square centered on Śākyamuni, and a third square centered on Mañjuśrī. In the east of the second square are depicted Śākyamuni and his attendants, while Hindu deities who had received instructions from Śākyamuni are arranged in the southern, western, and northern strips. Thus in the south, west, and north protective deities are depicted on the inside while bodhisattvas are placed on the outside. This is the reverse of the norm, since protective deities ought to be arranged in the outer square. To resolve this difficulty, Śubhākarasiṃha, who translated the *Vairocanābhisambodhisūtra* into Chinese, prescribed in his commentary on the *Vairocanābhisambodhisūtra* that the second and third squares of the Garbha-maṇḍala should be transposed.[227]

Śubhākarasiṃha's commentary on the *Vairocanābhisambodhisūtra* contains a "maṇḍala transmitted by the *ācārya* (i.e., Śubhākarasiṃha)," mentioned above. It is only a diagram indicating the body colors and arrangement of the deities and is not accompanied by any images. The *Taizō zuzō*, brought from China to Japan by Enchin (814–891), is a collection of iconographical line drawings in handscroll format that reflects a primitive form of the Garbha-maṇḍala transmitted by Śubhākarasiṃha. There are some points in common between these two versions, although there are discrepancies regarding the number and arrangement of the deities. In this section I consider the Garbha-maṇḍala transmitted by Śubhākarasiṃha, mainly on the basis of the *Taizō zuzō*, which includes illustrations of all the deities.

The *Taizō zuzō* depicts the four buddhas of the Garbha-maṇḍala with the same mudrās as the corresponding buddhas among the four buddhas of the Vajradhātu-maṇḍala. Some scholars consider this unusual. But the *Vairocanābhisambodhisūtra*, Śubhākarasiṃha's commentary, and Buddhaguhya's *Vairocanābhisambodhitantra-piṇḍārtha* and *Vairocanābhisambodhivikurvitādhiṣṭhānamahātantra-vṛtti* do not describe the mudrās of the four buddhas of the Garbha-maṇḍala. The *Sanzhong xidi po diyu zhuan yezhang chu sanjie bimi tuoluoni fa*, attributed to Śubhākarasiṃha, identifies the four buddhas of the Garbha-maṇḍala with those of the Vajradhātu-maṇḍala: Ratnaketu = Akṣobhya (east), Saṃkusumitarājendra = Ratnasambhava (south), Amitābha = Amitābha (west), and Dundubhisvara = Śākyamuni (= Amoghasiddhi, north).[228] In addition, the earliest extant example of the Garbha-maṇḍala

(Rossi and Rossi version), mentioned above, depicts the four buddhas similarly to the corresponding buddhas among the four buddhas of the Vajradhātu-maṇḍala.[229]

In the case of the five buddhas of Languli discussed earlier, Vairocanābhisambodhi is combined with four buddhas displaying the same mudrās as those of the Vajradhātu-maṇḍala. Thus the *Taizō zuzō*, depicting the four buddhas of the Garbha-maṇḍala with the same mudrās as those of the Vajradhātu-maṇḍala, was not unusual in India.

As mentioned, the *Taizō zuzō* transposed the second and third squares, and in addition it inserted a sector of four guardians protecting the four directions (Shidaigo-in) between the inner and second squares. This resulted in an overall structure consisting of four concentric squares (fig. 2.25).

In the Vajra[pāṇi] group in the south of the inner square, the sixteen *vajradharas* listed in chapter 11 of the *Vairocanābhisambodhisūtra* and several attendants were added to the five deities described in chapter 2. As a result, the total number of deities has increased to thirty. The Avalokiteśvara group in the north of the inner square, on the other hand, originally consisted of only seven deities, and this resulted in a marked imbalance between the left and

FIG. 2.25. *TAIZŌ ZUZŌ*

Śākyamuni Group

Mañjuśrī Group

Group of four guardians protecting the four directions

Omniscience Group

Kṣitigarbha Group

Avalokiteśvara Group

Central Lotus Group

Vajra[pāṇi] Group

Sarvanīvaraṇaviṣkambhin Group

Vidyādhara Group

Ākāśagarbha Group

Group of Hindu deities

right sides of the inner square. Śubhākarasiṃha accordingly also expanded the Avalokite-śvara group to forty deities.

The Omniscience group centered on the triangle symbolizing the Buddha's omniscience, in the east of the inner square, originally consisted of three deities. This number increased to thirty in the *Taizō zuzō* on account of the addition of deities symbolizing the Buddha's various virtues who also appeared in the Śākyamuni group.[230] The Vidyādhara group in the west of the inner square, on the other hand, consists of only the two wrathful deities Acala and Trailokyavijaya, resulting in a noticeable imbalance between the upper and lower parts of the inner square.

In contrast to the almost one hundred deities in the four sectors of the inner square, only six deities are depicted in the sector of four guardians in the second square. In the third square centered on Mañjuśrī, the total number of deities in the four directions is about thirty.

Thus the *Taizō zuzō* depicts 324 deities, almost three times as many as the approximately 120 deities mentioned in the *Vairocanābhisambodhisūtra*. It is still not known how to reconstruct the original maṇḍala, since the number of deities in each sector has become unbalanced. However, Ishida's study made it clear that the majority of deities supplemented in the *Taizō zuzō* were incorporated into the Genzu mandara. The *Taizō zuzō* thus represents a valuable source of material for clarifying the evolution of the Genzu mandara.

13. *Taizō Kyūzuyō*

The *Taizō kyūzuyō* is a collection of iconographical line drawings of the Garbha-maṇḍala in handscroll format deriving from the traditions of Vajrabodhi (671–741) and Amoghavajra (705–774) that was brought from China to Japan by Enchin. In contrast to the *Taizō zuzō*, the original form of which has not yet been successfully reconstructed because the arrangement of the large numbers of deities is unbalanced, Ishida Hisatoyo succeeded in restoring the original maṇḍala of the *Taizō kyūzuyō* on the basis of Enchin's handscroll (fig. 2.26).[231]

According to Ishida's reconstruction, the *Taizō kyūzuyō* modfied the triple-square structure of the original Garbha-maṇḍala and added a fourth square for protective deities adopted from Hinduism. However, the strips in the south, west, and north of the second square, where protective deities were originally placed, remained as they were. Thus protective deities are found in both the second and fourth squares. Ishida thought that the protective deities in the second square belonged to Amoghavajra's tradition (group B), while those in the fourth square followed Śubhākarasiṃha's tradition (group A).[232]

If the sixteen *vajradharas* listed in chapter 11 of the *Vairocanābhisambodhisūtra* as attendants of the Vajra family are depicted in the southern sector of the first square, it results in an extreme imbalance between the Vajra family and the Lotus family, the latter of which consists of only seven deities. Therefore the *Taizō kyūzuyō* placed the sixteen *vajradharas* in the western sector of the first square between Acala and Trailokyavijaya. This arrangement seems to have originated in India, since it is also found in the Tibetan Garbha-maṇḍala.[233]

On the central eight-petaled lotus, in contrast to the *Taizō zuzō*, which depicts the four buddhas of the Garbha-maṇḍala in the same way as those of the corresponding directions in the Vajradhātu-maṇḍala, the *Taizō kyūzuyō* depicts Ratnaketu with the boon-granting mudrā, Saṃkusumitarājendra with the fearlessness mudrā, and Akṣobhya (= Dundubhi-svara) with the earth-touching mudrā.

FIG. 2.26. *TAIZŌ KYŪZUYŌ*

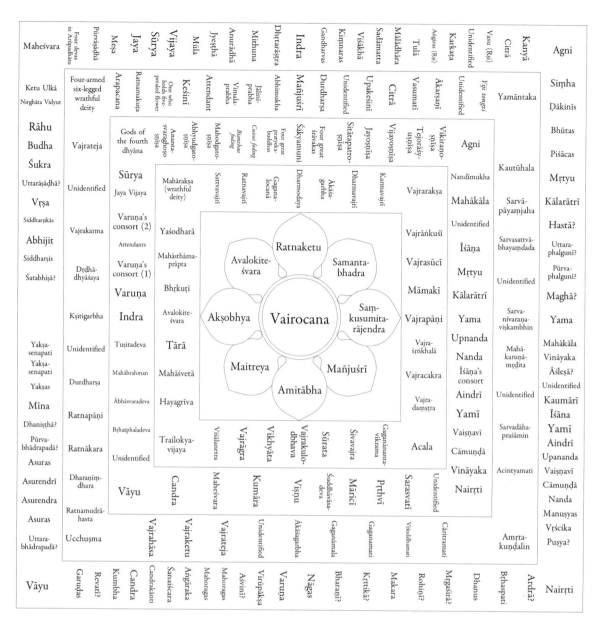

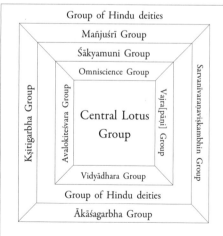

The arrangement of the deities is based mainly
on Ishida 1975, but the Sanskrit names
of deities have been restored by the author.

As was pointed out in chapter 1, the four buddhas of the Garbha-maṇḍala represent a system in which Saṃkusumitarājendra had intruded upon the four buddhas of the *Suvarṇaprabhāsasūtra*. Therefore Ratnaketu in the east corresponds not to Akṣobhya in the east of the Vajradhātu-maṇḍala but to Ratnasambhava in the south. In addition, in chapter 2 of the *Vairocanābhisambodhisūtra* the buddha in the north is not Dundubhisvara but Akṣobhya. The *Taizō kyūzuyō* accordingly made the buddha in the north Akṣobhya and made his mudrā the earth-touching mudrā in accordance with the Vajradhātu-maṇḍala.

Subsequently the four buddhas of the *Taizō kyūzuyō* were carried over into the Genzu mandara by Huiguo. Thus the four buddhas of the two-world maṇḍalas ended up having different mudrās. But it should be noted that there existed a tradition in which the corresponding buddhas in both maṇḍalas had the same mudrās.

As well, the *Taizō kyūzuyō* supplemented various deities in the empty parts of the maṇḍala in order to maintain symmetry and balance in each sector. It turns out that several of these additional deities do not belong to the Vairocanābhisambodhi cycle but were adopted from the Vajradhātu cycle.[234] This fact suggests that the *Taizō kyūzuyō* derives from the traditions of Vajrabodhi and Amoghavajra, who transmitted mainly the Vajradhātu cycle to China. Ishida showed that the iconography of the four *pāramitā* goddesses, Vajrateja (in Kṣitigarbha's sector), Vajraratna (i.e., Ākāśagarbha in the Omniscience sector),[235] and Vajrahāsa and Vajraketu (both in Ākāśagarbha's sector) tallies with the *She wu'ai jing* translated by Amoghavajra.[236] Therefore the *Taizō kyūzuyō* must date from after 746, when Amoghavajra returned to China from India.[237]

In this chapter I have shown how the Garbha-maṇḍala evolved by comparing it with the earlier maṇḍalas of early esoteric Buddhism. It turns out that the Garbha-maṇḍala was devised as a definitive version of the maṇḍala composed of the three families by reorganizing the theories found in earlier scriptures of the early and middle phases of esoteric Buddhism. But there remained problems, such as discrepancies between chapters of the *Vairocanābhisambodhisūtra* and asymmetry in the arrangement of deities.

It seems that when the *Vairocanābhisambodhisūtra* emerged, there remained differences of opinion about the Garbha-maṇḍala and a consensus had not yet been formed. It is to be surmised that not only Śubhākarasiṃha, Vajrabodhi, and Amoghavajra but also many other masters, basing themselves on the descriptions in the *Vairocanābhisambodhisūtra*, tried to create a vertically and horizontally balanced maṇḍala, although we do not have any materials to corroborate this hypothesis. The completion of a maṇḍala with a geometric pattern vertically as well as horizontally symmetrical was not realized until the emergence of the maṇḍalas of the *Prajñāpāramitānayasūtra* and *Sarvatathāgatatattvasaṃgraha*, to be treated in the next two chapters.

3. Maṇḍalas of the *Prajñāpāramitānayasūtra*

1. The Origins of the *Prajñāpāramitānayasūtra*

THE GARBHA-MAṆḌALA DESCRIBED in the *Vairocanābhisambodhisūtra*, which together with the Vajradhātu-maṇḍala forms the "two-world maṇḍalas" in Sino-Japanese Buddhism, represented the culmination of a maṇḍala system composed of three families that developed in early Indian esoteric Buddhism. The Vajradhātu-maṇḍala, on the other hand, was a new type of maṇḍala that introduced a completely different system. After the ninth century, the Garbha-maṇḍala and other maṇḍalas belonging to the same category gradually went out of vogue in India, while the Vajradhātu-maṇḍala and the maṇḍalas of late tantric Buddhism that evolved from it became much more common.

The **Vajraśekharasūtra* (Jp. *Kongōchōkyō*), the source of the Vajradhātu-maṇḍala, is not a single text but a collection of eighteen tantras said to consist of a total of 100,000 stanzas. Among these tantras, the text usually referred to in Japan as *Kongōchōkyō* is the first of the eighteen tantras, the *Sarvatathāgatatattvasaṃgraha*.[238]

Amoghavajra, who spent his religious career introducing the Vajraśekhara cycle to China, did not translate the full text of the *Sarvatathāgatatattvasaṃgraha*. However, he did compose the *Jingangding jing yuga shibahui zhigui* (hereafter *Shibahui zhigui*), which summarizes the contents of the eighteen tantras in 100,000 stanzas.[239] It describes in detail the contents of the four main parts of the first assembly of the *Vajraśekharasūtra* and only summarizes the main points of the other seventeen tantras. Therefore many researchers have doubted the existence of a collection of eighteen tantras consisting of 100,000 stanzas. However, there exist among Chinese texts translated during the Northern Song dynasty and Tibetan texts translated after the ninth century several texts that tally with Amoghavajra's descriptions of the eighteen tantras. They have been identified with the second, third, fourth, sixth, eighth, ninth, thirteenth, fifteenth, and sixteenth assemblies (see fig. 3.1).[240]

The standard form of the Vajradhātu-maṇḍala widely used in Japan is the Kue mandara, or "nine-assembly maṇḍala," composed of nine maṇḍalas. Among these nine maṇḍalas, the Jōjin-e (or Jōjinne) is surrounded by the Sanmaya-e, Misai-e, Kuyō-e, Shiin-e (or Shi-inne), and Ichiin-e (or Ichiinne), all maṇḍalas that are explained in the first part of the *Sarvatathāgatatattvasaṃgraha*. Further, the Kue mandara also includes the Gōzanze-e and Gōzanze-sanmaya-e, explained in the second part of the *Sarvatathāgatatattvasaṃgraha*, and the Rishu-e, which is explained in the *Prajñāpāramitānayasūtra*.

The *Prajñāpāramitānayasūtra*, recited daily in the Japanese Shingon sect, is closely related to the *Sarvatathāgatatattvasaṃgraha*, and scholars consider the *Paramādyatantra*,[241]

an enlarged version of the *Prajñāpāramitānayasūtra*, to correspond to the sixth assembly of Amoghavajra's *Vajraśekharasūtra*. This is why the Rishu-e mandara, based on the *Prajñāpāramitānayasūtra*, was incorporated into the nine-assembly maṇḍala.

As will be seen later in this chapter, only the first half of the *Paramādyatantra*, referred to as the "Prajñākhaṇḍa," corresponds to the sixth assembly of the *Vajraśekharasūtra*, while the second half, that is, the "Mantrakhaṇḍa," corresponds to the seventh assembly, called the *Samantabhadrayoga*, and the eighth assembly, called the *Paramādyayoga*.

Thus the *Shibahui zhigui* identifies the *Sarvatathāgatatattvasaṃgraha* as the first of the eighteen assemblies and the *Prajñāpāramitānayasūtra* cycle as the sixth, seventh, and eighth assemblies. Some scholars consider the sequence of the eighteen tantras to reflect the order of their composition, and so they consider the *Sarvatathāgatatattvasaṃgraha* to pre-date the *Prajñāpāramitānayasūtra*.[242]

FIG. 3.1. THE EIGHTEEN ASSEMBLIES OF THE VAJRAŚEKHARA CYCLE

CHINESE TITLE (AND ANTICIPATED SANSKRIT TITLE)	CORRESPONDING CHINESE TRANSLATION	CORRESPONDING TIBETAN TRANSLATION
1. *Yiqie rulai zhenshishe jiaowang* (*Sarvatathāgatatattvasaṃgraha*)	T. 882, T. 865	P. 112
2. *Yiqie rulai bimiwang yujia* (*Sarvatathāgataguhyendrayoga*)		P. 113
3. *Yiqie jiaoji yuga* (*Sarvakalpasaṃgrahayoga*)		P. 113
4. *Xiangsanshi jingang yuga* (*Trailokyavijayavajrayoga*)	(T. 1040)	P. 115
5. *Shijian chushijian jingang yuga* (*Laukikalokottaravajrayoga*)		
6. *Da anle bukong sanmeiye zhenshi yuga* (*Mahāsukhāmoghasamayatattvayoga*)	T. 244	P. 119
7. *Puxian yuga* (*Samantabhadrayoga*)	(T. 1121)	P. 120
8. *Shengchu yuga* (*Paramādyayoga*)	T. 244	P. 120
9. *Yiqiefo jihui najini jiewang yuga* (*Sarvabuddhasamāyogaḍākinījālasaṃvarayoga*)	(T. 1051)	P. 8, P. 9
10. *Da sanmeiye yuga* (*Mahāsamayayoga*)		
11. *Dasheng xianzheng yuga* (*Mahāyānābhisamayayoga*)	T. 868?	
12. *Sanmeiye zuisheng yuga* (*Samayāgryayoga*)		
13. *Da sanmeiye zhenshi yuga* (*Mahāsamayatattvayoga*)	T. 883	
14. *Rulai sanmeiye zhenshi yuga* (*Tathāgatasamayatattvayoga*)		
15. *Bimi jihui yuga* (*Guhyasamājayoga*)	T. 885	P. 81
16. *Wu'er pingdeng yuga* (*Advayasamatāyoga*)	T. 887	P. 87
17. *Ru xukong yuga* (*Khasamayoga*)		P. 80?
18. *Jingang baoguan yuga* (*Vajramakuṭayoga*)		

Text numbers enclosed in parentheses represent a partial translation.

The *Prajñāpāramitānayasūtra* is quoted in the *Prasannapadā* by Candrakīrti of the Mādhyamika school, who was active in the seventh century.[243] The *Prajñāpāramitānayasūtra* was first translated into Chinese by Xuanzang (602–664), and there are considerable differences between Xuanzang's translation (T. 220–10) and the later translation by Amoghavajra (T. 243), which is used in the Shingon sect. However, we can confirm that the original version was already in existence by 646, when Xuanzang returned to China from India. Moreover, the next translation by Bodhiruci (T. 240) is closer to Amoghavajra's translation than that by Xuanzang. This textual evidence suggests that a Sanskrit text similar to the present version existed in seventh-century India. This date is the earliest for any of the Yoga tantras.

The *Vajraśekharamahāguhyayogatantra*, an explanatory tantra of the *Sarvatathāgatatattvasaṃgraha* that Sakai Shinten identified as the second and third assemblies of the *Vajraśekharasūtra*, mentions the *Dpal mchog dang po* (*Śrīparamādya*), thought to correspond to the second half of the *Paramādyatantra*.[244] It occurs in the part identified by Sakai as the second assembly of the *Vajraśekharasūtra*. I consider the date of the *Sarvatathāgatatattvasaṃgraha* and *Paramādya* in greater detail in the next chapter, but I can at least confirm that the eighth assembly, corresponding to the second half of the *Paramādya*, predates the second assembly, an explanatory tantra on the four parts of the *Sarvatathāgatatattvasaṃgraha*. I am therefore of the view that the *Prajñāpāramitānayasūtra* is the earliest among the Yoga tantras, and I also surmise that the process whereby the current *Paramādya* came into existence—following the incorporation of mudrās, mantras, and maṇḍala rites into the *Prajñāpāramitānayasūtra*—influenced the evolution of the *Sarvatathāgatatattvasaṃgraha* and Vajradhātu-maṇḍala. In this chapter I accordingly focus on the evolution of the *Prajñāpāramitānayasūtra* and its developed form, the *Paramādya*, before considering the emergence of the *Sarvatathāgatatattvasaṃgraha* and Vajradhātu-maṇḍala in the next chapter.

2. The *Prajñāpāramitānayasūtra* and Esoteric Buddhism

A primitive form of the *Prajñāpāramitānayasūtra* is the tenth assembly (*Bore liqu fen*) of the *Mahāprajñāpāramitāsūtra* translated by Xuanzang. This suggests that the *Prajñāpāramitānayasūtra* started its history as a condensed version of the *Prajñāpāramitāsūtra*, the basic scripture of Mahāyāna Buddhism. Esoteric Buddhism then attached great importance to it, and through the addition of mudrās, mantras, and maṇḍala rites it developed into the voluminous scripture known as the *Paramādyatantra*. Other condensed versions of the *Prajñāpāramitāsūtra* include the *Svalpākṣaraprajñāpāramitā* and *Prajñāpāramitāhṛdaya* (*Heart Sūtra*), to both of which mantras have been attached.

The recitation of the *Prajñāpāramitāsūtra* is considered to bring enormous merit, but it is difficult for ordinary adherents to recite or copy the full text, even that of the most compact version, the *Aṣṭasāhasrikā Prajñāpāramitā*. This is why condensed versions of the *Prajñāpāramitāsūtra* appeared, but without reducing its merit. This is also illustrated by the fact that in Japan the *Prajñāpāramitānayasūtra* translated by Xuanzang is recited when the ritualized speed-reading (*tendoku*) of the *Mahāprajñāpāramitāsūtra* is performed.[245] The mantra at the end of condensed versions would seem to be meant to guarantee that the efficacy of the condensed text is equal to that of the voluminous *Prajñāpāramitā*.

The mantra of the *Prajñāpāramitāhṛdaya* appears also in the *Tuoluoni jijing*, an early

esoteric Buddhist scripture, and this shows that condensed versions of the *Prajñāpāramitā* had connections with esoteric Buddhism from an early stage. This is confirmed by the fact that Tibetan translations of the *Svalpākṣaraprajñāpāramitā* and *Prajñāpāramitāhṛdaya* are included among the tantras in the Tibetan Tripiṭaka. It was thus not without reason that Kūkai, the founder of Shingon Buddhism, maintained in his commentary on the *Prajñāpāramitāhṛdaya* that it is an esoteric Buddhist scripture. Why, then, was it only the *Prajñāpāramitānayasūtra* among a number of condensed versions of the *Prajñāpāramitā* that developed to such a degree in the age of esoteric Buddhism? One reason may be that it expounded the doctrine of great bliss (*mahāsukha*), which, rather than negating the desires of sentient beings, affirms them on a higher level.

The *Prajñāpāramitāsūtra* classifies all existents into the five aggregates (*skandha*), twelve sense fields (*āyatana*), and eighteen elements (*dhātu*) and repeatedly asserts that they are void and lack any intrinsic nature. If the subject of such doctrinal propositions is all dharmas, we can reduce the doctrine to a single proposition, but if we expand all dharmas to the five aggregates, the number of propositions becomes five, and if this is repeated for the twelve sense fields and eighteen elements, we get thirty-five propositions. Thus in the *Prajñāpāramitāsūtra* doctrinal propositions are arranged in groups.

While Buddhism in general deified various doctrinal categories, mantras, and *dhāraṇīs*, the *Prajñāpāramitānayasūtra* deified each of the doctrinal propositions taught in Buddhism. There was thus established in the *Prajñāpāramitānayasūtra*, for the first time, a one-to-one correspondence between doctrinal propositions and deities such that if one put into practice a certain doctrinal proposition, one could experience the meditative state of the corresponding deity, and if one visualized a maṇḍala in which the deifications of these doctrinal propositions were brought together, one could master the entirety of esoteric Buddhist thought.

In the *Prajñāpāramitānayasūtra*, doctrinal propositions are arranged in groups of four or five,[246] and so the maṇḍala deities, who are deifications of these propositions, also form groups of four or five. This is where the five-family system that was brought to completion in the Vajraśekhara cycle is thought to have originated. The fact that only the *Prajñāpāramitānayasūtra* among a number of condensed versions of the *Prajñāpāramitā* developed to such a degree in the age of esoteric Buddhism seems to have been the result of these characteristics.

3. The *Prajñāpāramitānayasūtra* and Its Eighteen Maṇḍalas

A commentary on the *Prajñāpāramitānayasūtra* translated by Amoghavajra, the *Dale jingang bukong zhenshi sanmeiye jing bore boluomiduo liqu shi* (*Liqu shijing*), which explains the relationship between the *Prajñāpāramitānayasūtra* and its maṇḍalas, divides the *Prajñāpāramitānayasūtra* into fifteen sections: (1) "Assembly of Mahāsukhāmoghavajra-Vajrasattva," (2) no title, (3) "Trailokyavijaya," (4) "Avalokiteśvara's Prajñāpāramitānaya," (5) "Ākāśagarbha," (6) "Vajramuṣṭi's Prajñāpāramitānaya," (7) "Mañjuśrī's Prajñāpāramitānaya," (8) "Sacittotpādadharmacakrapravartin's Prajñāpāramitānaya," (9) "Gaganagañja's Prajñāpāramitānaya," (10) "Sarvamārapramardin's Prajñāpāramitānaya," (11) "Trailokyavijaya's Ājñācakra," (12) "Assembly of the Outer Vajra Family," (13) "Assembly of Seven Mātṛkās," (14) "Assembly of Three Brothers," and (15) "Assembly of Four Sisters." The titles of section 2 and the final two sections are not given in the *Liqu shijing*.[247]

Here, referring to the divisions given in Kūkai's *Shinjitsukyō monku*, I have divided the *Prajñāpāramitānayasūtra* into the following eighteen sections: "Introduction," (1) "Vajrasattva," (2) "Vairocana," (3) "Trailokyavijaya," (4) "Avalokiteśvara," (5) "Ākāśagarbha," (6) "Vajramuṣṭi," (7) "Mañjuśrī," (8) "Sacittotpādadharmacakrapravartin," (9) "Gaganagañja," (10) "Mārapramardin," (11) "Trailokyavijaya's Ājñācakra," (12) "Outer Vajra Family,"[248] (13) "Seven Mātṛkās," (14) "Three Brothers," (15) "Four Sisters," (16) "Great Maṇḍala in the Four-Pāramitā Family," and (17) "Five Kinds of Secret Samādhi" (fig. 3.2).

According to the *Liqu shijing*, the total number of maṇḍalas explained in the *Prajñāpāramitānayasūtra* is eighteen, since each section explains one maṇḍala. In Japan, these eighteen maṇḍalas are called the "maṇḍalas of the eighteen assemblies of the *Prajñāpāramitānayasūtra*," and several maṇḍalas in line drawing have been transmitted. However, apart from a seed-syllable maṇḍala in the possession of Tentokuin on Mount Kōya, no colored example depicting all eighteen maṇḍalas is known.

FIG. 3.2. THE EIGHTEEN SECTIONS OF THE *PRAJÑĀPĀRAMITĀNAYASŪTRA* AND THE EIGHTEEN MAṆḌALAS

LIQU SHIJING	*SHINJITSUKYŌ MONKU*	MAṆḌALAS OF THE EIGHTEEN ASSEMBLIES
Introduction	Introduction	1. Sermon Assembly
1. Assembly of Mahāsukhāmogha-Vajrasattva	1. Vajrasattva	2. Vajrasattva
2. no title	2. Vairocana	3. Vairocana
3. Trailokyavijaya	3. Trailokyavijaya	4. Trailokyavijaya
4. Avalokiteśvara's Prajñāpāramitānaya	4. Avalokiteśvara	5. Avalokiteśvara
5. Ākāśagarbha	5. Ākāśagarbha	6. Ākāśagarbha
6. Vajramuṣṭi's Prajñāpāramitānaya	6. Vajramuṣṭi	7. Vajramuṣṭi
7. Mañjuśrī's Prajñāpāramitānaya	7. Mañjuśrī	8. Mañjuśrī
8. Sacittotpādadharmacakrapravartin's Prajñāpāramitānaya	8. Sacittotpādadharmacakrapravartin	9. Vajracakra
9. Gaganagañja's Prajñāpāramitānaya	9. Gaganagañja	10. Gaganagañja
10. Sarvamārapramardin's Prajñāpāramitānaya	10. Mārapramardin	11. Sarvamārapramardin
11. Trailokyavijaya's Ājñācakra	11. Trailokyavijaya's Ājñācakra	12. Vajrapāṇi
12. Assembly of the Outer Vajra Family	12. Outer Vajra Family	13. Maheśvara
13. Assembly of Seven Mātṛkās	13. Seven Mātṛkās	14. Seven Mātṛkās
14. Assembly of Three Brothers	14. Three Brothers	15. Three Brothers
15. Assembly of Four Sisters	15. Four Sisters	16. Four Sisters
	16. Great Maṇḍala in the Four-Pāramitā Family	17. General Assembly Maṇḍala of the Five Families
	17. Five Kinds of Secret Samādhi	18. Five Secrets

Among the eighteen maṇḍalas, the first maṇḍala, based on the "Introduction," is the Sermon Assembly maṇḍala, which will be discussed in detail in the next section. The next maṇḍala is a seventeen-deity maṇḍala based on (1) "Vajrasattva." It is regarded as the representative maṇḍala of the *Prajñāpāramitānayasūtra*, since it has been incorporated into the nine-assembly maṇḍala (Kue mandara) as the Rishu-e, and it will be discussed in detail in section 5 of this chapter. Examples of the seventeen-deity maṇḍala of Vajrasattva have survived in Shalu monastery in central Tibet and Jampa Lhakhang in Lo Manthang, Mustang.[249] However, the most common maṇḍalas of the *Prajñāpāramitānayasūtra* in Tibet are the Paramādya-Vajrasattva maṇḍala, in which many deities have been added to the seventeen-deity maṇḍala, and the Sarvakula-maṇḍala of the *Paramādyatantra*, which integrates all the maṇḍalas explained in the "Prajñākhaṇḍa" of the *Paramādyatantra*; the former will be considered in section 9 of this chapter and the latter in section 10.

According to the *Liqu shijing*, section 2 and the following sections also explain maṇḍalas. The number of the principal deities in these maṇḍalas is five, since they consist of a main deity and the doctrinal propositions of each section. However, in extant versions of the eighteen maṇḍalas of the *Prajñāpāramitānayasūtra* there have been added attendant deities found in the four corners or four gates of the seventeen-deity maṇḍala or the Vajradhātu-maṇḍala, resulting in maṇḍalas of seventeen or more deities.

The maṇḍala explained in (11) "Trailokyavijaya's Ājñācakra" is called the "general assembly maṇḍala" and integrates all the maṇḍalas explained so far. The corresponding maṇḍala explained in Tibetan materials differs greatly from that of the Sino-Japanese tradition, and it will be considered in section 10 below.

The maṇḍalas explained in sections 12–15 are centered on the Outer Vajra family (*bāhyavajrakula*), namely, Hindu deities adopted into Buddhism. The *Liqu shijing* equates the maṇḍala explained in (16) "Great Maṇḍala in the Four-Pāramitā Family" with "Vajrabodhi's yoga maṇḍala drawn in gold ink" and explained in the third assembly of the *Vajraśekharasūtra*, that is, a general assembly maṇḍala consisting of the five families.[250] Consequently, in extant versions of the eighteen maṇḍalas of the *Prajñāpāramitānayasūtra* it is depicted as a seed-syllable maṇḍala consisting of the five families. However, Tibetan materials do not interpret it as a maṇḍala consisting of the five families.[251] As was noted in section 1 above, the *Vajraśekharamahāguhyayogatantra*, found only in the Tibetan Tripiṭaka, corresponds to the third and second assemblies of the *Vajraśekharasūtra*, and it mentions the "Mantrakhaṇḍa" of the *Paramādyatantra*. It is therefore unlikely that the General Assembly maṇḍala consisting of the five families had already appeared when the *Prajñāpāramitānayasūtra* came into existence.

The final section, (17) "Five Kinds of Secret Samādhi," consists of not four but five doctrinal propositions. The *Liqu shijing* identifies them with Vajrasattva and his four attendants sitting on the same lotus seat. We cannot confirm from Tibetan materials whether this section corresponds to the so-called Five Secrets, who do, however, appear in another part of the *Paramādya* and the *Vajraśekharamahāguhyayogatantra*, both of which are definitely of Indian origin, and Amoghavajra may have referred to them.[252]

In this fashion, the doctrinal propositions of the *Prajñāpāramitānayasūtra* were deified and collectively arranged to form maṇḍalas. But a Chinese translation of the *Paramādyatantra*, which explains the maṇḍala of each section, did not exist when Amoghavajra translated the *Liqu shijing*.

As indicated above, with regard to the later sections, such as the General Assembly maṇḍala consisting of the five families, there are considerable differences between Amoghavajra's interpretation found in the *Liqu shijing* and the Chinese and Tibetan translations of the *Paramādyatantra*. But the differences between them are small in the first few sections, such as the seventeen-deity maṇḍala of Vajrasattva, and this suggests that Amoghavajra was familiar with a text similar to the present *Paramādyatantra*. As will be discussed in detail below, I think that the greater part of the present *Paramādyatantra* had already appeared when the *Sarvatathāgatatattvasaṃgraha* and Vajradhātu-maṇḍala came into existence.

4. The Sermon Assembly Maṇḍala and the Eight Great Bodhisattvas of the *Prajñāpāramitānayasūtra*

Many examples of the standard eight great bodhisattvas, which emerged in the seventh century, have been found in India. However, there is another important combination of the eight great bodhisattvas, even though its existence in India has, at present, been confirmed only in texts. This is the eight great bodhisattvas of the *Prajñāpāramitānayasūtra*.

At the start of the text, the *Prajñāpāramitānayasūtra* lists the eight bodhisattvas who assembled as the principal listeners in the heaven called Paranirmitavaśavartin, where Vairocana taught this sūtra. They are Vajrapāṇi, Avalokiteśvara, Ākāśagarbha, Vajramuṣṭi, Mañjuśrī, Sacittotpādadharmacakrapravartin, Gaganagañja, and Sarvamārapramardin. These eight bodhisattvas correspond to the initial sections of the *Prajñāpāramitānayasūtra* as follows: Vajrapāṇi = (1) "Vajrasattva," Avalokiteśvara = (4) "Avalokiteśvara," Ākāśagarbha = (5) "Ākāśagarbha," Vajramuṣṭi = (6) "Vajramuṣṭi," Mañjuśrī = (7) "Mañjuśrī," Sacittotpādadharmacakrapravartin = (8) "Sacittotpādadharmacakrapravartin," Gaganagañja = (9) "Gaganagañja," and Sarvamārapramardin = (10) "Mārapramardin." The eight great bodhisattvas of the *Prajñāpāramitānayasūtra* could be said to be deifications of these sections.

In contrast to the standard eight great bodhisattvas, no examples of these eight great bodhisattvas of the *Prajñāpāramitānayasūtra* have yet been discovered in India. However, this combination occurs not only in the *Prajñāpāramitānayasūtra* but also in a number of esoteric Buddhist scriptures of the same period. The *Sarvatathāgatatattvasaṃgraha* mentions the same eight great bodhisattvas at the start as the principal listeners of this sūtra.[253] But the Vajradhātu-maṇḍala based on the *Sarvatathāgatatattvasaṃgraha* has the sixteen great bodhisattvas as its principal members, and the eight great bodhisattvas are mentioned only at the start of the text.

The site of the exposition of the *Prajñāpāramitānayasūtra* is the Paranirmitavaśavartin Heaven, the highest heaven in the realm of desire (*kāmadhātu*). This is because the *Prajñāpāramitānayasūtra* was expounded for subjugating the demon king of the Paranirmitavaśavartin Heaven.[254] In the *Sarvatathāgatatattvasaṃgraha*, on the other hand, the site was changed from the Paranirmitavaśavartin Heaven to the Akaniṣṭha Heaven, the highest heaven in the realm of form (*rūpadhātu*). But the opening sections of both sūtras are strikingly similar,[255] and there can be no doubt that the compiler(s) of the *Sarvatathāgatatattvasaṃgraha* referred to the *Prajñāpāramitānayasūtra*.

The Sermon Assembly maṇḍala of the *Prajñāpāramitānayasūtra*, the first of the eighteen maṇḍalas of the *Prajñāpāramitānayasūtra*, is centered on Vairocana displaying the meditation mudrā, and the eight great bodhisattvas of the *Prajñāpāramitānayasūtra* are arranged

FIG. 3.3. SERMON ASSEMBLY MAṆḌALA OF THE *PRAJÑĀPĀRAMITĀNAYASŪTRA*

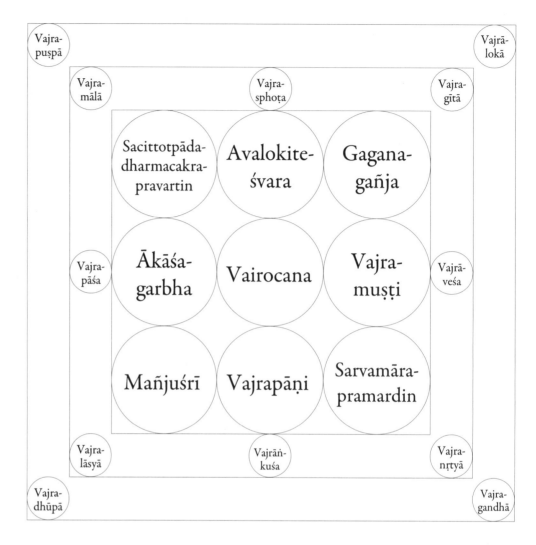

around him. They represent the bodhisattvas listening to Vairocana's exposition of the *Prajñāpāramitānayasūtra* in the Paranirmitavaśavartin Heaven. Not only is this maṇḍala included among the eighteen maṇḍalas of the *Prajñāpāramitānayasūtra*, but there have also survived colored examples, such as a painting in the possession of Daigoji temple in Japan.

A maṇḍala very similar to the Sermon Assembly maṇḍala is explained in the *Trailokyavijayamahākalparāja* (P. 115),[256] which Sakai Shinten identified as the fourth assembly of the *Vajraśekharasūtra*.[257] It does not give the names of all the eight great bodhisattvas and states only that Vajrapāṇi should be placed in front of the Buddha. However, in view of the structure of this text, the bodhisattvas are thought to be Vajrapāṇi, Avalokiteśvara, Ākāśagarbha, Vajramuṣṭi, Mañjuśrī, Vajracakra (= Sacittotpādadharmacakrapravartin), Gaganagañja, and Maitreya. These coincide with the bodhisattvas of the *Prajñāpāramitānayasūtra*, except that Mārapramardin has been replaced by Maitreya in the *Trailokyavijayamahākalparāja* (see fig. 4.23).

The Sermon Assembly maṇḍala is centered on Vairocanābhisambodhi even though the *Prajñāpāramitānayasūtra* is classified among the Yoga tantras. As has already been seen,

five examples of maṇḍalas centered on a buddha with the meditation mudrā surrounded by the eight great bodhisattvas have been found in Ellora Cave 12. The combination of Vairocanābhisambodhi and the eight great bodhisattvas was found not only in India but also in many places throughout Asia in the eighth to ninth centuries. The main deity of the Sermon Assembly maṇḍala, Vairocanābhisambodhi with the meditation mudrā, may have been influenced by these exemplars.

As mentioned in chapter 1, Vairocana corresponds to the *sambhogakāya* among the three bodies of a buddha, and he expounds the Mahāyāna teachings only to high-ranking bodhisattvas without leaving the Akaniṣṭha Heaven. The *Sarvatathāgatatattvasaṃgraha* may have been set in the Akaniṣṭha Heaven because of the influence of this doctrine in late Mahāyāna Buddhism. Therefore Vairocana surrounded by the eight great bodhisattvas may represent the Buddha's *sambhogakāya* expounding the teachings to an assembly of bodhisattvas.

At this stage, further investigation of this question is needed. However, it has become clear that a maṇḍala in which the main deity is surrounded by the eight great bodhisattvas is important for considering the genesis of the maṇḍala, and the Sermon Assembly maṇḍala had come to be regarded as a typical maṇḍala by the ninth century when late tantric Buddhism emerged.

5. The Seventeen *Viśuddhipadas* and the Seventeen-Deity Maṇḍala

As mentioned, the *Prajñāpāramitānayasūtra* is considered to explain eighteen maṇḍalas, among which the most important is the seventeen-deity maṇḍala that was incorporated into the Kue mandara as the Rishu-e. The seventeen deities in this maṇḍala are deifications of the doctrinal propositions explained in (1) "Vajrasattva" of the *Prajñāpāramitānayasūtra*.

The *Prajñāpāramitānayasūtra* explains that the defilements of sentient beings are pure (*viśuddhi*) by nature and represent nothing other than the state of a bodhisattva, and this idea is explained by means of the analogy of erotic love in the seventeen *viśuddhipadas*, or stations of purity. The visualization of the seventeen-deity maṇḍala, representing the deification of the seventeen *viśuddhipadas*, was thought to facilitate the attainment of enlightenment through the sublimation of the defilements into the mind of enlightenment (*bodhicitta*). The seventeen-deity maṇḍala of Vajrasattva became the representative maṇḍala of the *Prajñāpāramitānayasūtra*.

As will be seen in chapter 6, in late tantric Buddhism the act of purifying defiled dharmas by assigning deities to them was called *viśuddhi*. This may have been due to the influence of the seventeen *viśuddhipadas* of the *Prajñāpāramitānayasūtra*.

The *Bore liqu fen*, a primitive form of the *Prajñāpāramitānayasūtra* translated by Xuanzang, has as many as sixty-nine *viśuddhipadas*, and in several other translations in Chinese and Tibetan as well the *viśuddhipadas* do not number seventeen.[258] However, the correspondences between the seventeen *viśuddhipadas* and the seventeen deities explained in the *Liqu shijing* translated by Amoghavajra are also found in the *Paramāditīkā* by Ānandagarbha.[259] It thus seems to have been a well-established theory in India.

The *Vajramaṇḍalālaṃkāratantra*, belonging to the late Yoga tantras, has twenty *viśuddhipadas*, and in the *Vajramaṇḍalālaṃkāramahātantra-pañjikā* by Praśāntamitra the assignment of the *viśuddhipadas* to deities is explained quite differently from the way in which it is explained by Amoghavajra and Ānandagarbha.[260] This seems to be due to the fact that the

Vajramaṇḍālaṃkāratantra does not describe the seventeen-deity maṇḍala. That is to say, the process whereby the *viśuddhipadas* of the *Prajñāpāramitānayasūtra* were consolidated into seventeen went on in tandem with the compilation of ritual manuals based on the seventeen-deity maṇḍala, and a sequence of *viśuddhipadas* consistent with the seventeen-deity maṇḍala was adopted in developed forms of the *Prajñāpāramitānayasūtra* such as Amoghavajra's translation and the Tibetan translation of the *Paramādyatantra*. But in other versions in which the seventeen-deity maṇḍala is not explained, such as the *Vajramaṇḍālaṃkāratantra*, different sequences of the *viśuddhipadas* are thought to have been preserved.

The deities of the seventeen-deity maṇḍala are called by different names depending on the textual source. Here I have used the most popular names (for details, see fig. 3.4). According to the *Paramādyatantra* and the traditions of Japanese esoteric Buddhism, the gender of the seventeen deities was originally as follows: Vajrasattva and his four attendants (Vajramanodbhava, Vajrakīlikīla, Vajranismara, and Vajragarva) are male, the four offerings and four seasons are female, and the four gatekeepers are male. This way of arranging male deities in the four cardinal directions and female deities in the four intermediate directions was taken over by the Guhyasamāja-maṇḍala. However, in the developed form of the *Prajñāpāramitā-nayasūtra*, the four attendants and four gatekeepers became female, and this developed into the maṇḍala of the *Samāyogatantra*, the forerunner of the Mother tantras, in which all the deities except the main deity are female (see chapter 6).

Not only is the seventeen-deity maṇḍala included among the eighteen maṇḍalas of the *Prajñāpāramitānayasūtra*, but there have also survived colored examples such as a painting in the possession of Daikakuji temple.[261] But the best-known example is the Rishu-e in the nine-assembly Vajradhātu-maṇḍala.

The Aizen mandara (Rāgarāja-maṇḍala), a Japanese *besson mandara*, is identical to the seventeen-deity maṇḍala, except that the main deity has been changed from Vajrasattva to Rāgarāja. Sakai Shinten pointed out that it is based on the fourth assembly of the *Vajraśekharasūtra*, the *Trailokyavijayamahākalparāja*, which was not transmitted to Japan.[262] Only the Tibetan translation has survived, but since the *Trailokyavijayamahākalparāja* is a comparatively early text among the *Vajraśekhara* or Yoga tantras, Sakai's conjecture is not entirely unwarranted.

Next, let us consider the correspondences between the seventeen *viśuddhipadas* and the seventeen-deity maṇḍala. The first of the *viśuddhipadas*, pleasure (*surata*), corresponds to the main deity, Vajrasattva. Next, (2) desire (*kāma*), (3) touch (*sparśa*), (4) embrace (*bandhana*), and (5) sovereignty (*sarvaiśvarya*) correspond to Vajramanodbhava, Vajrakīlikīla, Vajranismara, and Vajragarva, respectively, arranged in the four cardinal directions around the main deity. Their iconography is as follows: Vajramanodbhava, symbolizing desire, holds an arrow, the symbol of the god of love; Vajrakīlikīla, symbolizing touch, embraces a vajra; Vajranismara, symbolizing embrace, holds a banner attached to a pole topped by a sea-monster (*makara*), the emblem of the god of love; and Vajragarva, symbolizing sovereignty, forms the gesture of adamantine pride (*vajragarva-mudrā*) with both hands. Thus their iconography tallies with the corresponding doctrinal propositions.

The next four *viśuddhipadas*, (6) looking (*dṛṣṭi*), (7) delight (*rati*), (8) craving (*tṛṣṇā*), and (9) pride (*garva*), correspond to the four goddesses—Lāsyā (*Manodbhavā*), Hāsyā (*Rativajrā*), Gītā (*Tṛṣṇā*), and Nṛtyā (*Vajragarvā*)—arranged in the four corners of the

outer square. Iconographically, they correspond to the four inner offering goddesses of the Vajradhātu-maṇḍala, although Hāsyā does not coincide with Vajramālā of the Vajradhātu-maṇḍala.

The next four *viśuddhipadas*, (10) ornament (*bhūṣaṇa*), (11) refreshing (*āhlādana*), (12) light (*āloka*), and (13) physical happiness (*kāyasukha*), correspond to the four goddesses of the four seasons, that is, *Madhuvajrī, *Vajrameghā, *Śāradavajrā, and *Hemantavajrā, arranged in the four corners of the inner square. *Madhuvajrī, the deification of ornament, corresponds to Puṣpā, who holds a garland in the Vajradhātu-maṇḍala. Vajrameghā, the deification of refreshing, corresponds to Dhūpā in the Vajradhātu-maṇḍala, since *āhlādana* means the act of refreshing, in this case by smelling incense. In the same way, *Śāradavajrā (= light) corresponds to Ālokā, who holds a lamp, and *Hemantavajrā (= physical happiness) corresponds to Gandhā, who holds a vessel for unguent to be applied to the body. These goddesses of the four seasons correspond to the four outer offering goddesses of the Vajradhātu-maṇḍala, but the ordering of Puṣpā, Dhūpā, Ālokā, and Gandhā, which tallies with the sequence of the *viśuddhipadas*, has been changed to Dhūpā, Puṣpā, Ālokā, and Gandhā in the Vajradhātu-maṇḍala.[263]

FIG. 3.4. THE SEVENTEEN *VIŚUDDHIPADAS* AND THE SEVENTEEN-DEITY MAṆḌALA

17 *VIŚUDDHIPADAS*		17-DEITY MAṆḌALA	RISHU-E
1. *surata*	Five Secrets	Vajrasattva	Vajrasattva
2. *kāma (dhenu)*		Vajramanodbhava	Vajramanodbhava
3. *sparśa*		Vajrakīlikīla	Vajrakīlikīla
4. *bandhana*		Vajranismara	Vajranismara
5. *sarvaiśvarya*		Vajragarva	Vajragarva
6. *dṛṣṭi*	Four Offering Goddesses	Lāsyā	Vajralāsyā
7. *rati*		Hāsyā	Vajramālā
8. *tṛṣṇā*		Gītā	Vajragītā
9. *garva*		Nṛtyā	Vajranṛtyā
10. *bhūṣaṇa*	Goddesses of Four Seasons	Madhuvajrī	Vajrapuṣpā
11. *āhlādana*		Vajrameghā	Vajradhūpā
12. *āloka*		Śāradavajrī	Vajrālokā
13. *kāyasukha*		Hemantavajrī	Vajragandhā
14. *rūpa*	Four Gatekeepers	Rūpavajra	Vajrāṅkuśa
15. *śabda*		Śabdavajra	Vajrapāśa
16. *gandha*		Gandhavajra	Vajrasphoṭa
17. *rasa*		Rasavajra	Vajrāveśa

As regards the sequence of the seventeen *viśuddhipadas*, the four offering goddesses—deifications of the four *viśuddhipadas* (6) *dṛṣṭi*, (7) *rati*, (8) *tṛṣṇā*, and (9) *garva*—ought to be arranged in the four inner corners, while the goddesses of the four seasons—deifications of the four *viśuddhipadas* (10) *bhūṣaṇa*, (11) *āhlādana*, (12) *āloka*, and (13) *kāyasukha*—ought to be arranged in the four outer corners, but in the seventeen-deity maṇḍala the goddesses of the four seasons are depicted in the inner square. This is because in the textual source, the "*Mahāsamayatattvavajra" of the *Paramādyatantra*, it is stated that "four deities holding flowers and so on [should be depicted] in the buddha's four corners."[264]

Lastly, (14) purity of form (*rūpaviśuddhi*), (15) purity of sound (*śabdaviśuddhi*), (16) purity of smell (*gandhaviśuddhi*), and (17) purity of taste (*rasaviśuddhi*) correspond to the four bodhisattvas arranged in the four gates of the outer maṇḍala, namely, Rūpavajra, Śabdavajra, Gandhavajra, and Rasavajra. Iconographically, they correspond to the four gatekeepers of the Vajradhātu-maṇḍala, that is, Vajrāṅkuśa, Vajrapāśa, Vajrasphoṭa, and Vajrāveśa, respectively (fig. 3.5).

The seventeen-deity maṇḍala, representing the deification of the seventeen *viśuddhipadas*, corresponds to the great maṇḍala described in the "*Mahāsamayatattvavajra,"[265]

FIG. 3.5. SEVENTEEN-DEITY MAṆḌALA OF VAJRASATTVA
(JAMPA LHAKHANG)

FIG. 3.6. SEVENTEEN-DEITY MAṆḌALA OF VAJRASATTVA

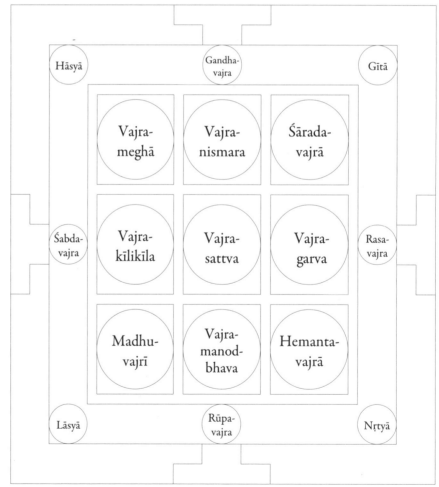

which explains seventeen *viśuddhipadas* (twenty in the Chinese translation). However, it is almost impossible to create the great maṇḍala solely on the basis of the description in the *Paramādyatantra* since it is unclear.

In the Tibetan translation of the "Prajñākhaṇḍa," the main deity of this maṇḍala is called Buddha, while in both the Tibetan and Chinese translations the deity in front of the main deity is called Vajrasattva.[266] But in commentaries and ritual manuals this wording has been corrected, and the main deity has been interpreted as Vajrasattva and the deity in front of the main deity as Manodbhava. Furthermore, the aforementioned transposing of the four inner offering goddesses and the goddesses of the four seasons also originated in discrepancies between the "*Mahāsamayatattvavajra*" and the order of the seventeen *viśuddhipadas*.

Therefore I have doubts about whether the seventeen-deity maṇḍala, representing the deification of the seventeen *viśuddhipadas*, and the Paramādya-Vajrasattva maṇḍala (to be mentioned below) existed when the "Prajñākhaṇḍa" was composed. The aforementioned structure of the seventeen-deity maṇḍala coincides not with the "*Mahāsamayatattvavajra*" but with the "*Paramarahasyamaṇḍala*" at the start of the "Mantrakhaṇḍa" (in the Chinese translation). It is to be surmised therefore that the seventeen-deity maṇḍala, the deification of the seventeen *viśuddhipadas*, came into existence not with the "Prajñākhaṇḍa" but with the "Mantrakhaṇḍa" of the *Paramādyatantra*.

As we have seen, various doctrinal categories were assigned to the deities depicted in maṇḍalas. The maṇḍala is not merely an assembly of deities and doctrinal categories are assigned to its constituent parts. This makes it possible to symbolize Buddhist ideas and cosmology by means of an icon. But a maṇḍala in which the deities and doctrinal propositions corresponded one-to-one had not previously existed, and as has been seen in this section, the iconography of the deities was devised so as to suit the corresponding doctrinal propositions.

Moreover, clear correspondences between deities and doctrinal propositions can also be seen in maṇḍalas other than the Sermon Assembly maṇḍala and seventeen-deity maṇḍala in the *Prajñāpāramitānayasūtra*. But it took some time for such one-to-one correspondences to be established, and they did not exist when the *Prajñāpāramitānayasūtra* first came into existence. The close correspondences between doctrinal propositions, deities, and their iconography would be established in the *Paramādyatantra*, especially its latter part, the "Mantrakhaṇḍa."

Thus the seventeen-deity maṇḍala of the *Prajñāpāramitānayasūtra* evolved through a process of trial and error. But it is worth noting that this sūtra closely combined the doctrines of esoteric Buddhism and the maṇḍala for the first time, a characteristic that was inherited by the subsequent Vajradhātu-maṇḍala.

6. Vajrasattva and the Four Inner Offering Goddesses

Vajrapāṇi was originally a protective deity who guarded a buddha, but in the *Prajñā-pāramitānayasūtra* he merged with Samantabhadra, who represented the ideal of the bodhisattva in Mahāyāna Buddhism, and became Samantabhadra-Vajrasattva. In connection with the merging of Samantabhadra and Vajrapāṇi, it is worth noting that the *Vajrapāṇyabhiṣeka-tantra* states that after Samantabhadra was conferred a vajra, he was called Vajrapāṇi.[267] In

the *Vairocanābhisambodhisūtra*, however, Vajrapāṇi and Samantabhadra are separate figures: Vajrapāṇi is the leader of the inner attendants of Vairocana, while Samantabhadra is the leader of the greater, or outer, attendants.

The merging of Samantabhadra and Vajrapāṇi is one of the characteristics of the Vajraśekhara cycle, starting with the *Prajñāpāramitānayasūtra*. Consequently, whereas Samantabhadra and Vajrapāṇi are separate figures in the standard eight great bodhisattvas, closely related to the Vairocanābhisambodhi cycle, Samantabhadra is not included among the eight great bodhisattvas of the *Prajñāpāramitānayasūtra* because he has been identified with Vajrapāṇi.

Samantabhadra-Vajrasattva, representing the merging of Samantabhadra and Vajrapāṇi, went on to develop into the principal deity of esoteric Buddhism. Images of Vajrasattva were produced throughout the Pāla dynasty and many examples have survived. Independent images of Samantabhadra, on the other hand, have not been found in India even though he was one of the most important bodhisattvas from the time of early Mahāyāna Buddhism. He does, however, appear as a member of the standard eight great bodhisattvas. After the eight century, the cult of Samantabhadra is thought to have been absorbed into that of Samantabhadra-Vajrasattva.

The standard iconography of Vajrasattva is to hold a vajra in his right hand in front of his chest, while with his left hand he forms the gesture of adamantine pride, with the elbow squared, and holds a vajra-topped bell. According to the *Prajñāpāramitānayasūtra*, Vajrasattva holds a vajra in his right hand and forms the gesture of adamantine pride with his left hand,[268] and there is no mention of a vajra-bell in his left hand. It has been suggested that the Vajrasattva figure holding a vajra and a vajra-bell belongs to the *Paramādyatantra*, whereas the gesture of adamantine pride without a vajra-bell in his left hand is characteristic of the *Sarvatathāgatatattvasaṃgraha*.[269]

The above iconographical description of Vajrasattva in the *Prajñāpāramitānayasūtra* occurs in a newly published Sanskrit manuscript, in the Chinese translation by Amoghavajra, and in the Tibetan translation. But because it is not found in Chinese translations pre-dating Amoghavajra, it is questionable whether this iconography existed when the *Prajñāpāramitā-nayasūtra* was originally compiled. However, the aforementioned "*Mahāsamayatattvavajra*" and "*Paramarahasyamaṇḍala*" of the *Paramādyatantra* state only that Vajrasattva holds a vajra, and there is no mention of a vajra-bell in his left hand.[270] It is the commentaries and ritual manuals that prescribe the iconography of a figure holding a vajra and a vajra-bell. Therefore we cannot ascribe this iconography to the *Paramādyatantra*. Based on textual evidence, I believe that when the *Prajñāpāramitānayasūtra* was first composed, Vajrasattva formed the gesture of adamantine pride with his left hand and the vajra-bell was a later addition.[271]

According to the *Sarvatathāgatatattvasaṃgraha* (§§34–189), all the deities of the Vajradhātu-maṇḍala, except the five buddhas, are emanations of Vajrasattva. Among the thirty-two bodhisattvas the first is Vajrasattva and the last is Vajrāveśa, and according to the *Sarvatathāgatatattvasaṃgraha* the attribute of Vajrasattva is a vajra while the symbol of Vajrāveśa is a vajra-bell. The current iconography of Vajrasattva holding a vajra and a vajra-bell in each hand would seem to symbolize the fact that he is not only the first bodhisattva but also the primordial bodhisattva among all the bodhisattvas in the Vajradhātu-maṇḍala.

As will be seen in chapter 4, Rasavajra, the final deity of the seventeen-deity maṇḍala of the *Prajñāpāramitānayasūtra*, who resides in the northern gate, corresponds to Vajrāveśa

in the Vajradhātu-maṇḍala. However, the four gatekeepers Rūpa, Śabda, Gandha, and Rasa were replaced by Aṅkuśa, Pāśa, Sphoṭa, and Āveśa only in the "Mantrakhaṇḍa" of the *Paramādyatantra*. This, too, suggests that the *Prajñāpāramitānayasūtra* pre-dates the *Sarvatathāgatatattvasaṃgraha*.

The iconography of Vajrasattva holding a vajra and a vajra-bell is common in images of this bodhisattva produced during the Pāla dynasty, but earlier examples from before the ninth century had not been identified until recently when a wooden standing statue was identified at Ropa temple in Kinnaur, India (fig. 3.7). This figure forms a pair of gatekeepers together with Avalokiteśvara (Vajradharma). As in Japanese examples, the vajra is held in front of the chest, unlike examples from the Pāla dynasty, in which the vajra is balanced on the tip of the middle finger. Some scholars have dated this wooden statue to after the tenth century, but it has been dated to as early as the eighth century.[272]

A seated image discovered at Sarnath (now in the Archaeological Museum at Sarnath) is well known as a comparatively early example of Vajrasattva, but it is thought to postdate the ninth century, since the vajra is balanced on the tip of the middle finger. This iconographical feature first appears in the works of Ānandagarbha, composed some time during the first half of the ninth century.[273] The Vajrasattva image from Ropa is an important find that suggests that the iconography of Vajrasattva prevalent in Japan originated in eighth-century India.

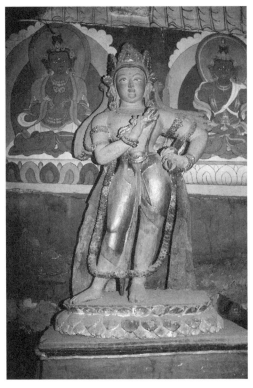

Several images of Vajrasattva dating from the Pāla period are accompanied by four attendants. Among these images, a seated statue of Vajrasattva (fig. 3.8) is significant because the four inner offering goddesses of the Vajradhātu-maṇḍala have been placed in the four corners of the halo and the throne.[274] A small statue with the four inner offering goddesses in the four corners has also been unearthed at Nālandā, India.[275]

Meanwhile, a painted maṇḍala depicting the Vajrasattva pentad (Musée Guimet, EO 1167) was discovered in the Mogao Caves at Dunhuang. As in Japanese examples, the central figure of Vajrasattva holds a vajra in reverse grip in front of his chest.[276] In this example, too, the four inner offering goddesses are arranged around Vajrasattva in the four corners.

From a stylistic point of view, the examples of Vajrasattva and his attendants from Bihar and Nālandā are thought to date from the tenth century, whereas the Guimet example is dated to as early as the ninth century. It would not be surprising if a pentad exhibiting such iconography had existed in eighth-century India, since time would have been required for the iconography to be transmitted from India to Dunhuang.

In addition, a maṇḍala centered on Vajrasattva accompanied by the four inner offering goddesses in the four cardinal directions is depicted on the northern wall of the second story of the three-storied chapel at Alchi monastery, Ladakh, India (fig. 3.9).

The figure of Vajradhātu-Vairocana from Udayagiri (to be discussed in chapter 4) is accompanied by the four outer offering goddesses of the Vajradhātu-maṇḍala. The reason that Vajrasattva is instead attended by the four inner offering goddesses is that the *Sarvatathāgatatattvasaṃgraha* calls Vajralāsyā, the first of the four inner offering goddesses, the "consort of Vajrasattva" (Vajrasattvadayitā).[277] By a strange coincidence, the fact that the figure of Vajradhātu-Vairocana is attended by the four outer offering goddesses and Vajrasattva is attended by the four inner offering goddesses is consistent with the transposing of the inner and outer offering goddesses in the Vajradhātu-maṇḍala and the seventeen-deity maṇḍala of the *Prajñāpāramitānayasūtra*. However, there is no guarantee that this will also apply to examples that may be discovered in the future.

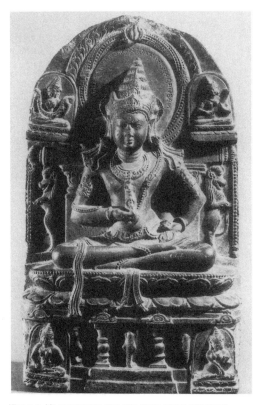

Fig. 3.9. Vajrasattva-maṇḍala at Alchi monastery (Ladakh, India)

Many images of Vajrasattva, the principal deity of the *Prajñāpāramitānayasūtra*, have been discovered in India and neighboring countries, and their number exceeds images depicting Vairocanābhisambodhi discussed in chapter 2 and images displaying the iconography of Vajradhātu-Vairocana to be discussed in the next chapter. In time, Vajrasattva acquired the position of the primordial buddha who ranks above the five buddhas of the Vajradhātu-maṇḍala. To date, examples of the iconography of the Five Secrets and the seventeen-deity maṇḍala that are directly related to the *Prajñāpāramitānayasūtra* have not been discovered in India. Nevertheless the above-mentioned images discovered in India and neighboring countries suggest that the *Prajñāpāramitānayasūtra* played an important role in the history of Indian esoteric Buddhism.

7. The *Paramādyatantra* and Its Maṇḍalas

As discussed, the doctrinal propositions expounded in the *Prajñāpāramitānayasūtra* were deified in esoteric Buddhism and these deified propositions became the figures in its maṇḍalas. Eventually a voluminous esoteric Buddhist scripture called the *Paramādyatantra* appeared. This text was translated into Chinese during the Northern Song dynasty by Faxian under the title *Zuishang genben dale jingang bukong sanmei dajiaowang jing*. In Tibet, the "Prajñākhaṇḍa," or "Wisdom Section," was translated as the *Śrīparamādya nāma mahāyānakalparāja*, while the "Mantrakhaṇḍa," or "Mantra Section," was translated

as the *Śrīparamādyamantrakalpakhaṇḍa nāma*, both of which are classified among the Yoga tantras along with the *Sarvatathāgatatattvasaṃgraha*.[278] The extant "Prajñākhaṇḍa" was translated by Rinchen Sangpo (958–1055) and the "Mantrakhaṇḍa" by Lhatsenpo Shiwa Ö, an ordained brother of King Lhatsunpa Jangchup Ö of western Tibet, who lived in the first half of the eleventh century. Thus both parts were translated in the eleventh century. The Nyingma school of Tibetan Buddhism classifies them among the eighteen tantras of the Mahāyoga cycle (see chapter 4), although the existence of an old translation during the time of the Tufan kingdom has not been confirmed yet.

The Chinese translation of the *Paramādyatantra* was transmitted to Japan during the Heian period. Although most of the texts translated during the Song dynasty were disregarded in Japan, this particular translation was studied by scholar-priests of the Shingon sect because it was thought to be an enlarged version of the *Prajñāpāramitānayasūtra*, a text recited daily in the Shingon sect, and also to correspond to the sixth assembly of the *Vajraśekhara*.

In modern times, Toganoo Shōun published a study of the *Prajñāpāramitānayasūtra* in 1930 and began comparative research using both Chinese and Tibetan materials. Sakai Shinten, meanwhile, argued that it was only the first half of the *Paramādya* ("Prajñākhaṇḍa") that corresponded to the sixth assembly of the *Vajraśekhara* and that the second half ("Mantrakhaṇḍa") corresponded to the eighth assembly.[279] Toganoo had already pointed out that the original Sanskrit title of the Chinese translation could be restored as *Paramādyamahā-sukhavajrāmoghasamaya*.[280] *Paramādya* corresponds to the title of the eighth assembly, *Shengchu*, while *mahāsukhavajrāmoghasamaya* derives from the title of the sixth assembly, *Da anle bukong sanmeiye zhenshi*. Thus the title *Paramādya* originally came from the eighth assembly of the *Vajraśekhara*, which roughly corresponds to the "Mantrakhaṇḍa," but in Tibet the "Prajñākhaṇḍa" and "Mantrakhaṇḍa" are both referred to as the *Paramādya*.

The *Caryāmelāpakapradīpa* of the Ārya school of the *Guhyasamājatantra* quotes the *viśuddhipadas* from the opening section of the "Prajñākhaṇḍa" as coming from the *Paramādyamahāyogatantra*.[281] This suggests that both the "Prajñākhaṇḍa" and "Mantrakhaṇḍa" were referred to as the *Paramādya* as early as the second half of the eighth century.

Using Indo-Tibetan materials, other Japanese scholars such as Nagasawa Jitsudō, Kanaoka Shūyū, and Matsunaga Yūkei have debated the origins of the *Prajñāpāramitānayasūtra* and *Paramādyatantra*. However, the most eminent scholar in this field is Fukuda Ryōsei, who has not only conducted a detailed comparison of the Chinese and Tibetan translations of the *Paramādyatantra* but has also attempted to gain a grasp of the overall structure of the *Paramādya* by referring to Ānandagarbha's *Paramādivṛtti* and *Paramāditīkā* as well as works composed by Tibetans.[282] As a result of his investigations, it has become clear that there are major differences in content between the Chinese and Tibetan translations of the *Paramādyatantra*. Fukuda has also found that, whereas the two commentaries by Ānandagarbha divide the text into four parts, from the first section to the fourth section, this division does not coincide with the current Tibetan and Chinese translations.

Fukuda has also taken note of differences in the chapter titles of the *Paramādyatantra*. That is to say, in the "Prajñākhaṇḍa" each chapter is said to have been taken "from the great ritual manual named *Mahāsukhavajrāmoghasamaya*." But in the first half of the "Mantrakhaṇḍa" this changes to "from the great ritual manual named *Mahāsukhaguhyavajra*," and then in the second half it changes to "from the great ritual manual named *Śrīparamādya*."

Fig. 3.10. The structure of the *Paramādyatantra*

Tibetan translation (Peking edition, vol. 5)			Chinese translation (Taishō edition, vol. 8)	
"Prajñākhaṇḍa" (P. 119), part 1	1	123-4-7~126-3-6	1	786c–789b
	2	126-3-6~127-1-6	2	789b–790a
	3	127-1-6~128-2-7	3	790b–791c
	4	128-2-7~129-1-1	4	791c–792b
	5	129-1-1~3-5	5	792b–792c
	6	129-3-5~130-2-5	6	792c–793c
	7	130-2-5~4-5	7	793c–794b
	8	130-4-5~131-1-4	8	794b–794c
	9	131-1-4~3-5	9	794c–795a
	10	131-3-5~5-8	10	795a–795c
	11	131-5-8~132-2-2	11	795c–796a
	12	132-2-2~133-2-4	12	796a–797a
	13	133-2-4~3-6	13	797b
	14	133-3-6~5-4	14	797b–797c
"Mantrakhaṇḍa" (P. 120): "Mahāsukhaguhyavajra" — *Mūlatantra*	15	133-5-4~137-1-5		
	16	137-1-5~3-5		
	17	137-3-5~5-5		
	18	137-5-5~138-1-8		
	19	138-2-1~3-5		
	20	138-3-5~138-4-6		
	21	138-4-6~139-2-5		
	22	139-2-5~143-3-2		
Uttaratantra		143-3-2~144-2-7		
	23	144-2-8~3-8		
	24	144-4-1~145-4-6		
	25	145-4-6~146-1-1		

Tibetan translation (Peking edition, vol. 5)				Chinese translation (Taishō edition, vol. 8)	
"Mantrakhaṇḍa" (P. 120): "Śrīparamādya"	Mūlatantra	26	146-1-1~148-3-3	14	797c–802a
		27	148-3-3~150-1-1	15	802a–804a
		28	150-1-2~151-1-1	16	804a–805b
		29	151-1-1~152-3-8	17	805b–807c
		30	152-3-8~153-2-7	18	807c–809a
		31	153-2-7~154-1-3	19	809a–810a
		32	154-1-3~155-2-8	20	810a–811b
		33	155-2-8~157-1-7	21	811b–814a
		34	157-1-7~159-4-4	22	814b–817a
		35	159-4-4~159-5-8	23	817a–819b
		36	159-5-8~165-5-5	24	819c–821c
		37	165-5-5~171-1-3	25	821c–824a
		38	171-1-3~3-2		
	Uttaratantra	39	171-3-2~173-1-8	(Uttaratantra)	

Thus Fukuda demonstrated that the Tibetan translation of the *Paramādyatantra* consists of three parts, each deriving from a different source.[283] The Chinese translation, on the other hand, lacks the part corresponding to the "*Mahāsukhaguhyavajra*."[284] Consequently, in the Chinese translation the "Mahāsukhavajrāmoghasamaya," corresponding to the "Prajñākhaṇḍa," connects directly with the "Śrīparamādya," corresponding to the second half of the "Mantrakhaṇḍa" in the Tibetan translation (fig. 3.10).

The first discussion of Tibetan representations of the maṇḍalas explained in the *Paramādyatantra* was probably my treatment of the Vajrasattva-maṇḍala (see section 9 below) in an earlier publication.[285] However, it is very difficult to study the maṇḍalas of the *Paramādyatantra* because of the limited number of extant examples in Tibet apart from the Vajrasattva-maṇḍala and *Kulasaṃgraha-maṇḍala. But since then examples of the maṇḍalas of the *Paramādyatantra* have been identified at Jampa Lhakhang in Lo Manthang, Mustang, Nepal, and at Shalu monastery in central Tibet. Kawasaki Kazuhiro has published comparative studies of these extant examples and their textual sources, the *Paramādyatantra* and Ānandagarbha's two commentaries.[286]

Ānandagarbha lists the numbers and names of the maṇḍalas explained in what he calls parts 1–4 of the *Paramādyatantra*, but there exist several differences of interpretation between his *Paramādivṛtti* and *Paramādiṭīkā* (figs. 3.11 and 3.12).[287] According to the former, part 1 explains fifteen maṇḍalas: (1) Vajra, (2) Tathāgata, (3) Trailokyavijaya, (4) Avalokiteśvara, (5) Ākāśagarbha, (6) Vajramuṣṭi, (7) Mañjuśrī, (8) Vajracakra, (9) Gaganagañja, (10) Vajrayakṣa,

(11) Assembly, (12) Śiva, (13) Mātṛkā, (14) Three Brothers, and (15) Four Sisters.[288] There can be no doubt that part 1 corresponds to the "Prajñākhaṇḍa" of the *Paramādyatantra*, since these fifteen maṇḍalas coincide with the fifteen maṇḍalas explained in the "Prajñākhaṇḍa."

According to the *Paramādiṭīkā*, on the other hand, part 2 consists of a *mūlatantra* and an *uttaratantra*. The *mūlatantra* explains ten maṇḍalas: (1) Vajrasattva, (2) Tathāgata, (3) *Krodhasuratavajra, (4) Avalokiteśvara, (5) Maṇiratnakula = Ākāśagarbha, (6) Assembly, (7) Three Brothers, (8) Four Sisters, (9) Asura, and (10) Nāga.[289] These ten maṇḍalas correspond to the ten maṇḍalas explained in chapters 15–20, which correspond to the "*Mahāsukhaguhyavajra." At the end of chapter 21 there is a colophon reading, "Ritual manual of ten maṇḍalas from the *mūlatantra* of part 2,"[290] and at the end of the next chapter there is another colophon, reading, "[Here] ends part 2, the *mūlatantra* of the 'Mantrakhaṇḍa.'"[291] Thus there can be no doubt that the first half of the "Mantrakhaṇḍa" corresponds to part 2 of Ānandagarbha's commentaries.

Opinions differ, however, regarding the second half of the "Mantrakhaṇḍa." According to Ānandagarbha, part 3 explains nine maṇḍalas: (1) Mahāsukhamahāvajra, (2) Sarvatathāgata, (3) Vajrajvālānalārka, (4) Avalokiteśvara, (5) Ākāśagarbha, (6) Three Brothers, (7) Four Sisters, (8) Nāga and emancipation from afflictions, and (9) Assembly. The order of the maṇḍalas is, on the whole, the same as in part 2. However, in part 3 the maṇḍalas of the Outer Vajra family—(6) Three Brothers and (7) Four Sisters—are explained not after but before the Assembly maṇḍala. This order coincides with that of the maṇḍalas explained in the section of the Chinese translation corresponding to the second half of the "Mantrakhaṇḍa," namely, the original *Paramādya*. Therefore I identified part 3 in Ānandagarbha's commentaries with the second half of the "Mantrakhaṇḍa" of the *Paramādyatantra*, namely, the original *Paramādya*.[292]

Kawasaki, on the other hand, argues that the "Śrīparamādya" corresponds not to part 3 of Ānandagarbha's commentaries but to the *uttaratantra* of part 2 and that parts 3 and 4 do not exist in the present Tibetan text.[293] Butön, too, examined the *Paramādyatantra*,[294] and his interpretation more or less coincides with that of Kawasaki. Furthermore, there have been inserted into the current Tibetan translation notes on the structure of the *Paramādyatantra* that coincide with Butön's synopsis.

However, the "*Mahāsukhaguhyavajra" has its own *uttaratantra*. If we regard the "Śrīparamādya" as the *uttaratantra* of part 2, that is, the "*Mahāsukhaguhyavajra," we end up with two *uttaratantra*s (see fig. 3.10). It is difficult to determine whether the "Śrīparamādya" corresponds to the *uttaratantra* of part 2 or to part 3, since the arrangement of the maṇḍalas in both is, according to Ānandagarbha, almost the same. The only difference between the *uttaratantra* of part 2 and part 3 is that, after the explanation of the above nine maṇḍalas, the former explains the *paṭas* of Trisamaya, Vajrajvālānalārka, Avalokiteśvara, Ākāśagarbha, and Secrets. In the latter half of the "Śrīparamādya," ritual instructions for *paṭas* are also given, but their order is different: Five Secrets, Trisamaya, Vajrajvālānalārka, Avalokiteśvara, and Ākāśagarbha. Furthermore, these ritual instructions do not form a continuous series, since chapter 22 of the Chinese translation, corresponding to chapter 34 of the Tibetan translation, has been inserted between the Five Secrets and Trisamaya.

In addition, we cannot find in the current Chinese and Tibetan versions of the *Paramādyatantra* any part that would correspond to Ānandagarbha's part 4. This caused Kawasaki to doubt the very existence of Ānandagarbha's part 4.[295] At any rate, it has become clear

that there are considerable differences between the text consulted by Ānandagarbha and the current Chinese and Tibetan versions of the *Paramādyatantra*.

Up until now scholars had considered the "Prajñākhaṇḍa" and "Mantrakhaṇḍa" of the *Paramādyatantra* to be the *mūlatantra* (root tantra) and *uttaratantra*, respectively. But it has become clear that the *Paramādyatantra* combines several tantras that were circulating separately and that its component parts, the "*Mahāsukhaguhyavajra" and "Śrīparamādya," each consist of a *mūlatantra* and *uttaratantra*.

FIG. 3.11. MAṆḌALAS EXPLAINED IN THE *PARAMĀDYATANTRA*

	MAṆḌALA	TIBETAN TRANSLATION (PEKING EDITION)		CHINESE TRANSLATION (TAISHŌ EDITION, VOL. 8)	
"Prajñākhaṇḍa" (P. 119)	1. Maṇḍala of Vajrasattva	1	124-3-5~124-5-1	1	787a–787b
	2. Maṇḍala of Vairocana	2	126-3-6~127-1-6	2	789c
	3. Maṇḍala of Trailokyavijaya	3	127-1-6~128-2-7	3	790c–791a
	4. Maṇḍala of Avalokiteśvara	4	128-2-7~129-1-1	4	791c–792a
	5. Maṇḍala of Ākāśagarbha	5	129-1-1~3-5	5	792b–792c
	6. Maṇḍala of Vajramuṣṭi	6	129-3-5~130-2-5	6	793a
	7. Maṇḍala of Mañjuśrī	7	130-2-5~4-5	7	794a
	8. Maṇḍala of Vajracakra	8	130-4-5~131-1-4	8	794b–794c
	9. Maṇḍala of Gaganagañja	9	131-1-4~3-5	9	795a
	10. Maṇḍala of Vajrayakṣa	10	131-3-5~5-8	10	795b
	11. Assembly maṇḍala	11	131-5-8~132-2-2	11	796a
	12. Maṇḍala of Śiva	12	132-2-2~3-5	12	796a–796b
	13. Maṇḍala of Eight Mātṛkās		132-3-5~5-2		796b
	14. Maṇḍala of Three Brothers		132-5-2~133-1-5		796c
	15. Maṇḍala of Four Sisters		133-1-5~133-2-4		797a
"Mantrakhaṇḍa" (P. 120): "Mahāsukhaguhyavajra"	1. Maṇḍala of Vajrasattva	15	134-1-8~4-6		
	2. Maṇḍala of Tathāgata	16	137-1-5~3-5		
	3. Maṇḍala of *Krodhasuratavajra	17	137-3-5~5-5		
	4. Maṇḍala of Avalokiteśvara	18	137-5-5~138-1-8		
	5. Maṇḍala of Ākāśagarbha	19	138-2-1~3-5		
	6. Assembly maṇḍala	20	138-3-5~4-6		
	7. Maṇḍala of Three Brothers	21	138-4-6~5-5		
	8. Maṇḍala of Four Sisters		138-5-5~139-1-4		
	9. Maṇḍala of Asura		139-1-4~1-7		
	10. Maṇḍala of Nāga		139-1-7~2-5		
	11. Maṇḍala of Secret Vajrasattva	22	139-2-5~4-4		

Chart continues on next page

	Maṇḍala	Tibetan translation (Peking edition)		Chinese translation (Taishō edition, vol. 8)	
"Mantrakhaṇḍa" (P. 120): "Śrīparamādya"	1. Maṇḍala of Vajrasattva	26	146-3-5~147-1-7	14	798b–799c
	2. Maṇḍala of Tathāgata	28	150-1-2~3-1	16	804a–804c
	3. Maṇḍala of Vajrajvālānala	29	151-3-5~4-8	17	806b–806c
	4. Maṇḍala of Lokeśvara	30	152-3-8~5-8	18	807c–808c
	5. Maṇḍala of Ratna	31	153-2-7~4-4	19	809b–809c
	6. Maṇḍala of Three Brothers	32	154-1-3~3-1		Missing
	7. Maṇḍala of Four Sisters		154-3-1~4-2		Missing
	8. Maṇḍala of Nāga King		154-4-2~5-1	20	810a–810b
	9. Maṇḍala of emancipation from afflictions		154-5-1~5-5		810b
	10. Assembly maṇḍala		154-5-5~155-2-8		810c–811b
	11. Paṭa of Vajrasattva	33	155-2-8~5-2	21	811c–812b
	12. Paṭa of Trisamaya	35	159-4-4~4-7	23	817a
	13. Paṭa of Vajrajvālānala		159-5-8~160-1-6		817c
	14. Paṭa of Lokeśvara		161-5-1~5-7		817c–818a
	15. Paṭa of Ākāśagarbha		161-5-7~162-1-5		818a

I therefore surmise that the *Paramādyatantra* took its present form in the following way. There were two versions of the *Śrīparamādya*: one was added as the sequel to the "*Mahāsukhaguhyavajra*," which had its own *uttaratantra*, while the other, with its own introduction, circulated as an independent text. However, when the three texts *Mahāsukhavajrāmoghasamaya*, *Mahāsukhaguhyavajra*, and *Śrīparamādya* were eventually combined into one scripture named the *Paramādyatantra*, the *uttaratantra* of part 2 and part 3 became virtually identical. The reason that the subdivisions of the "Mantrakhaṇḍa" in the Tibetan translation of the *Paramādyatantra* show some inconsistencies is that the "Mantrakhaṇḍa" was translated by Shiwa Ö, who also translated the *Paramāditīkā*, and in addition to the chapter titles present in the original Sanskrit manuscript he seems to have added subdivisions in accordance with the *Paramāditīkā*.

The Chinese translation of the *Paramādyatantra*, on the other hand, combines the "Mahāsukhavajrāmoghasamaya" (part 1) with the "Śrīparamādya" (part 3), which was circulating separately, rather than with the *uttaratantra* of the "*Mahāsukhaguhyavajra*" (part 2). When considered in this way, it becomes possible, I believe, to explain in a rational manner the complicated process whereby the *Paramādyatantra* took its present form.

If we compare the maṇḍalas explained in each part of the *Paramādyatantra*, parts 2 and 3 repeat the first five maṇḍalas explained in part 1 (Vajrasattva to Ākāśagarbha), and then the Assembly maṇḍala is explained without the intervening maṇḍalas of Vajramuṣṭi through to Vajrayakṣa (Sarvamārapramardin) (see fig. 3.12). Ānandagarbha's *Paramāditīkā* explains

FIG. 3.12. MAṆḌALAS OF THE *PARAMĀDYATANTRA* ACCORDING TO ĀNANDAGARBHA

PART 1	PART 2		PART 3		PART 4
	MŪLATANTRA	*UTTARATANTRA*	*MŪLATANTRA*	*UTTARATANTRA*	
1. Vajrasattva	1. Vajrasattva	12. Mahāsukhavajra	1. Vajrasattva	10. Secret	1. Vajrasattva
2. Tathāgata	2. Tathāgata	13. Tathāgata	2. Sarvatathāgata	11. *Paṭa* of the Five Secrets	2. Sarvatathāgata
3. Trailokyavijaya	3. Krodhamahā-sukhavajra	14. Vajrajvālānala	3. Vajrajvālānala		3. Vajrajvālānala
4. Avalokiteśvara	4. Lokeśvara	15. Avalokiteśvara	4. Āryāvalokiteśvara		4. Āryāvalokiteśvara
5. Ākāśagarbha	5. Ākāśagarbha	16. Ākāśagarbha	5. Ākāśagarbha		5. Ākāśagarbha
6. Vajramuṣṭi					
7. Mañjuśrī					
8. Vajracakra					
9. Gaganagañja					
10. Vajrayakṣa					
11. Assembly	6. Assembly	20. Assembly	9. Assembly	12. Assembly	9. Assembly
12. Maheśvara					
13. Eight Mātṛkās					
14. Three Brothers	7. Three Brothers	17. Three Brothers	6. Three Brothers		6. Three Brothers
		18. Four Sisters	7. Four Sisters		7. Four Sisters
	9. Deva (Asura)				
	10. Nāga	19. Nāga and emancipation from afflictions	8. Nāga and emancipation from afflictions		8. Nāga and demon of afflictions
		21. *Paṭa* of Trisamaya			
		22. *Paṭa* of Vajrajvālānala			
		23. *Paṭa* of Avalokiteśvara			
		24. *Paṭa* of Ākāśagarbha			10. Nature of the mantra
		25. *Paṭa* of the Five Secrets			11. *Paṭa* of the Five Secrets

the maṇḍalas, mudrās, and mantras of part 2 in detail, but with regard to parts 3 and 4 it merely points out differences with part 2. This suggests that Ānandagarbha thought that the maṇḍalas explained in parts 3 and 4 were basically identical to the ten maṇḍalas explained in part 2.

After the "*Mahāsukhaguhyavajra," the maṇḍalas of the five bodhisattvas from Vajra-muṣṭi to Sarvamārapramardin have been omitted. However, these five bodhisattvas, included among the eight great bodhisattvas of the *Prajñāpāramitānayasūtra*, are doctrinally import-ant. Why were these five bodhisattvas omitted in the "Mantrakhaṇḍa," which repeats the maṇḍalas of the Three Brothers and Four Sisters of the Outer Vajra family, doctrinally not so important as these five bodhisattvas? I consider this question later in this chapter.

8. The *Paramādyatantra* and the Eighteen Tantras of the Vajraśekhara Cycle

The *Paramādyatantra* is a collection of several esoteric Buddhist scriptures that evolved from the *Prajñāpāramitānayasūtra*. Ever since the publication of Sakai Shinten's research on the subject, it had been thought that the "Prajñākhaṇḍa" of the *Paramādyatantra* corresponds to the sixth assembly of the *Vajraśekhara*, that is, the *Mahāsukhavajrāmoghasamaya*, and the "Mantrakhaṇḍa" to the eighth assembly, the *Paramādyayoga*. However, it has turned out that the first half of the "Mantrakhaṇḍa," which is missing in the Chinese translation, is a text called the "*Mahāsukhaguhyavajra," which is different from the *Śrīparamādya* cor-responding to the eighth assembly. This raises the question of how to regard this section, which I now wish to consider.

As mentioned above, there is little difference between the maṇḍalas explained in the "*Mahāsukhaguhyavajra" and "Śrīparamādya," and it is safe to say that the contents of the root tantra of both texts are virtually identical. At the start of the "Mantrakhaṇḍa," mention is made of the place where the Buddha taught this text.[296] The "*Mahāsukhaguhyavajra" is said to have been expounded in the palace where Mahāsukhavajrasattva resides.[297]

As has been seen, the *Prajñāpāramitānayasūtra* equates Samantabhadra with Vajrasattva. Therefore the above statement coincides with the account in the *Shibahui zhigui*, according to which the seventh assembly of the *Vajraśekhara*, the *Samantabhadrayoga*, was expounded in the palace of the bodhisattva Samantabhadra. Furthermore, the *Shibahui zhigui* states that the eighth assembly "is slightly larger than the seventh although the two are roughly identical." If we compare the "*Mahāsukhaguhyavajra" and "Śrīparamādya," we find that they are very similar in content but the latter is more voluminous than the former.

Amoghavajra translated the *Puxian yuga gui*, extracted from the seventh assembly (*Samantabhadrayoga*), and the *Dale gui* and *Shengchu yuga gui*, both extracted from the eighth assembly (*Paramādyayoga*). These ritual manuals all have a similar structure, but the latter two include the 108 praises of Vajrasattva, beginning with "*Oṃ paramādyava-jrasattva*,"[298] which are missing in the former. In the *Paramādyatantra*, the 108 praises of Vajrasattva are found not in the seventeen-deity maṇḍala of the "*Mahāsukhaguhyavajra" but in the "Śrīparamādya"[299] and the Chinese translation[300] corresponding to the eighth assembly (*Paramādyayoga*).

For these reasons I think that the "Prajñākhaṇḍa," "*Mahāsukhaguhyavajra," and "Śrīparamādya" of the Tibetan translation of the *Paramādyatantra* correspond to the

sixth assembly of the *Vajraśekhara* (*Mahāsukhavajrāmoghasamaya*), the seventh assembly (*Samantabhadrayoga*), and the eighth assembly (*Paramādyayoga*), respectively. Thus the sequence of the three texts in the Tibetan translation of the *Paramādyatantra* reflects the order of the eighteen tantras of the Vajraśekhara cycle. As for the Chinese translation of the *Paramādyatantra*, Sakai's identification of the "Prajñākhaṇḍa" with the sixth assembly and the "Mantrakhaṇḍa" with the eighth assembly is appropriate, since the "*Mahāsukhaguhya-vajra*" is missing in the Chinese translation.

9. The Paramādya-Vajrasattva Maṇḍala in Tibet

Among the many maṇḍalas explained in the *Paramādyatantra*, the two most popular in Tibetan Buddhism are the Paramādya-Vajrasattva maṇḍala explained at the start of the "Prajñākhaṇḍa" and the Assembly maṇḍala, which brings together all the maṇḍalas explained in the "Prajñākhaṇḍa." The Paramādya-Vajrasattva maṇḍala is the more important for considering the historical development of the maṇḍala.

This maṇḍala is included in the Ngor maṇḍalas[301] and the *Mitra brgya rtsa* maṇḍala set (M-34), and a number of further examples have also survived in Tibet. In particular, all the maṇḍalas of the *Paramādyatantra* are depicted in the south chapel of Shalu monastery. Unfortunately they are in a poor state of preservation even though they are historically significant, having been executed at the instigation of Butön.[302] This monastery also preserves a thangka depicting the Paramādya-Vajrasattva maṇḍala. In spite of its being an obviously modern work, it is important because it is in good condition and the iconography of the deities is clear (fig. 3.13).[303]

In addition, in the center of the east wall of the north chapel in the dome of the Great Stūpa of Palkhor Chöde monastery in Gyantse there was originally depicted the *Dharma-dhātumahāvajramaṇḍalālaṃkāra-sarvatathāgataguhyamaṇḍala*,[304] but currently the Paramādya-Vajrasattva maṇḍala has been painted over it. This maṇḍala was not transmitted to Japan, but, using Tibetan materials, Toganoo Shōun reconstructed it and published it in his *Rishukyō no kenkyū*.[305]

The Paramādya-Vajrasattva maṇḍala is centered on Vajrasattva, who is surrounded in the four cardinal directions by his four attendants, Vajramanodbhava, Vajrakīlikīla, Vajranis-mara, and Vajragarva. Arranged in the four intermediate directions are the goddesses of the four seasons, the same as those in the seventeen-deity maṇḍala. In the four cardinal directions outside the innermost circle are the four buddhas: Akṣobhya, Ratnasambhava, Amitābha, and Amoghasiddhi. Their iconography is by and large the same as that in the Vajradhātu-maṇḍala. However, it is worth noting that Amitābha forms not the meditation mudrā but the dharma-wheel mudrā, for in India the majority of images thought to represent Amitābha—except for those among the five buddhas with the meditation mudrā—form the dharma-wheel mudrā. These four buddhas are each flanked by two of the eight great bodhisattvas of the *Prajñāpāramitānayasūtra*: Akṣobhya is attended by Vajrapāṇi and Mañjuśrī, Ratnasambhava by Ākāśagarbha and Gaganagañja, Amitābha by Avalokiteśvara and Sacittotpādadharmacakrapravartin, and Amoghasiddhi by Vajramuṣṭi and Sarvamārapramardin.

With regard to these four buddhas and eight bodhisattvas, the "*Mahāsamayatattva-vajra*" of the *Paramādyatantra* states simply that "in the inner maṇḍala one should depict

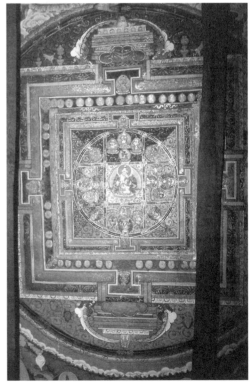

FIG. 3.13. PARAMĀDYA-VAJRASATTVA MAṆḌALA (SHALU MONASTERY)

Fig. 3.14. Paramādya-Vajrasattva maṇḍala

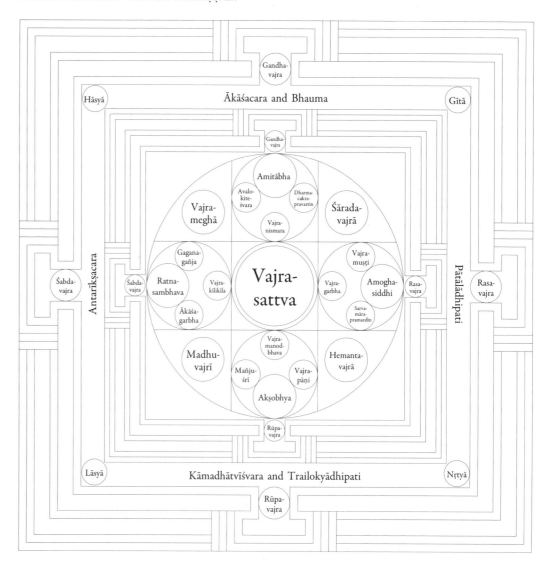

Vajrapāṇi (Tib. Vajradhara) and others; all sides of the vajra-wheel are filled with buddhas."
Thus neither the Chinese nor Tibetan translations give details of the arrangement of the
deities. However, commentators, starting with Ānandagarbha, interpreted "buddhas" as a
reference to Akṣobhya, Ratnasambhava, Amitābha, and Amoghasiddhi and "Vajradhara
and others" as a reference to the eight great bodhisattvas of the *Prajñāpāramitānayasūtra*.

The four buddhas of the Vajradhātu-maṇḍala do not appear in the *Prajñāpāra-
mitānayasūtra,* but they do appear in the last chapter of the Chinese translation of the
Paramādyatantra.[306] Furthermore, the passage in question is not found in the Tibetan
translation. The appearance of the five buddhas of the Vajradhātu-maṇḍala in texts affil-
iated to the *Prajñāpāramitānayasūtra* is limited to late Yoga tantras, starting with the
Vajramaṇḍalālaṃkāratantra, and the *Paramādyatantra* seems to intentionally avoid men-
tioning the four or five buddhas of the Vajradhātu-maṇḍala. Therefore the four buddhas
depicted in the Paramādya-Vajrasattva maṇḍala are thought to have been adopted from the
Sarvatathāgatatattvasaṃgraha.

However, if we examine the iconography of the buddhas, several features unusual for Yoga tantras can be detected. The first is that their body colors accord not with the standard colors—blue for Akṣobhya, yellow for Ratnasambhava, red for Amitābha, and green for Amoghasiddhi—but with another theory: white for Akṣobhya, blue for Ratnasambhava, gold for Amitābha, and multicolored for Amoghasiddhi.[307] In addition, Amitābha's mudrā is not the meditation mudrā but the dharma-wheel mudrā. As noted earlier, Amitābha's dharma-wheel mudrā is due to the influence of earlier traditions pre-dating esoteric Buddhism, while the alternative theory of the body colors of the five buddhas is frequently found in esoteric Buddhist manuals from Dunhuang dating from the Tibetan occupation.[308] It is therefore evident that the four buddhas and eight great bodhisattvas depicted in the Paramādya-Vajrasattva maṇḍala are a later addition.

In the four intermediate directions of the outer square, the four offering goddesses Lāsyā, Hāsyā, Gītā, and Nṛtyā are depicted. As mentioned, if Hāsya is replaced by Mālā, these four goddesses become identical to the four inner offering goddesses of the Vajradhātu-maṇḍala.

As for the four gates of the maṇḍala, the "*Mahāsamayatattvavajra" of the *Paramādyatantra* stipulates that the symbols of the objects of the four senses should be depicted in the four gates: "In the center of all the gates the assembled symbols of *rūpa* and so on should be placed."[309] In time, the symbols of the objects of the four senses became deified as the gatekeepers of the four gates, since they correspond to the final four *viśuddhipadas* (*rūpa*, *śabda*, *gandha*, and *rasa*).

In extant Tibetan examples of the Paramādya-Vajrasattva maṇḍala, these four gatekeepers appear twice, in the four inner and four outer gates of the maṇḍala. The anonymous *Śrīparamādimaṇḍalavidhi*[310] states that Rūpa, Śabda, Gandha, and Rasa, who hold a mirror, a lute (*vīṇā*), an incense container made of conch shell, and a container for food offerings, respectively, should be installed in the four gates of the inner square, while the gatekeepers of the four outer gates hold as attributes a hook (*aṅkuśa*), a noose (*pāśa*), a chain (*sphoṭa*), and a bell (*ghaṇṭā*), respectively, in accordance with the *mūlatantra*.[311] This is because both the "*Mahāsukhaguhyavajra" and "Śrīparamādya" of the "Mantrakhaṇḍa" give Aṅkuśa, Pāśa, Sphoṭa, and Ghaṇṭa as the gatekeepers of the seventeen-deity Vajrasattva-maṇḍala.[312]

The four gatekeepers Aṅkuśa, Pāśa, Sphoṭa, and Ghaṇṭa (Āveśa) are deifications of the process of unification with the deity, symbolized by the four-syllable *vidyā* "*Jaḥ hūṃ vaṃ hoḥ*"[313] with which the practitioner summons, inducts, binds, and delights the deity whom he visualizes in front of him. The four gatekeepers associated with the seed-syllables *jaḥ hūṃ vaṃ hoḥ* are also described in ritual manuals centered on Vajrasattva that survive in Chinese translation.[314] The four-syllable *vidyā* occurs frequently in the "Mantrakhaṇḍa" of the *Paramādyatantra* and in these ritual manuals that were translated into Chinese, but it is not explicitly mentioned in the "Prajñākhaṇḍa." Therefore the four-syllable *vidyā* became popular with the appearance of the "Mantrakhaṇḍa" of the *Paramādyatantra*, and it is to be surmised that the gatekeepers Rūpa, Śabda, Gandha, and Rasa, symbolizing *viśuddhipadas*, were then replaced by Aṅkuśa, Pāśa, Sphoṭa, and Ghaṇṭa, deifications of the four-syllable *vidyā*.

In the four directions of the outer square, protective deities are depicted. The "*Mahāsamayatattvavajra" of the *Paramādyatantra* explains this as follows: "In the outer maṇḍala, install the lords of the realm of desire. In front [of the main deity], place the lords of the triple world, namely, Śakra, Brahmā, and Śiva."[315] The special mention here of the lords of

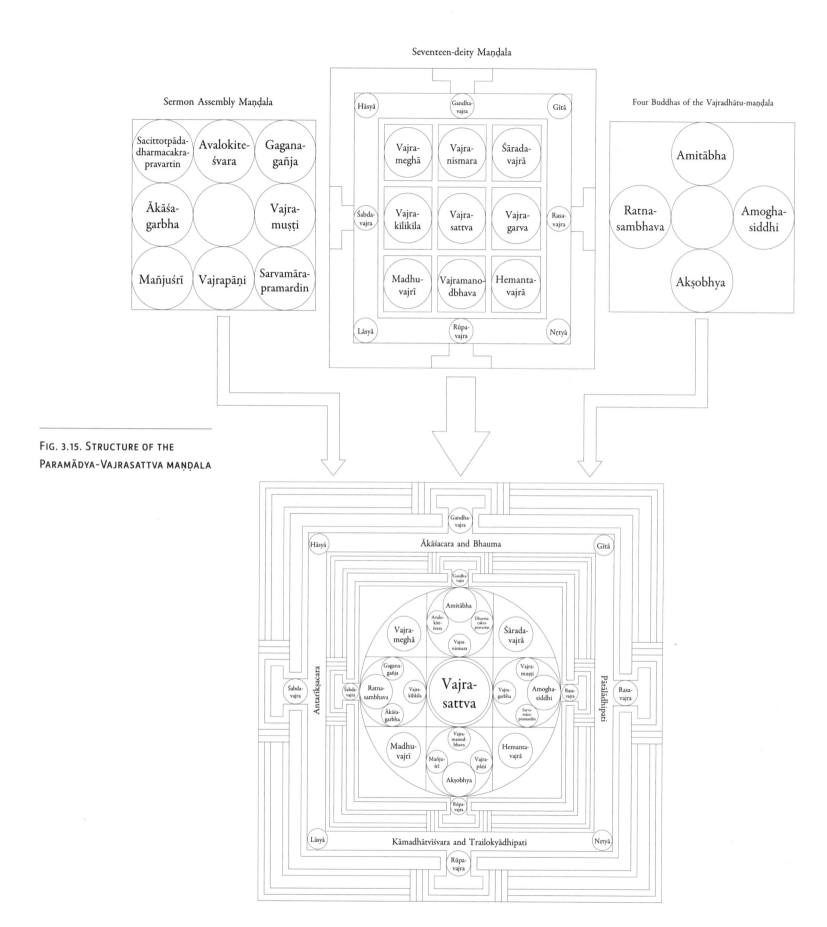

Sermon Assembly Maṇḍala

Sacittotpāda-dharmacakra-pravartin	Avalokite-śvara	Gagana-gañja
Ākāśa-garbha		Vajra-muṣṭi
Mañjuśrī	Vajrapāṇi	Sarvamāra-pramardin

Seventeen-deity Maṇḍala

Hāsyā · Gandha-vajra · Gītā

Vajra-meghā	Vajra-nismara	Śārada-vajrā
Vajra-kīlikīla	Vajra-sattva	Vajra-garva
Madhu-vajrī	Vajramanod-bhava	Hemanta-vajrā

Śabda-vajra · Rasa-vajra

Lāsyā · Rūpa-vajra · Nṛtyā

Four Buddhas of the Vajradhātu-maṇḍala

Amitābha

Ratna-sambhava · Amogha-siddhi

Akṣobhya

FIG. 3.15. STRUCTURE OF THE
PARAMĀDYA-VAJRASATTVA MAṆḌALA

the realm of desire (*kāmadhātu*) may be because the *Prajñāpāramitānayasūtra* was taught to the gods of the Paranirmitavaśavartin Heaven, the highest class of gods in the realm of desire, in order to subjugate Māra, the lord of the realm of desire.

In addition, the *Śrīparamādimaṇḍalavidhi* refers not only to the lords of the triple world in front of the main deity, namely, in the east, but also to flying deities such as Sūrya (Sun) and Soma (Moon) in the south, sky-dwelling deities (four kinds of Nandīkeśvara) and ground-dwelling deities such as Agni and Vāyu in the west, and underground deities such as Yama and Varuṇa in the north.[316] The classification and arrangement of these protective deities are almost identical to the outer square of the Vajradhātu-maṇḍala.

Thus the Paramādya-Vajrasattva maṇḍala is based on (1) "Vajrasattva" of the *Prajñāpāramitānayasūtra*. However, for its structure reference must be made to the "*Mahāsamayatattva-vajra*" of the *Paramādyatantra*. Further, the arrangement of the deities is described in detail in Ānandagarbha's two commentaries and the *Śrīparamādimaṇḍalavidhi*, which significantly altered the original descriptions of the *Paramādyatantra*. The Vajrasattva-maṇḍala based on these commentaries consists of the seventeen deities of the *Prajñāpāramitānayasūtra*, the four buddhas of the Vajradhātu-maṇḍala, and the eight great bodhisattvas of the *Prajñāpāramitānayasūtra*. It can also be interpreted as a synthesis of the Sermon Assembly maṇḍala and the seventeen-deity Vajrasattva-maṇḍala among the eighteen maṇḍalas of the *Prajñāpāramitānayasūtra* (see fig. 3.15). The reason that Ānandagarbha did not explain the Sermon Assembly maṇḍala may have been that by his time it had already merged with the Paramādya-Vajrasattva maṇḍala. I believe that this maṇḍala exerted a strong influence on the genesis of the Vajradhātu-maṇḍala, a topic that will be addressed in chapter 4.

10. The Assembly Maṇḍala of the *Paramādyatantra*

The *Paramādyatantra* describes many different maṇḍalas, among which the most popular in Tibet is the Paramādya-Vajrasattva maṇḍala. But some important maṇḍalas are included among the other maṇḍalas described in this text. When describing these maṇḍalas other than the Vajrasattva-maṇḍala, the *Paramādyatantra* frequently states that "one should depict the outer maṇḍala in the manner of the Vajrasattva-maṇḍala." That is to say, after having made an outer square like the Paramādya-Vajrasattva maṇḍala in the case of the "Prajñākhaṇḍa" or like the seventeen-deity maṇḍala in the case of the "Mantrakhaṇḍa," one should change only the principal deities in the inner circle. By this method one can create a maṇḍala with many attendants surrounding the main deity as the basic maṇḍala even in the case of (2) "Vairocana" and subsequent chapters, which mention only four or five doctrinal propositions.

Among the maṇḍalas explained in the *Paramādyatantra*, I attach particular importance to the Assembly maṇḍala described in the "Mantrakhaṇḍa" for considering the historical development of the maṇḍala in India. As an Assembly maṇḍala of the *Paramādyatantra*, there is the "Assembly maṇḍala of the *Paramādyatantra*," which integrates all the maṇḍalas described in the "Prajñākhaṇḍa." This maṇḍala is not only included in the Ngor maṇḍalas[317] but is also found at Shalu monastery (on the east wall of the east chapel)[318] and at Sakya monastery (along the corridor of the south monastery).[319]

The iconography of this Assembly maṇḍala is based on Ānandagarbha's *Paramādivṛtti*, which identifies it as the eleventh of the fifteen maṇḍalas explained in the "Prajñākhaṇḍa,"

corresponding to the eleventh maṇḍala (Assembly maṇḍala) among the eighteen maṇḍalas of the *Prajñāpāramitānayasūtra*.[320] However, the textual source for this maṇḍala, the "Prajñākhaṇḍa" of the *Paramādyatantra*, does not describe it in detail, stating only that it has the shape of eight wheels and that Trailokyavijaya and other deities are depicted.[321]

The *Paramādivṛtti*, on the other hand, describes this maṇḍala as follows. It is centered on the maṇḍala of (1) Vajrasattva and arranges the maṇḍalas of (3) Trailokyavijaya, (4) Lokeśvara (that is, Avalokiteśvara), (5) Ākāśagarbha, and (6) Vajramuṣṭi in the four cardinal directions of the inner square, and the maṇḍalas of (7) Mañjuśrī, (8) Sacittotpādadharmacakrapravartin, (9) Gaganagañja, and (10) Sarvamārapramardin (Vajrayakṣa) in the four intermediate directions. The maṇḍalas of the Outer Vajra family are arranged in the outer square. It thus constitutes a large-scale maṇḍala that synthesizes all the maṇḍalas explained in the "Prajñākhaṇḍa" of the Paramādyatantra (see fig. 3.16).

The "Mantrakhaṇḍa" of the *Paramādyatantra*, meanwhile, describes some different Assembly maṇḍalas. The first is the Assembly maṇḍala in chapter 6, in the "*Mahāsukhaguhyavajra," although it is difficult to reconstruct from the brief instructions given

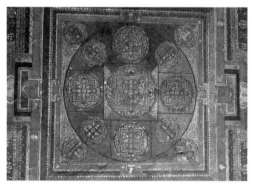

FIG. 3.16. SARVAKULA-MAṆḌALA
OF THE *PARAMĀDYATANTRA* (JAMPA LHAKHANG)

FIG. 3.17. SARVAKULA-MAṆḌALA OF THE *PARAMĀDYATANTRA*

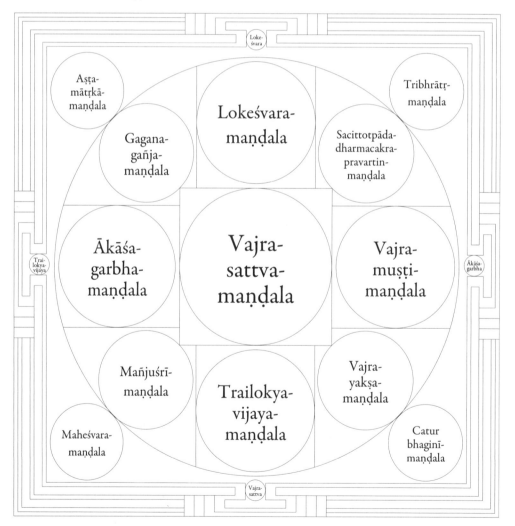

there.[322] There is, however, a detailed explanation in the Chinese translation[323] and chapter 32 of the Tibetan translation,[324] both of which correspond to the "Śrīparamādya." The arrangement of the deities in this maṇḍala and their mantras are given in figs. 3.18 and 3.19.

According to Ānandagarbha's *Paramādiṭīkā*, this maṇḍala is called the Assembly maṇḍala.[325] It was thus devised as a maṇḍala bringing together the main deity of each chapter of the "Mantrakhaṇḍa." Vajranārāyaṇa, Caṇḍīśvara, Vajrapadmodbhava, and Ākāśagarbha are arranged in the four cardinal directions around the main deity, Vajrasattva. In the four intermediate directions are the four goddesses Vajraśrī, Vajragaurī, Vajratārā, and Khavajriṇī. Nārāyaṇa is an epithet of Viṣṇu and Caṇḍīśvara/Caṇḍeśvara is an epithet or attendant of Śiva.[326] Vajrapadmodbhava, as is evident from his mantra given in fig. 3.20, is none other than Avalokiteśvara. Śrī is a consort of Viṣṇu and Gaurī a consort of Śiva, while Tārā is a goddess born from Avalokiteśvara's eyes.

Therefore the four male deities in the cardinal directions and the four female deities in the intermediate directions are thought to form four couples consisting of Nārāyaṇa and Śrī, Caṇḍīśvara and Gaurī, Avalokiteśvara and Tārā, and Ākāśagarbha and Khavajriṇī. This

FIG. 3.18. ASSEMBLY MAṆḌALA OF THE *PARAMĀDYATANTRA* ("MANTRAKHAṆḌA")

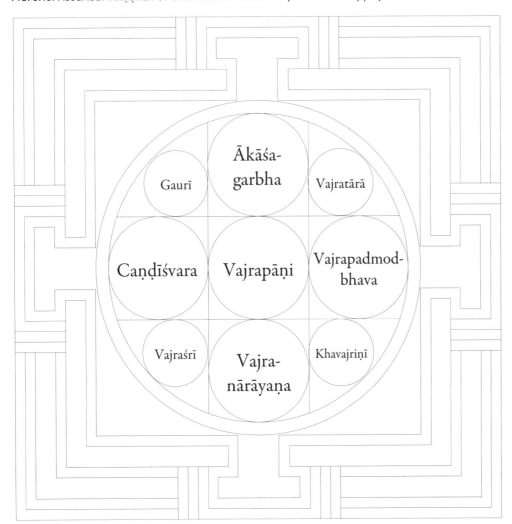

Vajranārāyaṇa is regarded as an emanation of Vairocana and Caṇḍīśvara as an emanation of Vajrajvālānalārka.

FIG. 3.19. DEITIES OF THE ASSEMBLY MAṆḌALA OF THE "MANTRAKHAṆḌA"

1. 金剛手	rDo rje sems dpa'	Vajrasattva
2. 那羅延	rDo rje sred med bu	Vajranārāyaṇa
3. 賛尼設囉	gTum dbang	Caṇḍīśvara
4. 金剛蓮華	rDo rje pad byung	Vajrapadmodbhava
5. 虛空藏	Nam mkha'i sñing po	Ākāśagarbha
6. 金剛吉祥	rDo rje dpal mo	Vajraśrī
7. 金剛偶梨	dKar mo	(Vajra)gaurī
8. 金剛多羅	rDo rje sgrol ma	Vajratārā
9. 虛空金剛	mKha' rdo rje	Khavajriṇī

way of pairing the male deities in the four cardinal directions with the female deities in the four intermediate directions has some points in common with the relationship between the four male attendants and the goddesses of the four seasons in the seventeen-deity maṇḍala and between the five buddhas and four buddha-mothers in the Guhyasamāja-maṇḍala to be discussed in chapter 5. This was probably a pattern that was typical for the arrangement of maṇḍala deities in India at the time.

It is worth noting that in his *Paramādiṭīkā* Ānandagarbha interprets Nārāyaṇa in this maṇḍala as Vairocana in the guise of Viṣṇu and Caṇḍīśvara as none other than Vajra-jvālānalārka.[327] That is to say, this maṇḍala, centered on Vajrasattva, the main deity of the *Paramādyatantra*, arranges Vairocana as Viṣṇu, Vajrajvālānalārka as Caṇḍīśvara, Vajrapad-modbhava (aka Avalokiteśvara), and Ākāśagarbha in the four cardinal directions. Thus the five families of the *Paramādyatantra* are all assembled together in this maṇḍala, which is precisely why it is called the "Assembly maṇḍala."

The Assembly maṇḍala of the "Mantrakhaṇḍa," unlike that of the "Prajñākhaṇḍa," is not included in the Ngor maṇḍalas, *Mitra brgya rtsa*, or other maṇḍala collections. Examples in Tibet had not been found until Kawasaki Kazuhiro recently identified one based on the "*Mahāsukhaguhyavajra*" in the south chapel of Shalu monastery.[328] Although in a poor state of preservation, it has Vairocana (Nārāyaṇa), Trailokyavijaya (Caṇḍīśvara), Ava-lokiteśvara (Vajrapadmodbhava), and Ākāśagarbha in the four cardinal directions, not as single deities but each at the center of a maṇḍala. It thus constitutes a compendium of the maṇḍalas explained in the "Mantrakhaṇḍa" of the *Paramādyatantra*.

The maṇḍalas affiliated to the *Prajñāpāramitānayasūtra* thus include large-scale, com-posite maṇḍalas in which multiple maṇḍalas are arranged in the four cardinal and four intermediate directions around a central maṇḍala, such as the General Assembly maṇḍala of the five families among the eighteen maṇḍalas of the *Prajñāpāramitānayasūtra* and the Assembly maṇḍalas of the "Prajñākhaṇḍa" and "Mantrakhaṇḍa" of the *Paramādyatantra*. These have points in common with the idea of mutual encompassment (*samavasaraṇa*) in the Vajradhātu-maṇḍala, to be discussed in the next chapter. However, since such maṇḍalas of a composite type are not explicitly explained in either the *Prajñāpāramitānayasūtra* or the

2. Nārāyaṇa
唵引嚩日囉二合那引囉引野拏親捺親捺一句阿鉢囉二合底賀多嚩日囉二合嚩訖哩二合拏呼引二
婆誐鑁嚩日囉二合怛他引誐多嘚吽二鑁呼引三
oṃ vajranārāyaṇa cinda cinda/ apratihatavajracakriṇa? hoḥ/
bhagavan vajratathāgata jaḥ hūṃ vaṃ hoḥ//
3. Caṇḍīśvara
嚩日囉二合怛他誐多吽引一句嚩日囉二合骨嚕二合馱摩賀瑜詣儞誐尼引説囉摩賀嚩日囉二合
戌邏阿屹囉二合播尼引呼引婆誐鑁嚩日囉二合賛尼説囉阿四賀賀賀賀係引五
vajratathāgata hūṃ/ vajrakrodhamahāyoginīgaṇeśvara/ mahāvajraśūlāgrapāṇe hoḥ/
bhagavan vajracaṇḍeśvara aḥ/ ha ha ha ha he//
4. Vajrapadmodbhava
嚩日囉二合達囉紇哩二合引一句嚩日囉二合鉢訥摩二合引訥婆二嚩呼引婆誐鑁嚩日囉二合阿嚩路吉帝引
説囉摩賀沒囉二合吽摩二合三悉馳唵引部哩部二合嚩莎四莎悉帝引那莫莎賀引五
vajradhara hrīḥ/ vajrapadmodbhava hoḥ/ bhagavan vajrāvalokiteśvara
mahābrahma/ siddhya oṃ bhūr bhuva svaḥ/ svasti namaḥ svāhā//
5. Ākāśagarbha
嚩日囉二合酤穌摩欲馱引薩哩嚩二合哥引摩引娑達野呼引婆誐鑁嚩日囉二合阿哥引舍
誐哩婆二合三嚩嚩吒吒怛囕二合引四
vajrakusumāyudha/ sarvakāmā[ṃ] me sādhaya hoḥ/ bhagavan vajrākāśagarbha/ va va ṭa ṭa trāṃ//
6. Vajraśrī
那謨曵那薩帝也引一句那婆誐嚩帝鉢囉二合倪也引播引囉彌多二合薩怖二合吒親捺嚩日哩二合尼
作訖哩二合拏引帝那薩帝也引那播鉢剛引三唵地室哩二合輸嚕二合底薩蜜哩二合底尾惹曵莎引賀引四
namo yena satyena bhagavatī prajñāpāramitā/ sphoṭa cinda vajriṇi
cakriṇe?/ tena satyena pāpakāṃ/ oṃ dhi śrī śrute smṛte vijaye svāhā//
7. Vajragaurī
唵引嚩日囉二合偶哩摩賀尾儞踰二合引一句怛哩二合路哥尾惹曵説哩引嚩日囉二合骨嚕二合馱儗儞二合
三摩曵引嚩日囉二合馱哩那謨窣覩引帝引四怛馳他引醯隸彌隸引隸引隸羅隸囉引隸七嚩日囉二合
哥引哩母二合哥曵莎引賀引八
oṃ vajrgauri mahāvidye/ trilokavijayeśvari/ vajrakrodhāgnisamaye/ vajradhāri namo 'stu te/
tad yathā/ hilemile/ lelilalilāli/ vajrakarmukaye svāhā//
8. Vajratārā
那謨曵那薩帝也二合引那婆誐嚩帝引沒馱冒地囉耨多囉二嚩日囉二合達哩摩二合鉢囉二合踰儗拏
帝那薩帝也二合那悉馳給四唵引多引哩觀多引哩觀哩引莎引賀引五
namo yena satyena bhagavatī/ buddhabodhir anuttarā/ vajradharmaprayogine[/]
tena satyena siddhya māṃ/ oṃ tāre tu tāre ture svāhā//
9. Khavajriṇī
唵引哥引摩嚩日哩二合尼悉馱引悉二尾戍馱引悉二誐誐怒訥婆二合嚩踰儗那悉馳給二合鉢囉摩引叉
哩引怛馳他誐誐怒訥婆二合尾六誐誐那尾輸提薩哩嚩二合鼻鉢囉二合引野鉢哩布囉尼引莎引賀引八
oṃ kāmavajriṇi siddhāsi/ viśuddhāsi/ gaganodbhavayogini siddhya māṃ/ paramākṣari/
tad yathā/ gaganodbhave/ gaganaviśuddhe/ sarvābhiprāyaparipuranī svāhā//

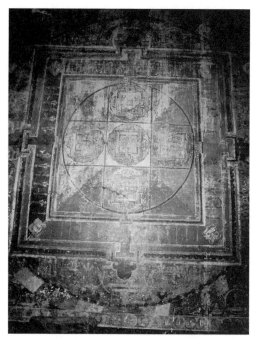

FIG. 3.21. ASSEMBLY MAṆḌALA OF THE *PARAMĀDYATANTRA* (SHALU MONASTERY)

Paramādyatantra, it is impossible to compose such complex maṇḍalas without referring to the commentaries and ritual manuals.

In contrast, the seventeen-deity maṇḍala affiliated to the *Prajñāpāramitānayasūtra*, which arranges nine deities on an eight-spoked wheel or nine-panel grid in the inner circle and eight deities in the four cardinal and four intermediate directions of the outer square, is structurally simpler than the Vajradhātu-maṇḍala, with its structure underpinned by the idea of mutual encompassment. This would suggest that the maṇḍalas of the *Prajñāpāramitānayasūtra* pre-date the Vajradhātu-maṇḍala. It is to be surmised that the General Assembly maṇḍala of the five families and the Assembly maṇḍalas with a structure characterized by mutual encompassment were introduced in later commentaries and ritual manuals after the establishment of this idea, which represents the structural principle underpinning the Vajradhātu-maṇḍala.

As mentioned, the *Paramādyatantra* elaborates on the maṇḍalas that were explained in the "Prajñākhaṇḍa" and again in the "*Mahāsukhaguhyavajra" and "Śrīparamādya" of the "Mantrakhaṇḍa." But the "Mantrakhaṇḍa" does not repeat the maṇḍalas from sections 6–10, even though the five bodhisattvas with which these chapters deal are doctrinally important. Why is this so?

When compared with the maṇḍalas of early esoteric Buddddhism, the maṇḍalas affiliated to the *Prajñāpāramitānayasūtra* are characterized by a structure that is completely symmetrical, both vertically and horizontally. This is because the doctrinal propositions expounded in the latter part of the *Prajñāpāramitānayasūtra* are arranged in groups of four or five. If one were to compose an Assembly maṇḍala bringing together the main deities of these sections, it would be centered on Vajrasattva, the main deity of section 1, surrounded by the main deities of the four subsequent sections, that is, Vairocana, Trailokyavijaya, Avalokiteśvara, and Ākāśagarbha. The Assembly maṇḍala of the "Mantrakhaṇḍa" would again be centered on Vajrasattva, with Vairocana in the east, Vajrajvālānalārka in the south (since Trailokyavijaya evolved into Vajrajvālānalārka in the latter part of the *Paramādyatantra*), Avalokiteśvara in the north, and Ākāśagarbha in the west.

The Sermon Assembly maṇḍala discussed in an earlier section is centered on Vairocana, who is surrounded by the eight great bodhisattvas. But the Assembly maṇḍala of the "Prajñākhaṇḍa" described at the start of this section omits Vairocana and places the four deities from (3) Trailokyavijaya to (6) Vajramuṣṭi in the four cardinal directions and the four deities from (7) Mañjuśrī to (10) Sarvamārapramardin in the four intermediate directions around the main deity Vajrasattva. It thus retains vertical and horizontal symmetry.

However, if one arranges the deities from (2) Vairocana to (5) Ākāśagarbha in the four cardinal directions and places the consorts of these four deities in the intermediate directions as in the Assembly maṇḍala of the "Mantrakhaṇḍa," there is no space for the five bodhisattvas from (6) Vajramuṣṭi to (10) Sarvamārapramardin. This seems to be the reason for the omission of the maṇḍalas of these five bodhisattvas in the "Mantrakhaṇḍa" of the *Paramādyatantra*. The maṇḍalas of the Outer Vajra family, such as (14) Three Brothers and (15) Four Sisters, were reexplained in the "Mantrakhaṇḍa" because they are arranged in the outer square of the Assembly maṇḍala.

The structure of a maṇḍala symmetrical vertically as well as horizontally, which originated in the *Prajñāpāramitānayasūtra*, developed into the five-family system of the Vajradhātu-maṇḍala. In the Vajradhātu-maṇḍala, deities belonging to the five families—

Tathāgata, Vajra, Ratna (Jewel), Dharma (Lotus), and Karma—are arranged uniformly in the five directions (center and four cardinal directions), thus making it possible to compose a maṇḍala that is completely symmetrical both vertically and horizontally. However, in the Assembly maṇḍala of the "Mantrakhaṇḍa" the main deity Vajrasattva, who belongs to the Vajra family, is surrounded by Vairocana (Buddha family) in the east, Trailokyavijaya (Vajra family) in the south, Avalokiteśvara (Lotus family) in the north, and Ākāśagarbha (Jewel family) in the west. Thus the Vajra family is duplicated in the center and south while the Karma family, placed in the north in the Vajradhātu-maṇḍala, is missing.

The Karma family developed from Vajramuṣṭi, whose chapter follows that of Ākāśagarbha in the *Prajñāpāramitānayasūtra*. In the Sermon Assembly maṇḍala and the Assembly maṇḍala of the "Prajñākhaṇḍa," Vajrapāṇi or Trailokyavijaya, belonging to the Vajra family, is placed in the east, Ākāśagarbha of the Jewel family in the south, and Vajramuṣṭi of the Karma family in the north. Thus this arrangement is compatible with the five-family system of the Vajradhātu-maṇḍala. The Assembly maṇḍala of the "Mantrakhaṇḍa," on the other hand, arranges the deities in accordance with the sequence of sections in the *Prajñāpāramitānayasūtra*, and this results in inconsistencies with the Vajradhātu-maṇḍala.

The arrangement of the Sermon Assembly maṇḍala is based on the *Liqu shijing* while that of the Assembly maṇḍala of the "Prajñākhaṇḍa" is based on the *Paramādivṛtti*, and details of their arrangement are not explained in the *Paramādyatantra*. Therefore the arrangement of the Sermon Assembly maṇḍala, the addition of the four buddhas in the Paramādya-Vajrasattva maṇḍala, and the arrangement of the maṇḍalas of the eight great bodhisattvas in the Assembly maṇḍala of the "Prajñākhaṇḍa" were all prescribed in commentaries and ritual manuals in accordance with the five families of the Vajradhātu-maṇḍala, which places the Karma family in the north, after the establishment of the fivefold system of the Vajradhātu-maṇḍala.

Placed in the four gates of the Assembly maṇḍala of the "Prajñākhaṇḍa" are the symbols of Vajrasattva (east), Trailokyavijaya (south), Lokeśvara (west), and Ākāśagarbha (north), an arrangement that is not compatible with the layout of the inner square. This arrangement preserves, I believe, the original arrangement of the *Paramādyatantra* when it first appeared.

In this fashion, the *Prajñāpāramitānayasūtra* forged close ties between the maṇḍala and philosophical ideas through the deification of doctrinal propositions to a degree never seen before. It also paved the way for a completely symmetrical maṇḍala, vertically as well as horizontally. However, the completion of the fivefold system, including the Karma family, and the method of structuring a maṇḍala on the basis of the principle of the mutual encompassment of the five families had to await the advent of the Vajradhātu-maṇḍala, described in the *Sarvatathāgatatattvasaṃgraha*.

11. Developments of the *Prajñāpāramitānayasūtra*

After the appearance of the *Prajñāpāramitānayasūtra* and *Sarvatathāgatatattvasaṃgraha*, this line of thinking underwent enormous development in India and produced a vast number of scriptures known as the Yoga tantras. Tibetan Buddhism styles the *Sarvatathāgatatattvasaṃgraha* cycle of texts as "Yoga tantras mainly explaining means" and the *Prajñāpāramitānayasūtra* cycle as "Yoga tantras mainly explaining wisdom."[329] As

representatives of the latter, apart from the *Paramādyatantra*, mention may be made of the *Sarvatathāgatakāyavākcittaguhyālaṃkāravyūhatantrarāja*, *Vajramaṇḍalālaṃkāratantra*, and *Āryaguhyamaṇitilaka*. As for a developed form of the maṇḍalas explained in the *Paramādyatantra*, we can mention the maṇḍala of the *Samāyogatantra*, the precursor of the Mother tantras. In this final section of this chapter, I wish to consider the maṇḍalas explained in later texts that evolved from the *Prajñāpāramitānayasūtra*.

The *Sarvatathāgatakāyavākcittaguhyālaṃkāravyūhatantrarāja* explains a number of maṇḍalas, four of which are depicted in the Great Stūpa of Palkhor Chöde monastery. The *Vajramaṇḍalālaṃkāratantra*, on the other hand, explains thirty-seven maṇḍalas,[330] the most important of which are the Vajramaṇḍa-maṇḍala explained in the first half and the Mahāyānābhisamaya-maṇḍala[331] explained in the second half.

The Mahāyānābhisamaya-maṇḍala basically adopted the plan of the Vajradhātu-maṇḍala, but it introduced the shapes of the four elements (*caturmahābhūta*) into this plan: the square maṇḍala (earth) of Akṣobhya in the east, the triangular maṇḍala (fire) of *Jñānaprabha in the south, the circular maṇḍala (water) of Amitābha in the west, and the semicircular maṇḍala (wind) of *Vajravikrama in the north.[332] The idea of assigning the five buddhas to the five elements originated not in the *Sarvatathāgatatattvasaṃgraha* but in the *Vairocanābhisambodhisūtra*. In the Garbha-maṇḍala, explained in the *Vairocanābhisambodhisūtra*, the five buddhas are assigned to the five elements as follows: Vairocana to space (center), Ratnaketu to earth (east), Saṃkusumitarājendra to fire (south), Amitābha to water (west), and Dundubhisvara to wind (north).[333]

The *Sanzhong xidi po diyu zhuan yezhang chu sanjie bimi tuoluoni fa*, attributed to Śubhākarasiṃha,[334] equates the four buddhas of the Garbha-maṇḍala with those of the Vajradhātu-maṇḍala and assigns the four elements to the four buddhas of the latter as follows: earth (east, yellow) to Ratnaketu = Akṣobhya; fire (south, red) to Saṃkusumitarājendra = Ratnasambhava; water (west, white) to Amitābha; and wind (north, black) to Dundubhisvara = Śākyamuni (Amoghasiddhi).[335] This is identical to the correspondences between the four buddhas of the Vajradhātu-maṇḍala and the four elements in the Mahāyānābhisamaya-maṇḍala. This maṇḍala thus amalgamates the thirty-seven deities of the Vajradhātu-maṇḍala and the theory of five elements that originated in the *Vairocanābhisambodhisūtra*.

As a precedent for the introduction of the shapes of the four elements into the maṇḍala, we can point to the *Mañjuśrīmūlakalpa* considered in chapter 2. However, the systematic introduction of these elements began with the *Vairocanābhisambodhisūtra*. In chapter 11 (of the Chinese translation) are explained "separate altars (or maṇḍalas)" (*bietan*), which represent particular groups from the Garbha-maṇḍala. Among these, the separate altars of the Lotus family and Vajra family are square in shape, that of the Buddha family, centered on a triangle symbolizing the Buddha's omniscience, is circular in shape, that centered on Hayagrīva is triangular in shape, and that of the *vidyārājas* is semicircular in shape. Thus the shapes of the four elements have been adopted as the layout of the maṇḍalas.[336]

However, in the Garbha-maṇḍala the body color of Ratnaketu, who presides over the earth element, is red, while yellow, assigned to the earth element, is the body color of Saṃkusumitarājendra, who presides over the fire element.[337] The shapes of the separate altars were determined mainly in accordance with the body color of the main deity and do not coincide with the assignment of the five elements to the five directions. Thus at the stage of the *Vai-*

FIG. 3.22. MAHĀYĀNĀBHISAMAYA-MAṆḌALA

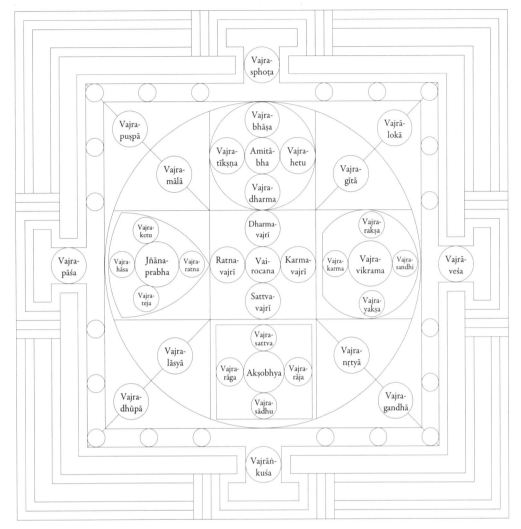

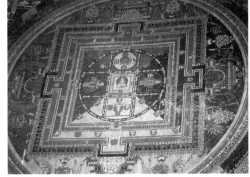

FIG. 3.23. MAHĀYĀNĀBHISAMAYA-MAṆḌALA
(PALKHOR CHÖDE)

rocanābhisambodhisūtra, the body colors of the five buddhas, the colors of the five elements, the assignment of the five elements to the five directions, and the shapes of the separate altars did not yet relate to one another and had not been integrated into a single consistent system. It was in the later Yoga tantras, which basically adopted the fivefold system of the Vajradhātu-maṇḍala, that the five-element theory was incorporated from the *Vairocanābhi-sambodhisūtra* and these merged into a single system.

It has become clear that the deities of the *Vajramaṇḍalālaṃkāratantra* influenced those of the *Māyājālatantra* (new translation) to be considered in chapter 5.[338] In contrast to the standard theory of the Vajraśekhara cycle, the *Māyājālatantra* determined the body colors of the five buddhas on the basis of the colors of the five elements,[339] and these body colors went on to be adopted in the *Kālacakratantra*. Therefore the synthesis of the maṇḍala and cosmology to which the late Yoga tantras aspired could be described as a precursor of the *Kālacakratantra*, with which Indian esoteric Buddhism ended.

Only a small number of examples of the maṇḍalas of late Yoga tantras deriving from the *Prajñāpāramitānayasūtra* are found in Tibet. However, in the north chapel in the dome of

the Great Stūpa of Palkhor Chöde monastery there are depicted the Vajramaṇḍa-maṇḍala and Mahāyānābhisamaya-maṇḍala of the *Vajramaṇḍalālaṃkāratantra* on the north wall and the Sarvatathāgataguhya-maṇḍala on the east wall, while on the south wall of the south chapel there are four maṇḍalas, namely, the Kāyavākcittaguhyālaṃkāravyūha-maṇḍala, Kāmadhātvīśvara-maṇḍala, *Prajñāpāramitāvistarasādhana-maṇḍala, and *Prajñāpāramitāpauṣṭika-maṇḍala.[340] These are all valuable exemplars, since most of them date from the early fifteenth century.

As will be seen in chapter 6, the *Paramādyatantra* and *Vajramaṇḍalālaṃkāratantra* share many identical or similar verses with the *Samāyogatantra*, the precursor of the Mother tantras. I will also show, chiefly on the basis of a comparison of the mantras of the deities of both maṇḍalas, that the maṇḍalas explained in the "Mantrakhaṇḍa" of the *Paramādyatantra* developed into the six-family maṇḍala of the *Samāyogatantra* (see fig. 6.3).[341]

When I first published my research on the above matters, no examples of the maṇḍalas explained in the "Mantrakhaṇḍa" of the *Paramādyatantra* had been identified in Tibet. But since then Kawasaki Kazuhiro has identified maṇḍalas explained in the "Mantrakhaṇḍa" at Jampa Lhakhang in Lo Manthang, Mustang, that confirm the iconographical development from the maṇḍalas of the *Paramādyatantra* to those of the *Samāyogatantra*.[342] Thus the *Prajñāpāramitānayasūtra* not only influenced the genesis of the *Sarvatathāgatatattvasaṃgraha* and Vajradhātu-maṇḍala, but also contains elements that link it directly to late tantric Buddhism. In this respect the *Prajñāpāramitānayasūtra* played an important role in the history of esoteric Buddhism.

4. The Emergence of the Vajradhātu-maṇḍala

1. The Legend of the Iron Stūpa in South India and the Eighteen Tantras of the Vajraśekhara Cycle in 100,000 Stanzas

THE *PRAJÑĀPĀRAMITĀNAYASŪTRA* CLOSELY combined theory with the maṇḍala to a degree never seen before through the deification of doctrinal propositions. In the *Prajñāpāramitānayasūtra* doctrinal propositions are arranged in groups of four or five. Thus a maṇḍala that was symmetrical vertically as well as horizontally could be easily created. The Vajradhātu-maṇḍala explained in the *Sarvatathāgatatattvasaṃgraha* is also considered to be a development of the *Prajñā-pāramitānayasūtra*. In this chapter, I survey the characteristics of the Vajradhātu-maṇḍala and consider how its revolutionary system came into existence.

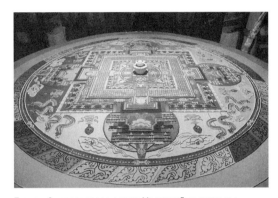

FIG. 4.1. SAND MAṆḌALA OF THE VAJRADHĀTU-MAṆḌALA (RAJA MONASTERY, QINGHAI)

The *Vajraśekharasūtra*, which explains the Vajradhātu-maṇḍala, is not a single sūtra but a collection of eighteen tantras called the "eighteen assemblies of the *Vajraśekharasūtra*." According to legend, after having recorded Vairocana's teachings, Vajrasattva concealed them in an iron stūpa in South India, and they were later discovered by Nāgārjuna, the first of the eight patriarchs of Shingon Buddhism, who opened the iron stūpa.

Although this Nāgārjuna has the same name as the great philosopher of Mahāyāna Buddhism who lived in the second to third centuries, he is thought to have been active in the seventh century and was a teacher of Nāgabodhi, who transmitted the Vajraśekhara cycle to Vajrabodhi (671–741). Japanese Shingon Buddhism regards these two Nāgārjunas as one and the same person and considers Nāgabodhi to have lived for seven hundred years so as to bridge the gap between Nāgārjuna in the second to third centuries and Vajrabodhi in the eighth century.[343]

As for the iron stūpa, various views have been put forward by Shingon scholar-priests, and there even appeared the view that the iron stūpa is not a physical structure but a symbol of the *bodhicitta* inherent in the minds of sentient beings. In contrast to this thesis of a noumenal tower (*ritō*), the assertion of the existence of an iron stūpa 160 feet in height in South India is referred to as the thesis of a phenomenal tower (*jitō*).

Toganoo Shōun, who modernized the study of esoteric Buddhism on Mount Kōya, argued that the model for the iron stūpa in South India was the great stūpa of Amarāvatī.[344] In fact, the stūpa at Amarāvatī is not an iron stūpa, since it is covered in white limestone slabs.[345] But Toganoo, inheriting the traditional interpretation of Shingon Buddhism, took the view that the shiny white slabs were mistaken for "white iron," or tin. I reconsider this question later in this chapter.

The *Shibahui zhigui*, Amoghavajra's summary of the contents of the eighteen great

FIG. 4.2A. KUE MANDARA

Shiin-e	Ichiin-e	Rishu-e
Kuyō-e	Jōjin-e	Gōzanze-e
Misai-e	Sanmaya-e	Gōzanze-sanmaya-e

FIG. 4.2B. KUE MANDARA (HASEDERA; FROM *TAISHŌ SHINSHŪ DAIZŌKYŌ ZUZŌBU*)

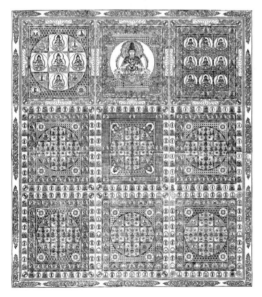

tantras of the Vajraśekhara cycle, describes in detail the contents of only the first text, the *Sarvatathāgatatattvasaṃgraha*, and briefly summarizes the main points of the other seventeen tantras. Therefore many researchers have doubted the existence of eighteen tantras in 100,000 stanzas. But several esoteric Buddhist scriptures translated into Chinese after Amoghavajra during the Northern Song dynasty and translated into Tibetan after the eighth century tally with Amoghavajra's descriptions, and some scholars have identified them with the second, third, fourth, sixth, eighth, ninth, thirteenth, fifteenth, and sixteenth tantras of the Vajraśekhara cycle.[346]

Although these texts do not always expound the same doctrines, they share the characteristics of a fivefold system consisting of the Tathāgata, Vajra, Ratna (Jewel), Dharma (Lotus), and Karma (Action) families in contrast to earlier systems up to the *Vairocanābhisambodhisūtra*, which had been based on a threefold system consisting of the Buddha, Lotus, and Vajra families. This fivefold system coincides, moreover, with the basic structure of the Vajradhātu-maṇḍala.

The *Sarvatathāgatatattvasaṃgraha* consists of four main parts—Vajradhātu, Trailokyavijaya, Jagadvinaya, and Sarvārthasiddhi—and explains twenty-eight maṇḍalas in all. Among these, the Vajradhātu-mahāmaṇḍala (corresponding to the Jōjin-e in the nine-assembly Kue mandara) explained at the start of the Vajradhātu section is the most important. It consists of thirty-seven deities—five buddhas, sixteen great bodhisattvas, four *pāramitā* goddesses, four inner and four outer offering goddesses, and four gatekeepers—and represents the basic pattern of the Vajradhātu cycle. The Samaya-maṇḍala (Sanmaya-e in the Kue mandara), Dharma-maṇḍala (Misai-e), and Karma-maṇḍala (Kuyō-e) also explained in the Vajradhātu section can be interpreted as variations of the same basic pattern. The Caturmudrā-maṇḍala (Shiin-e) is a simplified form of maṇḍala in which the basic structure has been extracted from the complex Vajradhātu-maṇḍala. The Ekamudrā-maṇḍala (Ichiin-e) is the ultimate simplification that shows only the primordial one.[347]

The Kue mandara, the current version of the Vajradhātu-maṇḍala in Sino-Japanese Buddhism, combines the six maṇḍalas described in the Vajradhātu section with the first two maṇḍalas described in the Trailokyavijaya section and the Rishu-e, which, as was seen in chapter 3, was adapted from the *Prajñāpāramitānayasūtra* (figs. 4.2a and 4.3). The Vajradhātu eighty-one-deity maṇḍala used mainly in the Japanese Tendai sect, on the other hand, depicts only the Vajradhātu-mahāmaṇḍala, corresponding to the Jōjin-e of the Kue mandara. The Vajradhātu-maṇḍala has also been transmitted in Tibetan Buddhism, and the twenty-eight maṇḍalas explained in the *Sarvatathāgatatattvasaṃgraha* are depicted as separate maṇḍalas.[348]

Today it is generally considered that it was Huiguo (746–805) who first combined nine separate maṇḍalas to create the Kue mandara, as was the case with the current version of the Garbha-maṇḍala. The reason that the Kue mandara was adopted as the Vajradhātu-maṇḍala in the two-world maṇḍalas was that if the eighty-one-deity maṇḍala had been adopted as the Vajradhātu-maṇḍala, this would have resulted in a marked lack of balance with its counterpart, the Genzu mandara consisting of 414 deities.

As in the case of the Genzu mandara, the Kue mandara devised by Huiguo is currently used in Japan, and therefore Japanese scholars had thought that a similar maṇḍala had existed in India. But the basic Vajradhātu-maṇḍala is not the Kue mandara but the Vajradhātu-mahāmaṇḍala, corresponding to the Jōjin-e of the Kue mandara. In the following sections I

FIG. 4.3. THE *SARVATATHĀGATATATTVASAṂGRAHA* AND KUE MANDARA

		TWENTY-EIGHT MAṆḌALAS	§§	KUE MANDARA
Vajradhātu section (Tathāgata family)		1. Vajradhātu-mahāmaṇḍala (M)	1–318	Jōjin-e
		2. Vajraguhya-maṇḍala (S)	319–417	Sanmaya-e
		3. Vajrajñāna-dharmamaṇḍala (D)	418–492	Misai-e
		4. Vajrakārya-karmamaṇḍala (K)	493–561	Kuyō-e
		5. Caturmudrā-maṇḍala (C)	562–596	Shiin-e
		6. Ekamudrā-maṇḍala (E)	597–617	Ichiin-e
Trailokyavijaya section (Vajra family)		7. Trilokavijaya-mahāmaṇḍala (M)	618–989	Gōzanze-e
		8. Krodhaguhyamudrā-maṇḍala (S)	990–1066	Gōzanze-sanmaya-e
		9. Vajrakula-dharmajñānasamayamaṇḍala (D)	1067–1120	
		10. Vajrakula-karmamaṇḍala (K)	1121–1168	
		11. Caturmudrā-maṇḍala (C)	1169–1190	
	Outer Vajra family	12. Ekamudrā-maṇḍala (E)	1191–1205	
		13. Trilokacakra-mahāmaṇḍala (M)	1206–1331	
		14. Sarvavajrakula-vajramaṇḍala (S)	1332–1373	
		15. Sarvavajrakula-dharmasamayamaṇḍala (D)	1374–1401	
		16. Sarvavajrakula-karmamaṇḍala (K)	1402–1467	
Jagadvinaya section (Lotus family)		17. Sarvajagadvinaya-mahāmaṇḍala (M)	1468–1612	
		18. Padmaguhya-mudrāmaṇḍala (S)	1613–1708	
		19. [Dharma-]jñānamaṇḍala (D)	1709–1750	
		20. [Padma-]karmamaṇḍala (K)	1751–1797	
		21. Caturmudrā-maṇḍala (C)	1798–1817	
		22. Ekamudrā-maṇḍala (E)	1818–1830	
Sarvārthasiddhi section (Jewel family)		23. Sarvārthasiddhi-mahāmaṇḍala (M)	1831–1961	
		24. Ratnaguhya-mudrāmaṇḍala (S)	1962–2036	
		25. [Ratna-]jñānamaṇḍala (D)	2037–2080	
		26. [Ratna-]karmamaṇḍala (K)	2081–2109	
		27. Caturmudrā-maṇḍala (C)	2110–2122	
		28. Ekamudrā-maṇḍala (E)	2123–2130	
Uttaratantra			2131–2708	
Uttarottaratantra			2709–2979	
Appendix			2980–3070	

(M): *mahā-maṇḍala*; (S): *samaya-maṇḍala*; (D): *dharma-maṇḍala*; (K): *karma-maṇḍala*; (C): *caturmudrā-maṇḍala*; (E): *ekamudrā-maṇḍala*.

shall consider how the Vajradhātu-maṇḍala, consisting of thirty-seven deities classified into five families, came into existence.

2. The Discovery of Esoteric Icons Belonging to the Vajradhātu Cycle in India

In India, late tantric Buddhism, which evolved from the Vajraśekhara cycle, prevailed after the ninth century. In contrast to the Garbha-maṇḍala, which was rapidly forgotten, the Vajradhātu-maṇḍala was revered as a classical maṇḍala during the age of late tantric Buddhism.[349] But examples of Vajradhātu-Vairocana, its main deity, are not common in India.

Among those that have been found to date, a gilt-bronze statue unearthed at Nālandā (held by the National Museum, New Delhi) is worth noting although it is quite small, being only 23.2 centimeters high. It is a four-headed Vajradhātu-Vairocana forming the enlightenment mudrā with both hands. He holds a five-pronged vajra in his fists, which form the enlightenment mudrā, and the tip of the vajra is visible above his right fist. This use of the enlightenment mudrā with a five-pronged vajra, not explained in the *Sarvatathāgatatattvasaṃgraha*, is thought to have been an iconographical feature current during the Pāla dynasty, since it occurs in the *Sarvatathāgatatattvasaṃgrahamahāyānābhisamaya nāma tantravyākhyā tattvālokakarī* (hereafter *Tattvālokakarī*)[350] by Ānandagarbha (ninth century), an authority on the Yoga tantras, and in the *Niṣpannayogāvalī*[351] by Abhayākaragupta.

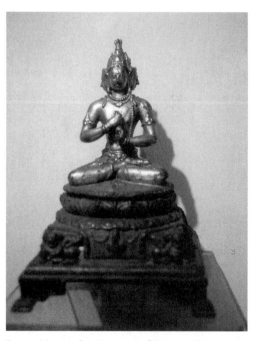

FIG. 4.4. VAJRADHĀTU-VAIROCANA (NATIONAL MUSEUM, NEW DELHI)

The symbols of the four buddhas of the Vajradhātu-maṇḍala are engraved on the seat of the above statue in the four cardinal directions. Although they can be interpreted as the symbols of the four buddhas, it is better to interpret them as the four *pāramitā* goddesses arranged around Vairocana in the four cardinal directions in the central circle of the Vajradhātu-maṇḍala. According to the above commentary by Ānandagarbha, the four *pāramitā* goddesses are depicted not in human form but as symbols of the four buddhas.[352] Judging from these iconographical characteristics, this statue is thought to have been produced in the late Pāla dynasty (tenth to eleventh centuries) (fig. 4.4).

Nālandā has also yielded a remarkable stone statue of Vajradhātu-Vairocana (Archaeological Museum, Nālandā). It is even smaller than the above gilt-bronze statue and had been identified as Vajrasattva.[353] It has additional faces on both sides of the main face and forms the enlightenment mudrā with both hands, but there is no evidence of a five-pronged vajra. It is notable that the head of the image does not have a crown of braided hair but is covered in tightly curled hair, as is usual with buddha images. Miyaji Akira judges it to have been produced in the tenth to eleventh centuries,[354] but in contrast to the gilt-bronze statue, which clearly shows iconographical features of the late Pāla dynasty, this statue has older elements dating from as early as the eighth to ninth centuries.

A stone statue kept in the central chapel at Udayagiri, Orissa, 1.8 meters in height (ninth century), is the largest among the images of Vajradhātu-Vairocana discovered in India. It forms the enlightenment mudrā with both hands and wears ornaments such as a necklace, upper arm bracelets, and a *yajñopavīta* (sacred thread). It has a crown of braided hair with hair falling down over the shoulders. On both sides of the halo and the throne the four outer offering goddesses (Dhūpā, Puṣpā, Ālokā, and Gandhā) have been engraved. The reason that the outer offering goddesses are arranged around Vajradhātu-Vairocana is that, whereas the

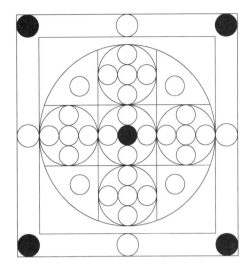

Puṣpā		Ālokā
	Vajradhātu-Vairocana	
Dhūpā		Gandhā

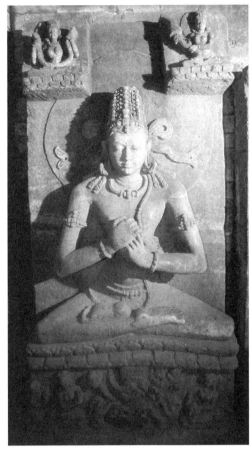

FIG. 4.5. VAJRADHĀTU-VAIROCANA (UDAYAGIRI)

inner offering goddesses were brought forth by Vairocana as offerings to the four buddhas, the outer offering goddesses are emanations of the four buddhas in response to Vairocana's offerings. This statue may be regarded as a representative example of Vajradhātu-Vairocana in India, since both its workmanship and condition are outstanding (fig. 4.5).

In the Potala Palace in Tibet there is a shrine called Lima Lhakhang (Bell Metal Shrine). It houses around 1,700 gilt-bronze statues, including some produced in India during the Pāla dynasty and in Kashmir. Several are related to the Vajradhātu-maṇḍala, and in particular a set of images of the five buddhas of the Vajradhātu-maṇḍala (Kashmir, eleventh century), 14.7 centimeters high and 25.6 centimeters across, is especially remarkable. An inscription in Tibetan script is engraved on the pedestal and records that they were a donation from a monk named Lhai Jangchup, namely, the king Lhatsunpa Jangchup Ö of western Tibet.[355]

The main deity in this set, Vajradhātu-Vairocana, is represented in the form of a bodhisattva (or *sambhogakāya*), whereas the four buddhas are represented as tathāgatas (or *nirmāṇakāya*). Indian examples of the five buddhas are frequently centered on Vairocana in tathāgata form with the dharma-wheel mudrā. This example, on the other hand, is centered on Vajradhātu-Vairocana in bodhisattva (or *sambhogakāya*) form, and animals and birds are arranged under the lotus seats. Moreover, Akṣobhya, Ratnasambhava, and Amoghasiddhi wear robes with the right shoulder exposed, whereas Amitābha wears a robe covering both shoulders, and this coincides with their iconography in the *Gobu shinkan* and with the images of the five buddhas of the Vajradhātu-maṇḍala at Anshōji temple, the earliest extant examples in Japan. This example held in the Lima Lhakhang thus seems to be the closest extant work of Indian provenance to the five buddhas of the Vajradhātu-maṇḍala transmitted in Japan (fig. 4.6).

In the so-called Jajpur compound, Orissa, there are preserved some remarkable images that are important for considering the emergence of the Vajradhātu-maṇḍala. They are seated images of Akṣobhya and Amitābha, both 60 centimeters high and 40 centimeters wide. They are said to have been enshrined in the four cardinal directions of a stūpa in Ratnagiri together with Ratnasambhava and Amoghasiddhi, now lost.[356] They are too small to have been the four buddhas enshrined in the four cardinal directions of the main stūpa at

FIG. 4.6. THE FIVE BUDDHAS OF THE VAJRADHĀTU-MAṆḌALA (LIMA LHAKHANG, POTALA PALACE, TIBET; © ULRICH VON SCHROEDER)

FIG. 4.7. AKṢOBHYA (JAJPUR COMPOUND)

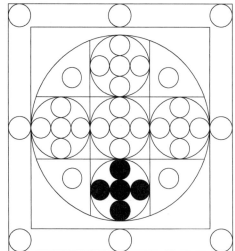

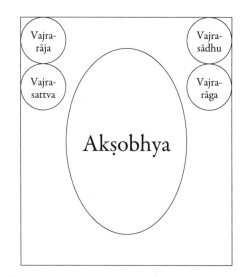

Vajra-rāja · Vajra-sādhu · Vajra-sattva · Vajra-rāga

Akṣobhya

Ratnagiri, but since Akṣobhya, Amitābha, and Ratnasambhava with a similar arrangement of attendants have been found at Ratnagiri, there can be no doubt that they were enshrined in a stūpa somewhere in Ratnagiri (figs. 4.7, 4.8).

As in the example of Vajradhātu-Vairocana from Udayagiri, images of the Vajradhātu cycle frequently take the form of a pentad in which the four attendants are arranged on the throne or in the halo. These two statues at Jajpur also have four attendants engraved on the upper part of the halo, two on each side. Investigations conducted by Shuchiin University in 1992 ascertained that these attendant bodhisattvas engraved on the halos of Akṣobhya and Amitābha are eight of the sixteen great bodhisattvas of the Vajradhātu-maṇḍala.

In the Vajradhātu-maṇḍala four of the sixteen great bodhisattvas are arranged around each of the four buddhas. These groups of four bodhisattvas are called the "four close attendants" of the four buddhas, and in the case of the four buddhas of Jajpur they were engraved on the upper part of the halo of each buddha. Such pentads of the Vajradhātu cycle can be interpreted as icons for worship purposes that were influenced by the fivefold system of the Vajradhātu-maṇḍala.

A considerable number of images belonging to the Vajradhātu cycle have thus been unearthed from Indian soil. In contrast to images of Vairocanābhisambodhi, which are

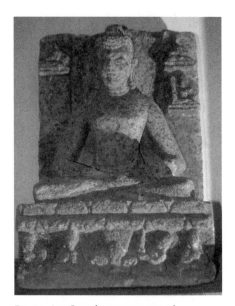

FIG. 4.8. AMITĀBHA (JAJPUR COMPOUND)

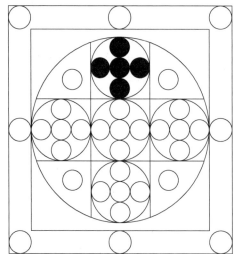

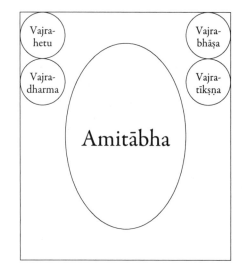

Vajra-hetu · Vajra-bhāṣa · Vajra-dharma · Vajra-tīkṣṇa

Amitābha

concentrated in Orissa, Vajradhātu-Vairocana is widely distributed from Kashmir in the north to Orissa in the south. This would suggest that the *Sarvatathāgatatattvasaṃgraha* circulated widely all over the Indian subcontinent.

3. From Three Families to Five Families

Thus the Vajradhātu-maṇḍala is characterized by a fivefold system that classifies all deities into five families. How did this pentalogy of the Vajradhātu-maṇḍala come into existence?

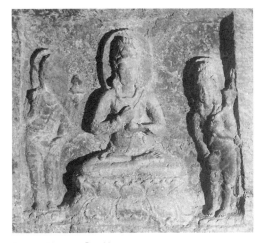

FIG. 4.9. VAJRADHĀTU-VAIROCANA TRIAD (SECOND STORY, ELLORA CAVE 12)

One of the keys to solving this mystery is the Vajradhātu-Vairocana triad carved in relief on a pillar in the hall on the second story of Ellora Cave 12. This triad is centered on Vajradhātu-Vairocana in bodhisattva (*sambhogakāya*) form with the enlightenment mudrā, flanked by two standing bodhisattvas. Unfortunately, the iconography of the bodhisattva on the right is not clear because his head is damaged, but he seems to be holding a lotus stalk (with the flower missing) growing up out of the ground. The bodhisattva on the left is clearly identifiable as Vajrapāṇi, since he is holding a lotus flower (*utpala*) surmounted by a vajra in his left hand (fig. 4.9).

The composition of this triad seems like the inverse of the Vairocanābhisambodhi triad in Chapel 4 at Ratnagiri, discussed in chapter 2. In the Ratnagiri triad, Avalokiteśvara and Vajrasattva exhibit a more developed iconography belonging to the Vajradhātu cycle even though the central figure is Vairocanābhisambodhi. In the Ellora triad, on the other hand, Avalokiteśvara and Vajrapāṇi display an iconography similar to the two flanking attendants in Śākyamuni triads frequently found in cave temples in western India, even though this triad is centered on Vajradhātu-Vairocana.

As mentioned, Buddhist icons belonging to the Vajradhātu cycle frequently take the form of a pentad. If we compare the five families of the Vajradhātu-maṇḍala—Tathāgata, Vajra, Ratna, Dharma, and Karma—with the three families of the Garbha-maṇḍala, the Tathāgata family of the former corresponds to the Buddha family of the latter, and the Dharma family of the former corresponds to the Lotus family of the latter. Therefore the five families of the Vajradhātu-maṇḍala can be interpreted as representing the addition of the Ratna and Karma families to the earlier three families. As has been pointed out by Yoritomi Motohiro, in comparatively well-developed early esoteric Buddhist scriptures such as the *Amoghapāśakalparāja* and *Ekākṣaroṣṇīṣacakravartinsūtra*, in addition to the three families (Buddha, Lotus, and Vajra), mention is made of the Maṇi (Jewel) family as the fourth family and of the Gandhahastin or Mahāhastin family as the fifth. Yoritomi further notes that the Maṇi family developed into the Ratna (Jewel) family of later times.[357] The *Subāhuparipṛcchā*, on the other hand, lists the Lotus, Vajra, Maṇi, and Pāñcika families.[358] Furthermore, the *Sarvatathāgatatattvasaṃgraha* refers to the Jewel family not as *ratna-kula* but as *maṇi-kula* even in its *uttaratantra*.

However, most of the deities assigned to the Maṇi family in early esoteric Buddhist scriptures are treasure gods who are *yakṣas*. Ratnasambhava and Ākāśagarbha (Vajraratna), who were to become the principal deities of the later Ratna family, were not included in the Maṇi family, which is why it was classified among the "mundane families" in early esoteric Buddhist scriptures. It is worth noting that the *Mañjuśrīmūlakalpa* calls Jambhala, one of the chief *yakṣa*-cum-treasure gods, a bodhisattva in the form of a *yakṣa* (*yakṣarūpī bodhisattva*).[359] Jambhala was widely worshiped also in late tantric Buddhism, and his crown was

frequently adorned with Ratnasambhava, the lord of the Ratna family.[360] This fact confirms that the Maṇi family developed into the later Ratna family.

Ākāśagarbha became the lord of the Maṇi family for the first time in the *Prajñāpāramitānayasūtra*. The expositor of chapter 5, "Ākāśagarbha," is a tathāgata named Sarvatraidhātukādhipati, who is identified with Ratnasambhava in the *Liqu shijing*.[361] But Ratnasambhava appears only in the last chapter of the Chinese translation of the *Paramādyatantra*.[362] Therefore the *Prajñāpāramitānayasūtra* originally did not incorporate the four-buddha theory originating in the *Suvarṇaprabhāsasūtra*. Ratnasambhava became the lord of the Jewel family for the first time in the *Sarvatathāgatatattvasaṃgraha*.[363]

The relationship between the Gandhahastin family, regarded as the fifth family in early esoteric Buddhist scriptures, and the Karma family is not clear.[364] It is also difficult to posit any connection between the Pāñcika family of the *Subāhuparipṛcchā* and the Karma family, since the Pāñcika family is related to Pāñcika, considered to be the husband of Hārītī.

The *Sarvatathāgatatattvasaṃgraha* is characterized by the fivefold system, and yet it consists of only four main parts and lacks a part corresponding to the Karma family. It introduced an unprecedented five-family system, but with regard to the classification of deities it followed earlier esoteric Buddhism. Therefore when compared with the three well-established families—Buddha, Lotus, and Vajra—the newly introduced Ratna and Karma families seem to be somewhat underdeveloped. Of these latter two families, the Ratna family is thought to have developed from the Maṇi family of early esoteric Buddhism and the *Paramādyatantra*, with Ratnasambhava, one of the five buddhas, having been adopted as the lord of the Ratna family.

The Karma family centered on Amoghasiddhi, on the other hand, is thought to have developed from chapter 6, "Vajramuṣṭi," in the *Prajñāpāramitānayasūtra*, coming immediately after the "Ākāśagarbha" chapter representing the Maṇi family. As will be seen in the next section, Vajramuṣṭi became one of the four attendants of Amoghasiddhi in the Vajradhātu-maṇḍala. But in the "Mantrakhaṇḍa" of the *Paramādyatantra* Ākāśagarbha became the lord of the Maṇi family, whereas Vajramuṣṭi did not form an independent family, since his maṇḍala was omitted in the "Mantrakhaṇḍa."

The *Sarvatathāgatatattvasaṃgraha* brought to completion the maṇḍala consisting of five families, with the addition of the Karma family to the four families of the *Paramādyatantra*. But the newly introduced Karma family had not yet developed as a group of deities. This seems to be the reason that a part corresponding to the Karma family is missing in the *Sarvatathāgatatattvasaṃgraha*.

The Vajradhātu-Vairocana triad on the second story of Ellora Cave 12 suggests that the five families of the Vajradhātu-maṇḍala developed from the three families of the Garbha-maṇḍala. As was seen in chapter 2, Ellora Cave 12 has been dated to the early eighth century, while the *Sarvatathāgatatattvasaṃgraha* is thought to have emerged in the second half of the seventh century. Therefore the Vajradhātu-maṇḍala already existed when Ellora Cave 12 was carved. However, it is reasonable to posit a time lag of half a century between the composition of a scripture and the actual creation of icons based thereon. It is significant that Vajradhātu-Vairocana appeared for the first time in Cave 12, the last Buddhist cave to be carved at Ellora.

From the eighth century on, it was the Vajradhātu-maṇḍala, consisting of five families, rather than the Garbha-maṇḍala consisting of three families, that spread rapidly throughout India.

FIG. 4.10. THE THIRTY-SEVEN DEITIES OF THE VAJRADHĀTU-MAṆḌALA

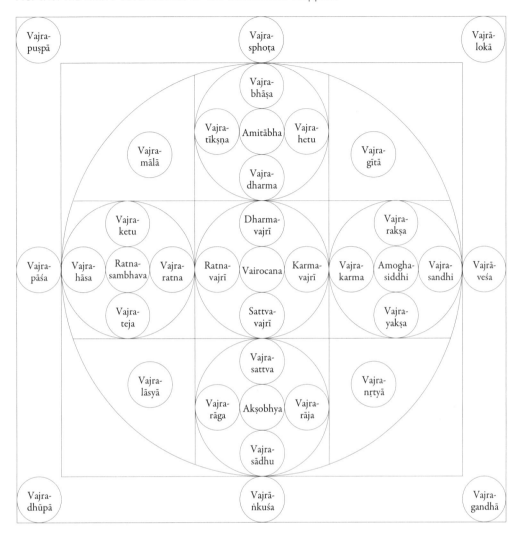

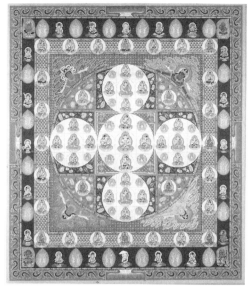

FIG. 4.11. VAJRADHĀTU EIGHTY-ONE-DEITY MAṆḌALA
(TAIYŪJI TEMPLE, OSAKA)

4. The Evolution of the Sixteen Great Bodhisattvas

Among the twenty-eight maṇḍalas explained in the *Sarvatathāgatatattvasaṃgraha*, the first one, the Vajradhātu-mahāmaṇḍala (Jōjin-e), is the most important. This maṇḍala presents the basic pattern of maṇḍalas belonging to the Vajradhātu cycle, consisting of thirty-seven deities collectively known as the thirty-seven deities of the Vajradhātu—five buddhas, sixteen great bodhisattvas, four *pāramitā* goddesses, eight offering goddesses, and four gatekeepers (fig. 4.10). The other twenty-seven maṇḍalas are variations or simplified forms of this basic pattern. Therefore when considering the emergence of the Vajradhātu-maṇḍala, it becomes important to elucidate the evolution of the thirty-seven deities.

Among these deities, the five buddhas of the Vajradhātu-maṇḍala have already been discussed above. In the following sections, I shall consider the evolution of the remaining thirty-two deities in the order of the sixteen great bodhisattvas (this section), the four *pāramitā* goddesses (section 5), the eight offering goddesses (section 6), and the four gatekeepers (section 7). In addition to these thirty-seven deities, the sixteen bodhisattvas or one thousand

buddhas of the Bhadrakalpa and the gods of the four elements (in Japanese examples) are also depicted in the Vajradhātu-maṇḍala. However, they have been excluded from consideration, since they are secondary deities not explained in the *Sarvatathāgatatattvasaṃgraha*.[365]

The sixteen great bodhisattvas are the representative deities of the *Sarvatathāgatatattvasaṃgraha* and are depicted in small moon discs arranged around the four buddhas occupying the central moon discs in the four cardinal directions of the central circle. Although they have various epithets, they are usually referred to by the heart mantras (*hṛdaya-mantra*) uttered in the course of the generation of each bodhisattva in the *Sarvatathāgatatattvasaṃgraha*. These names are styled by Śākyamitra, one of the three Indian commentators on the *Sarvatathāgatatattvasaṃgraha*, as "names from the point of view of the mantra."[366] They are all prefixed by "Vajra," as in Vajrasattva, Vajrarāja, Vajrarāga, and so on, and may be regarded as names unique to the Vajradhātu-maṇḍala.

In contrast, what Śākyamitra calls "names from the point of view of the *mahāmudrā*" are names taken over from earlier exoteric and early or middle-period esoteric Buddhism. They are the deities' usual names as bodhisattvas and are also their names in exoteric Buddhism before they receive their vajra name during their initiation into esoteric Buddhism.[367]

FIG. 4.12. THE SIXTEEN GREAT BODHISATTVAS AND THE EIGHT GREAT BODHISATTVAS OF THE *PRAJÑĀPĀRAMITĀNAYASŪTRA*

	SIXTEEN GREAT BODHISATTVAS	NAMES FROM THE POINT OF VIEW OF THE *MAHĀMUDRĀ*	EIGHT GREAT BODHISATTVAS OF THE *PRAJÑĀPĀRAMITĀNAYASŪTRA*
East	1. Vajrasattva	Samantabhadra	1. Vajrapāṇi
East	2. Vajrarāja	Amogharāja	
East	3. Vajrarāga	Māra	
East	4. Vajrasādhu	Prāmodyarāja	
South	5. Vajraratna	Ākāśagarbha	3. Ākāśagarbha
South	6. Vajrateja	Mahāteja	
South	7. Vajraketu	Ratnaketu	
South	8. Vajrahāsa	Nityaprītipramuditendrya	
West	9. Vajradharma	Avalokiteśvara	2. Avalokiteśvara
West	10. Vajratīkṣṇa	Mañjuśrī	5. Mañjuśrī
West	11. Vajrahetu	Sahacittotpāditadharmacakrapravartin	6. Sahacittotpādadharmacakrapravartin
West	12. Vajrabhāṣa	Avāca	
North	13. Vajrakarma	Sarvatathāgataviśvakarma	(7. Gaganagañja)
North	14. Vajrarakṣa	Duryodhanavīrya	
North	15. Vajrayakṣa	Sarvamārabalapramardin	8. Sarvamārabalapramardin
North	16. Vajrasandhi	Sarvatathāgatamuṣṭi	4. Vajramuṣṭi

The correspondence between Vajrakarma and Gaganagañja is based not on the *Sarvatathāgatatattvasaṃgraha* but on its explanatory tantra, the *Vajraśekhara*.

Therefore we must take up these "names from the point of view of the *mahāmudrā*" when considering the origins of the sixteen great bodhisattvas.

In the *Prajñāpāramitānayasūtra*, the eight great bodhisattvas were explained as deifications of each section, and at the start of the *Sarvatathāgatatattvasaṃgraha* (§5) these eight great bodhisattvas of the *Prajñāpāramitānayasūtra* are listed as the principal members of the audience. If we compare the eight great bodhisattvas of the *Prajñāpāramitānayasūtra* with the "names from the point of view of the *mahāmudrā*" of the sixteen great bodhisattvas, we arrive at the following correspondences: Vajrapāṇi = Vajrasattva, Mañjuśrī = Vajratīkṣṇa, Ākāśagarbha = Vajraratna, Avalokiteśvara = Vajradharma, Sacittotpādadharmacakrapravartin = Vajrahetu, Vajramuṣṭi = Vajrasandhi,[368] and Sarvamārapramardin = Vajrayakṣa (fig. 4.12).

As for Gaganagañja, whose "name from the point of view of the *mahāmudrā*" alone is missing from the eight great bodhisattvas of the *Prajñāpāramitānayasūtra*, the *Lüeshu jingangding yuga fenbie shengwei xiuzheng famen*[369] and *Jingangding yuga lüeshu sanshiqizun xinyao*[370] explain that he is identical to Vajrakarma among the sixteen great bodhisattvas. In the Rishukyō mandara transmitted in Japan, Gaganagañja is frequently depicted with the same iconography as that of Vajrakarma.[371] In Tibetan materials, too, the *Paramādiṭīkā* by Ānandagarbha makes the iconography of Gaganagañja the same as that of Vajrakarma in the Vajradhātu-maṇḍala.[372] Therefore Gaganagañja was identified with Vajrakarma in India too.

Many scholars had already noticed that the *Sarvatathāgatatattvasaṃgraha* and *Prajñāpāramitānayasūtra* have a lot in common. When considering the emergence of the Vajradhātu-maṇḍala, the question of which of these two texts pre-dates the other becomes an important issue. The *Prajñāpāramitānayasūtra* explains that one can attain buddhahood and the state of Vajradhara with the lives of the sixteen great bodhisattvas.[373] The *Liqu shijing* comments on this as follows: "'In the lives of the sixteen great [bodhisattvas]' means from the bodhisattva Vajrasattva to the bodhisattva Vajramuṣṭi, and in the final life one accomplishes Vairocana's body."[374]

Until recently the *Prajñāpāramitānayasūtra* had been thought to presuppose the existence of the sixteen great bodhisattvas of the Vajradhātu-maṇḍala. However, there also existed the view, as in the case of Ānandagarbha, that the sixteen great bodhisattvas correspond to Vajrarūpa through to Vajragarva, namely, the sixteen attendants in the seventeen-deity maṇḍala of the *Prajñāpāramitānayasūtra*.[375] In this case, the sixteen great bodhisattvas of the Vajradhātu-maṇḍala cannot necessarily be said to have existed when the *Prajñāpāramitānayasūtra* came into existence.

As Sakai Shinten has pointed out, the second of the eighteen assemblies of the *Vajraśekhara* supplements the rituals of the Karma family after having explained the contents of the four main parts of the first assembly (i.e., *Sarvatathāgatatattvasaṃgraha*).[376] Further, the third assembly explains the General Assembly maṇḍala of the five families, which consists of the four maṇḍalas explained in the four main parts of the first assembly plus the maṇḍala of the Karma family, which is explained only in the second assembly.[377] Therefore the first, second, and third assemblies are thought to have evolved in the same order as the order of these assemblies. In the case of the *Prajñāpāramitānayasūtra* cycle, the sixth, seventh, and eighth assemblies evolved in this order and ultimately developed into the ninth assembly, the *Sarvabuddhasamāyogaḍākinījālasaṃvara*, the forerunner of the Mother tantras.[378]

As will be discussed in the next section, the secret names of the four *pāramitās* given in the *Vajraśekharamahāguhyayogatantra*, thought to correspond to the second and third assemblies of the *Vajraśekhara*, are based on the structure of the Assembly maṇḍala of the "Mantra-khaṇḍa" of the *Paramādyatantra*. The fact that the second assembly, an explanatory tantra on the first assembly, refers to the sixth or eighth assembly suggests that the order of the tantras described in the *Shibahui zhigui* does not reflect the chronological order of their composition.

On the basis of the above considerations, it would be natural to assume that the *Prajñā-pāramitānayasūtra* pre-dates the *Sarvatathāgatatattvasaṃgraha* and that its content influenced that of the latter.

One of the chapters in the *Vajramaṇḍalālaṃkāratantra* explains the *sādhanas* of nine bodhisattvas from Vajrarāja to Vajramuṣṭi,[379] after having explained the *sādhanas* of the eight great bodhisattvas of the *Prajñāpāramitānayasūtra*.[380] Eight among these nine bodhisattvas are not included among the eight great bodhisattvas of the *Prajñāpāramitānayasūtra*. In contrast to the *Paramādyatantra*, which does not mention the sixteen great bodhisattvas, the *Vajramaṇḍalālaṃkāra*, belonging to the late Yoga tantras, frequently mentions the sixteen great bodhisattvas. However, it does not explain individually the *sādhanas* of the eight bodhisattvas not included among the eight great bodhisattvas of the *Prajñāpāramitā-nayasūtra*. The *Vajramaṇḍalālaṃkāra* explains the *sādhanas* of these bodhisattvas together, which suggests that the compiler of the *Vajramaṇḍalālaṃkāra* became aware that the sixteen great bodhisattvas had come into existence because of the addition of a further eight bodhi-sattvas to the eight great bodhisattvas of the *Prajñāpāramitānayasūtra*. Thus the sixteen great bodhisattvas, constituting the nucleus of the Vajradhātu-maṇḍala, can be interpreted as a twofold expansion of the eight great bodhisattvas of the *Prajñāpāramitānayasūtra*.

5. The Evolution of the Four *Pāramitās*

The four *pāramitās* are four female bodhisattvas who are positioned at the four cardinal points around the main deity Vairocana in the Vajradhātu-maṇḍala. In Japan they are called Vajrapāramitā, Ratnapāramitā, Dharmapāramitā, and Karmapāramitā,[381] but in Indo-Tibetan Buddhism they are called Sattvavajrī, Ratnavajrī, Dharmavajrī, and Karmavajrī. As has been made clear in earlier studies, the iconography of the four *pāramitās* in the Genzu mandara is based on the *She wu'ai jing*.[382]

It was seen earlier that Ānandagarbha, in his *Tattvālokakarī*, defines the four *pāramitās* as symbols, and consequently ritual manuals of the Vajradhātu-maṇḍala composed in Tibet also often define the four *pāramitās* as symbols. In pictorial representations, too, such as the wall paintings of the Great Stūpa of Palkhor Chöde monastery in Gyantse, Dungkar Cave I, and the Vajradhātu-maṇḍala in the Ngor maṇḍalas, they are represented by symbols.

However, it is unlikely that the four *pāramitās* did not exist in the form of goddesses in India. Abhayākaragupta's *Niṣpannayogāvalī* describes the four *pāramitās* in human form, and in wall paintings at Alchi and Tsatsapuri in Ladakh they are represented as goddesses. Therefore whether or not the four *pāramitās* are depicted as goddesses seems to have depended on the school.

The *Sarvatathāgatatattvasaṃgraha* refers to the four *pāramitās* not as *bodhisattvās* (female bodhisattvas) or *devīs* (goddesses) but simply as *mudrās* (seals).[383] This suggests that they were originally symbols of the Vajra, Ratna, Dharma, and Karma families, but later,

after *mudrā* had come to be interpreted as the consort of a deity, they assumed the form of goddesses. Therefore the four *pāramitās* in human form transmitted to Japan were a comparatively new style of iconography compared with those depicted as symbols.

The reason that the *Sarvatathāgatatattvasaṃgraha* did not deify the four *pāramitās* seems to have been to avoid a situation in which Vairocana, a tathāgata, had a consort in human form.[384] But in the section on the generation of the thirty-seven deities in the *Sarvatathāgatatattvasaṃgraha* there are passages in which the four *pāramitās* themselves utter verses called *udāna*, and so the deification of the four *pāramitās* would seem to have been a natural development.

Thus the four *pāramitās* were regarded as the mothers of the four families. The *Susiddhikaramahātantra* mentions Locanā, Pāṇḍarā, and Māmakī as the mothers of the three families,[385] and bypassing the *Sarvatathāgatatattvasaṃgraha*, they developed directly into the four buddha-mothers of the *Guhyasamājatantra*. The *Sarvarahasya*, an explanatory tantra on the *Sarvatathāgatatattvasaṃgraha*, and the *Māyājālatantra* treat the four *pāramitās* and four buddha-mothers as different groups of deities, which suggests that they originally belonged to different traditions.

The names Vajrapāramitā, Ratnapāramitā, Dharmapāramitā, and Karmapāramitā are not found in earlier esoteric Buddhist scriptures. However, these deities have other "secret" names similar to the "names from the point of view of the *mahāmudrā*" for the sixteen great bodhisattvas. They occur in the mantras of the four *pāramitās*—*vajraśrī hūṃ* (Vajrapāramitā), *vajragaurī traṃ* (Ratnapāramitā), *vajratārā hrīḥ* (Dharmapāramitā), and *khavajriṇi hoḥ* (Karmapāramitā)—recited in the section on the Sanmaya-e in the rite for the Vajradhātu-maṇḍala in Japanese esoteric Buddhism. If we remove the seed-syllables from these mantras and change the vocatives to nominatives, we get the following names: Vajrapāramitā = Vajraśrī, Ratnapāramitā = Vajragaurī, Dharmapāramitā = Vajratārā, and Karmapāramitā = Khavajriṇī.

These mantras, although not explained in the *Sarvatathāgatatattvasaṃgraha*, are found in the *Lianhuabu xingui*, a ritual manual for the Vajradhātu-maṇḍala translated by Amoghavajra.[386] The Japanese scholar-priest Kōnen (1121–1204) states in his *Kongōkai shō* that the *Extracted Sūtra* (T. 866) and *Great King of Teachings* (T. 865) do not explain the four *pāramitās*' mudrās and mantras for the Sanmaya-e,[387] and Donjaku (1674–1742), another scholar-priest, similarly says in his *Kongōkai shidai shiki* that the *Great King of Teachings* and *Extracted Sūtra* do not explain the four *pāramitās*' mudrās and mantras.[388] Thus Japanese Shingon priests had long been reciting these mantras without knowing their textual source.

However, I discovered that these secret names are given in the *Vajraśekharamahāguhyayogatantra*. There, the secret names of the four *pāramitās* are given as Mahāśrī, Vajragaurī, Vajratārā, and Khavajriṇī.[389] Thus we can confirm the textual source of the four *pāramitās*' mantras and their Indian origin.

Among these four deities, Vajrapāramitā is thought to be a Buddhist version of Śrīdevī, a consort of Viṣṇu in Hinduism, since her secret name is Vajraśrī or Mahāśrī. Ratnapāramitā is a Buddhist version of Gaurī, a consort of Śiva, since her secret name is Vajragaurī. Dharmapāramitā, on the other hand, is an esoteric Buddhist version of Tārā, a female emanation of Avalokiteśvara, since her secret name is Vajratārā. This tallies with the fact that Vajraniṣmara among the Five Secrets is identified with Dharmapāramitā and Tārā in the *Jingangding yuga jingangsaduo wu bimi xiuxing niansong yigui*.[390] The origin of the final Karmapāramitā

is not clear from her secret name. At any rate, the four *paramitās* evolved by combining Hindu goddesses and Buddhist female deities who were already being worshiped, so as to form the mothers of the four families. The adoption of secret names seems to have gone hand in hand with the move to deify the four *paramitās*, originally represented by symbols of the four families.

Among these four deities, Śrī and Gaurī are Hindu goddesses while Tārā is a Buddhist female deity, and they were completely unrelated. Why, then, were they grouped together to become the mothers of the four families? As mentioned, there existed a long tradition in esoteric Buddhism, from the *Susiddhikaramahātantra* to the late tantras, that regarded Locanā as the mother of the Buddha family, Māmakī as the mother of the Vajra family, and Pāṇḍarā as the mother of the Lotus family. Why would the Vajradhātu-maṇḍala have introduced a new group called the four *paramitās* as the mothers of the four families?

The Assembly maṇḍala of the "Mantrakhaṇḍa" of the *Paramādyatantra*, centered on Vajrapāṇi, arranges Nārāyaṇa, Caṇḍīśvara, Vajrapadma, and Ākāśagarbha in the four cardinal directions and the four goddesses Vajraśrī, Vajragaurī, Vajratārā, and Khavajriṇī in the four intermediate directions. In this maṇḍala, Nārāyaṇa and Caṇḍīśvara, regarded as emanations of Vairocana and Vajrajvālānalārka, respectively, are the main deities of two maṇḍalas explained in the "Mantrakhaṇḍa." The four goddesses arranged in the four intermediate directions, meanwhile, are thought to be the consorts of the deities depicted in the four cardinal directions, and, what is more, their names coincide with the secret names of the four *paramitās*.

Therefore these goddesses with the "secret names" of the four *paramitās* are not merely the consorts of Viṣṇu, Śiva, Avalokiteśvara, and Ākāśagarbha, but are representative female deities of the four families centered on Vairocana, Vajrajvālānalārka, Avalokiteśvara, and Ākāśagarbha, respectively. Later, these four goddesses were appropriated as the mothers of four families in the *Sarvatathāgatatattvasaṃgraha*, that is, the Vajra, Ratna, Dharma (Lotus), and Karma families.

On the basis of the above considerations, the hitherto unknown origin of Karmapāramitā's "secret name" Khavajriṇī can be interpreted as follows. She was given the name Khavajriṇī in her capacity as the consort of Ākāśagarbha (since both *kha* and *ākāśa* mean "space"). But in the *Sarvatathāgatatattvasaṃgraha* she was moved from the Ratna family centered on Ākāśagarbha to the Karma family, and so the origin of her name became unclear.[391]

It is worth noting that the phrase "*bhagavatī prajñāparamitā*"[392] occurs in the mantra of Vajraśrī given in the *Paramādyatantra*. It is thus evident that Vajraśrī, that is, Vajrapāramitā, was identified with Prajñāpāramitā in this text. This interpretation happens to tally with the identification of Vajrapāramitā with Prajñāpāramitā in Japanese esoteric Buddhism. It is difficult to imagine that the current version of the *Paramādyatantra* already existed in 746, when Amoghavajra returned to China from India. But it is possible that the prototypes of the present *Paramādyatantra*, that is, the *Mahāsukhavajrāmoghasamaya*, *Mahāsukhaguhyavajra*, and *Śrīparamādya*, were circulating separately during Amoghavajra's lifetime.[393] The identification of Vajrapāramitā with Prajñāpāramitā seems to have been transmitted to Japan via Amoghavajra and others who knew of the existence of such texts.

Thus the four *paramitās* were originally *mudrās* symbolizing the four families and were represented symbolically, but later they were personified and came to be equated with the four deities Vajraśrī, Vajragaurī, Vajratārā, and Khavajriṇī mentioned in the *Śrīparamādya*.

In tandem with this process of deification, the four *pāramitās* began to be represented not by means of symbols but in the form of celestial maidens.

In the previous section I showed that the sixteen great bodhisattvas among the thirty-seven deities of the Vajradhātu-maṇḍala developed from the eight great bodhisattvas of the *Prajñāpāramitānayasūtra*. In this examination of the four *pāramitās* I again obtained considerable material from the *Śrīparamādya*, thereby reconfirming the close links between the Vajradhātu-maṇḍala and the scriptural corpus deriving from the *Prajñāpāramitānayasūtra*.

6. The Evolution of the Eight Offering Goddesses

The eight offering goddesses are female bodhisattvas arranged in the four corners of the inner and outer squares of the Vajradhātu-maṇḍala. According to the *Sarvatathāgatatattvasaṃgraha*, Vairocana brought forth four inner offering goddesses—Lāsyā, Mālā, Gītā, and Nṛtyā—as offerings to the four buddhas Akṣobhya, Ratnasambhava, Amitābha, and Amoghasiddhi, respectively. The four buddhas, in response to Vairocana's offerings, then brought forth the four outer offering goddesses Dhūpā, Puṣpā, Ālokā, and Gandhā.[394] It has not yet been clarified how these offering goddesses evolved from earlier esoteric Buddhist scriptures.

However, it is worth noting in this connection that in the *Paramādyatantra* and ritual manuals of Vajrasattva transmitted in Sino-Japanese esoteric Buddhism, the four seasons and four offerings of the seventeen-deity maṇḍala of the *Prajñāpāramitānayasūtra* are iconographically similar to the eight offering goddesses of the Vajradhātu-maṇḍala. Consequently, in the Rishu-e of the Kue mandara of Sino-Japanese Buddhism, the inner and outer offering goddesses have been transposed and the four seasons (outer offering goddesses) and four offerings (inner offering goddesses) are depicted. As noted in chapter 3, the reason for the transposing of the inner and outer offering goddesses may have been a passage in chapter 1 of the "Prajñākhaṇḍa" of the *Paramādyatantra*, according to which the bodhisattvas in the four corners of the inner square hold "a flower and so on."

Since such iconographical correspondences would hardly be accidental, it may be assumed that there is a close relationship between the Vajradhātu-maṇḍala and the seventeen-deity maṇḍala of Vajrasattva. This then raises the question of the chronological order of the appearance of the Vajradhātu-maṇḍala and the seventeen-deity maṇḍala of Vajrasattva in the *Prajñāpāramitānayasūtra*. As discussed previously, in my view the *Prajñāpāramitānayasūtra* pre-dates the *Sarvatathāgatatattvasaṃgraha*.

It would therefore be natural to suppose that the seventeen-deity maṇḍala pre-dates the Vajradhātu-maṇḍala. However, the date when the number of *viśuddhipadas* of the *Prajñāpāramitānayasūtra* became fixed at seventeen was much later than the initial composition of the text. As seen in chapter 3, there exist considerable differences between the Vajrasattva-maṇḍala explained in chapter 1 of the "Prajñākhaṇḍa" of the *Paramādyatantra* and extant examples from Tibet. Furthermore, the seventeen-deity maṇḍala appeared for the first time in the "Mantrakhaṇḍa" of the *Paramādyatantra*. Therefore we cannot determine the dates of the seventeen-deity maṇḍala and the Vajradhātu-maṇḍala solely on the basis of the dates of their textual sources, the *Prajñāpāramitānayasūtra* and *Sarvatathāgatatattvasaṃgraha*.

I now wish to consider, in some detail, differences between the iconography of the eight offering goddesses of the Vajradhātu-maṇḍala and the iconography of the four seasons and four offerings of the seventeen-deity maṇḍala. The inner offering goddesses of

the Vajradhātu-maṇḍala—Lāsyā, Mālā, Gītā, and Nṛtyā—correspond to the four offering goddesses—Lāsyā, Hāsyā, Gītā, and Nṛtyā—of the seventeen-deity maṇḍala, with only Mālā and Hāsyā not corresponding. Hāsyā shows a similar iconography to Vajrahāsa among the sixteen great bodhisattvas of the Vajradhātu-maṇḍala even though Hāsyā is female, not male.[395]

The four outer offering goddesses of the Vajradhātu-maṇḍala, on the other hand, correspond to the four seasons in the seventeen-deity maṇḍala of the *Prajñāpāramitānayasūtra*. The goddesses of the four seasons—*Madhuvajrī, *Vajrameghā, *Śāradavajrā, and *Hemantavajrā—correspond to the four outer offerings not in the standard order of Dhūpā, Puṣpā, Ālokā (=Dīpā), and Gandhā but in the order of Puṣpā, Dhūpā, Ālokā, and Gandhā. This reversal of the normal order of Dhūpā and Puṣpā also occurs in other esoteric Buddhist scriptures.[396] In the seventeen kinds of miscellaneous offerings in the rite for the Vajradhātu-maṇḍala, the offerings corresponding to the outer offerings are not *dhūpā, puṣpā, dīpā,* and *gandhā,* but *puṣpā, dhūpā, dīpā,* and *gandhā.* The same reversal of order is also found in offerings in the *Durgatipariśodhanatantra.*[397] It must therefore be assumed that there was some reason for this.

In the correspondences between the seventeen *viśuddhipadas* and the seventeen deities of the *Prajñāpāramitānayasūtra*, Madhuvajrī corresponds to (10) *bhūṣana-viśuddhipada* and Vajrameghā corresponds to (11) *āhlādana-viśuddhipada* (see fig. 3.4). Flowers, the attribute of Madhuvajrī, are a typical form of adornment, and so Madhuvajrī is appropriate as the deification of *bhūṣana-viśuddhipada*. There would seem to be no relationship between Vajrameghā (= Dhūpā) and *āhlādana-viśuddhipada*. However, Dhūpā is the deification of the pleasure of smelling incense, since she is called Prahlādanī or Prahlādanavatī[398] in the *Sarvatathāgatatattvasaṃgraha*. This is why Vajrameghā (= Dhūpā) was assigned to *āhlādana-viśuddhipada*.

From their correspondences to the *viśuddhipadas*, the order of Puṣpā, Dhūpā, Ālokā, and Gandhā found in the seventeen-deity maṇḍala would seem to be more consistent. Why then was this order changed to Dhūpā, Puṣpā, Ālokā, and Gandhā in the Vajradhātu-maṇḍala? In the *Sarvatathāgatatattvasaṃgraha*, all doctrinal categories are assigned to the five families. From this perspective, Dhūpā, the deification of *āhlādana-viśuddhipada*, is suitable as an offering goddess in the southeast, belonging to the Vajra family, since the Vajra family corresponds to the mind among the three mysteries of body, speech, and mind, while Puṣpā, the deification of *bhūṣana-viśuddhipada*, is suitable as an offering goddess in the southwest, which belongs to the Ratna family.

In this fashion, *Madhuvajrī (Puṣpā), *Vajrameghā (Dhūpa), *Śāradavajrā (Ālokā), and *Hemantavajrā (Gandhā) in the seventeen-deity maṇḍala follow the order of the *viśuddhipadas*, while the order Dhūpā, Puṣpā, Ālokā, and Gandhā in the Vajradhātu-maṇḍala is a more developed form that evolved so as to accord with the theory of the five families, the basis of the Vajraśekhara cycle.

It is to be surmised that similar circumstances applied in the shift from Hāsyā among the four offerings to Mālā. Among the sixteen great bodhisattvas, Vajrahāsa has a function and iconography similar to Hāsyā in the seventeen-deity maṇḍala. Therefore Hāsyā was removed and a new offering goddess belonging to the Jewel family named Mālā was introduced to the Vajradhātu-maṇḍala. Mālā's attribute, a gem-garland, may derive from the iconography of Ākāśagarbha, a representative bodhisattva of the Maṇi family who, according to the *Prajñāpāramitānayasūtra*, "wears a vajra gem-garland around his neck."[399]

Thus it is to be surmised that the eight offering goddesses of the Vajradhātu-maṇḍala

evolved from the four seasons and four offerings of the seventeen-deity maṇḍala of the *Prajñāpāramitānayasūtra*, with modifications to make them more consistent with the five-family system of the Vajraśekhara cycle.

Regarding the origins of the seventeen-deity maṇḍala of the *Prajñāpāramitānayasūtra*, Kawasaki Kazuhiro supported my view that the sixteen great bodhisattvas evolved from the eight great bodhisattvas of the *Prajñāpāramitānayasūtra*. But with respect to the eight offering goddesses, he argued that the *Sarvatathāgatatattvasaṃgraha* pre-dates the seventeen-deity maṇḍala and that the four seasons and four offerings were modified in accordance with the seventeen *viśuddhipadas* of the *Prajñāpāramitānayasūtra*.[400]

I now wish to address Kawasaki's view. First, Kawasaki argues that the *Paramādyatantra* was influenced by the *Sarvatathāgatatattvasaṃgraha*, since the four buddhas of the Vajradhātu-maṇḍala appear in the Vajrasattva-maṇḍala in the "Prajñākhaṇḍa" of the *Paramādyatantra*. He therefore concluded that the *Sarvatathāgatatattvasaṃgraha* pre-dates the *Paramādyatantra*. However, as was pointed out in chapter 3, the *Paramādyatantra* mentions only "buddha(s)" and does not give the names of the four buddhas or describe their arrangement. This means that it was the commentators in later times who incorporated the four buddhas into the Vajrasattva-maṇḍala. If the four buddhas were incorporated into the Vajrasattva-maṇḍala of the *Paramādyatantra* from the *Sarvatathāgatatattvasaṃgraha*, their iconography and body colors ought to coincide with those in the Vajradhātu-maṇḍala. But as was seen in chapter 3, the iconography of the four buddhas in the Vajrasattva-maṇḍala is somewhat unusual for the Vajraśekhara cycle.

Kawasaki also maintains that terms occurring in the first section of the *Paramādyatantra*, such as *sarvatathāgatamahāyānābhisamaya*, *aśeṣānavaśeṣasattvadhātuvinayana-samartha*, and *sarvārthasiddha*, were influenced by the titles of the four main parts of the *Sarvatathāgatatattvasaṃgraha*. The term *mahāyānābhisamaya* occurs sixteen times in the *Sarvatathāgatatattvasaṃgraha*.[401] Six of these occurrences are in the chapter titles of part 1, while most of the others are related to Vajrasattva, such as in the generation of Vajrasattva, the eulogy of Vajrasattva in 108 names, and the Ekamudrā-maṇḍala (of Vajrasattva). Therefore the term *mahāyānābhisamaya* does not always refer to the first part of the *Sarvatathāgatatattvasaṃgraha*. The terms *trilokavijaya*, *jagadvinaya*, and *sarvārthasiddhi* also occur in the *Paramādyatantra*. When Kawasaki finds terms shared with the *Sarvatathāgatatattvasaṃgraha* not in the early Chinese translation of the *Prajñāpāramitānayasūtra*, but in comparatively newer parts, he attributes them to the influence of the *Sarvatathāgatatattvasaṃgraha*.

As was pointed out in chapter 3, the descriptions of Vairocana as expositor in the introductory sections of the *Sarvatathāgatatattvasaṃgraha* and *Prajñāpāramitānayasūtra* are so similar that it is no exaggeration to say that they are virtually identical. Here we find a passage corresponding to the four families—Vajra, Ratna, Dharma (Lotus), and Karma—even though the Karma family was undeveloped in the *Prajñāpāramitānayasūtra* cycle up to the *Paramādyatantra*. Furthermore, this passage exists in the earliest Chinese translation of the *Prajñāpāramitānayasūtra* by Xuanzang.[402] If this were due to the influence of the *Sarvatathāgatatattvasaṃgraha*, it would go against Kawasaki's theory that the primitive form of the *Prajñāpāramitānayasūtra* pre-dates the *Sarvatathāgatatattvasaṃgraha*.

It is very difficult to determine on the basis of similar passages whether the *Prajñāpāramitānayasūtra* or the *Sarvatathāgatatattvasaṃgraha* influenced the other, since both belong

to the same cycle of texts. I accordingly took note of the fact that the secret names of the four *pāramitās* were adopted from the Assembly maṇḍala explained in the "Mantrakhaṇḍa" of the *Paramādyatantra*.

Amoghavajra was aware of the general content of the sixth, seventh, and eighth assemblies of the *Vajraśekhara*, which were later incorporated into the *Paramādyatantra*, since he translated (or composed) the *Shibahui zhigui*, *Liqu shijing*, and ritual manuals for Vajrasattva. Furthermore, the secret names of the four *pāramitās* presuppose the structure of the Assembly maṇḍala explained in the **Mahāsukhaguhyavajra* or *Śrīparamādya*, although it is not clear which of the second, seventh, and eighth assemblies Amoghavajra consulted.

When we also take into consideration the fact that the *Vajraśekharamahāguhyayogatantra*, corresponding to the second assembly of the *Vajraśekhara*, quotes the *Śrīparamādya*, the dates of the texts making up the *Paramādyatantra* have been brought too far forward even if the present *Paramādyatantra* itself did not exist in Amoghavajra's time. Furthermore, the seventeen-deity maṇḍala could have existed if the first chapter of the **Mahāsukhaguhyavajra* or *Śrīparamādya* already existed.

As was shown in fig. 3.4, the attendant deities of the seventeen-deity maṇḍala have different names depending on the source. These are partly due to differences in the Chinese translations or transcriptions, but in many cases the original Sanskrit names also differed. I believe that this is because in the seventeen-deity maṇḍala doctrinal propositions existed before the deities, who were deifications of doctrinal propositions.

In contrast, the eight offering goddesses are always referred to by the same names, that is, Lāsyā, Mālā, Gītā, Nṛtyā, Dhūpā, Puṣpā, Ālokā, and Gandhā. If the attendants of the seventeen-deity maṇḍala evolved with reference to the eight offering goddesses of the Vajradhātu-maṇḍala, it becomes difficult to explain rationally why they have different names depending on the source.

In the *Vairocanābhisambodhisūtra* and Garbha-maṇḍala, on the other hand, there are no offering goddesses. But the second chapter of the *Vairocanābhisambodhisūtra* gives the mantras for six offerings,[403] and they constitute the mantras and mudrās used in the Garbha-maṇḍala rite. However, their order—(1) *gandha*, (2) *puṣpa*, (3) *dhūpa*, (4) *bali*, (5) *dīpa*, and (6) *argha*—does not coincide with that of the eight offerings of the Vajradhātu-maṇḍala. A ritual manual in Sanskrit belonging to early esoteric Buddhism held by Oxford University[404] explains the above-mentioned mantras from (1) *gandha* to (5) *dīpa* as the five offerings (*pañcopacāra*). Thus the offering system of the Vairocanābhisambodhi cycle was also adopted in other esoteric Buddhist manuals. If the eight offerings of the Vajradhātu-maṇḍala had an origin other than the *Prajñāpāramitānayasūtra*, an offering system similar to the eight offerings ought to be found in earlier esoteric Buddhist scriptures, but none has been found to date.

On the basis of the origins of the eight offering goddesses of the Vajradhātu-maṇḍala presented here, we can conclude that the eight offerings developed from the *Prajñāpāramitānayasūtra*, since it is unreasonable to suppose that they pre-date the four seasons and four offerings of the *Prajñāpāramitānayasūtra*.

7. The Evolution of the Four Gatekeepers

The four gatekeepers of the Vajradhātu-maṇḍala—Vajrāṅkuśa, Vajrapāśa, Vajrasphoṭa, and Vajrāveśa—are collectively known as *shishō* in Japanese esoteric Buddhism. The reason that they are called *shishō*, or "four means of gathering or attraction" (Skt. *catuḥ saṃgrahavastu*), is that the four gates of the maṇḍala are thought to symbolize the four means of attraction.[405] It may be noted that among the attendants of Vajrapāṇi in the Garbha-maṇḍala, Vajrāṅkuśī[406] and Vajrasṛṅkhalā have similar names and symbols to two of the four gatekeepers of the Vajradhātu-maṇḍala, but they are female deities and are probably not of the same origin.

In the Vajradhātu-maṇḍala, the sixteen great bodhisattvas are called the "sixteen deities of the gate of wisdom," while the four *pāramitās*, eight offering goddesses, and four gatekeepers are called the "sixteen deities of the gate of contemplation." This is because the sixteen great bodhisattvas are male while the four *pāramitās* and eight offering goddesses are female. In the *Sarvatathāgatatattvasaṃgraha* the four gatekeepers of the Vajradhātu-maṇḍala are male, but in late Yoga tantras and Highest Yoga tantras they are often female deities. In contrast to the sixteen great bodhisattvas, whose appearance is limited primarily to the Yoga tantras, the eight offering goddesses and four gatekeepers were carried over in the maṇḍalas of late tantric Buddhism even though their forms were changed from heavenly maidens to terrifying *ḍākinīs*. In this respect the eight offering goddesses and four gatekeepers were more influential than the sixteen great bodhisattvas.

The four gatekeepers—Aṅkuśa, Pāśa, Sphoṭa, and Āveśa—are deifications of the four-syllable *vidyā* "*Jaḥ hūṃ vaṃ hoḥ*,"[407] with which the practitioner summons (*ākarṣaṇa*), admits (*praveśana*), binds (*bandhana*), and manipulates (*vaśīkaraṇa*) the deity visualized in front of him. Thus they collectively symbolize the process whereby the practitioner identifies with the deity. This four-syllable *vidyā* originated in the *Paramādyatantra*, and in the four gates of the seventeen-deity maṇḍala there are arranged four female gatekeepers whose seed-syllables are *jaḥ*, *hūṃ*, *vaṃ*, and *hoḥ*, respectively.

As was explained in chapter 3, the "*Mahāsamayatattvavajra*," the first chapter of the "Prajñākhaṇḍa" of the *Paramādyatantra*, mentions only how to arrange the symbols of the objects of the four senses, stating that "in the center of all the gates the assembled symbols of *rūpa* and so on should be placed." Thus it does not clearly explain the gatekeepers. But in ritual manuals the four gatekeepers are called Rūpā, Śabdā, Gandhā, and Rasā, since they correspond to the *viśuddhipadas* of *rūpa*, *śabda*, *gandha*, and *rasa*. Aṅkuśā, Pāśā, Sphoṭā, and Āveśā, deifications of the four-syllable *vidyā*, on the other hand, were adopted as gatekeepers after the emergence of the "Mantrakhaṇḍa" of the *Paramādyatantra*. Therefore the gatekeepers of the Vajradhātu-maṇḍala are closer to those of the "Mantrakhaṇḍa" than those of the "Prajñākhaṇḍa."

Kawasaki Kazuhiro, basing himself on the fact that Aṅkuśā, Pāśā, Sphoṭā, and Āveśā are the gatekeepers in ritual manuals of Vajrasattva transmitted in Sino-Japanese esoteric Buddhism, argues that the four gatekeepers seem to have become Rūpā, Śabdā, Gandhā, and Rasā only after the *viśuddhipadas* were consolidated into seventeen under the influence of the seventeen-deity maṇḍala and the four gatekeepers were assigned to the final four *viśuddhipadas*, that is, *rūpa*, *śabda*, *gandha*, and *rasa*.[408] Thus his view is the opposite of mine.

In this connection, it would seem that Kawasaki overlooked the statement in the

"*Mahāsamayatattvavajra" that "in the center of all the gates the assembled symbols of *rūpa* and so on should be placed."[409] "*Rūpa* and so on" sometimes signifies the five aggregates (*skandha*), but in this case *rūpa*, *śabda*, *gandha*, and *rasa* are clearly intended. Ānandagarbha regards this passage as a textual source for the four gatekeepers of the Vajrasattva-maṇḍala explained in the "Prajñākhaṇḍa," that is, Rūpā, Śabdā, Gandhā, and Rasā.[410] He also specifies a mirror (*rūpa*), a lute (*śabda*), a perfume container made of conch shell (*gandha*), and a food offering (*rasa*) as the attributes of the four gatekeepers. These are nothing other than "the symbols of *rūpa* and so on."

As was seen in chapter 3, there are considerable discrepancies between the explanation given in the "*Mahāsamayatattvavajra" and the present Vajrasattva-maṇḍala of the *Paramādyatantra*. In the case of the four gates, *rūpa*, *śabda*, *gandha*, and *rasa*, originally depicted as symbols, were deified as gatekeepers in later commentaries and ritual manuals. It is unlikely that the seventeen-deity maṇḍala had already appeared when the "Prajñākhaṇḍa" of the *Paramādyatantra* was composed.

However, it is clearly implausible that Aṅkuśā, Pāśā, Sphoṭā, and Āveśā, appearing only in the "Mantrakhaṇḍa," could have appeared before Rūpā, Śabdā, Gandhā, and Rasā, based on the first chapter of the "Prajñākhaṇḍa," even though they had not yet been fully deified at this stage. In fact, the instruction in the "*Mahāsamayatattvavajra" to arrange the symbols of the objects of the four senses in the four gates of the maṇḍala probably led to the deification of the seventeen *viśuddhipadas*, which include the *viśuddhipadas* of *rūpa*, *śabda*, *gandha*, and *rasa* at the end.

These symbols of *rūpa*, *śabda*, *gandha*, and *rasa* became the symbols of the five or six adamantine goddesses of the Ārya and Jñānapāda schools of the *Guhyasamājatantra*, which will be discussed in chapter 5. In particular, in the *Samantabhadra nāma sādhana* belonging to the Jñānapāda school, *ja* [*sic*], *hūṃ*, *vaṃ*, and *hoḥ* are used as the seed-syllables of Rūpa-vajrā, Śabdavajrā, Gandhavajrā, and Rasavajrā, respectively.[411]

The adamantine goddesses of the *Guhyasamājatantra*, situated in the four corners of the courtyard, do not act as gatekeepers (more on this in chapter 5). Nevertheless, the fact that *jaḥ*, *hūṃ*, *vaṃ*, and *hoḥ* are used as their seed-syllables suggests that it was widely accepted that Rūpā, Śabdā, Gandhā, and Rasā corresponded to Aṅkuśā, Pāśā, Sphoṭā, and Āveśā of the *Paramādyatantra*. It is thus evident that the four gatekeepers, the final group among the thirty-seven deities of the Vajradhātu-maṇḍala, are deifications of the four-syllable *vidyā* of the "Mantrakhaṇḍa" of the *Paramādyatantra*.

It turns out that the sixteen great bodhisattvas, four *pāramitās*, eight offering goddesses, and four gatekeepers of the Vajradhātu-maṇḍala were adopted from the *Prajñāpāramitā-nayasūtra* and were reorganized in accordance with the fivefold system of the Vajraśekhara cycle. Therefore the Vajradhātu-maṇḍala may be considered to be a development of the *Prajñāpāramitānayasūtra*.

8. The *Paramādyatantra* and the Vajradhātu-maṇḍala

The Vajrasattva-maṇḍala of the *Paramādyatantra*, which added the four buddhas of the Vajradhātu-maṇḍala and the eight great bodhisattvas of the *Prajñāpāramitānayasūtra* to the seventeen-deity maṇḍala of Vajrasattva, has been transmitted in Tibetan Buddhism. The deities in this maṇḍala include the four buddhas of the Vajradhātu-maṇḍala, eight of

Paramādya-Vajrasattva maṇḍala (center)

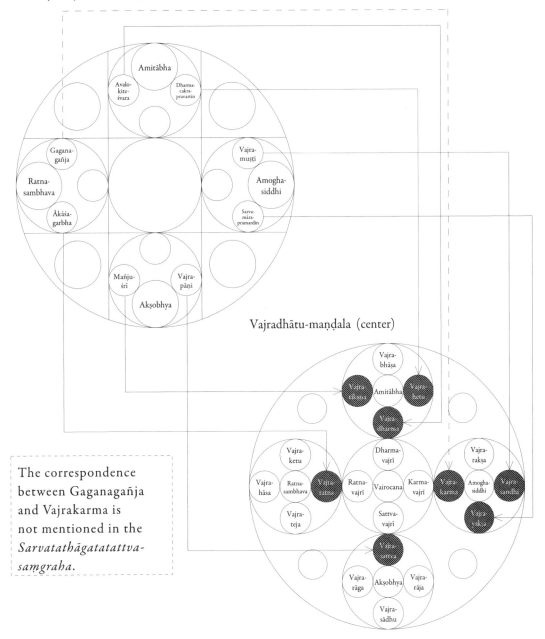

Vajradhātu-maṇḍala (center)

The correspondence between Gaganagañja and Vajrakarma is not mentioned in the *Sarvatathāgatatattva-saṃgraha.*

the sixteen great bodhisattvas, and eight female deities corresponding to the eight offering goddesses. As we saw in the previous section, the four gatekeepers in the maṇḍala of the *Prajñāpāramitānayasūtra*—Rūpā, Śabdā, Gandhā, and Rasā—developed into Aṅkuśā, Pāśā, Sphoṭā, and Āveśā, deifications of the four-syllable *vidyā* explained in the "Mantra-khaṇḍa" of the *Paramādyatantra*. Therefore if we also include the four gatekeepers, the Paramādya-Vajrasattva maṇḍala and the Vajradhātu-maṇḍala share twenty-four of the

thirty-seven deities of the Vajradhātu-maṇḍala. The connections between the four buddhas and eight great bodhisattvas in the Vajrasattva-maṇḍala and the four buddhas and sixteen great bodhisattvas in the Vajradhātu-maṇḍala are shown in fig. 4.13.

As can be seen in this diagram, the connections between the four buddhas and eight great bodhisattvas were by and large inherited by the Vajradhātu-maṇḍala, except that Mañjuśrī (Vajratīkṣṇa) moved from the position of an attendant of Akṣobhya in the east to that of an attendant of Amitābha in the west, and Gaganagañja (Vajrakarma)[412] moved from the position of an attendant of Ratnasambhava in the south to that of an attendant of Amoghasiddhi in the north.

This is comparable to the fact that, in contrast to the Udayagiri stūpa, where, as seen in chapter 2, the eight great bodhisattvas of the standard type, rather than those of the *Prajñā-pāramitānayasūtra*, became the attendants of the four buddhas, in Jajpur, as mentioned above, the sixteen great bodhisattvas are arranged in the halos of the four buddhas. Thus the development from the triad consisting of a central figure flanked by an attendant on each side to the pentad with four attendants around the main deity may be considered to parallel the development from the Garbha-maṇḍala, based on three families, to the Vajradhātu-maṇḍala, with its five-family system.

The *Prajñāpāramitānayasūtra* played an important role in the genesis of the Vajradhātu-maṇḍala. In the Paramādya-Vajrasattva maṇḍala there are depicted, in addition to the twenty-four deities from which I assume the sixteen great bodhisattvas, eight offering goddesses, and four gatekeepers have derived, four buddhas not explicitly mentioned in the *Paramādyatantra* and twenty protective deities arranged in the outer square of the Vajradhātu-maṇḍala (in Tibet, they are depicted only in the Trailokyavijaya-maṇḍala). Thus this maṇḍala can be regarded as the prototype of the Vajradhātu-maṇḍala if it came into existence before the Vajradhātu-maṇḍala.

As was seen in chapter 3, the Paramādya-Vajrasattva maṇḍala is based on the "*Mahāsa-mayatattvavajra," the first chapter of the "Prajñākhaṇḍa" of the *Paramādyatantra*. However, it is impossible to compose the current maṇḍala from its simple description. For the reconstruction of the maṇḍala, one must refer to the anonymous *Paramādimaṇḍalavidhi* and Ānandagarbha's *Paramādivṛtti* or *Paramāditīkā*. Ānandagarbha is thought to have lived in the first half of the ninth century, and therefore it has been considered that this maṇḍala, too, developed later than the Vajradhātu-maṇḍala. But as noted previously, the mudrās and body colors of the four buddhas in the Paramādya-Vajrasattva maṇḍala are different from those usually found in the Vajradhātu-maṇḍala. If the Paramādya-Vajrasattva maṇḍala had been developed with direct reference to the Vajradhātu-maṇḍala, the mudrās and body colors of the four buddhas ought to be the same. Therefore the Paramādya-Vajrasattva maṇḍala of the *Paramādyatantra*, while having modified the original description in the "*Mahāsamaya-tattvavajra," may preserve the earlier iconography of the *Prajñāpāramitānayasūtra* cycle.

The *Paramādyatantra* was translated into Chinese by Faxian during the Northern Song dynasty. The current Tibetan version, on the other hand, was translated in the early eleventh century, and there is no clear evidence of the existence of an old translation during the Tufan period,[413] even though it is counted as one of the eighteen great tantras of the Mahāyoga cycle (see section 13 below). Therefore the composition of the present *Paramādyatantra* had been thought to postdate the *Sarvatathāgatatattvasaṃgraha*.

Ritual manuals of Vajrasattva translated by Amoghavajra describe a seventeen-deity

maṇḍala closely related to the "Mantrakhaṇḍa" of the *Paramādyatantra*. In this regard, Matsunaga Yūkei has argued that, judging from extant materials, the content of the *Paramādyayoga* with which Amoghavajra was acquainted was concerned only with the Five Secrets, concentrated in chapter 14 of the Chinese translation, namely, the start of the second half (= "Mantrakhaṇḍa") of Faxian's *Prajñāpāramitānayasūtra* in seven fascicles (that is, *Paramādyatantra*), and is virtually unrelated to the subsequent chapters, starting from chapter 15 of the Chinese translation. Therefore, according to Matsunaga, the *Paramādyayoga* that existed during Amoghavajra's lifetime ought to be considered to have been an independent ritual manual centered on the Five Secrets, and there are no grounds for arguing that the current enlarged *Paramādyatantra*, which incorporates various *sādhanas* in its latter part, already existed.[414]

However, the secret names of the four *pāramitās* are not found in the latter part of the *Sarvatathāgatatattvasaṃgraha*, which Amoghavajra did not translate. They appear for the first time in the *Vajraśekharamahāguhyayogatantra*, which corresponds to the second assembly of the Vajraśekhara cycle. Moreover, this *Vajraśekharamahāguhyayogatantra* does not explain why these four goddesses, who had different origins, formed a group and became the mothers of the four families. In fact, it presupposes the structure of the Assembly maṇḍala explained in chapter 20 of the Chinese translation of the *Paramādyatantra*. This Assembly maṇḍala was devised so as to bring together the maṇḍalas explained after chapter 14 of the Chinese translation. Therefore the greater part of the "Mantrakhaṇḍa" of the *Paramādyatantra* would have existed at the time of Amoghavajra.

As was seen in chapter 3, there are considerable discrepancies between the *Paramādyatantra* (both Chinese and Tibetan translations) and the *Paramādiṭīkā* by Ānandagarbha. Unlike the *Sarvatathāgatatattvasaṃgraha* and *Guhyasamājatantra*, there is a possibility that a standard text of the *Paramādyatantra* did not yet exist. It is unlikely that a version of the *Paramādyatantra* similar to the present Chinese or Tibetan translation existed in India at the time of Amoghavajra, but it is quite possible that texts incorporated into the present *Paramādyatantra* were circulating separately during his lifetime.

I am therefore of the view that the maṇḍala explained in the "*Mahāsamayatattvavajra" is nothing other than the matrix of the maṇḍalas belonging to the Yoga tantras. There separated from it the seventeen-deity maṇḍala, which is consistent with the seventeen *viśuddhipadas*, the Paramādya-Vajrasattva maṇḍala, which is an amalgamation of the Sermon Assembly maṇḍala and seventeen-deity maṇḍala, and the Vajradhātu-maṇḍala, which has a structure underpinned by the mutual encompassment of the five families. Thus the *Paramādyatantra* is important for considering the genesis of the Vajradhātu-maṇḍala.

9. The *Gobu Shinkan* and Shōren'in Handscroll

The Buddhist icons related to the Vajradhātu cycle that have been identified in recent years in India indicate that esoteric Buddhism of the Vajraśekhara cycle once prospered in India, the home of Buddhism. However, no examples of the Vajradhātu-maṇḍala have been discovered in India apart from areas where Tibetan Buddhism is practiced in the Himalayas. Therefore in order to reconstruct the original Indian form of the Vajradhātu-maṇḍala it is important to examine examples from Japan and Tibet, where the traditions of esoteric Buddhism have survived. When doing so, modern examples have little value as source materials,

whereas early paintings and line drawings preserving the original Indian form are of great value. Accordingly, I shall survey early versions of the Japanese Vajradhātu-maṇḍala in this section and early examples of the Tibetan Vajradhātu-maṇḍala in the next section.

The *Gobu shinkan* is a collection of iconographical line drawings in handscroll form and depicts the deities of the Vajradhātu-maṇḍala together with their mudrās and mantras; its full title is *Ritasōgyara gobu shinkan*. It was brought from China to Japan by Enchin (814–91), as were the *Taizō zuzō* and *Taizō kyūzuyō*, but whereas the originals of the latter two works have been lost and only copies remain, the original version of the *Gobu shinkan* has been preserved at Onjōji (Shiga prefecture), a temple that was restored by Enchin. There are two manuscripts of this work preserved at Onjōji, one a complete manuscript and the other with the first half missing. Previously it had been thought that the latter incomplete version represented the original manuscript brought back to Japan by Enchin, but following an examination of the Siddham script used in the two manuscripts, Takata Osamu concluded that it was the complete manuscript that represented the original version.[415] The complete manuscript is a rare example of an iconographical collection of simple line drawings dating from the late Tang dynasty, while the incomplete manuscript is a fine example of similar drawings from the Heian period, and both have been designated National Treasures.[416] In content, the *Gobu shinkan* is considered to reflect the traditions of the lineage of Śubhākarasiṃha, who first introduced to China the esoteric Buddhism of the *Vairocanābhisambodhisūtra*, and it represents an early form of the Vajradhātu-maṇḍala pre-dating the Kue mandara.

Because the *Gobu shinkan* was carefully preserved as a rare work brought back to Japan by Enchin and was not generally made public, it did not exert much influence on the Buddhist iconography of Japan, although there does exist a commentary called *Rokushu mandara ryakushaku*.[417] Nonetheless, it provides valuable material for considering the evolution of the *Sarvatathāgatatattvasaṃgraha* and the Vajradhātu-maṇḍala.

The *Gobu shinkan* includes not only the Vajradhātu-mahāmaṇḍala but all six maṇḍalas explained in the Vajradhātu section of the *Sarvatathāgatatattvasaṃgraha*. The Ekamudrā-maṇḍala is centered not on Vairocana, as in the Kue mandara, but on Vajrasattva. Thus with regard to the five maṇḍalas starting with the Vajradhātu-samayamaṇḍala, not included in Amoghavajra's translation (T. 865), it tallies with the descriptions in the Sanskrit original of the *Sarvatathāgatatattvasaṃgraha*. Therefore if the *Gobu shinkan* is, in accordance with its colophon, attributed to Śubhākarasiṃha or was based on a Sanskrit manuscript brought to China by him,[418] then the Vajradhātu section of the *Sarvatathāgatatattvasaṃgraha* ought to have existed before 716 when he arrived in Chang'an. But there is also the view that only the first half is attributable to Śubhākarasiṃha and the latter half came into existence in the eighth century.[419]

However, if the compiler of the latter half referred to a new Sanskrit manuscript of the *Sarvatathāgatatattvasaṃgraha* that included the entire Vajradhātu section and had been brought to China by Amoghavajra or someone else, it becomes difficult to explain why eight maṇḍalas of the Kue mandara created by Huiguo, starting with the Vajradhātu-samayamaṇḍala, do not tally with the Sanskrit text and *Gobu shinkan*. In Japanese academic circles many scholars have dated the *Sarvatathāgatatattvasaṃgraha* to the first half of the eighth century, and so there may have been some resistance to dating the entire Vajradhātu section to no later than 716.

The newly discovered *Dkar chag 'phang thang ma* and an analysis of Tibetan esoteric Bud-

dhist manuscripts from Dunhuang make it clear, however, that not only the Vajradhātu section but also the *uttaratantra* at the end of the *Sarvatathāgatatattvasaṃgraha* were already known in Tibet during the Tufan period.[420] Therefore it is not unreasonable to suppose that the entire Vajradhātu section existed in its present form in the early eighth century.

A collection of iconographical line drawings in handscroll form depicting the deities of the Vajradhātu-maṇḍala, formerly in the Kissui collection of Shōren'in, depicts the thirty-seven deities of the Vajradhātu-maṇḍala, the two wrathful deities Trailokyavijaya and Aparājita, two protective deities, and the protectors of the eight directions (hereafter referred to as the Shōren'in handscroll; fig. 4.14). Yanagisawa Taka has shown that it does not tally with the Genzu mandara, Eizan version, Nezu version (eighty-one-deity maṇḍala), and so on, and is closely related to the *Gobu shinkan*. She also determined that it was copied from a manuscript held by Zentōin in 1083 and identified the original as the *Sanjūshichison-yō* (line drawings of thirty-seven deities) listed in the *Dengyō daishi shōrai Esshū roku*, a catalogue of works brought back from China by Saichō, the founder of the Japanese Tendai school.[421]

Saichō was initiated into esoteric Buddhism at Longxingsi, a temple in Yuezhou (present-day Shaoxing), by Shunxiao in 805 during his stay in China. It would be possible for the Shōren'in handscroll brought back by Saichō to be similar to the *Gobu shinkan* belonging to Śubhākarasiṃha's tradition, since Shunxiao was a second-generation disciple of Śubhākarasiṃha. Yanagisawa further pointed out that, compared with the *Gobu shinkan*, the Shōren'in handscroll was executed as if the figures had been taken from a maṇḍala in hanging-scroll format.[422] This suggests that maṇḍalas belonging to Śubhākarasiṃha's tradition were not only transmitted to China as line drawings but were also created as colored paintings for worship purposes.

The Shōren'in handscroll depicts two protective deities among the four deities corresponding to the four elements of earth, water, fire, and wind, the two wrathful deities Trailokyavijaya and Aparājita, and the protectors of the eight directions. Among these, the four deities corresponding to the four elements were incorporated into the present Kue mandara, while the protectors of the eight directions, though popular as protectors of directions (*dikpāla*) in India, were replaced in the outer square of the Kue mandara by the twenty protective deities explained in the Trailokyavijaya section of the *Sarvatathāgatatattvasaṃgraha*. These twenty protective deities are not depicted in the *Gobu shinkan*, which suggests that while Śubhākarasiṃha was well-versed in the Vajradhātu section, he did not know much about the Trailokyavijaya and subsequent sections.[423]

FIG. 4.14. SHŌREN'IN HANDSCROLL (METROPOLITAN MUSEUM OF ART)

10. Examples of the Vajradhātu-maṇḍala in Tibet and Nepal

In contrast to the Garbha-maṇḍala, examples of which are rare in Tibet, maṇḍalas belonging to the Yoga tantras, starting with the Vajradhātu-maṇḍala, are frequently found in Tibet. In this section I shall survey examples of the Vajradhātu-maṇḍala in Tibet and Nepal.

In Tibet, there does not exist a maṇḍala corresponding to the Kue mandara. However, the Vajradhātu-mahāmaṇḍala, corresponding to the Jōjin-e, the Trailokyavijaya-maṇḍala, corresponding to the Gōzanze-e, and other components of the Kue mandara are frequently found in Tibet.

Among these, the Vajradhātu-maṇḍala in the three-storied chapel at Alchi, Ladakh, is the earliest extant example and may date back to the eleventh or twelfth century. Its

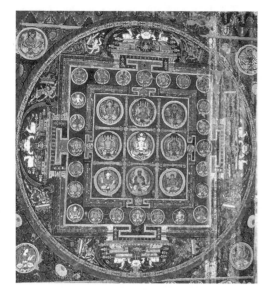

FIG. 4.15. VAJRADHĀTU-MAṆḌALA AT ALCHI
MONASTERY (© MORI KAZUSHI)

FIG. 4.16. VAJRADHĀTU-MAṆḌALA AT ALCHI MONASTERY

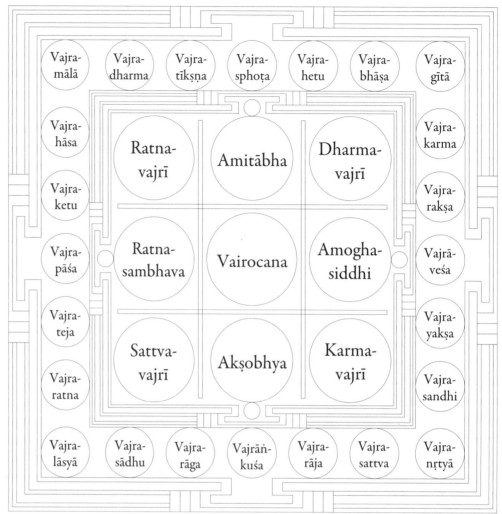

arrangement of the deities differs from the standard Vajradhātu-maṇḍala. The inner square takes the form of a nine-panel grid, and the main deity is surrounded in the four cardinal directions by the four buddhas and in the four intermediate directions by the four *pāramitās*. In the outer square, the four gatekeepers are arranged in the four gates and the four inner offering goddesses in the four corners, and between them are arranged the sixteen great bodhisattvas (figs. 4.14 and 4.15). In the same chapel, there are also depicted variations of the Vajradhātu-maṇḍala in which (1) all the deities are female, (2) all the deities except the five buddhas are female, (3) the main deity is Akṣobhya, Ratnasambhava, Amitābha, or Amogasiddhi, and (4) the main deity is Vajrasattva.[424] Some Japanese scholars have identified these (1) with the Samaya-maṇḍala, (2) with the Karma-maṇḍala, (3) with the Caturmudrā-maṇḍala, and (4) with the Ekamudrā-maṇḍala.[425]

The Trailokyavijaya-mahāmaṇḍala on the west wall of the Vairocana chapel at Alchi has more or less the same layout as the Gōzanze-e of the Japanese Kue mandara.[426] It is a valuable example not only artistically but also iconographically, since it accurately

depicts all the deities down to the twenty protective deities and their consorts in the outer square.

In the Dungkar Caves in western Tibet, which were rediscovered in 1992, there have been found maṇḍalas belonging to the Yoga tantras. In Dungkar Cave 1, the Vajradhātu-maṇḍala, Trailokyavijaya-maṇḍala, and Dharmadhātuvāgīśvara-maṇḍala are depicted. In Cave 2, the Dharmadhātuvāgīśvara-maṇḍala, with a four-tiered structure, is depicted on the ceiling. In Cave 3, the Navoṣṇīṣa-maṇḍala of the *Durgatipariśodhanatantra* is depicted on the ceiling. In the Vajradhātu-maṇḍala and Trailokyavijaya-maṇḍala, the four *pāramitās* are depicted not in human form but as symbols, which is a characteristic of the Ānandagarbha school. The maṇḍalas in the Dungkar caves are, at present, the earliest extant examples in western Tibet, but since they are datable to some time between the late eleventh century and thirteenth century, they are not as early as the maṇḍalas at Alchi in Ladakh.[427]

In the Assembly Hall of Tholing, the largest monastery in western Tibet, and in the White Chapel of Tsaparang, there have survived wall paintings depicting deities of the Vajradhātu-maṇḍala. My iconographical analysis has made clear that they are based mainly on the Ānandagarbha school. The wall paintings of Tholing and Tsaparang have turned out to be later than those at not only Alchi but also Dungkar, since they date from as late as the fifteenth to sixteenth centuries. However, they include unique iconography of the sixteen bodhisattvas of the Bhadrakalpa and the four *pāramitās* not found in central Tibet. This suggests that there existed in western Tibet a unique tradition of the Vajradhātu-maṇḍala deriving from Rinchen Sangpo.[428]

In the cupola surmounting the five-tiered base of the Great Stūpa of Gyantse constructed by Rapten Kunsang Phakpa (1389–1442) in the early fifteenth century, all of the twenty-eight maṇḍalas explained in the *Sarvatathāgatatattvasaṃgraha* are found, and maṇḍalas corresponding to the Sanmaya-e, Misai-e, Kuyō-e, Shiin-e, Ichiin-e, and Gōzanze-sanmaya-e of the Kue mandara have been identified.[429] Moreover, in the Vajradhātu chapel on the ground floor of the main hall there is enshrined a three-dimensional Vajradhātu-maṇḍala.[430] Several other examples of three-dimensional Vajradhātu-maṇḍalas used to exist in Tibet, but most of them were destroyed during the Cultural Revolution, and now there remain only a few, such as this one at Gyantse and one at Tabo monastery in Spiti.

The Sarvakula-maṇḍala of the *Vajraśekhara* corresponds to the General Assembly maṇḍala consisting of the five families that Vajrabodhi had painted at Jianfusi temple in Chang'an. In Japan, there remains only a seed-syllable maṇḍala showing the arrangement of the deities.[431] In Tibet, on the other hand, examples of colored representations of this maṇḍala have survived on the south wall of the south chapel of Shalu monastery and elsewhere. It shows the maṇḍalas explained in the four main sections of the *Sarvatathāgatatattvasaṃgraha*: the Vajradhātu-maṇḍala in the center, the Trailokyavijaya-maṇḍala in the east, the Jagadvinaya-maṇḍala in the west, the Sarvārthasiddhi-maṇḍala in the south, and the maṇḍala of the Karma family, missing in the *Sarvatathāgatatattvasaṃgraha*, in the north. Thus the Karma family, undeveloped since the *Paramādyatantra*, has been supplemented, and a maṇḍala consisting of the five families was created.

In Nepal, on the other hand, there have been discovered not only a Sanskrit manuscript of the *Sarvatathāgatatattvasaṃgraha* but also one of the *Sarvavajrodaya*, a ritual manual of the Vajradhātu-maṇḍala by Ānandagarbha. Many copies of the *Vajradhātumukhākhyāna*,[432]

a ritual manual on the Vajradhātu-maṇḍala compiled in Nepal, have also survived. This suggests that the rites of the Vajradhātu-maṇḍala were frequently performed by Nepalese Buddhists. A thangka of the Vajradhātu-maṇḍala in the possession of IsIAO in Italy[433] is thought to have been presented by a Nepalese Buddhist, since it has an inscription in Newari at the bottom. But today the traditions of the Vajradhātu-maṇḍala have been lost in Nepal and only the Navoṣṇīṣa-maṇḍala of the *Durgatipariśodhanatantra*, also belonging to the Yoga tantras, survives.

On the walls of the second story of Jampa Lhakhang in Lo Manthang in Mustang, Nepal, there are depicted fourteen maṇḍalas explained in the *Sarvatathāgatatattvasaṃgraha*. They can be dated to the time of the temple's foundation in the fifteenth century. Although they belong to the Sakya tradition, these maṇḍalas exhibit a Nepalese style, since Ngorchen Kunga Sangpo (1382–1456) invited Newari painters to produce them.[434]

11. The Meaning of the Introduction of the Fivefold System

As we have seen in the preceding sections, in contrast to the maṇḍalas of early esoteric Buddhism and the Garbha-maṇḍala, which were based on three families, and those of the *Prajñāpāramitānayasūtra*, based on four families by adding the Jewel (Maṇi) family, the Vajradhātu-maṇḍala introduced an epoch-making system based on five families. In this section I consider the meaning of the introduction of the fivefold system in the history of the maṇḍala.

The Vajradhātu-maṇḍala classifies all the deities into five families—Tathāgata, Vajra, Ratna (Jewel), Dharma (Lotus), and Karma (Action)—and arranges the deities of these five families in the center and four cardinal directions. Thus there was created a maṇḍala completely symmetrical both horizontally and vertically. These five families, through mutual encompassment, develop into twenty-five and then into innumerable families.[435] This mag-

FIG. 4.17. THE MUTUAL ENCOMPASSMENT OF THE FIVE FAMILIES

nificent hierarchical structure is called *samavasaraṇa* in esoteric Buddhism (fig. 4.17). The pattern of the Vajradhātu-maṇḍala, which arranges in the center and four cardinal directions of a large moon disc five moon discs in each of which are arranged five small moon discs, is nothing other than a representation of the mutual encompassment of the five families.

The term *samavasaraṇa*, the Sanskrit equivalent of "mutual encompassment," has a complicated history. It was confused with *samavaśaraṇa* because there was no phonetic distinction between *sa* and *śa* in medieval Bengal and Bihar, the center of Indian Buddhism. Consequently, it became a polysemic term meaning "meeting," "assembling," "assembly," "descent from heaven," and so on.

Amoghavajra and Dānapāla translated *samavasaraṇa* in the *Sarvatathāgatatattva-saṃgraha*[436] as "mutual interpenetration" (*huxiang sheru*). The Tibetan translator Rinchen Sangpo, on the other hand, translated it as "entering into equality" or "understanding equality" (*mñam pa ñid du 'jug pa*). There thus remained questions about whether *samavasaraṇa* originally did mean "mutual encompassment," but I discovered the following passage in the "Mañjuvajrabali" in the *Balimālikā* transmitted in Tibet: "*samavasaraṇa* of the Dharma-realm entering into mutually encompassing contemplation in the maṇḍala."[437] Thus there exists at least one example of its usage that supports Amoghavajra's understanding.

According to the *Viṃśatividhi*, when one spins five-colored threads symbolizing the five tathāgatas into a single cord used for demarcating the maṇḍala, the following mantra should be recited: "*Oṃ*, all dharmas are mutually indwelling and mutually encompassing" (*oṃ anyonyānugatāḥ sarvadharmāḥ parasparā/ atyantānupraviṣṭāḥ sarvadharmāḥ*).[438] This symbolizes the generation of various deities through the mutual encompassment of the five families represented by the five buddhas.

In Jainism, *samavasaraṇa* refers to the descent of the Jina to earth for the sake of sentient beings, and the assembly where various beings, starting with gods and human beings, come to hear the sermons of the Jina is also called *samavasaraṇa*. In Jain art, the Jina seated in the center of a *samavasaraṇa* is frequently depicted as facing the four cardinal directions.[439] Such a mode of representation is suggestive of Vajradhātu-Vairocana, who has four heads facing the four cardinal directions.[440] The idea that an omniscient being divides his person into four, facing the four directions, for revealing the truth to all beings equally may have developed into the idea of mutual encompassment, the basic principle of the Vajradhātu-maṇḍala.

The *Sarvatathāgatatattvasaṃgraha* explains twenty-eight maṇḍalas, among which the Vajradhātu-mahāmaṇḍala (the Jōjin-e of the Kue mandara) consisting of thirty-seven deities represents the basic pattern of the Vajradhātu cycle. Further, the structure in which the five buddhas are each surrounded by four attendants clearly shows the mutual encompassment of the five families, the basic principle of the Vajradhātu-maṇḍala. The Samaya-maṇḍala (Sanmaya-e), Dharma-maṇḍala (Misai-e), and Karma-maṇḍala (Kuyō-e), meanwhile, can be interpreted as variations of the basic pattern. The Caturmudrā-maṇḍala (Shiin-e) is a simplified form in which the basic structure has been extracted from the complex Vajradhātu-maṇḍala, and the Ekamudrā-maṇḍala (Ichiin-e) is the ultimate simplification that depicts only the primordial one.[441]

In this manner, all the other maṇḍalas explained in the *Sarvatathāgatatattvasaṃgraha* are variations or simplified forms of the Vajradhātu-mahāmaṇḍala explained at the start of the text. Such modification, transposition, expansion, and contraction of the basic pattern are found throughout the *Sarvatathāgatatattvasaṃgraha*.

The Vajradhātu-maṇḍala came into existence at a time when the number of Buddhist deities had increased, resulting in the formation of a huge pantheon, and it became necessary to integrate these deities systematically into a single system. Furthermore, the *Sarvatathāgatatattvasaṃgraha* attempted to arrange deities not included among the thirty-seven deities of the Vajradhātu-maṇḍala in a coherent system in accordance with the principle of mutual encompassment of the five families.

For example, in the Samaya-maṇḍala, where all the deities are depicted as symbols, the names of goddesses are assigned to the symbols of the thirty-seven deities. The symbol of Vajrateja becomes Ratnolkā, that of Vajraketu becomes Dhvajāgrakeyurā, and that of Vajrahetu becomes Sahasravartā,[442] all of which are the names of popular *dhāraṇīs* worshiped in India.[443] In this manner, the *Sarvatathāgatatattvasaṃgraha* incorporated the *dhāraṇī* cult that had existed since early esoteric Buddhism into the system of thirty-seven deities.

In the Trailokyavijaya section of the *Sarvatathāgatatattvasaṃgraha*, on the other hand, Vajrasattva transforms himself into Trailokyavijaya in order to subjugate Maheśvara, the supreme god of Hinduism. At the same time the thirty-seven deities of the Vajradhātu-maṇḍala also transform themselves into wrathful deities. The maṇḍala illustrating this is the Trailokyavijaya-maṇḍala, in which Vajrateja transforms himself into Vajrasūrya, Vajrahāsa transforms himself into Aṭṭahāsakrodha, and Vajrayakṣa transforms himself into Vajrayakṣakrodha.[444] In this fashion, the *Sarvatathāgatatattvasaṃgraha* also incorporated the cult of wrathful deities that had existed since early esoteric Buddhism into the system of thirty-seven deities.

In addition, in the Jagadvinaya-maṇḍala explained in the Jagadvinaya section of the *Sarvatathāgatatattvasaṃgraha*, the thirty-seven deities transform themselves into transformations of Avalokiteśvara: Vajrahāsa transforms himself into Eleven-headed Avalokiteśvara (Padmāṭṭahāsaikadaśamukha),[445] Vajrāṅkuśa among the four gatekeepers transforms himself into Hayagrīva, and Vajrapāśa transforms himself into Amoghapadmapāśakrodha.[446] As was seen in chapter 2, the *Amoghapāśakalparāja* explains the mudrās of various deities belonging to the Lotus family, and several of these were incorporated into the Jagadvinaya section of the *Sarvatathāgatatattvasaṃgraha*. Thus the *Sarvatathāgatatattvasaṃgraha* arranged mudrās that had developed since early esoteric Buddhism in accordance with the system of thirty-seven deities.

In this way, the *Sarvatathāgatatattvasaṃgraha* arranged the deities, mudrās, and mantras that had grown enormously in the course of the development of esoteric Buddhism by using the system of thirty-seven deities. By this means there was brought to completion a system for arranging all the elements of esoteric Buddhism by means of the mutual encompassment of the five families.

This idea of mutual encompassment led to the development of a maṇḍala five times larger than the Vajradhātu-maṇḍala, that is, the General Assembly maṇḍala of the five families explained in the third assembly of the *Vajraśekhara*, the Yoga (tantra) called *Compendium of All Teachings* (*Yiqie jiaoji yuga*). In China, this maṇḍala was called "the maṇḍala of Jianfusi drawn in gold ink," since Vajrabodhi, one of the eight patriarchs of Shingon Buddhism, produced it at Jianfusi in Chang'an. But it was not transmitted to Japan because it was so large.[447]

Nevertheless, this maṇḍala was transmitted to Tibet as the Sarvakula-maṇḍala of the *Vajraśekhara*.[448] It arranges five maṇḍalas similar to the Vajradhātu-maṇḍala in the center

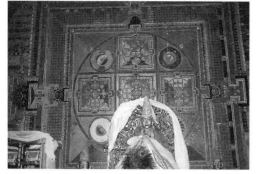

FIG. 4.18. THE ASSEMBLY MAṆḌALA OF THE *VAJRAŚEKHARA* (SOUTH CHAPEL, SHALU MONASTERY)

FIG. 4.19. THE EXPANSION AND CONTRACTION OF THE VAJRADHĀTU-MAṆḌALA

Vajradhātu-maṇḍala

Ekamudrā-maṇḍala

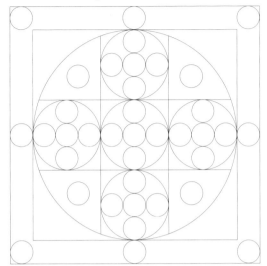

Caturmudrā-maṇḍala

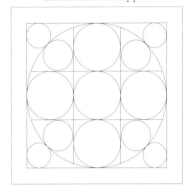

General Assembly maṇḍala of the five families

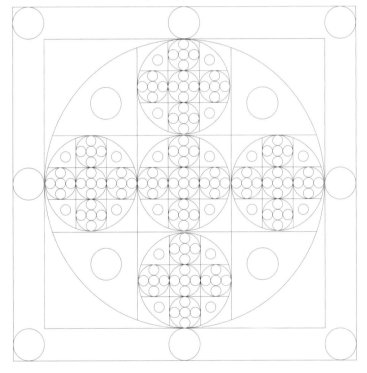

and four cardinal directions inside a large courtyard. It may be described as the culmination of the maṇḍalas that developed from the idea of mutual encompassment in the Vajraśekhara cycle (fig. 4.18).

In this way, the Vajradhātu-maṇḍala, through the modification, amalgamation, and expansion of the five families, its basic components, can be expanded and contracted like

a kaleidoscope, ranging from the General Assembly maṇḍala of the five families to the Ekamudrā-maṇḍala consisting of only a single deity (fig. 4.19).[449]

This idea of the mutual encompassment of the five families was introduced in the Vajradhātu-maṇḍala for the first time. But similar ideas are found in earlier Mahāyāna systems of thought. One example is the concept of *yinian sanqian*, or "three thousand [realms] in a single moment of thought," in the Tiantai school, according to which the ten realms, from the realm of the Buddha to hell, become one hundred realms through mutual encompassment. The mutual encompassment of the ten realms (*shijie huju*) in the Tiantai school is not a fivefold system, since the number of elements is not five but ten, but it could be based on similar thinking.

In the Huayan school, which is ranked with the Tiantai school in Chinese Buddhism, there is the analogy of Indra's net, which expresses the interdependent coarising of the dharma realm in which all dharmas are interconnected in multiple ways. Kūkai, the founder of the Japanese Shingon school, placed great importance on the Huayan school as the gateway to esoteric Buddhism and explains in his *Sokushin jōbutsu gi* that "the manifold interconnectedness of Indra's net is called this very body."[450] Kūkai seems to have thought that Indra's net in the Huayan school and the mutual encompassment of the Vajradhātu-maṇḍala had something in common as expressions of the ineffable world of enlightenment.

Similarly, it is reported as a typical pattern of mystical experience that all existents in the universe are in a state of grand harmony just as they are. The mutual encompassment of the five families in the Vajradhātu-maṇḍala could be an iconization of such an experience of enlightenment.

As will be discussed in chapter 5, the five-family system introduced in the *Sarvatathāgatatattvasaṃgraha* was adopted by late tantric Buddhism and further developed. But the pattern representing mutual encompassment in which the five buddhas are surrounded by four attendants came to an end in the late Yoga tantras, the direct descendants of the *Sarvatathāgatatattvasaṃgraha*. However, the Ārya school of the *Guhyasamājatantra*, which established the maṇḍala theory of late tantric Buddhism, posits the "*vivekakāya* of the supreme one hundred families" for explaining various aspects of the world through the mutual encompassment of the five families.[451] Thus the pattern of mutual encompassment that the Vajradhātu-maṇḍala introduced seems to have possessed universality as a psychogram illustrating the content of enlightenment.

12. The Emergence of the Fivefold System

As noted, the *Vajraśekhara* was an epoch-making corpus of scriptures introducing an unprecedented fivefold system that found expression in the Vajradhātu-maṇḍala. How did this fivefold system come into existence? In this section I suggest a solution to the enigma of the emergence of the fivefold system, which is characteristic of the Vajraśekhara cycle.

As mentioned earlier, there existed a legend of an iron stūpa in South India where eighteen tantras of the Vajraśekhara cycle, starting with the *Sarvatathāgatatattvasaṃgraha*, were discovered by Nāgārjuna. There have been various theses concerning the historical reality of this iron stūpa, and Toganoo identified it with the Amarāvatī stūpa. The Vajraśekhara cycle discovered at this iron stūpa was a series of esoteric Buddhist scriptures characterized by an

unprecedented fivefold system, whereby through mutual encompassment the five families develop into twenty-five and then innumerable families.[452]

In chapter 1, I considered the evolution of a maṇḍala-like arrangement of images from a stūpa enshrining four buddhas in the four cardinal directions. In esoteric Buddhism the stūpa became the symbol of Vairocana, the main deity of the two-world maṇḍalas. Therefore the stūpa enshrining the four buddhas in the four directions was, not unnaturally, considered to be the same as Vairocana and his maṇḍala.

The four buddhas of Jaipur used to be enshrined in the four cardinal directions of a stūpa at Ratnagiri. These buddhas are each accompanied by four of the sixteen great bodhisattvas in their halos. If these four buddhas had been enshrined in the four cardinal directions of a stūpa, this stūpa would have had the same structure as the Vajradhātu-maṇḍala. It could be said that the maṇḍala-like stūpa, which had been gradually developing in India since the fifth century, attained perfection in the four buddhas of Jaipur.

The great stūpa of Amarāvatī that Toganoo identified as the iron stūpa in South India can be dated back to the time of King Aśoka. It reached its current size during the second to third centuries when Nāgārjuna was active in South India. Therefore it is inconceivable that this stūpa had a maṇḍala-like structure from the very outset.

However, in the *Sekoddeśaṭīkā* there is a passage, to be discussed in chapter 7, which refers to this stūpa (called Dhānyakaṭaka) as the Vajradhātu-mahāmaṇḍala.[453] The *Sekoddeśaṭīkā* is a ritual manual belonging to the Kālacakra cycle and is more closely related to the *Guhyasamāja*, *Hevajra*, *Saṃvara*, and *Mañjuśrīnāmasaṅgīti* than to the *Sarvatathāgatatattvasaṃgraha*. That the *Sekoddeśaṭīkā* nonetheless identified Dhānyakaṭaka with the Vajradhātu-maṇḍala must have been because there existed some legend associating the great stūpa of Dhānyakaṭaka with the Vajradhātu-maṇḍala.

The great stūpa of Amarāvatī has rectangular pedestals in the four cardinal directions, and five pillars called *āyaka* were erected on each pedestal. There are various views on the meaning of these pillars, but if we regard the central pillars with a crest ornament as the four buddhas and the four pillars on either side of the central pillar as four attendant bodhisattvas, we can interpret the structure of the great stūpa as a likeness of the Vajradhātu-maṇḍala (fig. 4.21).

The inscription on a buddha image unearthed at Jaggayapeta, where the remains of an enormous stūpa with five *āyaka* pillars similar to those at Amarāvatī and Nāgārjunakonda were discovered, apprises us of the existence of another Nāgārjuna in South India after the time of the founder of the Mādhyamika school.[454] If one of the later Nāgārjunas got the idea of the fivefold system of the Vajradhātu-maṇḍala from the unique structure of the great stūpa of Amarāvatī with five *āyaka* pillars in the four cardinal directions, we can, I believe, rationally interpret the legend of the iron stūpa in South India (fig. 4.21). When Toganoo proposed his new theory, he was not aware of the existence of the five *āyaka* pillars because research on the restoration of the great stūpa had not yet developed. But his idea was entirely to the point.

Why was this stūpa called the "iron stūpa"? Toganoo thought that the stūpa's bright white lustre had been mistaken for "white iron," or tin. However, I would like to propose a different interpretation.

According to an inscription unearthed at the site of the stūpa, the great stūpa was called a *caitya*. If there existed the word *āyaka-caitya* in the sense of a *caitya* with *āyaka* pillars, it

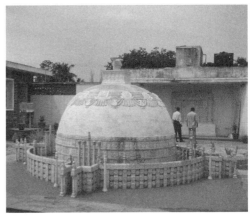

FIG. 4.20. MODEL OF THE GREAT STŪPA OF AMARĀVATĪ (ARCHAEOLOGICAL MUSEUM, AMARAVATI)

FIG. 4.21. THE VAJRADHĀTU-MAṆḌALA AND STŪPAS

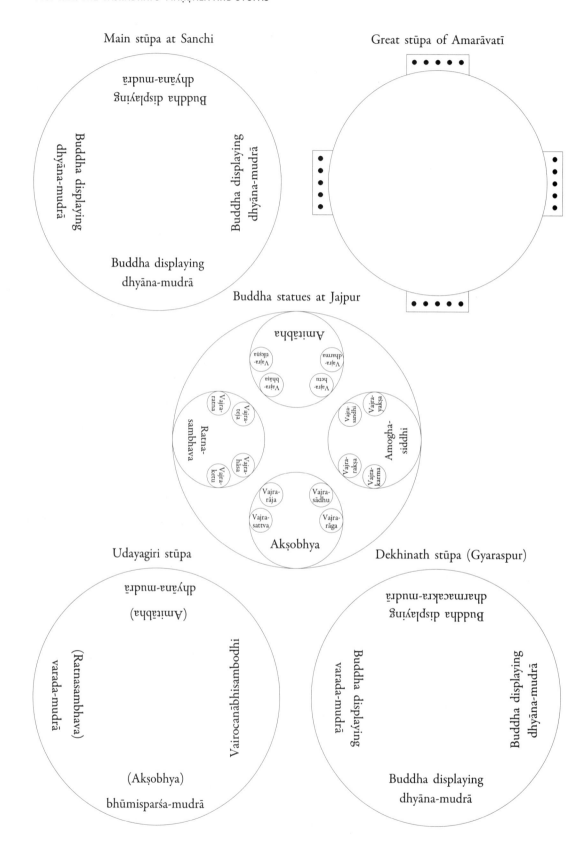

Main stūpa at Sanchi

Great stūpa of Amarāvatī

Buddha displaying
dhyāna-mudrā

Buddha displaying
dhyāna-mudrā

Buddha displaying
dhyāna-mudrā

Buddha displaying
dhyāna-mudrā

Buddha statues at Jajpur

Amitābha

Vajra-
akṣa

Vajra-
dharma

Vajra-
bhāṣa

Vajra-
hetu

Vajra-
ratna

Ratna-
sambhava

Vajra-
teja

Vajra-
sādhu

Vajra-
yakṣa

Amogha-
siddhi

Vajra-
hāsa

Vajra-
raksa

Vajra-
ketu

Vajra-
karma

Vajra-
rāja

Vajra-
sādhu

Vajra-
sattva

Vajra-
rāga

Akṣobhya

Udayagiri stūpa

Dekhinath stūpa (Gyaraspur)

dhyāna-mudrā

(Amitābha)

(Ratnasambhava)
varada-mudrā

Vairocanābhisambodhi

(Akṣobhya)

bhūmisparśa-mudrā

Buddha displaying
dharmacakra-mudrā

Buddha displaying
varada-mudrā

Buddha displaying
dhyāna-mudrā

Buddha displaying
dhyāna-mudrā

could have been interpreted as an iron *caitya*. The Sanskrit word for "iron" is *ayas*, a neuter noun with an *-as* stem. However, in Prākrit, including Pāli, it was frequently confused with masculine nouns with an *-a* stem and became *aya*. If the suffix *-ka* were added, the initial *a-* would be lengthened, resulting in *āyaka*, "made of iron." This is certainly an erroneous etymology, and the *āyaka* of *āyaka* pillar did not mean "made of iron." But if a translator who did not know of the unique style of stūpas in South India heard the word *āyaka-caitya*, it is quite possible that he might have misinterpreted it in this way.

Enormous stūpas with five *āyaka* pillars also existed at Nāgārjunakonda and Jaggayapeta in Andhrapradesh, and so the model for the iron stūpa in South India is not necessarily limited to the stūpa of Amarāvatī. Nāgārjunakonda in particular is thought to be where Nāgārjuna spent his later years, and the Nāgārjunakonda stūpa would have been shining with a white luster because it was also covered in limestone slabs. But in contrast to Nāgārjunakonda, which declined rapidly after the fall of the Ikṣuvāku dynasty, the great stūpa of Amarāvatī continued to prosper for a long time. Even after the disappearance of Buddhism in India, it survived until the fourteenth century with the support of Sri Lankan Buddhists.[455] Thus the great stūpa of Amarāvatī is the most suitable model for the iron stūpa in South India, since it survived until the age of esoteric Buddhism.

13. The Development of the Maṇḍala in the Yoga Tantras

After the emergence of the *Sarvatathāgatatattvasaṃgraha*, esoteric Buddhism belonging to this lineage developed rapidly in India and large numbers of scriptures called Yoga tantras appeared. Most of the texts included among the aforementioned eighteen assemblies of the Vajraśekhara cycle are thought to be further developments of the traditions of the *Sarvatathāgatatattvasaṃgraha* and *Prajñāpāramitānayasūtra* in India. However, some of these texts, such as the *Paramādyatantra*, corresponding to the sixth to eighth assemblies, are thought to have come into existence before the *Sarvatathāgatatattvasaṃgraha* and to have served as a prototype for the Vajraśekhara cycle.

In the Nyingma school of Tibetan Buddhism, which is based on the old esoteric Buddhism transmitted from the late eighth to ninth centuries, there have been transmitted eighteen great tantras of the Mahāyoga cycle.[456] Because the eighteen assemblies of the Vajraśekhara cycle and the eighteen great tantras of the Mahāyoga cycle share several important texts such as the *Paramādya*, *Guhyasamāja*, and *Sarvabuddhasamāyoga*, these two traditions have sometimes been confused in Tibetan Buddhism.[457]

A reference to the eighteen great tantras of the Mahāyoga cycle is found in Jñānamitra's *Prajñāpāramitānayaśatapañcaśatikāṭīkā*, which had been thought to be an old translation produced during the Tufan period, and this has been confirmed by the newly discovered *Dkar chag 'phang thang ma*.[458] Therefore the legend of the eighteen great tantras of the Mahāyoga cycle already existed in 842, when Tufan collapsed and the translation of Buddhist texts sponsored by the authorities ceased. However, there is a time difference of about one hundred years with the eighteen assemblies of the Vajraśekhara cycle transmitted by Amoghavajra, who returned to China in 746. The eighteen great tantras of the Mahāyoga cycle transmitted by the Nyingma school do not include the *Sarvatathāgatatattvasaṃgraha* but do include precursors of late tantric Buddhism.

The developed forms of the Vajraśekhara cycle also describe various maṇḍalas. Among these scriptures, those not included among the Highest Yoga tantras have until now been vaguely styled "late Yoga tantras," but there has been virtually no discussion of their definition and character. In this section I wish to discuss how to distinguish between early and late Yoga tantras.

Chronologically speaking, tantras that already existed by the first half of the eighth century are early Yoga tantras, whereas those dating from the second half of the same century are late Yoga tantras. If a text is mentioned in the *Shibahui zhigui* and the content of the extant corresponding text tallies with Amoghavajra's description, then the text should be classified among the early Yoga tantras, since the core part of the text would already have been known in India by 746.

As for groups of deities, early Yoga tantras do not include groups of deities belonging to other tantras. For example, the *Prajñāpāramitānayasūtra* and its developed forms describe the seventeen-deity maṇḍala and eight great bodhisattvas of the *Prajñāpāramitānayasūtra* while the *Sarvatathāgatatattvasaṃgraha* and its developed forms describe the thirty-seven deities of the Vajradhātu-maṇḍala.

The *Durgatipariśodhanatantra*, on the other hand, although classified among the Yoga tantras, incorporates the four buddha-mothers belonging to the *Guhyasamājatantra*. The *Vajramaṇḍalālaṃkāratantra*, discussed in chapter 3, belongs to the *Prajñāpāramitānayasūtra* cycle but incorporates the sixteen great bodhisattvas of the Vajradhātu-maṇḍala and the four buddha-mothers of the *Guhyasamājatantra*. On the basis of the makeup of their deities, these works clearly exhibit characteristics of late Yoga tantras.

Sakai Shinten identified the *Durgatipariśodhanatantra* as the fifth assembly of the *Vajraśekhara*, called the **Laukikalokottaravajrayoga*, and the *Vajramaṇḍalālaṃkāratantra* as the seventh assembly, called the *Samantabhadrayoga*.[459] However, there are considerable differences between the descriptions of the fifth and seventh assemblies in the *Shibahui zhigui* and the current versions of the *Durgatipariśodhanatantra* and *Vajramaṇḍalālaṃkāratantra*, and it is difficult to imagine that the core parts of these texts would have already existed in India by 746. Furthermore, with regard to the identification of the fifth assembly, there is a problem in that a quotation from the *Laukikalokottaravajratantra* in the *Tattvasiddhi*[460] is not found in the *Durgatipariśodhanatantra* (new translation). The *Vajramaṇḍalālaṃkāratantra*, on the other hand, incorporates and expands on the opening section of the *Sarvabuddhasamāyogatantra*, the earliest Mother tantra, which also corresponds to the ninth assembly of the *Vajraśekhara*.[461] Therefore, as was argued in chapter 3, it is better to identify the "*Mahāsukhaguhyavajra" of the *Paramādyatantra* with the seventh assembly, the *Samantabhadrayoga*.

In these developed forms of the Yoga tantras, we find that new elements or interpretations were introduced into the maṇḍalas of the Vajradhātu cycle. In the following, I wish to mention several such maṇḍalas that deserve special consideration.

The General Assembly maṇḍala of the five families explained in the *Vajraśekharamahāguhyayogatantra*, the culmination of the fivefold system of the Vajraśekhara cycle, has already been mentioned. This tantra has been identified with the second and third assemblies of the *Vajraśekhara*, and its contents also generally match the descriptions in the *Shibahui zhigui*. The General Assembly maṇḍala of the five families was depicted at Jianfusi in Chang'an by Vajrabodhi (671–761), who introduced the Vajraśekhara cycle to China for the

first time. It is also recorded that Shūei (809–884), one of eight Japanese monks who traveled to Tang China, brought a line drawing of this maṇḍala back to Japan.

Vajrabodhi arrived in China in 719. There can be little doubt that the third assembly of the Vajraśekhara cycle already existed in some form or another in India in the early eighth century, albeit in a primitive form when compared with the current Tibetan translation. There is a possibility that the main body of the second and third assemblies of the Vajraśekhara cycle, later incorporated into the *Vajraśekharamahāguhyayogatantra*, already existed in the early eighth century even though they would have been circulating separately. Therefore it is best not to include them in the later Yoga tantras.

A text corresponding to the *Sarvarahasya*, another explanatory tantra on the *Sarvatathāgatatattvasaṃgraha*, is not found among the eighteen assemblies of the Vajraśekhara cycle. Although classified among the Yoga tantras, it incorporates the four buddha-mothers of the *Guhyasamājatantra*. Furthermore, texts citing the *Sarvarahasya* are limited to those dating from after the second half of the eighth century, such as the *Caryāmelāpakapradīpa* belonging to the Ārya school of the *Guhyasamājatantra*, the *Khasamatantraṭīkā* by Ratnākaraśānti,[462] and the *Amṛtakaṇikā*, a commentary on the *Nāmasaṅgīti* belonging to the Kālacakra cycle.[463] Therefore the *Sarvarahasya* should be classified among the typical late Yoga tantras.

The *Trailokyavijayamahākalparāja* was identified by Sakai Shinten with the fourth assembly of the Vajraśekhara cycle, the *Trailokyavijayavajrayoga*. The full text is found only in the Tibetan Tripiṭaka, but it turns out that the *Jingangding xiangsanshi da yigui fawang jiao zhong guanzizai pusa xin zhenyan yiqie rulai lianhua da mannaluo pin*, the *Jingangding jing yuga wenshushili pusa fa yipin*, the *Jingangding chaosheng sanjie jing shuo wenshu wuzi zhenyan shengxiang*, and the *Jingangding jing manshushili pusa wuzi xin tuoluoni pin* in the Chinese canon were all extracted from this text.[464]

In Tibet, this text is regarded as an explanatory tantra on part 2 of the *Sarvatathāgatatattvasaṃgraha*. However, even though it refers to the eight great bodhisattvas of the *Prajñāpāramitānayasūtra*, it does not mention the sixteen great bodhisattvas.[465] Therefore the *Trailokyavijayamahākalparāja* may pre-date part 2 of the *Sarvatathāgatatattvasaṃgraha*. On the basis of an analysis of Tibetan esoteric Buddhist manuscripts from Dunhuang, I previously surmised that the *Trailokyavijayamahākalparāja* had already been translated into Tibetan during the Tufan period,[466] and this hypothesis is supported by the newly discovered *Dkar chag 'phang thang ma*.[467]

The Sarvatathāgata-maṇḍala and Ākāśagarbha-maṇḍala explained in the *Trailokyavijayamahākalparāja* were depicted on the east wall of the west chapel in the cupola of the Great Stūpa of Palkhor Chöde monastery together with the Sarvatathāgata-trilokacakra-maṇḍala explained in the same text.[468] Unfortunately, the Ākāśagarbha-maṇḍala has peeled away and other deities have been painted over it, but the Sarvatathāgata-trilokacakra-maṇḍala and Sarvatathāgata-maṇḍala preserve their original forms from the time of the construction of the monastery in the early fifteenth century. In these two maṇḍalas, the seat of the main deity is set on top of Mount Sumeru, which is surrounded by seven concentric squares symbolizing seven mountain ranges (*kāñcanaparvata*).

The inner square of the Sarvatathāgata-trilokacakra-maṇḍala has a layout in which Vairocana is surrounded by the eight great bodhisattvas, as in the Sermon Assembly maṇḍala of the *Prajñāpāramitānayasūtra* discussed in chapter 3. The eight great bodhisattvas are

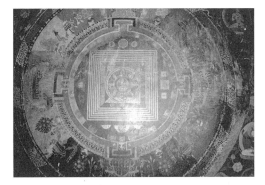

FIG. 4.22. SARVATATHĀGATA-TRILOKACAKRA-MAṆḌALA (PALKHOR CHÖDE)

FIG. 4.23. SARVATATHĀGATA-TRILOKACAKRA-MAṆḌALA

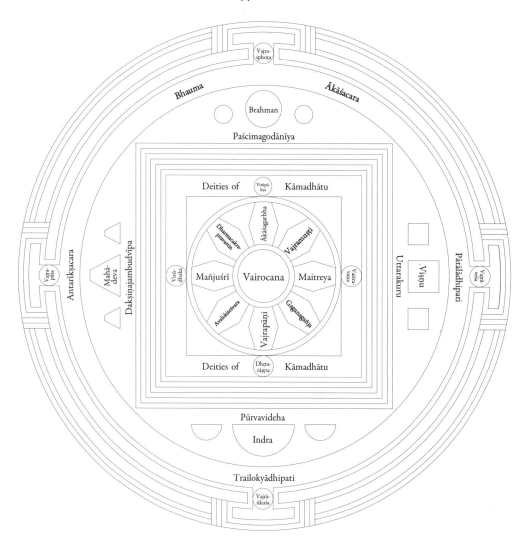

almost identical to those of the *Prajñāpāramitānayasūtra*, except that Mārapramardin has been replaced by Maitreya. In contrast to the Japanese Sermon Assembly maṇḍala and the Paramādya-Vajrasattva maṇḍala discussed in chapter 3, in this maṇḍala the assignment of the five families to the cardinal directions has not been taken into account in the arrangement of the eight great bodhisattvas (fig. 4.23).

The Sarvatathāgata-maṇḍala, on the other hand, is centered on Avalokiteśvara, who displays the gesture of forming an open lotus flower with his right hand, as explained in the *Prajñāpāramitānayasūtra*, and he is surrounded by eight tathāgatas. It is worth noting that an Amitābha-maṇḍala in which Avalokiteśvara displaying the gesture of forming an open lotus flower is surrounded by eight figures of Amitābha has been transmitted in Japan. These features, combined with the fact that there is no mention of the sixteen great bodhisattvas in the *Trailokyavijayamahākalparāja*, point to the early date of this text.

The color scheme of the courtyard in these maṇḍalas explained in the *Trailokyavijaya-mahākalparāja* is as follows: in the inside square, east (white) = Pūrvavideha, south (blue) =

FIG. 4.24. THE NAVOṢṆĪṢA-MAṆḌALA OF THE *DURGATIPARIŚODHANATANTRA*

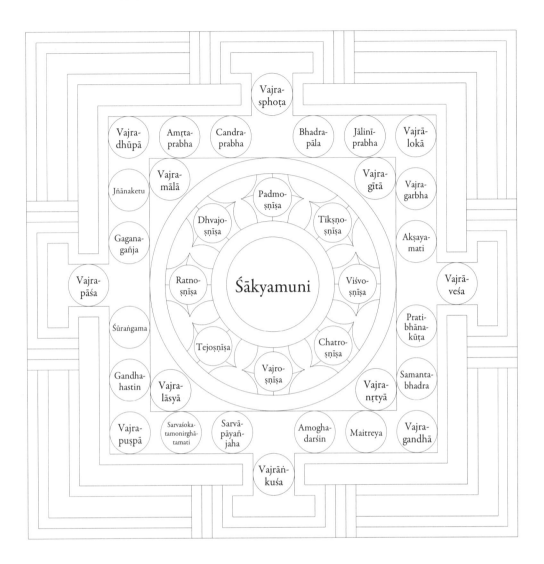

Jambudvīpa, west (red) = Aparagodhanīya, and north (yellow) = Uttarakuru; on the outside, east (blue) = Akṣobhya, south (yellow) = Ratnasambhava, west (red) = Amitābha, and north (green) = Amoghasiddhi. This seems to be a compromise between a variant theory based on Buddhist cosmology centered on Mount Sumeru[469] and a common theory that accorded with the body colors of the four buddhas. In addition, inside the protective circle there are arranged the four continents in the shape of a semicircle (white), a triangle (blue), a circle (red), and a square (yellow), respectively, as well as the eight intermediate continents (*antaradvīpa*).

The *Durgatipariśodhanatantra*, an explanatory tantra on part 2 of the *Sarvatathāgatatattvasaṃgraha*, circulated widely in Tibet because it was used for funerary rites, and it is the most popular text among the late Yoga tantras. In Tibet two versions, an old translation[470] and a new translation,[471] have been transmitted, and it is said to describe thirteen maṇḍalas in all.[472] Among these, the Sarvavid-Vairocana-maṇḍala (M-23), the basic maṇḍala of the old translation, and the Navoṣṇīṣa-maṇḍala (V-38; fig. 4.24), the basic maṇḍala of the new

Fig. 4.25. Dharmadhātuvāgīśvara-maṇḍala (center)

translation, have been extremely popular in Tibet, and consequently examples of these maṇḍalas are more numerous than those of the Vajradhātu-maṇḍala explained in the root tantra of the Yoga tantras. Furthermore, the Śākyamunikāya-maṇḍala, explained in the old translation and thought to be a prototype of the Navoṣṇīṣa-maṇḍala, has been found not only in Tibet but also in Dunhuang from the time of its Tibetan occupation.[473]

The Navoṣṇīṣa-maṇḍala is also found in Cave 3 at Dungkar. In contrast to the example included in the Ngor maṇḍalas (no. 39), it is worth noting that the central eight-petaled lotus is set on the hub of an eight-spoked wheel on which are arranged eight *uṣṇīṣa* deities. The same dual structure is also found on the east wall of the Vairocana chapel and in the New Chapel at Alchi, as well as on the south wall of Cave 3 of the Yulin Caves in Anxi, where it has been wrongly identified as the Garbha-maṇḍala.[474] In Cave 3 at Dungkar the symbols of the four families (four *pāramitās*) are arranged in the four cardinal directions of the inner eight-petaled lotus. At Alchi, on the other hand, a female deity is depicted only on the petal in the east, while in the Yulin Caves four goddesses are depicted in human form in the four

cardinal directions. They are all suggestive of consorts of the main deity and seem to be based on the same idea.

The *Mañjuśrīnāmasaṅgīti* (hereafter *Nāmasaṅgīti*) is an important text used for daily recitation in areas where Tibetan Buddhism is practiced, and it is placed at the start of the Tibetan Tripiṭaka (P. 2). It is a eulogy to Mañjuśrī thought to have been extracted from the "Samādhipaṭala" of the *Māyājālatantra*, although the current version of the *Māyājālatantra* does not contain the *Nāmasaṅgīti*.[475] This text became popular after the late eighth century, and many commentaries were composed in India, some of which interpret it as a Yoga tantra, while others interpret it as a Highest Yoga tantra. I have included it in this chapter because the structure of its maṇḍala is similar to that of the Yoga tantras.

The fifty-seven-deity *Saṃkṣiptakula-Mañjuśrī-maṇḍala of the Sangden school (M-35) is a maṇḍala based on this text.[476] A maṇḍala on the south wall of the Vairocana chapel at Alchi, formerly known as "a variety of the Vajradhātu-maṇḍala,"[477] may be the oldest extant example of this maṇḍala.

The Dharmadhātuvāgīśvara school founded by Mañjuśrīkīrti explains a large-scale maṇḍala centered on Mañjuśrī called the Dharmadhātuvāgīśvara-maṇḍala (V-39). This maṇḍala, which basically employs the system of the Vajradhātu-maṇḍala, has adopted the eight uṣṇīṣa deities from the *Vajramaṇḍalālaṃkāratantra* and the four buddha-mothers from the *Guhyasamājatantra*, and arranges goddesses representing deifications of doctrinal categories of Mahāyāna Buddhism in the outer square. Thus it can be regarded as the culmination of the development of maṇḍalas belonging to the Vajradhātu cycle (fig. 4.25). A well-known example is a wall painting on the west wall of the Vairocana chapel at Alchi. A considerable number of examples are also found in central Tibet. This maṇḍala is also popular in Nepal, and many examples have survived, mainly in the Kathmandu Valley.[478]

The late Yoga tantras other than the *Nāmasaṅgīti* and *Durgatipariśodhanatantra* were gradually forgotten over time, and examples of their maṇḍalas are not common even in Tibet. However, the merging of the maṇḍala with Buddhist cosmology centered on Mount Sumeru, found in late Yoga tantras, was taken over in the *Kālacakratantra*, the final system of Indian esoteric Buddhism.

5. The Emergence of the Guhyasamāja-maṇḍala

1. The Date of the *Mūlatantra*

THE *GUHYASAMĀJATANTRA* IS A representative esoteric Buddhist scripture of late tantric Buddhism. It is no exaggeration to say that late tantric Buddhism began with the appearance of the *Guhyasamājatantra*.

The *Guhyasamājayoga* is mentioned for the first time by Amoghavajra in his *Shibahui zhigui* as the fifteenth tantra of the Vajraśekhara cycle.[479] Amoghavajra states that, on hearing this scandalous tantra, Sarvanīvaraṇaviṣkambhin and other bodhisattvas implored the Buddha not to utter such obscene words. We can find a corresponding passage in chapter 5 of the extant *Guhyasamājatantra*.[480] However, the account given in the *Shibahui zhigui* is quite brief, and it is open to question whether the extant *Guhyasamājatantra* had already appeared by around 746 when Amoghavajra returned to China from India. But it may be accepted that a primitive form of this work appeared during the eighth century.

In Tibet, it had been thought that Rinchen Sangpo (958–1055) translated this text into Tibetan for the first time. However, the discovery of a manuscript of the Tibetan translation of the first seventeen chapters of the *Guhyasamājatantra* from Dunhuang proved the existence of an early translation made during the Tufan period.[481] A Tibetan translation of chapter 18, regarded as the *uttaratantra*, has not been found, although the commentary on chapter 18 by Viśvāmitra is thought to have been translated during the Tufan period.[482] Contentwise, this commentary reflects a primitive interpretation, which suggests the possibility of its being an early translation.[483] There is also a Chinese translation, the *Yiqie rulai jingang sanye zuishang bimi dajiaowang jing* translated by Dānapāla, but it did not circulate widely in Sino-Japanese Buddhism.

As regards the evolution of this scripture, Matsunaga Yūkei has put forward a thesis that posits three stages in its development: chapters 1 to 12, chapters 13 to 17, and chapter 18, the *uttaratantra*.[484] This thesis is widely accepted in Japan today.

That late tantric Buddhist scriptures, starting with the *Guhyasamājatantra*, appeared in the ninth century and later has been the mainstream view in Japanese academic circles, since these works were not translated into Chinese during the Tang dynasty. Moreover, in Tibet the *Ldan dkar ma* catalogue, dated to 824, does not include any late tantric Buddhist scriptures. Therefore in Japan there emerged the view that the late tantras, even comparatively early ones, did not exist in Tibet during the Tufan period.

The eighteen great tantras of the Mahāyoga cycle, mentioned in chapter 4, include several comparatively early late-Buddhist tantras such as the *Guhyasamāja* and *Sarvabuddhasamāyoga* (see chapter 6). Furthermore, the study of Tibetan manuscripts discovered at

Dunhuang, which was occupied by Tufan from 786 to the mid-ninth century, has revealed that several late tantras, including the *Guhyasamāja* and *Sarvabuddhasamāyoga*, were already known in Tibet during the Tufan period.[485]

Why, then, were these late tantras not included in the *Ldan dkar ma* catalogue? It is to be surmised that the royal family of Tufan prohibited the translation of late tantras because of their antisocial elements, such as sex and imprecations. The *Sgra sbyor bam po gnyis pa*, a Tibetan work explaining difficult terms included in the *Mahāvyutpatti*, a large Tibeto-Sanskrit Buddhist terminological dictionary, explains that tantras that should not be taught to unsuitable persons were previously translated and were permitted to be practiced, but there appeared people who, without understanding their profound meanings, wrongly practiced them literally.[486]

The late tantras were not translated into Chinese during the Tang dynasty. However, the *Shibahui zhigui* mentions not only the *Guhyasamāja* but also other late tantras. The descriptions of the assemblies after the first in the *Shibahui zhigui* are brief, and many Japanese scholars have doubted the existence of the extant versions of the second and subsequent assemblies in the middle of the eighth century. However, as will be seen in the next chapter, there is an instance in which a verse included in the description of the ninth assembly in the *Shibahui zhigui* has recently been identified in the *Sarvabuddhasamāyogatantra*, thought to correspond to the ninth assembly.

The discovery of the old Tibetan translation of the *Guhyasamājatantra* at Dunhuang, as well as the existence of Vajrahāsa's commentary on the *mūlatantra* and Viśvāmitra's commentary on the *uttaratantra* in the Tibetan Tripiṭaka, suggest that these texts had already been translated into Tibetan before the prohibition on the translation of such texts by the authorities in Tufan. The account in the aforementioned *Sgra sbyor bam po gnyis pa* suggests that the circulation of late tantras was already prohibited during the reign of King Tride Songtsen, who ascended the throne in 803.[487] Therefore the extant *Guhyasamājatantra*, including the *uttaratantra*, had already come into existence in the early ninth century at the latest.

Thus the reason that the transmission of late Buddhist tantras outside India was delayed was because of their antisocial elements. In my view, this does not mean that the later tantras did not exist in eighth-century India.

2. The Thirteen Basic Deities

The Guhyasamāja-maṇḍala is based on chapter 1 of the *Guhyasamājatantra*. However, the deities clearly mentioned in chapter 1 are only the five buddhas, the four buddha-mothers, and the four wrathful gatekeepers, who are collectively called the "thirteen basic deities." Among these deities the five buddhas are basically the same as those of the Vajradhātu-maṇḍala. But Vairocana, the main deity of the Vajradhātu-maṇḍala, has moved to the east while Akṣobhya, seated in the east in the Vajradhātu-maṇḍala, has become the main deity of the maṇḍala.

Akṣobhya had been worshiped since early Mahāyāna Buddhism as a buddha of the pure land in the east. In most cases he was placed in the east section of the maṇḍala, although he was also moved to the north section on account of the intrusion of Saṃkusumitarājendra, as discussed in chapter 1. However, in late tantric Buddhism after the *Guhyasamāja*, maṇḍalas

FIG. 5.1. THE THIRTEEN BASIC DEITIES OF *GUHYASAMĀJATANTRA*

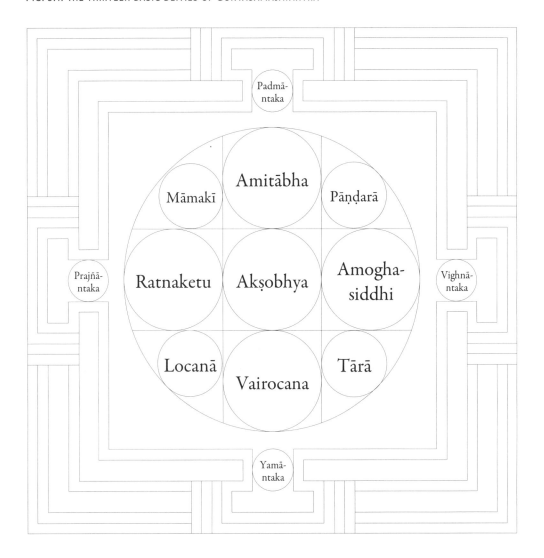

centered on Akṣobhya or a tutelary deity emanating from him prevail. This is one of the distinguishing characteristics of maṇḍalas of late tantric Buddhism.

As is clearly stated in v. 50 of chapter 17 in the *Guhyasamājatantra*,[488] the five buddhas symbolize the five aggregates (*pañcaskandha*). In this case, Vairocana is assigned to form (*rūpa*) and Akṣobhya to consciousness (*vijñāna*). In the case of the three mysteries, too, Vairocana is assigned to the body (*kāya*) and Akṣobhya to the mind (*citta*). The shift of the main deity from Vairocana to Akṣobhya suggests that the *Guhyasamājatantra* placed greater importance on ideational elements than on physical matter.[489]

The *Guhyasamājatantra* calls the buddha in the south Ratnaketu, not Ratnasambhava. This name coincides with that of the corresponding buddha not in the *Sarvatathāgata-tattvasaṃgraha* but among the four buddhas of the *Suvarṇaprabhāsasūtra*, the prototype of the five buddhas. In late tantric Buddhism the five buddhas are usually centered on Akṣobhya, and many tantras after the *Guhyasamāja* adopt Ratnasambhava, originating in the *Sarvatathāgatatattvasaṃgraha*, or Ratneśa, used in the Jñānapāda school,[490] as the

name of the buddha in the south, whereas Ratnaketu is seldom used in later texts. This fact suggests that the five buddhas of the *Guhyasamāja* preserve an old form originating in the *Suvarṇaprabhāsasūtra*.

Chapter 1 of the *Guhyasamājatantra* gives the heart-mantras (*hṛdaya*) of the five buddhas: *vajradhṛk* (Akṣobhya), *jinajik* (Vairocana), *ratnadhṛk* (Ratnaketu), *ārolik* (Amitābha), and *prajñādhṛk* (Amoghasiddhi). Among these, *jinajik*, *ārolik*, and *vajradhṛk* are explained in the *Susiddhikaramahātantra*, an early esoteric Buddhist scripture, as the "three-and-a-half-syllable mantras" of the three families.[491] These mantras are not found in the *Vairocanā-bhisambodhisūtra* or *Sarvatathāgatatattvasaṃgraha*, although they occur in other ritual manuals translated during the Tang dynasty. Therefore the *Guhyasamājatantra* is thought to have adopted them directly from early esoteric Buddhism, increased them to five, and made them the heart-mantras of the five buddhas.

According to both the Ārya and Jñānapāda traditions, the five buddhas of the *Guhyasamājatantra* are three-headed and six-armed, and they hold a vajra, a wheel, a jewel, a lotus, a sword, and a bell in their six hands. Among these attributes, the first five are the symbols of the five buddhas while the bell is regarded as the symbol of Vajrasattva, the sixth buddha. The five buddhas hold their own symbol in their first right hand, a bell in their first left hand, and the four symbols of the other four buddhas in their remaining hands.[492] This is thought to be an application of the mutual encompassment of the five families of the *Sarvatathāga-tatattvasaṃgraha* to the iconography of the five buddhas.

In the four intermediate directions of the maṇḍala, meanwhile, the four buddha-mothers are depicted. In contrast to the five buddhas, who symbolize the five aggregates, the four buddha-mothers symbolize the four elements: earth, water, fire, and wind.[493] The introduction of four or five elements into the maṇḍala is one of the characteristics of the Vairo-canābhisambodhi cycle. In the Garbha-maṇḍala, the four buddhas starting with Ratnaketu are considered to preside over the four elements. As was pointed out in chapter 3, the introduction of the four elements into the maṇḍala occurred in the late Yoga tantras. The *Guhya-samājatantra*, on the other hand, clearly states that the four buddha-mothers among the thirteen deities symbolize the four elements.

The four buddha-mothers consist of the mothers of the three families—Buddhalocanā, Pāṇḍaravāsinī, and Māmakī—explained in the *Susiddhikaramahātantra*, an early esoteric Buddhist scripture, with the addition of Tārā. The assignment of the four buddha-mothers to the five families is, according to the *Piṇḍīkrama* of the Ārya school, as follows: Locanā = Tathāgata family, Māmakī = Vajra family, Pāṇḍarā = Lotus family, and Tārā = Karma family.[494] The *Piṇḍīkramaṭippaṇī*, on the other hand, assigns Māmakī to both the Jewel and Vajra families.[495] The *Samantabhadra nāma sādhana* of the Jñānapāda school assigns Locanā to the Tathāgata family, Māmakī to the Vajra family, Pāṇḍarā to the Lotus family, and Tārā to the Jewel family.[496] There thus existed several opinions regarding the assignment of the four buddha-mothers.

When the *Sarvatathāgatatattvasaṃgraha* introduced the system of five families, the four *pāramitās* were introduced as the mothers of four of the five families. However, Khava-jriṇī, originally the consort of Ākāśagarbha, the main deity of the Jewel family, became the mother of the Karma family because the Karma family was undeveloped. In the same way, the *Guhyasamājatantra* introduced the four buddha-mothers by adding Tārā, originally a female emanation of Avalokiteśvara, to the mothers of the three families of the *Susiddhi-*

karamahātantra. If they are assigned to the five families, one goddess is still wanting. Further, the fact that Pāṇḍarā and Tārā originally belonged to the same Lotus family caused inconsistencies.

In the developed form of late tantric Buddhism, Vajradhātvīśvarī was added to the four buddha-mothers. This resulted in the introduction of five buddha-mothers, who are assigned to the five elements, namely, earth, water, fire, wind, and space. However, Vajradhātvīśvarī is not mentioned in the *Guhyasamājatantra*, since she is the female form of Vajradhātu-Vairocana explained in the *Sarvatathāgatatattvasaṃgraha*.[497] Originally Vajradhātvīśvarī belonged to the Tathāgata family because she is an emanation of Vajradhātu-Vairocana. Therefore her role overlaps with that of Locanā, the mother of the Buddha family since the time of the *Susiddhikaramahātantra*. There exist many different opinions regarding the assignment of the five buddha-mothers to the five families.

The four wrathful deities are gatekeepers arranged in the four gates of the Guhyasamāja-maṇḍala. Chapter 1 of the *Guhyasamāja* explains only the mantras of the four wrathful deities (*yamāntakṛt, prajñāntakṛt, padmāntakṛt,* and *vighnāntakṛt*), and their names are not given. But they are usually interpreted as being identical to the first four among the ten wrathful deities explained in chapters 13 and 14 of the *Guhyasamāja*, that is, Yamāntaka, Aparājita, Hayagrīva, and Amṛtakuṇḍalin. According to chapter 14, the assignment of the four wrathful deities to the five families is as follows: Yamāntaka = Vajra family, Amṛtakuṇḍalin = Tathāgata family, Aparājita = Jewel family, and Hayagrīva = Lotus family.[498] The *Piṇḍīkrama* assigns Yamāntaka to the Vajra family, Aparājita to the Jewel family, Hayagrīva to the Lotus family, and Amṛtakuṇḍalin to the Karma family.[499] The *Samantabhadra nāma sādhana* of the Jñānapāda school, on the other hand, assigns Yamāntaka to the Tathāgata family, Aparājita to the Vajra family, Hayagrīva to the Lotus family, and Amṛtakuṇḍalin to the Vajra family. But a Sanskrit commentary on the same work changes this as follows: Yamāntaka = Tathāgata family, Aparājita = Vajra family, Hayagrīva = Lotus family, and Amṛtakuṇḍalin = Karma family (see fig. 5.2).[500]

FIG. 5.2. THE FOUR WRATHFUL DEITIES OF THE *GUHYASAMĀJATANTRA*

	Yamāntaka	Aparājita	Hayagrīva	Amṛtakuṇḍalin
Guhyasamāja	Vajra	Jewel	Lotus	Tathāgata
Piṇḍīkrama	Vajra	Jewel	Lotus	Karma
Samantabhadra nāma sādhana	Tathāgata	Vajra	Lotus	Vajra
Sanskrit commentary	Tathāgata	Vajra	Lotus	Karma

As was seen in chapter 2, the *Susiddhikaramahātantra* mentions Uṣṇīṣavijaya (Buddha family), Hayagrīva (Lotus family), and Sumbha (Vajra family) as the *vidyārājas* of the three families, and Aparājita (Buddha family), Śivāvaha (Lotus family), and Amṛtakuṇḍalin (Vajra family) as the *mahākrodhas* of the three families. Therefore three of the four wrathful deities of the *Guhyasamāja* had already appeared in the *Susiddhikaramahātantra*. Yamāntaka, on the other hand, had already appeared in the retinue of Mañjuśrī in the *Mañjuśrīmūlakalpa*.

Thus the four wrathful deities of the *Guhyasamāja* came about by combining several wrathful deities already worshiped in early esoteric Buddhism.

However, the assignment of the four wrathful deities to the five families was not fixed except for Hayagrīva, who had already been associated with the Lotus family since the time of early esoteric Buddhism. This suggests that, as in the case of the four buddha-mothers, a process of trial and error was involved in reorganizing in five families deities formerly classified into three families.

In considering the origins of the thirteen basic deities of the Guhyasamāja-maṇḍala, it thus turns out that the *Guhyasamājatantra* was directly influenced by early esoteric Buddhism without the intermediation of the *Sarvatathāgatatattvasaṃgraha*. At present, an example of a maṇḍala depicting only the thirteen basic deities has not yet been identified, even though these deities influenced not only the *Guhyasamāja* but also the maṇḍala theory of late tantric Buddhism in general. The Ārya and Jñānapāda schools, examples of whose maṇḍalas are numerous, added many deities to these thirteen basic deities.

In connection with this issue, an interesting passage occurs in the *Samājamaṇḍalavyavastholī* by Nāgabodhi/Nāgabuddhi[501] of the Ārya school.[502] According to Nāgabodhi, the *mūlatantra* did not explain all the deities of the maṇḍala because one must not practice the maṇḍala rite without oral instructions from a master (*ācārya*). In Japanese esoteric Buddhism it is also said that the *Vairocanābhisambodhisūtra* should be interpreted in accordance with oral instructions from a master because there are missing sentences or ambiguities in the text. The situation seems to be very similar in both cases.

According to Tibetan sources, there existed a thirteen-deity maṇḍala belonging to the Indrabhūti school in addition to the thirty-two-deity maṇḍala of the Ārya school and the nineteen-deity maṇḍala of the Jñānapāda school. However, no examples of a thirteen-deity maṇḍala have been found in Tibet. At least one scholar therefore concluded that Indrabhūti was not involved in the evolution of the *Guhyasamājatantra*.[503] But another has surmised, on the basis of chapter 15 of the *Jñānasiddhi*, that the thirteen-deity maṇḍala of the Indrabhūti school was the same as the thirteen basic deities,[504] a view that I also support.

There are different views regarding Indrabhūti. Some recognize a great Indrabhūti and a minor Indrabhūti, while others recognize a great, a middle, and a minor Indrabhūti. The great Indrabhūti was considered to have been a great king during the Buddha's lifetime. According to the *Zuishang dasheng jingang dajiao baowang jing*, the king Indrabhūti was conferred the teachings of esoteric Buddhism by the Buddha and Vajrapāṇi.[505] This seems to be a fiction that makes Indrabhūti, a historical figure, a contemporary of the Buddha.

The Tibetan Tripiṭaka, on the other hand, includes many texts attributed to Indrabhūti, not only the aforementioned *Jñānasiddhi* but also a commentary on an early Mother tantra, the *Samāyogatantra*, and some *sādhanas*. Moreover, the *Jñānasiddhi* frequently quotes the *Samāyogatantra* as the *Saṃvara*, which is characteristic of esoteric Buddhist texts that came into existence during the late eighth century. The texts related to the Cakrasaṃvara cycle and attributed to Indrabhūti, on the other hand, are based on the sixty-two-deity maṇḍala of Cakrasaṃvara (see chapter 6), and so they are thought to have been composed by a later author. Therefore Hadano's comment that "Indrabhūti's character and legend themselves contain to a large extent elements of the Prajñātantras of the Anuttarayoga"[506] is applicable to the last Indrabhūti but not to the author of the *Jñānasiddhi* and texts related to the *Samāyogatantra*.

At present, the following hypothesis is the most probable: the great Indrabhūti is a fictional character; the middle Indrabhūti was the author of the *Jñānasiddhi* and texts related to the *Samāyogatantra*; and the minor Indrabhūti had connections with the late Saṃvara cycle. The Indrabhūti who played some part in the genesis of the *Guhyasamāja* and is thought to have been the founder of the Indrabhūti school was the middle Indrabhūti.

Judging from the characteristics of works cited in the *Jñānasiddhi*, this text can be dated to the late eighth century. As I will argue below, Buddhajñānapāda, who enlarged the thirteen-deity maṇḍala to a nineteen-deity maṇḍala, is thought to have flourished between 750 and 800, meaning that the thirteen basic deities had already appeared before the mid-eighth century. It is also suggestive that in chapter 5 of the *Guhyasamāja*, belonging to Matsunaga's first stage, which explains the thirteen-deity maṇḍala, there is found a passage coinciding with the description in the *Shibahui zhigui* translated by Amoghavajra, who returned to China in 746. Therefore the thirteen basic deities of the *Guhyasamāja* had already come into existence by the middle of the eighth century at the latest.

3. The Jñānapāda School

The Jñānapāda school is, along with the Ārya school, a famous lineage deriving from the *Guhyasamājatantra*. The Jñānapāda school was established by Buddhajñānapāda, a renowned esoteric Buddhist who lived during the early Pāla dynasty. When the king Dharmapāla of the Pāla dynasty founded Vikramaśīla monastery, he is said to have been appointed *vajrācārya* of the monastery. This is corroborated by the fact that there existed a strong tradition of the Jñānapāda school among monks of Vikramaśīla monastery throughout the Pāla dynasty. Hadano Hakuyū surmised that he was active from 750 to 800.[507]

It is also recorded that Buddhajñānapāda was initiated into the mysteries of the *Guhyasamājatantra* by Mañjuśrī and wrote fourteen works, including the *Dvikramatattvabhāvanā nāma mukhāgama*, *Mukhāgama*, and *Samantabhadra nāma sādhana*. We can refer to most of these fourteen works, since they are included in the Tibetan Tripiṭaka, but their Sanskrit originals have been lost. I had long been searching for the Sanskrit manuscript of the *Samantabhadra nāma sādhana*, the basic text on the generation stage of the Jñānapāda school, and I eventually came across a manuscript entitled *Kasyacidbauddhatantrasya ṭīkā* (pra.1697, kha 2) at the National Archives in Kathmandu and was able to ascertain that it is an incomplete commentary on the *Samantabhadra nāma sādhana* by an unknown author.[508]

The Jñānapāda school explains a nineteen-deity maṇḍala centered on Mañjuvajra. However, some dispute arose about the nineteen-deity maṇḍala because the pioneering studies by Sakai and Hadano did not mention the composition of the nineteen deities. Matsunaga Yūkei, in his history of the formation of esoteric Buddhist scriptures, states that "the nineteen deities of the Jñānapāda school consist of the five buddhas centered on Mañjuvajra, the four consorts (i.e., buddha-mothers), and the ten wrathful deities, including the four wrathful deities."[509] Matsunaga took note of the fact that the thirteen basic deities explained in chapter 1 were expanded to a system including the ten wrathful deities in chapter 13 and subsequent chapters. He then interpreted this as corresponding to the evolution from thirteen basic deities to the nineteen deities of the Jñānapāda school.

In contrast, I pointed out on the basis of the *Rgyud sde kun btus*[510] and the Ngor maṇḍalas[511] that the nineteen deities consist of the thirteen basic deities (five buddhas, four

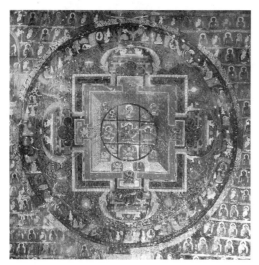

FIG. 5.3. NINETEEN-DEITY MAÑJUVAJRA-MAṆḌALA
(TSATSAPURI, LADAKH; © MORI KAZUSHI)

FIG. 5.4. NINETEEN-DEITY MAÑJUVAJRA-MAṆḌALA

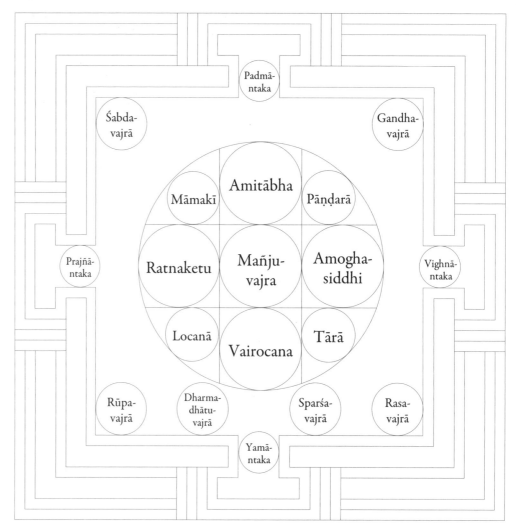

buddha-mothers, and four wrathful deities) plus six adamantine goddesses.[512] Another scholar, Kanamoto Takuji, reached the same conclusion on the basis of the Tibetan translation of the *Samantabhadra nāma sādhana*.[513]

The nineteen-deity maṇḍala of the Jñānapāda school takes the form of a nine-panel grid in the center of which is depicted the main deity Mañjuvajra embracing his consort Māmakī. As in the case of the thirteen basic deities, the four buddhas are arranged in the four cardinal directions while the four buddha-mothers are arranged in the four intermediate directions. There are two types of representation, with the four buddhas and four buddha-mothers being depicted either without partners or as couples.

Outside the central nine-panel grid are the six adamantine goddesses, that is, Rūpavajrā (southeast), Śabdavajrā (southwest), Gandhavajrā (northwest), Rasavajrā (northeast), Sparśavajrā (north side of east gate), and Dharmadhātuvajrā (south side of west gate). The six adamantine goddesses symbolize the six sense objects (*āyatana*) and six *pāramitās*. They, too, are depicted either without a partner or coupled with six bodhisattvas. In the Hahn Foundation handscroll, this maṇḍala (V-1) is depicted as a double pavilion, contrary to the norm, but

in many cases it is depicted as a single pavilion. In the four gates are the same four wrathful deities as included in the thirteen basic deities. Thus this maṇḍala consists of nineteen deities: Mañjuvajra, four buddhas, four buddha-mothers, six adamantine goddesses, and four wrathful deities. It should be noted that the four wrathful deities are usually accompanied by consorts who are, however, not counted among the nineteen deities (see fig. 5.4).

In ritual manuals of the Jñānapāda school, ten wrathful deities are visualized during the production of the protective circle (rakṣācakra). The *Samantabhadra nāma sādhana* quotes the eulogy of the five buddhas[514] and the eulogy of Mahāvajradhara by the four buddha-mothers from chapter 17 of the *Guhyasamāja*. Therefore Matsunaga's thesis, which associates chapters 13–17, corresponding to the second stage of the *Guhyasamāja*, with the Jñānapāda school, turns out to have been on the right track after all.

Why, then, did the Jñānapāda school add the six adamantine goddesses to the thirteen basic deities instead of the ten wrathful deities mentioned in the *mūlatantra*? And how should we regard the historical relationship between the nineteen deities of the Jñānapāda school and the thirty-two deities of the Ārya school? I shall consider these questions in section 6 below.

4. The Introduction of Sexual Theory

The father-mother image (Tib. *yab yum*), representing a male and a female deity embracing each other or engaging in sexual union on the same lotus throne, is an icon characteristic of late tantric Buddhism, although in many actual examples they do not actually engage in sexual union. According to the *Abhidharmakośa*, there are four types of sexual union in the realm of desire (*kāmadhātu*), and sentient beings in the higher heavenly realms achieve sexual union by merely embracing or holding each other's hands.[515]

The introduction of female deities into Buddhism dates from the beginning of the first century. Initially, most of these female deities, such as Sthāvarā, the earth goddess who witnessed the Buddha's enlightenment, and Hārītī, a goddess of fertility, were adopted from indigenous beliefs. As Mahāyāna Buddhism developed, there appeared female deities as deifications of doctrinal categories. Among these, Prajñāpāramitā—the deification of the perfection of wisdom, a fundamental idea of Mahāyāna Buddhism—is considered to be the mother of all buddhas in the ten directions and in the past, present, and future, since *prajñāpāramitā* is a feminine noun. This deification of *prajñāpāramitā* as a buddha-mother is already found in the *Prajñāpāramitāstuti* by Rāhulabhadra.[516]

After the emergence of esoteric Buddhism, the number of female deities in Buddhism increased dramatically. From its early stages esoteric Buddhism had developed the *dhāraṇī* cult, and many *dhāraṇīs*, or spells, were deified and worshiped as female deities, since *dhāraṇī* is a feminine noun. Mahāmāyūrī, Mahāpratisarā, and Cundā are such female deifications of *dhāraṇīs* worshiped from the time of early esoteric Buddhism.

The mothers of the three families of the *Susiddhikaramahātantra* seem to have been selected from among such female deities. The four buddha-mothers of the *Guhyasamāja* are a developed form of these mothers of the three families, and in late tantric Buddhism they form couples with buddhas as their consorts.

Chapter 1 of the *Guhyasamāja* introduces the five buddhas, the four buddha-mothers, and the four wrathful deities. Because the five buddhas occupy the center and four cardinal

directions while the four buddha-mothers occupy the four intermediate directions, they do not form couples with each other. In the Jñānapāda school, it is clearly stated that the main deity, Mañjuvajra, forms a couple with Māmakī.[517] In the Ārya school, on the other hand, the main deity, Akṣobhyavajra, forms a couple with Sparśavajrā.

The forty-two peaceful deities discovered at Dunhuang and preserved in the Pelliot collection (EO 1144; ninth century) seem to be the earliest extant example depicting such father-mother couples.[518] In this icon, the five buddhas centered on Akṣobhya or Vajrasattva, as well as the eight great bodhisattvas, are accompanied by consorts, but their postures are quite different from the *yab yum* style of later ages, and the consorts depicted on the viewer's right of the buddha or bodhisattva and on the same lotus seat place their hands on their partner's shoulders. Such a manner of depiction is thought to be a primitive representation of father-mother images.

How did such father-mother images come to be introduced into late tantric Buddhism? Here I wish to consider the circumstances in which father-mother images were introduced and how they were interpreted in the context of esoteric Buddhist theory.

We can posit both external and internal causes for the introduction of father-mother images. As an external cause, we can point to the rise of the *śākta* cult, which worships the consorts of Hindu gods as symbols of their energy. As will be shown in chapter 6, in part 2 of the *Sarvatathāgatatattvasaṃgraha* the principal Hindu deities are subjugated together with their consorts and are arranged in the outer square of the Trailokyavijaya-maṇḍala as twenty protective deities and twenty mothers (*mātṛkā*).[519] The introduction of Hindu deities accompanied by their consorts (*śakti*), as well as a tendency for the subjugator to inherit the attributes of a subjugated Hindu deity, were external causes of the introduction of buddhas accompanied by consorts.

As for internal causes, we can point out that the process whereby the main deity's retinue is produced from the main deity himself is likened to the conception and birth of sentient beings. The *Mukhāgama* and *Samantabhadra nāma sādhana*, both belonging to the Jñānapāda school, link the production of the maṇḍala and the twelve limbs of dependent origination (*pratītyasamutpāda*) in the following way.

Prior to the production of the maṇḍala, one should visualize three truths (*tritattva*)— the syllable *Oṃ* (white), the syllable *Āḥ* (red), and the syllable *Hūṃ* (blue)—entering one's mouth from space. These three letters are the seed-syllables of Vairocana, Amitābha, and Akṣobhya, who symbolize the Buddha's body, speech, and mind, respectively, while white, red, and blue are the body colors of Vairocana, Amitābha, and Akṣobhya. At the same time, they symbolize the three elements of conception: semen (white), menstrual blood (red), and the consciousness of a sentient being, or *gandharva*, which is implanted into the womb (blue). Reciting the mantra "*Oṃ śūnyatājñānavajrasvabhāvātmako 'haṃ*"[520] given in chapter 3 of the *Guhyasamāja*, one should contemplate that all existents lack any inherent substantiality, just like a mirage or a rainbow. According to the *Mukhāgama*, this practice corresponds to *avidyā*, or "ignorance," the first limb of dependent origination.

The seed syllables that have entered one's mouth transform themselves into a moon disc, and the syllable *Hūṃ* visualized in the center of the moon disc turns into a red vajra from which three-headed and six-armed Samantabhadra and his consort are born. From Samantabhadra and his consort a triangle symbolizing the world (*dharmodaya*) is born, from which Vairocana and his consort are then born. From a ray emitted from Vairocana and his con-

sort there appears the square pavilion of the maṇḍala, furnished with four gates and eight pillars. This corresponds to *saṃskāra*, or "formative forces," the second limb of dependent origination.

Inside the pavilion, sun discs and moon discs, which are to be the seats of the deities, are visualized. The sun and moon discs number nineteen because the Guhyasamāja-maṇḍala of the Jñānapāda school consists of nineteen deities. The sun discs are as a rule for male deities and number seven, and the moon discs, numbering twelve, are for female deities. However, the seats for Mañjuvajra, the main deity, and Vairocana are moon discs.[521]

Moreover, two moon discs should be visualized above Mañjuvajra's moon disc. In the left moon disc the sixteen vowels should be visualized and in the right moon disc the consonants from *ka* to *ha*. The string of vowels is white, while that of consonants is red. These two moon discs symbolize the elements coming from the father and mother during conception. The arrangement of the two moon discs side by side, symbolizing the father and mother, bears a certain resemblance to the father-mother images of the aforementioned forty-two peaceful deities from Dunhuang. The two moon discs symbolizing the father and mother are thought to have been arranged side by side because at the time of Buddhajñānapāda father-mother images facing and embracing each other were not yet widespread and it was common for male and female deities to be seated side by side.

In between the two moon discs the syllable *Raṃ*, symbolizing fire or thermic energy, is visualized. The two moon discs melt with its heat, and from the radiating rays there appears the syllable *Hūṃ*, from which a vajra is born. The syllable *Hūṃ* transforms itself into the body of Vajradhara as a buddha adorned with the thirty-two special marks (*mahāpuruṣa-lakṣaṇa*) and eighty secondary marks (*anuvyañjana*) of a buddha.

The *Mukhāgama* gives only the first mantra, "*Oṃ cittaprativedhaṃ karomi*,"[522] of the five-stage process of enlightenment (*pañcākārābhisambodhi*) explained in the *Sarvatathāga-tatattvasaṃgraha*, but later commentaries and manuals apply the entire five-stage process to the emergence of Vajradhara. Vajradhara born by this process is called "Causal Vajradhara" because he is the primordial being who gives rise to all the deities in the maṇḍala. The above corresponds to the practice for the fulfillment of self-benefit, namely, the process of one's own enlightenment.

Next, Vajradhātvīśvarī, the mother of the entire world, is visualized. After making offerings to all the tathāgatas, she enters into the practitioner's body through his mouth and is ejaculated through the adamantine path (*vajramārga*), that is, the urethra, to become a cosmic vagina. The four buddha-mothers and adamantine goddesses are also ejaculated one by one through the urethra into the vagina into which Vajradhātvīśvarī has transformed herself.

After having given rise to all the deities of the Guhyasamāja-maṇḍala in this way, to share this pleasure with all sentient beings living in this world system is said to correspond to the practice for the fulfillment of benefiting others, namely, the process whereby the Buddha, after enlightenment, saves sentient beings. The above corresponds to *vijñāna*, or "consciousness," the third limb of dependent origination.

According to the *Abhidharmakośa*, the moment when a *gandharva*, the consciousness of a deceased sentient being, enters the womb of the mother corresponds to *vijñāna* among the twelve limbs of dependent origination. Needless to say, the process corresponding to *vijñāna* in the *Mukhāgama* simulates sexual intercourse. Buddhajñānapāda introduced

sexual theory into the visualization of the maṇḍala by likening the production of the deities of the maṇḍala to the conception of sentient beings.

Next, one should extinguish the images of the deities hitherto visualized. The four buddha-mothers awaken Vajradhara, who remains in the state of the *dharmakāya*, with a hymn[523] given in chapter 17 of the *Guhyasamāja*. In response, Vajradhara emanates the *nirmāṇakāya* for the sake of sentient beings. This corresponds to *nāmarūpa*, or "name-and-form," the fourth limb of dependent origination.

According to the *Abhidharmakośa*, the stage in which, after the absorption of consciousness by the mixture of semen and menstrual blood formed inside the mother's womb, the primitive forms of *nāma*, or mind, and *rūpa*, or body, appear is called *nāmarūpa*. The *Mukhāgama* interpreted the process whereby the main deity remaining in an abstract state, corresponding to the *dharmakāya*, gives rise to the physical body (*rūpakāya*) for the sake of sentient beings as *nāmarūpa* among the twelve limbs of dependent origination.

At this point an esoteric form of Mañjuśrī, three-headed and six-armed Mañjuvajra, appears. Further, the six bodhisattvas—Kṣitigarbha, Vajrapāṇi, Ākāśagarbha, Avalokiteśvara, Sarvanīvaraṇaviṣkambhin, and Samantabhadra—together with six adamantine goddesses symbolizing the six sense objects, are arranged on his six sense organs, that is, his eyes, ears, nose, tongue, body, and mind, respectively. This corresponds to *ṣaḍāyatana*, or "six sense fields," the fifth limb of dependent origination.

According to the *Abhidharmakośa*, the stage in which the original forms of the six sense organs appear in an embryo in the mother's womb corresponds to the six sense fields. The *Mukhāgama* interpreted the process whereby the six bodhisattvas and six adamantine goddesses are arranged on the sense organs of the newly born physical body of Mañjuvajra as the six sense fields among the twelve limbs of dependent origination.

The six supernatural faculties (*ṣaḍabhijñā*) are acquired through the arrangement of the six bodhisattvas and six adamantine goddesses on the six sense organs. This corresponds to *sparśa*, or "contact," the sixth limb of dependent origination. This may be because *sparśa* was interpreted as meaning that a newly born infant becomes able to discern sense objects.

After having empowered the sense organs, the empowering of the three actions by arranging Cittavajra in the heart, Vāgvajra in the throat, and Kāyavajra in the head, respectively, is the stage corresponding to *vedanā*, or "sensation," the seventh limb of dependent origination. The relationship between this practice and *vedanā* among the twelve limbs of dependent origination is not entirely clear. An inconsistency seems to have arisen when the practice for visualizing the Guhyasamāja-maṇḍala that had existed before the emergence of the Jñānapāda school was reorganized in accordance with the twelve limbs of dependent origination.

Next, after the practitioner has invoked all the tathāgatas pervading space, they emit rays from which the adamantine goddesses starting with Rūpavajrā are born. They each hold in their hands vases containing the water of wisdom with which they confer initiation on the practitioner. Then the practitioner is united with Mañjuvajra, and Akṣobhya, the lord of the Vajra family, takes his seat on his crown. This corresponds to *tṛṣṇā*, or "craving," the eighth limb of dependent origination.

Next, the consort of Mañjuvajra is born. As was the case with Mañjuvajra, the seed-syllables of the six bodhisattvas starting with Kṣitigarbha are arranged on her sense organs, and her body, speech, and mind are empowered with the three syllables *Oṃ Āḥ Hūṃ*. Fur-

thermore, the seed-syllables of the five buddhas—*Oṃ Hūṃ Svā Āḥ Hā*—are arranged on her head, heart, navel, genital organ, and both thighs.

Her genital organ turns into the pericarp of a multicolored lotus through the syllable *Āḥ*, and it is then transformed into an eight-petaled lotus through the syllable *Hūṃ*. The practitioner, united with the main deity, empowers his vajra (that is, genital organ) with the syllable *Hūṃ* and enters into sexual union with his consort while reciting the mantra "*Oṃ sarvatathāgatānuragaṇavajrasvabhāvātmako 'haṃ*"[524] given in chapter 6 of the *Guhyasamāja*.

The process whereby the main deity, Mañjuvajra, and his consort, Māmakī, are born and take their seat in the center of the maṇḍala corresponds to *jāti*, or "birth," and *jarāmaraṇa*, or "old age and death," among the twelve limbs of dependent origination.

According to the *Abhidharmakośa*, the stage in which one does not pursue pleasure even though sexual desire may arise corresponds to *tṛṣṇā*; the stage in which one engages in various activities, including sexual activity, after coming of age corresponds to *upādāna*, or "attachment"; the moment when the five aggregates of a deceased sentient being are absorbed into the next mother's womb is *jāti*; and the subsequent process corresponds to *jarāmaraṇa*, the final limb of dependent origination. The *Mukhāgama* interpreted the sexual union in which Causal Vajradhara engages together with his consort as *upādāna* among the twelve limbs of dependent origination and the resultant birth of the main deity as *jāti* and *jarāmaraṇa*.

This ritualization of sex came about by simulating the process of conception in which a sentient being in the intermediate state between death and birth is absorbed into the mixture of semen and menstrual blood formed inside a mother's womb. According to the interpretation of the twelve limbs of dependent origination in the *Abhidharmakośa*, sexual union manifests in two situations, namely, when the five aggregates of the previous life are absorbed into the present mother's womb, corresponding to *vijñāna*, and when the five aggregates of the present life enter the womb of the future mother, corresponding to *jāti*.

Buddhajñānapāda introduced sexual theory into the visualization of the maṇḍala by equating the former process with the birth of Causal Vajradhara, the progenitor of the maṇḍala deities, and the latter process with the birth of the main deity from Causal Vajradhara. Further, the five-stage process of enlightenment in the *Sarvatathāgatatattvasaṃgraha* was incorporated as a form of visualization whereby Causal Vajradhara is born, corresponding to *vijñāna* among the twelve limbs of dependent origination. Thus the *Mukhāgama* sanctified the process of cyclic existence by associating the process of visualizing the maṇḍala deities with the twelve limbs of dependent origination.

In this way, late tantric Buddhism introduced sexual elements into the visualization of the maṇḍala, which had already been largely perfected in the middle phase of esoteric Buddhism. Further, the generation stage, the prevalent practice of late tantric Buddhism compared with the completion stage, came into existence through the introduction of sexual elements into the visualization of the maṇḍala.

It is thus evident that father-mother images, characteristic of late tantric Buddhism, were conceived of as the parents of the maṇḍala deities. In the *Mukhāgama* it is only Causal Vajradhara, who is not depicted in the maṇḍala, and the main deity who are accompanied by a consort, and the other deities are depicted as single deities.

In the thirty-two-deity maṇḍala of Akṣobhyavajra belonging to the Ārya school, only Akṣobhyavajra, the main deity, and Sparśavajrā form a father-mother couple. In actual

examples of the thirty-two-deity maṇḍala found in Tibet, the ten wrathful deities are also accompanied by consorts, but their consorts are not counted among the thirty-two deities. In the case of the Mañjuvajra-maṇḍala of the Jñānapāda school, there are two types: one depicts only Mañjuvajra, the main deity, and Māmakī as a father-mother couple, while the other depicts all nineteen deities as father-mother couples.[525] In the latter, the five buddhas and four buddha-mothers form couples, and the six adamantine goddesses, symbolizing sense objects, form couples with six bodhisattvas, symbolizing the sense organs. However, this seems to have been a later development in the Jñānapāda school, since there is no mention of the partners of members of the retinue in texts attributed to Buddhajñānapāda himself.

In the *Māyājālatantra*, to be discussed later in this chapter, only Vairocana, Amitābha, and Akṣobhya among the five buddhas form father-mother couples. These three buddhas are more important than Ratnasambhava and Amoghasiddhi, since they are equated with Kāyavajra, Vāgvajra, and Cittavajra, who preside over the three mysteries.[526] These three vajra deities are visualized as being accompanied by consorts in the process corresponding to *vedanā* in the *Mukhāgama* and the *Piṇḍīkrama*[527] of the Ārya school. Therefore the *Māyājāla*, in which Vairocana, Amitābha, and Akṣobhya are accompanied by consorts, acts as an intermediary between comparatively early tantras in which only the main deity represents a father-mother couple, and later tantras in which the retinue also includes many father-mother couples.

5. The Ārya School

Along with the Jñānapāda school, the Ārya school is another influential lineage deriving from the *Guhyasamājatantra*. It was founded by Ārya Nāgārjuna, and instructors (*ācāryas*) of this school took the names of masters of the Mādhyamika school of Mahāyāna Buddhism, and consequently in later times they were confused with masters of the Mādhyamika school. Tsongkhapa, the founder of the Geluk order of Tibetan Buddhism, seems to have attached great importance to the Ārya school because he held the Mādhyamika school of exoteric Buddhism in such high regard. For this reason, the Ārya school flourished in Tibet, and there are many examplars of its maṇḍala.

As mentioned earlier, there existed a strong tradition of the Jñānapāda school at Vikramaśīla monastery, the final center of Indian Buddhism. Masters of Vikramaśīla, such as Ratnākaraśānti, Nāropa, Atīśa, and Abhayākaragupta, all transmitted the Jñānapāda school. The translator Naktso (1011–64) left Atīśa on his deathbed and visited Jñānākara, who was residing in Nepal, to study the Ārya school.[528] Marpa (1012–97), the founder of the Kagyü order of Tibetan Buddhism, is said to have studied the Ārya school under Jñānagarbha, to whom he was introduced by his teacher Nāropa.[529] In his *Vajrāvalī* and *Niṣpannayogāvalī*, Abhayākaragupta places the nineteen-deity maṇḍala of Mañjuvajra (V-1) belonging to the Jñānapāda school first and explains the thirty-two-deity Akṣobhya-maṇḍala (V-2) of the Ārya school next among the twenty-six maṇḍalas he describes. These facts suggest that masters at Vikramaśīla did not make the Ārya school their main repertory even though they were familiar with it. Where, then, was the Ārya school transmitted?

According to Tibetan sources, Nāgārjuna was active at Nālandā. However, it is clearly anachronistic to regard the Nāgārjuna of the second to third centuries as having been active

FIG. 5.5. THIRTY-TWO-DEITY AKṢOBHYAVAJRA-MAṆḌALA

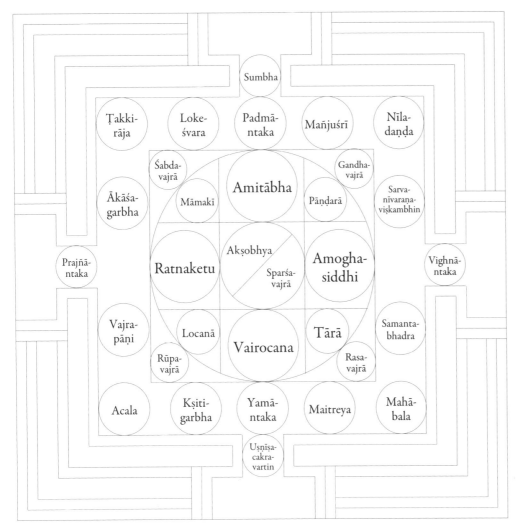

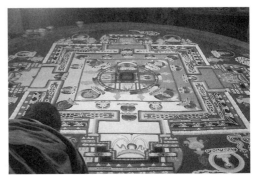

FIG. 5.6. SAND MAṆḌALA OF THE AKṢOBHYAVAJRA-MAṆḌALA (RAJA MONASTERY, QINGHAI)

at Nālandā, which was established in the fifth century. The *Dpal gsang ba 'dus pa'i rgyud 'grel gyi bshad thabs kyi yan lag, gsang ba'i sgo 'byed* by Butön (1290–1364) records that the Nāgārjuna who founded the Ārya school stayed at Nālandā. That esoteric Buddhism was flourishing at Nālandā around the seventh to eighth centuries is supported by historical sources as well as archaeological excavations. The king Gopāla, the founder of the Pāla dynasty, established Odantapuri monastery in collaboration with scholars from Nālandā, which was geographically close to Odantapuri.[530] Therefore the Ārya school seems to have been transmitted among masters of Nālandā or Odantapuri, while the Jñānapāda school was transmitted at Vikramaśīla.

The maṇḍala of the Ārya school, centered on Akṣobhyavajra, consists of thirty-two deities: the thirteen basic deities plus five adamantine goddesses, eight great bodhisattvas, and six wrathful deities (see fig. 5.6). The central circle of the maṇḍala takes the form of a nine-panel grid. The arrangement of the five buddhas and four buddha-mothers is the same as that in the thirteen basic deities of the *Guhyasamājatantra*.

The five adamantine goddesses are the six adamantine goddesses of the Jñānapāda school

minus Dharmadhātuvajrā. Among these goddesses, Sparśavajrā occupies a seat in the center of the maṇḍala and forms a couple with Akṣobhyavajra, the main deity.

The eight great bodhisattvas in the corridor of the courtyard (*paṭṭikā*) belong to the standard grouping. In ritual manuals such as the *Piṇḍīkrama*, however, Avalokiteśvara is called Lokeśvara or Lokeśa and Ākāśagarbha is called Khagarbha for metrical reasons.

The six wrathful deities added to the four wrathful deities mentioned in chapter 1 of the *Guhyasamājatantra* are Ṭakkirāja, Mahābala, Nīladaṇḍa, Acala, Uṣṇīṣacakravartin, and Sumbha, who were added in later chapters. They are arranged in the southwest, northeast, northwest, northeast, top, and bottom sections[531] of the maṇḍala. They are not only the protectors of the ten directions but are also allocated to different parts of the body, such as the left and right arms.[532] This is worth noting as a precursor of the *Kālacakratantra*, which allocates wrathful deities to the action organs (*karmendriya*). In most extant examples, the ten wrathful deities are accompanied by consorts, whose names are given in the *Piṇḍīkrama*,[533] although they are not counted among the thirty-two deities of the Ārya school.

The basic text on the generation stage of the Ārya school is the *Piṇḍīkrama*, which explains the visualization and iconography of the thirty-two-deity maṇḍala of Akṣobhyavajra. But details of rites such as initiation (*abhiṣeka*) using the maṇḍala are not explained in the *Piṇḍīkrama*. For these we must refer to the *Viṃśatividhi* attributed to Nāgabodhi.

Even today the Geluk school of Tibetan Buddhism, which bases itself primarily on the *Guhyasamājatantra*, performs maṇḍala rites on the basis of the *Viṃśatividhi*.[534] No Sanskrit manuscript of the *Viṃśatividhi* had been known except for one discovered by Rāhula Sāṅkṛtyāyana at Shalu monastery in Tibet.[535] But during my period of study in Nepal (1988–89), I came to know of the existence of a Sanskrit manuscript entitled *Vajrācāryanayottama*[536] in a private collection photographed by the Nepal-German Manuscript Preservation Project, which includes a work combining the text of the *Viṃśatividhi* with explanatory comments. I subsequently included a romanized text of that part of the *Vajrācāryanayottama* corresponding to the *Viṃśatividhi* in the original Japanese version of this book.[537]

The differentiation of the body (*kāyaviveka*) into one hundred clans is one of the distinctive theories of the Ārya school. The idea of one hundred clans is not explicitly explained in the *mūlatantra* or the *Pañcakrama*, the basic text of the Ārya school, and we must refer to chapter 2 of the *Caryāmelāpakapradīpa* for details.[538] This text states that "each of these aggregates, elements, and so on (*skandhadhātvādaya*) divided into five each results in one hundred parts."[539] The intention here is to explain everything in the world through the mutual encompassment of the five families and to assign them to the deities of the Guhyasamāja-maṇḍala (see fig. 5.7).

As was pointed out in chapter 4, the five families introduced in the *Sarvatathāgatatattvasaṃgraha* developed into twenty-five families or innumerable families through the mutual encompassment of the five families. The pattern peculiar to the Vajradhātu-maṇḍala is an iconographical representation of this mutual encompassment. The Guhyasamāja-maṇḍala, on the other hand, in both the Ārya and Jñānapāda schools, takes the form of an *aṣṭamaṇḍalaka*, or "that which has eight circles," in which the five buddhas and four buddha-mothers are arranged.[540] It does not have a pattern representing mutual encompassment.

However, the differentiation of the body into the "supreme one hundred clans" of the Ārya school is a successor to the mutual encompassment of the Vajradhātu-maṇḍala, not

in respect to the pattern of the maṇḍala but in respect to the underlying idea. Furthermore, this idea of explaining everything in the world by assigning doctrinal categories to the deities of the maṇḍala was taken over by the last tantric system to appear in India, the *Kālacakratantra*.

6. The Symbolism of the Adamantine Goddesses and Bodhisattvas

As we have seen, different maṇḍalas deriving from the *Guhyasamāja* were transmitted by different schools. In particular, the addition of the adamantine goddesses and bodhisattvas had significant implications. In this section I wish to consider the symbolism of the adamantine goddesses and bodhisattvas whom both the Ārya and Jñānapāda schools added to the thirteen basic deities.

The Mañjuvajra-maṇḍala of the Jñānapāda school consists of the thirteen basic deities plus six adamantine goddesses—Rūpavajrā, Śabdavajrā, Gandhavajrā, Rasavajrā, Sparśavajrā, and Dharmadhātuvajrā—making a total of nineteen deities. The Akṣobhya-maṇḍala of the Ārya school, on the other hand, depicts five adamantine goddesses—Rūpavajrā, Śabdavajrā, Gandhavajrā, Rasavajrā, and Sparśavajrā—and eight great bodhisattvas, starting with Maitreya.

Male bodhisattvas are not included among the nineteen deities of the Jñānapāda school, but the *Mukhāgama* by Buddhajñānapāda describes six bodhisattvas starting with Kṣitigarbha as the partners of the six adamantine goddesses.[541] Like the six wrathful deities among the ten wrathful deities, they are not counted among the maṇḍala deities, but they already existed as a group of deities when the Jñānapāda school came into existence.

These adamantine goddesses symbolize five sense objects—visible objects (*rūpa*), sound (*śabda*), smell (*gandha*), taste (*rasa*), and touch (*sparśa*)—or six sense objects in the Jñānapāda school, which adds mental objects (*dharma*).

In chapter 1 of the *Guhyasamājatantra* we read as follows: "Then, all the tathāgatas, to please Sarvatathāgatakāyavākcittavajrādhipati, transformed themselves into women born from the body of glorious Mahāvairocana. Some dwelt in the form of Buddhalocanā, some in the form of Māmakī, some in the form of Pāṇḍaravāsinī, and some in the form of Samayatārā. Some dwelt in the form of the nature of visible objects, some in the form of the nature of sound, some in the form of the nature of smell, some in the form of the nature of taste, and some in the form of the nature of touch."[542] Compared with the four buddha-mothers starting with Buddhalocanā, the nature of visible objects and so on have not yet been fully deified. But we can surmise that this idea developed into the adamantine goddesses.

Tsuda Shin'ichi, basing himself on the above passage, reconstructed the arrangement of the deities in the proto-*Guhyasamāja*, making the arrangement of the four buddha-mothers and adamantine goddesses the reverse of the norm.[543] As I argued in chapter 3, however, there is a tendency, frequently seen also in maṇḍalas other than those of the *Guhyasamāja*, for the four male deities in the cardinal directions and the four female deities in the intermediate directions to form couples. Therefore it is most likely that the four buddhas and four buddha-mothers were originally arranged in the four cardinal and four intermediate directions, respectively, whereas the positions of the adamantine goddesses had not yet been fixed.

The six or eight great bodhisattvas are thought to symbolize the six sense organs. The idea that the male bodhisattvas are assigned to sense organs (*indriya*) and the female adamantine

FIG. 5.7. THE DIFFERENTIATION OF THE BODY INTO ONE HUNDRED CLANS

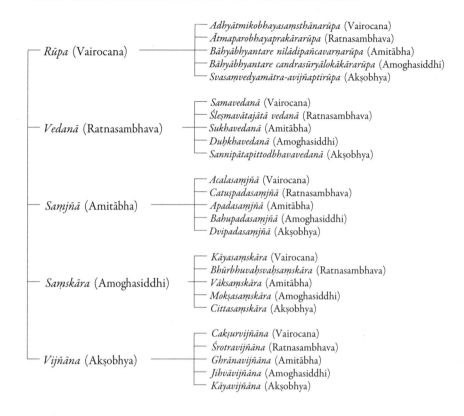

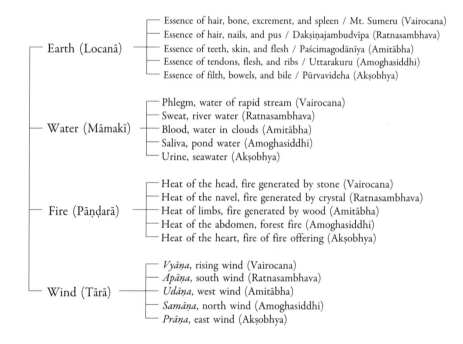

- Eyes (Kṣitigarbha)
 - Perception of three colors (Vairocana)
 - Nature of pupils (Ratnasambhava)
 - Both eyes in parallel (Amitābha)
 - Movement of sight (Amoghasiddhi)
 - Minute visual sense organ inside the eyeball (Akṣobhya)
- Ears (Vajrapāṇi)
 - Nature of ears (Vairocana)
 - Perception of three sounds (Ratnasambhava)
 - Earholes (Amitābha)
 - Root of the ear (Amoghasiddhi)
 - Auditory sense organ in the shape of a musical instrument with integration of atoms (Akṣobhya)
- Nose (Ākāśagarbha)
 - Nature of the nose (Vairocana)
 - Inside of the nose (Ratnasambhava)
 - Perception of three smells (Amitābha)
 - Nostril (Amoghasiddhi)
 - Olfactory sense organ with integration of atoms (Akṣobhya)
- Tongue (Avalokiteśvara)
 - Nature of the tongue (Vairocana)
 - Root of the tongue (Ratnasambhava)
 - Tip of the tongue (Amitābha)
 - Perception of three tastes (Amoghasiddhi)
 - Semicircular gustatory sense organ with integration of atoms (Akṣobhya)
- Body (Sarvanīvaraṇaviṣkambhin)
 - Whole body as tactile sense organ with integration of atoms (Vairocana)
 - Nature of bone (Ratnasambhava)
 - Nature of flesh (Amitābha)
 - Nature of skin (Amoghasiddhi)
 - Perception of three touches (Akṣobhya)
- Mind (Mañjuśrī)
 - *Ādarśajñāna* (Vairocana)
 - *Samatājñāna* (Ratnasambhava)
 - *Pratyavekṣaṇājñāna* (Amitābha)
 - *Kṛtyānuṣṭhānajñāna* (Amoghasiddhi)
 - *Dharmadhātujñāna* (Aksobhya)

- Visible objects (Rūpavajrā)
 - Whole visible objects (Vairocana)
 - Visible objects for eros (Ratnasambhava)
 - Visible objects recognized in dependence on likes and dislikes (Amitābha)
 - Visible objects which accomplish all deeds (Amoghasiddhi)
 - Visible objects for amusement, pleasure, and love (Akṣobhya)
- Sound (Śabdavajrā)
 - Sound inside ears and sound of hair (Vairocana)
 - Sound of song and stringed instrument (Ratnasambhava)
 - Sound of palate, lips, and conversation (Amitābha)
 - Sound of wood, river, clapping, and drum (Amoghasiddhi)
 - Sound of syllable Hūṃ and peaceful and wrathful sounds (Akṣobhya)
- Smell (Gandhavajrā)
 - All smells (Vairocana)
 - Smell of all limbs (Ratnasambhava)
 - Three smells (Amitābha)
 - Smell [accompanied by] taste (Amoghasiddhi)
 - Smell of environment (Akṣobhya)
- Taste (Rasavajrā)
 - Taste of honey (Vairocana)
 - Astringent taste (Ratnasambhava)
 - Taste of salt (Amitābha)
 - Distinction of six tastes (Amoghasiddhi)
 - Pungent taste (Akṣobhya)
- Touch (Sparśavajrā)
 - Touch of sitting together (Vairocana)
 - Touch of embracing (Ratnasambhava)
 - Touch of kissing (Amitābha)
 - Touch of sucking (Amoghasiddhi)
 - Touch of sexual union (Akṣobhya)

goddesses to sense objects (*viṣaya*) derives from v. 50 in chapter 17 of the *Guhyasamāja*: "The adamantine sense fields and so on are nothing other than the maṇḍala of the supreme bodhisattvas."[544] But it is not clear here which bodhisattva is to be assigned to which sense organ. *Nidānakārikā* 16, cited in the *Pradīpoddyotana* of the Ārya school, on the other hand, states: "The eyes and so on are, by their nature, the sons of the Victor, beginning with Kṣiti-garbha."[545] Here it is clearly stated that Kṣitigarbha and the other bodhisattvas are assigned to the eyes and so on.

As Matsunaga has pointed out, the *Vajramālā*, an explanatory tantra on the *Guhyasa-māja* that includes the *nidānakārikā*, postdates the emergence of the Ārya school,[546] and so it cannot be dated to before the emergence of the Jñānapāda school. However, it is possible that such verses had been circulating among masters of the *Guhyasamāja*.

In the Ārya school, if the eight great bodhisattvas are assigned to the six sense organs, two bodhisattvas remain, in which case Maitreya is assigned to the psychic nerves (*nāḍī*) and Samantabhadra to all the joints of the body.[547] There is also another interpretation that assigns the remaining two bodhisattvas to mind (*manas*) and store conscious-ness (*ālaya-vijñāna*), and so the eight great bodhisattvas together symbolize the eight consciousnesses.

Thus in the *Guhyasamāja* the natures of visual objects and so on alluded to in chap-ter 1 were deified as adamantine goddesses, and male bodhisattvas were assigned as their partners to the five or six sense organs, starting with the eyes. But it is to be surmised that when the *mūlatantra* first came into existence, there were not yet any fixed views regarding the positions of the female deities symbolizing the sense objects and the assignment of the bodhisattvas to the sense organs.

7. The *Guhyasamāja* and the Forty-Two Peaceful Deities

In the Nyingma school of Tibetan Buddhism, which derives from the old tantric Buddhism transmitted during the late eighth and ninth centuries, there have been transmitted deities named "one hundred peaceful and wrathful deities." The forty-two peaceful deities consist of Dharmakāya Samantabhadra (father-mother), five buddhas, five buddha-mothers, eight great bodhisattvas, eight offering goddesses, buddhas of the six destinies, four wrathful dei-ties, and four consorts of the four wrathful deities (fig. 5.8).[548] Although they do not include the adamantine goddesses, they do include the eight offering goddesses borrowed from the *Sarvatathāgatatattvasaṃgraha*. The four consorts of the four wrathful deities are Aṅkuśī, Pāśā, Sphoṭā, and Ghaṇṭā, female forms of the four gatekeepers of the Vajradhātu-maṇḍala. Thus these forty-two peaceful deities combine the deities of the *Guhyasamāja* with those of the *Sarvatathāgatattvasaṃgraha*.

As noted in chapters 3 and 4, the eight offering goddesses originated in the deification of the seventeen *viśuddhipadas* of the *Prajñāpāramitānayasūtra* and became deities sym-bolizing the mutual offerings of Vairocana and the four buddhas in the *Sarvatathāgatatat-tvasaṃgraha*. In the case of the forty-two peaceful deities, however, they are thought to symbolize sense objects (*viṣaya*). The eight offering goddesses among the forty-two peaceful deities play the same role as the adamantine goddesses in the *Guhyasamājatantra* of the new tantric school.

For example, Gītā, playing a *vīṇā*, a musical instrument similar to a lute, fulfills the same

role as Śabdavajrā, who also holds a *vīṇā*, because they both symbolize the offering of the sense of hearing. Dhūpā, holding an incense burner, plays the same role as Gandhavajrā, who holds an incense container, because they both symbolize the offering of the sense of smell. But there are no goddesses among the eight offering goddesses who symbolize the offerings of the senses of sight and taste. Therefore, among the forty-two peaceful deities, Lāsyā symbolizes the offering of sight through a change in her iconography so that she holds a mirror, while Nṛtyā symbolizes the offering of taste through a change in her iconography so that she holds a food offering.[549] This was a last-ditch measure to make these two goddesses symbolize the senses of sight and taste, since neither of them hold anything in the Vajradhātu-maṇḍala.

The Nyingma school shares many doctrines with the new tantric schools, but some of these were adopted from the new tantric schools after they had been transmitted to Tibet. Therefore we cannot conclude that doctrines transmitted by both already existed in the eighth to ninth centuries.[550] However, Lāsyā holding a mirror is found in a depiction of the forty-two peaceful deities from Dunhuang (Musée Guimet EO 1148),[551] a work that Akiyama Terukazu has dated to before the tenth century owing to stylistic considerations. In addition, several old tantras thought to be Indian in origin also describe Lāsyā as holding a mirror.[552] A mirror is an attribute of both Rūpavajrā of the Vajrasattva-maṇḍala, described in chapter 3, and of Rūpavajrā, who symbolizes the sense of sight in the Guhyasamāja-maṇḍala.[553] Therefore an interpretation that assigned the eight offering goddesses to sense objects originally existed in the case of the forty-two peaceful deities.

If four of the eight offering goddesses are assigned to the senses of sight, sound, smell, and taste, four goddesses remain. Some Nyingma scholars assign the remaining four goddesses to the past, present, future, and indeterminate time.[554]

The eight great bodhisattvas among the forty-two peaceful deities are also assigned to the six sense organs or eight consciousnesses. In the Nyingma school there exist considerable differences of opinion about the assignment of the bodhisattvas to the sense organs, except for Kṣitigarbha, who is always assigned to the eyes, presumably because there had been transmitted a verse similar to *Nidānakārikā* 16. But there are no fixed views regarding the other bodhisattvas.

Previously I had overlooked the importance of the forty-two peaceful deities, since I thought that they belonged to a collateral line in the development of the Guhyasamāja cycle. But now I am of the view that these deities are the missing link connecting the primitive *Guhyasamāja* with later schools such as the Jñānapāda and Ārya schools, which happened to be transmitted to Tibet and preserved there.

8. Examples of Icons of the Guhyasamāja Cycle in India and Tibet

After the ninth century, late tantric Buddhism rapidly developed in India. Until recently, however, no icons deriving from the *Guhyasamājatantra* had been identified. Late tantric Buddhism was transmitted in secret, and to show tantric icons and ritual implements to people who had not been initiated was strictly forbidden. Therefore tantric icons were enshrined in places that could not be visited by ordinary people.

But in recent years several icons related to the *Guhyasamāja* have been discovered and identified in India. They represent Mañjuvajra, the main deity of the Jñānapāda school. To

FIG. 5.8. FORTY-TWO PEACEFUL DEITIES

Group	Sanskrit	Tibetan
Primordial Buddha Father-Mother	1. Ādibuddha-Samantabhadra	Chos sku Kun tu bzang po
	2. Samantabhadrā	Kun tu bzang mo
Five Buddhas	3. Vairocana	rNam par snang mdzad
	4. Akṣobhya (or Vajrasattva)	Mi bskyod pa
	5. Ratnasambhava	Rin chen 'byung gnas
	6. Amitābha	sNang ba mtha' yas
	7. Amoghasiddhi	Don yod grub pa
Five Buddha-mothers	8. Vajradhātvīśvarī	dByings phyug ma
	9. Buddhalocanā	Sańs rgyas spyan ma
	10. Māmakī	Mā ma kī
	11. Pāṇḍaravāsinī	Gos dkar mo
	12. Samayatārā	Dam tshig sgrol ma
Eight Great Bodhisattvas	13. Kṣitigarbha	Sa'i snying po
	14. Maitreya	Byams pa
	15. Samantabhadra	Kun tu bzang po
	16. Ākāśagarbha	Nam mkha'i snying po
	17. Avalokiteśvara	sPyan ras gzigs
	18. Mañjughoṣa	'Jam dbyangs
	19. Sarvanīvaraṇaviṣkambhin	sGrib pa thams cad rnam par sel ba
	20. Vajrapāṇi	Phyag na rdo rje
Eight Offering Goddesses	21. Lāsyā	sGeg mo
	22. Mālā	Phreng ba ma
	23. Gītā	Glu ma
	24. Nṛtyā	Gar ma
	25. Puṣpā	Me tog ma
	26. Dhūpā	bDug spos ma
	27. Ālokā	Mar me ma
	28. Gandhā	Dri chabs ma
Four Wrathful Deities	29. Vijaya	rNam par rgyal ba
	30. Yamāntaka	gShin rje gshed
	31. Hayagrīva	rTa mgrin
	32. Amṛtakuṇḍalin	bDus rtsi 'khyil ba

Group	Sanskrit	Tibetan
Consorts of Four Wrathful Deities	33. Aṅkuśī	lCags kyu ma
	34. Pāśī	Zhags pa ma
	35. Sphoṭā	lCags sgrog ma
	36. Ghaṇṭā	Dril bu ma
Buddhas of Six Destinies	37. Indra	brGya sbyin
	38. Śākyamuni	Sha kya thub pa
	39. Vemacitra	Thags bzang ris
	40. Siṃha	Seng ge dang ldan
	41. Jvalaṃmukha	Kha 'bar
	42. Dharmarāja	Chos rgyal po

date, one has been discovered at Nālandā, three in Bihar and Bengal, and one in Orissa,[555] and a cast metal statue (unearthed at an unknown location)[556] has also been discovered.

All of these are three-headed and six-armed, with both arms crossed in front of the chest. In the example from Amaraprasadhgarh in Orissa, we can confirm that the two main hands hold a vajra and a bell, while the remaining four hands hold a sword and an arrow (right) and an *utpala* and a bow (left). The two examples from Bengal and an unknown location have a book (*pustaka*) on top of the *utpala*.[557] This iconography agrees with that of the main deity of the nineteen-deity maṇḍala of Mañjuvajra (V-1) in the *Niṣpannayogāvalī* but not with that described in a Sanskrit commentary on the *Samantabhadra nāma sadhana*.[558]

The above three examples are not accompanied by a consort, one of the characteristics of late tantric Buddhism. In the case of Saṃvara, too, the tutelary deity most frequently represented among images unearthed in India, many examples are not accompanied by a consort. The consort is thought to have been omitted so as to avoid her being seen by ordinary people. A three-headed and six-armed statue unearthed at Nālandā and now kept in the Indian Museum is the only example of Mañjuvajra from India accompanied by a consort.[559]

Among all these examples, a high-relief statue in the possession of the Metropolitan Museum of Art is the most notable. Above the three-headed and six-armed figure of Mañju-vajra are arranged five stūpas similar to the Mahābodhi temple at Bodhgaya in which the five buddhas of the *Guhyasamāja* are enshrined (fig. 5.9). The attributes held by the six arms of the five buddhas almost completely coincide with those explained in the Sanskrit commentary on the *Samantabhadra nāma sādhana*.[560] A strikingly similar high-relief statue is also kept in the Rubin Museum of Art in New York. It may be a reproduction of the Metropolitan Musuem statue, since a part missing in the former is preserved in complete condition.

Thus images of the main deity of the Jñānapāda school were produced in eastern India, where Buddhism survived. Examples of Akṣobhyavajra, the main deity of the Ārya school, on the other hand, have not been discovered in India, although many examples remain in Nepal and Tibet.

In Tibet, all Buddhist schools attach great importance to the *Guhyasamājatantra*. The Geluk school regards it as the fundamental text of all Highest Yoga tantras. Therefore examples of esoteric Buddhist art belonging to the Guhyasamāja cycle are abundant in Tibet. In this section I shall focus mainly on early examples of the maṇḍala.

In Cave 1 at Dungkar in western Tibet there are depicted two examples of the Guhyasamāja-maṇḍala, the thirty-two-deity maṇḍala of Akṣobhyavajra of the Ārya school and the nineteen-deity maṇḍala of Mañjuvajra of the Jñānapāda school. The maṇḍalas on the north wall of Dungkar Cave 1 render the deities that ought to be depicted as father-mother couples separately. In particular, in the thirty-two-deity maṇḍala of Akṣobhyavajra, Sparśavajrā, Akṣobhyavajra's consort, is placed in the outer square, and consequently another deity has been added to the outer square to maintain left-right symmetry, resulting in changes to the arrangement of the deities. This is thought to have been the result of a rigorous application of the rule in late tantric Buddhism that father-mother images should be shown only to initiates and must not to be shown to the public.

In Tibet most examples of the thirty-two-deity maṇḍala of Akṣobhyavajra of the Ārya school have four gates without a roof (*har sgo*). This is based on v. 11 in chapter 4 ("Khaṭikāsūtrapātanavidhi") of the *Viṃśatividhi*.[561] Further, in the *Mitra brgya rtsa* set of maṇḍalas the Guhyasamāja-maṇḍalas of both the Jñānapāda school (V-1) and Ārya school (V-2) are included. However, the iconometry and design of the gates in the maṇḍala of the Ārya school in the Hahn Foundation handscroll[562] differ from the norms of the Ārya school, which follows the *har sgo* style frequently found in other examples from Tibet.

The Guhyasamāja-Lokeśvara maṇḍala is a variant form of the Guhyasamāja-maṇḍala (Jñānapāda school) in which Mañjuvajra has been replaced as the main deity by Lokeśvara, a form of Avalokiteśvara with three heads and six arms. It was devised by Atīśa for King Lhatsunpa Jangchup Ö of western Tibet, who worshiped the *Guhyasamājatantra* and Avalokiteśvara.[563] It became popular in Tibet, and examples are found in the Ngor maṇḍalas[564] and among the wall paintings along the corridor of the Southern monastery at Sakya.[565]

In addition to the Indrabhūti, Jñānapāda, and Ārya schools, the existence of an Ānandagarbha school as a school of interpretation of the *Guhyasamāja* has also been reported.[566] However, no examples of maṇḍalas belonging to either the Indrabhūti or Ānandagarbha schools have been found in Tibet.

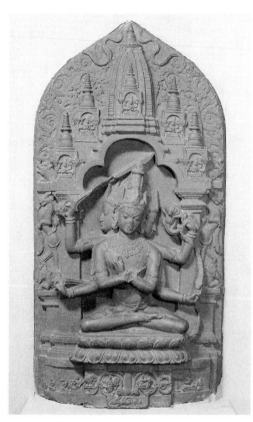

FIG. 5.9. MAÑJUVAJRA (METROPOLITAN MUSEUM OF ART)

9. The Emergence of the *Skandhadhātvāyatana* System

The *Guhyasamājatantra*, which inherited the five-family system established in the *Sarvatathāgatatattvasaṃgraha*, introduced a unique maṇḍala theory. The Guhyasamāja-maṇḍala was revered as a model maṇḍala throughout the age of late tantric Buddhism because the maṇḍala theory of the *Guhyasamāja* was effective for analyzing and interpreting the world that sentient beings experience.

The maṇḍala theory of the *Guhyasamājatantra*, which assigns the five buddhas to the five aggregates, the four buddha-mothers to the four elements, and bodhisattvas and adamantine goddesses to sense organs and sense objects, was in later texts called *skandhadhātvāyatana*, or "aggregates, elements, and sense fields." In the *Guhyasamājatantra* itself, the term *skandhadhātvāyatana* occurs twice, in chapters 2 and 18, the former occurrence being found in the famous Bodhicitta verse.[567]

Commentaries of the Ārya and Jñānapāda schools interpret *skandhadhātvāyatana* occurring in these two instances as the five aggregates, eighteen elements, and twelve sense fields in accordance with other Abhidharma and Mahāyāna texts, and there is no interpretation that links *skandhadhātvāyatana* to the Guhyasamāja-maṇḍala. The Bodhicitta verse itself also has its own commentaries, and in these, too, *skandhadhātvāyatana* is interpreted as the five aggregates, eighteen elements, and twelve sense fields.[568] This term also occurs once in chapter 8 of the *Caryāmelāpakapradīpa*.[569] But this is in a quotation from the *Laṅkāvatārasūtra*, and it again refers to the five aggregates, eighteen elements, and twelve sense fields. However, in chapter 2 of the *Caryāmelāpakapradīpa*, which explains the differentiation of the body (*kāyaviveka*) into one hundred clans, there occurs a passage that refers to the five aggregates and four elements assigned to the five buddhas and four buddha-mothers simply as *skandhadhātu*.[570]

In his *Pradīpoddyotana* Candrakīrti, who belonged to the same Ārya school, also rephrases *sarvadharmāṇi* occurring in chapter 9 of the *Guhyasamāja* as *skandhadhātvāyatana*.[571] Therefore *skandhadhātvāyatana* is not an enumeration of doctrinal categories but a term expressing the totality of the world that sentient beings experience.

As for the assignment of the maṇḍala deities to these doctrinal categories, there exists a difference of opinion between the Ārya and Jñānapāda schools. I have drawn up a table based on the *Caryāmelāpakapradīpa*,[572] *Piṇḍīkramaṭippaṇī*,[573] and *Samājasādhanavyavastholī*[574] (fig. 5.10). Thus the maṇḍala theory that originated in the *Guhyasamāja* and assigned the five buddhas to the five aggregates, the four buddha-mothers to the four elements, the adamantine goddesses to the sense objects, and the bodhisattvas to the sense organs was inherited by later tantric Buddhism and eventually came to be referred to as *skandhadhātvāyatana*, which gave expression to all existents (see fig. 5.11).

Among these three doctrinal categories, the five aggregates refer to all existents, including external objects, although they were originally a category posited in order to deny the real existence of the self (*ātman*) and present an analysis of the functions of the subject from the viewpoint of Buddhism. The four elements, on the other hand, although included in form (*rūpa*) among the five aggregates, correspond to the material causes of the physical world and present an analysis of the objective world from the viewpoint of Buddhism. Finally, the twelve sense fields are a category for analyzing the functions of the senses in cognizing the external world. Therefore *skandhadhātvāyatana* represents an ordering of the world we are experiencing on the basis of the duality of the objective (*grāhya*) and the subjective (*grāhaka*).

In this way the maṇḍala acquired a system for symbolizing all existents or the whole world by means of a limited number of deities. The *skandhadhātvāyatana* system would be inherited by later Mother tantras and the last tantric system to appear in India, the *Kālacakratantra*, which developed it still further.

10. The Emergence of the Father Tantras

After the emergence of the *Guhyasamājatantra*, this lineage developed to a remarkable degree in India and resulted in the formation of a group of scriptures known as the Father tantras or Upāya tantras. It has become clear that in India the *Guhyasamāja* and related tantras were called *mahāyoga*.[575] However, the eighteen great tantras of the Mahāyoga cycle

Fig. 5.10. Doctrinal categories assigned to deities of the *Guhyasamāja*

Group	Sanskrit	CMP	PKT	SSV
Five Buddhas	1. Akṣobhya	*vijñāna*		*vijñāna*
	2. Vairocana	*rūpa*	*ādarśajñāna*	*rūpa*
	3. Ratnaketu	*vedanā*	*samatājñāna*	*vedanā*
	4. Amitābha	*saṃjñā*	*pratyavekṣaṇajñāna*	*saṃjñā*
	5. Amoghasiddhi	*saṃskāra*	*kṛtyānuṣṭhānajñāna*	*saṃskāra*
Four Buddha-mothers	6. Locanā	earth	earth	earth
	7. Māmakī	water	water	water
	8. Pāṇḍaravāsinī	fire	fire	fire
	9. Tārā	wind	wind	wind
Five Adamantine Goddesses	10. Rūpavajrā	visible objects	visible objects	
	11. Śabdavajrā	sound	sound	
	12. Gandhavajrā	smell	smell	
	13. Rasavajrā	taste	taste	
	14. Sparśavajrā	touch	touch	
Eight Great Bodhisattvas	15. Maitreya			muscle
	16. Kṣitigarbha	eyes	eyes	eyes
	17. Vajrapāṇi	ears		ears
	18. Ākāśagarbha/Gaganagañja	nose	ears	nose
	19. Avalokiteśvara/Lokeśvara	tongue	nose	tongue
	20. Mañjughoṣa		mind	mind
	21. Sarvanīvaraṇaviṣkambhin	body	tongue	body
	22. Samantabhadra	mind		joints
Ten Wrathful Deities	23. Yamāntaka		(right hand)	right hand
	24. Prajñāntaka		(left hand)	left hand
	25. Padmāntaka		(mouth)	mouth
	26. Vighnāntaka		(genitals)	genitals
	27. Acala		(right armpit)	right arm
	28. Ṭakkirāja		(left armpit)	left arm
	29. Nīlaṇḍa		(right knee)	right knee
	30. Mahābala		(left knee)	left knee
	31. Uṣṇīṣacakravartin			crown of head
	32. Sumbha		(sole)	sole

CMP: *Caryāmelāpakapradīpa*; PKT: *Piṇḍīkramaṭippanī*; SSV: *Samājasādhanavyavasthoū*.
Piṇḍīkrama vv. 98–101 assign the consorts of the ten wrathful deities to the action organs.

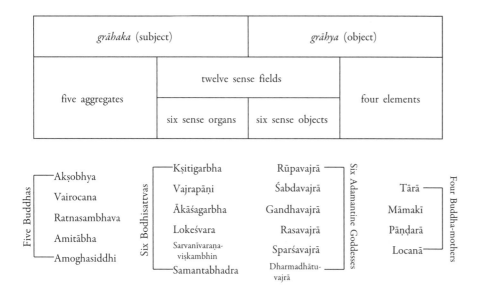

of the Nyingma school include the *Paramādyatantra*, usually classified among Yoga tantras, and the *Samāyogatantra*, which belongs to the Mother tantras. Compared with Tibetan Buddhism, in which the affiliation of each tantra included in the Tibetan Tripiṭaka is clearly fixed in accordance with scriptural catalogues, it is not always clear how individual tantras were classified in Indian Buddhism. In this book, I therefore refer to the *Guhyasamājatantra* and related scriptures as "Father tantras" in accordance with their classification in Tibetan Buddhism.

Among the Father tantras of the Highest Yoga tantras, those that equalled or surpassed the *Guhyasamāja* in popularity were the three tantras of Yamāntaka, namely, Red (*Rakta-yamāri*), Black (*Kṛṣṇayamāri*), and Fearsome (*Vajrabhairava*). The *Mitra brgya rtsa* maṇḍala set in the possession of the Hahn Cultural Foundation, which shows the final stage of the evolution of the maṇḍala in India, includes ten maṇḍalas belonging to the Father tantras, and six of these are centered on Yamāntaka. This shows how popular the Yamāntaka cult was in Indian late tantric Buddhism.

Yamāntaka is a wrathful deity who had been worshiped from the time of early esoteric Buddhism, and this deity was believed to be most effective for rites of subjugation (*abhicāra*). As reasons for the popularity of Yamāntaka's cult in the Father tantras, it can be pointed out that Yamāntaka is the first among the four wrathful deities of the *Guhyasamāja*, and the yoga simulating the process of death and rebirth in the completion stage of the *Guhyasamāja* matches the cult of Yamāntaka, the god of death.[576]

Among the three tantras of Yamāntaka, a Sanskrit manuscript of the *Raktayamāritantra* was discovered by Rāhula Sāṅkṛtyāyana at Shalu monastery in Tibet[577] and two modern Sanskrit manuscripts survive in Nepal,[578] but no critical edition has been published. A critical edition of the *Kṛṣṇayamāritantra*, on the other hand, together with the commentary *Ratnāvalī* by Kumāracandra, was published in 1992 by the Central Institute of Higher Tibetan Studies.[579] Sanskrit manuscripts of the *Vajrabhairavatantra* have been found in Tibet and Nepal,[580] and a Chinese translation also exists in the Chinese Tripiṭaka,[581] but no critical edition has been published.

FIG. 5.12. KRSNAYAMĀRI-MANDALA AND VAJRABHAIRAVA-MANDALA

Krsnayamāri-mandala

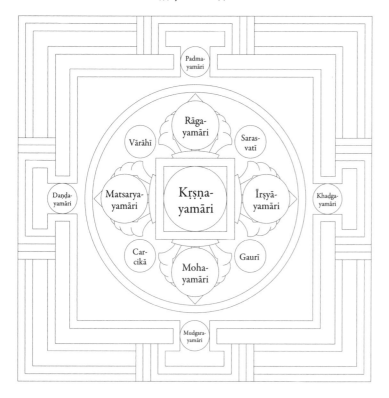

Vajrabhairava-mandala

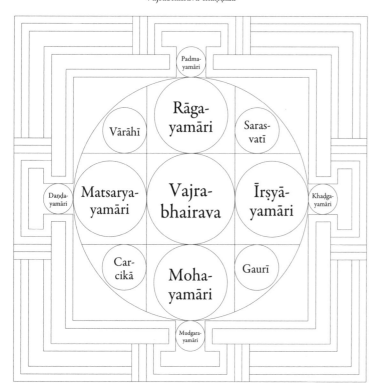

Among the three forms of Yamāntaka, the cult of Vajrabhairava is the most popular in Tibet, particularly in the Geluk school.[582] In India, however, Krsnayamāri is thought to have been more popular,[583] for six-armed images of Krsnayamāri have been found at Nālandā,[584] the Mahant complex at Buddhagaya,[585] and Ratnagiri in Orissa,[586] and in Tibet there exist two cast metal statues dated to the late Pāla dynasty.[587] Images of Vajrabhairava, on the other hand, have not been found in India, but there exist many examples in Tibet and Nepal.

The mandalas of Yamāntaka take the form of a wheel with four spokes in the shape of a crossed vajra in the case of Raktayamāri and Krsnayamāri. The mandala of Vajrabhairava, on the other hand, takes the form of a nine-panel grid like that of the *Guhyasamāja*.[588] In all cases the arrangement of the deities is similar to that of the *Guhyasamāja*.

In the center, one of the three forms of Yamāntaka is depicted as the main deity: Raktayamāri is one-headed and two-armed, Krsnayamāri is six-headed and six-armed, and Vajrabhairava is nine-headed (with a buffalo's head as the main head) and has thirty-four arms. All three forms have the same consort, named Vajravetālī. The *Pindīkrama* of the Ārya school already mentions Vajravetālī as the consort of Yamāntaka.[589]

Next, Mohayamāri (east), Matsaryayamāri (south), Rāgayamāri (west), and Īrsyāyamāri (north) are arranged in the four cardinal directions around the main deity. They correspond to the four buddhas—Vairocana, Ratnaketu, Amitābha, and Amoghasiddhi—of the *Guhyasamāja*, respectively, although they are named after the desires over which they preside.

In the four intermediate directions are the four wrathful goddesses Carcikā (southeast), Vārāhī (southwest), Sarasvatī (northwest), and Gaurī (northeast). They correspond to the four buddha-mothers of the *Guhyasamāja*, since they preside over the four elements earth, water, fire, and wind.

In the four gates are the four wrathful gatekeepers—Mudgarayamāri (east), Dandayamāri (south), Padmayamāri (west), and Khadgayamāri (north). They are all three-headed and six-armed and are named after the attributes held in their second left hand, that is, a hammer, a club, a lotus, and a sword. They are thought to correspond to the four wrathful gatekeepers of the Guhyasamāja-mandala.

Thus the mandalas of the three forms of Yamāntaka all consist of thirteen deities whose names are also the same except for that of the main deity (see fig. 5.12).[590] In contrast to the thirteen basic deities of the *Guhyasamāja*, who have a peaceful appearance, except for the four wrathful deities, the thirteen deities of Yamāntaka's mandalas are all wrathful deities. There thus exists a considerable

difference between the *Guhyasamāja* and Yamāntaka's maṇḍalas in the appearance of the deities. However, if they are depicted as symbols, they turn out to be virtually the same.[591] Thus the maṇḍalas of the three forms of Yamāntaka are closely related to the *Guhyasamāja*. It is no exaggeration to say that if the thirteen basic deities of the *Guhyasamāja* assume wrathful forms, they become the thirteen deities of the maṇḍalas of the three forms of Yamāntaka. This suggests that the maṇḍalas of the Father tantras evolved from the *Guhyasamāja*.

There exists another type of Vajrabhairava-maṇḍala called "thirty-two weapons," many examples of which have been identified from Tibet.[592] Around the main deity are Brahmā's head (*śiras*) in the east, a hand (*hasta*) in the south, bowels (*antra*) in the west, a foot (*pada*) in the north, a skull cup (*kapāla*) in the northeast, a skull (*caṣaka*) in the southeast, a rag from charnel grounds (*śmaśānakarpaṭa*) in the southwest, and a speared body (*śūlabhinnapuruṣa*) in the northwest, and in the outer square twenty-four symbols are arranged. Thus the total number of symbols in this maṇḍala comes to thirty-two.

These symbols are the attributes held by Vajrabhairava in thirty-two of his thirty-four hands, and this maṇḍala corresponds to the maṇḍala explained in chapter 1 ("Maṇḍala-nirdeśa") of the *Vajrabhairavatantra*.[593] Therefore the original maṇḍala of Vajrabhairava is thought to have been of this type. The current thirteen-deity maṇḍala used by the Geluk school seems to have come about by changing the main deity of the thirteen-deity Kṛṣṇayamāri-maṇḍala to Vajrabhairava with nine heads and thirty-four arms.

The reason that the thirteen-deity maṇḍala became popular in later times is that it is consistent with the system of the *Guhyasamājatantra*, the basis of the Father tantras. This shows that the *Guhyasamāja* is fundamental to the Father tantras, and other maṇḍalas were interpreted in accordance with the system of the *Guhyasamāja*.

11. The Māyājāla-maṇḍala and Four Buddhas in Haripur

So far in this chapter we have surveyed the maṇḍalas of the *Guhyasamājatantra* and Father tantras. An important text apart from those already mentioned is the *Māyājālamahātantrarāja* (hereafter *Māyājālatantra*), a late tantra classified among the Father tantras of the Highest Yoga tantras in Tibet, although it is sometimes deemed a Yoga tantra. As will be seen in chapter 7, the *Vimalaprabhā*, a commentary on the *Kālacakra*, characterizes the *Māyājālatantra* as *kriyāyoga*. This shows that the *Māyājāla* adopted elements of early and middle esoteric Buddhism even though it belongs to late tantric Buddhism.

A Chinese translation, the *Yuga dajiaowang jing* translated by Faxian, is included in the Chinese Tripiṭaka. The *Huanhuawang da yugajiao shi fennu mingwang daming guanxiang yigui jing*, also translated by Faxian, is an excerpt from this tantra of the section related to the ten wrathful deities. The *Nāmasaṃgīti*,[594] frequently recited in Tibet and Nepal, is said to have been extracted from the "Samādhipaṭala" of the *Māyājāla*, but the corresponding verses cannot be found in the extant *Māyājāla*.

In the section on old tantras in the Tibetan Tripiṭaka, there is another text called the *Vajrasattvamāyājāla*, which has been thought by some to be an early translation of the *Māyājāla*, but it differs considerably in content. It is considered to summarize the contents of the eighteen great tantras of the Mahāyoga cycle.[595] Therefore it may be best regarded as a tantra related to the forty-two peaceful deities.

The *Pradīpoddyotana* of the Ārya school quotes the *Māyājāla* three times, and two of the corresponding passages can be found in chapter 1[596] and the other in chapter 7[597] of the extant version of the *Māyājāla*. The *Viṃśatividhi* does not explicitly mention the *Māyājāla* as the source of the *sthānakas* and *ākṣepas* that other texts identify as doctrines of the *Māyājāla*.[598] Therefore the date of the extant version of the *Māyājāla* can be placed between the *Viṃśatividhi* and *Pradīpoddyotana*.

The Māyājāla-maṇḍala consists of the following forty-one deities: five buddhas, four buddha-mothers, four *pāramitā* goddesses, four goddesses, sixteen bodhisattvas, and eight wrathful deities. However, a forty-three-deity maṇḍala, with the addition of two wrathful deities protecting the top and bottom, is frequently used (fig. 5.14).

Among these deities, the five buddhas and four buddha-mothers are shared with the *Guhyasamāja*, although in the *Māyājāla* they are centered not on Akṣobhya but on Vairocana. It is worth noting that the four buddha-mothers and four *pāramitās*, whose functions overlap, coexist in the same maṇḍala. This suggests that the *Māyājāla* evolved as a compromise between the *Sarvatathāgatatattvasaṃgraha* and *Guhyasamāja* after the emergence of the basic parts of these two scriptures. Four of the female deities—Cundā, Ratnolkā, Bhṛkuṭī, and Vajraśṛṅkhala—on the other hand, are a group of deities peculiar to the *Māyājāla*. The *Vajramaṇḍalālaṃkāratantra*, a late Yoga tantra considered in chapter 3, explains eight successive *sādhanas* of the female deities Prajñāpāramitā, Buddhalocanā, Pāṇḍarā, Tārā, Bhṛkuṭī, Māmakī, Vajraśṛṅkhala, and Cundā.[599] If we compare these eight female deities with the four buddha-mothers and four female deities of the *Māyājāla*, seven coincide, with Prajñāpāramitā being replaced by Ratnolkā. Therefore we can surmise that the *Vajramaṇḍalālaṃkāratantra* was a precursor of the *Māyājālatantra*.[600]

The eight wrathful deities are the ten wrathful deities of the *Guhyasamāja*, apart from the two protectors of the top and bottom. They are thought to be basically the same as those of the *Guhyasamāja* because there is a section explaining the ten wrathful deities in the *Māyājāla* itself.

The outer square consists of the sixteen bodhisattvas of the Bhadrakalpa starting with Maitreya, although they differ somewhat from those in the Vajradhātu-maṇḍala. They represent the final manifestation of a group of bodhisattvas that evolved from the audiences of Mahāyāna sūtras, and in late tantric Buddhism after the *Māyājāla* no maṇḍala places bodhisattvas in the outer square.

The *Māyājāla* explains the body colors of the four buddhas as follows: Akṣobhya is blue, Ratnasambhava is red, Amitābha is white, and Amoghasiddhi is green.[601] These colors have been determined with reference to the five elements presided over by the five buddhas. This differs from the Vajradhātu-maṇḍala and Guhyasamāja-maṇḍala, in which the body colors of the five buddhas were determined with reference to the rites presided over by the five buddhas. It has become clear that this correspondence between the five buddhas and five elements coincides with the Mahāyānābhisamaya-maṇḍala of the *Vajramaṇḍalālaṃkāratantra*. As will be seen in chapter 7, this method of determining the body colors of the five buddhas on the basis of the five elements over which they preside was inherited by the *Kālacakratantra*, the last tantric system to appear in India.

As for the historical position of the *Māyājālatantra*, there are two views. According to Matsunaga, it lies somewhere on the line of development from the Yoga tantras, beginning

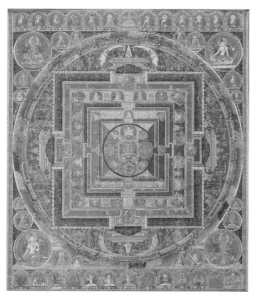

FIG. 5.13. MĀYĀJĀLA-MAṆḌALA (METROPOLITAN MUSEUM OF ART)

with the *Sarvatathāgatatattvasaṃgraha*, to the *Guhyasamājatantra*, a Highest Yoga tantra. Kawasaki, on the other hand, holds that it postdates the *Guhyasamājatantra*.[602]

The *Guhyasamāja* mentions the four wrathful deities in an early part of the text, and they were expanded to ten wrathful deities from chapter 13. The *Māyājāla*, meanwhile, explains eight wrathful deities in chapter 2. If the *Māyājāla* pre-dated the *Guhyasamāja*, this would mean that the *Guhyasamāja* adopted four of the eight wrathful deities explained in the *Māyājāla* in an early section, and in a later section, in a sudden turnabout, created ten wrathful deities by adding the four wrathful deities omitted in an earlier section along with two further wrathful deities. This seems rather improbable to me.

The forty-three-deity Mañjuvajra-maṇḍala explained in the *Māyājālatantra* (V-3) is included not only in the *Vajrāvalī* but also in the *Mitra brgya rtsa* maṇḍala set.[603] But only a small number of examples are found in Tibet. As an authentic example, we can point to a wall painting in the Maṇḍala chapel on the fourth floor of the main hall of Palkhor Chöde monastery (early fifteenth century). This maṇḍala, small in size, has been depicted in an

FIG. 5.14. MĀYĀJĀLA-MAṆḌALA

empty space between larger maṇḍalas occupying the entire wall, a fact suggesting that this maṇḍala was not highly esteemed in Tibet.

In 1956 four statues in high relief were discovered on Aragoda Hill overlooking Haripur, a small village on the outskirts of Bhubaneswar, Orissa. Today these four statues are enshrined in a small temple in Haripur and are worshiped as Hindu deities by the villagers. I have identified three of them as Akṣobhya, Ratnasambhava, and Amitābha, as described in the *Māyājālatantra* (fig. 5.15).[604]

They are all high-relief statues made of khondalite, and the size of each statue is about 23 centimeters × 35 centimeters. Akṣobhya, previously wrongly identified as Mañjuśrī or Mañjuvajra,[605] is three-headed and eight-armed and has his right leg pendent (*lalitāsana*). Amitābha, wrongly identified as Vajradharma, is three-headed and six-armed and assumes the semi-cross-legged pose (*ardhaparyaṅka*). Ratnasambhava, wrongly identified as Maitreya, is three-headed and four-armed and also assumes the semi-cross-legged pose. The remaining buddha, in an ordinary form displaying the earth-touching mudrā, differs considerably in iconographical terms from the other three buddhas in esoteric form. But in terms of their size and the style of their halos and seats, it would seem that these four statues originally formed a set.

The iconography of the five buddhas explained in chapter 2 of the *Māyājālatantra* differs somewhat from Abhayākaragupta's description of the Vairocana-Mañjuvajra-maṇḍala in his *Niṣpannayogāvalī*. The iconography of the four buddhas from Haripur tallies with chapter 2 of the *Māyājālatantra*, although the second left hands of Akṣobhya and Amitābha do not hold anything, whereas the *Māyājālatantra* describes them as touching their consort's breast.

This suggests that these statues were enshrined in an open space frequently visited by ordinary worshipers, since it was customary not to display images of father-mother (*yuganaddha*) images in the presence of people not initiated into esoteric Buddhism. Therefore the four buddhas from Haripur were originally enshrined in the four cardinal directions of a stūpa. The reason that the buddha with the earth-touching mudrā was enshrined instead of Amoghasiddhi on the north side of the stūpa seems to have been that the stūpa faced north,

FIG. 5.15. FOUR BUDDHA STATUES FROM HARIPUR

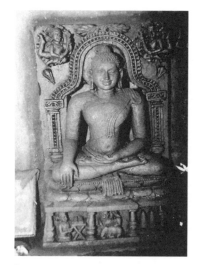
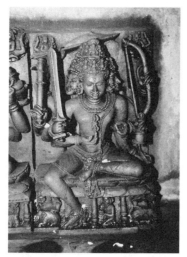
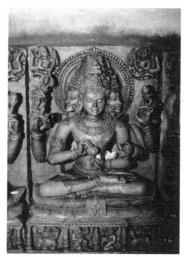
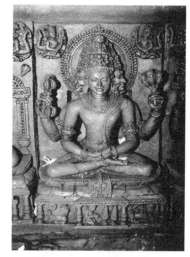

BUDDHA AKṢOBHYA AMITĀBHA RATNASAMBHAVA

like the main stūpa at Udayagiri in Orissa, and the buddha with the earth-touching mudrā, possibly Śākyamuni, was the main deity of the stūpa.

From a stylistic point of view, the four buddhas from Haripur have been dated to the late tenth or eleventh century. This shows that the *Māyājālatantra* of the Father tantras was still popular in Orissa as late as the eleventh century when the Mother tantras were in their heyday. This fact, together with the great influence exerted by the *Māyājālatantra* on the *Kālacakratantra*, seems to support Kawasaki's view that the *Māyājāla* appeared after the *mūlatantra* of the *Guhyasamāja* rather than Matsunaga's view, which regards the *Māyājāla* as a transitional scripture between the Yoga tantras and the *Guhyasamāja*.

6. Maṇḍalas of the Mother Tantras

1. The *Samāyogatantra* and the Origins of the Mother Tantras

AFTER THE NINTH CENTURY, India entered the age of late tantric Buddhism as the *Guhyasamājatantra* and its cycle evolved. The tantrism that developed explosively in medieval India contains many elements shared by Hinduism, Buddhism, and Jainism. Although the indigenous religion constituting the common basis of tantrism did not produce any scriptures, we can find vestiges of necromantic rites performed in charnel grounds (*śmaśāna*) in medieval India in the tantras of Hinduism, Buddhism, and Jainism. Tsuda Shin'ichi has called this "the religion of *śmaśāna*."

Recently, as research on Hindu Śaiva tantras has advanced, it has become clear that there exists a close relationship between these tantras and the Buddhist Mother tantras. It has already been confirmed that the Buddhist *Laghusaṃvaratantra* plagiarized parts of the Vidyāpīṭha cycle of Śaiva tantras.[606]

The title of the *Saṃvaratantra* is frequently mentioned in comparatively early late-tantric Buddhist texts that appeared from the eighth to early ninth centuries. Consequently, scholars in the West have advanced the thesis that the Buddhist Mother tantras came into existence from the very outset under the influence of Hindu tantras. However, several Japanese scholars have shown that the quotations from the *Saṃvaratantra* found in early late-tantric texts are not from the *Laghusaṃvaratantra* or *Saṃvarodayatantra* but from the *Sarvabuddhasamāyogaḍākinījālasaṃvaratantra* (hereafter *Samāyogatantra*), a manuscript of which was recently identified in the Sylvain Lévi collection in Paris.[607]

In Tibet, the *Samāyogatantra* is classified as a "tantra that explains the six families equally" among the Mother tantras. Its *uttaratantra*[608] and *uttarottaratantra*[609] are also included in the present Tibetan Tripiṭaka. To date, no passages suggestive of Hindu tantras have been found in the *uttaratantra*, the core part of the Samāyoga cycle. "Explaining the six families equally" means that it treats the six constituent families of the Mother tantras—Heruka, Vairocana, Vajrasūrya, Padmanarteśvara, Paramāśva, and Vajrasattva—equally. In contrast, the *Hevajratantra*, the *Laghusaṃvaratantra*, and so on belong to the Heruka family, while the *Catuṣpīṭhamahāyoginītantrarāja* belongs to the Vairocana family and the *Vajrāmṛtatantra* belongs to the Vajrasūrya family.[610]

In Dunhuang, which was occupied by the Tufan dynasty of Tibet from the end of the eighth century to the middle of the ninth century, there has been discovered a fragment of the Tibetan translation of this tantra.[611] This supports the Nyingma tradition that the *Samāyogatantra* had already been transmitted to Tibet during the Tufan period. The

Nyingma school prized it as the root tantra of the mystery of the body among the eighteen tantras of the Mahāyoga cycle. In the new tantric schools transmitted after the eleventh century, on the other hand, the *Samāyogatantra* is merely one of many Mother tantras, and it is far less popular than the *Hevajratantra* and *Saṃvaratantra* to be discussed below. This fact also suggests that the *Samāyogatantra* was in vogue in the eighth to early ninth centuries.

The *Samāyogatantra* is not included in the Chinese Tripiṭaka, but Amoghavajra mentions the *Yiqiefo jihui najini jiewang yuga* as the ninth assembly of the Vajraśekhara cycle in his *Shibahui zhigui*. Sakai Shinten equated the *Samāyogatantra* with this ninth assembly of the *Vajraśekhara* because *sarvabuddha* corresponds to *yiqiefo*, *samāyoga* to *jihui*, *ḍākinījāla* to *najini wang*, and *samvara* to *jie* in the full title of the *Samāyoga*.[612] Amoghavajra's description of the ninth assembly reads as follows:

> The ninth tantra is entitled "Yoga(tantra) of the Net of Ḍākinī Precepts of the Assembly of All the Buddhas." [The Buddha] preached it in the Mantra Palace. In this [tantra, the Buddha] explained the meditation (yoga) that makes one's own body the deity and criticized the yogin who worships an idol outside one's body as the deity. He explained extensively reality as it is. He also explained the origin of the five families. Moreover, he explained the meditation (yoga) that has nine tastes. They are: splendid (Vajrasattva), heroic (Vairocana), great compassion (Vajradhara), laughing (Avalokiteśvara), terrible (Vajrateja), fearful (Trailokyavijaya), ugly (Śākyamuni), wonderful (Vajrahāsa), and serene (Vairocana in meditation [yoga]). [He] explained [the bodhisattvas] from the bodhisattva Samantabhadra to Vajramuṣṭi. Each has four kinds of maṇḍalas [in this context, *mahā-*, *samaya-*, *dharma-*, and *karma-maṇḍala*]. Moreover, the initiation of the disciple [into the maṇḍala] and the songs, eulogia, and liturgic dances of the five families are explained.[613]

Fukuda Ryōsei has compared the description of the *Shibahui zhigui* with the extant text of the *Samāyoga* in the Tibetan Tripiṭaka and discovered a parallel to the statement that "the Buddha explained the meditation (yoga) that makes one's own body the deity and criticized the yogin who worships an idol outside one's body as the deity" in chapter 1 (vv. 20–25) of the *uttaratantra*. However, he was unable to find any passage corresponding to "the meditation (yoga) that has nine tastes."[614]

In this regard, I have previously pointed out that the "nine tastes" are nothing other than the *nava-rasa* valued in Indian aesthetics. A *rasa* denotes an emotional mental state that arises when we appreciate an artistic work of literature, music, or painting. According to the *Nāṭyaśāstra*, an Indian classic on the performing arts, there are eight *rasas*: (1) love (*śṛṅgāra*), (2) laughter (*hāsya*), (3) compassion (*karuṇa*), (4) fury (*raudra*), (5) heroism (*vīra*), (6) horror (*bhayānaka*), (7) disgust (*bībhatsa*), and (8) wonder (*adbhuta*). Around the ninth century, religious emancipation (*śānta*) came to be recognized as the ninth *rasa*. Amoghavajra, who returned to China in 746, brought back with him the latest *rasa* theory from India.

The "nine tastes" of the *Shibahui zhigui* are thought to correspond to the *nava-rasa* in the following way: (1) splendid (Vajrasattva) = *śṛṅgāra*; (2) heroic (Vairocana) = *vīra*; (3) great compassion (Vajradhara) = *karuṇa*; (4) laughing (Avalokiteśvara) = *hāsya*; (5) terrible (Vajrateja) = *raudra*; (6) fearful (Trailokyavijaya) = *bhayānaka*; (7) ugly (Śākyamuni)

= *bībhatsa*; (8) wonderful (Vajrahāsa) = *adbhuta*; and (9) serene (Vairocana in meditation [yoga]) = *śānta*.[615] On the assumption that the "nine tastes" correspond to the *nava-rasa*, I searched for a passage corresponding to Amoghavajra's description in the *Samāyogatantra* and discovered the following verses in chapter 9.[616]

> Vajrasattva is *śṛṅgāra*, *vīra* is the hero, [namely,] Tathāgata,
> Vajradhara is *karuṇa*, *hāsya* is supreme Lokeśvara,
> Vajrasūrya is *raudra*, cruel Vajra is *bhayānaka*,
> Śākyamuni is *bībhatsa*, *adbhuta* is Ārali,
> *praśānta* is the eternal Buddha. (chapter 9, vv. 219–21)[617]

The correspondence between the nine tastes in the *Shibahui zhigui* and the *nava-rasa* that I had previously posited proved to be correct.

Next, the allocation of the *nava-rasa* to Buddhist deities may be explained as follows. The compiler of the *Samāyogatantra* assigned six of the *nava-rasa* to the main deities of the six families and the remaining three *rasas* to Śākyamuni, Ārali, and Vairocana. In this schema, Vairocana occurs twice. This seems to be why Amoghavajra called the second Vairocana, assigned to *śānta-rasa*, "Vairocana in meditation (yoga)."

The names of the deities assigned by Amoghavajra and the *Samāyogatantra* to the *nava-rasa* completely coincide in the case of Vajrasattva, Vairocana, and Śākyamuni. In the *Sarvatathāgatatattvasaṃgraha*, Vajrasūrya is identified with Vajrateja.[618] In addition, as will be seen below, Padmanarteśvara is one of the esoteric forms of Avalokiteśvara, while Heruka developed from Vajradhara. Therefore it was not unreasonable for Amoghavajra to translate "Padmanarteśvara" as "Avalokiteśvara" and "Vajrasūrya" as "Vajrateja." The deity assigned to *adbhuta-rasa* is called "Vajrahāsa" by Amoghavajra, while the *uttaratantra* has "Ārali." But in the *Rnying ma'i rgyud 'bum* edition it is translated as "A la la," an interjection showing surprise (anticipated Sanskrit equivalent: *aho*). Therefore "Vajrahāsa," too, is not an unreasonable translation. The only problematic point is the occurrence of "Trailokyavijaya" in the *Shibahui zhigui* instead of "Paramāśva." But it may not be unreasonable if we take account of the fact that in the *Paramādyatantra* the family corresponding to the Karma family of the *Sarvatathāgatatattvasaṃgraha* and the Father tantras was underdeveloped and Paramāśva's retinue (corresponding to the Karma family of the Father tantras) has been borrowed from the Heruka clan, except for the triad centered on the main deity.

Thus the description of the ninth assembly in the *Shibahui zhigui* corresponds to the *Samāyogatantra*. Therefore the fact that the *Samāyogatantra*, the matrix of the Mother tantras, had already appeared by the time of Amoghavajra's return to China is incontrovertible. This date is the earliest among the extant Mother tantras. It is thus important to clarify the ideas and practices of the *Samāyogatantra* in order to reconstruct the historical development of the Mother tantras, which is still shrouded in mystery.

2. The Structure of the *Samāyogatantra*

Only the *uttaratantra* and *uttarottaratantra* of the *Samāyogatantra* are included in the Tibetan Tripiṭaka, and the *mūlatantra* (root tantra) was not transmitted in Tibet. However, Butön records the existence of the root tantra, translated by Lha Rinpoché, in his catalogue

of the Tibetan Tripiṭaka.[619] In addition, the Tibetan Tripiṭaka includes the lengthy commentary on the *uttaratantra* of the *Samāyoga* by Indranāla,[620] which frequently cites the *mūlatantra*. This text was transmitted by the Nyingma school, but Butön recognized its authenticity,[621] and his view was later widely accepted in Tibet.

In addition, the *Rnying ma'i rgyud 'bum*, a compendium of old tantras transmitted by the Nyingma school, includes another version of the *Samāyogatantra*[622] together with the *uttaratantra* and *uttarottaratantra*. This text may have been excluded from the Tibetan Tripiṭaka because it explains terms peculiar to the Nyingma school, such as the three inner vehicles (*mahā-*, *anu-*, and *ati-*) and the five categories, that is, body (*kāya*), speech (*vāk*), mind (*citta*), action (*karma*), and merit (*guṇa*). However, its content is interesting because it matches Indranāla's commentary and the exegeses of the six families of the *Samāyoga* by Kukurāja.[623]

As was explained above, the *Samāyogatantra* is frequently quoted not as the *Samāyoga* but as the *Saṃvara* or *Saṃvarottara* in comparatively early late-tantric Buddhist treatises such as those of the Ārya school on the *Guhyasamāja* and those on late Yoga tantras such as that of the Vilāsavajra school on the *Nāmasaṅgīti*. If we compare these quotations with the extant Tibetan translations, most of them coincide with the *uttaratantra*, and to date no quotations coinciding with the *mūlatantra* quoted in Indranāla's commentary have been identified. Leaving aside the question of whether the *mūlatantra* existed or not, these facts suggest that the *uttaratantra* is the most important text in the Samāyoga cycle.

Next, I wish to give an overview of the structure of the *uttaratantra* of the *Samāyoga*. As is shown in fig. 6.1, the *uttaratantra* consists of ten chapters, the first four of which are short, consisting of 25 verses each. In contrast, chapters 5 and 6 are relatively long, both exceeding 90 verses, and the total number of verses in chapter 9 is 543, which is more than the total number of verses in the other nine chapters. Thus the structure of the *uttaratantra* is quite unbalanced.

FIG. 6.1. THE STRUCTURE OF THE *SAMĀYOGATANTRA*

CHAPTER	NUMBER OF VERSES	CHAPTER	NUMBER OF VERSES
Chapter 1	25	Chapter 6	93
Chapter 2	25	Chapter 7	71
Chapter 3	25	Chapter 8	28
Chapter 4	25	Chapter 9	543
Chapter 5	98	Chapter 10	18

Many of the Sanskrit originals of the texts quoting the *Samāyogatantra* are extant. In addition, there are also many quotations from the *Samāyoga* that do not mention their source, and many verses that are shared with or similar to verses in other Mother tantras. By making use of these, it is possible to restore a considerable portion of the Sanskrit text of the *Samāyogatantra*. I have been able to restore approximately 100 verses, corresponding to about one-tenth of the approximately 1,000 verses of the *uttaratantra*.[624]

The *uttarottaratantra*, on the other hand, was translated by Smṛti, who visited Tibet during the turmoil after the fall of the Tufan dynasty and is considered to have been a pioneer in the translation of the new tantras. Therefore the *uttarottaratantra* is thought to postdate the *uttaratantra* by about half a century. The *uttarottaratantra* starts from chapter 18 and ends with chapter 22. If the *uttarottaratantra* immediately followed the *uttaratantra*, there should exist chapters 11–17, but they are missing in the Tibetan Tripiṭaka. Indranāla's commentary frequently cites a text referred to as "the *kalpa* consisting of seven [chapters]." At present, however, it is not clear whether this corresponds to the seven chapters from chapter 11 to 17.

In chapter 19 of the *uttarottaratantra* there occurs a passage that cryptographically describes the mantras of the deities by means of a grid-shaped syllabic chart. Tomabechi has discovered that a similar passage occurs in the Hindu *Viṇāśikhatantra*.[625]

At the end of the *uttarottaratantra* there is a colophon that reads "the *Sarvakalpasamuccaya* consisting of 117 [verses] from the *Sarvabuddhasamāyogaḍākinījālasaṃvara* consisting of 18,000 verses has ended."[626] This implies that the original *Samāyogatantra* consisted of 18,000 verses, which is eighteen times longer than the extant *uttaratantra*.

3. The Maṇḍala of the *Samāyogatantra*

In Tibet, there have been transmitted two forms of the Samāyoga-maṇḍala consisting of six families, that is, Heruka, Vairocana, Vajrasūrya, Padmanarteśvara, Paramāśva, and Vajrasattva. The first is centered on the Heruka family, around which are arranged the maṇḍalas of the other five families.[627] The second is centered on the Vajrasattva family, with the Vairocana family (east), Heruka family (south), Padmanarteśvara family (west), and Vajrasūrya family (north) arranged in the four cardinal directions and the four maṇḍalas of the Paramāśva family in the four intermediate directions.[628] The *Caturaṅgārthāloka* by Hūṃkārakīrti describes a maṇḍala centered on the Vajrasattva family, with four maṇḍalas for *śānta*, *abhicāruka*, *vaśīkaraṇa*, and *pauṣṭika* in the four intermediate directions, but no examples of this maṇḍala have been identified in Tibet (see fig. 6.3).

In the maṇḍalas of the six families, each family consists of twenty-one deities, except for the Paramāśva family, which consists of twenty-three deities. The twenty-three deities of the Paramāśva family are the twenty-one deities of the Heruka family plus two additional deities. Therefore the basis of the maṇḍala of six families is thought to be a twenty-one-deity structure in which eight deities are arranged around the main deity and twelve deities are placed in the outer periphery of the maṇḍala.

On a previous occasion, I examined the mantras and seed syllables of the deities of the six-family maṇḍala of the *Samāyogatantra* explained in commentaries and ritual manuals and showed that those of the maṇḍala of the Vajrasattva family were adopted from the seventeen-deity maṇḍala of Vajrasattva explained in the "Mantrakhaṇḍa" of the *Paramādya-tantra*.[629] As was shown in chapter 3, the seventeen-deity maṇḍala of Vajrasattva represents the deification of the seventeen *viśuddhipadas* explained in the *Prajñāpāramitānayasūtra*. The Vajrasattva-maṇḍala of the *Paramādya* ("Mantrakhaṇḍa") consists of seventeen deities, whereas the maṇḍala of the Vajrasattva family of the *Samāyoga* consists of twenty-one deities, with the addition of four goddesses of musical instruments, namely, Vaṃśā, Vīṇā, Mukundā, and Murajā. The addition of these goddesses is related to the fact that Heruka,

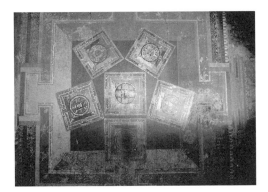

FIG. 6.2. SAMĀYOGA-MAṆḌALA (KYILKHOR LHAKHANG, PALKHOR CHÖDE)

FIG. 6.3. ARRANGEMENT OF THE SIX FAMILIES IN THE SAMĀYOGA-MAṆḌALA

Centered on Heruka family (Ngor Maṇḍalas)

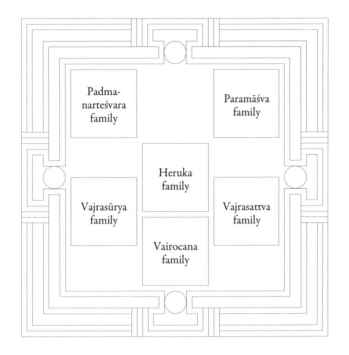

Centered on Vajrasattva family

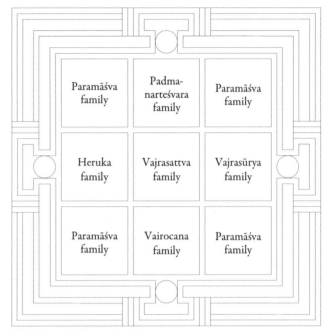

Centred on Heruka family (Palkhor Chöde)

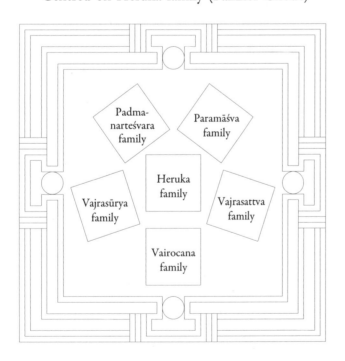

Caturaṅgārthāloka by Hūṃkārakīrti

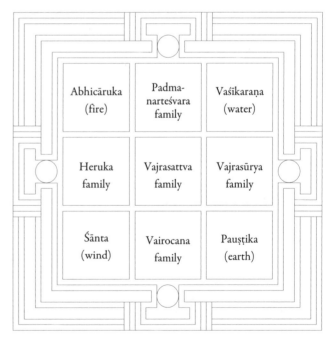

the main deity of later Mother tantras, is a dancing deity. In the same way, the maṇḍalas of Vairocana, Heruka, Padmanarteśvara, and Vajrasūrya correspond to those of the Tathāgata, Vajra, Lotus, and Jewel families of the *Paramādyatantra*, respectively.

From the above considerations, it is evident that the six-family maṇḍala of the *Samāyogatantra* is closely related to the "Mantrakhaṇḍa" of the *Paramādyatantra*. The maṇḍalas of the Vajrasattva, Vairocana, Heruka, Padmanarteśvara, and Vajrasūrya families correspond to those of the Vajrasattva, Tathāgata, Vajra, Lotus, and Jewel families of the "Mantrakhaṇḍa" (see fig. 6.4).

FIG. 6.4. FROM THE *PARAMĀDYATANTRA* TO THE *SAMĀYOGATANTRA*

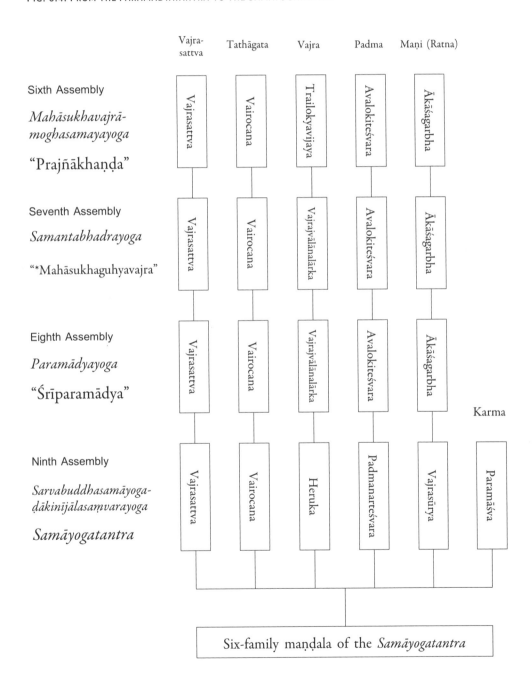

The fact that the Paramāśva family, corresponding to the Karma family of the Yoga and Father tantras, has merely added two deities to the Heruka family reflects the fact that the Karma family is missing in the "Mantrakhaṇḍa" of the *Paramādyatantra*. Thus the *Samāyogatantra* is thought to have created the six-family maṇḍala by rearranging some of the maṇḍalas described in the "Mantrakhaṇḍa" of the *Paramādyatantra* in the style of the Mother tantras.

A set of bronze statuettes ranging from 6 to 10 centimeters in height has been unearthed at Surocolo and Ponorogo in Indonesia, and Matsunaga Keiji has identified them as a three-dimensional maṇḍala of the Vajrasattva family of the *Samāyogatantra*.[630] A three-dimensional Vajradhātu-maṇḍala has also been discovered in Indonesia.[631] Discoveries of three-dimensional maṇḍalas belonging to late tantric Buddhism are very rare, but the discovery of the above set of statuettes makes it clear that the *Samāyogatantra* was transmitted not only in the Indian subcontinent but also to Southeast Asia.

I discovered that the *Lokeśvarakalpa* included in the Tibetan Tripiṭaka and the *Yiqiefo shexiangying dajiaowang jing sheng guanzizai pusa niansong yigui* included in the Chinese Tripiṭaka are, in spite of some errors in foliation, basically identical and constitute a ritual manual for the Padmanarteśvara family of the *Samāyogatantra*.[632] The Chinese translator Faxian translated "Padmanarteśvara" as "Avalokiteśvara." This was reasonable if we take into account the fact that the Padmanarteśvara family developed from the maṇḍala of the Lotus family centered on Avalokiteśvara in the *Paramādyatantra*. Furthermore, the eight goddesses arranged around the main deity as explained in the "Padmanarteśvaralokanāthasādhana" included in the *Sādhanamālā*[633] turn out to be identical to those of the Padmanarteśvara family in the *Samāyogatantra*. We can thus confirm that the Padmanarteśvara family of the *Samāyogatantra* was worshiped separately in India.

The existence of a three-dimensional maṇḍala from Indonesia and the *Lokeśvarakalpa* suggests that the maṇḍalas of the six families explained in the *Samāyogatantra* were originally independent maṇḍalas. A maṇḍala incorporating the maṇḍalas of all the families of a particular cycle in one large pavilion is called a Sarvakula-maṇḍala. We can point to the General Assembly maṇḍala consisting of five families discussed in chapter 4, as well as the Pañcaḍāka-maṇḍala of the Hevajra cycle and the Ṣaṭcakravartin-maṇḍala of the Saṃvara cycle, both to be discussed below, as typical examples of a Sarvakula-maṇḍala. The six-family maṇḍala of the *Samāyogatantra* can be interpreted as the Sarvakula-maṇḍala of the "Mantrakhaṇḍa" of the *Paramādyatantra*.

Furthermore, it turns out that the *Samāyogatantra* and the Paramādya cycle share many identical or similar verses. In particular, it is worth noting that the *Vajramaṇḍalālaṃkāratantra* has verses similar to verses 1–17ab of chapter 1 of the *Samāyogatantra* (*uttaratantra*).[634]

Thus the fact that the *Samāyogatantra* serves as a bridge between the *Prajñāpāramitānayasūtra* and the later Mother tantras is confirmed both iconographically and textually.

4. The Introduction of the Heruka Cult

One of the notable features of the *Samāyogatantra* is the introduction of the cult of Heruka. Henceforth, tutelary deities deriving from Heruka, such as Hevajra and Saṃvara, become the main deity of the maṇḍala in the Mother tantras.

There are various theories regarding the origins of the Heruka cult. According to Sanskrit

dictionaries, Heruka is an epithet of the Hindu deity Gaṇeśa. In Tibet, "Heruka" is translated as "blood drinker" (*khrag 'thung*), even though such a translation is etymologically unjustifiable.

One Japanese scholar, meanwhile, has put forward the bold hypothesis that Heruka derived from Hercules of Greek mythology.[635] The eighteen great tantras of the Mahāyoga cycle starting with the *Samāyoga* are thought to have first appeared in Uḍḍiyāna,[636] the cradle of tantric Buddhism. If Uḍḍiyāna, where the *Samāyogatantra*, the first text to introduce the Heruka cult on a full scale, came into existence, corresponds to the Swat Valley mentioned by Xuanzang as a place where esoteric Buddhism flourished, it would be close to Afghanistan, where vestiges of Hellenism still remained. Consequently, the Hercules hypothesis cannot be rejected out of hand.

However, taking into account the above-mentioned correspondences between the *Paramādya* and *Samāyoga*, I surmise that Heruka is a developed form of Trailokyavijaya, the wrathful aspect of Vajrasattva in the Mother tantras.[637] It is worth noting that the *Sarvatathāgatatattvasaṃgraha* gives the mantra of Heruka for summoning the mother-goddesses (*mātṛ*).[638] In this passage, Trailokyavijaya, after having subdued Maheśvara, the lord of Hindu gods, gives the mantras for summoning five kinds of Hindu deities, that is, *trailokyādhipati*, *antarīkṣacara*, *ākāśacara*, *bhauma*, and *pātālādhipati*, and lastly the mantra of Heruka is given for summoning the mother-goddesses. In the *Sarvatathāgatat-tvasaṃgraha*, the mother-goddesses signify the consorts of the above five kinds of Hindu deities and are collectively known as the "consorts of twenty deities." Therefore Heruka is thought to have played a role in subduing Hindu goddesses led by Umā, the consort of Maheśvara.

The transition from the middle phase of esoteric Buddhism to late tantric Buddhism has not been clarified yet. However, the Nyingma school of Tibetan Buddhism, deriving from the esoteric Buddhism of India of this period, transmits a set of deities called the "one hundred peaceful and wrathful deities,"[639] among whom the fifty-eight wrathful deities are centered on Heruka of five families: Buddhaheruka, Vajraheruka, Ratnaheruka, Padma-heruka, and Karmaheruka. Further, in the outer square there are mother-goddesses called *dbang phyug ma* in Tibetan (Skt. **īśvarī*). As I have shown elsewhere, these twenty-eight mother-goddesses consist of the above-mentioned consorts of twenty deities and eight additional goddesses (including Umā, the consort of Maheśvara; see fig. 6.6).[640] Therefore the fifty-eight wrathful deities followed in the tradition of the *Sarvatathāgatatattvasaṃgraha*, which made Heruka the conqueror of the mother-goddesses.

The reason for the explosive development of the cult of Heruka, who had originally performed the special task of subduing mother-goddesses in Buddhism, is closely related to the situation in Hinduism in medieval India, where the cult of mother-goddesses was at its zenith. This was the so-called Śākta cult, which worships Kālī or Durgā, the fearful consorts of Śiva, rather than their peaceful manifestation, Umā.

As noted, in Hinduism Heruka is an epithet of Gaṇeśa. Many statues of mother-goddesses have been discovered in India, and groups of statues of seven or eight mother-goddesses are frequently accompanied by Gaṇeśa. While the cult of the mother-goddess is inseparable from bloody sacrifices, Gaṇeśa is said not to require any such sacrifice. Therefore the role of Heruka as the subjugator of mother-goddesses in Buddhism is comparable to that of Gaṇeśa in Hinduism.

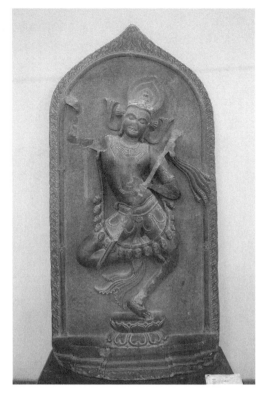

FIG. 6.5. TWO-ARMED HERUKA
(BANGLADESH NATIONAL MUSEUM)

	Twenty-eight *dbang phyug ma*	Consorts of twenty deities	Spouse
East	1. Srin mo dmar mo		
	2. Tshangs mo	3. Brahmāṇī	3. Brahmā
	3. lHa chen / 'Khrug mo	Umā	Maheśvara
	4. gTogs 'dod / 'Jug sred mo	1. Rukmiṇī	1. Nārāyaṇa
	5. gZhon nu ma	2. Ṣaṣṭhī	2. Sanatkumāra
	6. brGya sbyin / dBang mo	4. Indrāṇī	4. Indra
South	7. rDo rje ser mo / dMar ser mo	8. Jātahāriṇī	8. Piṅgala
	8. Zhi ba mo	13. Śivā	13. Kośapāla
	9. bDud rtsi mo	5. Amṛtā	5. Amṛtakuṇḍalin
	10. Zla ba mo / Zhi ba mo	6. Rohiṇī	6. Indu
	11. Be con mo	7. Daṇḍadhāriṇī	7. Mahādaṇḍāgri
	12. Srin mo ser nag		
West	13. Za ba mo	10. Aśanā	10. Madhukara
	14. dGa' ba mo / gCig pur spyod ma	12. Rati	12. Jayāvaha
	15. sTobs chen / Khrag 'thung myos ma	9. Māraṇī	9. Madhumatta
	16. Srin mo dmar mo		
	17. Yid 'phrog ma / 'Dod pa	11. Vaśanā	11. Jaya
	18. Nor srung / Gru mo	16. Kauverī	16. Kuvera
North	19. Rlung mo	14. Vāyavī	14. Vāyu
	20. Me mo	15. Āgneyī	15. Agni
	21. Phag mo	17. Vārāhī	17. Varāha
	22. rGan byed mo	18. Cāmuṇḍā	18. Yama
	23. sNa chad mo	19. Chinnanāsā	19. Pṛthivīcūlika
	24. Chu lha mo	20. Vāruṇī	20. Varuṇa
Four Gates	25. Nag mo chen mo		
	26. Ra mgo dmar ser chen mo		
	27. sNgo nag chen mo		
	28. gSus 'dzin ser nag chen mo		

At present, it is not clear whether the cult of Heruka was first introduced in Buddhism or Hinduism. But it is certain that Heruka was the conqueror of mother-goddesses who demand the blood of sacrifices as offerings. Because of the popularity of the mother-goddess cult, there was an increasing demand for Heruka, the subjugator of mother-goddesses. This would seem to have been the reason for the explosive development of Mother tantras centered on Heruka.

These mother-goddesses of the *Sarvatathāgatatattvasaṃgraha* are not depicted in the outer square of the Japanese Vajradhātu-maṇḍala, but they are frequently depicted in Tibetan examples of the Vajradhātu-maṇḍala. In particular, the consorts of twenty deities are depicted together with their spouses in the outer square of the Trailokyavijaya-maṇḍala in the Vairocana chapel at Alchi monastery and are iconographically interesting (fig. 6.7). In addition, in the Trilokacakra-mahāmaṇḍala on the west wall of the east chapel in the cupola of the Great Stūpa of Palkhor Chöde monastery in Gyantse the consorts of twenty deities are arranged in the outermost circle.[641]

Further, in the inner square of the maṇḍala of the fifty-eight wrathful deities, in which the twenty-eight mother-goddesses are arranged in the outer square, there are depicted the eight goddesses Gaurī, Caurī, Pramohā, Vetālī, Pukkasī, Ghasmarī, Caṇḍālī, and Śmaśānī, adopted from the Heruka family of the *Samāyogatantra*. Their iconography is similar to that of the twenty-eight mother-goddesses, but they are thought to be Buddhist in origin, since their mantras were adopted from those of members of the retinue of Vajrajvālānalārka given in the "Mantrakhaṇḍa" of the *Paramādyatantra*.

Wrathful deities are the foes of Hindu gods, but they also assume the attributes of the Hindu gods whom they subdue. Thus Heruka, the conqueror of mother-goddesses, is also accompanied by Buddhist female deities similar to mother-goddesses. Furthermore, the female deities taken over by later Mother tantras as the retinue of Heruka were not the Hindu goddesses arranged in the outer square but eight Buddhist female deities originating in the *Samāyogatantra*.

FIG. 6.7. BRAHMĀ, KUMĀRA, AND THEIR CONSORTS IN THE TRAILOKYAVIJAYA-MAHĀMAṆḌALA (VAIROCANA CHAPEL, ALCHI, LADAKH; © KATŌ KEI)

5. The Hevajra Cycle

The *Hevajratantra* is a representative Mother tantra that appeared after the Samāyoga cycle. The extant *Hevajratantra* is said to be an excerpt of 2 *kalpas*, the "Vajragarbhābhisambodhi" and "Māyākalpa," from the root tantra, which consisted of 500,000 verses, or *ślokas*, in 30 or 32 *kalpas*. Therefore the present version is also called the *Dvikalpa*, or text consisting of two *kalpas*. Opinion differs among Indo-Tibetan scholars as to whether the two extant *kalpas* correspond to the first two or last two *kalpas* in the root tantra of 32 *kalpas*.

The entire text of the *Hevajratantra* is composed in somewhat irregular verses, some of which are written not in Sanskrit but in Prākrit. The organization of the text is also rather haphazard. For example, it says "as mentioned above" when no earlier explanation is given,[642] and conversely it says "not explained before" when an explanation is found in an earlier part of the text.[643] Indo-Tibetan commentators attributed these discrepancies to the fact that it had been extracted from the root tantra of 500,000 *ślokas*. Today many scholars doubt the existence of the root tantra, but there is a possibility that verses intended to constitute a voluminous text were brought together in the present tantra without this process having

been completed. There is also a Chinese translation, the *Dabei kongzhi jingang dajiaowang yigui jing* translated by Faxian, but it did not circulate widely in China or Japan.

The *Mahāmudrātilakatantra* is said to be the *uttaratantra* and the *Jñānagarbhatantra* the *uttarottaratantra* of the *Hevajratantra*. An explanatory tantra, the *Ḍākinīvajrapañjaratantra* (hereafter *Vajrapañjaratantra*), is said to summarize the root tantra in one *kalpa*. The Sakya school of Tibetan Buddhism, which is based on the *Hevajratantra*, attaches great importance to the *Vajrapañjaratantra*. As is discussed in the next section, there is some dispute about the order in which the *Hevajratantra* and *Vajrapañjaratantra* came into existence.

The *Hevajratantra* was one of the most popular tantras in late tantric Buddhism, and consequently many commentaries were written. Snellgrove's edition of the *Hevajratantra* includes the *Yogaratnamālā*, attributed to Kṛṣṇa/Kāṇhapāda. The CIHTS edition,[644] on the other hand, is accompanied by the *Muktāvalī* by Ratnākaraśānti. In addition, M. J. Shendge has published the extant portion of the *Ṣaṭsāhasrikā-Hevajraṭīkā*,[645] attributed to Vajragarbha. This commentary is one of the three commentaries said to have been composed by bodhisattvas that were brought to India by Cilūpa. It is a commentary on the *Hevajra* from the standpoint of the *Kālacakra*.

Rāhula Sāṅkṛtyāyana discovered Sanskrit manuscripts of the *Vajrapañjaratantra* in Tibet, but they went missing during the Cultural Revolution. Several Sanskrit manuscripts of commentaries on the *Vajrapañjaratantra* are transmitted in Nepal,[646] but a Sanskrit manuscript of the tantra itself is not known, and no Sanskrit edition has been published.

6. Maṇḍalas of the Hevajra Cycle

There are several styles of the Hevajra-maṇḍala, such as nine-deity or seventeen-deity, and the nine-deity maṇḍala is the most popular in Tibetan Buddhism. However, some scholars doubt whether the nine-deity maṇḍala was originally the representative maṇḍala of the Hevajra cycle.

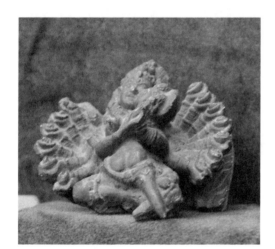

FIG. 6.8. HEVAJRA (PAHARPUR, BANGLADESH)

The nine-deity maṇḍala takes the form of an eight-petaled lotus, on the pericarp of which Hevajra is depicted embraced by his consort, Nairātmyā. There are two-armed, four-armed, six-armed, and sixteen-armed representations of Hevajra, and the name of his consort also changes depending on the number of his arms, that is, Nairātmyā (two-armed and sixteen-armed), Vajravārāhī (four-armed), and Vajrasṛṅkhalā (six-armed). The goddesses arranged around Hevajra are Vajraraudrī and so on in the case of two-armed, four-armed, and six-armed Hevajra, while in the case of sixteen-armed Hevajra they are Gaurī (east), Caurī (south), Vetālī (west), Ghasmarī (north), Pukkasī (northeast), Śabarī (southeast), Caṇḍālī (southwest), and Ḍombī (northwest) (see fig. 6.9).

In Tibet, maṇḍalas centered on two-armed, four-armed, and six-armed Hevajra are assigned to the three mysteries of body, speech, and mind respectively (V-6–8), while that of sixteen-armed Hevajra, the most common in Tibet, is called Garbha/Hṛdaya Hevajra (V-5). The structure of the Garbha-Hevajra maṇḍala is strikingly similar to that of the Heruka family of the *Samāyogatantra*.

In the classification of the Mother tantras, the *Hevajratantra* belongs to the Heruka family, while the *Samāyogatantra* belongs to "tantras that explain the six families equally." This fact tallies with the structure of the Hevajra-maṇḍala, which separated the Heruka family

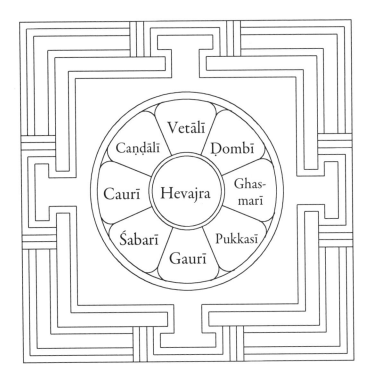 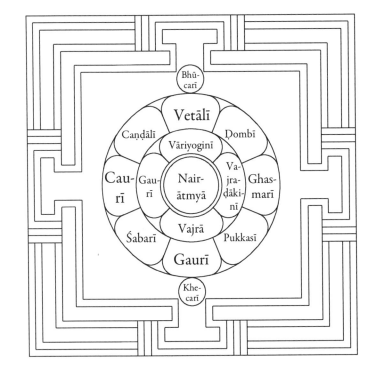

from the six families of the *Samāyogatantra*. However, the *Hevajratantra* has an affinity with the *Guhyasamāja*, a representative Father tantra, in contrast to the *Samāyoga*, which developed from the *Paramādyatantra*.

The *Hevajratantra* explains the assignment of deities in the maṇḍala of Nairātmyā, the consort of Hevajra, to doctrinal categories. This maṇḍala consists of the nine deities of the Hevajra-maṇḍala (Hevajra himself is not depicted), four goddesses starting with Vajrā, Bhū-carī at the bottom, and Khecarī at the top (fig. 6.9). Nairātmyā, the main deity, and the four goddesses starting with Vajrā are assigned to the five aggregates; the four goddesses of the four intermediate directions, starting with Pukkasī, are assigned to the four elements; and the goddesses of the four cardinal directions, starting with Gaurī, and Bhūcarī and Khecarī are assigned to the six sense objects.[647] This is thought to be an adaptation of the *skandhadhātvāyatana* system of the *Guhyasamājatantra* to the deities of the Hevajra cycle (fig. 6.10).

The *Hevajratantra* (II.iii.32) explains sense objects (*viṣaya*), sense organs (*indriya*), sense fields (*āyatana*), aggregates (*skandha*), and elements (*dhātu*). In this context, *dhātu* signifies not the four elements but the eighteen elements of the Abhidharma. Therefore the *Hevajra* did not originally refer to the maṇḍala theory of the *Guhyasamāja* as *skandhadhātvāyatana*.

On the other hand, Vajragarbha's commentary, which interprets the *Hevajra* from the standpoint of the *Kālacakra*, clearly states that the fifteen deities starting with Nairātmyā correspond to the five aggregates, four elements, and six sense objects.[648]

In the nine-deity maṇḍala of Hevajra, on the other hand, the main deity and four *ḍākinīs* starting with Gaurī are assigned to the five buddhas. According to the *Āmnāyamañjarī* by Abhayākaragupta,[649] the four goddesses in the cardinal directions starting with Gaurī

	NAME OF DEITY	DOCTRINAL CATEGORY	*GUHYASAMĀJA*
Five aggregates	1. Nairātmyā	*vijñāna*	1. Akṣobhya
	2. Vajrā	*rūpa*	2. Vairocana
	3. Gaurī	*vedanā*	3. Ratnaketu
	4. Vāriyoginī	*saṃjñā*	4. Amitābha
	5. Vajraḍākinī	*saṃskāra*	5. Amoghasiddhi
Four elements	6. Pukkasī	earth	6. Locanā
	7. Śabarī	water	7. Māmakī
	8. Caṇḍālī	fire	8. Pāṇḍaravāsinī
	9. Ḍombī	wind	9. Tārā
Six sense objects	10. Gaurī	visible objects	10. Rūpavajrā
	11. Caurī	sound	11. Śabdavajrā
	12. Vetālī	smell	12. Gandhavajrā
	13. Ghasmarī	taste	13. Rasavajrā
	14. Bhūcarī	touch	14. Sparśavajrā
	15. Khecarī	*dharmas*	15. Dharmadhātuvajrā

correspond to the four buddhas starting with Vairocana and the four sense objects, while Hevajra, the main deity, corresponds to tactile objects (*sparśa*) and his consort Nairātmyā to *dharmadhātu*.[650] The *Niṣpannayogāvalī* by the same author, on the other hand, explains the correspondence as follows: Hevajra and Nairātmyā correspond to Akṣobhya, Gaurī to Akṣobhya, Caurī to Vairocana, Vetālī to Ratnasambhava, and Ghasmarī to Amitābha. Thus there is no goddess corresponding to Amoghasiddhi.[651]

As mentioned, the nine-deity maṇḍala of Hevajra has selected the principal deities of the Heruka family of the *Samāyogatantra*. But doctrinally speaking, the *Hevajratantra* was influenced by the maṇḍala theory of the *Guhyasamāja*, whereas the *Samāyoga* developed from the "Mantrakhaṇḍa" of the *Paramādyatantra*.

However, it was unreasonable to interpret the nine-deity maṇḍala of Hevajra, which originally belonged to a different tradition, in accordance with the *skandhadhātvāyatana* system of the *Guhyasamāja*. The four goddesses starting with Vajrā, Bhūcarī, and Khecarī are thought to have been newly introduced to conform with the *skandhadhātvāyatana* system. The second of the four goddesses starting with Vajrā is called Gaurī, which is the same name as the first of the eight goddesses adopted from the *Samāyoga*. It is very rare for there to be two deities with the same name in the same maṇḍala. This fact, too, suggests that the four goddesses starting with Vajrā were adopted from another unknown system.

Examples of the Nairātmyā-maṇḍala, which is consistent with the *skandhadhātvāyatana* system, are rare, whereas examples of the nine-deity Hevajra-maṇḍala, in which Heruka is surrounded by eight goddesses, starting with Gaurī adopted from the *Samāyoga*, are common in Tibet and Nepal. This would suggest that the nine-deity maṇḍala of Heruka was strongly felt to be a representative maṇḍala of the Mother tantras.

The Pañcaḍāka-maṇḍala (V-9) is a development of the Hevajra-maṇḍala and is described in the *Vajrapañjaratantra*, an explanatory tantra of the Hevajra cycle. This maṇḍala is called Pañcaḍāka (five *ḍākas*) because it consists of five small maṇḍalas, each depicting in the center as the main deity one of the five *ḍākas*: Vajraḍāka (center), Buddhaḍāka (east), Ratnaḍāka (south), Padmaḍāka (west), and Viśvaḍāka (north). These five *ḍākas* have the five buddhas as their lords. Therefore Vajraḍāka corresponds to Heruka, Buddhaḍāka to Vairocana, Ratnaḍāka to Vajrasūrya, Padmaḍāka to Padmanarteśvara, and Viśvaḍāka to Paramāśva.

In the Maṇḍala chapel in Tsaparang in western Tibet, there has survived a wall painting of the Pañcaḍāka in which Viśvaḍāka is depicted as horse-headed.[652] This confirms the fact that Viśvaḍāka corresponds to Paramāśva, since this iconography was inherited from the earlier iconography of Paramāśva.

Among the Pañcaḍāka, Vajraḍāka in the center is surrounded by the same eight female deities as appear in the nine-deity Hevajra-maṇḍala. But the eight goddesses arranged around the main deities of the maṇḍalas in the four directions do not correspond to those of the six-family maṇḍala of the *Samāyogatantra*, and they include the eight offering goddesses of the Vajradhātu-maṇḍala, the four buddha-mothers of the *Guhyasamāja*, and the four goddesses of musical instruments of the *Samāyogatantra*.

There is the view that the *Vajrapañjaratantra*, although thought to be an explanatory tantra of the Hevajra cycle, pre-dates the *Hevajratantra*, since it does not explicitly explain the bio-yogic practices peculiar to the completion stage of the Mother tantras. It has also been argued that the maṇḍala of the Heruka family of the *Samāyogatantra* developed into the nine-deity Hevajra-maṇḍala via the Vajraḍāka-maṇḍala of the Pañcaḍāka-maṇḍala.[653]

However, as I have made clear elsewhere, chapter 4 of the *Vajrapañjaratantra* clearly explains the five visions (*pañcadhā-nimitta*) that appear as signs of proficiency in the yoga of the completion stage.[654] Chapter 15 of the same tantra explains a tenfold initiation system, a development of the fourfold initiation of late tantric Buddhism, and this tenfold initiation of the *Vajrapañjaratantra* had an influence on that of the *Kālacakratantra*.[655] The five visions and four initiations are topics not discussed in the root tantra of the *Guhyasamāja* and appear for the first time in its *uttaratantra* (chapter 18).

Moreover, it becomes difficult to explain rationally why the retinues of the Pañcaḍākas, apart from Vajraḍāka, do not coincide with those of the *Samāyogatantra*, if it is maintained that the six-family maṇḍala of the *Samāyogatantra* developed into the Pañcaḍāka-maṇḍala and the principal deities of the Heruka family of the latter formed the nine-deity maṇḍala of Hevajra.

Therefore it is to be surmised that the Pañcaḍāka-maṇḍala is a fivefold expansion of the nine-deity Hevajra-maṇḍala that emerged after the latter had evolved from the Heruka family of the *Samāyogatantra*. This is comparable to the General Assembly maṇḍala of the five families that developed from the Vajradhātu-maṇḍala. Thus the Pañcaḍāka-maṇḍala is the Sarvakula-maṇḍala of the Hevajra cycle.

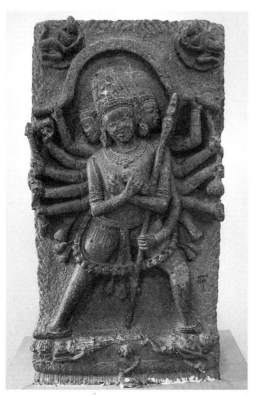

FIG. 6.11. CAKRASAMVARA (PATNA MUSEUM)

7. The Saṃvara Cycle

The *Saṃvaratantra* is another representative Mother tantra along with the *Hevajratantra*. It is not a single tantra but a generic designation for a series of tantras referred to as the "Saṃvara cycle."

As is indicated by the fact that *Sarvabuddhasamāyogaḍākinījālasaṃvara*, the full title of the *Samāyogatantra*, the archetype of the Mother tantras, was translated into Chinese as "Net of Ḍākinī Precepts of the Assembly of All the Buddhas," the term *saṃvara* originally meant "religious precept." However, it was confused with *śaṃvara*, meaning "supreme bliss," because the consonants *sa* and *śa* merged in medieval eastern India, the homeland of Buddhism. It eventually became a term signifying the supreme principle of the Mother tantras.[656] This is why in Tibetan translations *saṃvara* has two equivalents, "religious precept" (*sdom pa*) and "supreme bliss" (*bde mchog*).

As was mentioned earlier, in esoteric Buddhist texts dating from the eighth to early ninth centuries, such as those of the Ārya school on the *Guhyasamāja* and the Vilāsavajra school on the *Nāmasaṅgīti*, the *Samāyogatantra* rather than the *Saṃvaratantra* is referred to as *Saṃvara*. There are major differences between the *Samāyoga* and the later Saṃvara cycle, but curiously the opening one and a half verses of the *Samāyogatantra* and *Laghusaṃvaratantra*—the core text of the Saṃvara cycle—are the same. This would suggest that the present Saṃvara cycle came into existence after the late ninth century by modifying the *Samāyogatantra*, then known as the *Saṃvara*.

The present Saṃvara cycle is said to have been extracted from a legendary root tantra, the *Abhidhānatantra* or *Khasamatantra*, which consisted of 100,000 or 300,000 *ślokas*. But this *mūlatantra* is no longer extant. The Tibetan Tripiṭaka includes the *Yathālabdhakhasamatantra*, which belongs not to the Heruka family but to the Vajradhara family of the Mother tantras. *Khasama* in its title is suggestive of the seventeenth assembly of the Vajraśekhara cycle, *Ru xukong yuga* (Yoga [tantra] like Space). The relationship between the *Yathālabdhakhasamatantra* and the seventeenth assembly of the Vajraśekhara cycle is not clear, since the description of the seventeenth assembly in the *Shibahui zhigui* mentions no characteristic tenets such as the "nine tastes" of the ninth assembly.

There is no evidence of the *Yathālabdhakhasamatantra* having circulated in Tibet. It is, however, worth noting that Ratnākaraśānti composed a commentary entitled *Khasama nāma ṭīkā*, and the Sanskrit manuscript of this text has survived in Nepal.[657] According to these materials, this tantra explains three kinds of maṇḍalas symbolizing the three mysteries of body, speech, and mind. They are simple five-deity maṇḍalas and do not coincide with the thirteen-deity or sixty-two-deity maṇḍala of the Saṃvara cycle. Nor can we find any names of goddesses shared by these two tantras. Therefore the extant *Khasamatantra* can hardly be regarded as the root tantra of the Saṃvara cycle.

The *Laghusaṃvaratantra*, the core text of the Saṃvara cycle, claims to be a "light" tantra (*laghutantra*) extracted from the root tantra. In Tibet it is called the *Cakrasaṃvaratantra* and is deemed to be in fact the root tantra. No Sanskrit manuscript had been known to exist, but in 2002 the CIHTS published a critical edition based on manuscripts from Nepal.[658]

The *Laghusaṃvara* enumerates the titles of other tantras to demonstrate its superiority over them.[659] The titles of the *Tattvasaṃgraha*, *Saṃvara* or *Cakrasaṃvara*, *Guhya(tantra)*, *Vajrabhairava*, and *Paramādya* are mentioned. Therefore the *Laghusaṃvara* must at least

postdate these tantras. The reason that it mentions the *Saṃvara* as if it were another text may be that it had in mind the *Samāyoga*, previously known as the *Saṃvara*.[660]

The CIHTS edition of the *Laghusaṃvara* is accompanied by the *Cakrasaṃvaravivṛti* by Bhavabhaṭṭa.[661] A Sanskrit manuscript of the *Cakrasaṃvaramūlatantrapañjikā* has been transmitted in Nepal, and a critical edition has been published.[662] The commentary by Vajrapāṇi, on the other hand, is one of the three commentaries composed by bodhisattvas that were brought to India by Cilūpa, and a critical edition based on a manuscript from Nepal has been published.[663] It provides a systematic description of the Cakrasaṃvara cycle from the standpoint of the *Kālacakra* and is not a word-for-word commentary.

The *Abhidhānottaratantra* styles itself as the *uttaratantra* and *uttarottaratantra*[664] of the *Abhidhāna*, the root tantra of the Saṃvara cycle. It is thought to be the *uttaratantra* of the *Laghusaṃvara*. A critical edition has yet to be published, but Lokesh Chandra has published a facsimile reproduction of a Sanskrit manuscript from Nepal.[665]

Tsuda Shin'ichi has published nineteen of the thirty-three chapters of the *Saṃvaro-dayatantra*, an explanatory tantra of the Saṃvara cycle,[666] and I use this edition when referring to the *Saṃvarodayatantra*. In his introduction, Tsuda makes the *Saṃvarodaya* the basic and earliest text of the extant Saṃvara cycle. Sugiki, on the other hand, considers it to belong to the third phase of the Saṃvara cycle, since it is seldom cited in ritual manuals and commentaries composed in India.[667]

The Sanskrit manuscript of another explanatory tantra of the Saṃvara cycle, the *Śrī-vajraḍākamahātantrarāja*, has also survived in Nepal, and Sugiki has published a critical edition of several chapters.[668] The *Yoginīsañcāratantra*, another explanatory tantra of the Saṃvara cycle, expounds a distinctive theory according to which the *yoginīs* who constitute the maṇḍala change their positions over time, a general outline of which had already been provided by Tsuda.[669] A critical edition of this text has been published by the CIHTS.[670]

In addition to the above texts, various ritual manuals on the Saṃvara cycle are included in the Tibetan Tripiṭaka, and many Sanskrit manuscripts of the Saṃvara cycle are preserved in Nepal. Some of them have already been published and consulted by researchers, while others have yet to be published.

8. Maṇḍalas of the Saṃvara Cycle

There are a great variety of maṇḍalas of the Saṃvara cycle if we include maṇḍalas of the mother cycle (Tib. *yum 'khor*) centered on Vajravārāhī, the consort of Saṃvara. Basically, they can be divided into two types, a sixty-two-deity maṇḍala (if *yab yum* couples are counted as single deities, it becomes a thirty-seven-deity maṇḍala) and a thirteen-deity maṇḍala (if the *yab yum* couple is counted as two deities, it becomes a fourteen-deity maṇḍala).

The sixty-two-deity Cakrasaṃvara-maṇḍala takes the form of five concentric circles, namely, an eight-petaled lotus, three eight-spoked wheels, and the outer square, and they are called the wheel of great bliss (*mahāsukha-cakra*) or wheel of wisdom (*jñāna-cakra*), the wheel of the mind (*citta-cakra*), the wheel of speech (*vāk-cakra*), the wheel of the body (*kāya-cakra*), and the wheel of the pledge (*samaya-cakra*), respectively. These five concentric circles are associated with Ratnasambhava, Akṣobhya, Amitābha, Vairocana, and Amoghasiddhi, respectively. This is because the tradition assigning the three mysteries of body, speech, and mind to Vairocana, Amitābha, and Akṣobhya had been established since

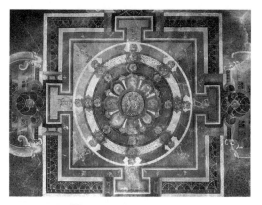

FIG. 6.12. SIXTY-TWO-DEITY CAKRASAṂVARA-MAṆḌALA
(SHEY MONASTERY, LADAKH; © MORI KAZUSHI)

FIG. 6.13. SIXTY-TWO-DEITY CAKRASAṂVARA-MAṆḌALA

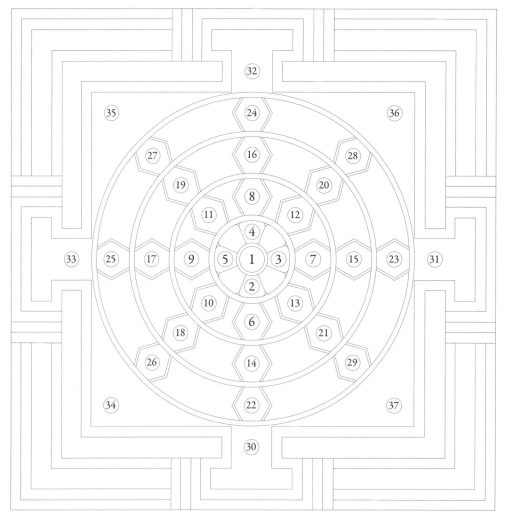

Names of deities are given in fig. 6.14.

the *Guhyasamājatantra*. In the center of the wheel of great bliss, the main deity Saṃvara and his consort Vajravārāhī are depicted. Saṃvara is represented in various ways, and according to the *Niṣpannayogāvalī* he is four-headed and twelve-armed and holds a vajra and a bell in his two principal hands.

Four images of Saṃvara (apart from cast-metal statues) have been unearthed in India,[671] and their iconography basically matches that of the four-headed and twelve-armed form. They appear to be three-headed because in the case of high relief it is difficult to represent the rear head among his four heads. None of these four examples are accompanied by consorts, probably because it was prohibited to show father-mother images to laypeople who had not been initiated into esoteric Buddhism.[672]

These images were discovered in Bihar and Orissa, and several cast metal statues in Kashmir style have also been found. These facts suggest that the Saṃvara cycle was widespread in Bengal, Orissa, and Kashmir, where Buddhism survived until the very end of Indian Buddhism.

FIG. 6.14. NAMES OF DEITIES IN THE SIXTY-TWO-DEITY CAKRASAṂVARA-MAṆḌALA

	SANSKRIT	TIBETAN	SPOUSE	TIBETAN
Wheel of great bliss	1. Saṃvara	Bde mchog	Vajravārāhī	Rdo rje phag mo
	2. Ḍākinī	Mkha' 'gro ma		
	3. Lāmā	Lā mā		
	4. Khaṇḍarohā	Dum skyes ma		
	5. Rūpiṇī	Gzugs can ma		
Wheel of the mind	6. Pracaṇḍā	Rab tu gtum ma	Khaṇḍakapāla	Thod pa'i dum bu
	7. Caṇḍākṣī	Gtum pa'i mig can ma	Mahākaṅkāla	Keng rus chen po
	8. Prabhāvatī	'Od ldan ma	Kaṅkāla	Keng rus
	9. Mahānāsā	Sna chen ma	Vikaṭadaṃṣṭrin	Mche ba rnam par gtsigs pa
	10. Vīramatī	Dpa' ba'i blo gros ma	Surāvairi	Chang dgra ma
	11. Kharvarī	Mi'u thung ma	Amitābha	'Od dpag med
	12. Laṅkeśvarī	Lang ka'i dbang phyug ma	Vajraprabha	Rdo rje 'od
	13. Drumacchāyā	Shing grib ma	Vajradeha	Rdo rje'i lus
Wheel of speech	14. Erāvatī	Sa bsrungs ma	Aṅkurika	Myu gu can
	15. Mahābhairavā	'Jigs byed chen mo	Vajrajaṭila	Rdo rje ral pa can
	16. Vāyuvegā	Rlung gi shugs can ma	Mahāvīra	Dpa' bo chen po
	17. Surābhakṣī	Chang 'thung ma	Vajrahūṃkāra	Rdo rje hūṃ mdzad
	18. Śyāmadevī	Sngo bsangs ma	Subhadra	Rdo rje bzang po
	19. Subhadrā	Shin tu bzang mo	Vajraprabha	Rdo rje 'od
	20. Hayakarṇā	Rta rna ma	Mahābhairava	'Jigs byed chen mo
	21. Khagānanā	Bya gdong ma	Virūpākṣa	Mig mi bzang
Wheel of the body	22. Cakravegā	'Khor lo'i shugs can ma	Mahābala	Stobs po che
	23. Khaṇḍarohā	Dum skyes ma	Ratnavajra	Rin chen rdo rje
	24. Śauṇḍinī	Chang 'tshong ma	Hayagrīva	Rta mgrin
	25. Cakravarmiṇī	'Khor lo'i go cha 'dzin ma	Ākāśagarbha	Rnam mkha'i snying po
	26. Suvīrā	Rab dpa' mo	Śrīheruka	Dpal he ru ka
	27. Mahābalā	Stobs chen mo	Padmanarteśvara	Padma gar gyi dbang phyug
	28. Cakravartinī	'Khor los bsgyur ma	Vairocana	Rnam par snang mdzad
	29. Mahāvīryā	Brtson 'grus chen mo	Vajrasattva	Rdo rje sems dpa'
Wheel of the pledge	30. Kākāsyā	Khva gdong ma		
	31. Ulūkāsyā	'Ug gdong ma		
	32. Śvānāsyā	Khyi gdong ma		
	33. Śūkarāsyā	Phag gdong ma		
	34. Yamadāhī	Shin rje brtan ma		
	35. Yamadūtī	Shin rje pho nya mo		
	36. Yamadaṃṣṭrī	Shin rje mche ba ma		
	37. Yamamathanī	Shin rje 'joms ma		

On the lotus petals in the four cardinal directions around Saṃvara in the wheel of great bliss, four goddesses—Ḍākinī (east), Lāmā (north), Khaṇḍarohā (west), and Rūpiṇī (south)—are arranged counterclockwise. This counterclockwise arrangement of deities is a characteristic of the Saṃvara cycle. This part corresponds to the central part of the Samāyoga- and Hevajra-maṇḍalas, in which the main deity is surrounded by eight goddesses. In the Saṃvara-maṇḍala, however, *kapālas* instead of goddesses are depicted on the four lotus petals in the intermediate directions.

Among the four images of Saṃvara mentioned above, that in the possession of the Indian Museum shows four goddesses, one-headed and four-armed, above and below Saṃvara.[673] Judging from their iconography, they are the four goddesses starting with Ḍākinī arranged in the wheel of great bliss.

The wheel of great bliss in the shape of an eight-petaled lotus is surrounded by three eight-spoked wheels symbolizing the three mysteries of body, speech, and mind. These three wheels ought to be arranged three-dimensionally, but when they are represented pictorially, they become three concentric circles, that is, the wheels of mind, speech, and body, starting from the inside. The outer rims of the wheels of the three mysteries are blue (mind), red (speech), and white (body), in accordance with the body colors of Akṣobhya, Amitābha, and Vairocana, who preside over the three mysteries. On the wheels of the three mysteries eight couples are depicted in the cardinal and intermediate directions of each wheel. Thus the total number of deities in the three wheels becomes forty-eight (see figs. 6.13 and 6.14).

The twenty-four couples on the wheels of the three mysteries play an important role in the Saṃvara cycle. First, the seats of the twenty-four couples correspond to the twenty-four sacred places (*pīṭhas*) of the Saṃvara cycle. Furthermore, these couples also correspond to the twenty-four loci and twenty-four constituent elements (*dhātus*) of the body. By assigning these deities to the constituent elements of the body, the Body maṇḍala is completed (fig. 6.15).

In the case of Caṇḍākṣī and Mahākaṅkāla, the second couple on the wheel of the mind, their locus, the topknot (*uṣṇīṣa*), corresponds to their element, hair. But in the case of Prabhāvatī and Kaṅkāla, the next couple, their locus, the right ear, does not match their element, skin and scurf. Such inconsistencies are thought to have come about by combining two systems of different origins through the medium of the sixty-two-deity maṇḍala.[674]

As a precursor of the idea of assigning maṇḍala deities to parts of the body, we can point to the *dharma-maṇḍala* in part 1 of the *Sarvatathāgatatattvasaṃgraha*, which makes the vajra-fist superimposed on parts of the body the pledge mudrā (*samaya-mudrā*) of the sixteen great bodhisattvas.[675] However, the locations assigned to the deities do not match. In the Vajradhātu-maṇḍala the parts of the body assigned are determined by the bodhisattvas' characteristics, whereas the twenty-four loci of the Saṃvara cycle are arranged from the upper to lower parts of the body in the order of the wheels of the three mysteries of mind, speech, and body. In the case of the twenty-four elements, it is worth noting that all eight elements corresponding to the wheel of the body are liquid, such as mucus and blood.

In the sixty-two-deity maṇḍala of Saṃvara, the main deities of the six families of the *Samāyogatantra* appear as heroes or the goddesses' partners on the wheels of the three mysteries. The heroes of the three mysteries are explained in vv. 10–13 of chapter 48 of the *Laghusaṃvara*.[676] However, the names of the heroes are listed not in the normal order of mind, speech, and body but in reverse order—body, speech, and mind. Thus the heroes'

FIG. 6.15. NAMES OF DEITIES IN THE BODY MAṆḌALA OF THE SAṂVARA CYCLE

	DEITY	LOCUS IN THE BODY	CONSTITUENT ELEMENT OF THE BODY
Wheel of great bliss	1. Saṃvara	heart	
	2. Ḍākinī	first right hand	
	3. Lāmā	second right hand	
	4. Khaṇḍarohā	first left hand	
	5. Rūpiṇī	second left hand	
Wheel of the mind	6. Pracaṇḍā	head	nails and teeth
	7. Caṇḍākṣī	lock of hair on the head	hair
	8. Prabhāvatī	right ear	skin and scurf
	9. Mahānāsā	occiput	flesh
	10. Vīramatī	left ear	sinew
	11. Kharvarī	glabella	bones
	12. Laṅkeśvarī	both eyes	heart (*bukka*)
	13. Drumacchāyā	both shoulders	heart (*hṛdaya*)
Wheel of speech	14. Erāvatī	both armpits	both eyes
	15. Mahābhairavā	both breasts	bile
	16. Vāyuvegā	navel	lungs
	17. Surābhakṣī	nose tip	bowels
	18. Śyāmadevī	mouth	rectum
	19. Subhadrā	neck	abdomen
	20. Hayakarṇā	heart	excrement
	21. Khagānanā	limbs	joints
Wheel of the body	22. Cakravegā	penis	phlegm (*śleṣma*)
	23. Khaṇḍarohā	anus	pus
	24. Śauṇḍinī	both thighs	blood
	25. Cakravarmiṇī	both shanks	sweat
	26. Suvīrā	toe	marrow
	27. Mahābalā	instep	tears
	28. Cakravartinī	big toe	phlegm (*kheṭa*)
	29. Mahāvīryā	both knees	nasal mucus
Wheel of the pledge	30. Kākāsyā	third right hand	
	31. Ulūkāsyā	fourth right hand	
	32. Śvānāsyā	fifth right hand	
	33. Śūkarāsyā	sixth right hand	
	34. Yamadāhī	third left hand	
	35. Yamadūtī	fourth left hand	
	36. Yamadaṃṣṭrī	fifth left hand	
	37. Yamamathanī	sixth left hand	

names begin with the main deities of the six families starting with Vajrasattva.[677] Therefore the twenty-four heroes of the wheels of the three mysteries expanded to twenty-four the main deities of the six families of the *Samāyogatantra*.

The outermost square is called the wheel of the pledge, and in the four gates are four animal-headed female gatekeepers—Kākāsyā (east), Ulūkāsyā (north), Śvānāsyā (west), and Śūkarāsyā (south). The *Saṃvara* is thought to have adopted these gatekeepers from the *Samāyoga*.[678] In the four corners of the courtyard are arranged four goddesses—Yamadāḍhī (southeast), Yamadūtī (southwest), Yamadaṃṣṭrī (northwest), and Yamamathanī (northeast)—who have different body colors on their right and left sides. Displaying fierce expressions, they guard the four cardinal and four intermediate directions of the maṇḍala.

Thus the total number of deities becomes sixty-two, since the eight goddesses of the wheel of the pledge are not couples. If we count a couple as one deity, the number of deities becomes thirty-seven, and they are associated with the thirty-seven prerequisites for the attainment of enlightenment (*bodhipakṣikadharma*) (see fig. 6.17).

The *Vajrāvalī* maṇḍala set includes five variant forms of the Cakrasaṃvara-maṇḍala: a sixty-two-deity maṇḍala of two-armed Saṃvara (V-20), a sixty-two-deity maṇḍala of Yellow Saṃvara (V-21), a thirty-seven-deity maṇḍala of Red Vajravārāhī (V-22), a thirty-seven-deity maṇḍala of Blue Vajravārāhī (V-23), and a thirty-seven-deity maṇḍala of Yellow Vajravārāhī (V-24). The maṇḍalas of two-armed Saṃvara and Yellow Saṃvara are variants of the sixty-two-deity Cakrasaṃvara-maṇḍala in which four-headed and twelve-armed Saṃvara has been replaced as the main deity by a one-headed and two-armed form of Saṃvara. The three types of Vajravārāhī-maṇḍala belong to the mother cycle in which Saṃvara has been replaced as the main deity by his consort Vajravārāhī. In maṇḍalas of the mother cycle, heroes (male deities) do not appear and only heroines (female deities) are depicted on the wheels of the three mysteries. Thus the total number of deities is thirty-seven.

As mentioned, the Saṃvara cycle is said to have been influenced by Hindu Śaivism. There are two currents in Śaiva tantras, a Śaiva current centered on the male deity Śiva and a Śākta current centered on the female deity Durgā, his consort, and the Śākta current is considered to be more esoteric. We can assume a similar background in the evolution of the Saṃvara cycle.

Although the mother cycle of Saṃvara was transmitted to Tibet, its popularity did not surpass that of the father cycle. In Nepal, on the other hand, the mother cycle became very popular, and many Sanskrit manuscripts belonging to this cycle have been preserved there.

The *Saṃvarodayatantra* explains a thirteen-deity maṇḍala (if couples are counted as two deities, it becomes a fourteen-deity maṇḍala).[679] In composition, it corresponds to the sixty-two-deity maṇḍala of Saṃvara minus the circles of the three mysteries of body, speech, and mind. It is thought to be the original form of the Saṃvara-maṇḍala rather than a simplified version.

As mentioned, some scholars consider the *Saṃvarodaya* to postdate the *Laghusaṃvara*. However, in the Saṃvara cycle the deities of the wheels of great bliss and the pledge and the deities of the wheels of the three mysteries are frequently mentioned separately. Further, the description in chapter 2 of the *Laghusaṃvara*, thought to be the textual source of the sixty-two-deity maṇḍala, is so vague that it is impossible to reconstruct the sixty-two-deity maṇḍala correctly without referring to the commentaries. Therefore I cannot rid myself of the suspicion that the sixty-two-deity maṇḍala had not yet emerged when

the *Laghusaṃvara* came into existence. It is most likely that the sixty-two-deity maṇḍala evolved by inserting the wheels of the three mysteries between the wheel of great bliss and the wheel of the pledge.

The thirteen-deity maṇḍala is not explained in the *Vajrāvalī* but is included in the *Mitra brgya rtsa* set as the thirteen-deity Cakrasaṃvara-maṇḍala (M-48). The *Saṃvarodayatantra* describes a three-headed and six-armed image of Saṃvara,[680] while the *Abhisamayamuktāmālā* explains a four-headed and twelve-armed image.[681] In areas where Tibetan Buddhism prevails there are many examples of the sixty-two-deity maṇḍala of Saṃvara, whereas examples of the thirteen-deity maṇḍala of Saṃvara are more prevalent in Nepal.

The *Abhidhānottaratantra* (chapter 21) describes the Ṣaṭcakravartin-maṇḍala (V-26), consisting of the six pavilions of Jñānaḍāka (center), Buddhaḍāka (east), Ratnaḍāka (south), Padmaḍāka (southwest), Vajraḍāka (northwest), and Viśvaḍāka (north). These six deities are called "Ṣaṭcakravartin," or the six universal rulers. It is worth noting that the *Abhidhānottaratantra* explains the correspondences between the parts of this maṇḍala and the ten stages (*bhūmi*) of the bodhisattva.

In the four intermediate directions of the central pavilion are four goddesses—Ḍākinī, Lāmā, Khaṇḍarohā, and Rūpiṇī—who are the same four goddesses as are depicted on the wheel of great bliss in the sixty-two-deity Cakrasaṃvara-maṇḍala. In the four cardinal directions of the central pavilion, on the other hand, four couples—Khaṇḍakapāla, Mahākaṅkāla, Kaṅkāla, and Vikaṭadaṃṣṭra—are depicted. They are identical with the couples in the cardinal directions of the wheel of the mind in the sixty-two-deity maṇḍala of Saṃvara.

Moreover, in the four cardinal directions of the eastern pavilion of Buddhaḍāka are the four couples found in the intermediate directions of the wheel of the mind in the sixty-two-deity maṇḍala of Saṃvara. In the same way, the eight couples of the wheel of the mystery of speech are arranged around Ratnaḍāka in the south and Padmaḍāka in the southeast, while the eight couples of the wheel of the mystery of the body are arranged around Vajraḍāka in the northwest and Viśvaḍāka in the north.

In the four gates of the outer pavilion are the four animal-headed female gatekeepers starting with Kākāsyā, and in the four corners of the outer pavilion are the four wrathful goddesses starting with Yamadāḍhī, as on the wheel of the pledge in the sixty-two-deity maṇḍala of Saṃvara.

Thus the Ṣaṭcakravartin-maṇḍala and the sixty-two-deity maṇḍala of Saṃvara share attendant deities even though they have completely different patterns and the arrangement of their deities is also quite different. The Ṣaṭcakravartin-maṇḍala symbolizes the six families of the Mother tantras by means of six pavilions, whereas the sixty-two-deity maṇḍala of Saṃvara has five concentric circles corresponding to the five families. It could be said that the Ṣaṭcakravartin-maṇḍala is the Sarvakula-maṇḍala of the Saṃvara cycle, just as the Pañcaḍāka-maṇḍala is the Sarvakula-maṇḍala of the Hevajra cycle.

In this fashion, the Saṃvara cycle created complex and varied maṇḍalas. But iconographically speaking, the attendant deities of the sixty-two-deity maṇḍala of Saṃvara have the same iconography in each of the five wheels of great bliss, mind, speech, body, and pledge, and they are differentiated only by their body colors and positions in the maṇḍala. This is quite simple when compared with the *Samāyoga* and the Hevajra cycle, in which each deity has a unique body color and attribute. The Saṃvara cycle seems to have attached much

importance to the bio-yogic practice and body theory of the completion stage to the neglect of iconographical diversity.

9. The Symbolism of the Saṃvara-maṇḍala

The Hevajra cycle adopted the maṇḍala theory of the *Guhyasamāja*, which assigned deities to the five aggregates, four elements, and six sense objects. But in the *Hevajratantra* *dhātu* in *skandhadhātvāyatana* signifies not the four elements but the eighteen *dhātus*. Thus the *Hevajratantra* does not refer to the maṇḍala theory originating in the *Guhyasamāja* as *skandhadhātvāyatana*.

In the Saṃvara cycle, on the other hand, there appeared a theory that interpreted *dhātu* in *skandhadhātvāyatana* as the four elements—earth, water, fire, and wind—and assigned them to the five buddhas, four buddha-mothers, adamantine goddesses, and bodhisattvas, respectively.

In chapter 3 of the *Saṃvarodayatantra*, goddesses (*devī*) are assigned to the four elements, (five) aggregates, and six sense objects.[682] However, it does not explain which goddesses are assigned to which categories.

The *Cakrasaṃvarābhisamaya* by Lūyīpa,[683] thought to be the earliest ritual manual among the three major Saṃvara schools, explains purification by assigning deities to the practitioner's five aggregates, six sense organs, and five elements.[684] In this text, six aggregates (in this context, all tathāgatas, or the totality of the five aggregates, become the sixth element) are assigned to the main deities of the six families of the *Samāyogatantra*. The six sense organs are assigned to male deities who purify mental defilements, while the five elements, including space (*ākāśa*), are assigned to female deities. Lūyīpa calls this "purification by assigning deities to *skandhadhātvāyatana*" (*skandhadhātvāyataneṣu devatāviśuddhi*).

As has been pointed out by others, the *Cakrasaṃvarābhisamaya* has many parallels with tantras belonging to the Saṃvara cycle.[685] With regard to the above passage, almost the same assignment of deities is found in the *Abhidhānottaratantra*[686] and *Vajraḍākatantra*.[687] Moreover, an almost identical passage occurs in chapter 1 of the *Yoginīsañcāratantra*,[688] which summarizes this process with the statement that "in this way one should generate pride of the deity in *skandhadhātvāyatana*."

The *Cakrasaṃvarābhisamaya* and *Yoginīsañcāratantra* explain the assignment of deities in the order of the five aggregates, six sense organs, and five elements, whereas the *Abhidhānottaratantra* explains it in the order of the five elements, five aggregates, and six sense organs. In each case, however, the reason that the term *skandhadhātvāyatana* is used may be that it had already become an established term for denoting the maṇḍala theory of the Guhyasamāja cycle.

The same assignment is also found in the *Saṃpuṭatantra*,[689] an explanatory tantra on both the *Hevajra* and the *Saṃvara*. In addition, Abhayākaragupta, in the *Āmnāyamañjarī*, his commentary on the *Saṃpuṭa*, equates the deities of the Saṃvara and Guhyasamāja cycles assigned to the same doctrinal categories.[690] The *Abhisamayamañjarī*, belonging to the mother cycle of the Saṃvara, also expresses the same idea (fig. 6.16).[691] Although some scholars attribute the *Abhisamayamañjarī* to Śāntarakṣita, it is unlikely that the mother cycle of the Saṃvara had already appeared in the eighth century. It would seem more reasonable to suppose that the author was either Śākyarakṣita, given as the author at the

	Deity	Doctrinal category	*Guhyasamāja*
Five aggregates	1. Vajrasattva	*vijñāna*	1. Akṣobhya
	2. Vairocana	*rūpa*	2. Vairocana
	3. Vajrasūrya	*vedanā*	3. Ratnaketu
	4. Padmanarteśvara	*saṃjñā*	4. Amitābha
	5. Vajrarāja	*saṃskāra*	5. Amoghasiddhi
	6. Śrīheruka	*sarvatathāgata*	
Five elements	7. Pātanī	earth	6. Locanā
	8. Māraṇī	water	7. Māmakī
	9. Ākarṣaṇī	fire	8. Pāṇḍaravāsinī
	10. Padmanarteśvarī	wind	9. Tārā
	11. Padmajvālinī	space	
Six sense organs	12. Mohavajra	eyes	10. Kṣitigarbha
	13. Dveṣavajra	ears	11. Vajrapāṇi
	14. Īrṣyāvajra	nose	12. Ākāśagarbha
	15. Rāgavajra	tongue	13. Avalokiteśvara
	16. Mātsaryavajra	body	14. Sarvanīvaraṇaviṣkambhin
	17. Aiśvaryavajra	sense fields	15. Samantabhadra

end of the Sanskrit manuscript, or Śubhākaragupta, given as the author in the Tibetan translation.

Thus the Saṃvara cycle is thought to have used the term *skandhadhātvāyatana* as a full-fledged term for the first time for assigning deities to doctrinal categories. This does not, however, mean that the term *skandhadhātvāyatana* originated in the Saṃvara cycle.

Most of the deities assigned to *skandhadhātvāyatana* are not depicted in maṇḍalas of the Saṃvara cycle. The maṇḍalas belonging to the Saṃvara cycle are based not on *skandhadhātvāyatana* but on the thirty-seven prerequisites for the attainment of enlightenment or the above-mentioned twenty-four loci or *dhātus* (see fig. 6.15). In other words, the use of *skandhadhātvāyatana* in the Saṃvara cycle is due to the influence of the maṇḍala theory of the *Guhyasamāja*, and the occurrence of *skandhadhātvāyatana* in the Saṃvara cycle suggests that the Saṃvara cycle postdates the Ārya and Jñānapāda schools of the *Guhyasamāja*.

Thus the Saṃvara cycle adopted the *skandhadhātvāyatana* theory from the *Guhyasamāja* and assigned the five aggregates and six sense organs to male deities and the five elements (including space) to female deities. However, in the sixty-two-deity maṇḍala of Saṃvara only the four deities adopted from the *Samāyogatantra* (Śrīheruka, Padmanarteśvara, Vairocana, and Vajrasattva) and assigned to the aggregates are depicted. Moreover, they can hardly be said to play an important role in the sixty-two-deity maṇḍala.

In the Saṃvara-maṇḍala, particularly the sixty-two-deity maṇḍala of Saṃvara, various doctrinal categories are assigned to the deities. However, as was pointed out in the previous section, there are inconsistencies between the twenty-four loci and twenty-four *dhātus*, and it is unlikely that these two systems were both incorporated into the sixty-two-deity maṇḍala from the very outset. But the interpretation that assigns the thirty-seven deities or couples of the Saṃvara-maṇḍala to the thirty-seven prerequisites for the attainment of enlightenment[692] was a typical interpretation of the maṇḍala in India, since it is mentioned in many texts (fig. 6.17).

It is said that when the Buddha was staying in Vaiśālī en route to Kuśinagara, Pāpīyas, the king of demons, asked the Buddha to enter nirvāṇa, whereupon he promised to do so three months later. Further, when the Buddha gave his final sermon in the assembly hall at Vaiśālī, he is said to have explained the thirty-seven prerequisites for the attainment of enlightenment as the grand summation of his teachings.[693] In later times this legend was reinterpreted in such a way that the Buddha was said to have abandoned the impermanent physical body (*rūpakāya*) and created an eternal truth body (*dharmakāya*). The stūpa constructed at Vaiśālī, called the Victorious Stūpa and counted among the eight great stūpas, is considered to commemorate the Buddha's creation of an eternal truth body.[694]

In the *Abhisamayālaṃkāra*, a representative treatise of late Mahāyāna Buddhism, twenty-one kinds of taintless wisdom, starting with the thirty-seven prerequisites for the attainment of enlightenment, are viewed as constituent elements of the Buddha's *dharma-* or *jñānakāya*.[695] These taintless dharmas corresponding to *dharma-* or *jñānakāya* in the *Abhisamayālaṃkāra* are listed in the *Pañcaviṃśatisāhasrikā Prajñāpāramitā*.[696] However, this passage is not found in the corresponding section of the Chinese *Da bore boluomiduo jing*, translated by Xuanzang, although the thirty-seven prerequisites for the attainment of enlightenment are included in lists of taintless dharmas in Chinese translations pre-dating Xuanzang. The reason that the *Abhisamayālaṃkāra* regarded the twenty-one kinds of taintless dharmas as the substance of the *dharma-* or *jñānakāya* is thought to lie in the theoretical development of Buddhism that had continued for a thousand years.[697]

Furthermore, the *Saṃpuṭatantra*[698] and chapter 2 of the *Yoginīsañcāratantra*[699] deal with the thirty-seven prerequisites for the attainment of enlightenment. It is extremely rare for the exposition of an exoteric Buddhist theory to become the subject matter of a chapter in a late tantric scripture. This gives an indication of the importance that was placed on the thirty-seven prerequisites for the attainment of enlightenment in late tantric Buddhism. It seems to me that the reason for this was that the thirty-seven prerequisites for the attainment of enlightenment were thought to be a constituent element of the *dharmakāya* in late Mahāyāna Buddhism. A relationship was posited between the sixty-two-deity maṇḍala of Saṃvara and the thirty-seven prerequisites for the attainment of enlightenment because the former was meant to symbolize the *dharmakāya* of the Buddha.

Maṇḍalas consisting of thirty-seven principal deities began with the Vajradhātu-maṇḍala, and many examples are found among maṇḍalas of late tantric Buddhism, particularly in the Mother tantras. However, in the *Sarvatathāgatatattvasaṃgraha* itself there is no interpretation that associates the thirty-seven deities of the Vajradhātu-maṇḍala with the thirty-seven prerequisites for the attainment of enlightenment. Instead, in Yoga tantras such as the *Sarvatathāgatatattvasaṃgraha* and in the Guhyasamāja cycle the seven categories into which the thirty-seven prerequisites for the attainment of enlightenment are divided are assigned

SEVEN CATEGORIES			GODDESSES
Four foundations of mindfulness	1. *kāyānusmṛtyupasthāna*	Wheel of great bliss	2. Ḍākinī
	2. *vedanānusmṛtyupasthāna*		3. Lāmā
	3. *cittānusmṛtyupasthāna*		4. Khaṇḍarohā
	4. *dharmānusmṛtyupasthāna*		5. Rūpiṇī
Four right efforts	5. *prahāṇaprahāṇa*	Wheel of the pledge	34. Yamadāhī
	6. *saṃvaraṇaprahāṇa*		35. Yamadūtī
	7. *anurakṣaṇaprahāṇa*		36. Yamadaṃṣṭrī
	8. *bhāvanāprahāṇa*		37. Yamamathanī
Four supernatural powers	9. *chanda-ṛddhipāda*	Wheel of the mind	6. Pracaṇḍā
	10. *vīrya-ṛddhipāda*		7. Caṇḍākṣī
	11. *citta-ṛddhipāda*		8. Prabhāvatī
	12. *mīmāṃsā-ṛddhipāda*		9. Mahānāsā
Five faculties	13. *śraddhendriya*		10. Vīramatī
	14. *vīryendriya*		11. Kharvarī
	15. *smṛtīndriya*		12. Laṅkeśvarī
	16. *samādhīndriya*		13. Drumacchāyā
	17. *prajñendriya*	Wheel of speech	14. Erāvatī
Five powers	18. *śraddhābala*		15. Mahābhairavā
	19. *vīryabala*		16. Vāyuvegā
	20. *smṛtibala*		17. Surābhakṣī
	21. *samādhibala*		18. Śyāmadevī
	22. *prajñābala*		19. Subhadrā
Seven prerequisites for the attainment of enlightenment	23. *smṛtisaṃbodhyaṅga*	Wheel of the body	25. Cakravarmiṇī
	24. *dharmapravicayabodhyaṅga*		24. Śauṇḍinī
	25. *vīryasaṃbodhyaṅga*	Wheel of speech	21. Khagānanā
	26. *prītisaṃbodhyaṅga*	Wheel of the body	22. Cakravegā
	27. *praśrabdhisaṃbodhyaṅga*		23. Khaṇḍarohā
	28. *samādhisaṃbodhyaṅga*	Wheel of speech	20. Hayakarṇā
	29. *upekṣāsaṃbodhyaṅga*	Wheel of the body	26. Suvīrā
Noble eightfold path	30. *samyagvyāyāma*	Wheel of the pledge	32. Śvānāsyā
	31. *samyaksmṛti*		33. Śūkarāsyā
	32. *samyaksamādhi*	Main deity	1. Saṃvara
	33. *samyagdṛṣṭi*	Wheel of the body	27. Mahābalā
	34. *samyaksaṃkalpa*		28. Cakravartinī
	35. *samyagvag*		29. Mahāvīryā
	36. *samyakkarmānta*	Wheel of the pledge	30. Kākāsyā
	37. *samyagājīva*		31. Ulūkāsyā

not to deities constituting the maṇḍala but to parts of the maṇḍala, such as the eaves of the pavilion (Tib. *khyams*), the *toraṇa* (*rta babs*), and the gate door (*sgo khyud*).[700]

In the *Lüeshu jingangding yuga fenbie shengwei xiuzheng famen*, a ritual manual on the Vajradhātu-maṇḍala, there occurs a passage that contrasts the thirty-seven prerequisites for the attainment of enlightenment of the (inferior) two vehicles with the thirty-seven deities of the Vajradhātu-maṇḍala of esoteric Buddhism.[701] Therefore an interpretation that linked the thirty-seven deities of the Vajradhātu-maṇḍala to the thirty-seven prerequisites for the attainment of enlightenment had already appeared in the middle of the eighth century when Amoghavajra returned to China from India, although it is doubtful whether such an interpretation existed in the *Sarvatathāgatatattvasaṃgraha* from the very outset.

In Sino-Japanese Buddhism the thirty-seven prerequisites for the attainment of enlightenment are regarded as a method of practice characteristic of Hīnayāna Buddhism, as in the above ritual manual, which associated them with the (inferior) two vehicles. In India, however, they were regarded as a basic method of Buddhist practice right down to the age of late Mahāyāna and tantric Buddhism, and via the Saṃvara cycle they were, moreover, incorporated into the maṇḍala theory of the *Kālacakratantra* to be discussed in the next chapter.

10. Other Maṇḍalas of the Mother Tantras

In this chapter I have surveyed maṇḍalas of the Mother tantras, a large-scale movement in late tantric Buddhism, focusing mainly on the *Samāyoga*, *Hevajra*, and *Saṃvara*. The *Mitra brgya rtsa* maṇḍala set, indicative of the final phase of the maṇḍala in India, includes 110 maṇḍalas in total (according to the Hahn Foundation handscroll),[702] and fifty of them belong to the Mother tantras. This is eloquent testimony to the prevalence of the Mother tantras in the last phase of tantric Buddhism. Among these fifty maṇḍalas, twelve belong to the Hevajra cycle in a broad sense,[703] twenty belong to the Saṃvara cycle, and only one, an eighteen-deity Hayagrīva-Padmanarteśvara-maṇḍala (M-63), is related to the Samāyoga cycle.[704]

The Samāyoga cycle is thought to have declined after the appearance of the *Hevajra* and *Saṃvara*, although the traditions of the *Samāyoga* still existed as late as the eleventh century, since it is referred to in the *Saṃpuṭa*, an explanatory tantra on both the *Hevajra* and the *Saṃvara*, and in the *Vajraḍākatantra*, an explanatory tantra on the *Saṃvara*. But by the late twelfth century when Mitrayogin appeared, the *Samāyogatantra* had become history.

Sanskrit manuscripts of the Mother tantras and their ritual manuals—other than those of the above three cycles—are preserved mainly in Nepal. The *Vajrāvalī* and the *Mitra brgya rtsa* maṇḍala set include four maṇḍalas based on the *Vajrāmṛtatantra*, three based on the *Mahāmāyātantra*, two based on the *Catuṣpīṭhatantra*, and two based on the *Buddhakapālatantra*.

The *Vajrāmṛtatantra* is classified among tantras of the Vajrasūrya family among the six families of the Mother tantras. The four above-mentioned maṇḍalas (V-27–30), collectively called "four kinds of Vajrāmṛta" and consisting of the Vajrāmṛta-maṇḍala and three variant forms, are included in the *Vajrāvalī*, but none of them are explained in the *Abhisamaya-muktāmālā* by Mitrayogin. Therefore it is questionable just how popular the *Vajrāmṛta-tantra* was in late Indian tantric Buddhism.

The *Mahāmāyātantra* describes a six-deity maṇḍala included in the *Vajrāvalī* (V-33) as

well as a five-deity maṇḍala (M-60) and single-deity maṇḍala (M-61) described in the *Abhisamayamuktāmālā*, together known as the large, medium, and small versions in Tibet.[705] They have a simple structure consisting of five families and contain nothing new in terms of maṇḍala theory. The *Mahāmāyātantra* is said to be characterized by the extreme simplification of visualization procedures,[706] and this is matched by the structure of its maṇḍala.

The *Catuṣpīṭhatantra* is classified as a tantra belonging to the Vairocana family among the six families of the Mother tantras. It is characterized by thanatology, such as omens of death and the transference of consciousness at the time of death.[707] It is the only text among tantras of the new tantric schools of Tibet to be mentioned in Tibetan manuscripts from Dunhuang, being mentioned in a manuscript from the late tenth century in the final years of Tibetan Buddhism in Dunhuang, presumably because it had been translated by Smṛti-jñānakīrti before the commencement of new translations by Rinchen Sangpo.

The *Vajrāvalī* and the *Mitra brgya rtsa* set include two maṇḍalas based on the *Catuṣpīṭhatantra*: a fifty-eight-deity maṇḍala of Yogāmbara (V-34) and a thirteen-deity maṇḍala of Jñānaḍākinī (V-35).[708] These two maṇḍalas differ in form and scale although both share the eight goddesses surrounding the main deity. A maṇḍala similar to the thirteen-deity maṇḍala of Jñānaḍākinī is explained in the *Saṃpuṭatantra* (III.ii), which would seem to have adopted it from the *Catuṣpīṭhatantra*, since the latter pre-dates the former and because of the eclectic nature of the former.

In Tibet the *Catuṣpīṭha* was frequently referenced as a textual source for the transference of consciousness (Tib. *'pho ba*) and so on, but it was far less popular than the *Hevajra* and *Saṃvara*. In Nepal, on the other hand, there have been transmitted Sanskrit manuscripts of the tantra and commentaries. Moreover, Yogāmbara, the tutelary deity based on this tantra, is worshiped as a deity enshrined in esoteric shrines, comparable in popularity to Saṃvara.[709] Thus the *Catuṣpīṭhatantra* could be said to have been somewhat underestimated in modern academic circles.

The *Buddhakapālatantra*, on the other hand, is a text that is thought to have been influenced by the Kāpālikas of Hinduism.[710] The two maṇḍalas included in the *Vajrāvalī* and the *Mitra brgya rtsa* set are a twenty-five-deity maṇḍala (V-31) and a nine-deity maṇḍala (V-32), and they differ considerably in the names of their attendant deities and in their shape.

These maṇḍalas of Mother tantras are characterized by a common structure in which the main deity is surrounded by four or eight goddesses. But the names of the attendant deities agree neither with the Hevajra and Saṃvara cycles nor among the various maṇḍalas themselves. Furthermore, the names of the attendants of the *Vajrāmṛta* belonging to the Vajrasūrya family and those of the *Catuṣpīṭha* belonging to the Vairocana family do not agree at all with those of the Vajrasūrya family and Vairocana family of the *Samāyogatantra*. Thus in contrast to the *Samāyoga* and the Hevajra cycle, we cannot determine the date of these tantras from the structure of their maṇḍalas.

The *Niṣpannayogāvalī* mentions the five buddhas as the lords of these female attendant deities, and the center and four cardinal directions of the courtyard of the maṇḍalas in the Hahn Foundation handscroll are painted in accordance with the body colors of the five buddhas corresponding to the female deities. From a historical point of view, however, the maṇḍalas of the Mother tantras came into existence independently.

The Vajrasattva-maṇḍala explained in the *Saṃpuṭatantra*, called "Saṃvara-Vajrasattva" in Tibet (V-18), has a central circle consisting of the same five buddhas and four buddha-mothers

as are found in the *Guhyasamāja*. In the second circle are the same eight goddesses, starting with Vajraraudrī, as appear in the Citta-Hevajra-maṇḍala (V-15). Thus the composition of this maṇḍala is eclectic in that appropriate deities have been adopted from earlier maṇḍalas. Part 3 of this tantra also describes several maṇḍalas.[711] A commentary on the *Saṃpuṭa*, the *Āmnāyamañjarī* by Abhayākaragupta, provides much interesting information about the philosophical interpretation of the maṇḍala.[712]

Chapter 1 of the *Vajraḍākatantra*, an explanatory tantra on the Saṃvara cycle, also explains a maṇḍala centered on Vajrasattva.[713] It resembles the Vajrasattva-maṇḍala of the *Saṃpuṭatantra* but it is not included in any maṇḍala set, and no examples have been found in Tibet or Nepal. Further investigation is needed to determine the order in which these two maṇḍalas centered on Vajrasattva appeared.

The *Ḍākārṇavatantra* is classified among the explanatory tantras on the Saṃvara cycle. Among maṇḍalas explained in this text, only the five-deity maṇḍala of Black Vārāhī (M-59) is included in the *Mitra brgya rtsa* set. This tantra also describes the Ḍākārṇavacakra-maṇḍala, an extremely large maṇḍala, consisting of three main sections (*tilakacakra*, *vajracakra*, and *hṛdayacakra*), which are further subdivided into a total of thirteen concentric circles. Several examples of this maṇḍala have survived in Tibet. It includes deities drawn not only from the *Hevajratantra* and *Saṃvaratantra*, the two main Mother tantras, but also from the *Guhyasamājatantra*, representative of the Father tantras.[714]

The *Ḍākārṇavatantra* is thought to be the most recent of the Mother tantras, and through an analysis of the Apabhraṃśa passages included in it, N. N. Chaudhuri proposed that it postdates the *Dohakośa*, thought to date from the twelfth century.[715] The suggestion is that this maṇḍala was created after the main scriptures of the later phase of tantric Buddhism had appeared, in order to integrate the content of these texts. Its structure, consisting of several concentric circles, has a close resemblance to the Kālacakra-mahāsaṃvara-maṇḍala to be discussed in the next chapter. Therefore it is thought to represent one stage in the development from the Mother tantras to the *Kālacakra*. However, if we adopt Chaudhuri's view, there is a possibility that the *Ḍākārṇava* was conversely influenced by the *Kālacakra*.

Thus among the various maṇḍalas belonging to the Mother tantras, there exist two types. Some of them have a different origin from the *Samāyoga*, Hevajra, and Saṃvara cycles, while others were created in order to integrate the deities of the principal maṇḍalas of late tantric Buddhism. It has been suggested that the *Saṃpuṭa* appeared no later than the middle of the eleventh century.[716] The *Ḍākārṇa* emerged most certainly after the eleventh century. Therefore the *Mahāmāyā*, *Catuṣpīṭha*, *Buddhakapāla*, and other texts had appeared before the tenth century, while the *Saṃpuṭa*, *Ḍākārṇava*, and so on appeared in the eleventh century or later, possibly even after the *Kālacakra*.

7. The Maṇḍala of the *Kālacakratantra*

1. The Origins and Dates of the *Laghutantra* and *Vimalaprabhā*

I NDIAN ESOTERIC BUDDHISM reached its final stage with the emergence of the *Kālacakratantra*. The *Kālacakratantra* was not only the last Buddhist scripture to appear in India but also represented the culmination of the development of Indian Buddhism over a period of 1,700 years. In this chapter, I shall survey the maṇḍala theory of this final stage of Indian esoteric Buddhism.

According to the root tantra quoted in the *Sekoddeśaṭīkā*, the Buddha expounded the *Śrīparamādibuddha*, the root tantra of the Kālacakra cycle, at the great stūpa of Dhānya(kaṭaka), present-day Amarāvatī in South India.[717] King Sucandra of Śambhala, an emanation of Vajrapāṇi, was present at this sermon and taught it to the people of Śambhala upon his return to his homeland.

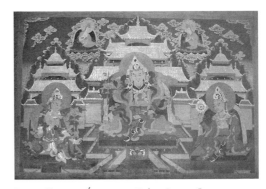

FIG. 7.1. KINGS OF ŚAMBHALA: YAŚAS, PUṆḌARĪKA, AND BHADRA (RAJA MONASTERY, QINGHAI)

Following his death, a line of six kings is said to have ruled Śambhala for a period of six hundred years, each king ruling for one hundred years. Then King Yaśas, Sucandra's seventh-generation descendant, foreseeing an impending crisis for Buddhism due to the establishment of Islam, edited the abridged version (*laghutantra*) of the root tantra for people living in the latter days of the Dharma. This corresponds to the *Kālacakratantra* circulating today in Nepal and Tibet. He also conferred on the people of Śambhala an initiation combining all the castes into a single Vajra caste. King Yaśas is known as *kalkin*, that is, a king who unites (*kalka*) the various tribes or castes into a single united group,[718] and the kings of Śambhala from Yaśas onward are also known as *kalkins*.

The commentary composed by Sucandra is said to have consisted of 60,000 verses. One of Yaśas's sons, King Puṇḍarīka, regarded as the second *kalkin*, composed a large commentary of 12,000 verses based on the root tantra and called the *Vimalaprabhā*.[719]

The current version of the *Kālacakratantra*, the *Laghukālacakratantra* of 1,047 verses in *sragdharā* meter, consists of five chapters: "Lokadhātupaṭala," "Adhyātmapaṭala," "Abhiṣekapaṭala," "Sādhanapaṭala," and "Pañcamapaṭala" (or "Jñānapaṭala").[720] Its Sanskrit is somewhat irregular and abnormal in comparison with the *Sarvatathāgatatattvasaṃgraha* and *Guhyasamājatantra*, which are written in standard Buddhist Sanskrit. The *Vimalaprabhā* attributes the grammatical irregularities of the *Kālacakratantra* to its Śambhala origins.[721] But they would suggest rather that the *Laghukālacakratantra* was composed by someone who was not proficient in Sanskrit composition.

The text of the *Vimalaprabhā*, on the other hand, can be read with a knowledge of standard Buddhist Sanskrit. In the *Śrīparamādibuddha*, the root tantra quoted in the *Vimalaprabhā*,

we cannot detect any grammatical irregularities such as are found in the *Laghukālacakra*. Therefore it is unlikely that the *Laghukālacakra* and *Vimalaprabhā* were composed by the same author.

There have existed two theories regarding the place of origin of the *Kālacakra*, namely, that it originated in either Central Asia or eastern India. According to the *Kālacakra*, Śambhala is located on the northern banks of the river Śītā, which is considered to be one of the four great rivers flowing out of Lake Manasarovar at the foot of Mount Kailash and has been frequently identified with the Amu Darya (Oxus) or Syr Darya in Central Asia, both of which flow into the Aral Sea. The *Kālacakratantra* explains that the area to the south of the river Śītā is the territory of Aryans. When the *Kālacakratantra* came into existence, the area to the north of the Syr Darya was inhabited by Turkic nomads, while Iranians, who were of Aryan stock, inhabited the area to the south.

The *Kālacakratantra* also explains the astronomical constants said to be measured in Śambhala. On the basis of these, Alexander Csoma de Kőrös calculated the latitude of Śambhala to lie between 45° N and 50° N. Some scholars have maintained, therefore, that Śambhala corresponds to Bokhara in Transoxiana, the latitude of which is roughly equivalent to that of Śambhala.

As for the theory of its eastern Indian origin, some scholars have identified Śambhala with Sambalpur in Orissa, since Cilūpa, one of the disseminators of the *Kālacakra*, is said to have taken refuge for a time from the Muslim invasions in Ratnagiri in Orissa. Sambal corresponds to Śambhala, since there was no phonetic distinction betweeen *śa* and *sa* in medieval eastern India. Moreover, Orissa is close to Amarāvatī, the place of origin of the root tantra, and Buddhists in both areas were in contact with one another.

When it comes to the date of composition of the *Kālacakra*, some scholars claim that it was brought to India from Śambhala in 967. This theory is said to be based on the *Kālacakrāvatāra* by Abhayākaragupta (1064–1125?), one of the leading authorities of Indian esoteric Buddhism. However, this date falls only one sexagenary cycle before the year of "fire, sky, and sea" (Tib. *me mkha' rgya mtsho* = 1027) when the Kashmirian scholar Somanātha first introduced the *Kālacakra* to Tibet. Hadano Hakuyū accordingly argued that it was actually composed in the eleventh century.[722]

In Tibet, on the other hand, Atīśa, who reached Tibet in 1042, is said to have introduced the *Kālacakra* for the first time. This is because his *Bodhipathapradīpa* mentions the *Śrīparamādibuddha* as the textual source of the prohibition against the use of female partners by monks in the secret and wisdom initiations of tantric Buddhism.[723] Hadano could not find any corresponding passage in the *Kālacakratantra*, and he thus concluded that it is wrong to suggest that Atīśa knew of the *Kālacakra*[724] and it was transmitted to Tibet after 1050 at the earliest.[725]

However, I discovered that in the *Sekoddeśaṭīkā*,[726] a ritual manual on initiation in the Kālacakra cycle, there is a rule according to which *bhikṣus* and *śrāmaṇeras*, who must take vows of celibacy, use a Caṇḍālī as their partner.[727] Generally speaking, a Caṇḍālī is a female belonging to the Caṇḍāla caste, but in this case it signifies *jñānamudrā*, or an ideal partner created by the practitioner's visualization.

Atīśa seems to have had this passage in mind, although it is not explicitly mentioned in the *Laghukālacakratantra* itself. Therefore by 1042 when Atīśa visited Tibet not only the

Laghukālacakra but also several related ritual manuals had already come into existence. This suggests that the *terminus ante quem* of the *Kālacakratantra* can be placed around 1042 CE.

The *Sekoddeśaṭīkā* is a ritual manual for initiation rites belonging to the Kālacakra cycle that is attributed to the great Indian adept Nāropa. Nāropa was the guru of Marpa, the founder of the Kagyü school of Tibetan Buddhism, and was active in the early eleventh century.[728] The *Sekoddeśaṭīkā* is to some degree related to chapter 3 of the *Vimalaprabhā*, with which it shares numerous passages. Therefore scholars who date the *Kālacakra* to the late eleventh century do not attribute the *Sekoddeśaṭīkā* to Nāropa. However, it is not surprising that Nāropa should have composed a text related to the *Kālacakra*, since his contemporary Atīśa knew of the existence of the *Śrīparamādibuddha*.

One of the main themes of the *Kālacakratantra* is the rallying of the traditional religions of India in order to confront the Muslim invasion. The organized invasion of India by Muslims began in 1001, when Sultan Mahmud of Ghazni (r. 998–1031) launched an invasion of northern India. Having as one of its themes resistance to the Muslim invasion, it is unlikely that the *Kālacakratantra* would have emerged in eastern India by 967, before Mahmud started his campaign. Central Asia, on the other hand, was already under the rule of Islamic régimes and Buddhism was on the brink of annihilation. If the date of the *Kālacakratantra* is as early as the tenth century, as suggested by Abhayākaragupta, this would be favorable to its Central Asian origins, but if it dates from the eleventh century, this would be favorable to its eastern Indian origins.

As regards the irregular Sanskrit of the *Laghukālacakratantra*, there is the interesting case of the Zoroastrians who fled from Persia when it came under Islamic rule. After their settlement in India, where they came to be known as Parsees, they composed religious texts in Sanskrit in order to adapt to Indian culture, and Okada Akinori has reported that irregular forms not found in Paninian grammar occur in their Sanskrit.[729]

Chapter 1 of the *Laghukālacakratantra* describes the rise of Islam, the decline of astronomy, and the introduction of the *laghukaraṇa*, a simple method for calculating an intercalary month. In ancient India the lunisolar calendar was used, whereas the Islamic calendar is a true lunar calender. In the Islamic calendar, the length of a year is determined only by the waxing and waning of the moon, and therefore the length of a year is about 354 days. When compared with a solar year of 365¼ days, this results in a discrepancy of more than ten days per year. The lunisolar calendar can make adjustments for such a discrepancy by adding an intercalary month at suitable intervals. However, the Islamic lunar calendar does not have any such system, and the start of the year moves from spring to winter, autumn, and summer in less than thirty years. The *Kālacakratantra* therefore explains the *laghukaraṇa* for calculating a suitable interval for inserting an intercalary month in areas where the Islamic calendar is used. But in eastern India the *laghukaraṇa* was not necessary, since a lunisolar calendar was in use up until the early thirteenth century when Buddhism went into decline in India. This fact, too, suggests that the *Kālacakratantra* came into existence in an area under Islamic rule or in a region neighbouring on such an area.

The place of origin and date of the *Kālacakratantra* need further consideration, but at present the following hypothesis may be the most probable. Namely, the *Laghukālacakratantra* was composed in Central Asia or northwest India under Islamic rule by Buddhists who were not proficient in Sanskrit grammar, and its commentary, the *Vimalaprabhā*,

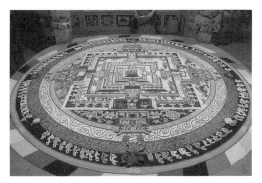

FIG. 7.2. SAND MAṆḌALA OF THE KĀLACAKRA-MAṆḌALA
(RAJA MONASTERY, QINGHAI)

FIG. 7.3. KĀYAVĀKCITTAPARINIṢPANNA-KĀLACAKRA-MAṆḌALA

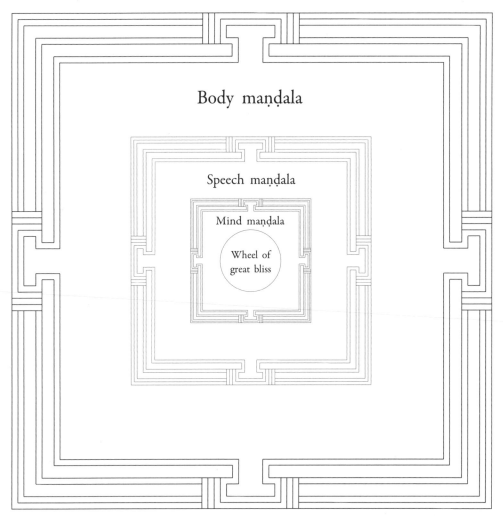

was compiled by scholar-paṇḍits after the *Laghutantra* had been brought to a Buddhist center in eastern India.

2. The Kāyavākcittapariniṣpanna-Kālacakra-maṇḍala

The *Kālacakratantra* explains two maṇḍalas, the Kāyavākcittapariniṣpanna-Kālacakra-maṇḍala and the Kālacakra-mahāsaṃvara-maṇḍala. The Kāyavākcittapariniṣpanna-Kalacakra-maṇḍala is the largest of all Buddhist maṇḍalas, consisting of three concentric squares symbolizing the body, speech, and mind of the Buddha.[730]

According to the *Vimalaprabhā*, maṇḍalas symbolizing the three mysteries are all square in shape. The maṇḍalas of body, speech, and mind are arranged from the outside inward, and the ratio of the lengths of one side of the squares is 4:2:1.[731] This type of threefold structure is also found in the sixty-two-deity maṇḍala of Cakrasaṃvara seen in chapter 6. However, the threefold structure of the Kāyavākcittapariniṣpanna-Kālacakra-maṇḍala has been greatly expanded so that each square has the appearance of an independent maṇḍala (see fig. 7.3).

In the center of the innermost Mind maṇḍala is the wheel of great bliss (*mahāsukha-*

cakra), circular in shape. Its diameter is half the length of one side of the Mind maṇḍala. On the pericarp of the eight-petaled lotus in the center of the wheel of great bliss Kālacakra, the main deity, is depicted together with his consort Viśvamātā as a father-mother couple.

On the four lotus petals in the cardinal directions surrounding the main deity are four goddesses—Kṛṣṇadīptā (east), Raktadīptā (south), Śvetadīptā (north), and Pītadīptā (west)—whose body colors each match that of the corresponding four buddhas, four continents, and four elements arranged in the four quarters of the Kālacakra-maṇḍala. A unique feature of the *Kālacakra* is that the deities are arranged not clockwise from east to south, west, and north but in the order east, south, north, and west.

On the four lotus petals in the intermediate directions surrounding the main deity are four goddesses—Dhūmā (southeast), Mārīcī (southwest), Khadyotā (northeast), and Pradīpā (northwest). These goddesses are named for the four visions that appear in the practice of night yoga, peculiar to the completion stage of the *Kālacakra*.[732] The above eight goddesses of the wheel of great bliss are considered to symbolize the vital airs (*prāṇa*) circulating in the human body.

In the square outside the lotus the four buddhas are depicted in the cardinal directions, while the four buddha-mothers are placed in the intermediate directions. These four buddhas and four buddha-mothers were inherited from the *Guhyasamāja*, but the directions and body colors of the four buddhas have changed considerably: Amoghasiddhi (east, black), Ratnasambhava (south, red), Amitābha (north, white), and Vairocana (west, yellow). The color scheme of the courtyard of the maṇḍala has also changed in accordance with the colors of the four buddhas and four faces of the main deity, Kālacakra, as follows: east (black) = Amoghasiddhi; south (red) = Ratnasambhava; west (yellow) = Vairocana; and north (white) = Amitābha.[733]

In a second square outside the above square there are six bodhisattvas and six adamantine goddesses who were introduced into the maṇḍala as deities symbolizing the six sense organs and six sense objects. These six bodhisattvas and six adamantine goddesses coincide with those of the Jñānapāda school of the *Guhyasamājatantra*.

In the four gates are four wrathful gatekeepers—Atibala (east), Jambhaka (south), Stambhaka (west), and Mānaka (north). Although they have different names from the gatekeepers of the *Guhyasamāja*, Atibala, Jambhaka, Stambhaka, and Mānaka correspond to Vighnāntaka (Amṛtakuṇḍalin), Prajñāntaka (Aparājita), Yamāntaka, and Padmāntaka (Hayagrīva) of the *Guhyasamāja*.

In this fashion, the wheel of great bliss in the Mind maṇḍala was influenced by the Mother tantras, while the surrounding squares show the influence of the Father tantras, particularly the Jñānapāda school (see fig. 7.4).

Outside the Mind maṇḍala is the Speech maṇḍala, with four gates. One side of the square of the Speech maṇḍala is twice as long as that of the Mind maṇḍala. In the four cardinal directions of the Speech maṇḍala are four red eight-petaled lotuses, and in the four intermediate directions are four white eight-petaled lotuses. There are thus eight eight-petaled lotuses in the Speech maṇḍala.[734] On the pericarp of these eight lotuses are eight mother-goddesses— Carcikā (east), Vaiṣṇavī (southeast), Vārāhī (south), Kaumārī (southwest), Aindrī (west), Brahmāṇī (northwest), Raudrī (north), and Lakṣmī (northeast). They are accompanied by their spouses, namely, Indra (east), Brahmā (southeast), Rudra (south), Gaṇeśa (southwest), Nairṛti (west), Viṣṇu (northwest), Yama (north), and Kārtikeya (northeast).

FIG. 7.4. KĀYAVĀKCITTAPARINIṢPANNA-KĀLACAKRA-MAṆḌALA (MIND MAṆḌALA)

Mother-goddesses are the consorts of Hindu deities. The *Vairocanābhisambodhisūtra* of the middle phase of esoteric Buddhism lists seven mother-goddesses as attendants in the Outer Vajra family of the Garbha-maṇḍala. The *Prajñāpāramitānayasūtra* increased their number to eight, but the eight mother-goddesses depicted in the Speech maṇḍala are closer to the traditions of Hinduism than to the eight mothers of the *Prajñāpāramitānayasūtra*.

In the "Jñānapaṭala" of the *Kālacakratantra*, the assignment of the deities of the Kālacakra-maṇḍala to the six families is explained.[735] According to this explanation, Raudrī and Lakṣmī are assigned to Amitābha (water), Carcikā and Vaiṣṇavī to Amoghasiddhi (wind), Vārāhī and Kaumārī to Ratnasambhava (fire), and Aindrī and Brahmāṇī to Vairocana (earth). Thus the arrangement of the eight mother-goddesses in the Speech maṇḍala is based on the assignment of the four elements (earth, water, fire, and wind) to the four cardinal directions peculiar to the *Kālacakra*.

In the Speech maṇḍala the eight mother-goddesses form couples with male gods who are different from their original spouses. This seems to be an application of a principle of the

Kālacakra, according to which male and female deities belonging to the same family do not form couples. In the case of buddhas and buddha-mothers, deities of the Wisdom family form couples with deities of the Space family, deities of the Earth family with deities of the Wind family, and deities of the Fire family with deities of the Water family. However, this rule is not always applied to the male and female deities in the Speech maṇḍala.[736]

The attendant goddesses of the mother-goddesses arranged on the eight petals of each lotus are collectively known as the sixty-four *yoginīs*. The sixty-four *yoginīs* are also found in Hindu tantras, but their names differ.[737]

The next square beyond the Speech maṇḍala is the Body maṇḍala, with four gates. One side of the square of the Body maṇḍala is twice as long as that of the Speech maṇḍala. In the Body maṇḍala there are twelve triple lotuses, the first circle of petals of which has four petals, the second eight, and the third sixteen, making a total of twenty-eight petals. The eight twenty-eight-petaled lotuses in the four directions are red, while the four in the four corners are white,[738] and they symbolize the twelve months of the year.

On the pericarps of the twelve twenty-eight-petaled lotuses are depicted twelve Hindu deities together with their consorts: Nairṛti (left of the eastern gate, month of Caitra), Vāyu (southeast, Vaiśākha), Yama (right of the southern gate, Phālguna), Agni (left of the southern gate, Jyeṣṭha), Ṣaṇmukha (southwest, Āṣāḍha), Kubera (right of the western gate, Pauṣa), Śakra (left of the western gate, Āśvina), Brahmā (northwest, Kārtika), Rudra (right of the northern gate, Mārgaśīrṣa), Samudrā (left of the northern gate, Śrāvaṇa), Gaṇeśa (northeast, Bhādrapada), and Viṣṇu (right of the eastern gate, Māgha).

In India, gods introduced by the Aryans had been worshiped since the time of the Vedas. After the rise of Hinduism, centered on Śiva and Viṣṇu, other deities lost their status as supreme gods and became protectors of directions (*dikpāla*) under a supreme god. Their most common allocation to the directions is as follows: Indra (east), Agni (southeast), Yama (south), Nairṛti (southwest), Varuṇa (west), Vāyu (northwest), Kubera (north), and Īśāna (northeast). In Buddhism, these are collectively known as the "gods of the eight directions." If we add Brahmā (top) and Pṛthivī or the Earth goddess (bottom), they become the "gods of the ten directions." In Japanese esoteric Buddhism the most popular set of protective deities is the Twelve Gods, with the addition of Sūrya and Candra to the gods of the ten directions. In India, however, the gods of the eight directions and ten directions are the most common.

If we compare the twelve deities in the Body maṇḍala with the gods of the eight directions, both roughly coincide, except that Varuṇa has been replaced by Samudrā, who has a similar function, and Indra and Īśāna are referred to by their epithets Śakra and Rudra, respectively. Further, deities not included among the gods of the eight and ten directions and added in the Body maṇḍala are Ṣaṇmukha (i.e., Kumāra), Gaṇeśa, and Viṣṇu. The *Kālacakra* thus adopted anew some popular deities of Hinduism who were worshiped in India throughout the medieval period.

In this fashion, the Body maṇḍala adopted the system of protectors of directions and added the new symbolism of the twelve months of the year. On the lotuses symbolizing the twelve months, the male deity symbolizes the day of the new moon while his consort symbolizes the day of the full moon of the corresponding month.[739] On the surrounding twenty-eight petals are arranged twenty-eight goddesses whose names are combinations of vowels and consonants based on the phonological theory of the *Kālacakratantra*. One month generally consists of thirty days, since the Kālacakra calendar is a lunisolar calendar,[740] and the

twenty-eight goddesses on the surrounding petals are said to symbolize the other days of the month.[741]

Inside the four gates and at the top and bottom of the Body maṇḍala are six wrathful deities—Nīladaṇḍa (eastern gate), Ṭakkirāja (southern gate), Acala (northern gate), Mahābala (western gate), Uṣṇīṣa(cakravartin) (top), and Sumbharāja (bottom). They ride on chariots and embrace their consorts, Mārīcī, Cundā, Bhṛkuṭī, Vajraśṛṅkhalā, Atinīlā, and Raudrākṣī, respectively. These six wrathful deities correspond to the six deities in the intermediate directions and at the top and bottom among the ten wrathful deities of the *Guhyasamāja*, but the names of their consorts differ from those given in the *Piṇḍīkrama* of the Ārya school. It is worth noting that Cundā, Bhṛkuṭī, and Vajraśṛṅkhalā coincide with three of the four female bodhisattvas mentioned in the *Māyājālatantra*. This fact suggests that the *Kālacakratantra* bypassed the *Guhyasamāja* and referred directly to the *Māyājāla*.

Apart from these deities, many other *nāga* kings and offering goddesses are depicted as well, and the total number of deities in the Kāyavākcittapariniṣpanna-Kālacakra-maṇḍala is said to be 634, 714, or 722.

Furthermore, outside the maṇḍalas of the three mysteries are depicted the wheels of the four elements, which form the base of the world system centered on Mount Sumeru, and Sanskrit syllables and heavenly bodies such as the sun and moon are depicted on them. This arrangement suggests that the *Kālacakratantra* has close connections with phonology and cosmology.

3. The Kālacakra-mahāsaṃvara-maṇḍala

The Kālacakra-mahāsaṃvara-maṇḍala, which represents the doctrines of the *Kālacakra* by means of a structure resembling the Saṃvara-maṇḍala, is based on vv. 25–28 of the "Jñānapaṭala," the fifth chapter ("Pañcamapaṭala") of the *Kālacakratantra*.[742]

This maṇḍala is circular in shape and has eight gates in contrast to an ordinary maṇḍala, which is square and has four gates.[743] On the pericarp of the sixteen-petaled multicolored lotus at the center of the maṇḍala, Kālacakra accompanied by his consort Viśvamātā is depicted as the main deity. On the eight lotus petals surrounding the main deity are the same eight goddesses as in the wheel of great bliss of the Kāyavākcittapariniṣpanna-Kālacakra-maṇḍala.

Outside the wheel of great bliss are six concentric circles called, starting from the innermost circle, wheel of the wisdom element (*jñānadhātu-cakra*), wheel of the earth element (*pṛthvīdhātu-cakra*), wheel of the water element (*toyadhātu-cakra*), wheel of the fire element (*tejodhātu-cakra*), wheel of the wind element (*vāyudhātu-cakra*), and wheel of the space element (*ākāśadhātu-cakra*). Thus this maṇḍala represents the theory of six elements, characteristic of the *Kālacakra*, by means of six concentric circles.

These wheels of the six elements are colored as follows: the spokes of the wheel of the wisdom element are blue and its ground is green; the spokes of the wheel of the earth element are yellow and its ground is black; the spokes of the wheel of the water element are white and its ground is red; the spokes of the wheel of the fire element are red and its ground is white; the spokes of the wheel of the wind element are black and its ground is yellow; and the spokes of the wheel of the space element are green and its ground is blue.[744] It seems that the spokes have the color of the corresponding element, while the ground has the color of the element that has a spousal relationship with the corresponding element.[745]

FIG. 7.5. KĀLACAKRA-MAHĀSAMVARA-MANDALA

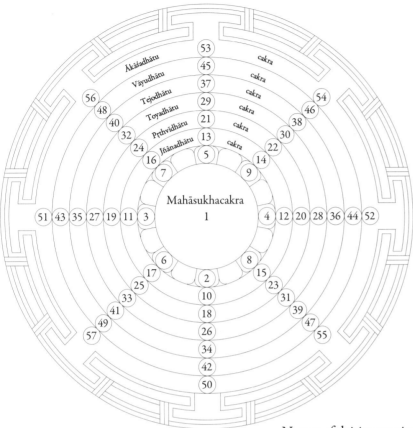

Names of deities are given in fig. 7.6.

On the six concentric wheels symbolizing the six elements, eight couples are arranged in the cardinal and intermediate directions of each wheel. These sixty-four couples bear names formed by combining vowels and consonants in accordance with the distinctive phonological theory of the *Kālacakratantra*.[746] According to the phonology of the *Kālacakratantra*, the five guttural consonants (*k, kh, g, gh, ṅ*) correspond to space among the six elements, the five cerebral consonants (*ṭ, ṭh, ḍ, ḍh, ṇ*) correspond to fire, the five dental consonants (*t, th, d, dh, n*) correspond to earth, the five labial consonants (*p, ph, b, bh, m*) correspond to water, the five palatal consonants (*c, ch, j, jh, ñ*) correspond to wind, and the sibilants (*ś, ṣ, s*) correspond to the wisdom element. The goddesses on the wheels of the six elements have seed-syllables that combine four consonants (apart from nasals) of the six families with the four vowels *i, u, ṛ*, and *ḷ* (four cardinal directions) or the corresponding long vowels *ī, ū, ṝ*, and *ḹ* (four intermediate directions). Because there are only three sibilants, the letter χ (*jihvāmūlīya*), which does not exist in the Sanskrit syllabary, was added to make four consonants.

In the case of male deities, the spouses of the goddesses, their seed-syllables have a voiced aspirate consonant of the same family if the goddess's consonant is a voiceless nonaspirate, a voiced nonaspirate if the goddess's consonant is a voiceless aspirate, a voiceless aspirate if the goddess's consonant is a voiced nonaspirate, and a voiceless nonaspirate if the goddess's consonant is a voiced aspirate, and these are combined with the four vowels *i, u, ṛ*, and *ḷ*

FIG. 7.6. NAMES OF DEITIES IN THE KĀLACAKRA-MAHĀSAMVARA-MANDALA

	Name	Spouse		Name	Spouse
Main deity	1. Kālacakra	Viśvamātā			
Wheel of great bliss (*mahāsukha-cakra*): four cardinal directions	2. Kṛṣṇadīptā		Wheel of great bliss (*mahāsukha-cakra*): four intermediate directions	6. Dhūmā	
	3. Raktadīptā			7. Marīcī	
	4. Śvetadīptā			8. Khadyotā	
	5. Pītadīptā			9. Pradīpā	
Wheel of the wisdom element (*jñānadhātu-cakra*)	10. Śivajrā	SĪvajra	Wheel of the fire element (*tejodhātu-cakra*)	34. Ḍhivajrā	ṬĪvajra
	11. Ṣrvajrā	χūvajra		35. Ḍrvajrā	Ṭhūvajra
	12. χuvajrā	Ṣṛvajra		36. Ṭhuvajrā	Ḍṛvajra
	13. Slvajrā	Śīvajra		37. ṬĮvajrā	Ḍhīvajra
	14. SĪvajrā	Śivajra		38. ṬĪvajrā	Ḍhivajra
	15. χūvajrā	Ṣrvajra		39. Ṭhūvajrā	Ḍṛvajra
	16. Ṣṛvajrā	χuvajra		40. Ḍĭvajrā	Ṭhuvajra
	17. Śīvajrā	Slvajra		41. Ḍhīvajrā	ṬĮvajra
Wheel of the earth element (*pṛthvīdhātu-cakra*)	18. Dhivajrā	TĪvajra	Wheel of the wind element (*vāyudhātu-cakra*)	42. Jhivajrā	CĪvajra
	19. Dṛvajrā	Thūvajra		43. Jṛvajrā	Chūvajra
	20. Thuvajrā	DĪvajra		44. Chuvajrā	JĪvajra
	21. TĮvajrā	Dhīvajra		45. CĮvajrā	Jhīvajra
	22. TĪvajrā	Dhivajra		46. CĪvajrā	Jhivajra
	23. Thūvajrā	Dṛvajra		47. Chūvajrā	Jṛvajra
	24. DĪvajrā	Thuvajra		48. JĪvajrā	Chuvajra
	25. Dhīvajrā	TĮvajra		49. Jhīvajrā	CĮvajra
Wheel of the water element (*toyadhātu-cakra*)	26. Bhivajrā	PĪvajra	Wheel of the space element (*ākāśadhātu-cakra*)	50. Ghivajrā	KĪvajra
	27. Brvajrā	Phūvajra		51. Grvajrā	Khūvajra
	28. Phuvajrā	BĪvajra		52. Khuvajrā	GĪvajra
	29. PĮvajrā	Bhīvajra		53. KĮvajrā	Ghīvajra
	30. PĪvajrā	Bhivajra		54. KĪvajrā	Ghivajra
	31. Phūvajrā	Brvajra		55. Khūvajrā	Grvajra
	32. BĪvajrā	Phuvajra		56. GĪvajrā	Khuvajra
	33. Bhīvajrā	PĮvajra		57. Ghivajrā	KĮvajra

(four cardinal directions) or the corresponding long vowels *ī, ū, ṝ,*and *ḹ* (four intermediate directions).

Male and female deities named after seed-syllables that combine a consonant and a vowel are also found among the deities symbolizing the days of the twelve months in the Body maṇḍala of the Kāyavākcittapariniṣpanna-Kālacakra-maṇḍala. However, it is worth noting that in this maṇḍala they are arranged on the wheels of the six elements, the core of the maṇḍala.

Thus the Kālacakra-mahāsaṃvara-maṇḍala has a structure resembling the sixty-two-deity maṇḍala of Cakrasaṃvara, which has a fivefold structure consisting of the wheels of great bliss, mind, speech, body, and pledge. However, the fivefold structure of the sixty-two-deity maṇḍala of Cakrasaṃvara is related to the five buddhas or five families, whereas the sixfold structure of the Kālacakra-mahāsaṃvara-maṇḍala is interpreted in accordance with the theory of the six elements of earth, water, fire, wind, space, and wisdom, the basis of the *Kālacakra* system. Therefore in contrast to the Kāyavākcittapariniṣpanna-Kālacakra-maṇḍala, the culmination of the maṇḍala theory of the *Kālacakra*, this maṇḍala has eliminated all extraneous elements to illustrate succinctly the basic system of the *Kālacakra*.

Although the Kālacakra-mahāsaṃvara-maṇḍala is included in the Ngor maṇḍalas,[747] there are few exemplars of this maṇḍala when compared with the Kāyavākcittapariniṣpanna-Kālacakra-maṇḍala. Among these exemplars, that described by B. C. Olschak[748] is notable as a fine work datable to the fifteenth century.

4. The Synthesis of the Maṇḍala Theory of the Father Tantras

The *Kālacakratantra* was the culmination of the development of Indian Buddhism over a period of 1,700 years. In the "Adhyātmapaṭala" of the *Kālacakratantra*, maṇḍalas of the Father tantras, which preceded the *Kālacakra*, are mentioned in the following terms:

> The [maṇḍala of the] *Māyājāla* is of three kinds because of the division
> of the days: by the hole and the Veda properly;
> further, by the elements and oceans, and by the fire and oceans.
> The [maṇḍala of the *Guhya*]*samāja* has the differentiation of the seasons:
> that named "truth," that reduced by six, another divided by half of those two;
> further, that which is mixed has two kinds, of three plus ten and nine
> and directions, and that with the hole and the truth. (v. 52)[749]

The *Vimalaprabhā* comments as follows on this difficult verse:

> Now, starting with "*Māyājāla*" and so on, [regarding the number of deities,] there are three kinds and six kinds in the Kriyāyoga[750] and Yoga tantras. Three standard half-months are forty-five days, and one day is divided into twelve *lagnas*. Thus forty-five multiplied by twelve becomes 540, which corresponds to "the division of the days." Specified "by the division of the days," namely, 540, "the *Māyājāla* is of three kinds." One of them is "the hole (i.e., nine) and the Veda (i.e., four)," namely, forty-nine couples. "Further" means the second one, which is "the elements (i.e., five) and oceans (i.e., four)," which means forty-five couples. The other one is "the

fire (i.e., three) and oceans (i.e., four)," which means forty-three couples. The total of three kinds "by the division of the days" becomes 137. The number of male and female deities becomes twice this, namely, 274. This is an established theory regarding the *Māyājāla*. Details of it will be explained in the fifth chapter. This is an established theory regarding the *Māyājāla*, a Kriyāyoga tantra.

Now the differentiation of the six kinds of the *Guhyasamāja* is explained. Because of the remaining "division of the days" [apart from the *Māyājāla*], "the *Guhyasamāja* has the differentiation of the seasons (i.e., six)." "That named truth" has twenty-five deities—there are twenty-five couples specified by "the division of the days." Another view is nineteen deities, which are twenty-five "reduced by six," namely, nineteen deities. "Divided by half of those two" means the twenty-five and nineteen deities divided by half. Half of twenty-five is twelve and a half, and half of nineteen is nine and a half. If half is subtracted from here (i.e., nine and a half), it becomes nine deities. If half is added to twelve and a half, it becomes thirteen deities. "Further" means another view. "That which is mixed has two kinds" of *Samāja*. "Three plus ten" means thirteen deities. "Nine and directions (i.e., ten)" means nineteen deities. With these "three plus ten" and "nine and directions" there is the *Samāja* consisting of thirty-two couples. "Hole" means nine. "That with the truth (i.e., twenty-five)" means nine plus twenty-five, or thirty-four couples, which corresponds to the second *Samāja*. These are the six kinds of the *Samāja*.

In these six kinds of *tantrarājas*, 132 couples in all are expounded, and by doubling 132, the total number of male and female deities becomes 264. Thus in nine kinds of *tantrarājas*, namely, the (*Guhya*)*samāja* and *Māyājāla* (264 + 274), if the couple of the main deity is added, there are 540 deities in all, namely, "the division of the days." In these tantras there is a distinction depending on whether the aggregates, elements, sense fields, sun, moon, and feet have arisen or not. In the same way, in the fifth chapter it will be explained by means of the distinction between seats [of sun and moon discs]. This is an established theory regarding the Yoga tantras.

Here the arising of aggregates and elements in sentient beings born from an embryo is the nine-deity maṇḍala. In the same way, if the aggregates and elements arise in the *sahaja-*, *dharma-*, *sambhoga-*, and *nirmāṇa-cakra*, it becomes the thirteen-deity maṇḍala. In the same way, if the aggregates, elements, [four] cakras, and [six] sense objects arise, it becomes the nineteen-deity maṇḍala. If, in addition to the aggregates, elements, [four] cakras, and [six] sense objects, the six sense organs starting with the eyes arise, it becomes the twenty-five-deity maṇḍala. If, in addition to the aggregates, elements, [four] cakras, and [six] sense objects, the [six] sense organs, action organs, and lotuses in the genital organ and crown of the head arise, it becomes the thirty-two-deity maṇḍala. If, in addition to the aggregates, elements, six cakras, [six] sense objects, [six] sense organs, and action organs, the divine organ and joy enter, it becomes the thirty-four-deity maṇḍala. From conception to the age of sixteen there are six kinds of arising. This is an established theory regarding the *Guhyasamāja*, details of which will be explained in the fifth chapter.

In the same way, in the *Māyājāla* the aggregates and elements, the eight elements starting with downy hair, and the twelve sense fields together with the four cakras and six action organs accompanied by the accumulation of vital wind, bile, and phlegm become forty-three deities. If the lotuses of the crown of the head and genital organ are added, it becomes forty-five deities. With the further addition of greed, anger, foolishness, and pride, it becomes forty-nine deities. This is an established theory regarding the *Māyājāla*, details of which will be explained in the fifth chapter. This is an established theory regarding generation in the Yoginī and Yoga tantras.[751]

In this fashion, the "Adhyātmapaṭala" states that there are three kinds of Māyājāla-maṇḍalas, consisting of forty-nine, forty-five, and forty-three deities, and six kinds of Guhyasamāja-maṇḍalas, consisting of twenty-five, nineteen, nine, thirteen, thirty-two, and thirty-four deities.

As was explained in chapter 5, the Māyājāla-maṇḍala consists of forty-three deities: five buddhas, four buddha-mothers, four *pāramitā* goddesses, four female bodhisattvas, sixteen male bodhisattvas, and ten wrathful deities. Moreover, a forty-three-deity maṇḍala of Vairocana-Mañjuvajra (V-3) based on the *Māyājāla* is included in the *Vajrāvalī* and *Mitra brgya rtsa* sets. However, the *Niṣpannayogāvalī* mentions a variation with Uṣṇīṣacakravartin above the main deity, Sumbha further above Uṣṇīṣacakravartin, and the four buddha-mothers surrounding Uṣṇīṣacakravartin.[752] The forty-five-deity and forty-nine-deity maṇḍalas explained in the *Vimalaprabhā* would seem to correspond to these two maṇḍalas.

With regard to the *Guhyasamāja*, on the other hand, there are mentioned nine-deity, twenty-five-deity, and thirty-four-deity maṇḍalas in addition to the maṇḍala consisting of the thirteen basic deities, the nineteen-deity maṇḍala of the Jñānapāda school, and the thirty-two-deity maṇḍala of the Ārya school described previously in chapter 5. Among these, the nine-deity maṇḍala may be the five buddhas and four buddha-mothers, the core of the *Guhyasamāja*, while the twenty-five-deity maṇḍala seems to be the nineteen-deity of the Jñānapāda school plus the six wrathful deities of the four intermediate directions, top, and bottom, but the textual source of the thirty-four-deity maṇḍala is not clear. However, a thirty-three-deity maṇḍala, with one extra female deity, depicted on the northern wall of Dungkar Cave 1 and mentioned in chapter 5, may be related to this thirty-four-deity maṇḍala.

The *Vimalaprabhā* also links the differences in the numbers of deities to embryology,[753] the principal topic of the "Adhyātmapaṭala." This enables us to understand how the *Kālacakra* developed the *skandhadhātvāyatana* system of the Guhyasamāja cycle. In particular, the symbolism of the Māyājāla-maṇḍala gives a clue as to how the *Kālacakra* interpreted the *Māyājāla*, one of its principal precursors, since this symbolism is not clearly explained in the *Māyājāla* itself.

The *Vimalaprabhā* states that the reorganization of the maṇḍala theory of the *Guhyasamāja* and *Māyājāla* will be explained in the fifth chapter ("Jñānapaṭala"). This turns out to be v. 10 of the "Jñānapaṭala" and its commentary. The relevant passage reads as follows.

Now, inner purification of the mantra deities is explained "by the aggregates" (v. 10b) and so on. Here five deities are purified by the five "aggregates." Nine deities

are purified by the five aggregates and five "elements." With the addition of four "action organs," thirteen deities are purified. With the addition of the six sense organs, nineteen deities are purified. With the addition of the six sense objects, twenty-five deities are purified. With the addition of five action organs and a consort [iconographically] similar to oneself, thirty-two deities [are purified]. With the addition of the sixth action organ and its activity, thirty-four deities [are purified]. With the further addition of the sixth aggregate and sixth element, thirty-six deities [are purified]. Thus the six aggregates, six elements, six sense organs, six sense objects, six action organs, and their activities are the components (*dhātu*) of the maṇḍala deities (*māṇḍaleya*).[754]

The statement "Nine deities [are purified] by the five aggregates and five elements" assumes a nine-deity maṇḍala consisting of the five buddhas and four buddha-mothers. This also applies to the nine-deity maṇḍala of Hevajra described in chapter 6, since the four female deities in the four cardinal directions correspond to the four buddhas while those in the four intermediate directions correspond to the four buddha-mothers.

In the same way, "with the addition of four action organs, thirteen deities..." corresponds to the thirteen basic deities of the *Guhyasamāja* and other thirteen-deity maṇḍalas of the Father tantras, starting with that of Vajrabhairava. The four wrathful deities added in these maṇḍalas symbolize the action organs (*karmendriya*) such as the hands and feet. Next, "with the addition of the six sense organs, nineteen deities..." is thought to represent the nineteen-deity maṇḍala of Mañjuvajra of the Jñānapāda school, which added six adamantine goddesses to the thirteen basic deities, while "with the addition of five action organs and a consort (iconographically) similar to oneself, thirty-two deities..."[755] refers to the thirty-two-deity maṇḍala of Akṣobhyavajra of the Ārya school.

In this manner the *Kālacakratantra* not only created the Kāyavākcittapariniṣpanna-Kālacakra-maṇḍala on an unprecedented scale but also tried to reorganize various earlier maṇḍalas on the basis of a universal theory, the base of which was the *skandhadhātvāyatana* system, which assigned the deities of the *Guhyasamāja* and *Māyājāla* to the five aggregates, four elements, and twelve sense fields.

5. The Kālacakra-maṇḍala and the Thirty-Seven Prerequisites for the Attainment of Enlightenment

The *Kālacakratantra* thus reorganized the maṇḍala theory of the Father tantras on the basis of the *skandhadhātvāyatana* system. How, then, did the *Kālacakratantra* incorporate the thirty-seven prerequisites for the attainment of enlightenment, a maṇḍala theory of the Saṃvara cycle representative of the Mother tantras?

In the "Abhiṣekapaṭala," the deities of the Kālacakra-maṇḍala are assigned to the thirty-seven prerequisites for the attainment of enlightenment as follows (see fig. 7.7):

Now, the purification of *yoginīs* is explained. The Kālacakra clearly stated that "goddesses of light" (*devyo 'rcir*) (i.e., four) are the four foundations of mindfulness.
Prajñā is the mother of the prerequisites for the attainment of enlightenment. The others, namely, six goddesses beginning with Śabdavajrā, are, in the same

SEVEN CATEGORIES			GODDESSES
Four foundations of mindfulness	1. *kāyānusmṛtyupasthāna*	Four buddha-mothers	1. Locanā
	2. *vedanānusmṛtyupasthāna*		2. Pāṇḍarā
	3. *cittānusmṛtyupasthāna*		3. Māmakī
	4. *dharmānusmṛtyupasthāna*		4. Tārā
Four right efforts	5. *prahāṇaprahāṇa*	Eight mother-goddesses	5. Carcikā
	6. *saṃvaraṇaprahāṇa*		6. Vaiṣṇavī
	7. *anurakṣaṇaprahāṇa*		7. Maheśvarī
	8. *bhāvanāprahāṇa*		8. Mahālakṣmī
Four supernatural powers	9. *chanda-ṛddhipāda*		9. Brahmāṇī
	10. *vīrya-ṛddhipāda*		10. Aindrī
	11. *citta-ṛddhipāda*		11. Vārāhī
	12. *mīmāṃsā-ṛddhipāda*		12. Kaumārī
Five faculties	13. *śraddhendriya*	Ten wrathful consorts	13. Stambhī
	14. *vīryendriya*		14. Mārīcī
	15. *smṛtīndriya*		15. Jambhī
	16. *samādhīndriya*		16. Bhṛkuṭī
	17. *prajñendriya*		17. Raudrākṣī
Five powers	18. *śraddhābala*		18. Atinīlā
	19. *vīryabala*		19. Atibalā
	20. *smṛtibala*		20. Vajraśṛṅkhalā
	21. *samādhibala*		21. Mānī
	22. *prajñābala*		22. Cundā
Seven prerequisites for the attainment of enlightenment	23. *smṛtisaṃbodhyaṅga*	Six adamantine goddesses	23. Śabdavajrā
	24. *dharmapravicayabodhyaṅga*		24. Sparśavajrā
	25. *vīryasaṃbodhyaṅga*		25. Rūpavajrā
	26. *prītisaṃbodhyaṅga*		26. Gandhavajrā
	27. *praśrabdhisaṃbodhyaṅga*		27. Rasavajrā
	28. *samādhisaṃbodhyaṅga*		28. Dharmadhātuvajrā
	29. *upekṣāsaṃbodhyaṅga*		29. Vajradhātvīsvarī
Noble eightfold path	30. *samyagvyāyāma*	Eight female gatekeepers	30. Garuḍāsyā
	31. *samyaksmṛti*		31. Śūkarāsyā
	32. *samyaksamādhi*		32. Gṛdhrāsyā
	33. *samyagdṛṣṭi*		33. Śvānāsyā
	34. *samyaksaṃkalpa*		34. Kākāsyā
	35. *samyagvāg*		35. Vyāghrāsyā
	36. *samyakkarmānta*		36. Ulūkāsyā
	37. *samyagājīva*		37. Jambukāsyā

way, right efforts of the ocean (*abdhi*) (i.e., four) and supernatural powers of the ocean (*jaladhi*) (i.e., four).

The five wrathful [consorts] are powers while the [remaining] five [consorts] are certain to be the five faculties. (v. 167)

"*Devyo 'rciḥ*" and so on (v. 167): Here the four goddesses (i.e., four buddha-mothers) correspond to the four foundations of mindfulness: Locanā (in the west)[756] corresponds to mindfulness of the body, Pāṇḍarā (in the south) to mindfulness of sensation, Māmakī (in the north) to mindfulness of the mind, and Tārā (in the east) to mindfulness of dharmas, respectively. They are also *pīṭhas* and *upapīṭhas* owing to the distinctions of the body.[757] The *Kālacakra* "clearly stated," as above. That is to say, in other tantras it had not been stated clearly and had been kept secret by the Bhagavat. In the same way, one of the seven prerequisites for the attainment of enlightenment is the "mother," Vajradhātvīśvarī. She corresponds to Kulapīṭha and equanimity as a factor of enlightenment. "The others, namely, six goddesses beginning with Śabdavajrā, are, in the same way" means: mindfulness as a factor of enlightenment corresponds to Śabdavajrā, the investigation of dharmas as a factor of enlightenment to Sparśavajrā, and energy as a factor of enlightenment to Rūpavajrā. These four correspond to *upakṣetras* owing to the distinctions of the body.[758] In the same way, joy as a factor of enlightenment corresponds to Gandhavajrā, tranquility as a factor of enlightenment to Rasavajrā, and concentration as a factor of enlightenment to Dharmadhātuvajrā. There are two kinds of *kṣetras* (i.e., *upakṣetra* and *kṣetra*). In the same way, "right efforts of the ocean" means: Carcikā corresponds to right effort for the sake of the nonarising of evil that has not yet arisen, Vaiṣṇavī to right effort for the sake of the abandonment of evil that has already arisen, Moheśvarī to effort for the sake of the arising of good deeds that have not yet arisen, and Mahālakṣmī to right effort for the sake of the transference of good deeds that have arisen to enlightenment. The above-mentioned are the [four] *upacaṇḍohas*. "Supernatural powers of the ocean (i.e., four)" are the goddesses corresponding to the supernatural powers. In this case, Brahmāṇī is the supernatural power of intention, Aindrī is the supernatural power of energy, Vārāhī is the supernatural power of mind, and Kaumārī is the supernatural power of investigation. The above-mentioned are classified among the eight *chaṇḍohas*. In the same way, "the five wrathful [consorts] are powers" means: Atinīlā corresponds to the power of faith, Atibalā to the power of effort, Vajraśṛṅkhalā to the power of mindfulness, Mānī to the power of concentration, and Cundā to the power of wisdom. The above-mentioned are the [five] *upamelāpakas*. In the same way, "five [consorts] are certain to be the five faculties" means: Stambhī is the faculty of faith, Mārīcī is the faculty of effort, Jambhī is the faculty of mindfulness, Bhṛkuṭī is the faculty of concentration, and Raudrākṣī is the faculty of wisdom. Thus the *melāpakas* are ten.

O King! The noble eightfold path is assigned to eight demonesses.
The thirty-seven prerequisites for the attainment of enlightenment exist
 throughout the past, present, and future. (v. 168ab)

"O King! The noble eightfold path is assigned to eight demonesses" means: Śvānāsyā corresponds to right view, Kākāsyā to right thought, Vyāghrāsyā to right speech, Ulūkāsyā to right action, Jambukāsyā to right livelihood, Garuḍāsyā to right effort, Śūkarāsyā to right mindfulness, and Gṛdhrāsyā to right concentration.[759]

Thus the *Kālacakratantra* assigned the four buddha-mothers to the four foundations of mindfulness, the eight mother-goddesses (the principal deities of the Speech maṇḍala) to the four right efforts and four supernatural powers, the ten wrathful consorts to the five faculties and five powers, the six adamantine goddesses and Vajradhātvīśvarī, mother of the maṇḍala deities, to the seven factors of enlightenment, and the eight animal-headed female gatekeepers to the noble eightfold path.

The sixty-two-deity maṇḍala of Cakrasaṃvara consists of thirty-seven deities if the father-mother couples are counted as single deities, and these thirty-seven deities were assigned to the thirty-seven prerequisites for the attainment of enlightenment, which consist of seven categories: four foundations of mindfulness, four right efforts, four supernatural powers, five faculties, five powers, seven factors of enlightenment, and noble eightfold path. These include categories not divisible by four, that is, the five faculties, five powers, and seven factors of enlightenment. Therefore if these categories are assigned to the sixty-two-deity maṇḍala of Cakrasaṃvara, inconsistencies arise because deities in the same circle are assigned to different categories. In the *Kālacakra*, on the other hand, special care was taken to ensure that one category corresponds to one group of deities, and this shows a more advanced stage of development than the Saṃvara cycle.

In the thirty-six basic deities of the *Kālacakra* (see below), the numbers of male and female deities are the same, namely, eighteen. But the thirty-seven prerequisites for the attainment of enlightenment are all assigned to female deities. This suggests that the *Kālacakra* followed the Saṃvara cycle, in which female deities prevail.

As for the *pīṭha* theory, another characteristic of the Saṃvara cycle, the following correspondences are found: the four buddha-mothers correspond to *pīṭhas* and *upapīṭhas*, the six adamantine goddesses to *kṣetras* and *upakṣetras*, the eight mother-goddesses to *chaṇḍohas* and *upachaṇḍohas*, and the ten wrathful consorts to *melāpakas* and *upamelāpakas*. Furthermore, although it is not clear from vv. 167–168 quoted above, in v. 165 the eight animal-headed goddesses are assigned to charnel grounds (*śmaśāna*).

Thus the *Kālacakratantra* incorporated into its maṇḍala theory, with considerable improvements, not only the *skandhadhātvāyatana* theory of the Father tantras but also the thirty-seven prerequisites for the attainment of enlightenment and the *pīṭha* theory of the Saṃvara cycle, a representative Mother tantra.

6. The Synthesis of the Maṇḍala and Cosmology

The maṇḍala is considered to represent the Buddhist worldview, and Buddhist cosmology has two main aspects: a theory of five elements and a world system centered on Mount Sumeru. The former views the physical world from the perspective of its material causes, while the latter views it in relation to its shape and size. Esoteric Buddhism adopted the

theory of five elements and the world system centered on Mount Sumeru from an early stage, and the *Kālacakratantra* finally integrated these two theories into a single system. In this section I consider how the *Kālacakratantra*, the last tantric system to appear in India, synthesized the maṇḍala and cosmology.

The center and four cardinal directions of the courtyard in Tibetan and Nepalese maṇḍalas are painted in accordance with the body colors of the five buddhas who reside in the center and four directions of the maṇḍala (see fig. 8.3). The choice and arrangement of the five colors are not fixed and vary according to the maṇḍala. In maṇḍalas of the Yoga tantras, starting with the Vajradhātu-maṇḍala centered on Vairocana, the color scheme of the courtyard is as follows: center (white) = Vairocana, east (blue) = Akṣobhya, south (yellow) = Ratnasambhava, west (red) = Amitābha, and north (green) = Amoghasiddhi. These colors are determined by the color associated with the rite over which each of the five buddhas presides.

In Japan, on the other hand, the five buddhas are not generally differentiated by color. However, the *Zhufo jingjie shezhenshi jing* explains the body colors of the five buddhas as follows: center (white) = Vairocana, east (blue) = Akṣobhya, south (gold) = Ratnasambhava, west (red) = Amitābha, and north (multicolored) = Amoghasiddhi.[760] This coincides with the standard theory in Tibet, except for Amoghasiddhi's color, which has changed to multicolored. The commonly accepted theory in present-day Tibetan Buddhism is found in works by Buddhaguhya and Ānandagarbha, who both composed commentaries on the *Sarvatathāgatatattvasaṃgraha*. Therefore this theory is thought to have been established during the eighth to early ninth centuries when they were active.[761]

Maṇḍalas of late tantric Buddhism, on the other hand, starting with the *Guhyasamāja-tantra*, have Akṣobhya as their main deity, and the color scheme of the courtyard is as follows: center (blue) = Akṣobhya, east (white) = Vairocana, south (yellow) = Ratnasambhava, west (red) = Amitābha, and north (green) = Amoghasiddhi.[762] This is similar to the Vajradhātu-maṇḍala, except for the substitution of Akṣobhya for Vairocana as the main deity.

As mentioned earlier, the maṇḍala of the *Kālacakratantra* adopts an unprecedented color scheme: center (blue) = Akṣobhya, east (black) = Amoghasiddhi, south (red) = Ratnasambhava, west (yellow) = Vairocana, and north (white) = Amitābha. This change was made in order to integrate the maṇḍala and cosmology into a single system.

Many esoteric Buddhist paintings and manuscripts dating from the eighth to tenth centuries have been discovered in the Mogao Caves at Dunhuang.[763] An analysis of these materials has revealed that another theory regarding the body colors of the five buddhas was current in Dunhuang: center (yellow) = Vairocana, east (white) = Akṣobhya, south (blue) = Ratnasambhava, west (red) = Amitābha, and north (green) = Amoghasiddhi.[764] This theory of the body colors of the five buddhas is thought to have been determined in accordance with the colors of the four continents in the world system centered on Mount Sumeru: center (yellow) = Mount Sumeru, east (white) = Pūrvavideha, south (blue) = Jambudvīpa, west (red) = Aparagodānīya, and north (yellow/green) = Uttarakuru.

The *Abhidharmakośa* explains that Mount Sumeru is made of four precious metals (*caturatnamaya*), its four sides being made of gold (north), silver (east), lapis lazuli (*vaiḍūrya*) (south), and red quartz (west), respectively. The color of the side facing each of the four continents is said to be reflected in the sky of that continent. Therefore in the southern continent the color of the sky, reflecting the lapis lazuli of Mount Sumeru's south side, is blue.[765] In

the same way, it seems that the color of Uttarakuru came to be fixed as yellow or gold, that of Pūrvavideha as white, and that of Aparagodānīya as red.[766]

The *Abhidharmakośa* explains the shapes of the four continents as follows: Pūrvavideha is square, Jambudvīpa is triangular, Aparagodānīya is circular, and Uttarakuru is semicircular.[767] These shapes coincide exactly with those of the elements earth, fire, water, and wind. The *Abhidharmakośa* explains that the world system gradually evolved from the four elements after wind appeared out of space at the beginning of the eon, and the shapes of the four continents are considered to reflect the shapes of the four elements, the material causes of the world system.

Theories about the maṇḍala and the world system started to move toward consolidation in the late Yoga tantras. The Sarvatathāgata-trilokacakra-maṇḍala and Sarvatathāgata-maṇḍala explained in the *Trailokyavijayamahākalparāja* introduced a structure shaped like a world system centered on Mount Sumeru, while the Mahāyānābhisamaya-maṇḍala explained in the *Vajramaṇḍalālaṃkāratantra* introduced the shapes of the four elements into the Vajradhātu-maṇḍala. However, these Yoga tantras adopted the traditional theory regarding the body colors of the four buddhas, and consequently they could not unify the color scheme of the courtyard of the maṇḍala with that of the four continents in the world system centered on Mount Sumeru.

Thus the task of integrating the maṇḍala and cosmology was passed on to the *Kālacakratantra*. As mentioned above, the *Kālacakratantra* changed the arrangement and body colors of the five buddhas in accordance with their assignment to the five elements as follows: center (space, blue) = Akṣobhya, east (wind, black) = Amoghasiddhi, south (fire, red) = Ratnasambhava, west (earth, yellow) = Vairocana, and north (water, white) = Amitābha.

The scripture that assigned the five buddhas to the five elements for the first time was the *Vairocanābhisambodhisūtra*. The late Yoga tantras, on the other hand, assigned not the five buddhas of the Garbha-maṇḍala but those of the Vajradhātu-maṇḍala to the five elements. In particular, the assignment of the five buddhas to the five elements in the Mahāyānābhisamaya-maṇḍala of the *Vajramaṇḍalālaṃkāratantra* more or less coincides with the arrangement found in the *Kālacakratantra*.

In addition, the new translation of the *Māyājālatantra* explains the body colors of the five buddhas as follows: center (yellow) = Vairocana, east (blue) = Akṣobhya, south (red) = Ratnasambhava, west (white) = Amitābha, and north (green) = Amoghasiddhi. This coincides with the *Kālacakratantra*, except for Amoghasiddhi (who is black, according to the *Kālacakra*). The *Vajramaṇḍalālaṃkāratantra* and *Māyājālatantra* are closely related, and the former can be regarded as a precursor of the latter. Therefore the task of integrating the maṇḍala and the theory of the five elements is also thought to have been passed from the late Yoga tantras, starting with the *Vajramaṇḍalālaṃkāratantra*, through the *Māyājāla*, and to the *Kālacakratantra*.

The shapes of the four continents, meanwhile, are explained in v. 17 of the "Lokadhātu-paṭala" of the *Kālacakratantra*. This verse and its exposition in the *Vimalaprabhā* read as follows:

> O King! The east corresponds to wind and a half (i.e., a semicircle), the south
> is fire and a triangle,

the north is water and a full moon, the west is supreme golden earth and
the corners of the ocean (i.e., four).
Mount Sumeru is the shape of space. In the center of wheels, the earth made
of supreme vajra
is a rocky mountain, *nāga*, planets, and directions[768] of 1,000 *yojanas*. (v. 17)[769]

"The east corresponds to wind and a half" means that the eastern [continent] is
semicircular by the nature of wind. The southern [continent] is triangular by the
nature of fire. The northern [continent] is the shape of a full moon by the nature
of water. The western [continent] is the "corners of the ocean,"[770] namely, square.
Mount Meru in the center is the shape of a drop of water by the nature of the
wheel of space. Therefore it was explained that Mount Meru exists "in the center
of wheels, the earth (i.e., Mount Meru) made of supreme vajra."[771]

Thus the cosmology of the *Kālacakratantra* basically adopted the world system of the
Abhidharmakośa, but it changed the shape of Aparagodānīya to a square and that of Uttara-
kuru to a circle. Furthermore, this change in the shapes of the four continents is paralleled by
the above-mentioned correspondence between the five buddhas and five elements peculiar
to the *Kālacakratantra*.

The precious metals on the four sides of Mount Sumeru, on the other hand, are explained
in the *Kālacakratantra* in v. 169 of the "Jñānapaṭala." This verse and its exposition in the
Vimalaprabhā read as follows:

The king of all mountains has stainless sapphire in the east, ruby in the south,
yellow cat's-eye in the west, and white moonstone like the moon in the north.
It is dark green in the center, and in its core a large circle is hidden.
The first is the nature of the mind, and the nature of speech is two times larger
than the former. (v. 169)[772]

Now, the nature of Mount Sumeru in the world was explained before (in v.
169). [Mount Sumeru is] the "king of all mountains."[773] "In the east" means the
side that faces Pūrvavideha. It is "stainless sapphire" because it has the nature of
wind. It corresponds to the semivowel *ya* in the east among the four semivowels
ya, *ra*, *la*, and *va*.[774] The south is "ruby" because it has the nature of fire. The west
is "yellow cat's-eye" because it has the nature of the letter *la* (i.e., earth). The north
is "white moonstone like the moon" because it has the nature of the letter *va* (i.e.,
water). Thus it should be known that the four [semivowel] letters *ya*, *ra*, *la*, and
va are the four continents.[775]

Thus the *Kālacakratantra* also changed the precious metals on the four sides of Mount
Sumeru, with their colors becoming blue-black (east), red (south), yellow (west), and white
(north). It goes without saying that this color scheme coincides with the arrangement of the
five buddhas peculiar to the *Kālacakratantra* (see fig. 7.8).

In the Kāyavākcittapariniṣpanna-Kālacakra-maṇḍala, four circles symbolizing the four
elements—a black wind circle, a white water circle, a red fire circle, and a yellow earth

FIG. 7.8. COSMOLOGY OF THE KĀLACAKRA-MAṆḌALA

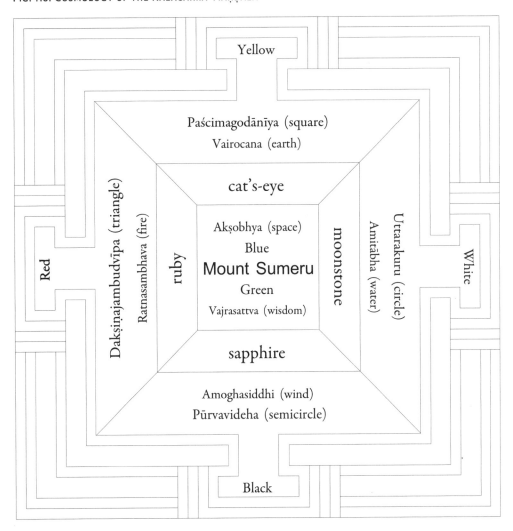

circle—are arranged from the outside inward. These four circles symbolize the process of the evolution of the physical world (*bhājanaloka*). Their size is explained in v. 11 of the "Lokadhātupaṭala" of the *Kālacakratantra*.

> From the end of the wind circle to its other end are the continents,
> rocky mountains, and oceans on the stable earth's surface.
> One quarter is 200,000 [*yojanas*]. The fire and wind circles are
> 200,000 *yojanas*.[776]

The *Vimalaprabhā* explains this difficult half-verse as follows:

"From the end of the wind circle to its other end" is 400,000 *yojanas*. From one end to the other end of the wind means from the east end to the west end. From the south end to the north end is also similar. "Are the continents, rocky mountains, and oceans on the stable earth's surface" means that in the wind circle there is the fire circle, circular in shape. In the same way, there is the water circle in the

fire circle, and there is the earth circle in the water circle. It (i.e., the earth circle) is nothing other than "the stable earth's surface." On it, six "continents," six "rocky mountains," and six oceans exist.[777] With the addition of the seventh water circle (saline ocean) they become seven oceans. With the addition of the seventh continent (Mahājambudvīpa) they become seven continents. With the addition of the adamantine mountain (Vajraparvata) they become seven mountains. The adamantine mountain is the fire from the mare's mouth (vāḍavāgni).[778] It rises horizontally on the edge of the saline ocean, namely, the water circle. The earth [circle] extends up to the end of Mahājambudvīpa, beneath which lies the saline ocean in all directions.

From the end of the saline ocean to its other end is "half" of 400,000 yojanas. "One quarter is 200,000" means that it is 200,000 yojanas from the center of Mount Meru to the edge of the saline ocean. That is to say, 100,000 yojanas on the right and on the left. In the east, west, northwest, southeast, southwest, and northeast is the same. "The fire and wind circles are 200,000 yojanas" means that from the water circle, namely, the saline ocean, there are 200,000 yojanas on the right and on the left. It means 100,000 yojanas on the right and on the left and in the north and in the other directions.[779]

Thus the wind circle among the circles of the four elements is 400,000 yojanas in diameter, and the circles of fire, water, and earth are 300,000, 200,000 and 100,000 yojanas across, respectively. The saline ocean spreading beyond Mahājambudvīpa corresponds to the water circle among the circles of the four elements.

The correspondences between this world system and the Kāyavākcittapariniṣpanna-Kālacakra-maṇḍala are explained in v. 9 of the "Sādhanapaṭala" as follows:

> In the Speech maṇḍala on the outside are the lotuses of Vasu (i.e., eight).
> They lack moons and suns.[780]
> In the four directions and corners further outside are the lotuses of
> Āditya (i.e., twelve). In the center of the gates there are chariots
> [for wrathful deities]....[781]

In its commentary on this verse, the *Vimalaprabhā* explains the correspondences between the world system and the Kāyavākcittapariniṣpanna-Kālacakra-maṇḍala as follows:

> The Mind maṇḍala extends up to the end of the earth circle. "The Speech maṇḍala on the outside" is up to the end of the ocean, namely, the water circle. It has "lotuses of Vasu," namely, eight lotuses, and "they lack moons and suns." The Body maṇḍala further outside extends up to the end of the wind circle. It has "lotuses of Āditya," namely, twelve lotuses, and they "lack moons and suns." In the four gates "there are chariots." Such a Body maṇḍala is 400,000 yojanas in diameter. The Speech maṇḍala is one half of that. The Mind maṇḍala is further one half of that. The wheel of great bliss is further one half of that. Further one half of that is the lotus throne of the glorious Kālacakra.[782]

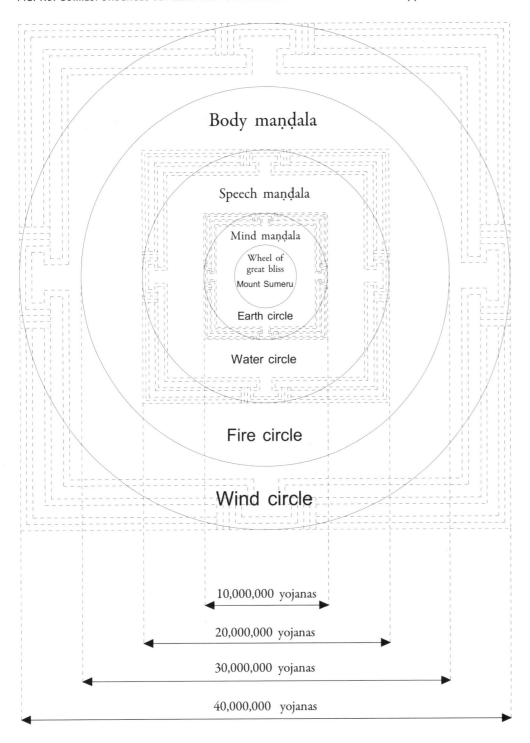

Thus the inner Mind maṇḍala among the maṇḍalas of the three mysteries corresponds to the inner earth circle among the four circles, the basis of the world system, while the Speech maṇḍala corresponds to the second water circle and the Body maṇḍala to the outermost wind circle. The diameters of the four circles are 100,000, 200,000, 300,000

and 400,000 *yojanas*, respectively. Therefore the ratio of the diameters of the circles of earth, water, and wind corresponds to the ratio of one side of the maṇḍalas of the three mysteries. Thus the world system centered on Mount Sumeru and the maṇḍala are iconometrically parallel (see fig. 7.9). Strictly speaking, the four circles and the maṇḍalas of the three mysteries should overlap, but they are placed outside the maṇḍalas for pictorial convenience.

The above examination makes it clear that the unique color scheme, the arrangement of the five buddhas, and their body colors in the Kālacakra-maṇḍala are meant to explain without any inconsistencies the theories of the five buddhas, five elements, and world system that had hitherto developed independently. With this cosmogram, the *Kālacakratantra* achieved the complete integration of the maṇḍala and cosmology with respect to color, shape, and iconometry.

7. The Development of the *Skandhadhātvāyatana* System and the Thirty-Six Basic Deities

The *Guhyasamājatantra*, by assigning its deities to traditional categories of Buddhism such as the five aggregates, four elements, and twelve sense fields, succeeded in representing the Buddhist worldview with a limited number of deities. This maṇḍala theory was known as *skandhadhātvāyatana* when the Saṃvara cycle appeared in India, and this *skandhadhātvāyatana* system was basically adopted by the *Kālacakratantra*.

As mentioned, the *Kālacakratantra* introduced the six-tathāgata system with the addition of Vajrasattva to the five buddhas. In this case, Vajrasattva is assigned to wisdom, in contrast to the five buddhas, who symbolize the five aggregates. The Saṃvara cycle assigned the five aggregates to the main deities of the six families of the *Samāyoga*. In this case Heruka, the sixth buddha ranking above the five buddhas, was assigned to all tathāgatas, or the totality of the five aggregates. The six-tathāgata system of the *Kālacakratantra* seems to have adopted this idea.

As for the buddha-mothers, the *Kālacakratantra* introduced six buddha-mothers with the addition of Vajradhātvīśvarī and Prajñāpāramitā to the existing four buddha-mothers symbolizing the four elements. Vajradhātvīśvarī is the female form of Vajradhātu-Vairocana in the *Sarvatathāgatatattvasaṃgraha*, but in late tantric Buddhism she is considered to symbolize space, the fifth element. Prajñāpāramitā is the deification of the *Prajñāpāramitāsūtra*, the basic scripture of Mahāyāna Buddhism. The *Kālacakratantra* assigned her to the Wisdom family over which Vajrasattva presides. Thus the number of buddha-mothers is six, the same as the number of buddhas, and this is more consistent with the six-family system of the *Kālacakratantra*.

The Vajradhātu-maṇḍala created a maṇḍala completely symmetrical, both horizontally and vertically, by arranging deities belonging to the five families in the center and four cardinal directions. However, it became difficult to maintain this symmetry when the five families developed into six families. Therefore in earlier Mother tantras six small maṇḍalas were arranged inside a large pavilion, as in the six-family maṇḍala of the *Samāyoga* and the Ṣaṭcakravartin-maṇḍala of the Saṃvara cycle. The Mother tantras were thus trying to find a way of arranging the six families inside the square pavilion of the maṇḍala. The *Kālacakratantra* solved this problem brilliantly by arranging the four buddhas in the four cardi-

FIG. 7.10. THIRTY-SIX BASIC DEITIES OF THE *KĀLACAKRATANTRA*

	NAME OF DEITY (*KĀLACAKRA*)	DOCTRINAL CATEGORY	NAME OF DEITY (*GUHYASAMĀJA*)
Six aggregates	1. Akṣobhya	*vijñāna*	1. Akṣobhya
	2. Vairocana	*rūpa*	2. Vairocana
	3. Ratneśa	*vedanā*	3. Ratnaketu
	4. Amitābha	*saṃjñā*	4. Amitābha
	5. Amoghasiddhi	*saṃskāra*	5. Amoghasiddhi
	6. Vajrasattva		
Six elements	7. Vajradhātvīsvarī	space	
	8. Locanā	earth	6. Locanā
	9. Māmakī	water	7. Māmakī
	10. Pāṇḍaravāsinī	fire	8. Pāṇḍaravāsinī
	11. Tārā	wind	9. Tārā
	12. Prajñāpāramitā	wisdom	
Six sense organs	13. Kṣitigarbha	eyes	Kṣitigarbha
	14. Vajrapāṇi	ears	Vajrapāṇi
	15. Khagarbha	nose	Ākāśagarbha
	16. Lokeśvara	tongue	Avalokiteśvara
	17. Sarvanīvaraṇaviṣkambhin	body	Sarvanīvaraṇaviṣkambhin
	18. Samantabhadra	mind	Samantabhadra
Six sense objects	19. Rūpavajrā	visible objects	10. Rūpavajrā
	20. Śabdavajrā	sound	11. Śabdavajrā
	21. Gandhavajrā	smell	12. Gandhavajrā
	22. Rasavajrā	taste	13. Rasavajrā
	23. Sparśavajrā	touch	14. Sparśavajrā
	24. Dharmadhātuvajrā	*dharmas*	15. Dharmadhātuvajrā
Six action organs	25. Sumbha	genital organ	Sumbha
	26. Uṣṇīṣacakravartin	urethra	Uṣṇīṣacakravartin
	27. Atibala	mouth	19. Vighnāntaka
	28. Jambhaka	hands	17. Prajñāntaka
	29. Mānaka	feet	18. Padmāntaka
	30. Stambhaka	anus	16. Yamāntaka
Activities of six organs	31. Raudrākṣī	emission of semen	
	32. Atinīlā	urination	
	33. Stambhakī	talking	
	34. Mānakī	holding	
	35. Jambhakī	walking	
	36. Atibalā	defecation	

nal directions and depicting the pair consisting of Kālacakra, an emanation of Akṣobhya, and Viśvamātā, an emanation of Vajrasattva, in the center.[783]

Furthermore, the *Kālacakratantra* introduced six wrathful deities and their wrathful consorts in addition to six great bodhisattvas, symbolizing the six sense organs, and six adamantine goddesses, symbolizing the six sense objects. These six wrathful deities had developed from the four wrathful deities and ten wrathful deities of the *Guhyasamājatantra*, but in the *Kālacakra* they were assigned to the six action organs, and the *Vimalaprabhā* assigned them to the six families.[784] According to the *Sekoddeśaṭīkā*, Sumbha is assigned to the genital organ, Aparājita (Jambhaka) to the hands, Uṣṇīṣacakravartin to the urethra, Yamāntaka (Stambhaka) to the anus, Amṛtakuṇḍalin (Atibala) to the mouth, and Hayagrīva (Mānaka) to the feet (see fig. 7.10).[785]

It may be noted that in the "Śiṣyapraveśavidhi" of the *Vimśatividhi* (12.47), which belongs to the Ārya school of the *Guhyasamājatantra*, it is explained that the wrathful kings (*krodhendra*) starting with Yamāri (i.e., Yamāntaka) should be assigned to the arms and so on.[786] In addition, the *Piṇḍikramaṭippaṇī*[787] and *Samājasādhanavyavastholi*[788] explain that the ten wrathful deities are assigned to parts of the body as follows: Yamāntaka is assigned to the right hand, Aparājita to the left hand, Hayagrīva to the mouth, Amṛtakuṇḍalin to the genital organ, Acala to the right arm, Ṭakkirāja to the left arm, Nīladaṇḍa to the right knee, Mahābala to the left knee, Uṣṇīṣacakravartin to the crown of the head, and Sumbha to both feet. The assignment of the four wrathful deities to parts of the body in the Jñānapāda school is not clear, but this kind of thinking developed into a theory that associated wrathful deities with action organs.

In extant examples of the Guhyasamāja-maṇḍala, the four or ten wrathful deities are, in many cases, depicted as father-mother couples, although neither the Ārya nor Jñānapāda schools count the wrathful consorts among the number of deities. However, the *Piṇḍikrama* (vv. 98–101) gives the names of the ten wrathful consorts and states that they should be installed in the same locations as their spouses.[789]

The *Kālacakratantra*, on the other hand, included among its thirty-six basic deities six wrathful consorts symbolizing the activities of the action organs (*karmendriyakriyā*). The concept of "action organ" is one on which greater importance is placed in the Sāṅkhya philosophy of Hinduism than in Buddhism, but the *Kālacakratantra* actively adopted this concept and assigned the action organs to the wrathful deities and their consorts.

As was already made clear in the *Vimalaprabhā*'s commentary on v. 10 of the "Jñānapaṭala" quoted in section 4 above, the *Kālacakra* makes much of the six aggregates, six elements, six sense organs, six sense objects, six action organs, and their activities as elements of the maṇḍala deities. Therefore in the *Kālacakratantra* the six buddhas, six buddha-mothers, six bodhisattvas, six adamantine goddesses, six wrathful deities, and their consorts, symbolizing these thirty-six elements, become the principal members of the maṇḍala (see fig. 7.10).

Most of these thirty-six deities are depicted in the Mind maṇḍala, the core of the Kāyavākcittapariniṣpanna-Kālacakra-maṇḍala. However, Akṣobhya, Vajrasattva, Prajñāpāramitā, and Vajradhātvīśvarī are depicted not as such but as a couple formed of Kālacakra, the main deity, and his consort, Viśvamātā. Furthermore, Uṣṇīṣacakravartin at the top and Sumbha at the bottom among the six wrathful deities are depicted not inside the maṇḍalas of the three mysteries but outside them.

There exist in Tibet, although few in number, examples of only the Mind maṇḍala having

been extracted from the Kāyavākcittapariniṣpanna-Kālacakra-maṇḍala to form an independent maṇḍala.[790] This suggests that some importance was attached to the thirty-six deities, the principal members of the Mind maṇḍala, in Tibet too.

It is clear that the thirty-six deities developed from the *skandhadhātvāyatana* system of the *Guhyasamājatantra*. Of the two schools of interpretation of the *Guhyasamājatantra*—the Ārya and Jñānapāda schools—the *Kālacakratantra* is closer to the Jñānapāda school than the Ārya school, since it adopted the six adamantine goddesses and six great bodhisattvas.

There existed a strong tradition of the Jñānapāda school in Vikramaśīla monastery, the main center of late tantric Buddhism. Abhayākaragupta, who was active mainly at Vikramaśīla, composed the *Vajrāvalī* and *Niṣpannayogāvalī*, which place the Mañjuvajra-maṇḍala of the Jñānapāda school of the *Guhyasamāja* at the very beginning and the Kāyavākcittapariniṣpanna-Kālacakra-maṇḍala at the end of the twenty-six maṇḍalas explained in these two works. This suggests that Abhayākaragupta regarded the lineage from the Jñānapāda school to the *Kālacakra* as the mainstream of late tantric Buddhism. The Smaller Kālacakrapāda, on the other hand, is said to have installed himself at Vikramaśīla and refuted the views of all paṇḍits who did not recognize the *Kālacakra*.[791] This story suggests that the central ideas of the *Kālacakra* were transmitted to Vikramaśīla from the outside and were then systematized at this monastery.

We perceive the external world with our sense organs and act upon it with our action organs. The *Kālacakratantra* further developed the maṇḍala theory of *skandhadhātvāyatana* that had emerged in the *Guhyasamāja* and added to it action organs and their activities. Thus the *Kālacakra* tried to represent the entire structure of the world that we experience. The thirty-six deities symbolizing these categories are generally depicted in the Mind maṇḍala, the core of the Kālacakra-maṇḍala. With these deities, the *Kālacakratantra* created a cosmogram symbolizing the world that we are experiencing.

8. Subject and Object in the *Kālacakratantra*

The *Kālacakratantra* was thus not only the last Buddhist scripture to appear in India but also represented the culmination of the development of Indian Buddhism over a period of 1,700 years. It also explained two maṇḍalas that were without precedent. That being so, what is the significance of the maṇḍala theory of the *Kālacakratantra* in the history of Buddhist doctrine?

Vajragarbha's commentary on the *Hevajratantra*, which is thought to have been transmitted by Cilūpa together with the *Vimalaprabhā*, explains a developed form of the *skandhadhātvāyatana* theory:

> Adamantine bodies are nondual, like the nature of wisdom and
> means (*prajñopāya*).
> Like the six aggregates and elements, sense objects and organs are [nondual]. (v. 37)
> Action organs and their activities are certainly nondual.
> It is established in the syllable *evaṃ* (symbolizing nonduality), the precept of
> all Buddhas. (v. 38)[792]

Vajragarbha's commentary thus explains that all of *skandhadhātvāyatana*, together with

the action organs and their activities assigned to male and female deities, are nondual. Further, in the *Vimalaprabhā*'s commentary on v. 20cd of the "Adhyātmapaṭala" it is clearly stated that the sense organs assigned to male bodhisattvas and the sense objects assigned to female adamantine goddesses stand in a relationship of object and subject, or "apprehended" and "apprehender" (*grāhyagrāhakasambandha*).

> Space apprehends sounds. The progenitor of the victors indeed [apprehends]
> the element of dharmas, and wind smell,
> fire form, water taste, and the sustainer tangible objects. (v. 20cd)

Now the relationship between the apprehended and the apprehender is explained. Here, by embracing another family, action comes into existence. Action does not come into existence in the case of embracing one's own family, since one acts upon oneself. Therefore embracing another family is the cause of the generation of the body. Thus the auditory organ born from the "space" element "apprehends sounds" born from the wisdom element. "The progenitor of the victors indeed" means that the mind organ born from the wisdom element indeed apprehends its object, "the element of dharmas" born from the space element. "Wind," that is to say, the olfactory organ born from wind on account of the nondual nature of the generated and the generator, apprehends smell born from the earth element. "And fire" means that the visual organ born from the fire element apprehends "form" born from the water element. "Water," that is to say, the gustatory organ born from the water element, apprehends taste born from the fire element. The body born from "the sustainer," namely, the earth element, apprehends tangible objects born from the wind element. This is an established theory regarding the characteristics of the apprehended (*grāhyagrāhakalakṣaṇa*), namely, object (*viṣaya*) and subject (*viṣayin*).[793]

Moreover, in its commentary on v. 30 of the "Adhyātmapaṭala," the *Vimalaprabhā* states that the action organs assigned to wrathful deities and their activities assigned to wrathful consorts stand in a relationship of object and subject (*viṣaya-viṣayin*).

> Ears and so on [apprehend] sound and so on. Others also apprehend on account of
> their own buddha's family the characteristics of speech and so on.
> Thus it should be known that female deities and buddhas are in a relationship of
> object and subject. (v. 30cd)

In the same way, "ears and so on" means sound is wisdom (female) and the ear is means (male); smell is wisdom and the nose is means; form is wisdom and the eye is means; taste is wisdom and the tongue is means; a tangible object is wisdom and the body is means; the realm of dharmas is wisdom and the mind is means; defecation is wisdom and the anus is means; walking is wisdom and the foot is means; holding is wisdom and the hand is means; talking is wisdom and the verbal faculty is means; urination is wisdom and the male or female organ is means; and emission of semen is wisdom and the genital organ is means.

grāhaka (subject)		grāhya (object)
six aggregates	twelve sense fields	six elements
	action organs and their activities	

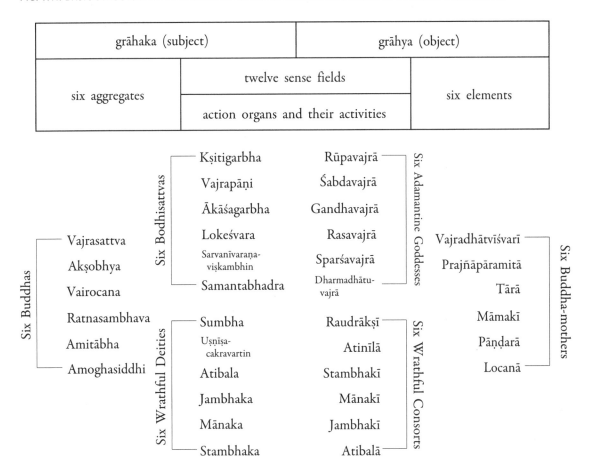

> "On account of their own buddha's family the characteristics of speech and
> so on" means owing to the action organs. "Thus" means by the aforementioned
> sequence, "female deities" means the earth (Locanā) and so on, "and buddhas"
> means that they are accompanied by Vairocana and others. They should be said
> to be in a relation of "object and subject" in the maṇḍala. This is an established
> theory regarding the mutual embracing of wisdom and means.[794]

The *Guhyasamājatantra* devised a system called *skandhadhātvāyatana* for symbolizing
all existents or the entire world by means of a limited number of deities representing the five
aggregates, or the components of the self, the four elements, or the material causes of the
physical world, the sense organs, and sense objects. The *Kālacakra* then added action organs
and their activities to *skandhadhātvāyatana*. In this case, male deities were assigned to the
subject (*viṣayin*) while female deities were assigned to the object (*viṣaya*) (see fig. 7.11). By
adding action organs and their activities to the maṇḍala theory of *skandhadhātvāyatana*,
the *Kālacakra* represented the world that we not only perceive but also act upon, that is, the
entire world that we are experiencing.

It had long been considered a basic tenet of the Yogācāra school that there is no dual-
ity of subject and object in the world of enlightenment, where false conceptualization has

disappeared. In esoteric Buddhism, too, as is shown by the Bodhicitta verse that was passed down from the *Vairocanābhisambodhisūtra* to the *Guhyasamāja*, it is clearly stated that there do not exist *skandhadhātvāyatana*, or subject and object, in ultimate truth.

Thus in Mahāyāna Buddhism the duality of subject and object is something that should be ultimately overcome. But for unenlightened beings the duality of subject and object clearly exists. It is evident from Vajragarbha's commentary and the *Vimalaprabhā* that the embracing of male and female deities belonging to different families was meant to symbolize the ultimately nondual nature of subject and object.

9. The Practice of the *Kālacakratantra* and the Maṇḍala

In this chapter we have surveyed the maṇḍala theory of the *Kālacakratantra*, and in this final section I wish to discuss the relationship between practice and the maṇḍala in the *Kālacakratantra*.

The practices of late tantric Buddhism can be encapsulated in the generation stage (*utpattikrama*) and the completion stage (*utpannakrama/niṣpannakrama*). The visualization of the maṇḍala and rites using the maṇḍala come under the generation stage. In the *Kālacakratantra*, however, elements of the completion stage were also introduced into the maṇḍala. One example is that Kṛṣṇadīptā and the other female deities arranged around the main deity, Kālacakra and his consort, correspond to the visions that appear in the practice of the *ṣaḍaṅgayoga*, the completion stage of the *Kālacakra*.[795]

In Tibetan Buddhism, on the other hand, the objective to be accomplished in the completion stage of the *Kālacakra* is considered to be supreme indestructible bliss (*paramākṣara-sukha*) and the empty body (*śūnyatābimba*). Like the clear light (*prabhāsvara*) and illusory body (*māyādeha*) in the completion stage of the *Guhyasamāja*, the union of both is thought to represent the highest state of being. In the *Vimalaprabhā*, however, far more space is devoted to the explanation of supreme indestructible bliss than to that of the empty body. Therefore the supreme state to be accomplished in the completion stage of the *Kālacakra* is thought to be supreme indestructible bliss.

The *Vimalaprabhā*'s commentary on the fifth and final chapter ("Jñānapaṭala") of the *Kālacakratantra* consists of four sections, the third of which is "The Great Commentary Called Accomplishment of Supreme Indestructible Knowledge" ("Paramākṣarajñānasiddhir nāma mahoddeśa") and accounts for about a quarter of the commentary on the "Jñānapaṭala." But it comments on only v. 127 among the 261 verses of this chapter,[796] which indicates that the self-styled King Puṇḍarīka of Śambhala, the redactor of the *Vimalaprabhā*, attached great importance to this particular verse. This verse originally explained the seed-syllable of the main deity, Kālacakra, but the *Vimalaprabhā* expands to an extreme degree the verse's implications and seeks to read into it meanings that it did not originally have.

The third section of the commentary on the "Jñānapaṭala" begins with a salutation to Vajrasattva and so on. Next, after having quoted v. 127, there follows a lengthy word-for-word commentary. Here I wish to quote a passage showing the relationship between the *skandha-dhātvāyatana* theory of the *Guhyasamāja* and the supreme principle of the *Kālacakra*. An almost identical passage is also found in the *Sekoddeśaṭīkā* attributed to Nāropa,[797] which suggests that it was highly valued in the Kālacakra cycle.

Akṣara means "word" because it is unchanging, unmoving, and does not become another state. A bad reciter [of the Vedas] wrongly interprets *akṣara* as a collection of vowels and consonants. On the absolute level, *akṣara* is not a collection of vowels and consonants. The word *akṣara* signifies the knowledge that recognizes supreme indestructible bliss, namely, Vajrasattva. In the same way, supreme indestructible knowledge is alluded to in [the etymological explanation] "it is a mantra because it saves the mind." In the same way, the victors (i.e., buddhas) said it is another inner wisdom, namely, *prajñāpāramitā*, luminous by nature (*prakṛti-prabhāsvara*), the great seal, one who has innate bliss by nature, the complete state of the immovable Dharma-realm (*dharmadhātuniḥspandapūrṇāvasthā*), and the innate body (*sahajatanu*). They are not objects of sense organs that have arisen from a cause. Vajrasattva and his consort, like an image in a mirror or a dream, transcend physical matter consisting of atoms and are the object of the divine sense organ (*divyendrya*), since they are supreme and indestructible by nature.

Here "indestructible" means the five unobstructed great emptinesses, namely, form, sensation, conception, mental formations, and consciousness. In the same way, it is the five unobstructed indestructibles, namely, earth, water, fire, wind, and space. It is the six unobstructed indestructibles free from grasping their own sense object, namely, eyes, ears, nose, tongue, body, and mind. In the same way, it is the six unobstructed indestructibles, namely, form, sound, smell, taste, tangible objects, and the realm of dharmas. The *skandhadhātvāyatana* dissolve into one taste and become an empty drop (*binduśūnya*). It is also an imperishable drop and is called the "supreme indestructible." The supreme indestructible is also the letter *a* (which signifies the unborn and indestructible nature of all *dharmas*). Vajrasattva born of the letter *a* is neuter, which has the nature of wisdom (i.e., female) and means (i.e., male), namely, the innate body (*sahajakāya*), the nature of knowledge and its object (*jñānajñeyātmakaḥ*) because cause and result are indivisible in them. It is glorious Kālacakra and the state of supreme indestructible bliss.[798]

Thus the *Kālacakra* calls the state in which *skandhadhātvāyatana* become unobstructed (*nirāvaraṇa*) and the sense organs are freed from apprehending their objects and dissolve into one taste an "empty drop" or an "imperishable drop." This empty drop correponds, moreover, to the vision of the drop (*binduka*), the final vision to appear in the practice of the completion stage of the *Kālacakra*, corresponding to the clear light of the *Guhyasamāja*.[799]

The *Kālacakratantra* adopted the *skandhadhātvāyatana* theory of the *Guhyasamāja* as a system representing the entire world that we are experiencing. But it also explained that these elements will dissolve into supreme indestructible bliss, symbolized by the main deity, Kālacakra and his consort, when we become enlightened after the completion of the completion stage. This supposition is also supported by the fact that the female deities symbolizing the visions appearing in the practice of the completion stage of the *Kālacakra* are arranged around the main deity, Kālacakra.

Thus in the *Kālacakratantra* the maṇḍala is related not only to the generation stage but also to the completion stage. It could be said that the Kālacakra-maṇḍala is closely associated with practice as well as cosmology and doctrine.

8. The Development of the Maṇḍala and Its Philosophical Meaning

1. The *Vajrāvalī* and *Mitra brgya rtsa* Maṇḍala Sets

I HAVE CONSIDERED THE development of the maṇḍala in chronological order from its early stages through to the *Kālacakratantra*. The *Kālacakratantra* was not only the last Buddhist scripture to appear in India but also aimed to integrate earlier maṇḍala theories into a single system. Therefore it is appropriate to describe the historical development of the maṇḍala in India in chronological order.

There are, however, some matters relating to the maṇḍala that cannot be explained solely from a historical point of view. These include the geometrical patterns found in maṇḍalas, the arrangement of the deities, the colors used in maṇḍalas, and their meaning in Buddhist doctrine. I will first discuss the patterns and colors and also the representation and arrangement of deities in the maṇḍalas that Indian Buddhism created in the course of its long history, and then I will consider the philosophical interpretation of the maṇḍala by bringing together some of the points discussed in previous chapters.

It is difficult to determine the number of maṇḍalas that evolved in India. However, there exist several compendia of maṇḍalas in Tibet, where the traditions of Indian Buddhism have been transmitted down to the present day. These are composed of hanging scrolls called "thangka" (*thang ka/kha/ga*) or miniature paintings called "tsakali" (*tsa ka li*),[800] and they are usually arranged in accordance with the fourfold classification of tantras, namely, Kriyā, Caryā, Yoga, and Highest Yoga. It is not unusual for a set to consist of several dozen or more than one hundred maṇḍalas. But most of these maṇḍala sets became scattered far and wide as a result of the Tibetan uprising in 1959 and the Cultural Revolution in the 1960s to 1970s, and are now found in collections around the world. Unfortunately, most of these works remain unidentified.

The first scholar to take notice of Tibetan maṇḍala sets was Lokesh Chandra, and in 1967 he included maṇḍala sets based on the *Vajrāvalī* and *Rgyud sde kun btus* in his *New Tibeto-Mongol Pantheon*.[801] Tachikawa Musashi, meanwhile, together with Sönam Gyatso, published in 1983 the Ngor maṇḍalas, consisting of 140 tsakalis that the latter had brought with him from Ngor monastery, the main monastery of the Sakya school in Tsang, Tibet. The maṇḍalas reproduced as line drawings by Lokesh Chandra and the Ngor maṇḍalas brought from Tibet by Sönam Gyatso in the form of tsakalis are basically identical, but a careful comparison reveals considerable differences in their iconography. I had previously ascribed these differences to errors made by the painter to whom Lokesh Chandra entrusted the production of the line drawings, but I have since noticed that some of them can be

attributed to differences in the originals on which Lokesh Chandra's publication was based, for Lokesh Chandra and Tachikawa have now published a reproduction of the original tsakalis to which the former referred when preparing his *New Tibeto-Mongol Pantheon*.[802]

As for the *Vajrāvalī* set, Mori Masahide has published several articles on the basis of a thangka set formerly held by Ngor monastery,[803] and he has also published several important articles on the *Mitra brgya rtsa* set, a set of maṇḍalas that was transmitted to Tibet by Mitrayogin in the late twelfth century when Indian Buddhism was on the brink of annihilation. Mori discovered that the *Abhisamayamuktāmālā* and *Patraratnamālā* by Mitrayogin, both included in the Tibetan Tripiṭaka, represent the textual sources of the *Mitra brgya rtsa* set.[804] The *Abhisamayamuktāmālā* explains the iconography, arrangement, and visualization of the deities, while the *Patraratnamālā* provides a summary of the names of the 108 maṇḍalas and the number of deities in each maṇḍala. However, Mori was unable to study the iconometry and design of the maṇḍalas, which are not explained in the *Abhisamayamuktāmālā* and *Patraratnamālā*, since no examples of this maṇḍala set were known.

However, in a Japanese collection that I was asked to appraise in 1991, I found a collection of maṇḍalas in the form of two handscrolls 46 × 540 centimeters and 46 × 800 centimeters in size, with an inscription at the end that read: "These are all the maṇḍalas of Maitri, and in addition there are also the Sixteen Drops and Antarsādhana-Amitāyus."[805] "Maṇḍalas of Maitri" is an error for "maṇḍalas of Mitra," and upon closer investigation I discovered that these two handscrolls constitute a complete set of the *Vajrāvalī* and Mitrayogin's collection of one hundred maṇḍalas.

The handscroll of the *Vajrāvalī* arranges forty-five maṇḍalas in accordance with the four-fold classification of the tantras, from the Highest Yoga tantras to the Kriyā tantras. The handscroll of the *Mitra brgya rtsa*, on the other hand, arranges sixty-five maṇḍalas from the Kriyā tantras to the Highest Yoga tantras, which is the opposite of the *Vajrāvalī*. Thus the total number of maṇḍalas is 110. The inscriptions in *dbu can* script give not only the names of the maṇḍalas but also the number of deities, and these are useful for identifying the maṇḍalas.

The maṇḍalas are arranged in two registers, with only the large Dharmadhātuvāgīśvara-maṇḍala (V-39) occupying both registers, and the design of its *toraṇa* and periphery also differs from other maṇḍalas. The iconometry and design of the square pavilion and periphery of the Kāyavākcittapariniṣpanna-Kālacakra-maṇḍala (V-36) also differ considerably from those of other maṇḍalas.[806] But these two handscrolls depict all the maṇḍalas uniformly, except for the Dharmadhātuvāgīśvara-maṇḍala (V-39).

The *Abhisamayamuktāmālā* explains 108 maṇḍalas in total. It turned out that maṇḍalas that are duplicated in the *Vajrāvalī* have been deliberately omitted in the handscroll of the *Mitra brgya rtsa*, and this would suggest that these two maṇḍala collections in handscroll format originally formed a set in spite of some minor differences in style.

Subsequently these handscrolls were purchased by the Hahn Cultural Foundation in Korea, and they were included in volume 2 of their official catalogue, *Art of Thangka* (1999). In 2001, they were exhibited at five museums in Japan during "The World of Thangka" exhibition and also at the "Tibetan Legacy" exhibition in 2003 at the British Museum. (These handscrolls are hereafter referred as the "Hahn Foundation handscrolls.")

In 1988, I had acquired a book on the iconometry of the *Vajrāvalī* and *Mitra brgya rtsa* by Rongtha Losang Damchö Gyatso (1865–?) (hereafter *Rongtha's Iconometry*).[807] But I was

unable to undertake a detailed study, since I did not know its textual sources and did not have access to any example of a set of the *Mitra brgya rtsa*. If we compare the Hahn Foundation handscrolls and *Rongtha's Iconometry*, the design of the maṇḍalas agrees in many cases. Thus the Hahn Foundation handscrolls turned out to preserve the traditional iconometry of the *Vajrāvalī* and *Mitra brgya rtsa* as transmitted in Tibet.

Owing to their handscroll format, neither of the Hahn Foundation handscrolls was lost, and despite the sketchy quality of the drawings of the maṇḍalas and their pale colors and small size, they provide us with valuable information for the study of both maṇḍalas in general and, more especially, the iconography of the Tibetan maṇḍala. I accordingly published an image database in full color based on the Hahn Foundation handscrolls in 2007,[808] and an English version was published in 2013.[809] In the following, the abbreviations used in these two publications will be used to refer to maṇḍalas in these two sets. For example, V-1 signifies the first maṇḍala of the *Vajrāvalī*, while M-3 signifies the third maṇḍala of the *Mitra brgya rtsa*.

2. The Principal Patterns Used in Maṇḍalas

The landscape maṇḍalas that belong to the early stage of the development of the maṇḍala present only a bird's-eye view of the pavilion in which the deities are assembled. But in the "Chapter on Constructing Maṇḍalas" in the *Mahāmaṇivipulavimānakalparāja*, instructions are given for representing four *toraṇa*s in the four entrances to the square pavilion, and these developed into the four gates of the Garbha-maṇḍala, the so-called "vajra gates" that are depicted from a bird's-eye view.

The square frame representing a pavilion in which the deities are assembled appears in the Sino-Japanese Vajradhātu-maṇḍala and *besson mandara* belonging to the Vajraśekhara cycle. Moreover, in Tibeto-Nepalese maṇḍalas there are depicted adornments of the pavilion such as banners, parasols, and wish-fulfilling trees, as well as the *toraṇa* on the four gates of the maṇḍala. This pavilion is further surrounded by a circle of lotus petals (*dalāvalī*), a circle of vajras (*vajrāvalī*), and a garland of flames (*raśmimālā*).[810]

Initially a circular outer enclosure was only visualized by practitioners as a barrier to protect the pavilion in which the deities are assembled, but later it is thought to have been also represented pictorially. As was noted in chapter 1, the maṇḍala for the *Bhaiṣajyagurusūtra* rite is unusual for a Tibetan maṇḍala in that it does not have a circular outer enclosure, showing instead only a rectangular palace. It is thought to have been transmitted to Tibet at the time of the ancient Tibetan empire of Tufan.

Chapter 4 of the *Viṃśatividhi* mentions the *toraṇa* and circular outer enclosure of the maṇḍala but does not give details of their structure. The *Vajrācāryanayottama*, meanwhile, has supplemented six verses absent in the *Viṃśatividhi* for explaining the iconometry of the *toraṇa* and circular outer enclosure.[811] If we compare the *Ācāryakriyāsamuccaya* and *Viṃśatividhi* in regard to their explanations of the "reality of the maṇḍala" to be considered below, we find that the latter lacks only one verse, corresponding to v. 12 of the "Abhiṣekavidhi"[812] of the former, which explains the banner (*patākā*) and wish-fulfilling tree (*kalpapādapā*) to be mounted on the pavilion.

These facts suggest that the outer enclosure of the maṇḍala had not yet fully developed when the *Viṃśatividhi* came into existence. They also tally with the fact that Sino-Japanese

FIG. 8.1. THREE BASIC PATTERNS OF THE MAṆḌALA

Eight-petaled Lotus

Nine-panel Grid

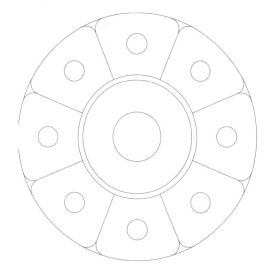

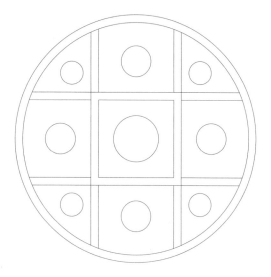

Eight-spoked Wheel

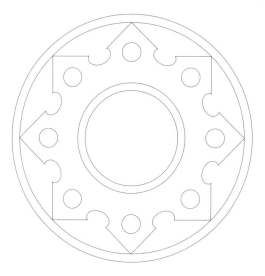

maṇḍalas, as well as maṇḍalas discovered at Dunhuang, do not have a circular outer enclosure. Taking all these facts into consideration, it is to be surmised that the circular outer enclosure of the maṇḍala came into common use in India only after the late ninth century.

As regards the patterns inside the square pavilion, on the other hand, there are no great differences between Tibetan and Japanese maṇḍalas. In the following, I shall provide an overview of the patterns found inside the square pavilion, comparing Sino-Japanese maṇḍalas and Tibeto-Nepalese examples as I do so.

With regard to Japanese maṇḍalas, Ishida Hisatoyo had already presented a theory for classifying all maṇḍalas except landscape maṇḍalas and illustrated genealogical charts into three patterns, namely, lotus, moon disc, and frame, and combinations thereof.[813] Yoritomi

Motohiro, on the other hand, has proposed the following six patterns based on the material constituting the patterns that appear in maṇḍalas: (1) lotus or lotus petal, (2) moon disc, (3) eight-spoked wheel, (4) frame, (5) landscape, and (6) illustrated genealogical charts.[814]

As for Tibetan maṇḍalas, *Rongtha's Iconometry* classifies the patterns inside the square pavilion (*kūṭāgāra*) of the maṇḍala into forty-nine categories. A comparison of *Rongtha's Iconometry* and the Hahn Foundation handscrolls makes it clear that the patterns inside the square pavilion of Tibetan maṇḍalas consist of three basic patterns, namely, lotus, wheel, and nine-panel grid (*navakoṣṭha*), and combinations thereof (see fig. 8.1).

In the lotus pattern, the main deity is depicted on the pericarp of a lotus and the attendants are arranged on the surrounding lotus petals. In the Hahn Foundation handscrolls, maṇḍalas of this pattern are the most common. The number of lotus petals is in many cases eight. But a four-petaled lotus occurs in some cases in Tibet. In Japan, the same pattern of an eight-petaled lotus is seen in the center of the Garbha-maṇḍala and several *besson mandara* such as the *Lotus* maṇḍala (Hokke mandara), while the thirty-five-deity Śākyamuni-maṇḍala (M-6) has a triple eight-petaled lotus pattern. It is interesting to note that the same pattern occurs in the maṇḍala of Buddhalocanā (Butsugen mandara) in Japan.

In the wheel pattern, the main deity is depicted on the hub and the attendants are arranged on the spokes. The number of spokes is in many cases eight. In Tibet, however, there are patterns of four-, six-, and twelve-spoked wheels. As has already been noted in chapter 1, this wheel pattern is not often found in Japan. Sakai Shinten has pointed out that the maṇḍala in the shape of an eight-spoked wheel originated in the *Prajñāpāramitānayasūtra*.

In Japan, the wheel (*cakra*) is depicted as a *dharmacakra* and the attendants are placed between the spokes. In Tibet, on the other hand, the wheel is often depicted in the shape of the *cakra* as a weapon and the attendants are placed on the spokes. Maṇḍalas in the shape of the *cakra* as a weapon are frequently encountered not only in Tibet but also in Dunhuang paintings.[815] Therefore maṇḍalas in the shape of the *cakra* as a weapon also originated in India.

The final pattern, the nine-panel grid, consists of a circle or a square that is divided into a grid of nine sections in which the deities are arranged. It corresponds to the "frame structure" proposed by Ishida and Yoritomi when classifying the patterns of Japanese maṇḍalas, and Yoritomi used the term "nine-sector structure formed by two pairs of intersecting lines" to refer to the nine-panel grid. *Rongtha's Iconometry*, on the other hand, refers to it as "nine grids" (*re'u mig dgu*). The original Sanskrit term was found to be *navakoṣṭha*, used in chapter 4 of the *Viṃśatividhi*.[816]

This nine-panel grid is the basic pattern of the Japanese Vajradhātu-maṇḍala. In Tibet, too, this pattern is common in maṇḍalas belonging to the Vajraśekhara cycle, starting with the Vajradhātu-maṇḍala and the Guhyasamāja-maṇḍala. As was seen in chapter 2, the maṇḍala of eight great bodhisattvas in Cave 12 at Ellora consists of a square divided into a grid of nine sections, and this, too, suggests that the nine-panel grid is one of the basic patterns of the maṇḍala.

The moon-disc pattern, which is prevalent in Japanese maṇḍalas, especially those belonging to the Vajraśekhara cycle, is seldom found in Tibet. For example, in the Vajradhātu-maṇḍala (V-37) nine moon discs should be arranged in a nine-panel grid and a further five small moon discs should be arranged in each of the moon discs in the center and four cardinal directions, but *Rongtha's Iconometry* prescribes a four-petaled lotus in the center of the

nine-panel grid. In Tibet, there is also an example in which eight-petaled lotuses instead of four-petaled lotuses are arranged in the nine-panel grid.[817]

In late tantric Buddhism, a moon disc was visualized not behind the deity, as in Sino-Japanese esoteric Buddhism, but below the deity, namely, on the pericarp of the lotus throne.[818] When visualized in this way, it becomes difficult to represent the moon disc in a maṇḍala that presents a front view of the deities. This seems to be why the moon-disc pattern is seldom used in Tibeto-Nepalese maṇḍalas.

In maṇḍalas with a complex structure, we can see combinations of the above three basic patterns. For example, in the Cakrasaṃvara-maṇḍala (V-19) a triple eight-spoked wheel is arranged around an eight-petaled lotus. The Vajrasattva-maṇḍala of the *Saṃpuṭatantra* (V-18) has a triple structure consisting of the three basic patterns of the maṇḍala, namely, from the center outward, a nine-panel grid, an eight-petaled lotus, and an eight-spoked wheel.[819] In addition, maṇḍalas of a composite type, such as the six-family maṇḍala of the *Samāyoga-tantra*, the Pañcaḍāka-maṇḍala (V-9), and the Ṣaṭcakravartin-maṇḍala (V-26) described in chapter 6, can also be classified under this category.

In Tibet, there are several maṇḍalas that have distinctive patterns, such as the crossed vajra (*viśvavajra*) in the Yamāntaka cycle[820] and a hexagram (Star of David) in the maṇḍala of a Nāropa-style *ḍākinī*.[821] But these are exceptional cases.

Tibetan maṇḍalas have an outer protective circle that is not depicted in Japanese maṇḍalas, and therefore at first sight they look different from Japanese maṇḍalas. But as regards the patterns inside the square pavilion, Tibetan and Japanese maṇḍalas have much in common. It is particularly interesting that the three basic patterns in Tibetan maṇḍalas, namely, lotus, wheel, and nine-panel grid, characterize the Japanese Garbha-, *Prajñāpāramitānayasūtra*, and Vajradhātu-maṇḍalas, respectively.

3. The Representation of Deities and Their Arrangement

The most common way to represent deities is to depict them as they are. However, in the case of a large maṇḍala with some hundreds of deities set out on an earthen altar, it is technically difficult to depict them all in human form. In present-day Tibet, monks specializing in esoteric ritual create elaborate sand maṇḍalas using a tool called an "iron hole" (*lcags phug*). But even so it is rare for the deities to be depicted in human form, and in most cases they are represented by their symbols (*samaya-mudrā*).

The *Guhyatantra*, an early esoteric Buddhist scripture, explains that if one is unable to depict the maṇḍala deities in human form, symbols should be used. It goes on to explain that even if it is possible to depict all the deities' physical characteristics, it is difficult to do so and wastes a lot of time, and if many figures are to be depicted, errors may occur or the figures may be incomplete in appearance, as a result of which the maṇḍala will have no efficacy and one will be unable to accomplish one's objective; therefore, images of the lords of the three families should be placed on the maṇḍala, while other deities should be represented by mudrās, or symbols.[822]

The *Tuoluoni jijing* states that the deities in the general maṇḍala of 16 cubits should be represented by their symbols. Compared with the later Garbha-maṇḍala and Vajradhātu-maṇḍala, the variety of symbols assigned to the deities of the general maṇḍala is small, and

consequently many deities are represented by the same symbol. Even so, we can confirm that a full-scale *samaya-maṇḍala* had already appeared in India.

But in the case of a still larger maṇḍala, it becomes difficult to represent the deities even by means of symbols, in which case the deities' seats are represented by small circles, as explained in the *Guhyatantra*: "Generally speaking, there are three ways to represent deities; use one as appropriate to create the maṇḍala. The first is to depict the deity's figure, the second is to depict their mudrā (i.e., symbol), and the third is to depict only their seat."[823]

In the Hahn Foundation's *Vajrāvalī* handscroll, all the deities are represented by small circles corresponding to their seats. In the *Mitra brgya rtsa* handscroll, which includes many maṇḍalas of a comparatively small size, on the other hand, the principal deities are represented by symbols, while their attendants are represented by small circles. This suggests that these handscrolls served as reference for the creation of sand maṇḍalas, and they may be assumed to reflect the realities of the production of sand maṇḍalas in Tibet.

Seed-syllable maṇḍalas, in which the deities are symbolized by seed-syllables (*bījākṣara*), or Sanskrit syllables, are also frequently used. Among Tibetan sand maṇḍalas, there are many examples of the maṇḍala of Eleven-Faced Avalokiteśvara of Great Compassion in the Lakṣmī tradition[824] in the form of a seed-syllable maṇḍala. In Tibet, however, seed-syllables are frequently written not in Indic but in Tibetan script.

In the *Vairocanābhisambodhisūtra*, the modes of representing the maṇḍala deities were linked to the theory of the three mysteries. It is considered that the *mahā-maṇḍala*, in which the deities are shown in their physical form, represents the buddhas' "mystery of the body," while the *dharma-maṇḍala*, in which they are indicated by means of seed-syllables, symbolizes the buddhas' "mystery of speech," and the *samaya-maṇḍala*, in which they are represented by means of symbolic objects, symbolizes the buddhas' "mystery of the mind."

In the maṇḍalas of early or middle esoteric Buddhism, the coexistence or commingling of the deities' figures with their symbols is not uncommon. In the maṇḍala of the *Mañjuśrīmūlakalpa*, the figures and symbols of the principal deities coexist. The inclusion of a triangle symbolizing the Buddha's omniscience and a wish-fulfilling jewel in the Garbha-maṇḍala, and also the four *pāramitā* goddesses depicted by means of symbols in the Vajradhātu-maṇḍala of the Ānandagarbha school, are good examples of the presence of symbols in a *mahā-maṇḍala*.

The three kinds of maṇḍalas in the *Vairocanābhisambodhisūtra* developed into the four kinds of maṇḍalas in the *Sarvatathāgatatattvasaṃgraha*, namely, the *mahā-*, *samaya-*, *dharma-*, and *karma-maṇḍalas*. The *mahā-maṇḍala* and *samaya-maṇḍala* do not differ greatly from the maṇḍalas of the same name in the *Vairocanābhisambodhisūtra*, but the *dharma-maṇḍala* and *karma-maṇḍala* of the *Sarvatathāgatatattvasaṃgraha* are distinctive.

The *dharma-maṇḍala* as expounded in the *Sarvatathāgatatattvasaṃgraha* is also called the "maṇḍala of the minute vajra." In the Misai-e of the Kue mandara, all the deities are depicted inside vajras (although in fact they are backed by vajras rather than being depicted inside them). This seems to be based on the stipulation in the *Sarvatathāgatatattvasaṃgraha* that a buddha should be depicted in the middle of a vajra.[825] In the *Gobu shinkan* and in an example in Palkhor Chöde monastery in Tibet (fifteenth century) described in chapter 4, all the deities form the meditation mudrā with both hands and are shown with their symbol in front of their heart. This is based on the statement in the *Sarvatathāgatatattvasaṃgraha*

that "the great beings should be depicted with their own symbol on their heart and seated in meditation."[826]

The *karma-maṇḍala* is also called the "offering maṇḍala," in which the deities apart from the five buddhas are depicted as goddesses offering up symbolic objects (*samaya-mudrā*).

The interpretation of the four kinds of maṇḍalas prevalent in Japanese esoteric Buddhism is not based solely on the *Sarvatathāgatatattvasaṃgraha* but is a compromise between the *Sarvatathāgatatattvasaṃgraha* and *Vairocanābhisambodhisūtra* found in the *Hizōki*.[827] Following the *Vairocanābhisambodhisūtra*, it regards the *dharma-maṇḍala* as a maṇḍala consisting of seed-syllables and the *karma-maṇḍala* as a maṇḍala in which the deities are represented by means of three-dimensional images.

This theory has not been found in texts of Indian origin. However, chapter 1 of Nāgabodhi's *Viṃśatividhi* classifies the representation of maṇḍala deities into the following five categories: seed-syllables (*bījanyāsa*), symbols (*cihna*), deity figures (*devatārūpa*), relief images (*ghaṭita*), and cast images (*niṣikta*). It is worth noting that Nāgabodhi's classification is somewhat similar to the Japanese interpretation of the four kinds of maṇḍalas, although he does not associate these categories with the four kinds of maṇḍalas.

In Tibet there exist many examples of three-dimensional maṇḍalas in which the deities are represented by means of concrete images and are arranged in the pavilion of the maṇḍala. There are two types of three-dimensional maṇḍalas in Tibet: one takes the form of a chapel in which all the deities of the maṇḍala are enshrined, while the other is a model of a pavilion in which small images of the maṇḍala deities are enshrined, and this is called a "maṇḍala created by the mind." An example of the former is a three-dimensional Vajradhātu-maṇḍala in the Vajradhātu chapel (Dorying Lhakhang) in the main hall of Palkhor Chöde monastery,[828] and as an example of the latter we can point to the three-dimensional maṇḍalas of the *Guhyasamāja*, *Cakrasaṃvara*, and *Vajrabhairava* in the three-dimensional maṇḍala chapel (Lölang Kyilkhor Khang) in the Potala Palace.

Next, let us turn to the arrangement of the deities. From the time of early esoteric Buddhism to the Garbha-maṇḍala, the maṇḍala faced west, but from the Vajradhātu-maṇḍala onward the maṇḍala generally faces east. In this case, the main deity is considered to face the bottom of the maṇḍala and the left, right, top, and bottom of the maṇḍala are determined in accordance with the direction in which the main deity faces.

If the four buddhas have their own attendants, as in the Vajradhātu-maṇḍala, the attendant deities are arranged in accordance with the direction in which the lord of their family (*kuleśa*) is facing. In the case of the sixteen great bodhisattvas in the Vajradhātu-maṇḍala, Vajrasattva should be placed in front of Akṣobhya, namely, in the west of the eastern moon disc, because Akṣobhya is facing Vairocana in the center even though a radial arrangement is not adopted. If there are multiple pavilions, as in the Pañcaḍāka-maṇḍala (V-9) and Ṣaṭcakravartin-maṇḍala (V-26), the attendant deities are arranged in accordance with the direction in which the main deity of each pavilion is facing, as in the Vajradhātu-maṇḍala.

There are two ways of arranging the deities in a maṇḍala. One is to depict all the attendant deities radially and facing the main deity, and the other is to depict them with their feet facing toward the bottom of the canvas. The former method is the norm in Tibetan Buddhism, although in early works of the fourteenth century and earlier, such as those at Alchi monastery in Ladakh, the latter arrangement is adopted. In Japan the latter is the norm, but in the case of the *shiki-mandara* a radial arrangement is adopted.

FIG. 8.2. ARRANGEMENT OF DEITIES IN THE VAJRADHĀTU-MAṆḌALA

Japanese *shiki-mandara*, MNAO (Rome)

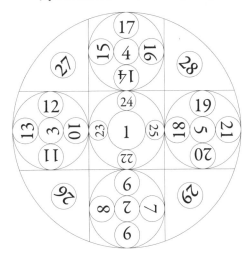

Palkhor Chöde, Kronos Collection

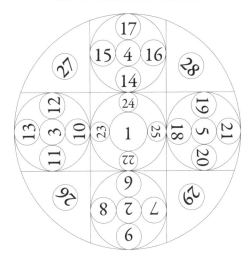

Vajradhātu-maṇḍala in the *Hizōki*,
Trailokyavijaya-maṇḍala (Alchi)

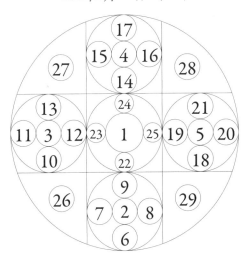

Japanese Vajradhātu-maṇḍala

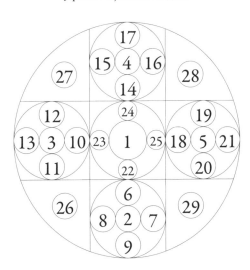

In India originally, on the occasion of an important rite an earthen altar would be constructed and a maṇḍala would be drawn using powdered pigment or colored sand. The arrangement of the deities in a radial manner as found in the Japanese *shiki-mandara*, used on the occasion of an initiation rite, is thought to reflect that of the earthen-altar maṇḍala in India.

There are however, exceptions to this rule. The Vajradhātu-maṇḍala described in the *Hizōki* and the maṇḍala of the *Shouhu guojiezhu tuoluoni jing*, which has the same structure as the Vajradhātu-maṇḍala, are not subject to the above rule. In the Vajradhātu-maṇḍala in Tshatshapuri monastery, Ladakh, the sixteen great bodhisattvas are arranged on the assumption that all four buddhas face east. There thus exist different views concerning details about the arrangement of the maṇḍala deities (see fig. 8.2).

4. The Color Scheme of the Courtyard

According to some introductory books on the Tibetan maṇḍala, only five colors (white, blue, yellow, red, and green) are used for coloring the maṇḍala, but strictly speaking this is incorrect. When creating a sand maṇḍala, eight or more kinds of colored powder are prepared, although the colors that have doctrinal meaning are limited to the above five colors or, in the case of the *Kālacakratantra* with its sixfold system, to six colors. These five colors are most clearly evident in the coloring of the courtyard of the maṇḍala, for the center and four cardinal directions of the courtyard of Tibeto-Nepalese maṇḍalas are painted in accordance with the body colors of the five buddhas who reside in the center and four cardinal directions of the maṇḍala.

As explained in chapter 2, the Tibetan Garbha-maṇḍala does not depict the four buddhas

FIG. 8.3A–D. COLOR SCHEMES OF THE COURTYARD

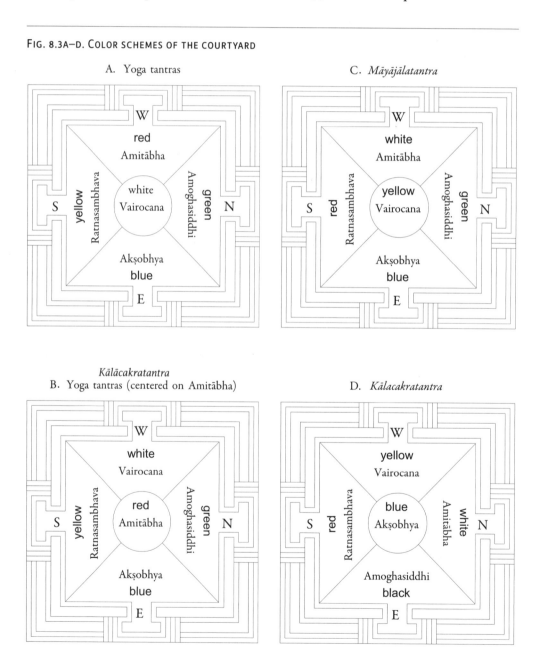

A. Yoga tantras

C. *Māyājālatantra*

Kālacakratantra
B. Yoga tantras (centered on Amitābha)

D. *Kālacakratantra*

on the central lotus, but the color scheme of its courtyard is, in many cases, as follows: center (white), east (red), south (yellow), west (green), and north (black).[829] These colors seem to have been determined by the body colors of the five buddhas: Vairocana (white), Ratnaketu (red), Saṃkusumitarājendra (yellow), Amitābha (green), and Dundubhisvara (black) (fig. 8.3H).[830]

Usually the body colors of the five buddhas of the Vajradhātu-maṇḍala are as follows: Vairocana (white), Akṣobhya (blue), Ratnasambhava (yellow), Amitābha (red), and Amoghasiddhi (green). These colors seem to have been determined in accordance with the rites over which the five buddhas preside: Vairocana (pacifying), Akṣobhya (subjugation), Ratnasambhava (increasing), Amitābha (captivation), and Amoghasiddhi (attraction). But as will be seen, several tantras explain their colors differently.

In maṇḍalas of the Yoga tantras, starting with the Vajradhātu-maṇḍala centered on

FIG. 8.3E–H. COLOR SCHEMES OF THE COURTYARD

E. Highest Yoga tantras

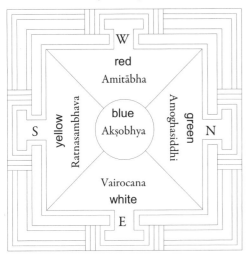

G. Highest Yoga tantras
(centered on Ratnasambhava)

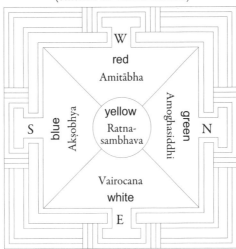

F. Highest Yoga tantras
(centered on Amitābha)

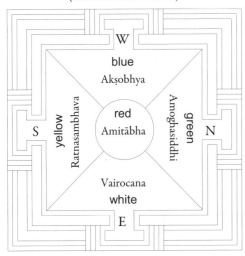

H. Garbha-maṇḍala

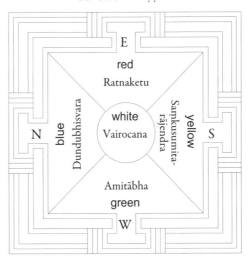

Vairocana, the color scheme of the courtyard is as follows: center (white) = Vairocana; east (blue) = Akṣobhya; south (yellow) = Ratnasambhava; west (red) = Amitābha; and north (green) = Amoghasiddhi (fig. 8.3A). In the Hahn Foundation handscrolls, this color scheme occurs nine times in the Kriyā tantras, nine times in the Yoga tantras, and three times in the Highest Yoga tantras. This means that this color scheme was also applied to the Kriyā tantras, which represent the early stage of Indian esoteric Buddhism.

This color scheme for the courtyard is not found in Japanese maṇḍalas, and the date of its appearance and prevalence in India are difficult to determine, since no colored examples of maṇḍalas have survived in India. Textually speaking, the *Sarvavajrodaya* by Ānandagarbha prescribes the color scheme of the courtyard of the Vajradhātu-maṇḍala as follows: center (white), east (blue), south (yellow), west (red), and north (madder).[831] This coincides with the commonly accepted assignment of colors in the Yoga tantras, except for madder (*mañjiṣṭhā*) in the north.

The Paramādya-Vajrasattva-maṇḍala, belonging to the same Yoga tantras, adopts an unusual color scheme. The example in the Hahn Foundation handscroll (M-34) has the following color scheme: white (center), red (east), yellow (south), blue (west), and green (north). However, most examples in Tibet are: white (center), red (east), green (south), blue (west), and yellow (north). This is quite the opposite of the norm for the Vajradhātu-maṇḍala. With regard to the assembly maṇḍala of the *Paramādyatantra*, Butön writes as follows: "The color scheme of the [five] directions is not clearly explained in commentaries, but masters say that east is red, south is green, west is blue, north is yellow, and the center is white and maintain that other maṇḍalas of the *Paramādya* are the same as this."[832] These colors seem to have been determined by the body colors of Vajrasattva and his four attendants, Vajramanodbhava, Vajrakīlikīla, Vajranismara, and Vajragarva, who are arranged in the center and the four cardinal directions of the maṇḍala.[833]

The Vajramaṇḍa-maṇḍala and Mahāyānābhisamaya-maṇḍala depicted in the cupola of the Great Stūpa of Palkhor Chöde monastery are valuable examples of the maṇḍala explained in the *Vajramaṇḍalālaṃkāratantra* belonging to the cycle of the *Prajñāpāramitānayasūtra*. Both have a unique color scheme: yellow (center), white (east), green (south), red (west), and blue (north). Butön ascribes this color scheme to the only commentary on the *Vajramaṇḍalālaṃkāratantra*, by Praśāntamitra.[834]

In maṇḍalas of the Highest Yoga tantras, starting with the *Guhyasamājatantra*, Akṣobhya is the main deity, and the color scheme of the courtyard is as follows: center (blue) = Akṣobhya, east (white) = Vairocana, south (yellow) = Ratnasambhava, west (red) = Amitābha, and north (green) = Amoghasiddhi (fig. 8.3E). This is the most common color scheme in the Hahn Foundation handscrolls, and 71 of the 110 maṇḍalas have this color scheme. The breakdown of these 71 maṇḍalas is as follows: 12 in the Kriyā tantras, 2 in the Caryā tantras, 10 in the Yoga tantras, and 47 in the Highest Yoga tantras. This means that this color scheme was applied not only to the Highest Yoga tantras but also to the three lower groups of tantras, which represent the early and middle phases of esoteric Buddhism. This is because this color scheme was used in maṇḍalas centered on a deity belonging to the Vajra family even if the maṇḍala was not classified among the Highest Yoga tantras.

This color scheme is clearly explained in chapter 10 of the *Vimśatividhi*.[835] Ānandagarbha was active in the ninth century, while Nāgabodhi, the author of the *Vimśatividhi*, was active in the late eighth century. Therefore the practice of painting the center and the four cardinal

directions of the courtyard of the maṇḍala in different colors already existed in India in the late eighth to ninth centuries.

In a maṇḍala of the Amoghapāśa pentad (Musée Guimet, EO 3579, tenth century)[836] from Dunhuang, only the insides of the four gates are painted in four colors, namely, white in the east, blue in the south, red in the west, and green in the north. This color scheme is based on a different theory in which the colors of the four directions in the maṇḍala are determined by the colors of the four continents in the world system centered on Mount Sumeru. This color scheme is found not only in esoteric Buddhist texts from Dunhuang but also in several esoteric Buddhist scriptures that emerged in the eighth to ninth centuries.[837]

In addition, the Kāyavākcittapariniṣpanna-Kālacakra-maṇḍala (V-36), which represents the final stage of Indian esoteric Buddhism, adopts a unique color scheme: center (blue) = Akṣobhya, east (black) = Amoghasiddhi, south (red) = Ratnasambhava, west (yellow) = Vairocana, and north (white) = Amitābha. As discussed in chapter 7, this is based on the cosmology peculiar to the *Kālacakratantra* (fig. 8.3D).

In the Hahn Foundation handscrolls, there is also found a color scheme in which Vairocana, the main deity of the Yoga tantras, is replaced by Amitābha (see fig. 8.3B); a color scheme in which Akṣobhya, the main deity of the Highest Yoga tantras, is replaced by Amitābha (fig. 8.3F); and another color scheme in which Akṣobhya is replaced by Ratnasambhava (fig. 8.3G).[838]

Further, in the Hahn Foundation handscrolls, the Vairocana-Mañjuvajra-maṇḍala (V-3), four variations of the nine-deity maṇḍala of Hevajra (V-5–8), and the maṇḍalas of Buddhakapāla (V-32), Jñānaḍākinī (V-35), Navoṣṇīṣa (V-38), and Paramādya-Vajrasattva (M-34), nine maṇḍalas in total, have unique color schemes that do not belong to any of the abovementioned schemes. Among these, the Vairocana-Mañjuvajra-maṇḍala adopts in many cases the courtyard color scheme of the Yoga tantras because it is centered on Vairocana even though it belongs to the Highest Yoga tantras. But in the Hahn Foundation handscroll an unusual color scheme is used: center (yellow), east (blue), south (red), west (white), and north (green) (fig. 8.3C). The *Māyājālatantra* (new translation), the textual source for this maṇḍala, prescribes the body colors of the four buddhas as follows: Akṣobhya (blue), Ratnasambhava (red), Amitābha (white), and Amoghasiddhi (green).[839] The color scheme of the Hahn Foundation handscrolls seems to be based on this divergent theory, which is determined by the correspondences between the five buddhas and five elements, and it is worth noting as a precursor of the *Kālacakratantra*.

Turning now to extant examples, we find that there are no maṇḍalas in Japan in which the courtyard is painted in five colors, and such maṇḍalas are by and large limited to Tibeto-Nepalese maṇḍalas. However, the coloring of the courtyard is also found in maṇḍalas from after the twelfth century discovered along the Silk Road in, for example, the Yulin Caves and Khara-khoto.[840]

Maṇḍalas in the Mogao Caves, like Japanese maṇḍalas, do not have courtyards painted in five colors. However, in the aforementioned Amoghapāśa-pentad maṇḍala the insides of the four gates are painted in four colors in accordance with a different theory that was current along the Silk Road.

Even in areas where Tibetan Buddhism is practiced, maṇḍalas in the three-storied chapel and Vairocana chapel at Alchi (eleventh to twelfth centuries) do not have the entire surface of the courtyard painted, and only the insides of the four gates are painted in four colors

in accordance with the commonly accepted color scheme of the Yoga tantras. Maṇḍalas in Dungkar Caves 1, 2, and 3 (thirteenth century)[841] in western Tibet, on the other hand, have the entire surface of the courtyard painted in four colors. Moreover, the coloring of the courtyard is also found in maṇḍalas of Tibetan Buddhism discovered in the Yulin Caves and Khara-khoto.

No examples of a colored maṇḍala have been discovered in India except in strongholds of Tibetan Buddhism. But judging from textual evidence, the coloring of the courtyard of the maṇḍala can be traced back as far as the late eighth to ninth centuries. However, at present, examples of maṇḍalas outside India in which the insides of the four gates are painted in four colors can be ascertained only from the tenth century and those in which the entire surface of the maṇḍala is colored from as late as the twelfth to thirteenth centuries.

5. The Reality of the Maṇḍala

The maṇḍala was not accompanied from the outset by any highly sophisticated theory or complex system. It evolved from the triad, which had a long history as a type of icon. Early maṇḍalas had not yet given expression to a philosophy or worldview, even though relationships between the main deity and attendants or guards can be discerned.

Nonetheless, Avalokiteśvara in the Amitābha triad is said to represent the compassion of Amitābha, while Mahāsthāmaprāpta represents the wisdom of Amitābha. This sort of interpretation, which assigns attributes of the main deity to the two attendants in a triad, is thought to have developed into the assignment of doctrinal categories to deities or the deification of doctrinal categories themselves frequently found in later maṇḍalas.

In the seventh to eighth centuries, when systematic esoteric Buddhist scriptures such as the *Vairocanābhisambodhisūtra* and *Sarvatathāgatatattvasaṃgraha* appeared, maṇḍala theory also developed dramatically. In particular, as was discussed in chapter 4, the fivefold system introduced in the *Sarvatathāgatatattvasaṃgraha* was adopted in late tantric Buddhism. Eventually this led to the highly systematized maṇḍala theories of the *Guhyasamāja* and *Kālacakra*. In these scriptures, the maṇḍala is not a mere icon for the purpose of worship but a representation of the very ideas expounded in these scriptures.

Even in scriptures belonging to the middle phase of esoteric Buddhism and late tantric Buddhism, in which maṇḍala theory has become highly developed, passages providing philosophical interpretations of the maṇḍala are fewer than those explaining the iconography and rites of the maṇḍala. Among such passages, the initiation rite in which the master shows the maṇḍala to an initiate and explains the reality (*tattva*) of the maṇḍala provides important leads for understanding how the maṇḍala was interpreted in Indian esoteric Buddhism.

The ritual procedures of the initiation rite have been clarified by Sakurai Munenobu, mainly with reference to a 450-verse text by Dīpaṃkarabhadra (*450 Verses*).[842] According to his research, this process consists of the revelation of two realities, that is, the "reality of the maṇḍala," which assigns doctrinal categories to parts of the pavilion, and the "reality of the deities," which assigns doctrinal categories to deities. Of the two realities, the "reality of the deities" is based on the assignment of doctrinal categories to deities of the Guhyasamāja cycle, already discussed. The "reality of the maṇḍala," on the other hand, has not yet been mentioned, and so I shall consider it here.

According to Sakurai, the "reality of the maṇḍala" signifies the assignment of doctri-

nal categories to parts of the maṇḍala, most of which are based on Yoga tantras such as the *Paramādyatantra*, *Vajraśekhara*, and *Sarvarahasya*. Sakurai therefore assumed that the "reality of the maṇḍala" was adopted from Yoga tantras by Dīpaṃkarabhadra, a direct disciple of Buddhajñānapāda, through the *Samantabhadra nāma sādhana*, the basic text of the Jñānapāda school.

It is true that an explanation similar to the "reality of the maṇḍala" is found in the *Samantabhadra nāma sādhana*. However, most of the verses in the *450 Verses* are *ślokas*, whereas those in the *Samantabhadra nāma sādhana* are a mixture of *āryā* and *gīti* meter. Consequently, there are no identical verses in the *Samantabhadra nāma sādhana* and *450 Verses*. The *450 Verses* does, however, share one verse with the *Paramādyatantra*.[843] The "reality of the maṇḍala" is also explained in the *Viṃśatividhi*,[844] which includes verses also found in the *Paramādyatantra* and *Sarvarahasya*.[845] Moreover, an almost identical explanation of the "reality of the maṇḍala" is also found in the "Śiṣyapraveśavidhi" of the *Kriyāsamuccaya*.[846]

Fig. 8.4 is a table showing the assignment of doctrinal categories to parts of the pavilion. The texts differ regarding correspondences between parts of the pavilion and doctrinal categories. Even so, it is worth noting that most of the doctrinal categories have been taken from the seven divisions of the thirty-seven prerequisites for the attainment of enlightenment. That is to say, the four foundations of mindfulness, the four right efforts, the four supernatural powers, the five faculties, the seven factors of enlightenment, and the noble eightfold path are mentioned in the *Sarvarahasya*; the four foundations of mindfulness, the four right efforts, the four supernatural powers, the five faculties, the five powers, and the seven factors of enlightenment are mentioned in the *450 Verses*; and the four supernatural powers, the five faculties, and the noble eightfold path are mentioned in the *Viṃśatividhi* and *Kriyāsamuccaya*.

The *Mukhāgama* by Buddhajñānapāda of the Guhyasamāja cycle, on the other hand, explains the visualization of the maṇḍala pavilion, corresponding to *saṃskāra* or "formative forces," the second limb of dependent origination, as "the maṇḍala of the

FIG. 8.4. PARTS OF THE MAṆḌALA AND THE THIRTY-SEVEN PREREQUISITES FOR THE ATTAINMENT OF ENLIGHTENMENT

SEVEN CATEGORIES	SARVARAHASYA	450 VERSES	VIṂŚATIVIDHI
four placements of mindfulness	*khyams* (courtyards)	eastern gate	
four right efforts	*rta babs rnams dang ka ba* (*toraṇa* and pillar)	southern gate	
four supernatural powers	*sgo khyud* (gate projections)	western gate	*niryūha* (gate projections)
five faculties	*ra ba lnga* (five fences)	northern gate	*pañcaprākāra* (five fences)
five powers		northern gate	
seven prerequisites for the attainment of enlightenment	*phreng ba me tog* (garlands and flower bundles)	*hārārdhahāra-candrārkādarśa-srakcāmarojjvalaṃ*	
eight noble paths	*ka ba brgyad* (eight pillars)		*aṣṭastambha* (eight pillars)

taintless thirty-seven prerequisites for the attainment of enlightenment."[847] Thus Buddha-jñānapāda, who established the maṇḍala theory of late tantric Buddhism, regarded the pavilion of the maṇḍala as a symbol of the thirty-seven prerequisites for the attainment of enlightenment.

As discussed in chapter 6, the Saṃvara cycle assigned to the thirty-seven deities or couples of the maṇḍala the thirty-seven prerequisites for the attainment of enlightenment, a traditional methodology of practice going back to the time of early Buddhism. Lama Anagarika Govinda has presented a maṇḍala-like diagram in which the thirty-seven prerequisites for the attainment of enlightenment are arranged in a pattern combining squares and circles that corresponds to the Stage of Meditation.[848] It is not clear when such a diagram came into existence and to what extent it spread in Theravāda Buddhism. But if such a diagram was used in Nikāya Buddhism, it was quite a natural development for this idea to evolve into the "reality of the maṇḍala," which assigns the seven divisions of the thirty-seven prerequisites for the attainment of enlightenment to parts of the pavilion.

In Sino-Japanese esoteric Buddhism, it is not common to assign doctrinal categories to parts of the pavilion. However, the practice of collectively referring to the four gatekeepers of the Vajradhātu-maṇḍala as the "four means of conversion" (shishō) in Japanese esoteric Buddhism coincides with the fact that the four gates of the maṇḍala are assigned to the "four means of conversion" in the "reality of the maṇḍala."

As noted, in the theories of late Mahāyāna Buddhism, which developed in parallel with esoteric Buddhism, the thirty-seven prerequisites for the attainment of enlightenment are the first component of the twenty-one kinds of taintless wisdom, which are regarded as the constituent elements of the Buddha's *dharma-* or *jñānakāya*. Therefore the interpretation assigning the thirty-seven prerequisites for the attainment of enlightenment to parts of the pavilion is in line with the view that would interpret the maṇḍala as a symbol of the Buddha's body, particularly the *dharmakāya*.

6. The Meaning of the *Skandhadhātvāyatana* System

The two realities revealed during the initiation rite were the "reality of the maṇḍala," which assigns doctrinal categories to parts of the pavilion, and the "reality of the deities," which assigns doctrinal categories to deities. In the "reality of the maṇḍala" the seven divisions of the thirty-seven prerequisites for the attainment of enlightenment played an important role, while in the "reality of the deities" the *skandhadhātvāyatana* system is of greatest importance.[849]

As an ordinary Buddhist term, *skandhadhātvāyatana* refers to the five aggregates, eighteen elements, and twelve sense fields, and many commentators on the *Guhyasamāja* also follow this interpretation. But in the *Caryāmelāpakapradīpa*, belonging to the Ārya school, and in the Saṃvara cycle it is interpreted as the five aggregates, four elements, and twelve sense fields in accordance with the system of the Guhyasamāja-maṇḍala, consisting of five buddhas, four buddha-mothers, and adamantine goddesses.

In his *Sngags rim chen mo*, Tsongkhapa discusses in the chapter on the generation stage the efficacy of visualizing the deities assigned to the *skandhadhātvāyatana*.[850] He first poses the question of what the purpose of the generation stage is, and replies that it is for eliminating "ordinary pride" (*tha mal pa'i nga rgyal*). In our daily lives we assume that various mundane things exist, and the everyday world we are experiencing is referred to as "ordinary

appearance." The distinctive feature of the generation stage is that it categorizes this ordinary appearance into the five aggregates, four elements, and twelve sense fields, which are then interpreted as emanations of buddhas, buddha-mothers, and bodhisattvas.

Furthermore, the physical world consisting of earth, water, fire, and wind is deemed to be nothing other than a pavilion in which buddhas and bodhisattvas assemble, while sentient beings wandering about the six realms of cyclic existence are none other than holy beings in the maṇḍala. The main purpose of the generation stage is considered to be to overcome the everyday worldview and eliminate "ordinary pride," which is attached to this worldview, by visualizing in this way. The *Sngags rim chen mo* thus concludes: "If the ability to eliminate ordinary appearance from consciousness by means of the splendid vision [of the maṇḍala] is acquired, one's objective can be achieved thereby. Even if one is not yet enlightened, with only the real self-confidence that one has become a deity one can achieve the objective [of eliminating ordinary appearance]."[851]

The textual sources mentioned by Tsongkhapa in this section are chapter 14 of the *Ḍākinī-vajrapañjaratantra* and chapter 2 of the *Caryāmelāpakapradīpa*. Although exactly the same verses as those quoted by Tsongkhapa cannot be found in these texts,[852] there is a verse of almost the same meaning. Tsongkhapa quotes only the first half of the verse, but since it runs into the second half, it is better to quote the entire verse.

> Right practice is recommended to extinguish ordinary appearance, but human effort cannot extinguish the ordinary state. Not to practice is the practice.[853]

The Sanskrit text of the *Caryāmelāpakapradīpa* has been published, and so we can refer to the passage quoted by Tsongkhapa.

> In this way the aggregates, elements, and sense fields that have existed through ordinary pride (*prākṛtāhaṅkāra*) from beginningless time are now shown to have the nature of an accumulation of particles of all tathāgatas.[854]

The aim of maṇḍala practices in late tantric Buddhism was thus to realize that the world we experience in daily life is nothing other than an emanation of all the buddhas (Heruka, in the context of the *Vajrapañjara*). But as is explained in the *Vajrapañjara*, this is not meant to negate or nullify the real world but rather change our view of it. The "reality of the deities" in the initiation rite could be said to explain which deities are assigned to which doctrinal categories.

The thirty-seven prerequisites for the attainment of enlightenment, which play an important role in the "reality of the maṇḍala," on the other hand, are assigned not to deities but to parts of the pavilion, except in the Saṃvara cycle. As was seen above, the thirty-seven prerequisites for the attainment of enlightenment are taintless dharmas free from afflictions and are regarded as the first component of the twenty-one kinds of taintless wisdom, the constituent elements of the Buddha's *dharma-* or *jñānakāya* in the theories of late Mahāyāna Buddhism based on the *Abhisamayālaṃkāra*. In the *Prajñāpāramitāsūtra*, the seven divisions of the thirty-seven prerequisites for the attainment of enlightenment are regarded as representative taintless dharmas while the aggregates, elements, and sense fields assigned to the maṇḍala deities are typical tainted dharmas.[855]

If we apply to this the theory that the pavilion of the maṇḍala corresponds to the physical world (*bhājanaloka*) and the deities of the maṇḍala to the world of sentient beings (*sattvaloka*), then the physical world is assigned to taintless dharmas and sentient beings are assigned to tainted dharmas. This is considered to reflect the basic idea of Buddhism that the physical world is nonsentient and free from afflictions and cyclic existence. In contrast, the world of sentient beings is nothing other than the world tainted by afflictions. And the maṇḍala functions as a means to show that the aggregates, elements, and sense fields, which exist on account of our ordinary pride, are nothing other than emanations of all tathāgatas.

It was noted previously that late tantric Buddhism frequently refers to the assignment of doctrinal categories to maṇḍala deities as "purification" (*viśuddhi*). This could be said to signify not purification through human effort but a change in our view of the world.

7. The Maṇḍala as Cosmogram

Thus, according to the maṇḍala theory of late tantric Buddhism, the physical world is symbolized by the pavilion, while the world of sentient beings is symbolized by the maṇḍala deities. From this theory there evolved the idea of interpreting the maṇḍala as a cosmogram that reveals the reality of the world. In Tibetan Buddhism, the maṇḍala is considered to symbolize the inseparability of saṃsāra and nirvāṇa (*'khor 'das dbyer med*). According to this view, the world of sentient beings wandering through the six realms of cyclic existence and the physical world that constantly arises and perishes are nothing other than the world of the Buddha, or the realm of nirvāṇa, just as they are. The maṇḍala as cosmogram functions as a means of showing that the world we are experiencing is nothing other than the realm of nirvāṇa. In this section I shall accordingly consider how the maṇḍala was interpreted as a cosmogram in each stage of Indian esoteric Buddhism.

In Buddhism, the physical world has traditionally been called the "world as receptacle" (*bhājanaloka*), since it "contains" sentient beings. It consists of the four elements—earth, water, fire, and wind—to which is sometimes added the fifth element, space, and the shape of the physical world was interpreted in accordance with the theory of the world system centered on Mount Sumeru.

In the maṇḍala of the *Mañjuśrīmūlakalpa* described in chapter 2, four small maṇḍalas (*maṇḍalaka*) in the shape of the four elements are arranged in the outermost square, that is, a square (earth) in the north, a circle (water) in the west, a triangle (fire) in the east, and a half-moon (wind) in the south. This is thought to be the earliest incorporation of the four elements into a maṇḍala. The *Vairocanābhisambodhisūtra* assigned the five buddhas, the principal members of the maṇḍala, to the five elements, and it introduced the shapes of the five elements in the "separate maṇḍalas" that represented particular groups of deities in the Garbha-maṇḍala.

In the *Sarvatathāgatatattvasaṃgraha*, on the other hand, the four-element theory does not occupy an important position. But in the Sino-Japanese Vajradhātu-maṇḍala, Indra, Varuṇa, Agni, and Vāyu, who preside over the four elements, are in many cases placed in the four corners.[856]

In the *Sarvarahasya*, an explanatory tantra on the *Sarvatathāgatatattvasaṃgraha*, four buddha-mothers presiding over the four elements are added to the thirty-seven deities of the

Vajradhātu-maṇḍala. The seats of these four buddha-mothers are not specifically described in the text, but in a Tibetan example they are arranged in the four corners of the inner square, where the gods of the four elements are depicted in Sino-Japanese examples, together with the four outer offering goddesses.[857] The reason that the deities presiding over the four elements are placed not in the four cardinal directions but in the four corners may be that in the system of protectors of directions (*dikpāla*), Agni, the god of fire, is assigned to the southeast and Vāyu, the god of wind, to the northwest.

In addition, the *Vajramaṇḍālaṃkāratantra*, a late Yoga tantra, explains maṇḍalas in the shape of the four elements—a yellow square (earth [*mahīndra*]), a white circle (water), a red triangle (fire), and a blue-black half-moon (wind).[858]

As regards the introduction of the world system centered on Mount Sumeru into the maṇḍala, it is worth noting that the *Sarvatathāgatatattvasaṃgraha* made the Vajradhātu-maṇḍala an assembly of all the tathāgatas in a pavilion called Vajramaṇiratnaśikharakūṭāgāra on the summit of Mount Sumeru.[859] Thus the seat of the main deity of the maṇḍala coincides with the summit of Mount Sumeru towering up in the center of the world.

Furthermore, in some Yoga tantras that developed from the *Sarvatathāgatatattvasaṃgraha*, the influence of the world system centered on Mount Sumeru can also be seen in the shape of the maṇḍala. In the Sarvatathāgata-trilokacakra-maṇḍala and Sarvatathāgata-maṇḍala of the *Trailokyavijayamahākalparāja*, not only does the seat of the main deity correspond to the summit of Mount Sumeru, but the seven mountain ranges, four continents, eight subcontinents, and somma (*cakravāḍa*) of the world system are also depicted in the maṇḍala.

Thus the idea that identified the maṇḍala with a cosmogram had already appeared in scriptures belonging to early and middle esoteric Buddhism. However, in the Garbha-maṇḍala, the colors of the five elements and the five buddhas who preside over them do not coincide. In maṇḍalas of the late Yoga tantras, too, the body colors of the four buddhas arranged in the four cardinal directions of the maṇḍala, the color scheme of the courtyard, and the colors of the four continents do not coincide.[860] The integration of cosmology and the maṇḍala was thus incomplete in early and middle esoteric Buddhism.

The commonly accepted theory about the body colors of the five buddhas was determined in accordance with the rites over which they preside. The shapes of the four continents, on the other hand, derive from the triangular shape of the Indian subcontinent, while the colors of the four continents derive from our experiential knowledge that in our world the color of the sky and sea is blue. Consequently, difficulties arose when it came to integrating these systems of cosmology that had each developed separately.

The *Māyājālatantra* determined the body colors of the five buddhas with reference to the five elements over which they preside. This method of determining the body colors of the five buddhas was adopted by the *Kālacakratantra*, the last tantric system to appear in India, and with this assignment of the five buddhas to the five elements the *Kālacakratantra* achieved the complete integration of the maṇḍala, the five-element theory, and a cosmology centered on Mount Sumeru into a single system.

The *Kālacakratantra* prescribes which part of the maṇḍala corresponds to which part of the world system. Thus in the *Kālacakra* the world system centered on Mount Sumeru and the maṇḍala have become parallel in respect to shape and iconometry. Therefore the maṇḍala as cosmogram was brought to completion in the *Kālacakratantra*, the last tantric system in India. Further, in the *Kālacakratantra* the deities symbolizing the world of

sentient beings are interpreted in accordance with the *skandhadhātvāyatana* system that originated in the *Guhyasamājatantra*, whereas Mount Sumeru, the four continents, and the wheels of the four elements[861] correspond to the triple square pavilion symbolizing mind, speech, and body and to the four circles symbolizing the four elements. This suggests that the principle that the pavilion of the maṇḍala symbolizes the physical world while the deities symbolize the world of sentient beings was observed in Indian tantric Buddhism right down to its final stage.

8. The Maṇḍala as Psychogram

It was through the work of the Swiss psychoanalyst Carl Jung that the term "maṇḍala" gained the universal currency that it enjoys today. His views on the maṇḍala are a typical example of how to interpret the maṇḍala as a psychogram that reveals the depths of the human psyche. But his interpretation of the maṇḍala has been criticized by Mori Masahide and myself.[862]

The aim of this book has been to elucidate the genesis and historical development of the maṇḍala in India, and so maṇḍalas of Tibetan origin belonging to the *gter ma* cycle, the two-world maṇḍalas of Chinese origin, and those of Japanese origin such as the Ninnōkyō mandara have not been covered in this book even though they are traditional maṇḍalas. Likewise, modern interpretations of the maṇḍala in the West will not be discussed here. However, it is necessary to consider the maṇḍala's relationship to the Vijñaptimātra theory, the traditional psychology of Buddhism, if it is to be interpreted as a psychogram.

The five buddhas of the Vajradhātu-maṇḍala were called "buddhas of the five wisdoms" in Japanese esoteric Buddhism, and its fivefold system has been interpreted in accordance with the five-wisdom theory. The idea that the five families of the Vajradhātu-maṇḍala evolve through mutual encompassment into twenty-five families and then into innumerable families is suggestive of Indra's net in the Huayan school. Although the Huayan school developed in China, its basis lies in the renowned statement in the *Daśabhūmikasūtra* that all existents in the triple world are mind-only.[863]

It was seen in chapter 5 that after the *Guhyasamājatantra* the change in the main deity from Vairocana to Akṣobhya became common in maṇḍalas of late tantric Buddhism. According to the maṇḍala theory of late tantric Buddhism, Vairocana is assigned to form (*rūpa*) and Akṣobhya to consciousness (*vijñāna*) among the five aggregates, and in the case of the three mysteries Vairocana is assigned to the body (*kāya*) and Akṣobhya to the mind (*citta*). This may be considered similar to Vijñaptimātra theory insofar as greater importance is placed on ideational elements than on matter. The differentiation of the body (*kāyaviveka*) into one hundred clans can be interpreted as the generation of the universe from Akṣobhya, who represents the ideational element, through the mutual encompassment of the five families. However, among commentators on the *Guhyasamājatantra*, an interpretation in accordance with the Vijñaptimātra theory is virtually limited to Ratnākaraśānti.[864]

The patriarchs of the Ārya school took their names from masters of the Mādhyamika school, such as Nāgārjuna, Āryadeva, and Candrakīrti, a fact that suggests that the Ārya school regarded itself as a successor to the Mādhyamika school. Moreover, in the case of the *Kālacakratantra*, the pinnacle of Indian esoteric Buddhism, the *Vimalaprabhā* clearly states that the Mādhyamika school represents definitive truth (*nītārtha*), whereas the Vijñapti-

mātra school is provisional (*neyārtha*).[865] Therefore it cannot be said that the maṇḍala theory of late tantric Buddhism was based on the Vijñaptimātra school.

In the concluding part of the revelation of the reality of the maṇḍala as explained in the *Viṃśatividhi*,[866] the center of the Guhyasamāja-maṇḍala is called "that which symbolizes the truth of the Dharma" (*dharmatattvārthasaṅketa*), and it is also called "the maṇḍala of the mind" (*cittamaṇḍala*) and "the supreme great castle of liberation" (*mahāmokṣapuram varam*).[867] Therefore the view that would regard the maṇḍala as a symbol of the mind or enlightenment cannot necessarily be regarded as a misinterpretation.

The *skandhadhātvāyatana* theory of the *Guhyasamājatantra* discussed in chapters 5–7 analyzed all existents (*sarvadharma*) into various doctrinal categories and assigned them to deities in the maṇḍala. According to the Bodhicitta verse inherited by the *Guhyasamāja* from the *Vairocanābhisambodhisūtra*, there exist neither *skandhadhātvāyatana* nor subject and object on the level of absolute truth.

Thus the maṇḍala may be regarded as a symbol of the entire world that we are experiencing rather than a mere ideational psychogram. Therefore the expression "maṇḍala of the mind" does not signify an idealism denying the existence of the outer world, and it should be interpreted as a symbol of enlightenment in which the duality of subject and object no longer exists. The other expression, "supreme great castle of liberation," could be said to be in line with the interpretation of the maṇḍala as symbolizing the taintless dharmas, or *dharmakāya*, such as the thirty-seven prerequisites for the attainment of enlightenment, which became one of the representative interpretations of the maṇḍala along with the *skandhadhātvāyatana* theory.

9. The Role of Male and Female Deities and Their Symbolism in the Maṇḍala

It should be evident by now that the symbolism of the maṇḍala is by no means uniform, and in many cases a single maṇḍala can be interpreted in a multilayered fashion. However, the most typical interpretation is the *skandhadhātvāyatana* theory that originated in the *Guhyasamājatantra*.

The *Kālacakratantra*, which further developed the maṇḍala theory of the *Guhyasamāja*, added action organs and their activities to the *skandhadhātvāyatana* theory, and it thus became possible to represent the entire world that we experience by means of thirty-six deities, the principal members of the maṇḍala. These thirty-six deities consist of eighteen male and eighteen female deities. The male deities are assigned to the six aggregates, six sense organs, and six action organs, while the female deities are assigned to the six elements, six sense objects, and the activities of the six action organs. The *Vimalaprabhā* referred to this relationship between male and female deities as that of apprehended and apprehender (*grāhya-grāhaka*) or object and subject (*viṣaya-viṣayin*).

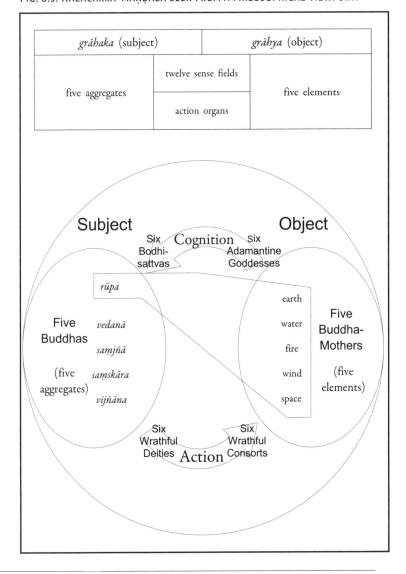

FIG. 8.5. KĀLACAKRA-MAṆḌALA SEEN FROM A PHILOSOPHICAL VIEWPOINT

The five aggregates are doctrinal categories that analyze the subject from the viewpoint of Buddhism. The four elements (*dhātu*), on the other hand, are the material causes of the physical world, corresponding to the object. It goes without saying that the six sense organs and six action organs are associated with the subject, while the six sense objects and activities of the six action organs are associated with the object.

Thus the maṇḍala theory of the *Kālacakra* added the action organs and their activities, which were missing in the *skandhadhātvāyatana* system of the *Guhyasamāja*, and assigned the subjective elements to male deities and the objective elements to female deities. In the Kāyavākcittapariniṣpanna-Kālacakra-maṇḍala, all of the five buddhas and five buddha-mothers,[868] six bodhisattvas and six adamantine goddesses, and six wrathful deities and their consorts are depicted as couples, or *yuganaddha*.

The father-mother image is thought to have first appeared in Father tantras, starting with the *Guhyasamāja*. The *Mukhāgama*, which systematized the sexology of late tantric Buddhism, incorporated the twelve limbs of dependent origination into the production of the maṇḍala. According to the *Mukhāgama*, the father-mother couples fulfill the function of giving birth to the deities in the limbs of dependent origination corresponding to *vijñāna*, or "consciousness," and *upādāna*, or "attachment."

It was noted above that in late tantric Buddhism the maṇḍala deities are considered to symbolize the world of sentient beings. Therefore the introduction of sexology into the visualization of the maṇḍala is thought to have had the aim of purifying the process of cyclic existence.

In Buddhajñānapāda's works it is clearly stated that the primordial buddha, or "Causal Vajradhara," and Mañjuvajra, the main deity of the maṇḍala, have their own consorts, but there is no mention of the consorts of other deities. In the visualization corresponding to the six sense fields (*ṣaḍāyatana*) among the twelve limbs of dependent origination, the assignment of six great bodhisattvas to the six sense fields is explained. But as is clear in a Sanskrit commentary on the *Samantabhadra nāma sādhana*,[869] six adamantine goddesses are depicted in the nineteen-deity maṇḍala of the Jñānapāda school and the six great bodhisattvas are not counted among the nineteen deities.

In later commentaries belonging to the Jñānapāda school[870] and in most extant examples from Tibet,[871] all of the nineteen deities of the Jñānapāda school become father-mother couples. In these cases, the six adamantine goddesses symbolizing the six sense fields form couples with the six great bodhisattvas symbolizing the six sense organs.

In the Kāyavākcittapariniṣpanna-Kālacakra-maṇḍala most of the deities become father-mother couples, except for the eight female deities starting with Kṛṣṇadīptā in the wheel of great bliss and the sixty-four *yoginīs* in the Speech maṇḍala. Furthermore, not only the six adamantine goddesses symbolizing the six sense fields and the six great bodhisattvas symbolizing the six sense organs but also the six wrathful deities symbolizing the six action organs and their consorts symbolizing the activities of the action organs form couples.

In the comparatively early stages of late tantric Buddhism, only the primordial buddha and the main deity of the maṇḍala formed couples. They were thought to symbolize the non-dual nature of wisdom (*prajñā*) and means (*upāya*), and the practice of calling a female deity *prajñā* and a male deity *upāya* was fairly widespread. But the buddha-mother Prajñāpāramitā does not always form a couple with a male deity symbolizing means.

The *Kālacakratantra* assigned opposing concepts such as the six sense fields and six sense organs or the six action organs and their activities to male and female deities who form couples. Thus the father-mother couple came to be used to symbolize the relationship between subject and object.

Mahāyāna Buddhism teaches that the duality of subject and object does not exist on the level of absolute truth, since subject and object are created by the conceptual discrimination of unenlightened people. The *Kālacakratantra* assigned subject and object to thirty-six male and female deities who are, however, all depicted as father-mother couples, regardless of whether the male or female is the principal deity of the pair. In this way, the *Kālacakratantra* represented all male and female deities, symbolizing subject and object, as father-mother couples. It is to be surmised that the *Kālacakratantra* intended to show by this means that the duality of subject and object is false on the level of absolute truth.

10. What Did the Maṇḍala Ultimately Come to Represent?

In late tantric Buddhism after the ninth century, the *skandhadhātvāyatana* system that originated in the *Guhyasamājatantra* became a typical interpretation of the maṇḍala. Later, the *Kālacakratantra*, the last tantric system to appear in India, further developed it and brought to completion a system that symbolizes the entire world that we are experiencing by means of male and female deities assigned to subject and object.

The idea of the nonduality of subject and object in the realm of enlightenment has occupied an important position in Eastern thought from the *Madhyāntavibhāga* down to the Japanese philosopher Nishida Kitarō's "pure experience prior to differentiation of subject and object." However, it has not been clear what this really means, since many different interpretations coexist. In this section I accordingly wish to consider what the maṇḍala ultimately came to represent, focusing mainly on the question of subject and object in the *Kālacakratantra*.

The maṇḍala is generally thought to be a still image. However, time plays an important role when the maṇḍala is visualized. For example, when visualizing the maṇḍala, the pavilion in which the deities assemble is visualized first, and this parallels the process whereby the world system centered on Mount Sumeru appears at the beginning of an eon through the merging of the four elements and also the process whereby the fetus develops in the womb after conception.

Again, when the deities are dismissed from the maṇḍala, first the attendant deities are dismissed, and the main deity is dismissed last. This parallels the process whereby the world system disappears at the end of an eon through the dissolution of the four elements and also the process whereby a sentient being is destined to die on account of the dysfunctioning of the four elements constituting the body.

In the Kāyavākcittapariniṣpanna-Kālacakra-maṇḍala, deities symbolizing the 360 days of the year and the orbits of celestial bodies are depicted. In this way, the *Kālacakratantra* introduced a temporal element into the maṇḍala, and by focusing on the "wheel" or cycle of time (*kālacakra*) it could be said to have attempted to integrate the entire system of earlier esoteric Buddhism. But why were the Buddhists who composed the *Kālacakratantra* so concerned about cycles of time? This is thought to have been related to another characteristic of the *Kālacakra*, astronomy and the study of the calendar.

Buddhism is a creed that does not recognize the existence of a single and absolute supreme deity and is centered on a belief in a universal law (*dharma*) applicable to all existents. This *dharma* has two aspects, that of a moral law of retributive justice and that of a physical law of causality. Buddhism prior to the *Kālacakratantra* had tended to emphasize moral law represented by retributive justice, whereas the *Kālacakratantra* would seem to have placed greater emphasis on physical laws of causality as the supreme principle.

In ancient times, when science had not yet developed, the existence of physical laws of causality was not so self-evident as it is today. However, the authors of the *Kālacakratantra* possessed advanced knowledge of astronomy. Their astronomy was a geocentric theory completely different from modern astronomy. Nonetheless, they were able not only to analyze the movements of celestial bodies but also to predict their future movements with considerable accuracy because they posited a Ptolemaic epicycle of planets around Mount Sumeru and knew how to correct the equation of the center that arises from the ellipticity of a planet's orbit. Such knowledge convinced them that the universe moves in temporal cycles, and this may have been one of the reasons that made them conceive of the idea of the supreme principle *kālacakra*.

This is comparable to the historical fact that Newton's discovery of the law of gravitation completely changed the view of nature in Europe and also encouraged the development of modern philosophy, beginning with Kant. Regrettably, owing to external factors in the form of the Muslim invasion, the *Kālacakratantra* had no successor in the intellectual world of India. Nevertheless, it can be recognized that the *Kālacakratantra* had ideas rather similar to the physical laws of causality in modern science.

Vesna A. Wallace has discussed the evaluation of secular sciences in the *Kālacakratantra*,[872] and according to her research, secular sciences are necessary for bodhisattvas to save sentient beings even though they belong only to the realm of conventional truth. However, they are forms of secular knowledge and differ from the Buddha's self-evidencing knowledge, which transcends the sense organs (*nirindriyaṃ svasaṃvedyaṃ jñānam*).

Buddhism regards the Buddha as an omniscient being (*sarvajña*) who can perceive everything in the past, present, and future. There has since early times been much debate about the scope of the Buddha's omniscience.[873] However, Mahāyāna and esoteric Buddhism assert that the Buddha can, if he so wishes, perceive everything in the infinite past and foresee anything in the distant future. That the Buddha can prophesy a certain sentient being's enlightenment, the name of his realm, and his name as a buddha in future eons certainly presupposes the omniscience of the Buddha.

When considered in this light, there are several episodes in the biography of the historical Buddha Śākyamuni that are at variance with such omniscience. Why, for example, did he beg for alms in the village of Pañcasāla, where he would not be given anything because many of the villagers were brahmins? And why did he ordain Devadatta and Sunakṣatra, who would bring much trouble to the Saṃgha? As Kawasaki Shinjō has pointed out, Buddhism has provided various apologias for responding to such criticism.[874] But it has to be said that it was impossible to make Śākyamuni, a real historical figure, an omniscient being as defined in Mahāyāna and esoteric Buddhism.

Such omniscience of the Buddha entails the same problems as the paradox of Laplace's demon in modern philosophy. That is to say, if the future is completely determined by the physical laws of causality and we can predict it by mathematical analysis, this future pre-

diction cannot be realized because if the result is unfavorable for a particular individual, he will take evasive action.

There exist various interpretations of this paradox, but in the context of Buddhism it is in itself erroneous to interpret the world on the basis of the duality of the physical world, to which the physical laws of causality are applicable without exception, and an individual, who has free will independent of the external world. This has something in common with the idea that the duality of subject and object exists in the cognition of an unenlightened being, whereas there exist neither subject nor object in the realm of enlightenment, an idea on which, ever since the *Madhyāntavibhāga*, much importance was placed in Mahāyāna and esoteric Buddhism.

The reason that the *Kālacakratantra* assigned subject and object to male and female deities and then represented them as father-mother couples was to show the limits of perceptual knowledge, premised on the duality of subject and object, and the Buddha's self-evidencing knowledge, which transcends the senses.

The *Kālacakratantra* placed great importance on physical laws of causality and applied mathematical analysis to the path to enlightenment, as can be seen in the accumulation of *bodhicitta* in the completion stage.[875] Even the *Kālacakratantra* teaches that the *skandhadhātvāyatana*, based on the duality of subject and object, disappear in the final stage of practice, whereupon there appears an imperishable drop (*bindur acyutaḥ*), representing the merging of both.

The *skandhadhātvāyatana* are tainted dharmas and do not in themselves constitute the world of enlightenment. But tantric Buddhism used the maṇḍala as a means not to negate or nullify the real world consisting of tainted dharmas but to change our view of it.

The maṇḍala theory of the *Kālacakratantra*, which represents the world that we experience by means of male and female deities symbolizing the duality of subject and object and which also shows that they are ultimately false on the level of absolute truth, was a fitting system with which to cap not only Buddhist doctrine, which had developed over the course of 1,700 years, but also Buddhist art, with a history of 1,200 years, and the development of the maṇḍala, which occurred over a period of 600 years, as described in this book.

11. Concluding Remarks

The development of esoteric Buddhist scriptures is set out in fig. 8.6, which I first used in *Maṇḍala Iconology* (1987). I have gradually refined this chart over the years, and some further improvements have been made on the basis of the findings described in this book.

The maṇḍala of early esoteric Buddhism, consisting of three families, developed from the triad of Śākyamuni, Avalokiteśvara, and Vajrapāṇi. In the landscape maṇḍala, the prototype of the maṇḍala that presents a bird's-eye view of the assembly of deities, there did not exist any geometrical patterns, characteristic of later maṇḍalas. In the *Mahāmaṇivipulavimānakalparāja*, an early esoteric Buddhist scripture, the differentiation between painted icons for the purpose of worship (*paṭa*) and the maṇḍala had already begun.

In the maṇḍala of the *Mañjuśrīmūlakalpa*, three outer squares in which various Hindu deities are arranged were added to an inner square similar to that of a landscape maṇḍala. This is thought to have been the first step toward the emergence of the maṇḍala with geometrical patterns. The Garbha-maṇḍala described in the *Vairocanābhisambodhisūtra*

FIG. 8.6. HISTORICAL DEVELOPMENT OF INDIAN ESOTERIC BUDDHISM

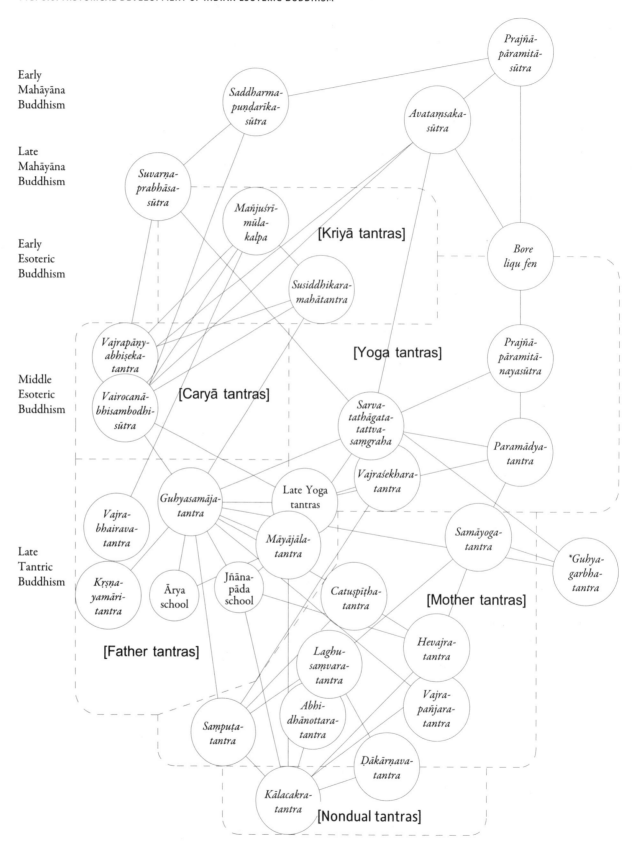

Early
Mahāyāna
Buddhism

Late
Mahāyāna
Buddhism

Early
Esoteric
Buddhism

Middle
Esoteric
Buddhism

Late
Tantric
Buddhism

Prajñā-pāramitā-sūtra

Saddharma-puṇḍarīka-sūtra

Avataṃsaka-sūtra

Suvarṇa-prabhāsa-sūtra

Mañjuśrī-mūla-kalpa

[Kriyā tantras]

Bore liqu fen

Susiddhikara-mahātantra

Vajrapāṇy-abhiṣeka-tantra

[Yoga tantras]

Prajñā-pāramitā-nayasūtra

Vairocanā-bhisambodhi-sūtra

[Caryā tantras]

Sarva-tathāgata-tattva-saṃgraha

Paramādya-tantra

Guhyasamāja-tantra

Late Yoga tantras

Vajraśekhara-tantra

Vajra-bhairava-tantra

Māyājāla-tantra

Samāyoga-tantra

**Guhya-garbhatantra*

Kṛṣṇa-yamāri-tantra

Ārya school

Jñāna-pāda school

Catuṣpīṭha-tantra

[Mother tantras]

Hevajra-tantra

[Father tantras]

Laghu-saṃvara-tantra

Vajra-pañjara-tantra

Saṃpuṭa-tantra

Abhi-dhānottara-tantra

Ḍākārṇava-tantra

Kālacakra-tantra

[Nondual tantras]

represents the culmination of maṇḍalas of the three-family system that had developed from the earlier triad. In the Garbha-maṇḍala, the second square with Śākyamuni and Hindu deities and the third square with bodhisattvas centered on Mañjuśrī and selected from listeners of Mahāyāna sūtras were added to an inner square consisting of three families, the Buddha family in the east (upper part), the Lotus family in the north (left), and the Vajra family in the south (right). These maṇḍalas with the three Buddha, Lotus, and Vajra families arranged in the upper part and on the left and right of the canvas, respectively, were basically horizontally symmetrical, but it was difficult to create a maṇḍala completely symmetrical both horizontally and vertically, since the Hindu deities were originally depicted in the lower part of the canvas.

The maṇḍalas of the *Prajñāpāramitānayasūtra*, on the other hand, are characterized by the deification of doctrinal propositions for the first time. Doctrinal propositions are arranged in groups of four or five, except in the first section, and so the maṇḍala deities, who are deifications of these propositions, also form groups of four or five. Thus a maṇḍala that is completely symmetrical, both vertically and horizontally, could be easily created. But even in the *Paramādyatantra*, a developed form of the *Prajñāpāramitānayasūtra*, the maṇḍala basically consists of four families, with the Jewel (Maṇi) family having been added to the traditional three families (Buddha, Lotus, and Vajra). The completion of the fivefold system, including the Karma family, had to await the advent of the Vajradhātu-maṇḍala.

The Vajradhātu-maṇḍala described in the *Sarvatathāgatatattvasaṃgraha* classifies all the deities into five families—Tathāgata, Vajra, Ratna (Jewel), Padma (Lotus), and Karma (Action)—and arranges the deities of these five families in the center and four cardinal directions. Thus there was created a maṇḍala completely symmetrical, both horizontally and vertically. These five families of the *Sarvatathāgatatattvasaṃgraha* develop through mutual encompassment into twenty-five, one hundred, and then innumerable families. With the idea of mutual encompassment, the *Sarvatathāgatatattvasaṃgraha* succeeded in systematically classifying and arranging the deities, mudrās, mantras, *dhāraṇīs*, and symbols that had been steadily growing in number since early esoteric Buddhism.

The *Guhyasamājatantra* is essentially based on the fivefold system of the Vajraśekhara cycle, but it also introduced the *skandhadhātvāyatana* system, which assigns the five aggregates, four elements, and twelve sense fields to the deities of the maṇḍala. Herewith there appeared a maṇḍala theory that symbolized the entire world with a limited number of deities.

The Mother tantras, on the other hand, evolved from the *Samāyogatantra*, a developed form of the *Paramādyatantra*. But the *Hevajratantra* and Saṃvara cycle, representing further developments of the Mother tantras, adopted the *skandhadhātvāyatana* system that had originated in the Guhyasamāja cycle. A distinctive feature of the Saṃvara cycle is the assigning of the thirty-seven prerequisites for the attainment of enlightenment to the maṇḍala deities.

The *Kālacakratantra* synthesized the maṇḍala theory of the Father and Mother tantras and established a monumental system unprecedented in the history of esoteric Buddhism. It was thus not only the last Buddhist scripture to appear in India but also the culmination of the development of Indian Buddhism over a period of 1,700 years. The Kāyavākcittapariniṣpanna-Kālacakra-maṇḍala is nothing other than a pictorial representation of this system. The *Kālacakratantra* created a system that symbolizes the entire world

that we are experiencing by adding the action organs and their activities to the *skandha-dhātvāyatana* theory of the *Guhyasamāja*. It also showed that the duality of subject and object underlying the world that we are experiencing is false on the level of absolute truth.

The maṇḍala was originally no more than an icon used as an object of worship. Later it became a magnificent form of religious art that gave expression to Buddhist thought through the assignment of doctrinal categories to deities. The six hundred years of Indian esoteric Buddhism that concluded the 1,700-year history of Indian Buddhism could also be said to have been the history of the development of the maṇḍala.

Postscript

THE ORIGINAL JAPANESE EDITION of this book, titled *The Genesis and Development of the Maṇḍala in India*, was published in 2010 and awarded the Suzuki Research Foundation Special Prize in 2013. It had already sold out by 2014, and in view of the depressed state of the Japanese publishing industry, I felt that it would be difficult to have it reprinted. I accordingly began to translate it into English, since interest in Indo-Tibetan Buddhism has been growing in the West, and this task has taken the best part of three years to complete.

This Wisdom edition also contains some new material. After the publication of the Japanese edition, several important studies on esoteric Buddhism and Buddhist iconography appeared both in Japan and elsewhere, and these have been mentioned chiefly in newly added footnotes. I have also added references to English translations of texts and articles to which I referred, and have supplemented the illustrative material with new photographs that I took in Bangladesh, in upper Mustang, and at Raja monastery in Amdo. (Part 2 of the Japanese edition, which contained a critical edition and annotated translation of the Sanskrit texts of two important works on the maṇḍala, the *Viṃśatividhi* by Nāgabodhi and an incomplete Sanskrit commentary on the *Samantabhadra nāma sādhana* by Buddhajñānapāda, has been omitted. A Japanese/English bilingual version of my study of the *Samantabhadra nāma sādhana* has since been published [Tanaka 2017a].)

Buddhist studies in Japan is currently facing unprecedented difficulties. As the first modernized nation in Asia, Japan had enjoyed the position of leader in Buddhist studies among traditional Buddhist countries. But because of a declining birthrate, Japanese universities are now suffering from a shortage of new entrants. Especially in private universities established by Buddhist sects, which have many chairs in Buddhist studies, low enrollment has become a serious problem, and they are being compelled to abolish nonessential courses. In national universities, the other centers of Buddhist studies, chairs in Buddhist studies have been reduced as a result of university reforms.

Japan will, I believe, continue to be a leading country in Buddhist studies in fields that bear closely on Japanese Buddhism. But in fields that have no direct connection to Japanese Buddhism, it is becoming very difficult to obtain research positions at universities or research institutes attached to universities. Unfortunately, late tantric Buddhism, Tibeto-Nepalese Buddhism, and Dunhuang esoteric Buddhism, the main subjects of this book, fall under this category.

In the West, on the other hand, Tibetan Buddhism has grown in popularity since the exile of spiritual leaders of Tibetan Buddhism, starting with the Fourteenth Dalai Lama, after the uprising in 1959. Chairs for Tibetan studies have been established in prestigious

universities, and some schools of Tibetan Buddhism have set up universities or colleges in the West. I have received many inquiries about esoteric Buddhism and Buddhist iconography from young scholars overseas, and the time has come to hand over the fruits of Buddhist studies hitherto accumulated in Japan to such dedicated researchers.

This volume should provide some new information to non-Japanese readers interested in esoteric Buddhism and Buddhist iconography, and it will, I hope, contribute to academic exchange between Japan and other countries. I look forward to presenting copies to teachers, former colleagues, and friends abroad.

Lastly, I would like to offer my heartful thanks to all those who have helped in the preparation of this publication, including Rolf Giebel, who helped with the English translation; the Japan Society for the Promotion of Science, which provided financial support for the translation from fiscal 2011 to fiscal 2013; the Archaeological Survey of India, Bangladesh National Museum, the Hahn Cultural Foundation (Seoul), Katō Kei, Christian Luczanits, the Metropolitan Museum of Art, Mori Kazushi, the State Hermitage Museum, Taiyūji temple (Osaka), Tajimi Miyoko, Tōji temple (Kyoto), and Ulrich von Schroeder, all of whom kindly provided me with valuable photographs; and Mary Petrusewicz and Ben Gleason of Wisdom Publications, who undertook to publish this book with great care.

List of Tibetan Terms

Bido	'Bis mdo
Butön	Bu ston
Döndrup Rinchen	Don grub rin chen
Dorying Lhakhang	Rdor dbyings lha khang
Drimé Drakpa	Dri med grags pa
Gawai Pal	Dga' ba'i dpal
Gyantse	Rgyal rtse
Jamdun	Byams mdun
Jampa Lhakhang	Byams pa lha khang
Jamyang Khyentse Wangpo	'Jam dbyangs mkhyen brtse'i dbang po
Jamyang Loter Wangpo	'Jam dbyangs blo gter dbang po
Kagyü	Bka' brgyud
Kyilkhor Lhakhang	Dkyil 'khor lha khang
Labrang	Bla brang
Lhai Jangchup	Lha'i byang chub
Lha Rinpoché	Lha rin po che
Lhatsenpo Shiwa Ö	Lha btsan po zhi ba 'od
Lhatsunpa Jangchup Ö	Lha btsun pa byang chub 'od
Lima Lhakhang	Li ma lha khang
Lölang Kyilkhor Khang	Blos bslangs dkyil 'khor khang
Losang Chökyi Gyaltsen	Blo bzang chos kyi rgyal mtshan

Marpa	Mar pa
Naktso	Nag tsho
Namnang Lhakhang	Rnam snang lha khang
Nesar	Gnas gsar
Ngorchen Kunga Sangpo	Ngor chen Kun dga' bzang po
Nyangtö	Myang stod
Nyingma	Rnying ma
Okmin	'Og min
Palkhor Chöde	Dpal 'khor chos sde
Rapten Kunsang Phakpa	Rab brtan kun bzang 'phags pa
Rinchen Sangpo	Rin chen bzang po
Rongtha Losang Damchö Gyatso	Rong tha Blo bzang dam chos rgya mtsho
Sakya	Sa skya
Sangden	Gsang ldan
Shalu	Zhwa lu
Shiwa Ö	Zhi ba 'od
Sönam Gyatso	Bsod nams rgya mtsho
Trangu	Khra 'gu
Trangu Rinpoche	Khra 'gu rin po che
Tride Songtsen	Khri lde srong btsan
Tsongkhapa	Tsong kha pa
Yumchenmo Lhakhang	Yum chen mo lha khang

List of Chinese, Japanese, and Korean Terms

Aizen mandara	愛染曼荼羅
Anshōji	安祥寺
Anxi	安西
Baoxianglou	寶相樓
besson mandara	別尊曼荼羅
bietan	別壇
Bimi jihui yuga	祕密集會瑜伽
Bodaijō mandara	菩提場曼荼羅
Butsugen mandara	佛眼曼荼羅
Buzan	豐山
Chang'an	長安
Cining gong	慈寧宮
Da anle bukong sanmeiye zhenshi	大安樂不空三昧耶眞實
Da anle bukong sanmeiye zhenshi yuga	大安樂不空三昧耶眞實瑜伽
Daigoji	醍醐寺
Daihi taizō sanmaya mandara	大悲胎藏三昧耶曼荼羅
Daikakuji	大覺寺
Da sanmeiye yuga	大三昧耶瑜伽
Da sanmeiye zhenshi yuga	大三昧耶眞實瑜伽
Dasheng xianzheng yuga	大乘現證瑜伽

Dongshentongsi	東神通寺
Donjaku	曇寂
Dunhuang	敦煌
Einin	永仁
Eizan	叡山
Enchin	圓珍
Enjōji	圓成寺
Faxian	法賢
gakuryo	學侶
Gekongō-bu	外金剛部
Genroku	元祿
Genzu mandara	現圖曼荼羅
geyi	格義
Gobu shinkan	五部心觀
Godai'in Annen	五大院安然
Gonda Raifu	權田雷斧
Gōzanze-e	降三世會
Gōzanze-sanmaya-e	降三世三昧耶會
gyōnin	行人
Henchi-bu	遍知部
Henchi-in	遍知院
hijiri	聖
Hirosawa	廣澤
Hōbodai'in	寶菩提院
Hokke mandara	法華曼荼羅
Hōrōkaku mandara	寶樓閣曼荼羅
Huayan	華嚴

Huiguo	惠果
Huiyu	灰欲
huxiang sheru	互相涉入
Ichiin-e	一印會
Ichiinne	一印會
Jianfusi	薦福寺
Jimyō-bu	持明部
Jimyō-in	持明院
jingang	金剛
Jingang baoguan yuga	金剛寶冠瑜伽
Jingang chengsheng mantuluo	金剛城勝曼荼羅
jitō	事塔
Jōdo	淨土
Jōgon	淨嚴
Jōjin-e	成身會
Jōjinne	成身會
Kaifuhuawang	開敷花王
Kannon-bu	觀音部
Kawaguchi Ekai	河口慧海
Kissui	吉水
kōdō	講堂
Kōgen	孝源
Kojima	子島
Kokūzō-in (*also* Kokuzō-in)	虛空藏院
kondō	金堂
Kōnen	興然
Kongō-bu	金剛部

Kongōchōkyō	金剛頂經
Kongōkai	金剛界
Kongōshu-in	金剛手院
Kōyasan	高野山
Kue mandara	九會曼荼羅
Kūkai	空海
Kushūon'in	久修園院
Kuyō-e	供養會
Kyŏngju	慶州
Longxingsi	龍興寺
Misai-e	微細會
Mogao	莫高
Monju-bu	文殊部
Nati	那提
Nezu	根津
Ninnaji	仁和寺
Ninnōkyō gohō shosonzu	仁王經五方諸尊圖
Ninnōkyō mandara	仁王經曼荼羅
Ōmura Seigai	大村西崖
Onjōji	園城寺
Ono Genmyō	小野玄妙
Puxian yuga	普賢瑜伽
Qianlong	乾隆
Rengebu-in	蓮華部院
Rishu-e	理趣會
Rishu-e mandara	理趣會曼荼羅
Rishukyō kuyō mandara	理趣經供養曼荼羅

Rishukyō mandara	理趣經曼荼羅
Ritasōgyara gobu shinkan	哩多僧蘗囉五部心觀
ritō	理塔
Riyuesheng	日月勝
Rulai sanmeiye zhenshi yuga	如來三昧耶眞實瑜伽
Ru xukong yuga	如虛空瑜伽
ryōbu mandara	兩部曼荼羅
ryōkai mandara	兩界曼荼羅
Ryūkōin	龍光院
Saeki Shungen	佐伯俊源
Saichō	最澄
Saidaiji	西大寺
Saidaiji taikan	西大寺大鑑
Sanjūshichison-yō	三十七尊樣
Sanmaya-e	三昧耶會
Sanmeiye zuisheng yuga	三昧耶最勝瑜伽
Shaka-bu	釋迦部
Shaoxing	紹興
Shengchu	勝初
Shengchu yuga	勝初瑜伽
Shidaigo-in	四大護院
Shiin-e	四印會
Shiinne	四印會
Shijian chushijian jingang yuga	世間出世間金剛瑜伽
shijie huju	十界互具
shiki-mandara	敷曼荼羅
shimyō	四明

Shin'an	新安
shinbutsu shūgō	神佛習合
Shingi Shingon	新義眞言
Shingon	眞言
Shinjaku	眞寂
shishō	四攝
Shōjōin	清淨院
shōmyō	聲明
Shōren'in	青蓮院
Shosetsu fudōki	諸說不同記
Shōugyō mandara	請雨經曼荼羅
Shūei	宗叡
Shuizizai	水自在
Shunxiao	順曉
Sōkaku	宗覺
Sŏkkuram	石窟庵
sonkaku	尊格
sonkaku-shi	尊格史
Sonshō mandara	尊勝曼荼羅
Soshitsuji-in	蘇悉地院
Suoluoshuhua Pubiankaifuwang	娑羅樹華普遍開敷王
Suoluoshuwang Huakaifu	娑羅樹王花開敷
Tada Tōkan	多田等觀
Taizō	胎藏
Taizō kyūzuyō	胎藏舊圖樣
Taizō zuzō	胎藏圖像

Tajimi Miyoko	多治見美代子
Takao	高尾
Ten-bu	天部
Tendai	天台
tendoku	轉讀
Tentokuin	天德院
Tiantai	天台
Tōji	東寺
Waijingang hui zhang	外金剛會章
Wu'er pingdeng yuga	無二平等瑜伽
Xiangsanshi jingang yuga	降三世金剛瑜伽
Xixia	西夏
Xuanzang	玄奘
Xukongku	虛空庫
Xukongyun	虛空孕
Xukongzang	虛空藏
Yamamoto Mosuke	山本茂助
Yijing	義淨
yinian sanqian	一念三千
Yiqiefo jihui najini jiewang yuga	一切佛集會拏吉尼戒網瑜伽
Yiqie jiaoji yuga	一切教集瑜伽
Yiqie rulai bimiwang yuga	一切如來祕密王瑜伽
Yiqie rulai zhenshishe jiaowang	一切如來眞實攝教王
Yuezhou	越州
Yulin	榆林
Zentōin	前唐院

Notes

1. The term "two-world maṇḍalas" (*ryōkai mandara*) is thought to have been first used by Godai'in Annen (841–?) of the Tendai school, and because of its associations with the Tendai sect, there are even today many scholars of the Shingon sect who instead use the term "maṇḍalas of the two divisions" (*ryōbu mandara*). However, the term "two-world maṇḍalas" is widely used by art historians and is also used in the designation of national treasures and important cultural properties. The original designation of the Garbha-maṇḍala was *Mahākaruṇāgarbha-maṇḍala (maṇḍala [born] of the womb of great compassion), but once it began being used in conjunction with the Vajradhātu-maṇḍala, it came to be known as the Garbhadhātu-maṇḍala. In this book, which deals mainly with the historical development of the maṇḍala in India, I use the term "Garbha-maṇḍala."

2. It is very difficult to determine the number of maṇḍalas transmitted in Tibetan Buddhism. However, there exist in Tibet several compendia of maṇḍalas. For example, the *Vajrāvalī* maṇḍala set consists of 45 maṇḍalas, the *Mitra brgya rtsa* set consists of 108 maṇḍalas, and the Ngor maṇḍala set consists of 140 maṇḍalas. The *Rin chen gter mdzod* maṇḍala set of the Nyingma school (held by the Hahn Cultural Foundation), which brings together maṇḍalas of the *gter ma* cycle, contains 176 maṇḍalas, but most of them originated in Tibet and are outside the scope of this book.

3. The maṇḍala for the *Bhaiṣajyagurusūtra* rite of Tibet, which was transmitted during the time of the Tufan kingdom, has no circular outer enclosure, and only a square pavilion is depicted. In some examples, the four gates of the maṇḍala are depicted as if seen from afar. See Tanaka 2005a, plate 10.

4. In this book Japanese names are given in their original order, with the family name preceding the given name.

5. Mori 2001a, 235–36.

6. Miyaji 2007, 163.

7. Yoritomi 2000; 2004b.

8. Nakamura, R. 2002; 2004.

9. When Toganoo began studying Tibetan materials, there was no copy of the Tibetan Tripiṭaka on Mount Kōya, and he had to borrow and copy the Peking edition held by Ōtani University and the Narthang edition brought back to Japan by Kawaguchi Ekai (see Toganoo 1927, Introduction).

10. Yamamoto 1967–68.

11. Takata, N. 1978.

12. On Guimet's three-dimensional maṇḍala, see Jarrige et al. 1989.

13. For critiques of Jung's interpretation of the maṇḍala from the standpoint of Buddhist studies, see Tanaka et al. 2001 and Mori 2005. Watanabe, M. 2005 is a response by a religious scholar to my criticism of Jung.

14. For a biography of Govinda, see Winkler 1990.

15. See Tanaka 1990b.

16. Śubhākarasiṃha, in his commentary on the *Vairocanābhisambodhisūtra*, suggests that reference be made to the *Daji xukongzang pusa suowen jing* with respect to Ākāśagarbha as depicted in the Garbha-maṇḍala (T. 1796.39.635c). This needs to be further investigated.

17. In Gandharan buddha images the robe covers both shoulders, whereas in Mathuran images the robe is worn so as to reveal the right shoulder. However, the influence of the Gandharan style can be seen in sculptures in the early Mathuran style, such as five scenes from the Buddha's life in the Government Museum, Mathura.

18. The iconography of the main deity of the Vajrāsana is explained in the "Vajrāsanasādhana" in the *Sādhanamālā* (Bhattacharya 1968a, nos. 3–5). In these *sādhanas*, Maitreya is the right-hand attendant while Lokeśvara is the left-hand attendant. It should be noted that Lokeśvara is another name for Avalokiteśvara in late tantric Buddhism. In the present Mahābodhi temple, the main deity enshrined inside the temple has no attendants, whereas the gilded panel in front of the Vajrāsana shows a triad consisting of the Buddha, Maitreya, and Avalokiteśvara.

19. No examples of the triad of Śākyamuni, Mañjuśrī, and Samantabhadra have been found in India. However, its Indian origin is confirmed by the fact that this combination is based on the *Gaṇḍavyūha*.

20. Sadakane Keiji (1994) has put forward the new theory that the gatekeepers hitherto thought to be bodhisattvas in the Ajantā caves are *yakṣas* mentioned in the *Mūlasarvāstivādavinaya*. Nagata Kaoru (2003) also basically supports this thesis. However, I am of the view that there was an independent tradition of gatekeepers in esoteric Buddhism, such as Lokātikrāntagāmin and Ajitaṃjaya in the *Mañjuśrīmūlakalpa* (see figs. 2.7 and 2.8) and Durdharṣa and Abhimukha in the *Vairocanābhisambodhisūtra* (see fig. 2.19). Although Sadakane accepts that the attendant bodhisattvas in Cave 17 at Ajantā are Vajrapāṇi and Padmapāṇi, he reserves judgment as to whether or not they are bodhisattvas.

21. In Tibetan Buddhism, Mahāsthāmaprāpta (Tib. mThu chen thob), or "one who has great power," is considered to be another name for Vajrapāṇi.

22. T. 310(3).11.68a.

23. Juhyung Rhi has surveyed recent studies on the stele unearthed at Mohammed Nari; see Saitō 2007, 134–45.

24. Buddha images that, judging from their inscriptions, are highly likely to represent Amitābha (apart from representations of the five buddhas of esoteric Buddhism) include the central figure displaying the dharma-wheel

mudrā in a triad from Gandhāra that was reported by Charles Kieffer and identified by John Brough (although Schopen has raised objections regarding the decipherment of the Kharoṣṭhī inscription), a seated tathāgata displaying the dharma-wheel mudrā held by Patna Museum, and a seated tathāgata from Nālandā held by the Archaeological Museum at Nālandā (missing both hands but surmised to have formed the dharma-wheel mudrā on account of the position of the arms and remnants of the hands in front of the abdomen). The example in the Government Museum, Mathura, cited by Nakamura Hajime (1980, 493–95) is important since Amitābha's name is confirmed by the inscription, although the body above the ankles has been lost and we cannot determine the mudrā. For further details on Gandharan images of Amitābha, see Tanaka 2016a.

25. Sadakane 1994, 89–90.

26. Lalou 1930.

27. Tanaka 2000b, plate 38.

28. Bo dong phyogs las rnam rgyal 1976.

29. Vaidya 1964, 44.

30. A relief of a triad centered on a buddha displaying the dharma-wheel mudrā whose seat is supported by two *nāga* kings is found at the entrance to Cave 8 at Kārlā.

31. Satō, S. 1985, 131.

32. Vaidya 1964, 43; T. 1191.20.861c.

33. T. 1185.20.794c.

34. T. 1101.20.453b. In this case, Hayagrīva is thought to be seated on a lotus throne supported by *nāga* kings.

35. T. 1116.20.505a. In this case, Avalokiteśvara is seated on a lotus throne supported by *nāga* kings.

36. Among these buddhas, those in the four corners are seated and display the dharma-wheel mudrā, as does the main deity, whereas the four buddhas on the outer edge on both sides are standing buddhas displaying the boon-granting mudrā with the right hand.

37. See chapter 3, section 4.

38. As examples of a maṇḍala of the *Bhaiṣajyagurusūtra* rite without a circular outer enclosure, one can point to a woodblock print in the Ekai Kawaguchi Collection (Kawa 2-131) held by Tōhoku University and a thangka in the possession of the Hahn Cultural Foundation (for an illustration of the latter, see Tanaka 2001a, plate 7).

39. Inagaki 1987, 41–42.

40. On how listeners to the Buddha's teachings in Mahāyāna sūtras became bodhisattvas depicted in maṇḍalas, see Tanaka 2017b.

41. Ishida 1984, 5–11.

42. Ishida 1969a, 20.

43. Takada 2000.

44. Hayashi 2002, 47–48.

45. Matsumura 1983.

46. Petrovsky 1993, 112–15.

47. For further details, see Tanaka 2002.

48. Yoritomi 1990, 35.

49. According to a personal communication from Peter Skilling, the Thai *Suat mon plae chabap ho phra samut vajirayan* gives the following buddhas of the ten directions: Padumuttaro (east), Revato (southeast), Kassapo (south), Sumaṅgalo (southwest), Buddhasikhī (west), Medhaṅkaro (northwest), Sākyamuni (north), Saraṇaṅkaro (northeast), Kakusandho (bottom), and

Dīpaṅkaro (top). Skilling also notes the existence of another set of buddhas of the ten directions in Theravāda Buddhism.

50. T. 366.12.347b.

51. T. 262.9.25bc.

52. There has been some debate about whether this Amitāyus is the same as Amitābha in Sukhāvatī, since it was thought unreasonable that Amitābha himself would appear to prove the validity of the Amitābha cult.

53. T. 663.16.336a.

54. Yoritomi 1990, 78–85.

55. T. 397.13.143c.

56. T. 402.13.562c–63a.

57. Kurumiya 1978, 121–22.

58. Yoritomi 1990, 81.

59. Watanabe, S. 1965; Miyasaka 1960.

60. The *Wenshushili fabaozang tuoluoni jing* includes the statement "Homage to the Buddha Kaifuhuawang, whose Sanskrit name is Saṃkusumita" (T. 1185.20.796a). The *Uṣṇīṣasitātapatrādhāraṇī* mentions a buddha named Suoluoshuhua Pubiankaifuwang (T. 976.19.401b), the Sanskrit equivalent of which turns out to be Saṃpuṣpitasālendrarāja in Nepalese manuscripts. This would suggest that Saṃkusumita and Sālendrarāja, mentioned before the former in the *Wenshushili fabaozang tuoluoni jing*, were merged into a single buddha. It is interesting that the *Darijing shu*, a commentary on the *Vairocanābhisambodhisūtra*, has taken over this name in the form Sālendrarāja-saṃkusumita (Suoluoshuwang Huakaifu [T. 1796.39. 622c]).

61. Satō, N. 2005, 794.

62. Sakai Shinten pointed this out for the first time (Sakai 1973, 183).

63. For further details on the questions discussed in this section, see Tanaka 2012a.

64. Mitra 1992, 18.

65. In his *Nanhai jigui neifa zhuan*, Yijing reports as follows on the difference between Mahāyāna and Hīnayāna: if they worship bodhisattvas and recite Mahāyāna sūtras, they are called Mahāyāna Buddhists, otherwise they are Hīnayāna Buddhists (T. 2125.54.205c). This suggests that whether or not people worshiped bodhisattvas was an important distinction. In India, buddha triads accompanied not by bodhisattvas but by monks were produced until the Pāla dynasty, and these are thought to have been donated by Hīnayāna Buddhists, who did not worship bodhisattvas.

66. During investigations conducted in 2012 the remains of a niche were found only in the eastern quarter, and it is to be surmised that the images in the other three directions were placed on pedestals.

67. Yamada 1984.

68. On stūpas depicting the eight major events in the Buddha's life, see Yoritomi 1990, 595–600. According to Yoritomi, the four cardinal directions of the stūpa are occupied by seated buddhas representing enlightenment (earth-touching mudrā), the first sermon (dharma-wheel mudrā), the appearance of one thousand emanations (dharma-wheel mudrā), and the monkey's offering of honey (meditation mudrā). However, this arrangement is completely different from that of the four buddhas at Gyaraspur.

69. Muramatsu 2003.

70. The Chinese equivalent is given as Baosheng 保生, but this is an error for Baosheng 寶生.

71. Naitō 1931.

72. According to Saeki Shungen, vice abbot of Shōjōin, a subtemple of Saidaiji, the present names of the four buddhas were fixed during the process of compiling the *Saidaiji taikan*. However, there is another view that places Bhaiṣajyaguru in the east and Maitreya in the north. Moreover, the buddha in the south would have been identified as Ratnasambhava only after the introduction of esoteric Buddhism, and it is unlikely that the buddha in the south would have been called Ratnasambhava from the outset.

73. Sakai 1973, 190–91.

74. Yoritomi 1990, 608–9.

75. T. 1011.19.680b. On differences in the audiences mentioned in various Chinese and Tibetan translations of the *Anantamukhanirhāradhāraṇī*, see Inagaki 1987, table 3.

76. Tanaka 2000a, 30–31.

77. Tanaka 2001c.

78. Tanaka 2000a, 20–36.

79. The inscription incorrectly has "*qingjing fashen* Lunashefo" 清淨法身盧那舍佛 instead of "...Lushenafo" 盧舍那佛.

80. Sha Wutian has reconstructed the arrangement of the bodhisattvas in this wall painting on the basis of a black-and-white photograph taken before the wall was damaged; see Sha 2011, 470–92.

81. This has been interpreted as "bodhisattva" (Tib. *byang chub sems dpa'*). However, when I examined a photograph of the back of the shrine, *byang chub* was visible, whereas *sems dpa'* was not.

82. Park 2001.

83. Mention of Ākāśagarbha is missing in the present version of the *rGyal rabs gsal ba'i me long* (Sa skya bSod nams rgyal mtshan 1981, 207–8). I have added Ākāśagarbha on the right of the main deity since otherwise the number of bodhisattvas on both sides would not agree, and it would also be inconsistent with the present state of the Dbu rtse restored after the destruction that occurred during the Cultural Revolution.

84. Sa skya bSod nams rgyal mtshan 1981, 208.

85. Richardson 1990.

86. Tanaka 2001c, 41–42.

87. Unlike Japanese examples, Vajradhātu-Vairocana in Indo-Tibetan Buddhism frequently holds a five-pronged vajra in the fist formed by the enlightenment mudrā. A typical example is a cast statue held by the National Museum in New Delhi, which was unearthed at Nālandā (tenth to eleventh centuries).

88. On the Jamdun relief, see Heller 1994. Heller suggests two possibilities regarding the monkey year in King Tride Songtsen's reign, 804 and 816. But according to Yamaguchi Zuihō (1978, 23–24), this king died in 815, and so the date of the Jamdun relief must be 804.

89. On the rNam par snang mdzad lha khang in Bido, see gNya' gong dkon mchog tshe brtan and Pad ma 'bum 1988. According to Trangu Rinpoche from Trangu monastery (Karmapa school), which managed the Namnang Lhakhang, this shrine was built in 1945, and before its construction Vairocana and the eight great bodhisattvas had been carved on a rock face.

90. Miyaji 1995, 10–11.

91. Tanaka 1996b.

92. As concrete examples, we can note "*oṃ akāro mukhaṃ sarvadharmāṇām ādyanutpannatvāt*," the first of the thirty-four letter gateways in chapter 2 of the *Vairocanābhisambodhisūtra*, and "*svabhāvaśuddhāḥ sarvadharmāḥ svabhāvaśuddho 'ham*," a mantra for purifying the three actions in the *Jingangding jing guanzizaiwang rulai xiuxing fa* (T. 931.19.73a).

93. In manuscripts, *sumbha nisumbha* is frequently written *śumbha niśumbha*. Cf. Horiuchi 1983.

94. On *yi dam* in Tibetan Buddhism, see Tanaka 1991.

95. Horiuchi 1983, §§656, 960.

96. Matsunaga Y. 1978, 65, ll. 16–17.

97. Among the various versions of the Sonshō mandara, those that place Acala and Trailokyavijaya on both sides of the main deity are the three-deity and eleven-deity versions (in both the Śubhākarasiṃha and Amoghavajra traditions).

98. T. 1201.21.13c–14a.

99. Horiuchi 1983, 343–51, §§707–33. See also Iyanaga 1985.

100. In Japan, the Yamāntaka cult was criticized as a heresy since it was frequently used for subjugation (*abhicāra*). On the connections between Yamāntaka and subjugation in Tibetan Buddhism, see Hadano 1986, 259–76.

101. Ōshima et al. 2001, 469a.

102. Tanaka 1991, 165, fig. 7.

103. Tanaka 2000a, 155.

104. The Acala cult in Buddhism is probably comparable with Caṇḍeśa, an attendant of Śiva in Hinduism, many examples of whom survive in South India. See Goodall 2009.

105. On the story in the *Sarvadurgatipariśodhanatantra* of a celestial being named Vimalamaṇiprabha who descended to hell, see Skorupski 1983, 42–43, n22.

106. On the maṇḍala of the *Guhyatantra*, see chapter 2, section 2.

107. This can be confirmed from the Sanskrit title of the Tibetan translation and the Sanskrit text brought back to Japan by Kūkai (T. 1168B).

108. Matsunaga, K. 1999, 60.

109. Tanaka 2010, 691.

110. Yoritomi (1991, 49) writes: "One method of dividing space is to divide it into nine parts in the form of two pairs of intersecting lines. This is possible for both a circle and a square." Thus, the nine-part division of a square in the form of two pairs of intersecting lines, as in the maṇḍala of the eight great bodhisattvas at Ellora, and of a circle, as in the Guhyasamāja-maṇḍala, would seem to be compatible.

111. Yoritomi 1991, 46, 49.

112. See chapter 4 ("Khaṭikāsūtrapātanavidhi") of the *Viṃśatividhi*.

113. Dairin Myōō (Mahācakra) is thought to be a wrathful aspect of Sahacittotpāda(-pādita)dharmacakrapravartin, one of the eight great bodhisattvas of the *Prajñāpāramitānayasūtra*.

114. Sakai 1985, 250–70.

115. A wheel-shaped weapon that was generally used for hurling at enemies.

116. In the *Mitra brgya rtsa* maṇḍala set held by the Hahn Cultural Foundation, most of the maṇḍalas with four- or eight-spoked wheels are depicted in the form of a *cakra* as a weapon.

117. Tanaka 2000a, 51–53.

118. Ibid., 87–93.

119. Matsunaga, Y. 1978, 119, v. 81.

120. Hadano 1987, 109.

121. Tanaka 2000a, 152.

122. Horiuchi 1983, 61, §102.

123. T. 848.18.6c; Giebel 2005, 32.

124. Yamada 1985, 25, 44.

125. Some scholars do not consider the left attendant to be Vajrapāṇi. However, he holds a three-pronged vajra at his waist with his left hand. The reason that the iconography of the flanking attendants and the central images of the two side walls differs is that the two flanking attendants hold a whisk, the symbol of an attendant.

126. Chapter 2 of the *Vairocanābhisambodhisūtra* describes only four deities of the Vajra family. Chapters 9 and 11 add Vajramuṣṭi, chapter 4 adds Shuizizai (Tib. Chu'i dbang po), and chapter 11 further adds Vajrāṅkuśī and Vajrakulodbhava. If the sixteen *vajradharas* (twelve in Tibet) are added to these, we get twenty-four deities in all.

127. The preface to the *Tuoluoni jijing* states: "This sūtra was extracted from the *Sūtra of the Adamantine Great Hall* and is a small portion of the great *Vidyādharapiṭaka*" (T. 901.18.785b).

128. Takata, N. 1970. In this section, differences between the Chinese and Tibetan translations have been indicated parenthetically.

129. Ishida 1975, 76–81.

130. In the system of protectors of directions (*dikpāla*) in India, west is assigned to Varuṇa, who was originally the god of the sky. Later he became the god of water and is considered to be the king of *nāgas*. Virūpākṣa among the Four Celestial Kings (also assigned to the west) is also regarded as the ruler of *nāgas*.

131. Regarding the attribution of Mañjuśrī, in the Yoga tantras he is thought to belong to the Lotus family since he is identified with Vajratīkṣṇa among the sixteen great bodhisattvas of the Vajradhātu-maṇḍala, while in late tantric Buddhism he frequently belongs to the Vajra family. However, in early esoteric Buddhism Mañjuśrī was regarded as the lord of the Buddha family, and Mañjuśrī, Avalokiteśvara, and Vajrapāṇi are collectively known as the lords of the three families (Tib. *rigs gsum mgon po*).

132. bSod nams rgya mtsho and Tachikawa 1983, no. 1: Thog mar dge ba rigs gsum spyi'i dkyil 'khor.

133. T. 897.18.765b.

134. On the classification of tantras in Tibet, see Wayman 1973, 233–39; Takata, N. 1978, 43–74; Nishioka 1983; Si tu Chos kyi 'byung gnas 1988, 387–448.

135. T. 897.18.766ab.

136. T. 893.18.603c–604a; Giebel 2001, 129–32.

137. Matsunaga, Y. 1978, 60.

138. T. 885.18.541b; P. 114, 5: 60-2-6-7.

139. See Lalou 1930.

140. T. 1276. Matsunaga Yūkei, basing himself on Kūkai's *Goshōrai mokuroku*, has argued that Amoghavajra translated only the first half of this text (Matsunaga, Y. 1980a, 323–24).

141. T. 1796.39.642a.

142. Moriguchi 1989a, 12. The manuscript entitled *Mañjuśrījñānatantra* (NGMPP.B106/32) corresponds to chapter 1 and the first half of chapter 2.

143. Horiuchi 1949–50.

144. Matsunaga, Y. 1980a, 315–30.

145. Yamashita 1979.

146. Vaidya 1964, 44.

147. Imaeda 1981.

148. Macdonald (Spanien) 1962.

149. Macdonald reconstructed the arrangement of the deities in the inner square correctly because the *Mañjuśrīmūlakalpa* describes the arrangement of the deities in the inner square in terms of left, right, top, and bottom rather than east, west, south, and north.

150. The collected works of Bo dong phyogs las rnam rgyal published under the title *Encyclopedia Tibetica* include several ritual manuals on the maṇḍala and *paṭa* explained in the *Mañjuśrīmūlakalpa* (vol. 29 [1971], vol. 123 [1976]). For details, see Tanaka 2012a, 2012b.

151. Tanaka 1987a, 89 (diagram). Fig. 1.11 in chapter 1 of this volume is a revised version of this diagram.

152. See Lalou 1930.

153. T. 2154.55.569b.

154. Lalou 1953, 326, no. 316.

155. The romanized text of the *Amoghapāśakalparāja* has been partially published in installments by Taishō University (Mikkyō Seiten Kenkyūkai 1998–2011).

156. Ishida 1975, 227–28.

157. Yoritomi 1990, 105.

158. For example, T. 1167, translated by Amoghavajra, contains iconographical descriptions of the eight great bodhisattvas not included in other translations (T. 1168A, B).

159. T. 1796.39.634a.

160. T. 1796.39.635c.

161. In chapter 2, "Maṇḍalavidhānaparivarta," *varapradāna* occurs as the mudrā of Saṃkusumitarājendra and Ajitaṃjaya, while *dhyānagatacetas* occurs as the mudrā of Akaniṣṭha-devaputra.

162. Pal 1966, 1967. As a representative example, we can point to MG 24026 held by the Musée Guimet.

163. bSod nams rgya mtsho et al. 1991, no. 12. This sixteen-deity maṇḍala adds eleven attendants to the Amoghapāśa pentad.

164. Tanaka 2000a, 58–71.

165. The collected works of Bo dong phyogs las rnam rgyal published under the title *Encyclopedia Tibetica* include a ritual manual on the maṇḍala of the *Amoghapāśakalparāja* entitled *Don zhags rnam grol gyi mngon rtogs rgyas 'bring bsdus gsum* (vol. 29 [1971]), and the large (*rgyas*) ritual corresponds to the Vast Emancipation maṇḍala explained in the Tibetan translation of the *Amoghapāśakalparāja*.

166. Currently held by Enjōji temple in Nara prefecture.

167. Śākyamuni is thought to be identical to Amoghasiddhi, who corresponds to Lokendrarāja in the *Amoghapāśakalparāja* (Chinese translation).

168. For example, the mudrā *mahācintāmaṇidhvajāgra* (Mikkyō Seiten Kenkyūkai 1998, 49, ll. 27–29) corresponds to the *padmaratnadhvajāgrī* explained in Horiuchi 1974, 35, §1597, while the mudrā of Amoghapāśa (Mikkyō Seiten Kenkyūkai 1998, 51, ll. 13–16) corresponds to that of Padmapāśa, that is, Amoghapāśa, explained in Horiuchi 1974, 39, §1609.

169. Sawa 1982, 9.

170. In the *Vairocanābhisambodhisūtra* Vairocana's abode is not the Akaniṣṭha Heaven but the Dharmadhātu palace. Later in Tibetan Buddhism there occurs the term '*og min chos kyi dbyings kyi pho brang* (Dharmadhātu Palace of Akaniṣṭha), which equates the two (see Tanaka 2001b, 35).

171. Held by the Archaeological Museum, Nālandā, but wrongly identified as Vāk, a form of Mañjuśrī.

172. Yoritomi 1992, 118–21.

173. Ibid.

174. Among the four buddhas from Haripur (see chapter 5, section 11), Akṣobhya,

Ratnasambhava, and Amitābha are also positioned in the east, south, and west, respectively, whereas the main deity, a buddha with the earth-touching mudrā, is enshrined in the north.

175. See Tanaka 2004a, 100–105.

176. However, the mudrās of these five buddhas differ from those of the five buddhas of the Garbha-maṇḍala seen in China and Japan; cf. chapter 2, section 13.

177. There is a difference of opinion among Yoritomi (1990), Malandra (1993), and Matsunaga Keiji (1999) regarding the identification of the eight great bodhisattvas. Throughout this book I have followed Yoritomi's view. For details, see Tanaka 2004a, 79 (diagram).

178. According to the *Lalitavistara*, when the Buddha attained enlightenment, he touched the earth with his hand to summon Sthāvarā, the earth goddess, in order to drive Māra away, and the Buddha's power to drive Māra away at that moment was deified as a wrathful female deity named Aparājitā. For details, see Yoritomi 2004a, 15–39.

179. Yoritomi 1990, 611–12.

180. Malandra 1993.

181. See chapter 4, section 3.

182. A similar example from Nālandā is held by the Asutosh Museum of Indian Art, Kolkata, India.

183. The Asutosh Museum of Indian Art in Kolkata has a similar maṇḍala of the eight great bodhisattvas, but it turns out to have been produced from the same mold as that of the Metropolitan Museum of Art.

184. On the classification of the tantras in Tibet, see note 134. There is also another view that would classify it among the Kriyā tantras.

185. Sakai 1973 was the first study to focus on the *Vajrapāṇyabhiṣekatantra* as a precursor of the *Vairocanābhisambodhisūtra*.

186. P. 130, 6: 48.4-4-5-3.

187. As will be discussed below, the Tibetan Garbha-maṇḍala does not depict four bodhisattvas on the central eight-petaled lotus. For details, see Tanaka 1996a, 46–53.

188. According to the traditional interpretation of the Garbha-maṇḍala, there exists a relationship of result and cause between the four buddhas and the four bodhisattvas of the Garbha-maṇḍala: Ratnaketu = Samantabhadra, Saṃkusumitarājendra = Mañjuśrī, Amitābha = Avalokiteśvara, and Dundubhisvara = Maitreya. As mentioned above, Saṃkusumitarājendra is a buddha of another world where Mañjuśrī resides, and the relationship between Mañjuśrī and Saṃkusumitarājendra is identical to that between Avalokiteśvara and Amitābha. Therefore the Genzu mandara seems to have transposed the positions of Avalokiteśvara (northeast) and Maitreya (northwest).

189. Two commentaries on the *Vairocanābhisambodhisūtra* by Buddhaguhya are listed in the *Ldan dkar ma* catalogue, compiled in 824, according to Yamaguchi Zuihō (1978). Cf. Lalou 1953, 326, nos. 321, 322.

190. If we believe the legend that the two commentaries on the *Vairocanābhisambodhisūtra* by Buddhaguhya—the *Vairocanābhisambodhitantrapiṇḍārtha* and *Vairocanābhisambodhivikurvitādhiṣṭhānamahātantravṛtti*—were composed at the request of King Tride Songtsen, the transmission of this sūtra occurred during his reign (754–96).

191. According to Tāranātha (1970, 280–83), Buddhaguhya was a disciple of Buddhajñānapāda during the first part of his life, and so he would have known about comparatively early tantric Buddhism such as the Jñānapāda school of the *Guhyasamājatantra*.

192. Lokesh Chandra 1967, pt. 15, no. 20 (122-fold Abhisambodhi-karuṇodgata Bhagavad-Vairocana).

193. On tsakalis, see Tanaka 1990a, 241.

194. bSod nams rgya mtsho and Tachikawa 1983.

195. Photographs of this maṇḍala have appeared in several publications, e.g., Toyamaken [Tateyama Hakubutsukan] 1992, 9.

196. Rossi and Rossi 1993.

197. Tshe tan zhabs drung (Caidanxiarong) 1982, 278.

198. A monochrome plate of this line drawing appeared in the Buddhist magazine *Daihōrin* (November 1999).

199. This maṇḍala was exhibited for the first time at Toga Meditation Museum in 2005. It was also exhibited at the Okura Shukokan Museum of Fine Arts, Tokyo, in August 2006.

200. See Tanaka 1996a, 20–45.

201. Tanaka 1987c; 1996a, 66–80.

202. On the *liupin folou*, see Nasu 1987.

203. Tanaka 1998a.

204. Tanaka 1996a, 46–65.

205. T. 848.18.36c.

206. On the body colors of the four buddhas of the Garbha-maṇḍala, see Tanaka 1987a, 123; Ochi 1977. Dundubhisvara's black color is based on Butön's ritual manual on the Garbha-maṇḍala, although there is another view that it should be blue. In the Raja version, Dundubhisvara is blue with the earth-touching mudrā, the same as Akṣobhya. In May 2014, I attended a Great Maṇḍala Rite at Raja monastery and was informed by monks of the Kālacakra College who had produced the Garbha-maṇḍala in colored powders (fig. 2.22) on this occasion that they equate the four buddhas of the Garbha-maṇḍala with the four Vajradhātu buddhas of the same color and mudrā.

207. T. 848.18.34bc. Dafen 大忿 should be corrected to Dafen 大分 since his name in Sanskrit is Mahābhāga.

208. T. 1796.39.631c.

209. Nakamura, R. 2002, 23.

210. Takata, N. (1970), in a note on fig. 13, writes, "The arrangement of deities is based on the *Guhyatantra*. In this case, the main deity is Vairocana." However, he does not cite his source.

211. Noguchi 2001.

212. Ishida 1975, 127.

213. In the Ngor version, Aparājita and others are arranged in the west of the inner square, while the Tateyama version depicts them at the feet of Śākyamuni in the east of the second square.

214. As was pointed out above, four bodhisattvas are not depicted on the central eight-petaled lotus in the Tibetan Garbha-maṇḍala. However, they originated in India since their arrangement is based on chapter 13 of the *Vairocanābhisambodhisūtra*. On the positions of Samantabhadra and Maitreya, see section 7 above.

215. T. 1796.39.642a.

216. T. 897.18.765c.

217. On the Sanskrit names of the one thousand buddhas, see Moriguchi 1989b.

218. Bhattacharyya (1968b, 82–83) lists three sets of sixteen bodhisattvas. The sixteen bodhisattvas of the Bhadrakalpa in the Vajradhātu-maṇḍala correspond to List 3, while Lists 1 and 2 correspond to those of the Dharmadhātuvāgīśvara-maṇḍala (V-39) and Vairocana-Mañjuvajra-maṇḍala

(V-3), respectively. Thus there existed other combinations of sixteen bodhisattvas arranged in the outer square of the maṇḍala. On the sixteen bodhisattvas of the Bhadrakalpa from Dunhuang, see Tanaka 2000a, 79 (table).

219. According to Takata, N. (1970, accompanying chart), the strip in the east of the outer square (corresponding to the Mañjuśrī group) depicts five attendants who correspond to five bodhisattvas belonging to the Ākāśagarbha group (indicated by ● in fig. 2.24). However, I have been unable to find their names in either the Chinese or Tibetan translation of the *Guhyatantra*.

220. Inagaki 1987, table 3.

221. P. 130, 6: 38-5-3–39-2-6.

222. Ishida 1975, 76–81.

223. In the First Panchen Lama's manual on the Garbha-maṇḍala mentioned in section 8 above (fols. 730–32) there appear the mudrās and mantras of deities symbolizing the Buddha's various virtues, but they are not deified.

224. In chapter 2 of the *Vairocanābhisambodhisūtra* Indra's position is defined as the "initial quarter" (Sanskrit unknown). If we interpret this as the strip in the east of the second square, it not only overlaps with Śākyamuni and his retinue, but an empty space remains in the strip in the north of the second square. The Tibetan translation, on the other hand, interprets the initial quarter as the north (*byang*). This may be a vestige of the fact that Indra was depicted in the east of the outer square in early esoteric Buddhist scriptures such as the *Guhyatantra*.

225. In the general maṇḍala of the *Tuoluoni jijing*, *yakṣas* are arranged on the west side of the northern gate.

226. Ishida 1975, 149.

227. T. 1796.39.711a.

228. T. 905.18.911c.

229. The four buddhas are not usually depicted in the Tibetan Garbha-maṇḍala. However, in this instance they are depicted above the *toraṇas* of the four gates.

230. Ishida 1975, 76–81.

231. A diagram showing Ishida's reconstruction is found in Ishida 1975, plates.

232. Ishida 1979, 108–9.

233. Tanaka 1996a, 49–51.

234. Ishida 1969b.

235. This deity corresponds to the wish-fulfilling jewel in the *Vairocanābhisambodhisūtra* and Mahāvīra of the Genzu mandara. However, iconographically speaking, he tallies with Vajraratna in the Vajradhātu-maṇḍala.

236. Ishida 1975, 238, 246.

237. Recently several scholars have argued that the *She wu'ai jing* must postdate Amoghavajra since it is not recorded in Kūkai's *Goshōrai mokuroku*. However, as Ishida argued in detail, without the *She wu'ai jing* it would have been impossible to create the present Kokūzō-in (Ākāśagarbha's sector) and Soshitsuji-in (Susiddhikara's sector) of the Genzu mandara that Kūkai brought back to Japan. It is also inconceivable that the *She wu'ai jing* would have been composed on the basis of the present Kokūzō-in of the Genzu mandara. Therefore there can be no doubt that the *She wu'ai jing* already existed by the time of Huiguo's final years even if it was not translated by Amoghavajra. For further details, see Tanaka 2016b.

238. Amoghavajra's Chinese translation (T. 865) corresponds to only the first section of the first part of the full text (for an English translation, see Giebel 2001). Dānapāla's later Chinese translation (T. 882) and Rinchen

Sangpo's Tibetan translation (P. 112), on the other hand, correspond to the full text, which consists of four main parts as well as an *uttaratantra* and *uttarottaratantra*.

239. Yoritomi (1988, 340, 398) argues that the designation *Jingangding jing yuga shibahui zhigui* is wrong and should be emended to *Jingangding yuga jing shibahui zhigui*. For an English translation of this text, see Giebel 1995.

240. As mentioned in the introduction, the task of identifying a number of tantras in the Vajraśekhara cycle from the second onward was carried out mainly by Sakai Shinten, but I have amended his views in fig. 3.1.

241. The extended Chinese version is called *Zuishang genben dale jingang bukong sanmei dajiaowang jing*, while the extended Tibetan version consists of the *Śrīparamādya nāma mahāyānakalparāja* (P. 119 = "Prajñākhaṇḍa") and *Śrīparamādyamantrakalpakhaṇḍa nāma* (P. 120 = "Mantrakhaṇḍa").

242. Soeda (1979) argues that a primitive form of the *Sarvatathāgatatattvasaṃgraha* influenced the earliest version of the *Prajñāpāramitānayasūtra* translated by Xuanzang.

243. Vaidya 1960, 193. It is a quotation from section 7, "Mañjuśrī."

244. P. 113, 5: 29-5-7.

245. In Tibetan and Nepalese Buddhism a ceremony is held in which the *Mahāprajñāpāramitāsūtra* is recited by a group of monks, with each monk reciting a different volume simultaneously to save time, and since the monks' voices intermingle, it becomes very noisy. In Sino-Japanese Buddhism it seems to have been recognized that the recitation of the *Prajñāpāramitānayasūtra* can accrue the same merit as the recitation of the entire *Mahāprajñāpāramitāsūtra*.

246. Most of the sections of the *Prajñāpāramitānayasūtra*, apart from (1) "Vajrasattva" with its seventeen propositions, consist of four doctrinal propositions; only (17) "Five Kinds of Secret Samādhi" has five doctrinal propositions.

247. Fukuda 1987, 448. Fukuda writes that "the title of section 3 is missing," but this is because he has counted the introduction as section 1.

248. Also called "Outer Vajra Assembly" (Waijingang hui zhang).

249. Kawasaki, K. 1998. On Kawasaki's identification of the maṇḍalas, see Tanaka 2018.

250. On the General Assembly maṇḍala consisting of the five families, see chapter 4, section 11.

251. Toganoo 1927, 369.

252. Ibid., 390–91.

253. Horiuchi 1983, 2, §5.

254. Tanaka 1997, 64–66.

255. Unfortunately, the opening section of the *Prajñāpāramitānayasūtra* is missing in E. Leumann's edition (1930) based on a Sanskrit-Khotanese manuscript, but we can ascertain it in Tomabechi 2009, 3–5.

256. P. 115, 5: 64-5-1–65-1-5.

257. Sakai 1985, 252–54.

258. There are instances where, when compared with Amoghavajra's translation, one proposition is missing or another proposition has been added. Among these, the addition of *sparśa-viśuddhi* after *rūpa-*, *śabda-*, *gandha-*, and *rasa-viśuddhi* may have been influenced by the *Prajñāpāramitāsūtra*, while instances where one proposition is missing may be due to a lacuna in the original text.

259. P. 3335, 72: 186-5-4–187-4-4.

260. Fukuda 1987, 222–24.

261. Hayashi 2002, plate 10.

262. Sakai 1985; 1985, 254–57.

263. In the Rishu-e of the Kue mandara the sequence of the goddesses of the four seasons has been changed to Dhūpā, Puṣpā, Ālokā, and Gandhā in accordance with other maṇḍalas in the Kue mandara.

264. P. 119, 5: 124-4-6–7.

265. T. 244.8.787ab.

266. P. 119, 5: 124-4-1–5.

267. P. 130, 6: 41-1-3–44-4-8.

268. T. 243, 8: 784b; Tomabechi 2009, 9.

269. Kawasaki, K. 2005, 28.

270. T. 244.8.798ab.

271. On the evolution of the iconography of Vajrasattva, see Tanaka 2016c.

272. Paper read by A. K. Singh at the sixth IATS conference held in Fagernes, Norway, in 1992, but not included in the proceedings, *Tibetan Studies*, published in 1994.

273. P. 3333, 71: 185-5-3–4.

274. Yoritomi 1990, fig. 107.

275. Saraswati 1977, plate 161.

276. Jarrige et al. 1994, plates 49-1, 2.

277. Horiuchi 1983, 84, §153.

278. The Derge edition and some other editions of the Tibetan canon have *Śrīparamādi* for *Śrīparamādya*.

279. Sakai 1985, 306.

280. Toganoo 1930, 65.

281. Pandey 2000, 69–70.

282. See Fukuda 1987.

283. Ibid., 83–88.

284. Ibid., 88–104.

285. Tanaka 1987a, 182–89.

286. Kawasaki, K. 1998; 2001. See also Tanaka 2018.

287. P. 3334, 72: 155-4-7–156-3-1; bsTan 'gyur, 30: 10-9-33-8. P. 3335, 72: 177-2-3–184-2-1; bsTan 'gyur, 30: 134-1-172-15.

288. P. 3334, 72: 156-3-1–158-3-2; bsTan 'gyur, 30: 10-9-20-16.

289. P. 3335, 72: 179-5-6–181-2-6; bsTan 'gyur, 30: 148-16–156-8.

290. P. 120, 5: 139-2-5.

291. Ibid., 143-3-2.

292. My earlier arguments (Tanaka 1996a, 206) were based on the premise that part 2 of the *Paramādyatantra* corresponds to the "*Mahāsukhaguhyavajra," while part 3 corresponds to the "Śrīparamādya," but this requires further consideration.

293. Kawasaki, K. 2000.

294. Bu ston Rin chen grub, *rNal 'byor rgyud kyi rgya mtshor 'jug pa'i gru gzings*, in *The Collected Works of Bu-ston*, Part 11 [Da] (New Delhi, 1968), fols. 64–69.

295. Kawasaki, K. 2001, 57.

296. Part 2 begins from the second chapter of the Tibetan translation of the "Mantrakhaṇḍa" because the last chapter of the "Prajñākhaṇḍa" is included at the start of the "Mantrakhaṇḍa."

297. P. 120, 5: 134-1-1–2.

298. T. 1119.20.512ab; T. 1120A.20.518a–19b.

299. P. 120, 5: 147-3-4–4-6.

300. T. 244.8.800bc.

301. bSod nams rgya mtsho and Tachikawa 1983, no. 26: dPal mchog rdo rje sems dpa' lha bdun cu don bdun gyi dkyil 'khor.

302. Kawasaki, K. 2001.

303. Tanaka 2004a, 165.

304. Tucci 1989, part 2: 107.

305. Toganoo 1930, diagram 13. There are considerable differences in the arrangement of the deities when compared with extant examples in Tibet.

306. T. 244.8.787ab.

307. The *Paramādyatantra* does not specify the body colors of the four buddhas. But in the "*Mahāsukhaguhyavajra" in the Tibetan translation, the standard four colors are given for the four families (excluding the Karma family) (P. 119, 5: 144-1-2).

308. On the alternative theory of the body colors of the five buddhas, see Tanaka 1994b.

309. P. 119, 5: 124-4-7–8. The Chinese translation, which reads, "In between each of the four gates, images or symbols [of deities should be depicted]," differs from the Tibetan translation because the translator interpreted *rūpa* in the original not as *rūpa* in the meaning of one of the five sense objects but as image of a deity.

310. Fukuda (1969) suggests that it was written by Ānandagarbha or by someone belonging to the same school. In Tibet several texts have been attributed to Ānandagarbha because he was a famous authority on the Yoga tantras. The fact that the name of the author is not mentioned in this text suggests that it was composed by someone else.

311. P. 3343, 74: 56-2-3–6.

312. P. 120, 5: 134-4-7–8; 147-1-6–7.

313. Generally known as *shimyō* in Japan, this *vidyā* is referred to as *shishō* in the Hirosawa branch of the Shingon sect.

314. T. 1119.20.511a; T. 1120.20.516c; T. 1123.20: 530a; T. 1124.20.533b.

315. T. 244.8.787b; P. 119, 5: 124-4-8–5-1. In the Tibetan translation, Śakra is replaced by Kāma.

316. P. 3343, 74: 56-2-6–3-1.

317. bSod nams rgya mtsho and Tachikawa 1983: no. 25, dPal mchog rigs bsdus pa lha sum brgya dang bcu dgu'i dkyil 'khor.

318. Kawasaki, K. 2001.

319. Bod rang skyong ljongs rig dngos do dam u yon lhan khang 1985, plate 61.

320. P. 3334, 72: 157-5-3–158-1-1.

321. T. 244.8.795ab.

322. P. 120, 5: 138-3-5–4-6.

323. T. 244.8.810a–11b.

324. P. 120, 5: 154-1-3–155-2-8.

325. P. 3335, 73: 125-2-3–127-3-2.

326. See Goodall 2009.

327. P. 3334, 73: 190-2-1–195-5-3. Vajrajvālānalārka is described in the *Paramādyatantra*, *Durgatipariśodhanatantra*, and *Sarvavajrodaya* as a wrathful deity belonging to the Vajra family. He is thought to have evolved from Trailokyavijaya.

328. Kawasaki, K. 2001, fig. 7.

329. On the classification of the tantras in Tibet, see note 134.

330. According to Bu ston (1968, fols. 73–74), the *Vajramaṇḍalālaṃkāratantra* explains thirty-seven maṇḍalas, and when we include the variant forms explained in Praśāntamitra's commentary, this number becomes forty-one.

331. P. 123, 5: 216-5-7–218-5-4.

332. *Dbang chen dkyil 'khor mi bskyod pa/ me yi dkyil 'khor ye shes 'od/ chu yi dkyil 'khor 'od dpag med/ rdo rjes rnam gnon rlung dkyil 'khor//* (P. 123, 5: 217-3-4—5).

333. These correspondences are thought to have been transmitted by Śubhākarasiṃha.

334. Many researchers working on Chinese Buddhism doubt Śubhākarasiṃha's authorship and consider it to date from the mid- to late Tang.

335. T. 905.18.911c.

336. Illustrations of the *bietan* are included in the iconographic section of the Taishō Tripiṭaka (TZ. 1.625–26, icons 1–18). On Buddhaguhya's interpretation, see Sakai 1987, 329–46; Hodge 2003, 286–300.

337. On the body colors of the five buddhas of the Garbha-maṇḍala, see Ochi 1977.

338. Tanaka 2007b.

339. Tanaka 2007a, 9–10; 2013, 9–10.

340. Five maṇḍalas are depicted on the south wall of the south chapel, and according to the inscription, four are based on the *Prajñāpāramitānayasūtra* and *Sarvatathāgatakāyavākcittaguhyālaṃkāravyūhatantrarāja*. But in actual fact all of them are based on the latter since the *Prajñāpāramitānayasūtra* does not explain their iconography in detail. On the arrangement of the maṇḍalas in the dome of the Great Stūpa of Palkhor Chöde, see Tanaka 1996a, 126–40.

341. Tanaka 1984b; 1996a, 196–211.

342. Kawasaki, K. 2000.

343. On Nāgabodhi's longevity, see Kūkai's *Himitsu mandara fuhōden*, 8–10. On the legend of the longevity of Nāgabodhi (Tib. Klu byang) in Tibetan Buddhism, see Tanaka 2010, 553–56.

344. Toganoo 1933, 40–48.

345. Some scholars had called it "Amarāvatī marble," but it turned out to be not marble imported from Rome, but limestone.

346. These identifications were made mainly by Sakai Shinten, and I support most of them.

347. The current Ichiin-e of the Kue mandara depicts only Vairocana, whereas the *Gobu shinkan* and Tibetan Ekamudrā-maṇḍala depict Vajrasattva, which is more faithful to the description given in the *Sarvatathāgatatattvasaṃgraha*.

348. Tanaka 1988, 1–13; 1996a, 126–40.

349. In maṇḍala sets of Tibetan Buddhism (which will be surveyed in chapter 8), only the Ngor maṇḍalas include the Garbha-maṇḍala, whereas the Vajradhātu-maṇḍala is included in all three major sets—the *Vajrāvalī, Mitra brgya rtsa*, and Ngor sets. Moreover, the Ngor maṇḍalas also include the Trailokyavijaya-maṇḍala, while the *Mitra brgya rtsa* set includes three other maṇḍalas explained in the *Sarvatathāgatatattvasaṃgraha*—Trailokyavijaya (M-31), Jagadvinaya (M-33), and Sarvārthasiddhi (M-32).

350. P. 3333, 71: 185-3-8–4-2.

351. Bhattacharyya 1972, 44. Abhayākaragupta describes four-headed eight-armed and one-headed two-armed styles. The enlightenment mudrā with a five-pronged vajra is the mudrā formed by the two main arms of the four-headed eight-armed style.

352. P. 3333, 71: 185-4-7–5-2.

353. Saraswati 1977, plate 169.

354. Miyaji 1995, 24–25.

355. Schroeder 2001, 1: 138–39.

356. Yoritomi 1983.

357. Yoritomi 1990, 95–115.

358. T. 895.18.731bc.

359. Vaidya 1964, 31.

360. The *Sādhanamālā* (no. 284) describes Ratnasambhava in the crown of Jambhala. As an example of such an image, we can point to a stone statue held by the Indian Museum.

361. T. 1003.19.612c.

362. See chapter 3.

363. As was seen in chapter 2, Ratnasambhava appears in the Chinese translation of the *Amoghapāśakalparāja*. However, this passage is missing in the Sanskrit manuscript and Tibetan translation, and Ratnasambhava in the Chinese translation may be a later addition from the *Sarvatathāgatatattvasaṃgraha*.

364. Yoritomi 1990, 98, 107 (n. 29).

365. On the sixteen bodhisattvas of the Bhadrakalpa, see chapter 2.

366. On the epithets of the sixteen great bodhisattvas, see Horiuchi 1975, 58–46.

367. Ibid., 57.

368. Vajramuṣṭi's "name from the point of view of the *mahāmudrā*" is Sarvatathāgatamuṣṭi in the section on the generation of Vajramuṣṭi (Horiuchi 1983, §134), whereas in the eulogy of 108 names (ibid., §200) it is Vajramuṣṭi.

369. T. 870.18.289c.

370. T. 871.18.292a, 293b, 298bc.

371. Gaganagañja, the main deity of the Rishukyō kuyō mandara brought back to Japan by Shūei (809–84), has the same iconography as Vajrakarma in the Kue mandara (TZ. 1.897, no. 22).

372. P. 3335, 72: 255-2-8–3-4. The iconography of Gaganagañja explained here coincides with that of Vajrakarma explained in the *Tattvālokakarī*, also by Ānandagarbha (Toganoo 1927, 236–37).

373. T. 243.8.784b.

374. T. 1003.19.609b.

375. The lives of the sixteen great bodhisattvas in the *Prajñāpāramitānayasūtra* have been considered in detail by Fukuda (1987, 357–402).

376. In the current Tibetan translation, the explanation from part 3 onward is missing.

377. Sakai 1939; 1985, 122–73.

378. Tanaka 1996a, 195–211.

379. P. 123, 5: 220-1-1–221-1-1.

380. P. 123, 5: 218-5-4–220-1-1. Here, a *sādhana* for Trailokyavijaya is given instead of that for Vajrapāṇi.

381. On the reason for their being called "°pāramitā," see Tanaka 1996a, 92–93.

382. T. 1067.20.132ab.

383. Horiuchi 1983, 78.

384. As was explained in chapter 2, Locanā, Pāṇḍarā, and Māmakī had existed from the time of early esoteric Buddhism. However, Pāṇḍarā, the mother of the Lotus family, and Māmakī, the mother of the Vajra family, were considered to be the consorts not of Amitābha and Akṣobhya but of Avalokiteśvara and Vajrapāṇi, respectively. It would not be inconsistent with Buddhist doctrine for Avalokiteśvara and Vajrapāṇi to have consorts, since there existed lay bodhisattvas in Mahāyāna Buddhism, but there may have been doctrinal resistance to Vairocana's having a consort, since he was the supreme tathāgata.

385. See chapter 2.

386. T. 873.18.306a; T. 875.18.324b.

387. SZ. 24.98.

388. SZ., 24.115.

389. P. 113, 5: 29-3-1-2 (/de nas 'di rnams kyi gsang ba'i ming ni/ /dpal chen rdo rje dkar mo dang/ /rdo rje sgrol ma mkha' rdo rje/).

390. T. 1125.20.538bc.

391. As was seen in chapter 3, in the "Mantrakhaṇḍa" of the *Paramādyatantra* the Karma family was undeveloped. Khavajriṇī is therefore thought to have been appropriated as the mother of the Karma family, which had not previously existed.

392. T. 244.8.811a; P. 120, 5: 155-1-5.

393. These parts explain the Assembly maṇḍala that integrated the maṇḍalas explained in the preceding chapters, which means that the preceding chapters of the "Mantrakhaṇḍa" already existed.

394. Horiuchi 1983, 83–94, §§152–77.

395. Both of them have a row of teeth (*dantapaṅkti*) as their symbol.

396. The sequence Puṣpā, Dhūpā, Ālokā, and Gandhā for the four outer offerings is found in the Navoṣṇīṣa-maṇḍala of the *Durgatipariśodhanatantra* (V-38) belonging to the Yoga tantras and the Saṃpuṭa-Vajrasattva-maṇḍala (V-18) and Pañcaḍāka-maṇḍala (V-9) belonging to the Highest Yoga tantras.

397. Skorupski 1983, 142–45.

398. Horiuchi 1983, 90, §§165, 167.

399. T. 243.8.785a.

400. Kawasaki, K. 2007.

401. Horiuchi 1983, §§1, 35, 42, 201, 212, 225, 318, 417, 492, 561, 598, 599, 617, 1894, 2697, 2715.

402. T. 220.7.986ab.

403. T. 848.18.13a; cf. Giebel 2005, 62.

404. C. 36 (A11). This is a *sādhana* of a goddess named Mahāvegavatī, of which only two folios remain.

405. See Tanaka 2010, 691, v. 39.

406. Vajrāṅkuśī is mentioned only in chapter 11 (Chinese translation).

407. *Kongōkai shichishū*, 195bc; Toganoo 1935, 305. However, the *Sarvatathāgatatattvasaṃgraha* gives the seed-syllables of the four gatekeepers as *jaḥ, hūṃ, vaṃ,* and *aḥ* (Horiuchi 1983, 172, §283).

408. Kawasaki, K. 2007, 468.

409. As was pointed out in note 309, Faxian did not translate this passage correctly.

410. P. 3335, 72: 192-2-5-7.

411. P. 2718, 65: 16-3-8. For the corresponding Sanskrit text, see Kanō 2014, 67.

412. On the identification of Gaganagañja with Vajrakarma, see section 4 of this chapter.

413. Jñānamitra's *Prajñāpāramitānayaśatapañcaśatikāṭīkā*, to be discussed later in this chapter, mentions the *Śrīparama* (Tib. *dPal dam pa*) as the original text of the *Prajñāpāramitānayasūtra*. But no text of this name is recorded in the *Ldan dkar ma* or *'Phang thang ma* catalogues, and no manuscripts of the *Paramādyatantra* have been discovered at Dunhuang even though manuscripts of the *Prajñāpāramitānayasūtra* have been discovered there.

414. Matsunaga, Y. 1980a, 218.

415. Takata, O. 1954.

416. Bunkazai Hogo Iinkai 1961, 5.

417. A reproduction of the Shōren'in manuscript is included in the iconographic section of the Taishō Tripiṭaka (TZ. 2.1–71).

418. According to the *Rokushu mandara ryakushaku* (TZ. 2.2b), Śubhākarasiṃha was well acquainted with Yoga [tantras] and brought a text in 100,000 stanzas to China.

419. Hatta 1981, 271–73.

420. The *'Phang thang ma* catalogue mentions the "*De bzhin gshegs pa thams cad kyi de kho na nyid bsdus pa'i rgyud phyi ma dang bcas pa/ bam po dgu*" and its commentary and other Yoga tantras (Bod ljongs rten rdzas bsams mdzod khang 2001, 61). This shows that not only the four main parts of the *Sarvatathāgatatattvasaṃgraha* but also the *uttaratantra* (Tib. *rgyud phyi ma*) were already known during the Tufan period. Among Tibetan esoteric Buddhist manuscripts from Dunhuang, texts related to parts 2 and 3 of the *Sarvatathāgatatattvasaṃgraha* have been identified (Tanaka 2000a, 4).

421. Yanagisawa 1966a; 1966b.

422. Yanagisawa 1966a, 33.

423. The Jingang chengsheng mantuluo, a maṇḍala explained in the *Shouhu guojiezhu tuoluoni jing* (T. 997.19.566bc) translated by Prajña and Muniśrī, contemporaries of Huiguo, arranges the protectors of the ten directions in the outer square of the maṇḍala, which is similar to the Vajradhātu-maṇḍala. Therefore a maṇḍala that does not depict the twenty protective deities is not necessarily old. However, the fact that the *Gobu shinkan*, which is faithful to part 1 of the *Sarvatathāgatatattvasaṃgraha* in other respects, does not depict the twenty protective deities suggests that Śubhākarasiṃha was not familiar with part 2, or that he did not set much value on the latter part of the *Sarvatathāgatatattvasaṃgraha*.

424. See Katō et al. 1985.

425. The identification of the Vajradhātu-maṇḍala at Alchi has been discussed by Kobayashi Chōzen (Katō et al. 1985, 1: 75–87), Matsunaga Yūkei (1980b), and Kawasaki Kazuhiro (2005).

426. In Japan, Trailokyavijaya is depicted instead of Vajrasattva in the Jōjin-e. In Tibet, on the other hand, Trailokyavijaya is depicted instead of Akṣobhya (in the center of the moon disc in the east). Moreover, the eight offering goddesses are each accompanied by four attendants.

427. Tanaka 2003a.

428. Tanaka 1996a, 141–56.

429. Ibid., 126–40.

430. Ibid., 104–25.

431. It is included among the maṇḍalas of the eighteen assemblies of the *Prajñāpāramitānayasūtra* described in chapter 3.

432. Moriguchi Mitsutoshi has published a series of articles on the *Vajradhātumukhākhyāna*. It is a practical manual for performing maṇḍala rites and contains little in the way of iconographical information.

433. Tucci 1949, Tanka n. 185 (plate 219).

434. Kawasaki, K. 1998; Tanaka 2018.

435. "The five families are the five wisdoms. One wisdom is endowed with the five wisdoms. Therefore it becomes twenty-five families. In this way it develops into immeasurable families" (*Hizōki*, 1.9a).

436. For example, the Sanskrit equivalent of "mutual interpenetration of all tathāgatas" in Amoghavajra's translation (T. 865.18.207a: 一切如來互相涉入) is "*sarvatathāgata-samavasaraṇatayā*" (Horiuchi 1983, 9, §8).

437. Miyasaka 1983, 181 (maṇḍalaparamparāntargatasamāpattyavasthitadharma-dhātusamavasaraṇa).

438. Tanaka 2010, 670.

439. I am indebted to Yajima Michihiko for this observation.

440. See Horiuchi 1983, 30, §32. In Japan, a figure of four-headed Vajradhātu-Vairocana is enshrined in Ryūkōin on Mount Kōya, but this form of Vairo-cana is seldom found in Japan. In Tibet, on the other hand, there are many examples of four-headed Vajradhātu-Vairocana. At Tabo monastery in Spiti, there are four statues of Vajradhātu-Vairocana placed back to back, an arrangement that is rather similar to that of samavasaraṇa in Jain art.

441. The current Ichiin-e of the Kue mandara depicts only Vairocana, while the Ekamudrā-maṇḍala transmitted in Tibet depicts Vajrasattva. See Tanaka 1996a, 126–40.

442. Horiuchi 1983, 220–21, §§330–36.

443. Ratnolkā, Dhvajāgrakeyūrā, and Sahasravartā are deifications of the Ratnolkādhāraṇī (T. 299, P. 472), Dhvajāgrakeyūrādhāraṇī (T. 943, P. 306), and Sahasravartādhāraṇī (T. 1036, P. 216), respectively.

444. Horiuchi 1983, 390–93, §§871–80.

445. Horiuchi 1974, 14, §1518.

446. Ibid., 19, §§1535–36.

447. Shūei is said to have brought a line drawing back to Japan, but it has not survived, and only a diagram with the seed-syllables is included among the maṇḍalas of the eighteen assemblies of the Prajñāpāramitānayasūtra.

448. bSod nams rgya mtsho and Tachikawa 1983, plate 24: rDo rje rtse mo rigs bsdus pa lha stong dang nyis brgya don gcig gi dkyil 'khor. Examples of this maṇḍala are comparatively abundant in Tibet and include a wall painting in the south chapel of Shalu monastery.

449. A succinct expression of this idea of mutual encompassment can be seen in the following passage in the Shibahui zhigui: "The eighteen assemblies of the Yoga teachings have either four thousand verses, five thousand verses or seven thousand verses, and in all they consist of one hundred thousand verses. They have five divisions, four kinds of maṇḍalas, four seals, and have thirty-seven deities; each division has thirty-seven [deities], and [each] single deity embodies thirty-seven [deities] and also has four maṇḍalas and four seals. They interpenetrate one another just as the radiance of the pearls of Indra's net is reflected from one to another in an endless progression" (T. 869.18.287bc; Giebel 1995, 200).

450. T. 2428.77.381c; Giebel and Todaro 2004, 68.

451. On the vivekakāya of the supreme one hundred families, see Sakai 1974, 120–27 and chapter 5, section 5 below.

452. See note 435 above.

453. This passage comments on the root tantra of the Kālacakra, which is quoted in chapter 7, note 1: śrīdhānye niyatamantranayadeśanāsthāne mahā-sukhavāse vajradhātumahāmaṇḍale vajrasiṃhāsane sthitaḥ/ (Carelli 1941, 3; Sferra and Merzagora 2006, 65).

454. Sadakata 1994, 30–31.

455. Sadakata 1995, 28, 38.

456. For the names of the tantras making up the eighteen great tantras, see Fukuda 1987, 25, n5.

457. The translator mGon po skyabs, who was active in the early Qing period, translated the Shibahui zhigui as "tantra sde bco brgyad kyi sdom (yo ga sde bco brgyad zer)" (mGon po skyabs 1983, 225).

458. Bod ljongs rten rdzas bsams mdzod khang 2001, 36. Shes rab kyi pha rol du phyin pa tshul brgya lnga bcu pa'i 'grel pa slob dpon dnya[sic]namitras mdzad pa/ bam po gnyis.

459. Sakai 1985, 272, 306.

460. Dwivedi 1990, 55.

461. Tanaka 2007b.

462. On the Khasamatantra, see chapter 6.

463. Lal 2001, 84–85.

464. See Sakai 1985, 174–98.

465. Maitreya is included instead of Mārapramardin.

466. Tanaka 2000a, 135–49.

467. Bod ljongs rten rdzas bsams mdzod khang 2001, 61. 'Jig rten gsum las rnam par rgyal ba'i rgyud/ bam po gnyis.

468. Tanaka 1996a, 126–40.

469. On the variant theory of the color scheme of the courtyard, see chapter 8.

470. P. 116, Sarvadurgatipariśodhanatejorājasya tathāgatasya arhate [sic] samyak-sambuddhasya kalpa nāma.

471. P. 117, Sarvadurgatipariśodhanatejorājasya tathāgatasya arhate [sic] samyak-sambuddhasya kalpa-ekadeśa nāma.

472. bSod nams rgya mtsho and Tachikawa 1983, plates 27–39.

473. On the maṇḍalas of the Durgatipariśodhatantra in Dunhuang, see Tanaka 2000a, 72–96.

474. Dunhuang Yanjiuyuan 1990, plate 154.

475. Sakurai Munenobu, in Matsunaga, Y. 2005, 115–30.

476. bSod nams rgya mtsho and Tachikawa 1983, plate 41A; M-35 in Mitra brgya rtsa. However, M-35 consists of fifty-three deities because it does not dupli-cate the four gatekeepers, and the arrangement of the deities also differs slightly from other examples.

477. Katō et al. 1985, 1: 47.

478. On those called "Dharmadhātu" among Nepalese examples, see Tanaka and Yoshizaki 1998, 144–46.

479. T. 869.18.287ab.

480. Matsunaga, Y. 1978, 15.

481. Eastman 1980.

482. Matsunaga, Y. 1980a, 265–72.

483. On Viśvāmitra's interpretation of chapter 18, see Tanaka 1994a, 187–88.

484. Matsunaga, Y. 1980a, 236.

485. Eastman 1980; Tanaka 2000a, 163–94.

486. Ishikawa 1990, 4, ll. 26–30.

487. With regard to the chronology of the Tufan dynasty, I have referred to Yamaguchi 1978.

488. Pañcaskandhāḥ samāsena pañcabuddhāḥ prakirtitāḥ/ (Matsunaga, Y. 1978, 104, l. 4)

489. A Sanskrit commentary on the Samantabhadra nāma sādhana interprets a stotra on Akṣobhya as follows: "he is the chief of the triple adamant because the adamantine mind is the most important in the triple adamant" (kāyādi-vajreṣu cittasya pradhānatvāt trivajrāgraḥ). This clearly indicates the preem-inence of Akṣobhya, who presides over the mind (Tanaka 2017a, 138).

490. See Tanaka 2017a, 86–88, v. 75. Here the name Ratneśa, occurring in the verse, has been rephrased as Ratnasambhava in the Sanskrit commentary. This clearly shows that Ratneśa and Ratnasambhava are identical.

491. T. 893.18.607c.

492. La Vallée Poussin 1896, 7–9. The attributes of the five buddhas of the

Jñānapāda school are explained in vv. 72–78 of the *Samantabhadra nāma sādhana* (see Tanaka 2010, 520–24).

493. *Pṛthivī locanākhyātā abdhātur māmakī smṛtā/ pāṇḍarākhyā bhavet tejo vāyus tārā prakīrtitā/ khavajradhātusamayaḥ saiva vajradharaḥ smṛtaḥ//* (Matsunaga, Y. 1978, 104, ll. 8–10).

494. La Vallée Poussin 1896, 9.

495. Ibid., 15.

496. The lords (*kuleśa*) of the four buddha-mothers are given in vv. 79–82 of the *Samantabhadra nāma sādhana* (see Tanaka 2017a, 94–101).

497. As is explained in v. 51 (*pādas* ef) of chapter 17 in the *Guhyasamāja*, Vajradhara, the primordial buddha, is assigned to space (*khadhātu*).

498. The lords of the wrathful deities can be inferred from the fact that one of the five buddhas recites the generation mantra of the corresponding wrathful deity.

499. La Vallée Poussin 1896, 10–11.

500. See Tanaka 2017a, 114–15, v. 91.

501. Nāgabodhi has the same name as one of the eight patriarchs of the Japanese Shingon sect, but it is not clear whether they are one and the same person. In manuscripts his name is given not as Nāgabodhi but as Nāgabuddhi. Nāgabuddhi appears in the manuscript of the *Vajrācāryanayottama* (27b1) that I discovered in Nepal. In Tibet, however, he is frequently called "Klu'i byang chub" (Nagabodhi) or its abbreviation "Klu byang" because the Tibetan translation of the *Vimśatividhi* gives the author's name as Klu'i byang chub (i.e., Nāgabodhi).

502. See Tanaka 2016d, 119–20.

503. Hadano 1987, 50–165.

504. Matsunaga, Y. 1980a, 237.

505. T. 1128.20.545b–48b.

506. Hadano 1987, 69.

507. Hadano 1987, 46.

508. For the romanized text of the *Samantabhadra nāma sādhana* and an English translation, see Tanaka 2017a, 50–143.

509. Matsunaga, Y. 1980a, 237.

510. I referred to the *dPal gsang ba 'dus pa 'jam pa'i rdo rje'i dkyil 'khor gyi cho ga, si ta'i [sic] klung chen 'jigs bral seng ge'i kha 'babs zhes bya ba* (Ngag dbang legs grub 1971, ff. 485–651).

511. bSod nams rgya mtsho and Tachikawa 1983, plate 44: Ngor lugs gsang 'dus 'jam dpal rdo rje lha bcu dgu'i dkyil 'khor.

512. Tanaka 1984a, 37.

513. Kanamoto 1986.

514. Matsunaga, Y. 1978, 96, vv. 1–5; *Samantabhadra nāma sādhana*, vv. 102–6 (Tanaka 2010, 503 [table]).

515. See Lessing and Wayman 1968, 168–69, n19.

516. According to Chinese tradition, Rāhulabhadra was a teacher of Nāgārjuna, whereas Tibetan sources make him a disciple of Āryadeva.

517. This point is not clear in the *Samantabhadra nāma sādhana*. However, the *Mukhāgama* clearly explains that Akṣobhya has Māmakī as his consort.

518. Tanaka 2000a, 97–117.

519. The Trailokyavijaya-mahāmaṇḍala in the Vairocana chapel at Alchi depicts twenty protective deities together with their consorts in the outermost square. The Japanese Vajradhātu-maṇḍala, on the other hand, does not depict the twenty mothers, but the vajras depicted between the twenty protective deities are said to symbolize their consorts.

520. Matsunaga, Y. 1978, 11.

521. Tanaka 1997, 102–9.

522. Horiuchi 1983, 24, §20.

523. Matsunaga, Y. 1978, 110.

524. Ibid., 17.

525. For some examples, see note 871.

526. Matsunaga, Y. 2005, 87–88.

527. La Vallée Poussin 1896, 5–6.

528. Hadano 1986, 87–88.

529. Khrag 'thung rgyal po 1984, 14–17. Khrag 'thung rgyal po mentions only the *Guhyasamāja*. However, according to Tsongkhapa's *Gsan yig* (Tib. Ye shes snying po), Jñānagarbha belonged to the lineage of Mātaṅgīpa, a disciple of Nāgārjuna, that is, the Ārya school.

530. Mullick 1991, 15.

531. Uṣṇīṣacakravartin at the top and Sumbha at the bottom are actually depicted in the east (top) and west (bottom), respectively.

532. La Vallée Poussin 1896, 5.

533. Ibid., 7.

534. Through a study of the *Dpal gsang ba 'dus pa'i sgrub thabs rnal 'byor dag pa'i rim pa* by Tsongkhapa (see Kitamura and Tshul khrims skal bzang 1995), I noticed that he relies on the *Vimśatividhi* as the most authoritative source on maṇḍala rites.

535. Sāṅkṛtyāyana 1937, 45.

536. On the *Vajrācāryanayottama*, see Tanaka 1998b. I was subsequently informed by T. Tomabechi and H. Isaacson that another manuscript of the *Vajrācāryanayottama* is included in Sector B of photograph Xc14/30 among the manuscripts photographed by Rāhula Sāṅkṛtyāyana and later acquired by the Niedersächsische Staats- und Universitätsbibliothek, Göttingen. I later acquired a CD-ROM of this manuscript when visiting Europe in 2002 and confirmed the existence of parallels between the two manuscripts. However, the part corresponding to the *Vimśatividhi* is not included in the Göttingen photograph. This fact suggests that the manuscripts of a commentary on the *Vimśatividhi* and of the *Vajrācāryanayottama* had been mixed up in a single work.

537. Tanaka 2010, 629–716. Referring to Tucci's photograph of the Shalu manuscript, I have prepared a revised English edition of the *Vimśatividhi* for inclusion in the Manuscripta Buddhica series, but owing to unforeseen circumstances it has not yet been published.

538. Pandey 2000, 9–11.

539. *Ete skandhadhātvādayaḥ punar ekaikaśaḥ pañcapañcākārair bhidyamānāḥ śatadhā bhavanti/* (Pandey 2000, 9, ll. 7–8).

540. On the *aṣṭamaṇḍalaka*, see chapter 1, section 11.

541. Danzhu'er 21-886-19-887-2; P. 2127, 65, 13-1-4-6.

542. *Atha te sarvatathāgatā bhagavataḥ sarvatathāgatakāyavākcittavajrādhipateḥ paritoṣaṇārtham svabimbāni strībimbāny abhinirmāya bhagavato mahāvairocanasya kāyād abhiniṣkrāntā abhūvan/ tatra kecid buddhalocanākāreṇa kecin māmakyākāreṇa kecit pāṇḍaravāsinyākāreṇa kecit samayatārākāreṇa saṃsthitā abhūvan/ tatra kecid rūpasvabhāvākāreṇa kecit śabdasvabhāvākāreṇa kecit gandhasvabhāvākāreṇa kecid rasasvabhāvākāreṇa kecit sparśasvabhāvākāreṇa saṃsthitā abhūvan/* (Matsunaga, Y. 1978, 5, ll. 2–7).

543. Tsuda 1987, 195. Tsuda points to (3) of chapter 1 as a textual source for the adamantine goddesses (ibid., 191), but (3) may be a misprint for (5).

544. Matsunaga, Y. 1978, 104, l. 5 (*vajra-āyatanāny eva bodhisattvāgrya-maṇḍalam//*).

545. Chakravarti 1984, 14–17; Wayman 1977, 10 (*cakṣurādy ātmanā tatra Kṣiti-garbhādi jinaurasāḥ//*).

546. Matsunaga, Y. 1980a, 288–302.

547. Hadano 1987, 132.

548. Tanaka 1987a, 243–53. Reference should be made to the second impression or later, in which an inappropriate explanation in the first printing has been amended.

549. On the iconography of the one hundred peaceful and wrathful deities in the present-day Nyingma school, see Tanaka 1990a, 50–67.

550. For example, the *Bar do thos grol* explains the emergence of the one hundred peaceful and wrathful deities during the process of death, the intermediate state, and rebirth. The one hundred peaceful and wrathful deities are thought to be original to the old tantric school since they appear in Dunhuang manuscripts. However, no text associating them with death, the intermediate state, and rebirth has been discovered at Dunhuang. The associating of these deities with this process is thought to have been adopted from the new tantric schools, in particular the Ārya school of the *Guhyasamājatantra*.

551. Nicolas-Vandier 1974, 62–66.

552. The *Gsang ba'i snying po*, *Vajrasattvamāyājāla*, and so on explain that Lāsyā holds a mirror. A fragment of the *Gsang ba'i snying po* giving the mantras of the forty-two peaceful deities has been discovered at Dunhuang. A manuscript of the *Vajrasattvamāyājāla* has not been identified among manuscripts from Dunhuang, although there exists a manuscript in the Pelliot collection that mentions the title of this text. However, there are few old tantras stipulating that Nṛtyā holds a food offering, and this may be a later development in Tibet.

553. Tanaka 2010, 676, v. 7.

554. Lauf 1976, 151; Guenther 1984, 112.

555. Behera and Donaldson 1998, plate 32.

556. Schroeder 1981, plates 73C, 73D.

557. Guhyasamāja-Mañjuvajra holds only an *utpala*, and there is no manuscript resting on top of it. However, a manuscript, not mentioned in the text, is frequently added to an *utpala* in images of Mañjuśrī in India.

558. Tanaka 2010, 521, v. 73.

559. Saraswati 1977, plate 175 (identified by Saraswati as Sambara).

560. Tanaka 2010, 520–23, vv. 72–77.

561. Tanaka 2010, 583 (fig. 1), 652.

562. See chapter 8, section 1.

563. Hadano 1987, 78–79.

564. bSod nams rgya mtsho and Tachikawa 1983, plate 45: gSang 'dus 'jig rten dbang phyug lha bcu dgu'i dkyil 'khor.

565. Bod rang skyong ljongs rig dngos do dam u yon lhan khang 1985: plate 57 (in which left and right have been reversed).

566. Kanamoto 1985.

567. On the Bodhicitta verse, see Namai 1970. In the context of the *Guhyasamāja*, it corresponds to Vairocana's verse among the Bodhicitta verses uttered by the five buddhas starting with Akṣobhya. However, this verse is in a different meter from the other four verses, which are *ślokas*. This suggests that the *Guhyasamāja* expanded the Bodhicitta verse originating in the *Vairocanābhisambodhisūtra* to five verses. The reason that this verse was associated with Vairocana may have been its origin in the *Vairocanābhisam-bodhisūtra*.

568. Texts related to the Bodhicitta verse have been brought together in Ācārya 1991.

569. Pandey 2000, 69.

570. Ibid., 9–11.

571. Chakravarti 1984, 86, ll. 18–20.

572. Pandey 2000, 9–17.

573. La Vallée Poussin 1896, 15–16.

574. Tanaka 2016d. This passage is a quotation from the *Vajramālā*. An almost identical quotation is found in Chakravarti 1984, 27–28.

575. On the classification of tantras in India, see Shizuka 2006.

576. On the completion stage of the *Guhyasamāja*, see Tanaka 1997. The fact that the final chapter of the *Raktayamāritantra* deals with the practice of transferring one's consciousness into another body (Skt. *parapurāveśa*; Tib. *grong 'jug*) also supports this hypothesis.

577. Sāṅkṛityāyana 1935, Ms. no. 18.

578. Reel no. D37/11 and E1323/2 (both in a private collection in Patan) photographed by the Nepal German Manuscript Preservation Project are manuscripts of the *Raktayamāritantra*. I have confirmed that the former corresponds to the final chapters of the Tibetan translation, starting from chapter 10.

579. Dwivedi 1992.

580. Śrīmahāvajrabhairavayogatantra, Bṛhatsūcīpatram, ca 19(2-136); Saṅkṛityayana 1937, Ms. no. 277.

581. *Miaojixiang yuga dajiao da jingang peiluomolun guanxiang chengjiu yigui jing* (T. 1242).

582. This is because Tsongkhapa, the founder of the Geluk school, was devoted to Vajrabhairava, his tutelary deity conferred on him by his teacher Döndrup Rinchen. Thereafter the Geluk school came to count Vajrabhairava as one of three major repertories of the tantric college, that is, the *Guhyasamāja*, *Cakrasaṃvara*, and *Vajrabhairava* (Tib. *gSang bde 'jigs gsum*).

583. The *Vajrāvalī* does not explain the maṇḍalas of Raktayamāri and Vajrabhairava and includes only the Kṛṣṇayamāri-maṇḍala (V-4).

584. Mullick 1991, fig. 65.

585. Matsunaga, Y. 2005, 93 (fig.).

586. Sawa 1982, 174, fig. 33 (caption identifies it as Mahākāla).

587. Schroeder 2001, I: plates 102B, C.

588. On the patterns of Tibetan maṇḍalas, see chapter 8, section 2.

589. La Vallée Poussin 1896, 7.

590. Very few texts mention the maṇḍala of Raktayamāri and a critical edition of the *Raktayamāritantra* has not yet been published. The first chapter of the *Raktayamāritantra* and the *Abhisamayamuktāmālā* (Danzhu'er 47-1006-7) explain that the four Yamāris and four female deities form couples. However, examples of such a maṇḍala are very rare in Tibet and Nepal.

591. There are only two differences between the two: Tārā's symbol is an *utpala*, whereas Gaurī's symbol is a sword, and Vighnāntaka's symbol is a crossed vajra whereas Khaḍgayamāri's symbol is a sword.

592. bSod nams rgya mtsho and Tachikawa 1983, plates 54A, 54B, 58.

593. T. 1242.21.203c.

594. P. 2; T. 1187–90.

595. Dargyay 1977, 28.

596. T. 890.18.560ab.

597. T. 890.18.577c.

598. Tanaka 2010: 639–646.

599. P. 123, 5: 215-3-3–216-2-4. Fukuda (1987, 119) inserted "*sādhana* of the lotus maṇḍala" (Tib. *pad ma'i dkyil 'khor sgrub pa'i thabs*) between the *sādhanas* of Locanā and Pāṇḍarā, but it should be included in the *sādhana* of Pāṇḍarā.

600. Tanaka 2007b.

601. Tanaka 2007a, 10.

602. Kawasaki, K. (1997) initially followed Matsunaga in situating the *Māyā-jālatantra* between the *Sarvatathāgatatattvasaṃgraha* and *Guhyasamāja-tantra*, but in a subsequent article (Kawasaki, K. 2003) he points out that the *Māyājālatantra* quotes from the *Guhyasamājatantra*. However, Kawasaki's thesis has been criticized by Ōmi (2006).

603. *Abhisamayamuktāmālā*, no. 74.

604. Tanaka 2008a; 2008b.

605. Behera and Donaldson 1998, 110–11.

606. Sanderson 1995, 87–102.

607. The *Tattvasiddhi* attributed to Śāntarakṣita, the *Jñānasiddhi* by Indrabhūti, the *Nāmamantrārthāvalokinī* by Vilāsavajra, the *Samājasādhana-vyavastholī* by Nāgabuddhi, the *Caryāmelāpakapradīpa* by Āryadeva, and the *Pradīpoddyotana* by Candrakīrti all quote the *Samāyogatantra* as the *Saṃvara*. These are all texts associated with the late Yoga tantras or comparatively early late-tantric Buddhism that appeared in the late eighth to early ninth century.

608. *Śrīsarvabuddhasamayogaḍākinījālasambara nāma uttaratantra* (P. 8).

609. *Sarvakalpasamuccaya nāma sarvabuddhasamayogaḍākinījālasambara-uttarottaratantra* (P. 9).

610. On the classification of the tantras in Tibet, see note 134.

611. Stein Tibetan no. 419, XI in the British Library corresponds to chapter 5 of the *uttaratantra*.

612. Sakai 1944, 23.

613. T. 869.18.286c; Giebel 1995, 179–80.

614. Fukuda 1987, 499–500.

615. Tanaka 1989.

616. Tanaka 1992a; 1994c.

617. *Rdo rje sems dpa' steg pa la/ dpa' la dpa' bo de bzhin gshegs/ rdo rje 'dzin pa snying rje la/ rgod pa 'jig rten dbang phyug mchog//9.219// rdo rje nyi ma khro ba la/ rdo rje drag po 'jigs pa la/ shā kya thub pa mi sdug la/ ngo mtshar la ni a ra li//9.220// rab tu zhi la sangs rgyas rtag/* (P. 8, 1, 195-3-6–7).

618. Horiuchi 1983, 105, §198.

619. Nishioka 1983, 69.

620. *Śrīsarvabuddhasamayogaḍākinījālasambaratantrārthaṭīkā nāma* (P. 2531).

621. Roerich 1949, 103.

622. *Rnying ma'i rgyud 'bum* 16, 273–314. For further details, see Kaneko 1982, no. 207.

623. P. 2536–41. These are exegeses of the six families of the Samāyoga-maṇḍala. On Kukurāja, see Kanaoka 1967.

624. I have not yet been able to refer to the recently identified Sanskrit manuscript of the *Samāyogatantra*.

625. Tomabechi 2007.

626. P. 9, 1: 210-2-2.

627. bSod nams rgya mtsho and Tachikawa 1983, plate 60: Sangs rgyas mnyam sbyor rigs bsdus pa lha brgya dang sum cu so lnga'i dkyil 'khor.

628. Ibid., plate 61: Sangs rgyas mnyam sbyor rdo rje sems dpa' rigs bsdus lha mang gi dkyil 'khor.

629. Tanaka 1984b; 1996, 195–211.

630. Matsunaga, K. 1999, 241–58.

631. Ibid., 213–41.

632. For further details, see Tanaka 1993, 1–24.

633. Bhattacharya 1968b, no. 30.

634. P. 123, 5, 216-2-4-3-6. For further details, see Tanaka 2007b.

635. Shimada 1990.

636. On the location of Uḍḍiyāna, see Matsunaga, Y. 1991, 163–67.

637. Tanaka 1984b; 1996a, 195–211.

638. Horiuchi 1983, 372, §794.

639. Tanaka 1990a, 50–67.

640. Tanaka 1986; 1992b.

641. Tachikawa and Masaki 1997, 302–4.

642. For example, in I.xi.12 it says that it (i.e., *sādhana* of Kurukullā) has been mentioned before in brief and is stated in full in twelve parts, but the twelve parts are not found in the extant text.

643. In II.v.4, Nairātmyā asks Hevajra, "What is your own maṇḍala like, O Lord? Of this I have so far known nothing." However, the maṇḍala of Hevajra has already been explained in I.iii.

644. Tripathi and Negi 2001.

645. Shendge 2004.

646. On the *Vajrapañjarapañjikā tattvaviṣadā* (corresponding to P. 2326), see Tanaka 1998b.

647. *Rūpaskandhe bhaved vajrā gaurī vedanāyāṃ smṛtā/ saṃjñāyāṃ vāriyoginī saṃskāre vajraḍākinī//8// vijñānaskandharūpeṇa sthitā nairātmyayoginī/ sadā tāsāṃ viśuddhyā vai sidhyanti tattvayoginaḥ//9// adhyātmapuṭam/ paścād bāhyapuṭe vakṣye aparagauryādiyoginyaḥ/ aiśānyāṃ pukkasī khyātā agnau śavarī kīrtitā/ nairṛtye sthāpya caṇḍālīṃ vāyave ḍombinī sthitā//10// indre gaurī yame caurī vetālī vāruṇe diśi/ kauvere ghasmarī caiva adhastād bhūcarī smṛtā//11// ūrdhvaṃ ca khecarī proktā utpattikramapakṣataḥ/ bha-vanirvāṇasvabhāvena sthitāv etau dvidevate//12// rūpe gaurī samākhyātā śabde caurī prakīrtitā/ vetālī gandhabhāge ca rase ghasmarī kīrtitā//13// sparśe ca bhūcarī khyātā khecarī dharmadhātutaḥ/ sadā hy āsāṃ viśud-dhyā tu sidhyanti tattvayoginaḥ//14// bhujānāṃ śūnyatā śuddhiś caraṇā māraśuddhitaḥ/ mukhāny aṣṭavimokṣeṇa netraśuddhis trivajriṇām//15// pṛthivī pukkasī khyātā abdhātuḥ śavarī smṛtā/ tejaś caṇḍālinī jñeyā vāyur ḍombī prakīrtitā//16// dveṣā khyāpitā nairātmyā rāgā ca vāriyoginī/ īrṣyā ca vajraḍākinī paiśunyaṃ guptagaurikā//17//* (I.ix.8–17).

648. *Idānīṃ yoginīnām utpattikāraṇam ucyate/ iha tantre yoginyaḥ paṃcaskan-dhāḥ catvāra dhātavaḥ ṣaḍāyatanāni paṃcadaśacandrakalābhedena nairāt-mādayaḥ/* (Shendge 2004, 20).

649. *Śrīsampuṭatantrarājaṭīkā āmnāyamañjarī nāma* (P. 2328).

650. *Gauri la sogs pa bzhi rnams rnam par snang mdzad la sogs pa bzhin du rnam par dag go/ gzugs la sogs pa yul dag pas kyang 'di rnams so/ pu kka si la sogs pa bzhi rnams spyan ma la sogs pa dang 'dra bar rnam par dag pa'o// sa dang khrag dang khu ba dang rkang dang tshil bu dag rnam par dag pas kyang 'di rnams so/ mi bskyod pa bzhin du he ru ka ste reg bya dag pa yang ngo/ chos thams cad bdag med pa nyid dang chos kyi dbyings kyi yul dag pas bdag med ma'o// sgo skyong ma rnams ni sgo skyong bzhin rnam par dag pa'o//* (Dan-zhu'er 4-399–400).

651. Bhattacharya 1972, 21.

652. Tanaka 1985.

653. Shimada 1984.

654. Tanaka 1997, 161–62.

655. Tanaka 1994a, 122–45.

656. Verse 10 of chapter 1 of the *Samāyoga* explains that *śaṃ* of *saṃvara* means "bliss" (*sukha*). I have not yet seen the Sanskrit manuscript of the *Samāyoga*, but this passage can be restored on the basis of the *Cakrasaṃvaravivṛti* as "*sukhaṃ śam iti cākhyātam.*" The *uttaratantra* of the *Saṃpuṭatantra* also gives the same interpretation (P. 27, 2: 281-5-6–7).

657. Kaisar Library, Ms. no. 227; National Archives Kathmandu, Paṃ-108.

658. Pandey 2002.

659. Ibid., 1: 43, chap. 3, v. 24; 2: 494, chap. 23, vv. 23–24.

660. This is confirmed by the fact that Bhavabhaṭṭa wrote "*saṃvara iti saṃvarottare*" (ibid., 2: 494). As was noted in the first section of this chapter, the extant *Samāyogatantra* is frequently referred to as the *Saṃvarottara*, since it was said to be the *uttaratantra*.

661. The Tibetan translation gives the author as Bapabhaṭi/Bhavabhadra and the title as *Śrīcakrasaṃvarapañjikā*.

662. Sugiki 2001.

663. Cucuzza 2001.

664. The first three chapters are thought to be the *uttaratantra* and the remaining sixty-six chapters the *uttarottaratantra*.

665. Lokesh Chandra 1981.

666. Tsuda 1974.

667. Sugiki 2007, 12–19.

668. Sugiki 2002; 2003.

669. Tsuda 1972.

670. Pandey 1998.

671. For further details, see Mori 1990, table 3.6.

672. In contrast, images accompanied by a consort are found among cast metal statues because cast metal statues are comparatively small and can be enshrined in a miniature shrine not visible to laypeople.

673. Mori 1990, plate 5.

674. The twenty-four *dhātus* are similar but not identical to the thirty-one *dhātus* found in the *Mahāsatipaṭṭhānasutta* in the Pāli Tipiṭaka, and they seem to reflect a theory that already existed in Buddhism.

675. Horiuchi 1983, 272–73, §§485–88.

676. Pandey 2002, 577.

677. *Pādas* ab of v. 11 refer to Vajrasūrya as Ākāśagarbha and Paramāśva as Hayagrīva. As I argued in section 3 of this chapter, Vajrasūrya of the *Samāyoga* developed from Ākāśagarbha of the *Paramādya*, while Paramāśva is frequently depicted as horse-headed, as was pointed out earlier in this chapter. It turns out that these six deities are the main deities of the six families of the *Samāyogatantra*.

678. There are various combinations of animal-headed female gatekeepers in the Mother tantras. The four gatekeepers of the maṇḍala consisting of the six families of the *Samāyogatantra* are horse-headed (Tib. rTa gdong ma) in the east and boar-headed (Phag gdong ma) in the south, but it is not clear whether the gatekeepers in the west (sNang ba ma) and north (Thal byed ma) are also animal-headed. However, ritual manuals transmitted in Tibet explain that sNang ba ma is crow-headed and Thal byed ma dog-headed. Therefore three of the four female gatekeepers of the *Samāyoga* and *Saṃvara* match. In the Heruka-maṇḍala explained in the *Saṃpuṭatantra* III.1, resembling that of the *Samāyoga*, Horse-headed (Skt. Hayāsyā) is in the east, Boar-headed (Śūkarāsyā) in the south, Dog-headed (Śvānāsyā) in the west, and Lioness (Siṃhinī) in the north.

679. Tsuda 1974, 115–17.

680. Ibid., XIII.15–24.

681. Danzhu'er 47-1022–23.

682. *Catvāro dhātavaḥ skandhāḥ ṣaḍviṣayātmakās tathā/ devyā herukajñānan tu tasya bhedaṃ na kalpayet//7//* (Tsuda 1974, III.7).

683. On this text, see Sakurai 1997. Ghaṇṭapa, the founder of the Ghaṇṭā school, is said to have been Lūyīpa's disciple, while Kṛṣṇapa is said to have been a fourth-generation disciple of Ghaṇṭapa. Therefore the Lūyīpa school is the earliest among the three major Saṃvara schools (Sugiki 1996, 59).

684. Sakurai 1998, 3.

685. Ibid., 31. Generally speaking, a tantra predates ritual manuals based on it. The *Yoginīsañcāratantra* belongs to the late phase of the Saṃvara cycle, while Lūyīpa was the founder of the earliest school on the Saṃvara. Therefore it is better to suppose that the *Cakrasaṃvarābhisamaya* predates the *Yoginīsañcāratantra*.

686. *Pṛthivīdhātu[ḥ] pātanī/ ābdhātu māraṇī/ tejodhātur ākarṣaṇī/ vāyudhātu[ḥ] padmanarteśvarī/ ākāśadhātu[ḥ] padmajvālini [sic]// rūpaskandhe vairocanaḥ/ vedanāskandhe vajrasūryaḥ/ saṃjñāskandhe padmanarteśvaraḥ/ saṃskāraskandhe vajrarājaḥ/ vijñānaskandhe vajrasattvaḥ/ sarvatathāgatatve śrīherukavajraḥ// cakṣuṣor mohavajraḥ/ śrotrayor dveṣavajraḥ/ ghrāṇayor īrṣyāvajraḥ/ vaktre rāgavajraḥ/ sparśe mātsaryavajraḥ/ sarvāyataneṣu aiśvaryavajraḥ//* (Lokesh Chandra 1981, 57, ll. 4–7).

687. Sugiki 2002, 84–85.

688. Pandey 1998, 13–17.

689. A critical edition of the Sanskrit text of this passage has not yet been published, but Sugiki (2002, 107) has transcribed it as follows: *Rūpaṃ vairocano buddho vajrasūryas tu vedanā/ padmanarteśvaraḥ saṃjña saṃskāro vajrarājas tathā// vijñānaṃ vajrasattvas tu sarvarūpas tu herukaḥ/ netraṃ tu mohavajrākhyaṃ dveṣavajrābhidhā śrutiḥ// īrṣyāvajras tathā ghrāṇaṃ rāgavajro mukhaḥ smṛtaḥ/ sarvāyatanadhātus tu herukaḥ parameśvaraḥ// pātanī pṛthivīdhātur abdhātur māraṇī smṛtā/ ākarṣaṇy agnidhātuś ca vāyur narteśvarī tathā// ākaśadhātur uktas tu padmajāliny anākulāt/.*

690. *Rdo rje nyi ma ni rin chen 'byung ldan no/ padma gar dbang ni snang ba mtha' yas so/ rdo rje rgyal po ni don yod grub pa'o/ rdo rje sems dpa' ni 'dir chos kyi dbyings shin tu rnam par dag pa'i ye shes kyi rang bzhin no/ kun gyi ngo bo zhes pa/ gzugs la sogs pa'i rang gi ngo bo thams cad 'di'i yin pa zhes pas gzugs la sogs pa'i rang bzhin nyid kho na he ru ka ste mi bskyod pa zhes pa'i don to// gti mug rdo rje ni gti mug 'jig par byed pa'i phyir sa'i snying po ste rnam par snang mdzad kyi rgyu mthun pa'o/ zhe sdang rdo rje ni zhe sdang ba'i phyir phyag na rdo rje ste mi bskyod pa'i rgyu mthun pa'o/ phrag dog rdo rje ni phrag dog rnam par 'jig pa'i phyir nam mkha'i snying po ste rin chen dbang po'i rgyu mthun pa'o/ 'dod chags rdo rje ni 'dod chags pa thams cad 'jig pa'i phyir 'jig rten dbang po'i ste snang ba mtha' yas kyi rgyu mthun pa'o/ kha ni gtso bo lce'o 'dis reg par byed do zhes pas reg byed ni lus so/ ser sna rdo rje ni ser sna 'jig pa'i phyir sgrib pa thams cad rnam par sel ba ste/ don yod grub pa'i rgyu mthun pa'o/ skye mched khams kun ni yid de skye mched thams cad kyi rjes su 'gro ba nyid kyi phyir to/ he ru ka ni kun du bzang po ste mi bskyod pa'i rgyu mthun no/ rdo rje sems dpa'i rgyu mthun du yang 'di gzhan du bshad do zhes pa nang gi skye mched rnam par dag pa'i rang bzhin byang chub sems dpa' rnams te/ mngon par shes pa 'grub pa'i rgyu rnams so/ zhi bas nad la sogs pa*

lhung bar byed pa'i phyir lhung byed ma ni spyan ma'o/ gsod byed ma ni ma ma ki'o/ 'gug byed ma ni gos dkar mo'o/ dbang du byed pa'i don du rnam pa sna tshogs pa'i gzugs rnams kyis gar byed pa'i phyir gar byi dbang phyug ma ni sgrol ma'o/ yang dag par 'dzin pa dang lta bar byed pa dang mi dge ba bsregs pa dang bsod rnams dang ye shes nye bar 'phel bar byed pa nyid kyis sa la sogs pa rnam par dag pa'i rang bzhin spyan ma la sogs pa bzhi rnams mngon par brjod do//...nang gi padma gsal bar byed pa'i phyir padma 'bar ba ma rdo rje snyems ma ni rnam mkha' khams te/ bde ba chen po'i ngo bo nyid kyi phyir dang chos thams cad stong pa nyid kyi ngo bo nyid kyi phyir ro/ (Danzhu'er 4-383–384).

691. *cakṣuḥ śrotraghrāṇavaktrasparśeṣu mohavajradveṣavajra-īrṣyāvajrarāga-vajramātsaryavajrāḥ, kṣitigarbhavajrapāṇikhagarbhalokeśvarasarva-nīvaraṇaviṣkambhī nāmāntarāḥ...pṛthivyaptejovāyudhātuviśuddha-svabhāvāḥ{/} pātanī-māraṇī-ākarṣaṇī-narteśvaryaḥ pītakṛṣṇa-raktaharitavarṇāekavaktrāścaturbhujā/ cakrakarti-vajra-karti-padmakarti-khaḍgakartidhāridakṣiṇabhujadvayāḥ, kapālakhaṭvaṅgadhārivāmabhuja-dvayāḥ/ locanā-māmakī-pāṇḍarā-tārākhyā[/] ākāśadhātusvabhāvāḥ{//} padmajālinī dhūmravarṇā dhūmraśuklaraktatrimukhā ṣaḍbhujā kapāla-khaṭvāṅgapāśadhārivāmabhujatrayā aṅkuśabrahmamuṇḍakartibhūṣita-dakṣiṇabhujatrayo dharmadhātusvabhāvā/* (Abhisamayamañjarī, in *Dhī* 13 [1992], 126–27).

692. Sakurai 1998, 7–8.

693. Waldschmidt 1950, 1: 222–25. On the deeds of the Buddha during his stay in Vaiśālī according to Tibetan sources, see Jo nang, Tā ra nā tha 1997, §113 (*sku tshe'i 'du byed btang ba*). On the interpretation of the eight great *caityas* (*aṣṭamahāsthāna-caitya*) in India and the origins of the stūpa at Vaiśālī, see Skorupski 2001, 47–50.

694. In the *Gnas chen po brgyad kyi mchod rten la bstod pa* attributed to Nāgārjuna, the stūpa in Vaiśālī is described as follows: "I bow down to the miraculous stūpa in Vaiśālī that commemorates the Buddha's abandonment of vital energy (*āyuḥsaṃskāra*) and empowerment of [eternal] life (= *dharmakāya*)" (*sku tshe 'du byed btang ba las/ slar yang sku tshe byin brlabs pa/ rnam grol yangs pa can gyi ni/ byin brlabs mchod rten phyag 'tshal lo//* [Danzhu'er 1-250]).

695. Haribhadra divided the *dharmakāya* into the *svabhāvakāya* and *jñānakāya*, and his theory was accepted in Tibet even though it had been criticized by Ratnākaraśānti, Abhayākaragupta, and others in India.

696. Kimura 2006, 43. In the Sanskrit edition, the eighteen attributes peculiar to the Buddha (*āvenikadharma*) are missing.

697. See Tanaka 2009a.

698. Skorupski 1996, 224–31 (I.ii).

699. Pandey 1998, 19–30.

700. On this topic, see chapter 8, section 5.

701. T. 870.18.291a.

702. A set consisting of 108 maṇḍalas has also been discovered.

703. I have included the four seventeen-deity Hevajra-maṇḍalas and the twenty-three-deity Nairātmyā-maṇḍala described in the *Saṃpuṭatantra* in the Hevajra cycle, since they are related to the *Hevajratantra*.

704. Padmanarteśvara is the main deity of the Padmanarteśvara family among the six families of the *Samāyogatantra*, and the eight goddesses arranged around the main deity include three attendants of the Padmanarteśvara family mentioned in the *Samāyogatantra*. See Tanaka 2007a, 126; 2013, 126.

705. The inscription in the Hahn Foundation handscroll counts the four *kapālas*

as deities, making a total of five, but this would seem to be unwarranted. See Tanaka 2007a, 124; 2013, 124.

706. Ōmi 2005, 100–1.

707. Tanaka 1997, 202–21.

708. Kawasaki, K. 2006, 139–42.

709. Yoshizaki 2001.

710. Matsunaga, Y. 2006, 115–21.

711. See Shimada 1984; Noguchi 1987a, 1987b, 1988.

712. Tanaka 2009b.

713. Sugiki 2002, 85, 113–15.

714. Tanaka 1987, 229–30.

715. Chaudhuri 1935, 16.

716. Noguchi 2006, 145–72.

717. *Uktaṃ ca mūlatantre—gṛdhrakūṭe yathā śāstaḥ prajñāpāramitānaye/ tathā mantranaye proktā śrīdhānye dharmadeśanā//* (Carelli 1941, 3; Sferra and Merzagora 2006, 66).

718. *Vajrakulābhiṣekeṇa sarvavarṇānām ekakalkakaraṇāya yaśaḥ kalkīti/* (Upadhyaya 1986, 24, ll. 16–17).

719. *Ṭīkā sucandralikhitā sarvayānārthasūcikā/ ṣaṣṭisāhasrikā yā"sīt puṇḍarīkeṇa sā mayā// likhyate laghutantrasya mūlatantrānusāriṇī/ granthadvādaśasāhasrī savajrapadabhedinī//* (ibid., 3, ll. 17–20).

720. On the order of the five chapters of the *Kālacakratantra*, see Tanaka 1994a, 4–5.

721. Upadhyaya 1986, 41, ll. 14–27.

722. Hadano 1987, 14–20.

723. *Dang po sangs rgyas rgyud chen las/ rab tu 'bad pas bkag pa'i phyir/ gsang ba shes rab dbang bskur ni/ tshangs par spyod pas blang mi bya//* (P. 5343, 103: 21-5-1).

724. Hadano 1987, 211–14.

725. Ibid., 20.

726. There are many parallels between the "Abhiṣekapaṭala" of the *Vimalaprabhā* and the *Sekoddeśaṭīkā*. Some scholars think that the *Sekoddeśaṭīkā* influenced the *Vimalaprabhā*, but the *Sekoddeśaṭīkā* refers to the *Vimalaprabhā*, and further research is needed regarding the dates of the *Vimalaprabhā* and *Sekoddeśaṭīkā*.

727. *Bhikṣuśrāmaṇerāṇām caṇḍālī svabhāryā kartavyā/* (Dwivedi and Bahulkar 1994a, 106, ll. 1–2; Carelli 1941, 23–24; Sferra and Merzagora 2006, 99).

728. Douglas and White 1976 give Nāropa's dates as 1016–1100, seemingly on the basis of the *Rwa lo tsa ba'i rnam thar*. If we accept this date, Nāropa was younger than his disciple Marpa the translator (1012–97).

729. Okada 2005, 297–305.

730. *Caturasraṃ samaṃ bhūmyaṃ kṛtvā ṣoḍaśabhāgikam/ kāyamaṇḍala-kaṃ tyaktvā punaḥ ṣoḍaśabhāgikam// vāgādyaṃ maṇḍalaṃ kuryāt tato vāṅmaṇḍalaṃ tyajet/ cittamaṇḍalakaṃ kuryāt punaḥ ṣoḍaśabhāgikam//* (Dwivedi and Bahulkar 1994a, 45, ll. 10–13).

731. See note 782.

732. See Tanaka 1994a, 186–203.

733. *Pūrve śrīkṛṣṇabhūmir bhavati ravinibhā dakṣiṇe paścime ca hemābhā cottare 'nyā śaśadharadhavalā vajriṇo vaktrabhedaiḥ/* (Banerjee 1985, 100; Dwivedi and Bahulkar 1994a, 50, ll. 9–10).

734. *Api vasukamalā aṣṭakamalā "dhārapaṭṭikā sarvadikṣu vidikṣu/ tatra dig-bhāge raktavarṇāni padmāni bhavanti/ jinavaśāt buddhavaśāt śvetapad-maṃ ca koṇe padmānīti/* (Dwivedi and Bahulkar 1994a, 51, ll. 24–26).

735. Dwivedi and Bahulkar 1994b, 10–13 (vv. 13–17).

736. The assignment of male deities to the six families is explained in vv. 13–17 of the "Jñānapaṭala."

737. Shimizu 1982.

738. *Kāyamaṇḍale paṭṭikāsu dvādaśapadmāni candrasūryarahitāni/ tatra dikpadmāni raktāni koṇasthāni śvetāni/* (Lee 2003, 106; cf. Bhattacharya 1972, 88).

739. *Karṇikāyāṃ tu pūrṇimāmāvāsī ca nāyakatvena sthitā/ tatra pūrṇimā prajñāmāvāsyā tūpāyo nairṛtyādiḥ/* (ibid.).

740. In the Kālacakra calendar one month does not necessarily have thirty days since some months may have a missing day or an intercalary day.

741. *Teṣu bahiṣparimaṇḍalapūrvadalāt prabhṛti dakṣiṇāvartena pratipadāditithidevīnyāsaḥ/* (Lee 2003, 106; cf. Bhattacharya 1972, 88).

742. Dwivedi and Bahulkar 1994b, 15, ll. 15–24.

743. *Aṣṭadvārāṇi kuryād diśividiśi mahāmaṇḍalaṃ vṛttam* (ibid., 15, l. 12).

744. Ibid., 16, ll. 11–16.

745. In the *Kālacakra*, deities belonging to the water and fire, earth and wind, and wisdom and space families form couples. See Tanaka 1996a, 171.

746. The seed-syllables of the goddesses arranged on the six wheels are explained in vv. 29–34 of the "Jñānapaṭala" (Dwivedi and Bahulkar 1994b, 16–19). See also fig. 7.6.

747. bSod nams rgya mtsho and Tachikawa 1983, plate 98: Dus 'khor sdom chen lha bdun cu don gsum gyi dkyil 'khor.

748. Olschak and Wangyal 1973: 111. According to Lokesh Chandra et al. 2006 (Foreword), this maṇḍala belongs to the Ngor maṇḍala set.

749. *Māyājālaṃ dināṅgāt trividham api bhaved randhravedaiś ca samyak bhūyo bhūtārṇavaiḥ syāc chikhijalanidhibhiḥ śrīsamājartubhedaiḥ/ tattvākhyaṃ ṣaḍbhir hīnaṃ tv aparam api tayor ardhabhedair vibhinnair bhūyo miśro dvibhedas tridaśanavadiśābhiś ca randhraiḥ satattvaiḥ//52//* (Banerjee 1985, 53; Upadhyaya 1986, 185–186). I compared both editions and adopted the best readings. See also Wallace 2004, 63.

750. Here the *Māyājāla* is referred to as a Kriyāyoga tantra. This may be because, although belonging to the Highest Yoga tantras, it describes rites similar to those of the Kriyā tantras, such as the five *sthānakas* and fifty-three *ākṣepas* found in the *Viṃśatividhi*, 3. "Vighnopaśamanavidhi" (see Tanaka 2010, 573–81).

751. *Idānīṃ kriyāyoga-yogatantrāṇi triṣaṭprakārabhedenocyante māyājālam ityadinā—iha madhyamātripakṣadināni pañcacatvāriṃśaddināni dvādaśaguṇitāni tāni dināṅgāni catvāriṃśadadhikapañcaśatasaṃkhyāni bhavanti pratidinadvādaśalagnabhedād iti/ tasmād dināṅgāt catvāriṃśadadhikapañcaśatād vyavakalitaṃ māyājālaṃ trividham api bhavet, ekaṃ randhravedair ekonapañcāśadbhir devatāyugmair bhavati, bhūto dvitīyaṃ bhūtārṇavaiḥ syād iti pañcacatvāriṃśadbhir yugmair devatānāṃ bhavatīti/ aparaṃ śikhijalanidhibhiḥ trayaścatvāriṃśadbhir devatāyugmair iti/ ato dināṅgād vyavakalitas tribhedaiḥ saptatriṃśadadhikaśatasaṃkhyā bhavanti, dviguṇadevatādevyaḥ catuḥsaptatyadhikadviśatasaṃkhyā bhavanti, iti māyājālaniyamaḥ/ asya prapañcārthaḥ pañcamapaṭale vaktavya iti māyājālakriyāyogatantraniyamaḥ/ idānīṃ ṣaṭprakāraḥ samājabheda ucyate—tasmāt vyavakalitāvaseṣād dināṅgāt śrīsamājartubheda iti/ tattvākhyam iti pañcaviṃśatyātmakam, tasmād dināṅgāt pañcaviṃśadbhir vyavakalitair devatāyugmair bhavati/ aparamataḥ pañcaviṃśatiḥ ṣaḍbhir hīnam ekonaviṃśatyātmakam, ekonaviṃśatibhir devatābhir vyavakalitair iti/ aparam api tayoḥ pañcaviṃśaty ekonaviṃśatyātmakayor ardhabhedair*

vibhinno bhedo bhavati/ pañcaviṃśatyardhaḥ sārddhadvādaśaikonaviṃśatyarddhaḥ sārddhanava, ato 'rddhaḥ sārddha dvādaśe praviśati/ tatra ekonavātmakaḥ samājaḥ, aparas trayodaśātmakaḥ/ bhūyo 'paro miśro dvibhedo bhavati samājaḥ/ tridaśa iti trayodaśa/ navadiśā ekonaviṃśatiḥ/ ebhis tridaśanavadiśābhiś ca dvātriṃśadbhir devatāyugmai samājo bhavati; randhrair navabhiḥ satattvaiḥ pañcaviṃśadbhiḥ sahaḥ dvitīyaḥ samājaḥ catustriṃśadbhir devatāyugmair bhavati/ evaṃ samājaḥ ṣaḍbhedabhinnaḥ/ eṣu ṣaṭsu tantrarājeṣu dvātriṃśadadhikaśatadevatāyugmaiḥ saṃkhyā dviguṇitā devatādevīsaṃkhyā catuḥṣaṣṭyadhikadviśatā iti/ evaṃ samājamāyājāleṣu navasu tantrarājeṣv adhipatiyugmena sārddhaṃ catvāriṃśadadhikapañcaśata dināṅgasaṃkhyā devatādevatyo bhavanti/ eṣu tantreṣu skandhadhātvāyatanacandrasūryacaraṇaniṣpattibhedena bhedo garbhe yathā tathā pañcamapaṭale āsanabhedena vaktavya iti yogatantraniyamaḥ/ iha garbhe jātakasya skandhadhātuniṣpattyā navātmakaḥ samājaḥ, tathā skandhadhātusahajadharmasambhoganirmāṇacakre niṣpattyā trayodaśātmakaḥ, tathā skandhadhātucakraviṣayaniṣpattyā ekonaviṃśatyātmakaḥ, tathā skandhadhātucakraviṣayaṣaṭnetrādiniṣpattyā pañcaviṃśatyātmaka iti/ tathā skandhadhātuṣaṭcakraviṣayendriyakarmendriyaguhyoṣṇīṣakamalaniṣpattyā dvātriṃśatātmaka iti/ tathā skandhadhātuṣaṭcakraviṣayendriyakarmendriyadivyendriyānandān upetyā catustriṃśadātmakaḥ samāja iti/ garbhādhānāt ṣoḍaśavarṣādher yāvat ṣaṭprakāra utpādo bālānām iti samājaniyamaḥ pañcamapaṭale vistareṇa vaktavyaḥ/ evaṃ māyājāle skandhadhātavo navalomādyaṣṭadhātavo dvādaśāyatanāni catuṣ[sic]cakrasahitāni vātapittaśleṣmasannipātadhātusahitāni ṣaṭkarmendryāṇīti trayaścatvāriṃśadātmako māyājālaḥ/ uṣṇīṣaguhyakamalasahitam pañcacatvāriṃśadātmakam iti rāgadveṣamohamānena sārddham ekonapañcāśadātmakam iti māyājālaniyamaḥ pañcamapaṭale vistareṇa vaktavya iti yoginīyogatantrotpādaniyamaḥ/ (Upadhyaya 1986, 185–86). See also Wallace 2004, 63–65.

752. Bhattacharyya 1972, 52; Lee 2003, 64.

753. On the embryology of the *Kālacakra*, see Tanaka 1994a, 105–21.

754. *Idānīṃ mantradevatānām adhyātmaśuddhir ucyate—skandhair ityādi/ iha pañcaskandhaiḥ pañcātmā śuddhyati, skandhapañcabhūtair navātmā śuddhyati, catuḥkarmendriyaiḥ saha trayodaśātmā śuddhyati, ṣaḍindriyaiḥ saha ekonaviṃśadātmā śuddhyati, ṣaḍviṣayaiḥ saha pañcaviṃśadātmā śuddhyati, pañcakarmendriyakriyābhiḥ saha pañcakarmendriye praviṣṭe svābhaprajñayā saha dvātriṃśadātmā, ṣaṣṭhakarmendriya-ṣaṣṭhakarmendriyakriyāyuktaś [sic] catustriṃśadātmā, ṣaṭskandhadhātubhyāṃ yuktaḥ ṣaṭtriṃśadātmā iti/ evaṃ ṣaṭskandhāḥ ṣaḍdhātavaḥ ṣaḍindriyāṇi ṣaḍviṣayāḥ ṣaṭkarmendriyāṇi ṣaṭkarmendriyakriyā iti dhātavo maṇḍaleyāḥ/* (Dwivedi and Bahulkar 1994b, 7).

755. Seven deities must be added for the twenty-five-deity maṇḍala to become a thirty-two-deity maṇḍala. However, if we add five action organs and a consort who resembles the main deity (*svābhaprajñā*), we get six, not seven, deities. In the thirty-two-deity maṇḍala of Akṣobhyavajra, ten wrathful deities are depicted. The consort of the main deity is Sparśavajrā, who has already been counted. Therefore six action organs, namely, six wrathful deities, and Maitreya and Samantabhadra, who are not assigned to sense organs, should be added while Dharmadhātuvajrā, not depicted in this maṇḍala, should be omitted.

756. The seats of the four buddha-mothers are rotated counterclockwise by 45 degrees.

757. "Owing to the distinctions of the body" means that, according to the pre-

ceding v. 166, *pīṭhas* are assigned to the front and left sides of the body while *upapīṭhas* are arranged on the back and right sides of the body.

758. This too means that, according to v. 166, *kṣetras* are assigned to organs in the left side of the body while *upakṣetras* are assigned to organs in the right side of the body.

759. *Idānīṃ saptatriṃśad bodhipakṣikadharmair yoginīnāṃ viśuddhir ucyate devyo 'rciḥ smṛtyupasthānam api bhavati vai kālacakre prasiddhaṃ prajñā bodhyaṅgamātā tv aparam api tathā śabdavajrādi ṣaṭkam/ abdhiḥ samyakprahāṇāny aparajaladhayaś ca rddhipādāṣṭakaṃ syāt pañca krodhā balāni prakaṭitaniyatānīndriyāṇy eva pañca//167// devyo 'rcir ityādinā/ iha catasro devyo yathākrameṇa kāyānusmṛtyupasthānaṃ locanā vedanānusmṛtyupasthānaṃ pāṇḍarā iti paścimadakṣiṇam/ cittānusmṛtyupasthānaṃ māmakī, dharmanusmṛtyupasthānaṃ tāreti vāmapūrvaṃ kāyabhedena pīṭhopapīṭhadvayam iti kālacakre prasiddham/ nānyasmiṃs tantre prasiddhaṃ gopitaṃ bhagavatety arthaḥ/ tathā saptabodhyaṅgānāṃ madhye ekaṃ bodhyaṅgaṃ mātā vajradhātvīśvarī kulapīṭham upekṣāsambodhyaṅgam iti/ aparam api tathā śabdavajrādiṣaṭkam iti/ smṛtisambodhyaṅgaṃ śabdavajrā/ dharmapravicayasambodhyaṅgaṃ sparśavajrā/ vīryasambodhyaṅgaṃ rūpavajrā/ upakṣetraṃ kāyabhedāt/ tathā prītisambodhyaṅgaṃ gandhavajrā/ praśrabdhisambodhyaṅgaṃ rasavajrā/ samādhisambodhyaṅgaṃ dharmadhātuvajreti/ kṣetraṃ dvidhā/ tathābdhiḥ samyakprahāṇānīti/ anutpannānāṃ pāpānāṃ anutpādāya prahāṇaṃ carcikā/ utpannānāṃ pāpānāṃ prahāṇaṃ kuśalamūlaṃ vaiṣṇavī/ anutpannānām akuśalānāṃ prahāṇaṃ kuśalotpādanaṃ moheśvarī/ utpannā(=a) kuśalānāṃ buddhatva(=tve)pariṇāmanāprahāṇaṃ mahālakṣmīḥ/ upachandohāś catvāraḥ/ aparajaladhayaś catasro devyā ṛddhipādā bhavanti/ tatra chanda-ṛddhipādo brahmāṇī/ vīrya-ṛddhipāda aindrī/ citta-ṛddhipādo vārāhī/ mīmāṃsā-ṛddhipādaḥ kaumārīti chandohabheda ity aṣṭakaṃ syāt/ tathā pañca krodhabalānīti/ iha śraddhābalam atinīlā/ vīryabalam atibalā/ smṛtibalaṃ vajraśṛṅkhalā/ samādhibalaṃ māṇī/ prajñābalaṃ cundety upamelāpakam/ tathā prakaṭitaniyatānīndriyāṇy eva pañceti/ tathā śraddhendriyaṃ stambhī/ vīryendriyaṃ mārīcī/ smṛtīndriyaṃ jambhī/ samādhīndriyaṃ bhṛkuṭī/ prajñendriyaṃ raudrākṣīti melāpakam evaṃ daśakam//samyak caṣṭāṅgamārgo bhavati narapate cāṣṭakaṃ daityajānāṃ saptatriṃśat-prabhedais tribhuvananilaye bodhipakṣāś ca dharmāḥ//168ab//samyak caṣṭāṅgamārgo bhavati narapate cāṣṭakaṃ daityajānām iti/ iha samyagdṛṣṭiḥ śvānāsyā/ samyaksaṃkalpaḥ kākāsyā/ samyagvāg vyāghrāsyā/ samyak-karmānta ulūkāsyā/ samyagājīvo jambukāsyā/ samyagvyāyāmo garuḍāsyā/ samyaksmṛtiḥ śūkarāsyā/ samyaksamādhiḥ [sic] gṛdhrāsyeti/* (Dwivedi and Bahulkar 1994a, 129–30).

760. T. 868.18.280b.

761. For further details, see Tanaka 1994b.

762. Tanaka 2010, 673–74 (vv. 3–4).

763. See Tanaka 2000a.

764. See Tanaka 1994b, 36–37.

765. *Catūratnamayo meruḥ, suvarṇamayaḥ, rūpyamayaḥ, vaidū[sic]ryamayaḥ, sphaṭikamayaś ca yathāsaṃkhyaṃ caturṣu pārśveṣu/ yac ca yanmayaṃ pārśvaṃ sumeroḥ, tasyānubhāvena tadvarṇaṃ tasyāṃ diśi nabho dṛśyate/ jambūdvīpakasya pārśvaṃ vaidūryamayaṃ varṇayanti/ tasyeha prabhānurāgeṇa vaidūryamayaṃ nabho dṛśyata iti/* (Shastri 1971, 2, 508).

766. The *Abhidharmakośa* refers to the precious metal on the west side of Mount Sumeru as quartz (*sphaṭika*) without specifying its color, but it was inter-

preted as red quartz in later texts. This seems to have been because the sky turns red at sunset on Jambūdvīpa, where humans live.

767. Shastri 1971, 2, 511–12.

768. This explains the size of the four continents. The *Kālacakra* uses many secret terms denoting numbers, on which see Banerjee 1985, Appendix I.

769. *Pūrvavāyvardhavṛttaṃ bhavati narapate dakṣiṇe 'gnis trikoṇaṃ pūrṇendus cottare 'mbor varakanakamaheḥ paścime cābdhikoṇam/ śūnyākāraḥ sumerur varakuliśamayo madhyato maṇḍalānāṃ śailā nāgā grahā dig bhavati bhuvitalaṃ yojanānāṃ sahasram//17//* (Banerjee 1985, 5; Upadhyaya 1986, 71). I compared both editions and adopted the best readings.

770. This is a secret term for "four" because the oceans are thought to be four in number. Therefore *abdhikoṇa* means "quadrangle."

771. Upadhyaya 1986, 72. The *Vimalaprabhā* (CIHTS edition) makes the shape of both Pūrvavideha and Uttarakuru a half-moon, whereas the Tibetan translations of the *Kālacakratantra* and *Vimalaprabhā* make the shape of Pūrvavideha circular and Uttarakuru a half-moon. Neither of these coincides with the *Kālacakratantra*. The interpretation of this point seems to have been considered difficult in Tibet. Lochen Dharmaśrī (1654–1718), a renowned scholar of the *Kālacakra*, writes in his *Rtsis kyi man ngag nyin byed snang ba'i rnam 'grel, Gser gyi sing rta*: "In this regard the tantra says, 'O King! east is wind and circular, south is fire and triangular, north is water and a full-moon.' This seems to coincide with the commentary (i.e., *Vimalaprabhā*). In the Sanskrit original, however, it says *pūrvavāyvardhavṛttaṃ bhavati*. Thus, the word *ardha* ('half') has been inserted. Scholars say that this is inconsistent because the commentary on a later part also says [Pūrvavideha a] 'half-moon'" (Lo chen Dharmaśrī 1983, 269–70). Therefore I think it best to emend the CIHTS edition of the *Vimalaprabhā* in accordance with the *Kālacakratantra* (Banerjee edition).

772. *Pūrve śuddhendranīlaḥ sakalagiripatir dakṣiṇe padmarāgaḥ pṛṣṭhe karketapīṭaḥ śaśadharadhavalaś cottare candrakāntaḥ/ madhye śyāmas tadantarnihitam iha mahāmaṇḍalaṃ tasya garbhe ādau cittasvabhāvaṃ dviguṇam api tato madhyato vāksvabhāvam//169//* (Banerjee 1985, 242).

773. The location of this sentence differs in the Sanskrit text and the Tibetan translation.

774. In the *Kālacakratantra*, the four semivowels are used as seed-syllables of the four elements wind, fire, earth, and water.

775. *Idānīṃ lokadhātau mervādīnāṃ lakṣaṇam ucyate— pūrva ityādi/ iha pūrva iti pūrvavidehābhimukhaḥ śuddhendranīlaḥ, vāyudharmātmakatvāt sakalagiripatir ityarthaḥ/ antaḥsthā ya ra la vāḥ/ pūrve ya/ dakṣiṇe padmarāgo rakāradharmātmakatvāt/ paścime karketapīṭhaḥ lakāradharmātmakatvāt/ śaśadharadhavalaś cottare candrakāntaḥ vakāradharmātmakatvāt/ evaṃ ya ra la vā caturdvīpeṣu jñātavyāḥ/* (Dwivedi and Bahulkar 1994b, 120–21).

776. *Vāyvantād vāyusīmnaḥ sthiradharaṇitale dvīpaśailāḥ samudrāś catvāryarddhaṃ dvilakṣaṃ śikhicalavalayaṃ yojanānāṃ dvilakṣam//11ab//* (Banerjee 1985, 3).

777. There are six continents, six rocky mountains, and six oceans on Mount Sumeru. They correspond to the seven golden mountains (*kāñcanaparvata*) and seven inner oceans (*saptasīta*) of the *Abhidharmakośa's* cosmology.

778. Vajraparvata is the somma of the world system centered on Mount Sumeru and corresponds to Cakravāda in the *Abhidharmakośa*.

779. *Vāyvantād vāyusīmnaḥ catvāri lakṣāṇi vāyor vāyvantaṃ pūrvād aparavāyuvalayāntaṃ yāvat/ evaṃ dakṣiṇād uttarāntaṃ yāvad iti/ sthiradharaṇitale dvīpaśailaḥ samudrā iti/ tato*

vāyumaṇḍalābhyantare vahnimaṇḍalaṃ valayākāram, evaṃ agni-valayamadhye toyavalayam, toyavalayamadhye pṛthvīvalayam tad eva sthiraṃ dharaṇitalam, tasmin ṣaḍ dvīpāḥ ṣaṭ śailāḥ, ṣaṭ samudrāḥ/ saptamenodakavalayena sahitāḥ sapta samudrāḥ, saptamena jambūdvīpena sahitāḥ sapta dvīpāḥ, vajraparvatena sārddhaṃ sapta parvatāḥ/ vajraparvato vāḍavāgniḥ/ kṣārasamudrāḥ toyavalayānte adhastatiryagvibhā-gena sthitaḥ pṛthvī mahājambūdvīpānte sarvadikṣu adhaś ca kṣārasamudro 'vasthitaḥ/ lavaṇasamudrāntāl lavaṇasamudr[ānt]am/ arddhaṃ caturlak-ṣāṇām/ catvāryarddhaṃ dvilakṣām iti/ meror madhyāt savyāpasavye kṣāra-samudrāvalayāntam/ dvilakṣaṃ savyenaikalakṣaṃ apasavyenaikalakṣam/ evaṃ pūrvāparaṃ vāyavyāgneyam, nairṛtyeśānam/ śikhicalavalayaṃ yojanānāṃ dvilakṣam iti/ tasmāt kṣārodakavalayāt savyāpasavye śikhivāyu-valayaṃ dvilakṣam bhavati, savyenaikalakṣaṃ, apasavyenaikalakṣam, uttareṇa lakṣam ekam evaṃ sarvadikṣu/ (Upadhyaya 1986, 67–68). Errors have been silently corrected.

780. "Lack moons and suns" means that the main deities ride on animals instead of being seated on thrones.

781. *Bāhye vāgmaṇḍale vai vasukamalam idaṃ candrasūryair vihīnaṃ bāhye dikkoṇabhāge dinakarakamalaṃ dvāramadhye rathāś ca/...//9//* (Banerjee 1985, 143).

782. *Cittamaṇḍalaṃ bhūvalayāntaṃ// tadbāhye vāṅmaṇḍale samudrāva-layānte vasukamalam idaṃ kamalāṣṭakaṃ candrasūryair vihīnam, tasyaiva bāhye kāyamaṇḍale vāyuvalayānte dinakarakamalam iti dvādaśakamalaṃ candrasūryair vihīnam/ evaṃ caturdvāre rathāś ca/ evaṃ kāyamaṇḍalaṃ caturlakṣayojanāyāmam, vāṅmaṇḍalaṃ tadardham, cittamaṇḍalaṃ tasyāpy ardham, mahāsukhacakraṃ tasyāpy ardhaṃ bhagavataḥ padmaṃ/* (Dwivedi and Bahulkar 1994a, 155–56). See also Wallace 2010, 29–30.

783. In the *Kālacakratantra*, deities belonging to the Space family, presided over by Akṣobhya, and deities belonging to the Wisdom family, presided over by Vajrasattva, form couples.

784. *Vāg-hastau pādapāyū marudanalajalakṣmāsu sarve babhūvuḥ//23//... dhātuvaśena karmendriyāṇy āha—vāgityādi/ iha vāgindriyaṃ vāyudhātor bhavati, pāṇīndriyaṃ tejodhātoḥ, pādendriyaṃ toyadhātoḥ, pṛthvīdhātoḥ pāyvindriyam, anuktatvāt ākāśadhātoḥ guhyendriyam/ ṣoḍaśavarṣānte jñānadhātau divyendriyaṃ bhavatīti ṣaṭkarmendriyaniyamaḥ/* (Upadhyaya 1986, 168). See also Wallace 2004, 27–28.

785. Carelli 1941, 73–74; Sferra and Merzagora 2006, 205.

786. Tanaka 2010, 692 (v. 47).

787. La Vallée Poussin 1896, 16.

788. Tanaka 2016d, 104–5.

789. La Vallée Poussin 1896, 7. Hadano (1987, 144–45) had already pointed out this fact.

790. For a typical example, see plate 5 in Tanaka 2005a, held by the Hahn Cul-tural Foundation.

791. Hadano 1987, 24.

792. *Prajñopāyātmakaṃ tadvat kāyavajrāṇi cādvayaḥ/ ṣaḍskandhā dhātavas tad-vat viṣaya (= viṣayā) indriyāṇi ca//37// kriyākarmendriyāṇy eva advayam yena saṃsthitaḥ/ saṃvaraḥ sarvabuddhānāṃ evaṃkāre pratiṣṭhitaḥ//38//* (Shendge 2004, 20).

793. *Śūnyaṃ gṛhṇāti śabdaṃ khalu jinajanako dharmadhātuṃ ca vāyuḥ gan-dhaṃ vahniś ca rūpaṃ rasam api salilaṃ sparśam eva dharitrī//20cd// idānīṃ grāhyagrāhakasambandha ucyate/ iha parakulāliṅganataḥ kāryasid-dhir bhavati, svakulāliṅgena svātmani kriyāvirodhāt/ ataḥ parakulāliṅga-*

naṃ śarīrotpattikāraṇaṃ bhavati/ tena śūnyam iti śūnyakulodbhūtaṃ śrotrendriyaṃ gṛhṇāti śabdaṃ jñānadhātūdbhūtam/ khalu jinajanaka iti niścitaṃ jñānadhātūdbhūtaṃ mana-indriyaṃ gṛhṇāti, dharmadhātum ākāśadhātūdbhūtaviṣayam/ vāyur iti janyajanakābhedatvena vāyūd-bhūtaṃ ghrāṇendriyaṃ bhūmidhātūdbhūtaṃ gandhaviṣayaṃ gṛhṇāti/ vahniś ceti agnidhātūdbhūtaṃ cakṣurindriyaṃ toyadhātujanitaṃ rūpaviṣayam/ vahnidhātujanitaṃ rasaviṣayaṃ jaladhātūdbhūtaṃ rasanen-driyaṃ gṛhṇāti/ dharitrī pṛthvīdhātūdbhutaṃ kāyendriyaṃ gṛhṇāti vāyudhātūdbhūtaṃ sparśaviṣayam iti viṣayaviṣayiṇāṃ grāhyagrāhaka-lakṣaṇaniyamaḥ/ (Upadhyaya 1986, 166–67). See also Wallace 2004, 23–24.

794. *Śrotrāc chabdādayo 'nye svajinakulavasād vāksvarūpādayaś ca evaṃ devyaḥ sabuddhā viṣayaviṣayiṇo maṇḍale veditavyāḥ//30cd//evaṃ śrotrāt śabdā-dayo* [sic] *'nye iti/ śabdaḥ prajñā śrotra upāyaḥ, gandhaṃ prajñā ghrāṇopāyaḥ (= ghrāṇa upāyaḥ), rūpaṃ prajñā cakṣur upāyaḥ, rasaḥ prajñā jihvopāyaḥ, sparśaḥ prajñā kāya upāyaḥ, dharmadhātuḥ prajñā mana upāyaḥ, viṭsrāvaḥ prajñā guda upayaḥ, gati prajñā pāda upayaḥ, ādānaṃ prajñā kara upāyaḥ, ālāpaḥ prajñā vāgindriyam upāyaḥ, mūtrakriyā prajñā bhaga upāyaḥ, liṅgaṃ vā śukracyavanaprajñā śaṅkhinīndriyam upāya iti/ svajinakula-vaśāt vāksvarūpādayaś ca karmendriyādyā iti/ evam uktakrameṇa devyaḥ pṛthivyādayaḥ sabuddhā vairocanādibhiḥ sārddha viṣayaviṣayiṇo maṇḍale vakṣyamāṇe vaktavyā iti parasparaṃ prajñopāyāliṅganavidhiniyamaḥ/* (Upadhyaya 1986, 172). See also Wallace 2004, 37–38.

795. For further details, see Tanaka 1994b, 186–203.

796. An outline of this section can be found in Tanaka 1999.

797. Carelli 1941, 3, ll. 1–20; Sferra and Merzagora 2006, 193–94.

798. *Na kṣarati na calaty aparasthānaṃ gacchatīty akṣaraśabdena svara ity ucyate/ tena kumantrī bhrānto 'kṣaratvena svarasamūhaṃ gṛhṇāti vyañjanasamūhaṃ vā/ paramārthataḥ svaravyañjanasamūho 'kṣaro na bhavati/ akṣaraśabdena paramākṣarasukhaṃ jñānaṃ vajrasattva iti/ tathā manastrāṇabhūtatvān mantro 'pi paramākṣarajñānam ucya-te/ tathā 'parādhyātmikī vidyā prajñāpāramitā prakṛtiprabhāsvarā mahāmudrā sahajānandarūpiṇī dharmadhātuniḥspandapūrṇāvasthā sahajatanur ity ucyate jinaiḥ/ tau pratītyasamutpannānām indriyāṇām agocarau/ divyendriyagocarau vajrasattvabuddhamātarau paramākṣara-sukhasvabhāvau paramāṇudharmatātītav ādarśapratisenāsvapnatulyau paramākṣarasvarūpav iti/ atrākṣarāṇīti rūpavedanāsaṃjñāsaṃskāravi-jñānāni/ nirāvaraṇāni pañcākṣarāṇi mahāśūnyāny uktāni/ tathā pṛthivyaptejovāyvākāśadhātavo nirāvaraṇāḥ pañcākṣarāṇy uktānīti/ ṣaḍakṣarāṇi cakṣuḥśrotraghrāṇajihvākāyamanāṃsi nirāvaraṇāni pratyekasvasvaviṣayagrahaṇavarjitāni/ tathā rūpaśabdagandhara-sasparśadharmadhātavo nirāvaraṇāś ca ṣaḍakṣarāṇy uktānīti/ etāni skand-hadhātvāyatanāny ekasamarasībhūtāni binduśūnyo bhavati/ sa ca bindur acyutaḥ san paramākṣara ucyate/ paramākṣaro 'py akāro 'kārasambhavaḥ samyaksambuddhaḥ prajñopāyātmako vajrasattvo napuṃsakapadaṃ sahajakāya ucyate jñānajñeyātmakaḥ, hetuphalayor abhedyatvāt/ sa ca kālacakro bhagavān paramākṣarasukhapadam ity* (Dwivedi and Bahulkar 1994b, 60, l. 21–61, l. 6).

799. For further details on the vision of the drop, see Tanaka 1994a, 186–203.

800. As a typical example of a maṇḍala set in tsakali format, reference can be made to the *Rin chen gter mdzod* set in the possession of the Hahn Cultural Foundation. See Tanaka 2005a, plate 13.

801. Lokesh Chandra 1967.

802. Lokesh Chandra, Tachikawa, and Watanabe 2006, "Foreword."

803. Mori 1998a; 1998b; 2001b.

804. Mori 1999a; 1999b.

805. *Mai tri'i dkyil 'khor cha tshang yod/ gzhan yang thig le bcu drug tshe dpag nang sgrub yod/.*

806. On the design of the *toraṇa* peculiar to the Kāyavākcittapariniṣpanna-Kālacakra-maṇḍala, see Dwivedi and Bahulkar 1994a, 47–48.

807. Rong tha Blo bzang dam chos rgya mtsho 1978.

808. Tanaka 2007a.

809. Tanaka 2013. Since the publication of the image database, many fragments of the *Mitra brgya rtsa* have been identified in collections around the world.

810. The Sanskrit terms for the three circles of the outer enclosure are given in the *Vajrācāryanayottama* (see Tanaka 2010, 654–55), and eight cemeteries (*aṣṭaśmaśāna*) were added in the maṇḍalas of late tantric Buddhism.

811. Tanaka 2010, 650–55.

812. The verse numbers of the *Ācāryakriyāsamuccaya* are based on Moriguchi 1990.

813. Ishida 1984.

814. Yoritomi 1991, 46–49.

815. The Amoghapāśa-pentad maṇḍala (Musée Guimet, EO.3579) and two line drawings of the Durgatipariśodhana-maṇḍala (Bibliothèque nationale de France, Pelliot chinois no. 3937, Pelliot tibétain no. 389) discussed in Tanaka 2000a are typical examples of maṇḍalas in the shape of the *cakra* as a weapon.

816. Tanaka 2010, 652.

817. Rossi and Rossi 1993, plate "Vajradhātu Maṇḍala."

818. In the generation of the nineteen deities of the Mañjuvajra-maṇḍala explained in a Sanskrit commentary on the *Samantabhadra nāma sādhana*, all the deities are visualized on a sun disc or a moon disc placed on top of the pericarp of the lotus seat (Tanaka 2017a, 50–143).

819. The Hahn Foundation handscroll depicts this maṇḍala in the form of a triple eight-spoked wheel.

820. This is seen in the Kṛṣṇayamāri-maṇḍala (V-5) and Raktayamāri-maṇḍala (M-42), but the Hahn Foundation handscroll depicts the crossed vajra only in the Raktayamāri-maṇḍala.

821. This corresponds to M-56, but the Hahn Foundation handscroll adopts an eight-petaled lotus in accordance with the *Abhisamayamuktāmālā*.

822. T. 897.18.765ab.

823. Ibid., 765a.

824. On the maṇḍala of Eleven-Faced Avalokiteśvara of Great Compassion in the Lakṣmī tradition, see Tanaka 1990a, 46–47.

825. Horiuchi 1983, 260, §450: *vajramadhye likhed buddhaṃ.*

826. Ibid., 260, §451: *mahāsatvāḥ [sic] samālekhyāḥ svamudrā hṛdayaṃ tathā/ samādhito niṣaṇṇas tu.*

827. TZ. 1.1b.

828. See Tanaka 1996a, 104–25.

829. This color scheme is found in the Garbha-maṇḍala among the Ngor maṇḍalas and in examples held by the Kālacakra College (Dus 'khor grva tshang) in Labrang monastery, by Tateyama Museum in Japan, and so on. Ritual manuals on the Garbha-maṇḍala by Butön and the First Panchen Lama also describe this color scheme.

830. The *Vairocanābhisambodhisūtra* describes the body color of Ratnaketu as "like the radiance of the sun (at sunrise)" and that of Saṃkusumita[rājendra] as "golden in color." This coincides with the color scheme of the courtyard of the Garbha-maṇḍala. However, the body colors of Amitābha and Dundubhisvara (Akṣobhya) are not mentioned (see Giebel 2005, 24). See Ochi 1977.

831. Mikkyō Seiten Kenkyūkai 1986, 259.

832. *Phyogs tshon ni/ 'grel par dngos su gsal bar ma gsungs la/ bla ma gong ma rnams kyis/ shar dmar po/ lho ljang gu/ nub sngon po/ byang ser po/ dbus dkar por gsungs shing/ dpal mchog gi dkyil 'khor gzhan thams cad kyang de dang 'dra bar bzhed do//* (Bu ston Rin chen grub 1969, part 17 [Tsa], fol. 161, ll. 4–5).

833. On the body colors of Vajrasattva and his four attendants, see Fukuda 1987, 36–40.

834. P. 3338 (*Śrī-vajramaṇḍalālaṅkāra-mahātantra-pañjikā*). *Mi bskyod pa yi dkyil 'khor ni/ zla 'od lta bu'i mdog tu bya/ zhes pas shar dkar por bya'o// lho la sogs pa ni 'grel par rin chen 'byung ldan la sogs pa'i dkyil 'khor ni/ ljang khu dang/ dmar po dang/ sngon po'i kha dog can du rim pas khong du chud par bya'o//* (Bu ston Rin chen grub 1969, part 17 [Tsa], fol. 382, ll. 3–4).

835. Tanaka 2010, 673–74.

836. On EO 3579, see Tanaka 2000a, 39–71.

837. On a different theory about the body colors of the five buddhas, see Tanaka 1994a, 33–53.

838. For further details, see Tanaka 2007a, 5–15 (Japanese); 2013, 5–15 (English).

839. T. 890.18.564a-c.

840. Apart from the Jeweled Pavilion maṇḍala (a landscape maṇḍala) mentioned in chapter 1, maṇḍalas of Uṣṇīṣavijayā, Saṃvara (six-deity), and Cakrasaṃvara (sixty-two-deity) have been discovered at Khara-khoto. In all of these the courtyard is colored. For further details, see Petrovsky 1993.

841. Tanaka 2003a.

842. P. 2728 (*Śrīguhyasamājamaṇḍalavidhi*). See Sakurai 1996, 136–50. When Sakurai published his study, no Sanskrit manuscript of the *450 Verses* was known. But it was subsequently brought to my notice that a manuscript of this text is included among the manuscripts photographed by Rāhula Sāṅkṛtyāyana and later acquired by the Niedersächsische Staats- und Universitätsbibliothek, Göttingen (Bandurski 1994, 113–14, Cod. ms. sanscr 257; fols. 6b5–16b6 correspond to Dīpaṃkarabhadra's text). This manuscript covers the first 415 verses, and S. S. Bahulkar restored the missing part on the basis of the Tibetan translation and published the full text (Bahulkar 2010).

843. Sakurai 1996, 544–45, v. 56 of text B (v. 338 in Bahulkar 2010). It corresponds to a verse in the "Mantrakhaṇḍa" of the *Paramādyatantra* (P. 120, 5: 146-5-3-4).

844. "Śiṣyapraveśavidhi," vv. 38–43. See Tanaka 2010, 691–92.

845. See the synopsis of the "Śiṣyapraveśavidhi" in Tanaka 2010, 622–23.

846. Moriguchi 1990, 24–26.

847. P. 2717, 65: 12-1-8-2-1.

848. Govinda 1976, fig. 15.

849. Tsongkhapa states in chapter 9 of his *Sngags rim chen mo* that for details on purification (*rnam dag*), that is, the reality of the deities, reference should be made to the *Āmnāyamañjarī* 18 (a commentary on *Sampuṭa* V.2) (Tsong kha pa, Blo bzang grags pa 1995, 366). There, the *skandhadhātvāyatana* system of the Guhyasamāja cycle is applied to maṇḍalas of the Mother tantras.

850. Ibid., 462–64.

851. *Des na khyad par can gyi snang bas yid shes kyi ngor tha mal pa'i snang ba 'gog*

pa'i nus pa thob na des dgos pa 'grub la/ dngos po la lhar ma song yang lha'i bcos min gyi nga rgyal skyes na'ang des dgos pa 'grub po// (ibid., 464, ll. 12–15).

852. Tsongkhapa may have referred not to the *Vajrapañjara* itself but to another text quoting it.

853. *Phal ba'i rnam pa gzhom pa'i phyir/ bsgom pa yang dag rab tu grags/ phal ba'i gnas skabs gzhom pa'i phyir/ bsgom pa yang ni bsgom pa min//* (P. 11, 1: 235-2-8-3-1).

　Rāhula Sāṅkṛtyāyana discovered some Sanskrit manuscripts of the *Vajra-pañjara* in Tibet, but the Sanskrit text has not yet been published. Sanskrit manuscripts of two commentaries have survived in Nepal, and one of these, the *Ḍākinīvajrapañjaraṭippaṇī*, quotes the second half of this verse as follows: *saṃskṛtatvair na vādhyate bhāvana na ca bhāvanā//*. This differs from the Tibetan translation, which has *prākṛta* (*phal ba*) for *saṃskṛta*. I have therefore emended the text to "*prākṛtatvaṃ na vādhyate bhāvanā na ca bhāvanā//*" and translated it accordingly.

854. *Punar eṣo* [sic] *skandhadhātvāyatanānām anādiprākṛtāhaṅkāravyavasthi-tānām adhunā sarvatathāgataparamāṇuparighaṭitasvabhāvo nirdiśyate/* (Pandey 2000, 8).

855. *Subhūtir āha: Katame Bhagavan sāsravā dharmāḥ?*

　Bhagavān āha: Pañca skandhā dvādaśāyatanāny aṣṭādaśa dhātavaś catvāri dhyānāni catvāry apramāṇāni catasra ārūpyasamāpattayaḥ, ima ucyante sāsravā dharmāḥ.

　Subhūtir āha: Katame Bhagavan anāsravā dharmāḥ?

　Bhagavān āha: Catvāri smṛtyupasthānāni catvāri samyakprahāṇāni cat-vāra ṛddhipādāḥ pañcendriyāṇi pañca balāni sapta bodhyaṅgāny āryāṣṭāṅgo mārgo daśa tathāgatabalāni catvāri vaiśāradyāni catasraḥ pratisaṃvido yāvad aṣṭādaśāveṇikā buddhadharmāḥ, ima ucyante anāsravādharmāḥ (Kimura 2009, 27). There is no corresponding passage in Xuanzang's transla-tion of the *Pañcaviṃśatiprajñāpāramitā* (part 2), and instead a correspond-ing passage is found in his translation of the *Śatasāhasrikā Prajñāpāramitā* (part 1) (T. 220.5.262bc).

856. The reason that Indra is associated with the earth may be that Great Indra (Mahendra) is interchangeable with Great Earth (Mahīndra). These four deities are depicted only in the Jōjin-e of the Kue maṇḍala. In the eighty-one-deity maṇḍala, the earth goddess, rather than the earth god, is depicted.

857. A wall painting datable to the building's original construction survives at Shalu monastery in Tibet in the south chapel (*gzhal yas khang lho ma*).

858. P. 123, 5: 206-3-3-5-7.

859. Horiuchi 1983, 30–31, §32.

860. On the color scheme of the courtyards of the Sarvatathāgata-trilokacakra-maṇḍala and Sarvatathāgata-maṇḍala of the *Trailokyavijayamahākalparāja*, see Tanaka 1994a, 43 (where I wrongly identified the Sarvatathāgata-maṇḍala as the Kāmadhātvīśvara-maṇḍala).

861. Traditional Buddhist views of the world, such as that set out in the *Abhi-dharmakośa*, mention only the wheels of wind, water, and earth. The *Kāla-cakratantra*, on the other hand, explains the wheels of the four elements with the addition of the wheel of fire.

862. Mori 2005; Tanaka et al. 2001, 174–205.

863. Vaidya 1967, 32: *Cittamātram idaṃ yad idaṃ traidhātukam.*

864. On Ratnākaraśānti's interpretation of the *Guhyasamāja*, see Ōmi 2006.

865. Tanaka 1999, 89–90.

866. Verse 43 of the "Śiṣyapraveśavidhi" (verse 44 in the revised edition to be published in Manuscripta Buddhica).

867. Tanaka 2010, 692.

868. The main deity Kālacakra is an emanation of Akṣobhya, while his consort Viśvamātā is an emanation of Vajrasattva.

869. See Tanaka 2017a, 102–5, v. 84 of the *Samantabhadra nāma sādhana*.

870. For example, Śrīphalavajra clearly states that the six adamantine goddesses form father-mother couples with the six great bodhisattvas in his comments on v. 84 in the *Samantabhadrasādhanavṛtti* (Danzhu'er 21-1279–1280).

871. bSod nams rgya mtsho and Tachikawa 1983, plate 44: Ngor lugs gsang 'dus 'jam dpal rdo rje lha bcu dgu'i dkyil 'khor, and a wall painting at Tsha-tshapuri monastery, Ladakh (Fujita 1983, 109), depict all the deities of the Mañjuvajra-maṇḍala as father-mother couples.

872. Wallace 2001, chapter 4.

873. Kawasaki, S. 1992.

874. Some such apologias are given in chapter 10 of the *Madhyamakahṛdaya* (Kawasaki, S. 1992, 402–403).

875. For further details, see Tanaka 1994a, 204–25.

Bibliography

Abbreviations

CIHTS Central Institute of Higher Tibetan Studies

IsIAO Istituto Italiano per l'Africa e l'Oriente

JIBS *Journal of Indian and Buddhist Studies* (*Indogaku Bukkyōgaku Kenkyū* 印度學佛教學研究)

KZ. *Kōbō daishi zenshū* 弘法大師全集 (Kōyasan: Mikkyō Bunka Kenkyūjo, 1978)

SZ. *Shingonshū zensho* 眞言宗全書 (Kōyasan: Shingonshū Zensho Kankōkai, 1936)

T. Taishō Shinshū Daizōkyō 大正新修大藏經

TZ. Taishō Shinshū Daizōkyō Zuzōbu 大正新修大藏經圖像部

Works Cited

Ācārya Gyalsten Namdol, trans. and ed. 1991. *Bodhicitta-Vivaraṇa of Ācārya Nāgārjuna and Bodhicitta-Bhāvanā of Ācārya Kamalaśīla.* Sarnath: CIHTS.

Bahulkar, S. S. 2010. *Śrīguhyasamājamaṇḍalavidhiḥ.* Sarnath: CIHTS.

Bandurski, Frank. 1994. "Übersicht über die Göttinger Sammlungen der von Rāhula Sāṅkṛtyāyana in Tibet aufgefundenen buddhistischen Sanskrit-Texte (Funde buddhistischer Sanskrit-Handschriften, III)." In *Sanskrit-Wörterbuch der buddhistischen Texte aus den Turfan-Funden*, Supplement 5, edited by Heinz Bechert, 12–126. Göttingen: Akademie der Wissenschaften zu Göttingen.

Banerjee, Biswasnath. 1985. *Śrī-Kālacakratantrarāja.* Calcutta: Asiatic Society.

Behera, K. S., and Thomas Donaldson. 1998. *Sculpture Masterpieces from Orissa: Style and Iconography.* New Delhi: Aryan Books.

Bhattacharyya, Benoytosh. 1968a. *Sādhanamālā.* Baroda: Oriental Institute.

———. 1968b. *The Indian Buddhist Iconography.* Calcutta: Firma K. L. Mukhopadhyay.

———. 1972. *Niṣpannayogāvalī.* Baroda: Oriental Institute.

Brauen, Martin. 1992. *Das Mandala.* Köln: DuMont Buchverlag.

bSod nams rgya mtsho and Tachikawa Musashi 立川武蔵. 1983. *Chibetto mandara shūsei* 西藏曼荼羅集成 [Tibetan mandalas: The Ngor collection]. Tokyo: Kōdansha.

bSod nams rgya mtsho et al. 1991. *The Ngor Mandalas of Tibet: Listings of the Mandala Deities.* Tokyo: Centre for East Asian Cultural Studies.

Bunkazai Hogo Iinkai 文化財保護委員会. 1961. *Kokuhō jiten* 国宝事典 [Encyclopedia of national treasures]. Tokyo: Benridō.

Carelli, Mario E. 1941. *Sekoddeśaṭīkā.* Baroda: Oriental Institute.

Chakravarti, Chintaharan. 1984. *Guhyasamājatantrapradīpoddyotanaṭīkā.* Patna: K. P. Jayaswal Research Institute.

Chattopadhyaya, Debiprasad. 1970. *Tāranatha's History of Buddhism in India.* Simla: Indian Institute of Advanced Study.

Chauduri, Nagendra Narayan. 1935. *Studies in the Apabhraṃśa Texts of the Ḍākārṇava.* Calcutta: Metropolitan Printing & Publishing House.

Cucuzza, Claudio. 2001. *The Laghutantraṭīkā by Vajrapāṇi.* Rome: IsIAO.

Dargyay, Eva M. 1977. *The Rise of Esoteric Buddhism in Tibet.* Delhi: Motilal Banarsidass.

Douglas, Nik, and Meryl White. 1976. *Karmapa: The Black Hat Lama of Tibet.* London: Luzac.

Dunhuang Yanjiuyuan 敦煌研究院 (Dunhuang Academy), ed. 1990. *Chūgoku sekkutsu: Ansei Yurin kutsu* 中国石窟 安西楡林窟 [Cave temples of China: Anxi Yulin caves]. Tokyo: Heibonsha.

Dwivedi, Vrajavallabha. 1990. *Luptabauddhavacanasaṃgraha,* part 1. Sarnath: CIHTS.

———. 1992. *Kṛṣṇayamāritantram Ratnāvalīpañjikayā sahitam.* Sarnath: CIHTS.

Dwivedi, Vrajavallabha, and S. S. Bahulkar. 1994a. *Vimalaprabhā,* vol. 2. Sarnath: CIHTS.

———. 1994b. *Vimalaprabhā,* vol. 3. Sarnath: CIHTS.

Eastman, Kenneth W. 1980. "Chibettoyaku Guhyasamājatantra no Tonkō shutsudo shahon" チベット訳Guhyasamājatantraの敦煌出土写本 [A manuscript of the Tibetan translation of the *Guhyasamājatantra* from Dunhuang]. *Nihon Chibetto Gakkai Kaihō* (*Report of the Japanese Association for Tibetan Studies*) 26: 8–12.

Evans-Wentz, W. Y. 1927. *Tibetan Book of the Dead.* Oxford: Oxford University Press.

Fujita Hiroki 藤田弘基. 1983. *Mikkyō: Chibetto bukkyō no sekai* 密教 チベット仏教の世界 [The world of Tibetan Buddhism]. Tokyo: Gyōsei.

Fukuda Ryōsei 福田亮成. 1969. "Chibettobun *Kichijō saishō honsho no mandara giki to shōsuru mono* ni tsuite" チベット文『吉祥最勝本初のマンダラ儀軌と称するもの』について [A study on the *Śrī-paramādi-maṇḍala-vidhi-nāma*]. *JIBS* 17.2: 260–64.

———. 1987. *Rishukyō no kenkyū—sono seiritsu to tenkai* 理趣経の研究—その成立と展開 [A study of the *Prajñāpāramitānayasūtra*: Its genesis and development]. Tokyo: Kokusho Kankōkai.

Giebel, Rolf W. 1995. "The *Chin-kang-ting ching yü-ch'ieh shih-pa-hui chih-kuei*: An Annotated Translation." *Naritasan Bukkyō Kenkyūjo Kiyō* (*Journal of Naritasan Institute for Buddhist Studies*) 18: 107–201.

———, trans. 2001. *Two Esoteric Sūtras*. Berkeley, CA: Numata Center for Buddhist Translation and Research.

———, trans. 2005. *The Vairocanābhisaṃbodhi Sūtra*. Berkeley, CA: Numata Center for Buddhist Translation and Research.

Giebel, Rolf W., and Dale A. Todaro, trans. 2004. *Shingon Texts*. Berkeley, CA: Numata Center for Buddhist Translation and Research.

Goodall, Dominic. 2009. "Who is Caṇḍeśa?" In *Genesis and Development of Tantrism*, edited by Einoo Shingo, 351–423. Tokyo: Sankibō Busshorin.

Govinda, Lama Anagarika. 1959. *Foundations of Tibetan Mysticism*. London: Rider.

———. 1961. *Mandala: Der heilige Kreis*. Zürich: Origo Verlag.

———. 1976. *Psycho-Cosmic Symbolism of the Buddhist Stūpa*. Emeryville, CA: Dharma Publishing.

Guenther, Herbert V. 1984. *Matrix of Mystery*. Boulder, CO: Shambhala Publications.

Hadano/Hatano Hakuyū 羽田野伯猷. 1986. *Chibetto Indogaku shūsei* チベット・インド学集成 [Selected works on Tibetology and Indology], vol. 1. Kyoto: Hōzōkan.

———. 1987. *Chibetto Indogaku shūsei*, vol. 3. Kyoto: Hōzōkan.

Hatta Yukio 八田幸雄. 1981. *Gobu shinkan no kenkyū* 五部心観の研究 [A study of the *Gobu shinkan*]. Kyoto: Hōzōkan.

Hayashi On 林温. 2002. *Besson mandara* 別尊曼荼羅 [Maṇḍalas of individual deities]. Nihon no bijutsu 433. Tokyo: Shibundō.

Heller, Amy. 1994. "Images at lDan-ma-brag." In *Tibetan Studies: Proceedings of the 6th Seminar of the International Association for Tibetan Studies, Fagernes 1992*, edited by Per Kvaerne, 1: 12–19. Oslo: Institute for Comparative Research in Human Culture.

Hodge, Stephen, trans. 2003. *The Mahā-vairocana-abhisaṃbodhi Tantra with Buddhaguhya's Commentary*. London: RoutledgeCurzon.

Horiuchi Kanjin 堀内寛仁. 1949. "Monju gikikyō no kōgai" 文殊儀軌経の梗概 [An outline of *Ārya-mañjuśrī-mūla-kalpa*], part 1. *Mikkyō Bunka* 7: 30–45.

———. 1950a. "Monju gikikyō no kōgai," part 2. *Mikkyō Bunka* 8: 47–54.

———. 1950b. "Monju gikikyō no kōgai," part 3. *Mikkyō Bunka* 9/10: 59–83.

———. 1974. *Shoe kongōchōkyō no kenkyū, bonpon kōtei hen* 初会金剛頂経の研究 梵本校訂篇 [A study of the *Sarvatathāgatatattvasaṃgraha*: Critical edition of the Sanskrit text], vol. 2. Kōyasan: Mikkyō Bunka Kenkyūjo.

———. 1975. "Hyakuhachi myōsan no chūshakuteki kenkyū" 百八名讃の註釈的研究 [Exegetic studies of the hymns on 108 names in the *Sarvatathāgata-tattvasaṃgraha*], part 3. *Mikkyō Bunka* 114: 112–46.

———. 1983. *Shoe kongōchōkyō no kenkyū: bonpon kōtei hen*, vol. 1. Kōyasan: Mikkyō Bunka Kenkyūjo.

Imaeda, Yoshirō. 1981. "Un extrait tibétain du Mañjuśrīmūlakalpa dans les manuscrits de Touen-houang." In *Nouvelles contributions aux études de Touen-Houang*, edited by Michel Soymié, 303–20. Geneva: Droz.

Inagaki Hisao 稲垣久雄. 1987. *The Anantamukhanirhāra Dhāraṇī Sūtra and Jñānagarbha's Commentary*. Kyoto: Nagata Bunshōdō.

Ishida Hisatoyo 石田尚豊. 1969a. *Mikkyōga* 密教画 [Esoteric Buddhist painting]. Nihon no bijutsu 33. Tokyo: Shibundō. [English translation, Ishida Hisatoyo (translated and adapted by E. Dale Saunders), *Esoteric Buddhist Painting*. New York: Kodansha International, 1987.]

———. 1969b. "Taizō mandara e no Kongōkaikei son no shinshutsu—Taizō kyūzuyō" 胎蔵曼荼羅への金剛界系尊の進出—胎蔵旧図様 [The advance of Vajradhātu deities into the Garbha-maṇḍala: The *Taizō kyūzuyō*]. *Bukkyō Geijutsu* 70: 24–41.

———. 1975. *Mandara no kenkyū* 曼荼羅の研究 [A study of the maṇḍala]. Tokyo: Tokyo Bijutsu.

———. 1979. *Ryōkai mandara no chie* 両界曼荼羅の智慧 [The wisdom of the two-world maṇḍalas]. Tokyo: Tōkyō Bijutsu.

———. 1984. *Mandara no mikata—patān ninshiki* 曼荼羅のみかた—パターン認識 [How to appreciate maṇḍalas: Pattern recognition]. Tokyo: Iwanami Shoten.

Ishikawa, Mie. 1990. *A Critical Edition of the sGra sbyor bam po gnyis pa*. Tokyo: Tōyō Bunko.

Iyanaga, Nobumi. 1985. "Récits de la soumission de Maheśvara par Trailokyavijaya," In *Tantric and Taoist Studies in Honour of R. A. Stein III*, edited by M. Strickmann, 633–745. Brussels: Institut Belge des Hautes Études Chinoises.

Jarrige, J. F., et al. 1989. *Yomigaeru Pari banpaku to rittai mandara ten* 甦るパリ万博と立体マンダラ展 [Les collections bouddhiques japonaises d'Emile Guimet]. Tokyo: Seibu Hyakkaten.

———. 1994. *Seiiki bijutsu—Gime bijutsukan Perio korekushon* 西域美術—ギメ美術館ペリオ・コレクション [Les arts de l'Asie Centrale: Collection pelliot du Musée Guimet], vol. 1. Tokyo: Kōdansha.

Jiang, Zhongxin, and Toru Tomabechi. 1996. *The Pañcakramaṭippaṇī of Muniśrībhadra: Introduction and Romanized Sanskrit Text*. Bern: Peter Lang.

Kanamoto Takuji 金本拓士. 1985. "'Himitsu shūe tantora' ni okeru misai yuga kan—Ānandagaruba no chūshaku o chūshin to shite" 「秘密集タントラ」に於ける微細瑜伽観—アーナンダガルバの注釈を中心として [Sūkṣmayoga system of the *Guhyasamājatantra*, with Ānandagarbha's commentary]. *Tōyō Daigaku Daigakuin Kiyō* (*Bulletin of the Graduate School, Toyo University Graduate Programme of Liberal Arts*) 22: 55–69.

———. 1986. "Butsuchisokuryū shōki shidai 'Fugen jōjuhō' ni okeru mandara ni tsuite" 仏智足流生起次第「普賢成就法」における曼荼羅について [On the maṇḍala in the *Samantabhadra-sādhana*, the *utpatti-krama* of the Jñānapāda school]. *JIBS* 35.1: (161)–(163).

Kanaoka Shūyū 金岡秀友. 1967. "Kukurāja." *JIBS* 15.1: (8)–(17).

Kaneko Eiichi 金子英一. 1982. *Kotantora zenshū kaidai mokuroku* 古タントラ全集解題目録 [A complete catalogue of the *rÑiṅ ma rgyud 'bum*]. Tokyo: Kokusho Kankōkai.

Kanō Kazuo 加納和雄. 2014. "*Fugen jōjuhō* no shinshutsu bonbun shiryō ni tsuite" 『普賢成就法』の新出梵文資料について [Newly discovered Sanskrit materials on the *Samantabhadrasādhana*]. *Mikkyōgaku Kenkyū* 46: 61–73.

Katō Takashi 加藤敏 et al. 1985. 2 vols. *Mandara renge* マンダラ蓮華 [Maṇḍala florescence]. Tokyo: Hirakawa Shuppansha.

Kawasaki Kazuhiro 川崎一洋. 1997. "*Genkamō tantora* no kōzō—mandara o chūshin to shite" 『幻化網タントラ』の構造—曼荼羅を中心として [On the structure of the *Māyājālatantra* as seen from maṇḍalas]. *Mikkyō Bunka* 198: (11)–(25).

———. 1998. "Rōmantan chanpa rakan no hekiga mandara ni tsuite—nikai no yuga tantora kaitei no mandara o chūshin ni" ローマンタン・チャンパ・ラカンの壁画マンダラについて—二階の瑜伽タントラ階梯のマンダラを中心に [The fifty-four maṇḍalas of the Yoga class at Byams pa lha khaṅ in Lo Manthang]. *Mikkyō Zuzō* 17: 110–22.

———. 2000. "Chanpa rakan genson no *Rishu kōkyō* 'Shingonbun' shosetsu no mandara" チャンパ・ラカン現存の『理趣広経』「真言分」所説の曼荼羅 [The

maṇḍalas of the *Śrīparamādyamantrakalpakhaṇḍa* at Byams pa lha khaṅ in Glo sMon thaṅ]. *Kōyasan Daigaku Daigakuin Kiyō* (*Bulletin of the Graduate School, Graduate Program of Liberal Arts, Koyasan University*) 4: 23–44.

———. 2001. "Chibetto ni okeru *Rishu kōkyō* no mandara no denshō—Sharuji nandō no sakurei o chūshin ni" チベットにおける『理趣広経』の曼荼羅の伝承—シャル寺南堂の作例を中心に [The maṇḍalas of the *Śrīparamādya* at Sha lu]. *Mikkyō Zuzō* 20: 49–61.

———. 2003. "*Genkamō tantora* ni mirareru gohimitsu shisō" 『幻化網タントラ』に見られる五秘密思想 [The five secret bodhisattvas in the *Māyājālatantra*]. *Mikkyō Bunka* 211: (53)–(34).

———. 2005. "Kongōkai mandara no shosō—'Kongōkai hon' shosetsu no rokushu mandara o chūshin ni" 金剛界曼荼羅の諸相—「金剛界品」所説の六種曼荼羅を中心に [Various aspects of the Vajradhātu-maṇḍala]. *Mikkyōgaku Kenkyū* 37: 19–41.

———. 2007. "*Rishukyō* jūshichison mandara no seiritsu ni kansuru ichi shiron" 『理趣経』十七尊曼荼羅の成立に関する一試論 [The formation of the seventeen-deity maṇḍala of Vajrasattva]. *Chisan Gakuhō* 56 (70): 457–73.

Kawasaki Shinjō 川崎信定. 1992. *Issaichi shisō no kenkyū* 一切智思想の研究 [A study of the omniscient being (*sarvajña*) in Buddhism]. Tokyo: Shunjūsha.

Kimura Takayasu 木村高尉. 2006. *Pañcaviṃśatisāhasrikā Prajñāpāramitā VI–VIII*. Tokyo: Sankibō Busshorin.

———. 2009. *Pañcaviṃśatisāhasrikā Prajñāpāramitā I–2*. Tokyo: Sankibō Busshorin.

Kitamura Taidō 北村太道. 1986. "Himitsu shūe mandara no 'chi giki' ni tsuite" 秘密集会マンダラの「地儀軌」について [On the *sa chog* rite of the Guhyasamāja-maṇḍala]. In *Daiikkai Chibetto mikkyō gakumonji Gyume chōsa hōkokusho* 第一回チベット密教学問寺・ギュメ調査報告書 [Report on the first investigation of Gyüme, a Tibetan tantric college], 23–56. Osaka: Seifū Gakuen.

Kitamura Taidō and Tshul khrims skal bzang. 1995. *Kichijō himitsu shūe jōjuhō shōjō yuga shidai—Chibetto mikkyō jissen nyūmon* 吉祥秘密集会成就法清浄瑜伽次第—チベット密教実践入門 [An annoted translation of Tsoṅ kha pa's *dPal gsaṅ ba 'dus pa'i sgrub thabs rnal 'byor dag pa'i rim pa*]. Kyoto: Nagata Bunshōdō.

Kurumiya Yenshu. 1978. *Ratnaketuparivarta: Sanskrit Text*. Kyoto: Heirakuji Shoten.

La Vallée Poussin, Louis de, ed. 1896. *Études et textes tantriques: Pañcakrama*. Gand: H. Engelcke; Louvain: J. B. Istas.

Lal, Banarsi. 2001. *Luptabauddhavacanasaṃgraha*, part 2. Sarnath: CIHTS.

Lalou, Marcelle. 1930. *Iconographie des étoffes peintes (paṭa) dans le Mañjuśrīmūlakalpa*. Paris: P. Geuthner.

———. 1953. "Les textes bouddhiques au temps du roi Khri-sroṅ-lde-bcan: Contribution à la bibliographie du Kanjur et du Tanjur." *Journal Asiatique* 241, 313–53.

Lauf, Detlef Ingo. 1976. *Tibetan Sacred Art*. New York: Shambhala Publications.

Lee, Yong-hyun. 2003. *The Niṣpannayogāvalī by Abhayākaragupta*. Seoul: Baegun Press.

Lessing, Ferdinand D., and Alex Wayman. 1968. *Introduction to the Buddhist Tantric Systems*. The Hague: Mouton.

Leumann, Ernst. 1930. "Die nordarischen Abschnitte der Adhyardhaśatikā Prajñāpāramitā: Text und Übersetzung mit Glossar." *Taishō Daigaku Gakuhō* 6/7: 47–87.

Lokesh Chandra. 1967. *A New Tibeto-Mongol Pantheon*. Śata-piṭaka Series: Indo-Asian Literatures 21, parts 13–15. New Delhi: International Academy of Indian Culture.

———. 1977a. *Kriyāsaṅgraha*. Śata-piṭaka 236. New Delhi: International Academy of Indian Culture.

———. 1977b. *Kriyāsamuccaya*. Śata-piṭaka 237. New Delhi: International Academy of Indian Culture.

———. 1977c. *Vajrāvalī*. Śata-piṭaka 239. New Delhi: International Academy of Indian Culture.

———. 1981. *Abhidhānottaratantra: A Sanskrit Manuscript from Nepal*. Śata-piṭaka 263. New Delhi: International Academy of Indian Culture.

Lokesh Chandra, Musashi Tachikawa, and Sumie Watanabe. 2006. *A Ngor Maṇḍala Collection*. Kathmandu: Vajra Publications.

Macdonald (Spanien), Ariane. 1962. *Le maṇḍala du Mañjuśrīmūlakalpa*. Paris: Adrien-Maisonneuve.

Malandra, Geri H. 1993. *Unfolding a Mandala*. New York: State University of New York Press.

Matsumura Hisashi 松村恒. 1983. "Girugitto shoden no mikkyō zuzō bunken" ギルギット所伝の密教図像文献 [A text on Esoteric iconography from the Gilgit manuscripts]. *Mikkyō Zuzō* 2: 71–79.

Matsunaga Keiji 松長恵史. 1999. *Indoneshia no mikkyō* インドネシアの密教 [Esoteric Buddhism in Indonesia]. Kyoto: Hōzōkan.

Matsunaga Yūkei 松長有慶. 1978. *Himitsu shūe tantora kōtei bonpon* 秘密集会タントラ　校訂梵本 [The Guhyasamāja tantra]. Osaka: Tōhō Shuppan.

———. 1980a. *Mikkyō kyōten seiritsu shiron* 密教経典成立史論 [A history of the formation of esoteric Buddhist scriptures]. Kyoto: Hōzōkan.

———. 1980b. "Aruchiji sansōdō nikai no mandara" アルチ寺三層堂二階の曼荼羅 [The maṇḍalas on the second floor of the three-storied chapel at Alchi monastery]. In *Bukkyō no rekishi to bunka—Bukkyōshi Gakkai sanjūshūnen kinen ronshū* 仏教の歴史と文化—仏教史学会30周年記念論集 [History and culture of Buddhism: Essays commemorating the thirtieth anniversary of the Society of the History of Buddhism], edited by Bukkyōshi Gakkai 仏教史学会, 87–103. Kyoto: Dōhōsha Shuppan.

———. 1991. "Pakisutan no mikkyō iseki, ihin no chōsa hōkoku" パキスタンの密教遺跡・遺品の調査報告 [A report on esoteric Buddhism in Pakistan]. In *Ihara Shōren hakushi koki kinen ronbunshū* 伊原照蓮博士古稀記念論文集 [Essays in honor of Dr. Shoren Ihara on his seventieth birthday], edited by Ihara Shōren Hakushi Koki Kinenkai 伊原照蓮博士古稀記念会, 161–77. Fukuoka: Ihara Shōren Hakushi Koki Kinenkai.

———, ed. 2005. *Indo kōki mikkyō* インド後期密教 [Indian late tantric Buddhism], vol. 1. Tokyo: Shunjūsha.

———, ed. 2006. *Indo kōki mikkyō*, vol. 2. Tokyo: Shunjūsha.

Mikkyō Seiten Kenkyūkai 密教聖典研究会 (Buddhist Tantric Texts Study Group). 1986. "Vajradhātumahāmaṇḍalopāyikā-Sarvavajrodaya—bonbun tekisuto to wayaku (I)" Vajradhātumahāmaṇḍalopāyikā-Sarvavajrodaya—梵文テキストと和訳 (I) [Vajradhātumahāmaṇḍalopāyikā-Sarvavajrodaya (I): Sanskrit text and Japanese translation]. *Taishō Daigaku Sōgō Bukkyō Kenkyūjo Nenpō* (*Annual of the Institute for Comprehensive Studies of Buddhism, Taisho University*) 8: (24)–(57).

———. 1987. "Vajradhātumahāmaṇḍalopāyikā-Sarvavajrodaya—bonbun tekisuto to wayaku (II)." *Taishō Daigaku Sōgō Bukkyō Kenkyūjo Nenpō* 9: (13)–(85).

———. 1998. "Transcribed Sanskrit Text of the Amoghapāśakalparāja, Part I." *Taishō Daigaku Sōgō Bukkyō Kenkyūjo Nenpō* 20: (1)–(54).

———. 1999. "Transcribed Sanskrit Text of the Amoghapāśakalparāja, Part II." *Taishō Daigaku Sōgō Bukkyō Kenkyūjo Nenpō* 21: (81)–(128).

———. 2000. "Transcribed Sanskrit Text of the Amoghapāśakalparāja, Part III." *Taishō Daigaku Sōgō Bukkyō Kenkyūjo Nenpō* 22: (1)–(64).

———. 2001. "Transcribed Sanskrit Text of the Amoghapāśakalparāja, Part IV." *Taishō Daigaku Sōgō Bukkyō Kenkyūjo Nenpō* 23: (1)–(76).

———. 2004. "Transcribed Sanskrit Text of the Amoghapāśakalparāja, Part V." *Taishō Daigaku Sōgō Bukkyō Kenkyūjo Nenpō* 26: (120)–(183).

———. 2010. "Transcribed Sanskrit Text of the Amoghapāśakalparāja, Part VI." *Taishō Daigaku Sōgō Bukkyō Kenkyūjo Nenpō* 32: (170)–(207).

———. 2011. "Transcribed Sanskrit Text of the Amoghapāśakalparāja, Part VII." *Taishō Daigaku Sōgō Bukkyō Kenkyūjo Nenpō* 33: (32)–(64).

Mimaki, Katsumi, and Toru Tomabechi. 1994. *Pañcakrama*. Bibliotheca Codicum Asiaticorum 8. Tokyo: Centre for East Asian Cultural Studies for Unesco.

Mitra, Debala. 1992. *Sanchi*. 6th ed. New Delhi: Archaeological Survey of India.

Miyaji Akira 宮地昭. 1995. "Indo no Dainichi nyorai zō no genson sakurei ni tsuite" インドの大日如来像の現存作例について [Images of Vairocana in Indian art]. *Mikkyō Zuzō* 14: 1–30.

———, ed. 2001. *Indo kara Chūgoku e no bukkyō bijutsu no denpa to tenkai ni kansuru kenkyū* インドから中国への仏教美術の伝播と展開に関する研究 [A study of the spread of Buddhist art from India to China]. Nagoya: Nagoya Daigaku.

———, ed. 2007. *Gandāra bijutsu to Bāmiyan iseki ten* ガンダーラ美術とバーミヤン遺跡展 [Gandhāra art and Bamiyan site]. Shizuoka: Shizuoka Shinbun.

Miyasaka Yūshō 宮坂宥勝. 1960. "Asura kara Birushana butsu e" アスラからビルシャナ仏へ [From Asura to Vairocana]. *Mikkyō Bunka* 47: 7–23.

———. 1983. "Chibetto shoden no Balimālikā bonpon ni tsuite" チベット所伝のBalimālikā梵本について [On the Sanskrit text of the *Balimālikā* transmitted in Tibet]. In Miyasaka Yūshō, *Indo koten ron* インド古典論 [Studies in Indian classics], 1: 174–89. Tokyo: Chikuma Shobō.

Mori Masahide 森雅秀. 1990. "Pārachō no shugoson, gohōson, zaihōshin no zuzōteki tokuchō" パーラ朝の守護尊・護法尊・財宝神の図像的特徴 [Iconographic characteristics of wrathful deities and the god of wealth of the Pāla dynasty]. *Nagoya Daigaku Furukawa Sōgō Kenkyū Shiryōkan Hōkoku (Bulletin of Nagoya University, Furukawa Museum)* 6: 69–104.

———. 1991. "Indo mikkyō ni okeru kenchiku girei—Vajrāvalī-nāma-maṇḍalopāyikā wayaku" インド密教における建築儀礼—Vajrāvalī-nāma-maṇḍalopāyikā和訳 [Architectural rituals of tantric Buddhism in India: Japanese translation of the *Vajrāvalī-nāma-maṇḍalopāyikā*], part 1. *Nagoya Daigaku Bungakubu Kenkyū Ronshū (Journal of the Faculty of Literature, Nagoya University)* 37: 53–73.

———. 1997. *Mandara no mikkyō girei* マンダラの密教儀礼 [Esoteric Buddhist rites of the maṇḍala]. Tokyo: Shunjūsha.

———. 1998a. "Tsinmāman korekushon no Vajrāvarī shi mandara—Chibetto ni okeru mandara denshō no ichi jirei" ツィンマーマン・コレクションのヴァジュラーヴァリー四曼荼羅—チベットにおけるマンダラ伝承の一事例 [Four maṇḍalas of the *Vajrāvalī* series in the Zimmerman Family collection: A case study of the transmission of maṇḍalas in Tibet]. *Bijutsushi* 145: 64–81.

———. 1998b. "'Vajurāvarī mandarashū' daijūyonban no gaiyō" 「ヴァジュラー ヴァリー・マンダラ集」第14番の概要 [An outline of the fourteenth thangka belonging to the *Vajrāvalī* maṇḍala collection]. *Kōyasan Daigaku Kiyō (Journal of Koyasan University)* 33: 55–72.

———. 1999a. "Mitorayōgin cho *Abisamaya-mukuta-mārā* shosetsu no mandara" ミトラヨーギン著『アビサマヤ・ムクタ・マーラー』所説のマンダラ [The 108 maṇḍalas in Mitrayogin's *Abhisamayamuktāmālā*]. *Mikkyōgaku Kenkyū* 31: 55–88.

———. 1999b. "*Abisamaya-mukta-mārā* shosetsu no 108 mandara" 『アビサマ ヤ・ムクタ・マーラー』所説の108マンダラ [The 108 maṇḍalas of the *Abhisamayamuktāmālā*]. *Kōyasan Daigaku Mikkyō Bunka Kenkyūjo Kiyō (Bulletin of the Research Institute of Esoteric Buddhist Culture)* 2: (1)–(93).

———. 2001a. *Indo mikkyō no hotoketachi* インド密教の仏たち [Deities of Indian esoteric Buddhism]. Tokyo: Shunjūsha.

———. 2001b. "*Vajurāvarī* shosetsu no mandara—sonmei risuto oyobi haichizu" 『ヴァジュラーヴァリー』所説のマンダラ—尊名リストおよび配置図 [Listing of the maṇḍala deities and their symbols in the *Vajrāvalī*]. *Kōyasan Daigaku Mikkyō Bunka Kenkyūjo Kiyō* 14: (1)–(117).

———. 2003. "Mikkyō bunken ni tokareru vāsutunāga" 密教文献に説かれるヴァーストゥナーガ [The Vāstunāga ritual described in Tantric Buddhist material]. *Kōyasan Daigaku Mikkyō Bunka Kenkyūjo Kiyō* 16: (21)–(49).

———. 2005. "Mandara wa kokoro o arawashite iru ka—Yungu no mandara rikai ni kansuru ichi kōsatsu" マンダラは心を表しているか—ユングのマンダラ理解に関する一考察 [Does the maṇḍala represent the mind? A study of Jung's interpretation of the maṇḍala]. In Yoritomi et al., *Mandara no shosō to bunka*, 1: 77–96.

Moriguchi Kōshun/Mitsutoshi 森口光俊. 1989a. *A Catalogue of the Buddhist Tantric Manuscripts in the National Archives of Nepal and Kesar Library*. Tokyo: Sankibō Busshorin.

———. 1989b. "Vajradhātumahāmaṇḍalopāyikā Sarvavajrodaya bonbun tekisuto hoketsu—shinshutsu shahon, zō-kan taishō: Kengō senbutsu myō o chūshin to shite" Vajradhātumahāmaṇḍalopāyika Sarvavajrodaya梵文テキスト補欠—新出写本・蔵・漢対照：賢劫千仏名を中心として [Sanskrit text of the *Sarvavajrodaya*, "Bhadrakalpikabodhisattvasahasranāmapaṭala"]. *Chisan Gakuhō* 38 (52): 1–37.

———. 1990. "Ācāryakriyāsamuccaya Kanjō (hon): Tekisuto to wayaku (II–1)" Ācāryakriyāsamuccaya灌頂(品)　テキストと和訳 (II–1) [*Ācāryakriyāsamuccaya*, "Abhiṣekavidhi": Text and Japanese translation (II–1)]. In *Shūkyō to Bunka* [Religion and culture], edited by Saitō Akitoshi Kyōju Kanreki Kinen Ronbunshū Kankōkai 斎藤昭俊教授還暦記念論文集刊行会, 876–844. Tokyo: Kobian Shobō.

———. 1991. "Ācāryakriyāsamuccaya Kanjō (hon): tekisuto to wayaku (I–1)." In *Ju-Butsu-Dō sankyō shisō ronkō* 儒・佛・道三教思想論攷 [Confucianism, Buddhism, Taoism: Studies on the thought of these three religions], edited by Makio Ryōkai Hakushi Kiju Kinen Ronshū Kankōkai 牧尾良海博士喜寿記念論集刊行会, 107–133. Tokyo: Sankibō Busshorin.

———. 1992. "Ācāryakriyāsamuccaya Kanjō (hon): Tekisuto to wayaku (I–2)." *Chisan Gakuhō* 41 (55): 1–31.

Mullick, C. C. 1991. *Nalanda Sculptures: Their Bearing on Indonesian Sculptures*. Delhi: Pratibha Prakashan.

Muramatsu Tetsufumi 村松哲文. 2003. "Santōshō Jintsūji shimontō nai no shibutsu ni tsuite" 山東省神通寺四門塔内の四仏について [The four buddhas

in the Four-Gate Pagoda of Shentongsi in Shandong]. *Bijutsushi Kenkyū* 41: 165–82.

Nagata Kaoru 永田郁. 2003. "Ajantā dainikutsu kōrō sayū shidō no yakusha zō ni tsuite—ōchō to yakusha shinkō o meguru mondai" アジャンター第2窟後廊左右祠堂のヤクシャ像について—王朝とヤクシャ信仰をめぐる問題 [A study of some *yakṣa* images in the rear shrinelets to the left and right in Ajantā cave 2: Questions concerning royal patronage and the *yakṣa* cult]. *Mikkyō Zuzō* 22: 48–62.

Naitō Tōichirō 内藤藤一郎. 1931. "Jōdai tōki shihō shibutsu no seiritsu katei ni tsuite—Hōryūji hekiga shibutsu jōdohen kō hosetsu" 上代塔基四方四仏の成立過程について—法隆寺壁画四仏浄土変考補説 [On the evolution of the four buddhas in the four directions of the stūpa base in ancient times: Supplementary remarks on the Hōryūji mural of a Pure Land transformation tableau with four buddhas]. *Tōyō Bijutsu* 13: 1–18.

Nakamura Hajime 中村元, ed. 1980. *Budda no sekai* ブッダの世界 [The world of the Buddha]. Tokyo: Gakken.

Nakamura Ryōō 中村涼應. 2002. "Jōgon no Shin Anshōjiryū mandara ni tsuite" 浄厳の新安祥寺流曼荼羅について [On the maṇḍala of Jogon's New Anshōji subbranch]. *Mikkyōgaku* 38: 23–45.

———. 2004. "Jōgon no Shin Anshōjiryū mandara ni tsuite," part 2. *Mikkyōgaku* 40: 55–72.

Namai Mamoru 生井衛. 1970. "Bodaishinge ni kansuru ichi kōsatsu" 菩提心偈に関する一考察 [On the Bodhicitta verse]. *Mikkyō Bunka* 91: 24–38.

Nasu Mayumi 那須真裕美. 1987. "Genson suru 'Daishin Kenryūnen keizō' mei no butsuzōgun to Hōsōrō butsuzōgun ni tsuite" 現存する「大清乾隆年敬造」銘の仏像群と宝相楼仏像群について [On the bronze images that have the inscription "Da Qing Qianlong nian jingzao" 大清乾隆年敬造 around the bottom of the lotus base in the Forbidden Palace and the Chengde Imperial Palace]. *Mikkyō Zuzō* 25: 47–62.

Nicolas-Vandier, Nicole. 1974. *Bannières et peintures de Touen-houang*. Paris: Adrien-Maisonneuve.

Nishioka Soshū 西岡祖秀. 1983. "*Putun Bukkyōshi* mokurokubu sakuin III" 『プトゥン仏教史』目録部索引III [Index to the catalogue section of Bu-ston's "History of Buddhism" (III)]. *Tōkyō Daigaku Bungakubu Bunka Kōryū Kenkyū Shisetsu Kiyō* (*Annual Report of the Institute for the Study of Cultural Exchange*) 6: 47–201.

Noguchi Keiya 野口圭也. 1986. "*Saṃpuṭodbhavatantra* to *Himitsusōkyō*" *Saṃpuṭodbhavatantra*と『秘密相経』 [The *Saṃpuṭodbhavatantra* and the *Bimixiang jing*]. *Buzan Gakuhō* 31: (39)–(63).

———. 1987a. "*Saṃpuṭodbhavatantra* shosetsu no Kongōsatta mandara" *Saṃpuṭodbhavatantra*所説の金剛薩埵曼荼羅 [The Vajrasattva-maṇḍala in the *Saṃpuṭodbhavatantra*]. *Mikkyō Zuzō* 5: 1–14.

———. 1987b. "*Saṃpuṭodbhavatantra* shosetsu no Hēruka mandara" *Saṃpuṭodbhavatantra*所説のヘールカ曼荼羅 [The Heruka-maṇḍala in the *Saṃpuṭodbhavatantra*]. *Mikkyōgaku Kenkyū* 19: 65–86.

———. 1988. "*Saṃpuṭodbhavatantra* shosetsu no Nāirātomiyā mandara" *Saṃpuṭodbhavatantra*所説のナーイラートミヤーマンダラ [The Nairātmyā-maṇḍala in the *Saṃpuṭodbhavatantra*]. *Buzan Kyōgaku Taikai Kiyō* 33: (75)–(92).

———. 2001. "Amoghapāśakalparāja no mandara—(2) 'Saijō kōdai gedatsu renge mandara' ni tsuite" Amoghapāśakalparājaのマンダラ—(2) 「最上広大解脱蓮華マンダラ」について [On the maṇḍalas of the *Amoghapāśakalparāja* (2)]. *Mikkyōgaku Kenkyū* 33: 19–35.

———. 2006. "*Sanputa-tantora* onko chishin" 『サンプタ・タントラ』温故知新 [The *Saṃpuṭatantra*: Learning from the past]. In Matsunaga, *Indo kōki mikkyō*, vol. 2, 145–72.

Ochi Junji 越智淳仁. 1977. "Buddhaguhya no busshinron—Taizōshō mandara no kōsei yori mita shishin, gochi, goshiki no kankei" Buddhaguhyaの仏身論—胎蔵生曼荼羅の構成よりみた四身、五智、五色の関係 [On the *buddha-kāya* theory in Buddhaguhya's commentary on the *Mahāvairocanatantra*]. *Mikkyō Bunka* 122: 49–31.

Okada Akinori 岡田明憲. 2005. "Pārushī no Bongo (Sansukuritto) bunken" パールシーの梵語(サンスクリット)文献 [Parsi Sanskrit texts]. In *Chūsei Indo no gakusaiteki kenkyū* 中世インドの学際的研究 [Interdisciplinary studies of medieval India], edited by Maeda Sengaku 前田専学, 297–305. Tokyo: Tōhō Kenkyūkai.

Olschak, B. C., and Thupten Wangyal. 1973. *Mystic Art of Ancient Tibet*. London: George Allen & Unwin.

Ōmi Jishō 大観慈聖. 2005. "*Mahāmāyā-tantora* no seiritsu ni kansuru ichi kōsatsu" 『マハーマーヤー・タントラ』の成立に関する一考察 [On the *Mahāmāyātantra*]. *JIBS* 54.1: (100)–(103).

———. 2006. "Ratonākarashānti chū *Kusumānjari* ni miru *Himitsu shūe tantora* no kōsei ni tsuite" ラトナーカラシャーンティ註『クスマーンジャリ』にみる『秘密集会タントラ』の構成について [On the theoretical and practical systems of the *Guhyasamājatantra* described in the *Kusumāñjali*, the commentary of Ratnākaraśānti]. *Mikkyō Bunka* 216: (36)–(77).

Ōmura Seigai 大村西崖. 1913. *Sanpon ryōbu mandarashū* 三本両部曼荼羅集 [Three versions of the two-world maṇḍalas]. Tokyo: Bussho Kankōkai.

———. 1918. *Mikkyō hattatsushi* 密教発達志 [The development of esoteric Buddhism]. Tokyo: Bussho Kankōkai.

Ōshima Tatehiko 大島建彦 et al. 2001. *Nihon no shinbutsu no jiten* 日本の神仏の辞典 [Comprehensive dictionary of Japan's religious culture]. Tokyo: Taishūkan Shoten.

Pal, Pratapaditya. 1966. "The Iconography of Amoghapāśa Lokeśvara—I." *Oriental Art* 12.4: 234–39.

———. 1967. "The Iconography of Amoghapāśa Lokeśvara—II." *Oriental Art* 13.1: 21–28.

Pandey, Janardan Shastri. 1997. *Bauddhalaghugranthasaṃgraha*. Sarnath: CIHTS.

———. 1998. *Yoginīsañcāratantram, with Nibandha of Tathāgatarakṣita and Upadeśānusāriṇīvyākhyā of Alakakalaśa*. Sarnath: CIHTS.

———. 2000. *Caryāmelāpakapradīpa*. Sarnath: CIHTS.

———. 2002. *Śrīherukābhidhānam Cakrasaṃvaratantram, with the Vivṛti Commentary of Bhavabhaṭṭa*. 2 vols. Sarnath: CIHTS.

Pandeya, Ramchandra. 1971. *Madhyānta-vibhāga-śāstra*. Delhi: Motilal Banarsidass.

Park Hyanggook 朴亨國. 2001. "Hachi daibosatsu no seiritsu to zuzō henka ni tsuite" 八大菩薩の成立と図像変化について [On the origins of the eight great bodhisattvas and their iconographic development]. In Miyaji, *Indo kara Chūgoku e no bukkyō bijutsu no denpa to tenkai ni kansuru kenkyū*, 327–56.

Petrovsky, Michail, ed. 1993. *Lost Empire of the Silk Road: Buddhist Art from Khara Khoto*. Milan: Electa.

Richardson, H. E. 1990. "The Cult of Vairocana in Early Tibet." In *Indo-Tibetan Studies*, edited by Tadeusz Skorupski, 271–74. Tring: Institute of Buddhist Studies.

Roerich, George N. 1949. *The Blue Annals*. Calcutta: Royal Asiatic Society of Bengal.

Rossi, Anna Maria, and Fabio Rossi. 1993. *Tibetan Painted Mandalas*. London: Rossi & Rossi.

Sadakane Keiji 定金計次. 1994. "Indo bukkyō kaiga no tenkai—hekiga no henten to raihaiga no seiritsu" インド仏教絵画の展開―壁画の変転と礼拝画の成立 [The development of Buddhist paintings in India: Changes in wall paintings and the formation of pictures for worship]. *Bukkyō Geijutsu* 214: 75–131.

Sadakata Akira 定方晟. 1994. "Kurishunagawa karyūiki no kokubun no wayaku" クリシュナ河下流域の刻文の和訳 [Japanese translation of the inscriptions of the lower Krishna river]. *Tōkai Daigaku Kiyō Bungakubu* (*Bulletin of the Faculty of Letters, Tokai University*) 61: 1–36.

———. 1995. "Kurishunagawa karyūiki no bukkyō iseki" クリシュナ河下流域の仏教遺跡 [Buddhist remains in the lower valley of the Krishna river]. *Tōkai Daigaku Kiyō Bungakubu* 63: 92–69.

Saitō Akira 斎藤明. 2007. *Daijō bukkyō no kigen to jittai ni kansuru sōgōteki kenkyū—saishin no kenkyū seika o fumaete* 大乗仏教の起源と実態に関する総合的研究―最新の研究成果を踏まえて [A comprehensive study on the origin and actual state of Mahāyāna Buddhism, based on the latest research findings]. Tokyo: Tōkyō Daigaku.

Sakai Shirō/Shinten 酒井紫朗・眞典. 1939. "Kongōchōkyō no daisan'e" 金剛頂経の第三会 [The third assembly of the *Vajraśekhara*]. *Mikkyō Kenkyū* 71: 1–30.

———. 1944. *Ramakyō no tenseki* 喇嘛教の典籍 [Texts of Lamaism]. Tokyo: Shingonshū Ramakyō Kenkyūjo.

———. 1973. *Shūtei Dainichikyō no seiritsu ni kansuru kenkyū* 修訂　大日経の成立に関する研究 [A study of the genesis of the *Vairocanābhisaṃbodhisūtra* (rev. ed.)]. Tokyo: Kokusho Kankōkai.

———. 1974. *Zōho shūtei Chibetto mikkyō kyōri no kenkyū* 増補修訂　チベット密教教理の研究 [A study of esoteric Buddhist doctrine in Tibet (enlarged and revised edition)]. Tokyo: Kokusho Kankōkai.

———. 1985. *Sakai Shinten chosakushū* 酒井眞典著作集 [Collected works of Sakai Shinten], vol. 3. Kyoto: Hōzōkan.

———. 1987. *Sakai Shinten chosaku shū*, vol. 2. Kyoto: Hōzōkan.

———. 1989. *Sakai Shinten chosaku shū*, vol. 4. Kyoto: Hōzōkan.

Sakurai Munenobu 桜井宗信. 1991. "Vajrāvalī shosetsu no kanjō shidai—bonbun kōtei tekusuto (1)" Vajrāvalī所説の灌頂次第―梵文校訂テクスト(1) [The initiation rite explained in the *Vajrāvalī*: Sanskrit text (1)]. In *Ju-Butsu-Dō sankyō shisō ronkō* 儒・佛・道三教思想論攷 [Confucianism, Buddhism, Taoism: Studies on the thought of these three religions], edited by Makio Ryōkai Hakushi Kiju Kinen Ronshū Kankōkai 牧尾良海博士喜寿記念論集刊行会, 81–105. Tokyo: Sankibō Busshorin.

———. 1996. *Indo mikkyō girei kenkyū—kōki Indo mikkyō no kanjō shidai* インド密教儀礼研究―後期インド密教の灌頂次第 [A study of tantric Buddhist ritual: *Abhiṣeka* rites in late tantric Buddhism]. Kyoto: Hōzōkan.

———. 1997. "Cakrasaṃvarābhisamaya kenkyū (1)—genten shiryō to chūshakusho no shoshi kenkyū" Cakrasaṃvarābhisamaya研究(1)―原典資料と註釈書の書誌研究 [On the *Cakrasaṃvarābhisamaya* (1): Bibliographical survey]. *Mikkyōgaku Kenkyū* 29: 31–52.

———. 1998. "Cakrasaṃvarābhisamaya no genten kenkyū" Cakrasaṃvarābhisamayaの原典研究 [A critical study of Lūyīpāda's *Cakrasaṃvarābhisamaya*]. *Chisan Gakuhō* 47 (61): 1–32.

Samdong Rinpoche and Vrajavallabha Dwivedi. 1987. *Guhyādi-aṣṭasiddhisaṃgraha*. Sarnath: CIHTS.

Sanderson, Alexis. 1995. "Vajrayāna: Origin and Function." In *Buddhism into the Year 2000: International Conference Proceedings*, 87–102. Bangkok: Dhammakaya Foundation.

Sāṅkṛityāyana, Rāhula. 1935. "Sanskrit Palm-leaf Mss. in Tibet." *Journal of the Bihar and Orissa Research Society* 21.1: 21–43.

———. 1937. "Second Search of Sanskrit Palm-leaf Mss. in Tibet." *Journal of the Bihar and Orissa Research Society* 23-1: 1–56.

Saraswati, S. K. 1977. *Tantrayāna Art: An Album*. Calcutta: Asiatic Society.

Satō Naomi 佐藤直美. 2005. "Daijō kyōten ni in'yō sareru Ashukubutsu shinkō no yakuwari" 大乗経典に引用される阿閦仏信仰の役割 [The role of the Akṣobhya cult in Mahāyāna scriptures]. In Yoritomi et al., *Mandara no shosō to bunka*, 2: 796–784.

Satō Sōtarō 佐藤宗太郎. 1985. *Indo sekkutsu jiin* インド石窟寺院 [The cave temples of India]. Tokyo: Tōkyō Shoseki.

Satō Tsutomu 佐藤努. 1995. "Jinyānapādaryū no mandara kōsei" ジニャーナパーダ流のマンダラ構成 [The composition of the maṇḍala in the Jñānapāda school]. *Mikkyō Zuzō* 14: 85–93.

Sawa Ryūken 佐和隆研, ed. 1982. *Mikkyō bijutsu no genzō: Indo Orissa chihō no bukkyō iseki* 密教美術の原像　インド・オリッサ地方の仏教遺蹟 [Prototypes of esoteric Buddhist art: Buddhist sites in Orissa]. Kyoto: Hōzōkan.

Schroeder, Ulrich von. 1981. *Indo-Tibetan Bronzes*. Hong Kong: Visual Dharma Publications.

———. 2001. *Buddhist Sculptures in Tibet*. 2 vols. Zurich: Visual Dharma Publications.

Sferra, Francesco, and Stefania Merzagora. 2006. *The Sekoddeśaṭīkā by Nāropā, Paramārthasaṃgraha*. Rome: IsIAO.

Sha Wutian 沙武田. 2011. *Tufan tongzhi shiqi Dunhuang shiku yanjiu* 吐蕃統治時期敦煌石窟研究 [Research on the caves of Dunhuang in the Tubo period]. Beijing: Zhongguo Shehui Kexue Chubanshe.

Shastri, Swami Dwarikadas. 1971. *Abhidharmakośam, bhāṣyasphuṭārthasahitam*, vol. 2. Varanasi: Bauddhabharati.

Shendge, Malati J. 2004. *Ṣaṭsāhasrikā-Hevajra-ṭīkā: A Critical Edition*. Delhi: Pratibha Prakashan.

Shimada Shigeki 島田茂樹. 1984. "Hēvajura mandara no kōsei—sono seiritsu to tenkai" ヘーヴァジュラ曼荼羅の構成―その成立と展開 [The composition of the Hevajra-maṇḍala: Its establishment and development]. *Mikkyō Zuzō* 3: 72–81.

———. 1990. "Heruka to Herakles" HerukaとHerakles [Heruka and Héraklēs]. *Shūkyō Kenkyū* (*Journal of Religious Studies*) 63.4: 205–6.

Shimizu Tadashi 清水乞. 1982. "Rokujūshi yuganyo no zuzō shiryō" 六十四瑜伽女の図像資料 [Some iconographic sources on the *catuḥṣaṣṭiyoginī*]. *Mikkyō Zuzō* 1: 72–88.

Shinbo Tōru 真保亨. 1985. *Besson mandara* 別尊曼荼羅 [Maṇḍalas of individual deities]. Tokyo: Mainichi Shinbunsha.

Shizuka Haruki 静春樹. 2006. "Kongōjō to tantora bunrui" 金剛乗とタントラ分類 [Vajrayāna and the classification of tantras]. *Mikkyō Bunka* 217: (7)–(32).

Skorupski, Tadeusz. 1983. *The Sarvadurgatipariśodhana Tantra*. Delhi: Motilal Banarsidass.

———. 1996. "The *Saṃpuṭatantra*: Sanskrit and Tibetan Versions of Chapter One." In *The Buddhist Forum*, edited by Tadeusz Skorupski, 4: 224–31. Tring: Institute of Buddhist Studies.

———. 2001. "Two Eulogies of the Eight Great Caityas." In *The Buddhist Forum*, edited by Tadeusz Skorupski, 6: 37–55. Tring: Institute of Buddhist Studies.

Soeda Ryūshō 添田隆昭. 1979. "Shinjitsushōkyō to Rishubun" 真実摂経と理趣分 [On the *Tattvasaṃgrahasūtra* and the "Li-ch'ü-fên"]. *Mikkyōgaku Kenkyū* 11: 45–61.

Sugiki Tsunehiko 杉木恒彦. 1996. "Sanvarakei mikkyō shoryūha no shōki shidai" サンヴァラ系密教諸流派の生起次第 [The process of generation in Saṃvara schools]. *Tōkyō Daigaku Shūkyōgaku Nenpō* (*Annual Review of Religious Studies, The University of Tokyo*) 14: 59–79.

———. 2001. "*Chakurasanvara tantora* no seiritsu dankai ni tsuite—oyobi Jayabhadra saku Śrīcakrasaṃvarapañjikā kōtei bonpon" 『チャクラサンヴァラタントラ』の成立段階について—およびJayabhadra作Śrīcakrasaṃvarapañjikā校訂梵本 [On the making of the *Śrīcakrasaṃvaratantra*: With a critical Sanskrit text of Jayabhadra's *Śrīcakrasaṃvarapañjikā*]. *Chisan Gakuhō* 50 (64): 91–141.

———. 2002. "A Critical Study of the Vajraḍākamahātantrarāja (I)—Chapter 1 and 42." *Chisan Gakuhō* 51 (65): 81–115.

———. 2003. "A Critical Study of the Vajraḍākamahātantrarāja (II)—Sacred Districts and Practices Concerned." *Chisan Gakuhō* 52 (66): 53–106.

———. 2007. *Samvarakei mikkyō no shosō—gyōja, seichi, shintai, jikan, shisei* サンヴァラ系密教の諸相—行者・聖地・身体・時間・死生 [Aspects of Saṃvara esoteric Buddhism: Practitioner, holy sites, body, time, and death and life]. Tokyo: Tōshindō.

Tachikawa Musashi 立川武蔵 and Masaki Akira 正木晃. 1997. *Chibetto Bukkyō zuzō kenkyū—Penkoru chūde buttō* チベット仏教図像研究—ペンコルチューデ仏塔 [Iconographic studies of the stupa of Gyantse]. *Kokuritsu Minzokugaku Hakubutsukan Kenkyū Hōkoku* (*Bulletin of the National Museum of Ethnology*), Special Issue 18. Osaka: Kokuritsu Minzokugaku Hakubutsukan.

Takada Yorihito 高田順仁. 2000. "*Murimandarajukyō* shosetsu no mandara" 『牟梨曼陀羅呪経』所説のマンダラ [A philological study of the maṇḍala of the *Ārya-mahāmaṇi-vipula-vimāna(-viśva)-supratiṣṭhita-guhya-paramarahasya-kalparāja*]. *Mikkyō Zuzō* 19: 1–17.

Takata Ninkaku 高田仁覚. 1970. "Mandara no tsūsoku ni tsuite—toku ni Sukiyakyō (guhyatantra) o chūshin to shite" 曼荼羅の通則について—とくに蘇呬耶経 (guhyatantra)を中心として [On the rules for rites that are a common requirement for all maṇḍalas: With a focus on the *Guhyatantra*]. *Kōyasan Daigaku Kiyō* (*Journal of Koyasan University*) 5: 1–29.

———. 1978. *Indo-Chibetto shingon mikkyō no kenkyū* インド・チベット真言密教の研究 [A study of Indo-Tibetan Mantrayāna Buddhism]. Kōyasan: Mikkyō Gakujutsu Shinkōkai.

Takata Osamu 高田修. 1954. "Gobu shinkan no kenkyū—sono kinyū bongo ni motozuku kōsatsu" 五部心観の研究—その記入梵語に基く考察 [A study of the *Gobu shinkan*, an old esoteric Buddhist scroll drawing, based mainly on the Sanskrit text contained in the scroll]. *Bijutsu Kenkyū* 173: 139–73.

———. 1959. *Daigoji gojūnotō no hekiga* 醍醐寺五重塔の壁画 [The wall paintings of the five-storied pagoda of Daigoji temple]. Tokyo: Yoshikawa Kōbunkan.

Tanaka Kimiaki 田中公明. 1984a. *Mandara no rekishi to hatten ni tsuite.* 曼荼羅の歴史と発展について [On the history and development of the maṇḍala]. Tokyo: Chibetto Bunka Kenkyūkai.

———. 1984b. "*Issaibutsu shūe dakini kaimō tantora* to sono mandara ni tsuite" 『一切仏集会拏吉尼戒網タントラ』とその曼荼羅について [The *Sarvabuddhasamāyogaḍākinījālasaṃvaratantra* and its maṇḍala]. *Mikkyō Zuzō* 3: 59–71.

———. 1985. "Guge iseki no Kongōkai mandara hekiga ni tsuite" グゲ遺跡の金剛界曼荼羅壁画について [The mural of the Vajradhātu-maṇḍala found in the ruins of Guge]. *JIBS* 33.2: (134)–(137).

———. 1986. "Tonkō shutsudo no Ninmaha mikkyō tenseki ni tsuite" 敦煌出土のニンマ派密教典籍について [On the Zhi-khro literature discovered from Tun-huang]. In *Chibetto no bukkyō to shakai* チベットの仏教と社会 [Buddhism and society in Tibet], edited by Yamaguchi Zuihō 山口瑞鳳, 199–214. Tokyo: Shunjūsha.

———. 1987a. *Mandara ikonorojī* 曼荼羅イコノロジー [Maṇḍala iconology]. Tokyo: Hirakawa Shuppansha.

———. 1987b. "*Himitsu shūe* Junyānapādaryū no shinshutsu bunken Mañjuvajramukhyākhyāna ni tsuite" 『秘密集会』ジュニャーナパーダ流の新出文献Mañjuvajramukhyākhyāna について [On the newly discovered *Mañjuvajramukhyākhyāna* of the Jñānapāda school of the *Guhyasamājatantra*]. In *Indogaku bukkyōgaku ronshū* インド学仏教学論集 [Collected essays on Indology and Buddology], edited by Takasaki Jikidō Hakushi Kanreki Kinenkai 高崎直道博士還暦記念会, 413–26. Tokyo: Shunjūsha.

———. 1987c. "Panchen rama no Taizō mandara giki" パンチェン・ラマの胎蔵曼荼羅儀軌 [The *Mahākaruṇāgarbhasambhava-maṇḍala-vidhi* by Paṇ chen, Blo bzaṅ chos kyi rgyal mtshan]. *Mikkyō Zuzō* 5: 99–109.

———. 1988. "Penkoru chūde buttō to *Shoe kongōchōkyō* shosetsu no 28 shu mandara" ペンコルチューデ仏塔と『初会金剛頂経』所説の28種曼荼羅 [The 28 maṇḍalas of the *Tattvasaṃgrahatantra* found in the dPal 'khor chos sde]. *Mikkyō Zuzō* 6: 1–13.

———. 1989. "*Issaibutsu shūe dakini kaimō yuga* shosetsu 'kumi' kō" 『一切佛集會拏吉尼戒網瑜伽』所説「九味」考 [A consideration of the nine sentiments (*navarasa*) found in the *Sarvabuddhasamāyogaḍākinījālasaṃvaratantra*]. *Tōhō* (*The East*) 5: 74–84.

———. 1990a. *Shōkai Kawaguchi Ekai korekushon—Chibetto Nepāru bukkyō bijutsu* 詳解河口慧海コレクション—チベット・ネパール仏教美術 [A catalogue of Ekai Kawaguchi's collection of Tibetan and Nepalese Buddhist art]. Tokyo: Kōsei Shuppansha.

———. 1990b. "Nepāru no Sansukurittogo bukkyō bunken kenkyū (1)—shahon hozon purojekuto to kenkyū no genjō" ネパールのサンスクリット語仏教文献研究(1)—写本保存プロジェクトと研究の現状 [On the Buddhist Sanskrit manuscripts in Nepal and the Nepal-German Manuscript Preservation Project]. *JIBS* 39.1: (121)–(125).

———. 1991. "Bukkyō no sonkaku no juyō to hen'yō—shugoson to gohōson o chūshin ni shite" 仏教の尊格の受容と変容—守護尊と護法尊を中心にして [The reception and transformation of Buddhist deities: With a focus on tutelary and Dharma-protecting deities]. In *Bukkyō no juyō to hen'yō* 仏教の受容と変容 [The reception and transformation of Buddhism], vol. 3, *Chibetto Nepāru hen* チベット・ネパール編 [Tibet and Nepal], edited by Tachikawa Musashi, 157–82. Tokyo: Kōsei Shuppansha.

———. 1992a. "*Issaibutsu shūe dakini kaimō yuga* shosetsu 'kumi' saikō" 『一切佛集會拏吉尼戒網瑜伽』所説「九味」再考 [The nine sentiments (*navarasa*) found in the *Sarvabuddhasamāyogaḍākinījālasaṃvaratantra* reconsidered]. *JIBS* 41.1: (139)–(144).

———. 1992b. "A Comparative Study of Esoteric Buddhist Manuscripts and Icons Discovered at Dun-huang." In *Tibetan Studies: Proceedings of the 5th Seminar of the International Association for Tibetan Studies, Narita 1989*, edited by Ihara Shōren 伊原照蓮 and Yamaguchi Zuihō, 275–79. Narita: Naritasan Shinshōji.

———. 1993. "The *Lokeśvarakalpa* and the *Yi-qie-fo she-xiang-ying da-jiao-wang-jing sheng-guan-zi-zai pu-sa nian-song yi-gui*." *Bukkyō Bunka* 30: 1–24.

———. 1994a. *Chō mikkyō: Jirin tantora* 超密教『時輪タントラ』 [Hyper-mikkyō: *Kālacakratantra*]. Osaka: Tōhō Shuppan.

———. 1994b. "Kosumorojī to mandara" コスモロジーと曼荼羅 [Buddhist cosmology and maṇḍalas]. *Mikkyō Zuzō* 13: 33–47.

———. 1994c. "*Navarasa* Theory in the *Sarvabuddhasamāyogaḍākinījālasaṃvaratantra* Reconsidered." *Tōhō* 10: 323–31. (English version of Tanaka 1992a.)

———. 1996a. *Indo Chibetto mandara no kenkyū* インド・チベット曼荼羅の研究 [Studies in the Indo-Tibetan maṇḍala]. Kyoto: Hōzōkan.

———. 1996b. "Hōjin no goketsujō ni tsuite" 報身の五決定について [On the five certainties of the *sambhogakāya* (*loṅs sku'i ṅes pa lṅa*)]. *Tōhō* 12: 74–84.

———. 1997. *Sei to shi no mikkyō* 性と死の密教 [The sexology and thanatology of Buddhism]. Tokyo: Shunjūsha.

———. 1998a. "Penkoru chūde buttō Fukūkensakudō no taizō mandara shoson hekiga ni tsuite" ペンコルチューデ仏塔不空羂索堂の胎蔵曼荼羅諸尊壁画について [The wall painting of Garbha-maṇḍala deities in the Don-żags lha-khaṅ, dPal-'khor chos-sde]. *Mikkyō Zuzō* 17: 51–59.

———. 1998b. "Nepāru no Sansukurittogo bukkyō bunken kenkyū—daiyonjūikkai gakujutsu taikai ni okeru happyō igo dōtei sareta danpen ni tsuite" ネパールのサンスクリット語仏教文献研究―第41回学術大会における発表以後同定された断片について [Newly identified Buddhist tantric manuscripts from Nepal]. *JIBS* 46.2: (148)–(152).

———. 1999. "Jirin tantora—saikō no fuhen tairaku to wa nani ka" 『時輪タントラ』―最高の不変大楽とは何か [What is *paramākṣarasukha*?]. In *Shirīzu mikkyō* シリーズ密教 [Series on esoteric Buddhism], vol. 1, *Indo mikkyō* インド密教 [Esoteric Buddhism in India], edited by Tachikawa Musashi and Yoritomi Motohiro, 81–92. Tokyo: Shunjūsha.

———. 2000a. *Tonkō: mikkyō to bijutsu* 敦煌 密教と美術 [Essays on Tantric Buddhism in Dunhuang: Its art and texts]. Kyoto: Hōzōkan.

———. 2000b. *Chibetto bukkyō kaiga shūsei* チベット仏教絵画集成 [Art of thangka: From the Hahn Kwang-ho collection], vol. 2. Seoul: Hahn Cultural Foundation.

———. 2001a. *Chibetto bukkyō kaiga shūsei*, vol. 3. Seoul: Hahn Cultural Foundation.

———. 2001b. *Chibetto mikkyō: jōju no hihō* チベット密教 成就の秘法 [A Japanese translation of the *Żal 'don gces btus grub gñis 'dod 'jo*]. Tokyo: Daihōrinkaku.

———. 2001c. "Taizō Dainichi hachi daibosatsu to hachi daibosatsu mandara no seiritsu to tenkai" 胎蔵大日八大菩薩と八大菩薩曼荼羅の成立と展開 [Vairocana and the eight bodhisattvas: Their iconography and symbolism]. *Mikkyō Zuzō* 20: 1–15.

———. 2002. "Seika, Gen jidai no shiruku rōdo mikkyō to sono zuzō—Harahoto shutsudo no Hōrōkaku mandara o chūshin ni shite" 西夏・元時代のシルクロード密教とその図像―ハラホト出土の宝楼閣曼荼羅を中心にして [Esoteric Buddhism along the Silk Road in the Xixia and Yuan periods and its iconography: With a focus on the Jeweled Pavilion maṇḍala from Kharakhoto]. In *Higashi Ajia Bukkyō—sono seiritsu to tenkai* 東アジア仏教―その成立と展開 [Buddhism in East Asia: Its formation and development], edited by Kimura Kiyotaka Hakushi Kanreki Kinenkai 木村清孝博士還暦記念会, 601–19. Tokyo: Shunjūsha.

———. 2003a. "Tunga sekkutsu no seiritsu nendai ni tsuite" トゥンガ石窟の成立年代について [On the dating of the Duṅ-dkar caves]. *Nihon Chibetto Gakkai Kaihō* (*Report of the Japanese Association for Tibetan Studies*) 49: 63–69.

———. 2003b. "Chibetto ni okeru Taizō Dainichi nyorai to Taizō mandara no denshō to sakurei ni tsuite" チベットにおける胎蔵大日如来と胎蔵曼荼羅の伝承と作例について [Materials concerning the *Vairocanābhisambodhisūtra* (*Dainichikyō*) and the Garbha (*Taizō*) maṇḍala in Tibet]. In *Seinaru mono no katachi to ba* 聖なるものの形と場 [Figures and places of the sacred], edited by Yoritomi Motohiro, 39–52. Kyoto: Kokusai Nihon Bunka Kenkyū Sentā.

———. 2004a. *Ryōkai mandara no tanjō* 両界曼荼羅の誕生 [The birth of the two-world maṇḍalas]. Tokyo: Shunjūsha.

———. 2004b. "Nāgabodhi no *Śrī-guhyasamājamaṇḍalopāyikā-viṃśati-vidhi* ni okeru 5 shu no sthānaka to 53 shu no ākṣepa ni tsuite" Nāgabodhiの*Śrī-guhyasamājamaṇḍalopāyikā-viṃśati-vidhi*における5種のsthānakaと53種のākṣepaについて [On the five postures (*sthānaka*) and fifty-three poses (*ākṣepa*) according to Nāgabodhi's *Śrī-guhyasamājamaṇḍalopāyikā-viṃśati-vidhi*]. *Tōyō Bunka Kenkyūjo Kiyō* (*Memoirs of the Institute of Oriental Culture*) 146: (109)–(130).

———. 2005a. *Chibetto bukkyō kaiga shūsei*, vol. 5. Seoul: Hahn Cultural Foundation.

———. 2005b. "Nāgabodhi no *Samājasādhanavyavasthāna* ni tsuite" Nāgabodhiの*Samājasādhanavyavasthāna*について [Nāgabodhi's *Samājasādhanavyavasthāna*: The Tibetan translation and Sanskrit text of 3-1-3 to 3-3-3]. *Tōyō Bunka Kenkyūjo Kiyō* 148: (111)–(133).

———. 2007a. *Mandara gurafikusu* 曼荼羅グラフィクス [Maṇḍala graphics]. Tokyo: Yamakawa Shuppansha. (English version, Tanaka 2013.)

———. 2007b. "*Kongōjō shōgon tantora* no seiritsu to Indo mikkyō shijō ni okeru ichi" 『金剛場荘厳タントラ』の成立とインド密教史上における位置 [The date of composition of the *Śrīvajramaṇḍalālaṃkāra* and its position in the history of Indian tantric Buddhism]. *Tōyō Bunka Kenkyūjo Kiyō* 152: 209–28.

———. 2007c. "Taizō mandara no daisanjū no seiritsu katei" 胎蔵曼荼羅の第三重の成立過程 [The historical formation of the third square of the Garbha-maṇḍala]. *Mikkyō Zuzō* 26: 1–12.

———. 2008a. "Haripuru no shibutsu ni tsuite" ハリプルの四仏について [Four Buddha statues from Haripur]. *Mikkyō Zuzō* 27: 48–59.

———. 2008b. "Four Buddha Statues from Haripur." In *Stupa: Cult and Symbolism*, edited by Gustav Roth, Lokesh Chandra, and K. Tanaka, Śata-piṭaka 624, 217–33. New Delhi: International Academy of Indian Culture. (English version of Tanaka 2008a.)

———. 2009a. "Chibetto bukkyō ni okeru sanjinsetsu to shishinsetsu no settei—*Genkan shōgonron* 'Hosshinshō' shosetsu no nijūisshu murochi (zag pa med pa'i ye shes sde tshan nyi shu rtsa gcig po) no kaishaku o chūshin ni" チベット仏教における三身説と四身説の設定―『現観荘厳論』「法身章」所説の二十一種無漏智zag pa med pa'i ye shes sde tshan nyi shu rtsa gcig poの解釈を中心に [The establishment of the three-body and four-body theories in Tibetan Buddhism: With a special reference to the interpretation of *zag pa med pa'i ye shes sde tshan nyi shu rtsa gcig po* in the "Dharmakāyābhisambodhādhikāra" of the *Abhisamayālaṃkāra*]. *Nihon Chibetto Gakkai Kaihō* 55: 131–39.

———. 2009b. "*Āmnāya mañjarī* ni miru Sanvara mandara no kaishakuhō" 『アームナーヤ・マンジャリー』に見るサンヴァラ曼荼羅の解釈法 [The interpretation of the Saṃvara-maṇḍala found in the *Āmnāyamañjarī*]. *Indo Tetsugaku Bukkyōgaku Kenkyū* (*Studies in Indian Philosophy and Buddhism*) 16: 55–68.

———. 2010. *Indo ni okeru mandara no seiritsu to hatten* インドにおける曼荼羅の成立と発展 [Genesis and development of the maṇḍala in India]. Tokyo: Shunjūsha.

———. 2011. "On the Tradition of the *Vairocanābhisambodhi-sūtra* and the Garbhamaṇḍala in Tibet." In *Art in Tibet: Issues in Traditional Tibetan Art from the Seventh to the Twentieth Century*, edited by Erberto F. Lo Bue, 193–201. Leiden: Brill. (English version of Tanaka 2003b.)

———. 2012a. "Taizō gobutsu no seiritsu ni tsuite—*Dainichikyō* no senkō kyōten to shite no *Monjushiri konpon gikikyō*" 胎蔵五仏の成立について—『大日経』の先行経典としての『文殊師利根本儀軌経』 [On the evolution of the five Buddhas of the Garbha-maṇḍala: The *Mañjuśrīmūlakalpa* as a precursor of the *Vairocanābhisaṃbodhisūtra*]. *Mikkyō Zuzō* 31: 83–95.

———. 2012b. "The *Mañjuśrīmūlakalpa* and the Origins of Thangka." *Asian Art*. http://www.asianart.com/articles/tanaka/index.html.

———. 2013. *Mitrayogin's 108 Maṇḍalas: An Image Database*. Kathmandu: Vajra Publications.

———. 2016a. "Gandāra kara gokuraku jōdo zu? Kodai Oriento Hakubutsukan kitaku no butsu seppōzu ni tsuite" ガンダーラから極楽浄土図?—古代オリエント博物館寄託の仏説法図について [A depiction of Sukhāvatī from Gandhāra? A sculptural relief of a preaching buddha on loan to the Ancient Orient Museum]. *Kodai Oriento Hakubutsukan Kiyō* (*Bulletin of the Ancient Orient Museum*) 35: 101–18.

———. 2016b. "Taizō mandara—Genzu mandara, *Hizōki*, *Shōmugekyō*, sanrinshinsetsu no seiritsu mondai ni tsuite" 胎蔵曼荼羅—現図曼荼羅・『秘蔵記』・『摂無礙経』・三輪身説の成立問題について [The Garbha-maṇḍala: On the origins of the Genzu mandara, *Hizōki*, *She wu'ai jing*, and triple-wheel theory]. In *Kūkai to Indo chūki mikkyō* 空海とインド中期密教 [Kūkai and the middle phase of Indian esoteric Buddhism], edited by Takahashi Hisao 高橋尚夫, Noguchi Keiya, and Ōtsuka Nobuo 大塚伸夫, 211–34. Tokyo: Shunjūsha.

———. 2016c. "Kongōshu no zuzōteki tenkai—*Rishukyō* 'tairaku no hōmon' no jūsetsu o chūshin ni shite" 金剛手の図像的展開—『理趣経』「大楽の法門」の重説を中心にして [The iconographical development of Vajrapāṇi, based on the second part of the Mahāsukha section in the *Adhyardhaśatikāprajñāpāramitāsūtra*]. *Mikkyō Bunka* 236: 248–35.

———. 2016d. *Bon-Zō taishō "Anryū shidairon" kenkyū* 梵蔵対照『安立次第論』研究 [*Samājasādhana-Vyavastholi* of Nāgabodhi/Nāgabuddhi: Introduction and romanized Sanskrit and Tibetan texts]. Tokyo: Watanabe Shuppan.

———. 2016e. "Taizō mandara no doryōhō to shoson no haichi ni tsuite" 胎蔵曼荼羅の度量法と諸尊の配置について [The iconometry and arrangement of deities in the Tibetan Garbha-maṇḍala]. *Mikkyō Zuzō* 35: 80–90.

———. 2017a. *Bonbun "Fugen jōjuhō chū" kenkyū* 梵文『普賢成就法註』研究 [The Sanskrit commentary on the *Samantabhadra nāma sādhana* of Buddhajñānapāda: Introduction, romanized Sanskrit text, and translation]. Tokyo: Watanabe Shuppan.

———. 2017b. *Ryōkai mandara no hotoketachi* 両界曼荼羅の仏たち [Deities of the two-world maṇḍalas]. Tokyo: Shunjūsha.

———. 2018. "Rō Mantan Chanpa rakan nikai no mandara hekiga ni tsuite" ローマンタン・チャンパラカン二階の曼荼羅壁画について [On the maṇḍala murals on the second floor of Byams pa lha khang in Lo Manthang]. In *Ajia Bukkyō bijutsu ronshū* アジア仏教美術論集 [Collected studies on Asian Buddhist art], vol. 11, *Chibetto* チベット [Tibet], edited by Mori Masahide, 31–60. Tokyo: Chūō Kōron Bijutsu Shuppan.

Tanaka Kimiaki et al. 2001. *Yungu shinrigaku to gendai no kiki* ユング心理学と現代の危機 [Jungian psychology and the crisis of modern times]. Tokyo: Kawade Shobō Shinsha.

Tanaka Kimiaki and Yoshizaki Kazumi 吉崎一美. 1998. *Nepāru bukkyō* ネパール仏教 [Nepalese Buddhism]. Tokyo: Shunjūsha.

Toganoo Shōun 栂尾祥雲. 1927. *Mandara no kenkyū* 曼荼羅の研究 [A study of the maṇḍala]. Kōyasan: Kōyasan Daigaku.

———. 1930. *Rishukyō no kenkyū* 理趣経の研究 [A study of the *Prajñāpāramitānayasūtra*]. Kōyasan: Kōyasan Daigaku.

———. 1933. *Himitsu Bukkyōshi* 秘密仏教史 [A history of esoteric Buddhism]. Kōyasan: Kōyasan Daigaku.

———. 1935. *Himitsu jisō no kenkyū* 秘密事相の研究 [A study of esoteric Buddhist rituals]. Kōyasan: Kōyasan Daigaku.

———. 1983. "Issai himitsu saijō myōgikyō no kenkyū" 一切秘密最上名義経の研究 [A study of the *Sarvarahasyatantra*]. In *Toganoo Shōun zenshū* 栂尾祥雲全集 [Complete works of Toganoo Shōun], sep. vol. 1: 53–117. Kyoto: Rinsen Shoten.

Tōkyō Kokuritsu Bunkazai Kenkyūjo 東京国立文化財研究所 (National Research Institute for Cultural Properties, Tokyo). 1967. *Takao mandara no kenkyū* 高雄曼荼羅の研究 [A study of the Takao maṇḍala]. Tokyo: Yoshikawa Kōbunkan.

Tomabechi Tōru 苫米地等流. 2004. "Iwayuru Vajrācāryanayottama ni tsuite—shinshutsu kanren shahon no shōkai" いわゆるVajrācāryanayottamaについて—新出関連写本の紹介 [On the so-called *Vajrācāryanayottama*: A Sanskrit manuscript of a related text]. *Mikkyō Zuzō* 23: 40–50.

———. 2007. "The Extraction of Mantra (*mantroddhāra*) in the *Sarvabuddhasamāyogatantra*." In *Pramāṇakīrtiḥ: Papers Dedicated to Ernst Steinkellner on the Occasion of His 70th Birthday*, edited by Birgit Kellner et al., 2: 903–23. Vienna: Arbeitskreis für Tibetische und Buddhistische Studien, Universität Wien.

———. 2009. *Adhyardhaśatikā Prajñāpāramitā: Sanskrit and Tibetan Texts*. Beijing: China Tibetology Publishing House; Vienna: Austrian Academy of Sciences Press.

Toyamaken [Tateyama Hakubutsukan] 富山県[立山博物館] (Toyama Prefecture [Tateyama Museum]). 1992. *Tateyama shinkō no genryū—mandara no sekai* 立山信仰の源流—マンダラの世界 [Origins of the Mount Tateyama cult: The world of the maṇḍala]. Tateyama: Toyamaken [Tateyama Hakubutsukan].

Tripathi, Ram Shankar, and Thakur Sain Negi. 2001. *Hevajratantram, with Muktāvalīṭīkā of Mahāpaṇḍitācārya Ratnākaraśānti*. Sarnath: CIHTS.

Tsuda Shin'ichi 津田真一. 1972. "Sañcāra (yuganyo no ten'i)" sañcāra (瑜伽女の転位) ['Sañcāra', transposition of yoginīs) *JIBS* 21.1: 377–81.

———. 1974. *The Saṃvarodaya Tantra: Selected Chapters*. Tokyo: Hokuseido Press.

———. 1987. *Han mikkyōgaku* 反密教学 [Anti-esoteric Buddhism]. Tokyo: Liburopōto.

Tucci, Guiseppe. 1949. *Tibetan Painted Scrolls*. Rome: La Libreria dello Stato.

———. 1989. *Gyantse and Its Monasteries*, part 2, *Inscriptions*. New Delhi: Aditya Prakashan.

Upadhyaya, Jagannatha, ed. 1986. *Vimalaprabhā*, vol. 1. Sarnath: CIHTS.

Vaidya, P. L., ed. 1960. *Madhyamakaśāstra of Nāgārjuna with the Commentary: Prasannapadā by Candrakīrti*. Darbhanga: Mithila Institute.

———, ed. 1964. *Mañjuśrīmūlakalpa, Mahāyānasūtrasaṃgraha Part II*. Darbhanga: Mithila Institute.

———. 1967. *Daśabhūmikasūtram*. Darbhanga: Mithila Institute.

Waldschmidt, Ernst, ed. 1950. *Das Mahāparinirvāṇasutra*, part 1. Berlin: Akademie-Verlag.

Wallace, Vesna A. 2001. *The Inner Kālacakratantra: A Buddhist Tantric View of the Individual*. Oxford: Oxford University Press.

———. 2004. *Kālacakratantra: The Chapter on the Individual Together with the Vimalaprabhā*. New York: American Institute of Buddhist Studies.

———. 2010. *The Kālacakratantra: The Chapter on Sādhanā Together with the Vimalaprabhā Commentary*. New York: American Institute of Buddhist Studies.

Watanabe Manabu 渡辺学. 2005. "Bunseki shinrigaku ni okeru mandara shōchō hyōgen" 分析心理学におけるマンダラ象徴表現 [Mandala symbolism in analytical psychology]. In Yoritomi et al., *Mandara no shosō to bunka*, 2: 501–14.

Watanabe Shōkō 渡辺照宏. 1965. "Virocana to Vairocana—kenkyū josetsu" VirocanaとVairocana—研究序説 [Virocana and Vairocana: A prolegomenon]. In *Studies of Esoteric Buddhism and Tantrism*, edited by Matsunaga Yūkei, 371–90. Kōyasan: Kōyasan Daigaku.

Wayman, Alex. 1973. *The Buddhist Tantras*. London: Routledge & Kegan Paul.

———. 1977. *Yoga of the Guhyasamājatantra*. Delhi: Motilal Banarsidass.

———. 1984. "The Sarvarahasyatantra." In *Shinpi shisō ronshū* 神秘思想論集 [Mysticism], edited by Naritsan Shinshōji Naritasan Bukkyō Kenkyūjo 成田山新勝寺成田山佛教研究所, 521–69. Narita: Naritasan Shinshōji.

Winkler, Ken. 1990. *A Thousand Journeys: The Biography of Lama Anagarika Govinda*. Longmead, UK: Element Books.

Yamada Kōji 山田耕二. 1984. "Gyarasupuru no shibutsu ni tsuite" ギャラスプルの四仏について [Buddhist triad sculptured on four sides of Gyaraspur Stūpa]. *Bukkyō Geijutsu* 156: 97–111.

———. 1985. "Nāshiku sekkutsu jiin no bosatsuzō ni tsuite" ナーシク石窟寺院の菩薩像について [On the bodhisattva statues in the Nasik Caves]. In Miyaji Akira and Yamada Kōji, *Indo Pakisutan no bukkyō zuzō chōsa* インド・パキスタンの仏教図像調査 [Iconographical study of Buddhist art in India and Pakistan], 25–47. Hirosaki: Hirosaki Daigaku.

———, trans. 1991. *Chibetto mikkyō no shinri* チベット密教の真理 (Japanese translation of Govinda 1959). Tokyo: Kōsakusha.

Yamaguchi Zuihō 山口瑞鳳. 1978. "Toban ōkoku bukkyō shi nendai kō" 吐蕃王国仏教史年代考 [On the chronology of Buddhism in Tufan]. *Naritasan Bukkyō Kenkyūjo Kiyō* (*Journal of Naritasan Institute for Buddhist Studies*) 3: 1–52.

Yamamoto Chikyō 山本智教. 1967a. "G. Tutchi cho *Mandara no riron to jissai*" G・トゥッチ著『曼荼羅の理論と実際』 (Japanese translation of G. Tucci's *Teoria e pratica del mandala*), part 1. *Mikkyō Bunka* 80: 1–16.

———. 1967b. "G. Tutchi cho *Mandara no riron to jissai*," part 2. *Mikkyō Bunka* 81: 24–48.

———. 1967c. "G. Tutchi cho *Mandara no riron to jissai*," part 3. *Mikkyō Bunka* 82: 39–65.

———. 1968. "G. Tutchi cho *Mandara no riron to jissai*," part 4. *Mikkyō Bunka* 83: 18–51.

———. 1969. "Mandara kenkyū shi" マンダラ研究史 [History of research on the maṇḍala]. *Mikkyō Bunka* 87: 66–91.

Yamashita Hiroshi 山下博司. 1979. "Mañjuśrīmūlakalpa seiritsushi no ichi danmen" Mañjuśrīmūlakalpa成立史の一断面 [One aspect of the formation of the *Mañjuśrīmūlakalpa*]. *JIBS* 28.1: 166–67.

Yanagisawa Taka 柳沢孝. 1966a. "Shōren'in denrai no hakubyō Kongōkai mandara shoson zuyō" 青蓮院伝来の白描金剛界曼荼羅諸尊図様 [An ink-drawing scroll representing the Vajradhātu-maṇḍala images in Shōren'in temple], part 1. *Bijutsu Kenkyū* 241: 20–42.

———. 1966b. "Shōren'in denrai no hakubyō Kongōkai mandara shoson zuyō," part 2. *Bijutsu Kenkyū* 242: 13–20.

Yoritomi Motohiro 頼富本宏. 1983. "Indo ni genson suru ryōkaikei mikkyō bijutsu" インドに現存する両界系密教美術 [Indian art of esoteric Buddhism belonging to the school of the Caryātantra and Yogatantra: Centering on remains unearthed in Orissa]. *Bukkyō Geijutsu* 150: 131–50.

———. 1988. *Daijō butten* 大乗仏典 [Scriptures of Mahāyāna Buddhism], vol. 8, *Chūgoku Nihon hen* 中国・日本篇 [China and Japan]. Tokyo: Chūō Kōronsha.

———. 1990. *Mikkyō butsu no kenkyū* 密教仏の研究 [The evolution of esoteric Buddhism]. Kyoto: Hōzōkan.

———. 1991. *Mandara no kanshō kiso chishiki* 曼荼羅の鑑賞基礎知識 [Basic knowledge for appreciating maṇḍalas]. Tokyo: Shibundō.

———. 1992. "Higashi Indo Orissa shū shozai Udayagiri iseki no shin hakkutsu" 東インド・オリッサ州所在ウダヤギリ遺跡の新発掘 [A report on the recent excavation of the Buddhist monuments at Udayagiri in Orissa]. In *Bukkyō mange* 仏教万華 [*Bauddha-maṇḍala*], edited by Shuchiin Daigaku Gakusha Shunkō Kinen Ronbunshū Kankōkai 種智院大学学舎竣工記念論文集刊行会, 107–27. Kyoto: Nagata Bunshōdō.

———. 2000. "Genrokubon ryōkai mandara zu no keifu" 元禄本両界曼荼羅図の系譜 [The genealogy of the Genroku-era version of the two-world maṇḍalas]. In *Bukkyō kyōiku: Ningen no kenkyū* 仏教教育・人間の研究 [Buddhist education: The study of human beings], edited by Saitō Akiyoshi Kyōju Koki Kinen Ronbunshū Kankōkai 斎藤昭俊教授古稀記念論文集刊行会, 599–618. Tokyo: Kobian Shobō.

———. 2004a. "Munōshō myōō, myōhi no seiritsu to tenkai" 無能勝明王・明妃の成立と展開 [The origin and development of Aparājita and Aparājitā]. In *Indo tetsugaku bukkyō shisō ronshū* インド哲学仏教思想論集 [Studies on Indian philosophy and Buddhist thought], edited by Mikogami Eshō Kyōju Shōju Kinen Ronshū Kankōkai 神子上恵生教授頌寿記念論集刊行会, 15–39. Kyoto: Nagata Bunshōdō.

———. 2004b. "Edo jidai seisaku no ryōkai mandara" 江戸時代制作の両界曼荼羅 [The two-world maṇḍalas painted in the Edo period]. In *Kūkai no shisō to bunka* 空海の思想と文化 [Kōbō Daishi Kūkai's thought and culture], edited by Taishō Daigaku Shingongaku Buzan Kenkyūshitsu Onozuka Kichō Hakushi Koki Kinen Ronbunshū Kankōkai 大正大学真言学豊山研究室小野塚幾澄博士古稀記念論文集刊行会, 1: 389–406. Tokyo: Nonburusha.

Yoritomi Motohiro et al. 2005. *Mandara no shosō to bunka* マンダラの諸相と文化 [Aspects of the maṇḍala and its culture]. 2 vols. Kyoto: Hōzōkan.

Yoshizaki Kazumi 吉崎一美. 2001. "Nepāru no yōgānbarakei mikkyō" ネパールのヨーガーンバラ系密教 [Yogāmbara tantrism in Newar Buddhism]. *Mikkyō Bunka* 207: (23)–(44).

Tibetan Indigenous Sources

Bo dong phyogs las rnam rgyal. 1971. *Don zhags rnam grol gyi mngon rtogs rgyas 'bring bsdus gsum*. In *Encyclopedia Tibetica*, vol. 29. New Delhi: Tibet House.

———. 1976. *'Jam dpal rtsa rgyud kyi mthong ba don ldan gyi ras bris mchog gi mngon par rtogs pa 'bring po bshad pa*. In *Encyclopedia Tibetica*, vol. 123. New Delhi: Tibet House.

Bod ljongs rten rdzas bsams mdzod khang. 2001. *dKar chag 'phang thang ma/ sgra sbyor bam po gnyis pa*. Beijing: Mi rigs dpe skrun khang.

Bod rang skyong ljongs rig dngos do dam u yon lhan khang. 1985. *Sa skya dgon pa*. Beijing: Rig dngos dpe skrun khang.

Bu ston, Rin chen grub. 1967–69. *The Collected Works of Bu-ston*. New Delhi: International Academy of Indian Culture.

———. 1967. *dPal gsang ba 'dus pa'i rgyud 'grel gyi bshad thabs kyi yan lag, gsang ba'i sgo 'byed*. In *The Collected Works of Bu-ston*, part 9 [Ta].

———. 1968. *rNal 'byor rgyud kyi rgya mtshor 'jug pa'i gru gzings*. In *The Collected Works of Bu-ston*, part 11 [Da]. New Delhi: International Academy of Indian Culture.

———. 1969. *Cha mthun dpal mchog rigs bsdus kyi dkyil 'khor gyi bkod pa*. In *The Collected Works of Bu-ston*, part 17 [Tsa].

———. 1969. *rDo rje snying po rgyan gyi rgyud kyi dkyil 'khor gyi rnam gzhag*. In *The Collected Works of Bu-ston*, part 17 [Tsa].

gNya' gong dkon mchog tshe brtan and Pad ma 'bum. 1988. "Yul shul khul gyi bod btsan po'i skabs kyi rten yig brag brkos ma 'ga'." *Zhongguo Zangxue (China Tibetology)* 1988–4 [April].

Jo nang, Tā ra nā tha. 1997. *bCom ldan 'das ston pa shā kya thub pa'i rnam thar*. Xining: mTsho sngon mi rigs dpe skrun khang.

Khrag 'thung rgyal po. 1984. *Mar pa lo tsa'i rnam thar*. Chengdu: Si khron mi rigs dpe skrun khang.

Lo chen Dharmaśrī. 1983. *rTsis kyi man ngag nyin byed snang ba'i rnam 'grel, gSer gyi shing rta*. Lhasa: Bod ljong mi dmangs dpe skun khang.

mGon po skyabs. 1983. *rGya nag chos 'byung*. Chengdu: Si khron mi rigs dpe skrun khang.

mKhas grub dge legs dpal bzang. 1982. *rJe btsun bla ma tsong kha pa chen po'i ngo mtshar rmad du byung ba'i rnam par thar pa, dad pa'i 'jug ngogs*. Xining: mTsho sngon mi rigs dpe skrun khang.

Ngag dbang legs grub. 1971. *dPal gsang ba 'dus pa 'jam pa'i rdo rje'i dkyil 'khor gyi cho ga, si ta'i [sic] klung chen 'jigs bral seng ge'i kha 'babs zhes bya ba*. In *rGyud sde kun btus*, vol. 7, fols. 485–651. New Delhi: N. Lungtok & N. Gyaltsan.

Tshe tan zhabs drung (Caidanxiarong). 1982. *bsTan rtsis kun las btus pa*. Xining: mTsho sngon mi rigs dpe skrun khang.

Tsong kha pa, Blo bzang grags pa. 1995. *sNgags rim chen mo*. Xining: mTsho sngon mi rigs dpe skrun khang.

———. *dPal gsang ba 'dus pa'i sgrub thabs, rnal 'byor dag pa'i rim pa* (P. 6194, Tohoku Tibetan no. 5303).

Rong tha Blo bzang dam chos rgya mtsho. 1971. *dPal gsang ba 'dus pa'i thig gi lag len gsal bar bkod pa dang dkyil 'khor gyi rnam bzhag las blos bslang ba tshad dang dbyibs kyi khyad par gsal bar bshad pa, bzo rig mdzes pa'i kha rgyan (The Creation of Mandalas)*. New Delhi: Don 'grub rdo rje.

———. 1978. *rDor phreng dang mi tra sogs dkyil chog rnams las 'byung ba'i yi dam rgyud sde bzhi yi dkyil 'khor so so'i nang thig mi 'dra ba'i khyad par bshad pa, bzo rig mdzes pa'i kha rgyan*. Delhi: Don 'grub rdo rje.

Sa skya bSod nams rgyal mtshan. 1981. *rGyal rabs gsal ba'i me long*. Beijing: Mi rigs dpe skun khang.

Si tu Chos kyi 'byung gnas. 1988. *sDe dge'i bka' 'gyur dkar chag*. Chengdu: Si khron mi rigs dpe skrun khang.

Chinese and Japanese Primary Sources

Amoghapāśakalparāja. See *Bukong juansuo shenbian zhenyan jing.*
Bore liqu fen 般若理趣分. T. 220 (fasc. 578), vol. 7.
Bukong juansuo shenbian zhenyan jing 不空羂索神變眞言經. T. 1092, vol. 20.

Chengjiu miaofa lianhua jingwang yuga guanzhi yigui 成就妙法蓮華經王瑜伽觀智儀軌. T. 1000, vol. 19.
Dabei kongzhi jingang dajiaowang yigui jing 大悲空智金剛大教王儀軌經. T. 892, vol. 18.
Da bore boluomiduo jing 大般若波羅蜜多經. T. 220, vols. 5–7.
Dafangguang Manshushili jing 大方廣曼殊室利經. T. 1101, vol. 20.
Daji xukongzang pusa suowen jing 大集虛空藏菩薩所問經. T. 404, vol. 13.
Dale gui 大樂軌. See *Dale jingangsaduo xiuxing chengjiu yigui.*
Dale jingang bukong zhenshi sanmeiye jing bore boluomiduo liqu shi 大樂金剛不空眞實三昧耶經般若波羅蜜多理趣釋. T. 1003, vol. 19.
Dale jingangsaduo xiuxing chengjiu yigui 大樂金剛薩埵修行成就儀軌. T. 1119, vol. 20.
Da piluzhena chengfo jing shu 大毘盧遮那成佛經疏. T. 1796, vol. 39.
Da piluzhena chengfo shenbian jiachi jing 大毘盧遮那成佛神變加持經. T. 848, vol. 18.
Darijing shu 大日經疏. See *Da pilushena chengfo jing shu.*
Dengyō daishi shōrai Esshū roku 傳教大師將來越州錄. T. 2160, vol. 55.
Dilisanmeiye budongzun shengzhe niansong bimi fa 底哩三昧耶不動尊聖者念誦祕密法. T. 1201, vol. 21.
Foding da baisangai tuoluoni jing 仏頂大白傘蓋陀羅尼經. T. 976, vol. 19.
Foding fang wugou guangming ru pumen guancha yiqie rulai xin tuoluoni jing 佛頂放無垢光明入普門觀察一切如來心陀羅尼經. T. 1025, vol. 19.
Goshōrai mokuroku 御請來目錄. T. 2161, vol. 55.
Guanzizai pusa shouji jing 觀自在菩薩授記經. T. 1101, vol. 20.
Himitsu mandara fuhōden 祕密漫荼羅付法傳. KZ., vol. 1.
Hizōki 祕藏記. TZ., vol. 1.
Huanhuawang da yugajiao shi fennu mingwang daming guanxiang yigui jing 幻化網大瑜伽教十忿怒明王大明觀想儀軌經. T. 891, vol. 18.
Jingangding chaosheng sanjie jing shuo wenshu wuzi zhenyan shengxiang 金剛頂超勝三界經說文殊五字眞言勝相. T. 1172, vol. 20.
Jingangding jing manshushili pusa wuzi xin tuoluoni pin 金剛頂經曼殊室利菩薩五字心陀羅尼品. T. 1173, vol. 20.
Jingangding jing yuga shibahui zhigui 金剛頂經瑜伽十八會指歸. T. 869, vol. 18.
Jingangding jing yuga wenshushili pusa fa yipin 金剛頂經瑜伽文殊師利菩薩法一品. T. 1171, vol. 20.
Jingangding lianhuabu xin niansong yigui 金剛頂蓮華部心念誦儀軌. T. 873, vol. 18.
Jingangding puxian yuga dajiaowang jing dale bukong jingangsaduo yiqie shifang chengjiu yi 金剛頂普賢瑜伽大教王經大樂不空金剛薩埵一切時方成就儀. T. 1121, vol. 20.
Jingangding shengchu yuga jing zhong lüechu dale jingangsaduo niansong yigui 金剛頂勝初瑜伽經中略出大樂金剛薩埵念誦儀軌. T. 1120, vol. 20.
Jingangding xiangsanshi da yigui fawang jiao zhong guanzizai pusa xin zhenyan yiqie rulai lianhua da mannaluo pin 金剛頂降三世大儀軌法王教中觀自在菩薩心眞言一切如來蓮華大曼拏羅品. T. 1040, vol. 20.
Jingangding yuga jingangsaduo wu bimi xiuxing niansong yigui 金剛頂瑜伽金剛薩埵五祕密修行念誦儀軌. T. 1125, vol. 20.
Jingangding yuga lüeshu sanshiqizun xinyao 金剛頂瑜伽略述三十七尊心要. T. 871, vol. 18.
Jingangshou guangming guanding jing zuisheng liyin sheng wudongzun da weinuwang niansong yigui fa pin 金剛手光明灌頂經最勝立印聖無動尊大威怒王念誦儀軌法品. T. 1199, vol. 21.
Kongōkai shichishū 金剛界七集. TZ., vol. 1.
Kongōkai shidai shiki 金剛界次第私記. SZ., vol. 24.

Kongōkai shō 金剛界鈔. SZ., vol. 24.

Lianhuabu xingui 蓮華部心軌. See *Jingangding lianhuabu xin niansong yigui* and *Lianhuabu xin niansong yigui*.

Lianhuabu xin niansong yigui 蓮華部心念誦儀軌. T. 875, vol. 18.

Liqu shijing 理趣釋經. See *Dale jingang bukong zhenshi sanmeiye jing bore boluomiduo liqu shi*.

Lüeshu jingangding yuga fenbie shengwei xiuzheng famen 略述金剛頂瑜伽分別聖位修證法門. T. 870, vol. 18.

Miaojixiang yuga dajiao da jingang peiluopolun guanxiang chengjiu yigui jing 妙吉祥瑜伽大教大金剛陪囉嚩輪觀想成就儀軌經. T. 1242, vol. 21.

Mouli mantuoluo zhoujing 牟梨曼陀羅呪經. T. 1007, vol. 19.

Nanhai jigui neifa zhuan 南海寄歸內法傳. T. 2125, vol. 54.

Puxian yuga gui 普賢瑜伽軌. See *Jingangding puxian yuga dajiaowang jing dale bukong jingangsaduo yiqie shifang chengjiu yi*.

Rokushu mandara ryakushaku 六種曼荼羅略釋. TZ., vol. 2.

Sanzhong xidi po diyu zhuan yezhang chu sanjie bimi tuoluoni fa 三種悉地破地獄轉業障出三界祕密陀羅尼法. T. 905, vol. 18.

Shengchu yuga gui 勝初瑜伽軌. See *Jingangding shengchu yuga jing zhong lüechu dale jingangsaduo niansong yigui*.

She wu'ai dabeixin da tuoluoni jing ji yifa zhong chu wuliangyi nanfang manyuan butuoluo haihui wubu zhuzun deng hongshili fangwei ji weiyi xingse zhichi sanmoye biaozhi mantuluo yigui 攝無礙大悲心大陀羅尼經計一法中出無量義南方滿願補陀落海會五部諸尊等弘誓力方位及威儀形色執持三摩耶幖幟曼荼羅儀軌. T. 1067, vol. 20.

She wu'ai jing 攝無礙經. See *She wu'ai dabeixin da tuoluoni jing ji yifa zhong chu wuliangyi nanfang manyuan butuoluo haihui wubu zhuzun deng hongshili fangwei ji weiyi xingse zhichi sanmoye biaozhi mantuluo yigui*.

Shibahui zhigui 十八會指歸. See *Jingangding jing yuga shibahui zhigui*.

Shinjitsukyō monku 眞實經文句. T. 2237, vol. 61.

Shizizhuangyanwang pusa qingwen jing 師子莊嚴王菩薩請問經. T. 486, vol. 14.

Shouhu guojiezhu tuoluoni jing 守護國界主陀羅尼經. T. 997, vol. 19.

Sokushin jōbutsu gi 卽身成佛義. T. 2428, vol. 77.

Tuoluoni jijing 陀羅尼集經. T. 901, vol. 18.

Uṣṇīṣasitātapatrādhāraṇī. See *Foding da baisangai tuoluoni jing*.

Vairocanābhisambodhisūtra. See *Da pilushena chengfo shenbian jiachi jing*.

Wenshushili fabaozang tuoluoni jing 文殊師利法寶藏陀羅尼經. T. 1185A, vol. 20.

Wuliangmen weimichi jing 無量門微密持經. T. 1011, vol. 19.

Xukongyun pusa jing 虛空孕菩薩經. T. 408, vol. 13.

Yiqiefo shexiangying dajiaowang jing sheng guanzizai pusa niansong yigui 一切佛攝相應大教王經聖觀自在菩薩念誦儀軌. T. 1051, vol. 20.

Yiqie rulai jingang sanye zuishang bimi dajiaowang jing 一切如來金剛三業最上祕密大教王經. T. 885, vol. 18.

Yizi foding lunwang jing 一字佛頂輪王經. T. 951, vol. 19.

Yuga dajiaowang jing 瑜伽大教王經. T. 890, vol. 18.

Zhufo jingjie shezhenshi jing 諸佛境界攝眞實經. T. 868, vol. 18.

Zuishang dasheng jingang dajiao baowang jing 最上大乘金剛大教寶王經. T. 1128, vol. 20.

Zuishang genben dale jingang bukong sanmei dajiaowang jing 最上根本大樂金剛不空三昧大教王經. T. 244, vol. 8.

Index

Chinese translations by, 31, 50, 74, 83, 85–88, 93–94, 98, 108, 135, 144–46, 306nn237–38

mandalas transmitted by, 5, 19, 60

on *Guhyasamāja*, 165, 171

on nine *rasas*, 200–201

on Prajñāpāramitā, 88, 90–91, 93–94, 98, 136

on *samavasaraṇa*, 151, 309n436

on Samāyogatantra, 200–201

on Vajraśekhara cycle, 85–87, 108, 123–24, 140, 157–58, 200

tradition, 33, 37, 78–79, 81, 83

Amṛtakaṇikā, 159

Amṛtakuṇḍalin, 36, 43–44, 48–49, 169, 186, 208, 233, 254

Ānandagarbha

on four *pāramitās*, 126, 134, 149, 267

on iconography, 99, 246, 272

on *Paramādyatantra*, 101–8, 110, 113, 115–16, 133–34, 142, 144–45

on *viśuddhipadas*, 93

school, 149, 188, 267, 307n310

Anantamukhanirhāradhāraṇī, 19, 31, 74–76, 303n75

Aparājitā, 48–49, 60, 72, 147, 169, 233, 254, 305n178

Ārya Nāgārjuna. *See* Nāgārjuna

Ārya school

classifications of deities, 184–85, 254, 312n550

history of, 178–79, 223

iconography in, 168

male and female deities in, 174, 192, 236

mutual encompassment in, 154

on adamantine goddesses, 142, 179–81

scholars of, 189, 280, 311n529

skandhadhātvāyatana theory, 276–77

texts of, 11–12, 101, 159, 184, 194, 202, 214

thirty-two-deity maṇḍala of, 37, 170, 173, 177–80, 187–88, 241–42

Āryadeva, 280, 311n516

Āryaguhyamaṇitilaka, 120

Āryatathāgatācintyaguhyanirdeśa, 16, 46

Aśoka, King, 155

aṣṭamaṇḍalaka, 37–38, 180

Aṣṭamaṇḍalakasūtra, 31, 37–38

Aṣṭasāhasrikā Prajñāpāramitā, 27, 87

Asuras, 27, 62, 82, 104–5, 107

Atīśa, 178, 188, 230–31

Auspicious Eon. *See* Bhadrakalpa

Avalokiteśvara

as one of eight great bodhisattvas, 30–32, 38, 59–62, 109, 132–33, 180

as one of lords of three families, 41–42, 46–47, 304n131

early depictions of, 15–16, 18, 20–21, 274, 285

eleven-headed, 152, 267, 319n824

female emanations of, 135–36, 168

icons of, 7, 23, 30–32, 41–42, 55, 57–61, 70–71, 80–82, 99, 129

in *Bhaiṣajyagurusūtra*, 20

in early maṇḍalas, 43–48

in Garbha-maṇḍala, 30, 61–63, 65

in *Guhyasamāja*, 176, 183, 186, 188, 190–91, 223, 253

in *Mañjuśrīmūlakalpa* maṇḍala, 51–53

in *Paramādyatantra*, 103–7, 109–10, 112, 114–19

in *Prajñāpāramitānayasūtra*, 88–89, 91–92, 109

in *Samāyogatantra*, 205–6

in Sarvatathāgata-maṇḍala, 160

in *Sarvatathāgatatattvasaṃgraha*, 152

rasa of, 200–201

See also Lokeśvara

Avataṃsakasūtra, 18, 23, 26–27, 71, 286

B

Balimālikā, 151

Baoxianglou collection, 68

Bar do thos grol, 8, 312n550

Barhut, 15

besson mandara, 6, 39, 94, 263, 265

Bhadrakalpa, 16, 19, 74–76, 132, 149, 194

Bhadrakalpikasūtra, 74, 305n217

Bhaiṣajyaguru, 18–20, 23, 32

Bhaiṣajyagurusūtra maṇḍala, 19–20, 263, 301n3, 302n38

Bhṛkuṭī, 43–44, 51–52, 57, 65, 82, 194–95, 236, 243–44

Bodhgaya, 187

Bodhicitta verse, 188–89, 258, 281, 312n567

Bodhimaṇḍālaṃkāradhāraṇī, 21

Bodhipathapradīpa (Atīśa), 230

Bodhiruci, 31, 54, 87

bodhisattvas

eight. *See* eight great bodhisattvas

sixteen, 17, 19, 74–76, 124, 128, 131–39, 141–44, 148–49, 155, 158–60, 194, 268–69, 305n218

twenty-five, 68, 73–76

Brahmā, 7, 15, 20, 28, 51–52, 78, 111, 208–9, 233–35

Brahmanism, 15, 77

buddha

dharmakāya, 176, 224, 276–77, 281, 315n695

jñānakāya, 224, 276–77

nirmāṇakāya, 57, 127, 176

of ten directions, 22, 24–25, 27, 173, 302n49

omniscience of, 46, 69–72, 80–83, 120, 267, 284

one thousand, 16–17, 74, 131–32, 305n217

primordial, 100, 124, 151, 175, 186, 282

relics of, 28

rūpakāya, 176, 224

sambhogakāya, 34, 57, 93, 127, 129

seven, 19

six, 25, 76, 252, 254

See also Kālacakra, six families of; *Samāyoga*, six families of

Buddha family, 36–37, 46, 50, 77, 119–20, 124, 287

as one of three families, 16, 41–43, 48–49, 53, 71, 73, 129–30

mother of, 136, 169

wrathful deity of, 169

See also Tathāgata family

buddha-mothers

seed syllables of, 177

study of, 5, 7

See also five families

five families

icons of, 149, 158

in *Guhyasamāja*, 168–70, 180

in Mother tantras, 200, 203, 207, 221, 227, 239

in *Prajñāpāramitānayasūtra*, 89–91

mutual encompassment of, 119, 145, 150–55, 180, 280

of Vajradhātu-maṇḍala, 11, 53, 116, 118–19, 126, 138, 150–54, 252, 287

origins of, 53, 129–30, 150–51

five secrets, 89–90, 95, 100, 104, 107, 135, 145

forty-two peaceful deities, 174–75, 184–86, 193

four buddhas

arrangement of, 268–69

colors of, 161, 194, 233, 247, 270–73, 305n206

equation between Garbha and Vajradhātu-maṇḍala, 120

icons of, 126–28, 148, 155–56, 196–97, 304n174

in *Guhyasamāja*, 167–68, 172–73, 181

in Japanese Garbha-maṇḍala, 79–80, 303n72

in *Kālacakra*, 233–34, 242, 252–53

in *Māyājālatantra*, 194–95, 273

in Paramādya-Vajrasattva maṇḍala, 109–13, 119, 142–44

in stūpas, 27–29, 58–59, 155–56, 302n68

in Tibetan Garbha-maṇḍala, 68–69

influence of *Suvarṇaprabhāsasūtra* on, 25–27, 71, 76, 83, 130, 167

of Vajradhātu-maṇḍala, 131–32, 137, 139, 142–44, 148

origins of, 23–27, 43, 53–55, 61

four goddesses of the seasons, 95–97, 109, 116, 137–40, 307n263

four offering goddesses. *See* offering goddesses, inner and outer

four *pāramitā* goddesses

evolution of, 134–37, 168

icons of, 149, 162

in Māyājāla-maṇḍala, 194, 241

in Vajradhātu-maṇḍala, 83, 124, 126, 131, 140–42, 145, 267

four sisters, 88–89, 104–8, 118

Fukuda Ryōsei, 101, 103, 200

G

Gaganagañja

in *Guhyasamāja*, 190

in Māyājāla-maṇḍala, 195

in Navoṣṇīṣa-maṇḍala, 161

in *Paramādyatantra*, 103, 105, 107, 109–10, 112, 114, 143–44

in *Prajñāpāramitānayasūtra*, 88–89, 91–92, 132–33, 308nn371–72

translations of name, 10

Gaṇḍavyūha, 46, 301n19

Gandhāran art, 15–17, 30–31, 301n17, 302n24

Gaṇeśa, 36, 62, 207, 233, 235

Garbha-maṇḍala

as lotus, 40, 265

bodhisattvas of. *See* eight great bodhisattvas

buddhas of. *See* five buddhas

colors, 120, 270–71, 279, 305n206, 319n829

combination with Vajradhātu-maṇḍala, 57–59, 79, 120

decline of, 12, 85

deities of, 34–35, 37, 42–49, 55, 64–67, 75, 82, 141, 234

evolution of, 56–57, 70–78, 301n1

icons of, 56–61

in China and Japan, 1, 5, 9, 12, 33, 79–83, 124

in Tibet, 63–70

relationship to *Vajrapāṇyabhiṣekatantra*, 61–63

structure of, 42–49, 80, 263

three families of, 16, 41–42, 57, 70, 129–30, 144, 285–87

See also Genzu mandara

Geluk school, 4, 9, 178, 180, 188, 192–93, 312n582

generation stage, 12, 171, 177, 180, 258–59, 276–77

Genzu mandara, 5, 27, 42, 46, 62–63, 69–73, 77, 79–83, 124, 134, 147, 305n188

Ghaṇṭāpa, 314n683

Gilgit manuscripts, 21, 38

Gobu shinkan, 5–6, 9, 127, 145–47, 267, 309n423

Gopāla, King, 11, 50, 179

Govinda, Anagarika, 8–9, 276

great bliss, 88, 215–21, 225, 232–33, 236, 238–39, 250–51, 282

Great King of Teachings, 135

Guhyasamājatantra

bodhisattvas in, 37–39, 172, 179–81, 184, 186, 188–90

colors of, 174, 246, 271–72

emergence of, 26, 165–66

five buddhas of. *See* five buddhas in *Guhyasamāja*

icons related to, 185–88, 268

influence on *Kālacakra*, 155, 180–81, 233, 236, 239–42, 255

interpretations of, 280

language of, 229

mantras, 35, 49, 168–69, 174–77

peaceful deities in, 8, 184

practice, 258–59

relation to Father tantras, 191–95

relation to Mother tantras, 211–12, 215–16, 223

sexual union in, 173–74

study of, 4,

theory of, 188–90, 222–24, 274–76, 281

thirteen deities of, 166–73, 179, 181, 192–93

See also Ārya school; buddha-mothers; Jñānapāda school

Guhyatantra, 37, 44–46, 48, 53, 63, 266–67, 306n219

influence on Garbha-maṇḍala, 70–75, 77–78

use of symbols in, 266–67

Guimet, Émile, 7, 99

Gupta period, 16–17, 25, 28–29, 41

Gyantse, great stūpa of, 68, 70, 109, 120, 122, 134, 149, 159, 209, 272, 308n340

Gyaraspur, 28–29, 156

H

Hadano Hakuyū, 4, 170–71, 230

Hahn Foundation handscrolls, 10, 17, 19, 172, 188, 191, 226–27, 262–65, 267, 272–73

Amaraprasadhgarh, 187
as source of Vairocanābhisambodhi, 6, 56–58, 61
Haripur, 196–97, 304n174
Jajpur compound, 127–28, 144
Ratnagiri, 31, 34, 57–58, 127–29, 155, 192, 230
Sambalpur, 230
Saṃvara cycle in, 216
triads at, 41
Udayagiri, 58–59, 99, 126–28, 144, 156, 197

P

Padmanarteśvara, 199, 201, 203–6, 213, 217, 223, 226, 315n704
Padmapāṇi, 16, 41
Pāla dynasty, 11, 15, 17, 41, 50, 98–99, 126–27, 171, 179, 192
Palkhor Chöde monastery, 195–96, 203–4, 267–69. See also Gyantse, great stūpa of
Pañcaḍāka-maṇḍala, 206, 213, 221, 266, 268
Pañcakrama, 180
Pañcaviṃśatisāhasrikā Prajñāpāramitā, 76, 224
Pāñcika family, 129–30
Pāṇḍarā
 in early maṇḍalas, 43–45, 49, 51–52
 in Garbha-maṇḍala, 65
 in Guhyasamāja, 167–69, 172, 179, 181–82, 186, 190–91, 212, 223
 in Kālacakra, 234, 243–44, 253, 257
 in Māyājāla-maṇḍala, 194–95
 mother of Lotus family, 49, 135–36, 308n384
Paramādimaṇḍalavidhi, 111, 113, 144, 307n310
Paramāditīkā (Ānandagarbha), 93, 101, 104, 106–7, 115–16, 133, 144–45
Paramādivṛtti (Ānandagarbha), 101, 103, 113–14, 119, 144
Paramādya-Vajrasattva maṇḍala, 90, 97, 109–13, 143–45, 160, 272–73
Paramādyatantra
 and Prajñāpāramitānayasūtra, 90–91, 94, 96–99
 colors, 111, 272, 307n307
 dates, 136–37, 139–40
 doctrines, 275, 287
 in Japan, 101–5
 in Nyingma school, 191
 in Tibet, 100–106, 109–10, 122
 influence on maṇḍala deities, 137–42
 influence on Mother tantras, 11, 122
 Karma family undeveloped in, 149, 201
 maṇḍalas, 103–7, 109–19
 mantras, 117
 relation to Mother tantras, 205–7, 209, 211–12, 214
 relation to Vajradhātu-maṇḍala, 85–87, 108–10, 116–19, 130, 142–45
 structure, 102–3
Paramādyayoga, 86, 108–9, 145, 205
Paramāśva family, 199, 201, 203–6, 213
Paranirmitavaśavartin heaven, 91–92, 113
paṭa scrolls, 17–18, 46, 50, 52–53, 104, 285, 304n150
Patraratnamālā (Mitrayogin), 262
Piṇḍikrama, 11, 168–69, 178, 180, 192, 236, 254

Piṇḍikramaṭippaṇī, 168, 189–90, 254
Potala Palace, 127, 268
Pradīpoddyotana (Candrakīrti), 184, 194
Prajñāpāramitā
 goddess, 42, 72, 136, 173, 194, 252–53, 257, 282
 text, 46, 76, 87–88, 252, 277
Prajñāpāramitāhṛdaya, 87–88
Prajñāpāramitānayaśatapañcaśatikāṭīkā (Jñānamitra), 157, 309n413
Prajñāpāramitānayasūtra
 bodhisattvas in. See eight great bodhisattvas
 buddha-families in, 120, 130, 138–39
 colors, 272
 eight mothers of, 234
 eight-spoked wheel in, 39–40, 265–66
 eighteen maṇḍalas of, 88–94, 114, 116, 118, 157
 history and development, 85–88, 100–101, 119–22, 139, 306n242
 iconography, 57
 in Japan, 19, 21, 85, 88, 306n245
 in Tibet, 90, 97, 100, 121–22, 272
 relationship to Mother tantras, 11, 133, 206
 relationship to Vajradhātu-maṇḍala, 118–19, 122–124, 133–34, 137–44
 role of Vajrasattva in, 97–100, 108–10, 113
 seventeen-deity maṇḍala, 93–97, 137–39, 184, 203
 study of, 3
 symmetry in, 83, 119–20, 123, 287
Prajñāpāramitāstuti (Rāhulabhadra), 173
Prasannapadā (Candrakīrti), 87
Praśāntamitra, 93, 272
protectors of directions, 19, 20, 42, 48, 78, 147, 235, 279, 304n130
Puṇḍarīka, King, 229, 258
Pure Land Buddhism, 2, 21, 25, 27, 43, 53

Q

Qianlong emperor, 68

R

Raktayamāritantra, 191–92, 312nn578, 590
rasa theory, 200–201
Rāṣṭrakūṭa dynasty, 60
Ratna family, 119, 124–25, 134, 136, 138–39, 150, 168–69, 205. See also Maṇi family
Ratnagiri, 31, 34, 57–58, 127–29, 155, 192, 230
Ratnākaraśānti, 159, 178, 210, 214, 280
Ratnaketu
 in Garbha-maṇḍala, 62, 69, 75, 79, 81–83, 120, 271, 305n188
 in Guhyasamāja, 167–68, 172, 179, 190, 212, 223
 in Kālacakra, 253
 in Mañjuśrīmūlakalpa, 52–53, 71
 in Suvarṇaprabhāsasūtra, 24–27
Ratnaketuparivarta, 25, 75–76
Ratnakūṭa cycle, 16, 46
Ratnasambhava
 color, 161, 194, 246, 271–73

Vairocanābhisambodhisūtra
 and Garbha-maṇḍala, 1, 12, 41–42, 70–77, 285–86
 and lotus pattern, 40
 development of, 31, 61, 63, 74–76
 five buddhas in, 26–27
 five-element theory in, 120–21, 247, 278
 goddesses in, 140, 234
 icons of, 31–34, 56–61
 in China and Japan, 79–83, 146, 170
 in Tibet, 63, 68–70
 mantras of, 49, 77, 168
 possible sources of, 53, 71–78
 relation to *Amoghapāśakalparāja,* 54–55
 relation to *Mañjuśrīmūlakalpa,* 53
 use of symbols in, 72, 267–68
 Vajrapāṇi and Samantabhadra in, 98
Vaiśālī, 224, 315n693
Vajra family
 as one of three families, 16, 41–43, 45–49, 53, 55–56, 73, 129–30
 buddha-mother of, 136, 168
 in Garbha-maṇḍala, 68–70, 287
 in *Guhyasamāja,* 168–69, 176
 in *Prajñāpāramitānayasūtra,* 88–90, 104, 108, 114, 118–19, 287
 in *Samāyogatantra,* 205
 in *Sarvatathāgatatattvasaṃgraha,* 125, 134, 136–39
 in Vajradhātu-maṇḍala, 119–120, 124–25, 129–30, 150, 287
 of Caryā tantras, 61
 vajradharas in, 81, 304n126
 wrathful deities in, 169
Vajrabhairava, 192–93, 242, 268
Vajrabhairavatantra, 191–93, 214, 312n582
Vajrabodhi, 5, 79, 81, 83, 123, 149, 152, 158–59
Vajracakra, 65, 69, 82, 89, 92, 103, 105, 107, 117, 228
Vajrācāryanayottama, 10, 180, 263, 311n536
Vajraḍākatantra, 215, 222, 226, 228
Vajradhara, 40, 65, 110, 175–77, 199–201, 214, 282. *See also* Vajrapāṇi
vajradharas, 68–69, 80–81
Vajradharma, 99, 132–33, 196. *See also* Avalokiteśvara
Vajradhātu cycle, 7, 57, 61, 83, 124, 131, 151, 158, 163
 icons belonging to, 126–29, 145
Vajradhātu-maṇḍala
 bodhisattvas. *See* bodhisattvas, sixteen
 buddhas. *See* five buddhas; four buddhas
 colors, 246, 271–72
 combinations with Garbha-maṇḍala, 57–59, 69, 80–81
 cosmological aspects of, 278–79
 decline of, 12
 evolution of, 29, 152–55
 fivefold system of, 11, 124, 129–31, 150–54, 252, 287
 gates and gatekeepers, 77, 141–42, 184
 goddesses, 95–96, 98–99, 111, 131, 134–40, 184–85, 209, 267
 in China and Japan, 9, 85, 145–47, 209. *See also* Kue mandara
 in India, 57–59, 126–28, 155

 in Indonesia, 206
 in Tibet and Nepal, 32–33, 55, 145–50, 152–53, 209
 influence of *Prajñāpāramitānayasūtra,* 85–87, 95–97, 113, 116, 118–19, 122, 142
 influence on Yoga tantras, 121, 157–63
 mutual encompassment in, 116, 150–54, 180
 relation to *Paramādyatantra,* 142–45
 relation to stūpas, 155–57
 Sarvatathāgatatattvasaṃgraha as source, 1, 11, 85, 123
 structure of, 39–40, 124, 263–66, 268–69
 thirty-seven deities of, 131–42, 152, 158, 224–26
 three-dimensional, 149, 206
 See also maṇḍala, two-world; *Vajraśekharasūtra*
Vajradhātu-Vairocana, 33, 61, 99–100, 126–30, 151, 169, 252, 303n87, 310n440
Vajradhātumukhākhyāna, 149–50, 309n432
Vajradhātvīśvarī, 169, 175, 186, 243–45, 252–54, 257
Vajragarbha, 31, 209–11, 255, 258
Vajrahāsa, 83, 132, 138, 152, 166, 200–201
Vajrajvālānalārka, 104, 106–7, 116, 118, 136, 209, 223, 307n327
Vajramālā, 95, 184
Vajramaṇḍa-maṇḍala, 120, 122, 272
Vajramaṇḍalālaṃkāramahātantra-pañjikā, 93
Vajramaṇḍalālaṃkāratantra, 93–94, 110, 120–22, 134, 158, 163, 194, 206, 247, 272, 279, 307n320
Vajrāmṛtatantra, 199, 226–27
Vajramuṣṭi
 as source of Karma family, 119, 130
 in early maṇḍalas, 43–45, 51–52
 in *Paramādyatantra,* 103, 105–10, 112, 114, 118–19, 143
 in *Prajñāpāramitānayasūtra,* 88–92, 132–34, 308n368
Vajranārāyaṇa, 115–17, 136
Vajrapadmodbhava, 115–17, 136
Vajrapāṇi
 as one of eight great bodhisattvas, 30–32, 38, 59–62, 133
 as one of lords of three families, 46–47
 icons of, 41–42, 57–61, 129
 in early triads, 15–18, 41–42, 44, 59, 70, 285
 in *Bhaiṣajyagurusūtra,* 20
 in Garbha-maṇḍala, 82, 141
 in *Guhyasamāja,* 170, 176, 183, 186, 190–91, 223
 in *Guhyatantra,* 45–46, 71
 in *Kālacakra,* 229, 253, 257
 in *Mañjuśrīmūlakalpa,* 52–53
 in *Paramādyatantra,* 115, 136
 in *Prajñāpāramitānayasūtra,* 89, 91–92, 97–98, 109–10, 112, 119, 133
 in Shōugyō mandara, 21–23
 in *Susiddhikaramahātantra,* 47–48
 relationship to wrathful deities, 34, 36
Vajrapañjaratantra, 210, 213, 277, 320n853
Vajrapāṇyabhiṣekatantra, 27, 40, 61–63, 73–78, 97, 286, 305n184
Vajrarāja, 42–44, 132, 134, 223
Vajrāsana, 15, 301n18
Vajrasattva, 35–36, 123
 as one of sixteen bodhisattvas, 132–33

colors, 272
equated with Samantabhadra, 97–98, 108, 132
family, 203–6, 220
iconography of, 98–99
in *Guhyasamājatantra*, 168, 174, 186
in *Kālacakra*, 249, 252–54, 257–59
in Mother tantras, 199–201, 203–7, 217, 223
in *Prajñāpāramitānayasūtra*, 88–91, 108
in *Samputatantra*, 227–28
in Vajradhātu-maṇḍala, 57, 148, 268
rasa of, 200–201
relation to Trailokyavijaya, 152
ritual manuals of, 137, 141, 144–45
Vajrasattva-maṇḍala, 100
in *Paramādyatantra*, 11, 103–7, 109–19, 139, 142–44, 185, 203
in *Samputatantra*, 227–28, 266
See also Paramādya-Vajrasattva maṇḍala
Vajrasattvamāyājāla, 193
Vajraśekhara cycle
eighteen assemblies of, 4, 85–86, 108–9, 133, 157–59, 165, 200, 214
fivefold system of, 88, 138–39, 154–55, 287
history of, 123–24
in China and Japan, 85–86, 158–59
in India, 145
influence on late tantric Buddhism, 126, 157, 214
maṇḍala patterns of, 263–65
merging of Samantabhadra and Vajrapāṇi in, 98
relation to *Guhyasamāja*, 165, 287
Vajraśekharamahāguhyayogatantra, 87, 90, 134–35, 140, 145, 158–59
Vajraśekharasūtra
as source of Vajradhātu-maṇḍala, 85–87, 123
in Japan, 92, 94, 123
in Tibet, 90
Vajraśṛṅkhalā, 65, 194, 210, 236, 244
Vajrasūrya, 199–201, 203–5, 213, 223, 226–27, 314n677
Vajrateja, 82–83, 132, 152, 200–201
Vajrāvalī (Abhayākaragupta), 10, 178, 195, 220–21, 226–27, 241, 255, 261–63, 267
Vajravārāhī, 210, 215–17, 220
Vajrāveśa, 95–96, 98, 141
Vajrayakṣa, 103, 105–7, 114, 132–33, 152
Vast Emancipation maṇḍala, 54–56, 61, 70, 74
vidyārāja deities, 34–37, 40, 48–49, 77, 120, 169. *See also* wrathful deities
Vijñaptimātra theory, 60, 280–81. *See also* Yogācāra
Vikramaśīla monastery, 171, 178–79, 255
Vilāsavajra school, 202, 214
Vimalakīrti, 31–33
Vimalakīrtinirdeśa, 75–76
Vimalaprabhā (Puṇḍarīka), 193, 229, 231–32, 239–241, 247–50, 254–58, 280–81
Vimśatividhi (Nāgabodhi), 10, 38, 44, 151, 180, 188, 194, 254, 263, 268, 272, 275, 281, 289
Viṣṇu, 51, 62, 66, 78, 115–16, 135–36, 233, 235
viśuddhipadas, 93–97, 101, 111, 137–39, 141–42, 145, 184, 203
Viśvamātā, 233, 236, 238, 254, 320n868

Viśvāmitra, 165–66

About the Author

D R. KIMIAKI TANAKA studied Indian philosophy and Sanskrit philology at the University of Tokyo, where he earned his doctorate in 2008. He has taught at several universities in Japan, as well as conducted fieldwork in India, Nepal, and Tibet. From 1997 to 2015 he was academic consultant for the Hahn Cultural Foundation (Seoul), and he is also chief curator of the Toga Meditation Museum in Toyama prefecture, Japan, and vice president of the Tibet Culture Centre International in Tokyo. He has published more than 50 books and 120 articles on esoteric Buddhism, Buddhist iconography, and Tibetan art and is currently a lecturer at the Toho Gakuin, Keio University, and Toyo University and also a research fellow at the Nakamura Hajime Eastern Institute.

What to Read Next from Wisdom Publications

Buddhist Teaching in India

Johannes Bronkhorst

"A most welcome addition to the growing literature on early Indian Buddhism."
—Charles Prebish, Redd Chair in Religious Studies, Utah State University

Ornament of Stainless Light

An Exposition of the Kālacakra Tantra
Khedrup Norsang Gyatso and Gavin Kilty

"Spectacular."—E. Gene Smith, founder, Buddhist Digital Resource Center

Himalayan Passages

Tibetan and Newar Studies in Honor of Hubert Decleer
Benjamin Bogin and Andrew Quintman

"The best new scholarship on the Himalayas."—Kurtis R. Schaeffer, chair, Religious Studies Department, University of Virginia

Principles of Buddhist Tantra

Kirti Tsenshap Rinpoche, Ian Coghlan, and Voula Zarpani

"Kirti Tsenshap Rinpoche was like the Kadam masters of the past in his profound renunciation. He showed not the slightest worldly activity, not a single one of the eight mundane concerns, and he had no self-cherishing thought. Everything he did, even talking, was utterly pleasing to the minds of sentient beings."—Lama Zopa Rinpoche

Vajrayoginī

Her Visualization, Rituals, and Forms
Elizabeth English

Editor's Choice—*Mandala*

About Wisdom Publications

Wisdom Publications is the leading publisher of classic and contemporary Buddhist books and practical works on mindfulness. To learn more about us or to explore our other books, please visit our website at wisdompubs.org or contact us at the address below.

Wisdom Publications
199 Elm Street
Somerville, MA 02144 USA

We are a 501(c)(3) organization, and donations in support of our mission are tax deductible.

Wisdom Publications is affiliated with the Foundation for the Preservation of the Mahayana Tradition (FPMT).